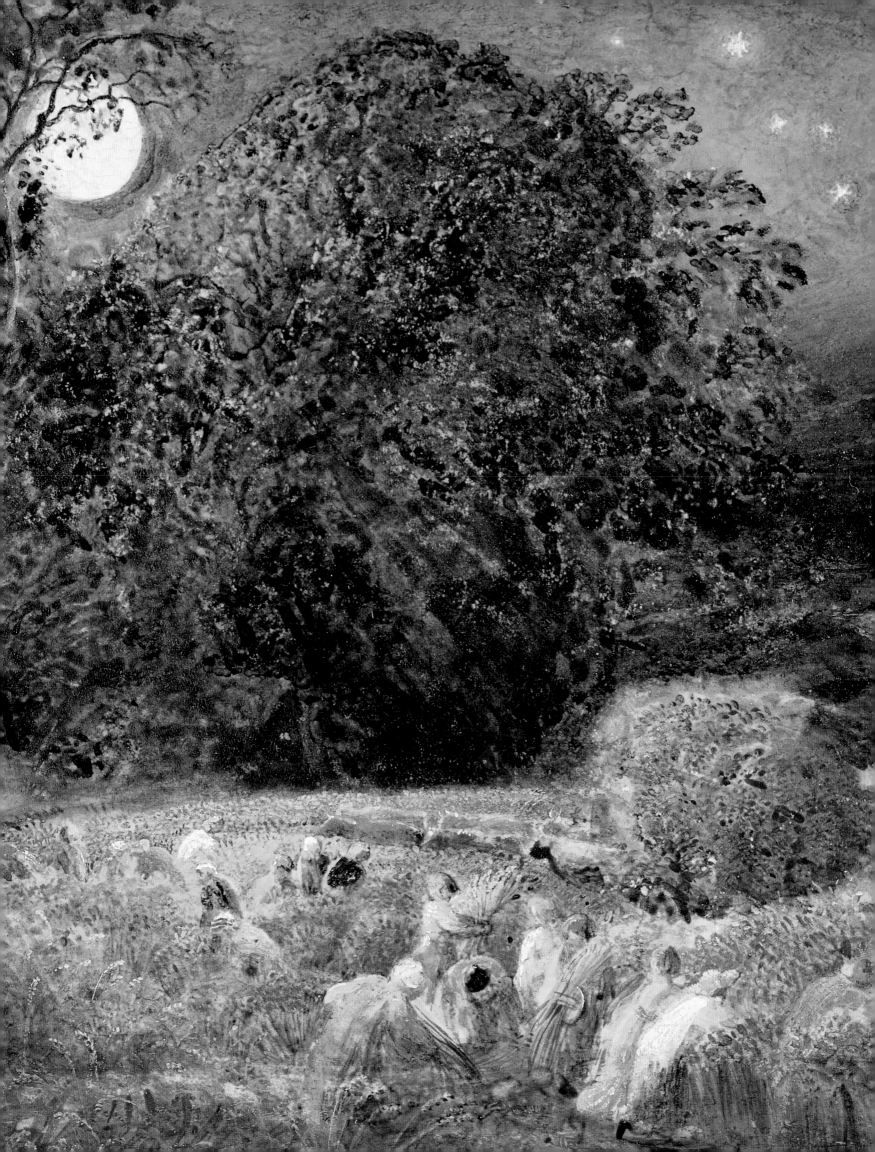

Paul Mellon's Legacy
A Passion for British Art

Masterpieces from the Yale Center for British Art

ESSAYS BY

John Baskett

Jules David Prown

Duncan Robinson

Brian Allen

William Reese

With contributions by Cassandra Albinson, Elisabeth Fairman, Lisa Ford, Gillian Forrester, Matthew Hargraves, Eleanor Hughes, Julia Marciari Alexander, Morna O'Neill, Stéphane Roy, Angus Trumble, and Scott Wilcox

YALE CENTER FOR BRITISH ART
ROYAL ACADEMY OF ARTS

YALE UNIVERSITY PRESS
NEW HAVEN AND LONDON

Page i
Paul Mellon's bookplate,
from his library at Oak Spring

Page ii
Detail of cat. 114

Page vi
Detail of cat. 131

Page viii
Detail of cat. 50

Page xi
Paul Mellon with the portrait bust
of Thomas, 1st Baron Dartrey,
by Joseph Wilton

Page 13
Detail of Prown, fig. 15

Page 27
Detail of cat. 68

Pages 40–41
Detail of Allen, fig. 8

Page 55
Detail of cat. 76

Pages 72–73
Detail of cat. 86

Pages 202–3
Detail of cat. 120

Page 317
Cat. 138, binding

Jacket illustration
J. M. W. Turner, *Dort, or Dordrecht,
the Dort Packet-boat from Rotterdam
Becalmed*, 1818 (cat. 90)

This book was produced in association with the exhibition *Paul Mellon's Legacy: A Passion for British Art,* organized by the Yale Center for British Art and the Royal Academy of Arts in celebration of the centenary of Paul Mellon's birth.

Exhibition dates: Yale Center for British Art, New Haven, Conn. (18 April–29 July 2007) and the Royal Academy of Arts, London (20 October 2007–27 January 2008).

**This publication has been generously supported
by Mellon Financial Corporation.**

Support for the exhibition in New Haven has been provided by Mr. and Mrs. Bart T. Tiernan, Yale LL.B. 1968.

Exhibition curated by Brian Allen, John Baskett, and MaryAnne Stevens.
Receiving curator at the Royal Academy of Arts: MaryAnne Stevens.

Exhibition coordinated by Timothy Goodhue, Julia Marciari Alexander, and Beth Miller, Yale Center for British Art, and Cayetana Castillo and Hillary Taylor, Royal Academy of Arts.

Designed by Jenny Chan, Jack Design
Set in Monotype Bulmer by Jenny Chan and Amy Storm

Printed and bound in Italy by Mondadori

Library of Congress Cataloging-in-Publication Data

Paul Mellon's legacy : a passion for British art masterpieces from the
Yale Center for British Art / essays by John Baskett ... [et al.] ;
with contributions by Cassandra Albinson ... [et al.].
 p. cm.
 Includes index.
 ISBN: 978-0-300-11746-2 (hardcover edition : alk. paper)
 ISBN: 978-0-9790378-0-1 (pbk. edition : alk. paper)
 ISBN: 978-1-905711-02-4 (pbk. edition : alk. paper)
 [etc.]
 1. Mellon, Paul—Art collections. 2. Yale Center for British Art.
 3. Art, British—Private collections—United States. I. Baskett, John.
 N5220.M55P38 2007
 709.41—dc22
 2006036240

10 9 8 7 6 5 4 3 2 1

A catalogue record for this book is available from the British Library.

The paper in this book meets the guidelines for permanence and durability of the Committee on Production Guidelines for Book Longevity of the Council on Library Resources.

Contents

FOREWORDS

vii Amy Meyers *Director, Yale Center for British Art*

ix Sir Nicholas Grimshaw *President, Royal Academy of Arts*

ESSAYS

1 Paul Mellon: A Remembrance

John Baskett

15 Paul Mellon and the Architecture of the Yale Center for British Art

Jules David Prown

29 Paul Mellon and the Yale Center for British Art

Duncan Robinson

43 Paul Mellon and Scholarship in the History of British Art

Brian Allen

57 Paul Mellon as a Book Collector

William Reese

GALLERY OF WORKS

73 Fine Arts

203 Book Arts

CATALOGUE

240 Fine Arts

298 Book Arts

312 Selected Exhibitions

318 Selected Literature

326 Index

335 Photography Credits

Okc:

Pynappl:

Pedie:

Rose:

Amy Meyers
Director, Yale Center for British Art

Foreword

Paul Mellon's Legacy: A Passion for British Art celebrates the thirtieth anniversary of the Yale Center for British Art and commemorates the centennial of the birth of its founder, Paul Mellon (Yale College, Class of 1929). Together, the related exhibitions presented at the Yale Center and at the Royal Academy of Arts demonstrate Mr. Mellon's unparalleled collecting activity in the field of British art. They also highlight his remarkable vision in creating an institution in North America that serves both as a public museum for British art and as a research institute at Yale, one of the world's great universities.

The Paul Mellon Collection is among the most comprehensive representations of the visual arts of a single culture ever assembled. As the largest collection of British art outside the United Kingdom, it includes approximately two thousand paintings, fifty thousand prints and drawings, thirty-five thousand rare books and manuscripts, and several hundred pieces of sculpture. Mr. Mellon also provided funds for a landmark building, designed by Louis I. Kahn, to house the collection, and an endowment to support the institution and ensure that public admission will always be free.

At the Yale Center, *Paul Mellon's Legacy* marks the first time since the institution opened in 1977 that the entire building has been devoted to the display of Mr. Mellon's collection. At the Royal Academy, the exhibition will include a major selection of works from the Center's display, representing both the most important of Mr. Mellon's gifts to the Center and his personal favorites. This catalogue records this very special selection.

Paul Mellon's Legacy has been sensitively curated by Brian Allen, Director of Studies, Paul Mellon Centre for Studies in British Art, London; John Baskett, former art advisor to and friend of Paul Mellon; and MaryAnne Stevens, Acting Secretary and Senior Curator at the Royal Academy; in consultation with Norman Rosenthal, Exhibitions Secretary of the Royal Academy. Special thanks are due to them, as well as to the Yale Center's curatorial staff, for their splendid efforts. The curators collaborated with the exceptional team of essayists including Duncan Robinson, Director of the Fitzwilliam Museum and Master of Magdalene College, University of Cambridge; Jules Prown, Paul Mellon Professor Emeritus of the History of Art, Yale University; and William Reese, former book advisor to Paul Mellon. They also worked closely with scholars at the Yale Center who have written the individual catalogue entries. Each staff member of the Yale Center has worked on this project in some meaningful way, and I am immensely grateful to all for their contributions.

The Yale Center is indebted to the Mellon Financial Corporation for its generous gift toward the publication of this catalogue, and we deeply appreciate the magnanimous support for the exhibition in New Haven given by Mr. and Mrs. Bart T. Tiernan, Yale LL.B. 1968. Gratitude is also extended to Christie's for hosting many of the opening festivities on both sides of the Atlantic. We wish to convey additional thanks to Mr. Mellon's Executors, Beverly Carter and Frederick A. Terry, Jr., Esq., for the warm enthusiasm they have expressed for the project from its genesis.

The Royal Academy of Arts is an ideal partner for this exhibition since a large number of artists represented in the Paul Mellon Collection were Royal Academicians, and, indeed, Mr. Mellon himself was an Honorary Corresponding Member of the Royal Academy. It is fitting, then, that we celebrate his relationships with both the Center and the Royal Academy as sister institutions. We are delighted that so many treasures from the Center can return to England as our centennial tribute to Paul Mellon, a man whose passion for British art created an unmatched legacy.

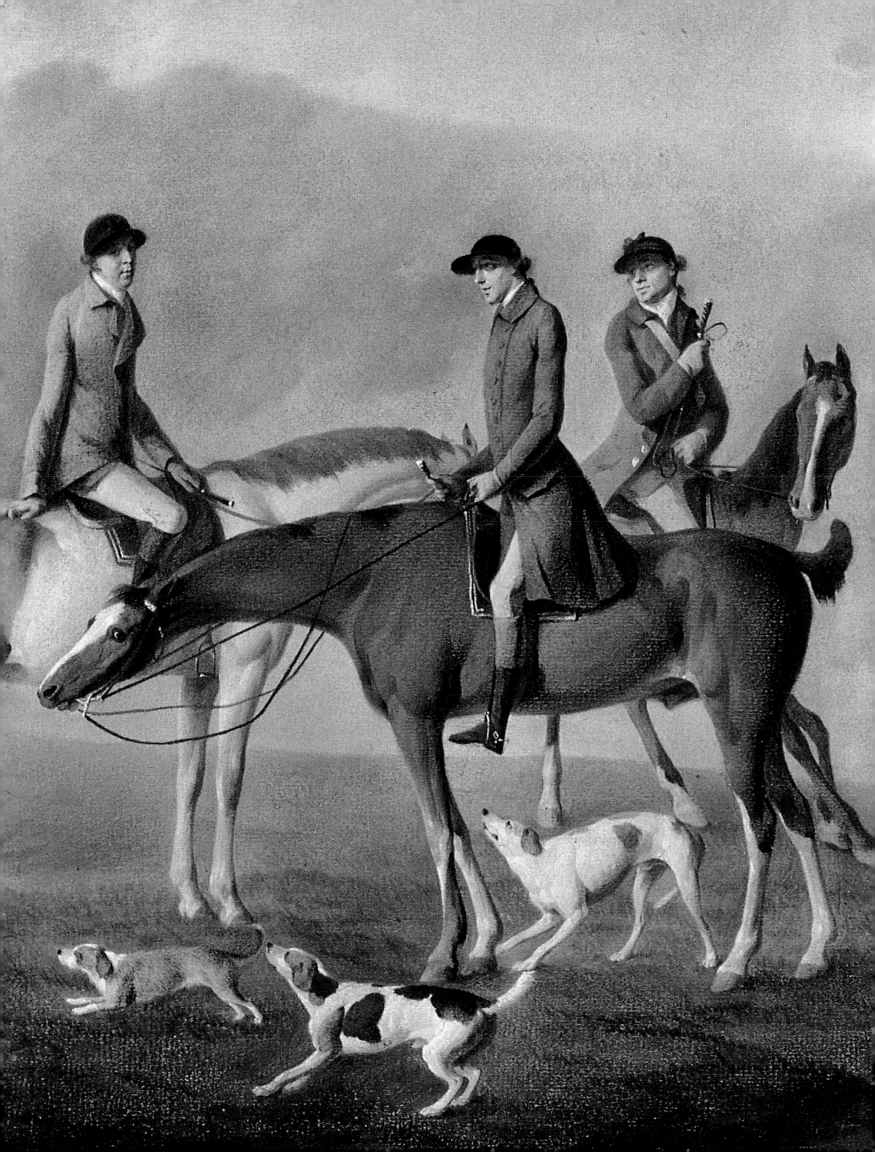

Sir Nicholas Grimshaw CBE
President, Royal Academy of Arts

Foreword

'Mr. Paul Mellon has long been known as a lover of English art, but it is only in recent years that he has assembled the very remarkable collection which now ranks as one of the finest of its kind either in private or public ownership anywhere in the world.' Thus wrote Sir Charles Wheeler, the then President of the Royal Academy, on the occasion of the presentation at the Royal Academy in the winter of 1964–65 of 304 works acquired by Paul Mellon.

The President's words were prescient, for over the ensuing three and a half decades Paul Mellon's taste and knowledge, together with his deep and lasting affection for Britain, ensured that he build so important a collection of British art that its distinction is unique beyond our shores and unquestionably rivals our own national holdings. This would be cause alone for the Royal Academy, an institution created over two hundred years ago for the promotion and support of art, to present an exhibition during the centenary year of his birth. However, there are other, equally compelling reasons for mounting this exhibition here. In recognition of the scale and quality of his acquisitions, the Royal Academy has over the past forty years already held not only the exhibition referred to above, namely *Painting in England, 1700–1850, from the Collection of Mr. and Mrs. Paul Mellon,* but also one drawn solely from Mr. Mellon's exceptional holdings of works by Thomas Rowlandson, *Rowlandson Drawings From the Paul Mellon Collection,* in 1978. Of equal significance is the fact that Paul Mellon, elected Honorary Corresponding Member in 1977, chose the Royal Academy as one of very few British institutional beneficiaries of his will. Through this selection of his finest paintings, drawings, watercolours, rare books and manuscripts, the current exhibition stands, therefore, as a tribute not only to an exceptional collector, but also to the person who provided the framework within which the academic study of the history of British art has flourished and who was a most generous benefactor.

Paul Mellon's Legacy: A Passion for British Art is the result of a close collaboration between the Royal Academy and the Yale Center for British Art. It was curated by Brian Allen, Director of Studies at the Paul Mellon Centre for Studies in British Art, London, John Baskett, former advisor to and close friend of Paul Mellon, and MaryAnne Stevens, Acting Secretary and Senior Curator at the Royal Academy, in consultation with Norman Rosenthal, Exhibitions Secretary of the Royal Academy. Invaluable and enthusiastic support has also been received from colleagues at the Yale Center for British Art, notably its Director, Amy Meyers, and its curators, Angus Trumble, Scott Wilcox and Elisabeth Fairman. In addition, important contributions have been made by the conservators, exhibition organisers and registrars in New Haven and London, including Timothy Goodhue, Hillary Taylor and Cayetana Castillo.

We extend our profound thanks to the Mellon Financial Corporation for their generous support. We also acknowledge Christie's for a wonderful series of opening events.

This exhibition provides a splendid survey of the great achievements of British art from the rise of the British School to its apogee during the careers of Constable and Turner. Equally it is a reflection of a great collector's taste and personal commitment to a school of art which until relatively recently had been little recognised. We would hope that our visitors will enjoy, appreciate and understand both aspects of this exceptional story.

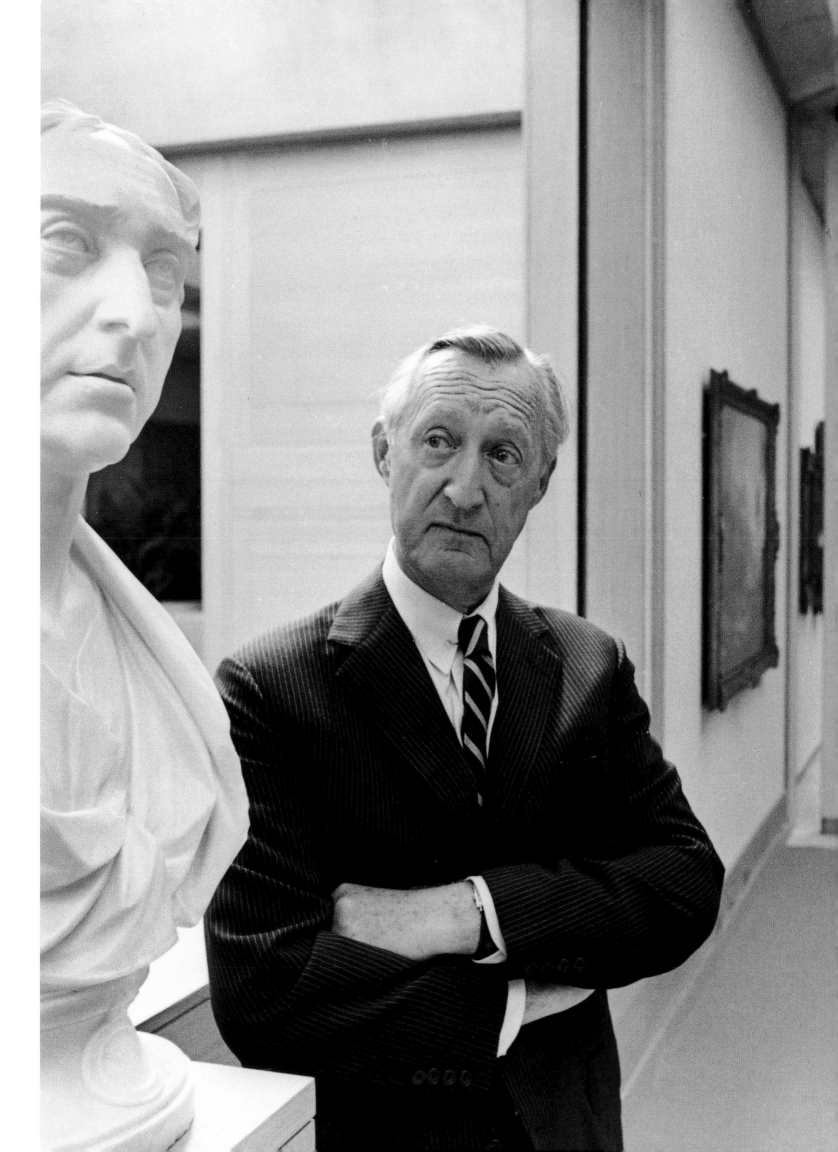

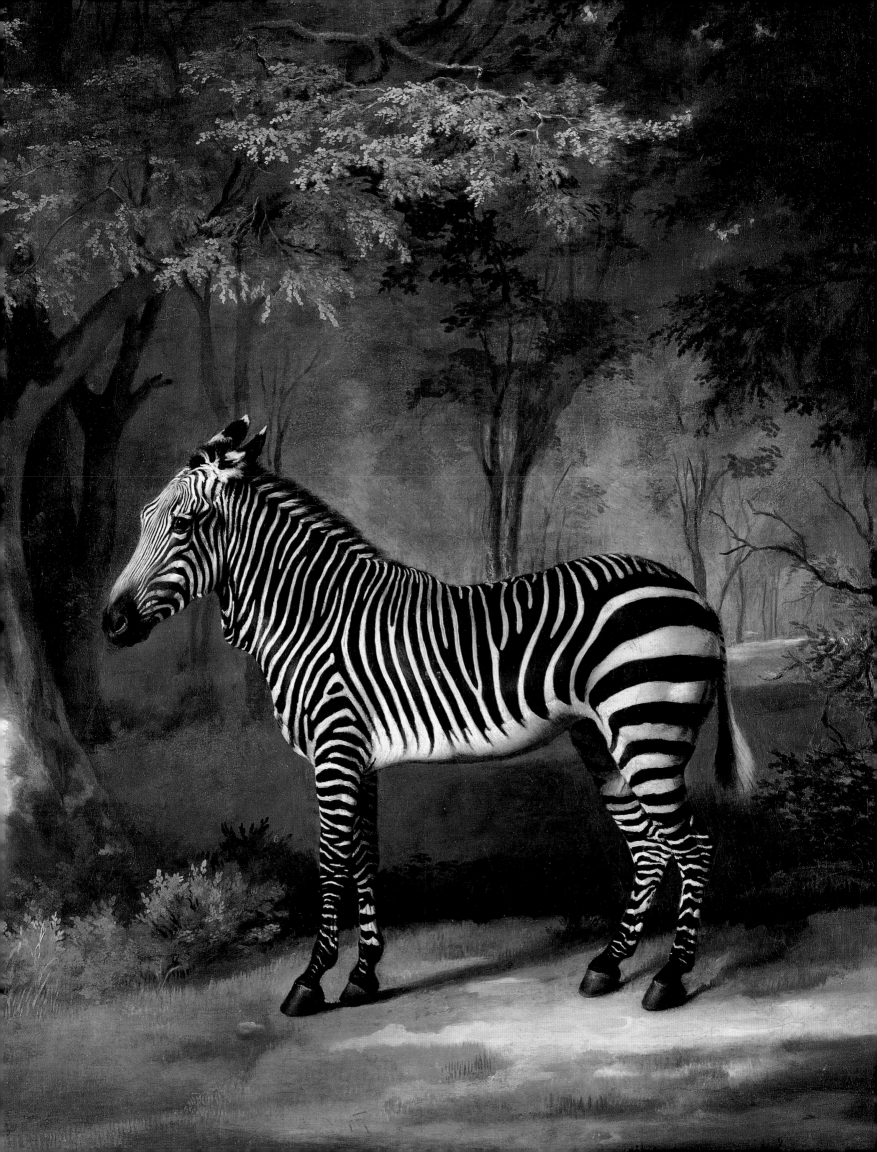

Paul Mellon:
A Remembrance

JOHN BASKETT

George Stubbs painted his beautiful picture of the Zebra (fig. 1) shortly after the animal's arrival in England. It travelled from the Cape of Good Hope aboard H.M.S. *Terpsichore* in 1762, and was duly presented to Queen Charlotte. This exotic specimen was installed in the Royal Menagerie, where it was to be found 'feeding in a paddock near her majesty's house'. Stubbs painted the animal from life against an imaginary forest background. He exhibited the picture the following year at the Society of Artists, a precursor of the Royal Academy, which was established five years later. After passing through a number of hands the painting reappeared nearly two hundred years later, in 1960, among a selection of old washing machines and second-hand goods that Harrods, the famous department store, used to offer for auction as a side-line. It did not go unnoticed and fetched £20,000, then not an insubstantial sum. Despite being pressed by the media, Colnaghi's, the Bond Street art dealers who had bought it, were not prepared to disclose for whom they had been acting. Paul Mellon, quietly, as was his way, had entered the stage as a collector of British art.

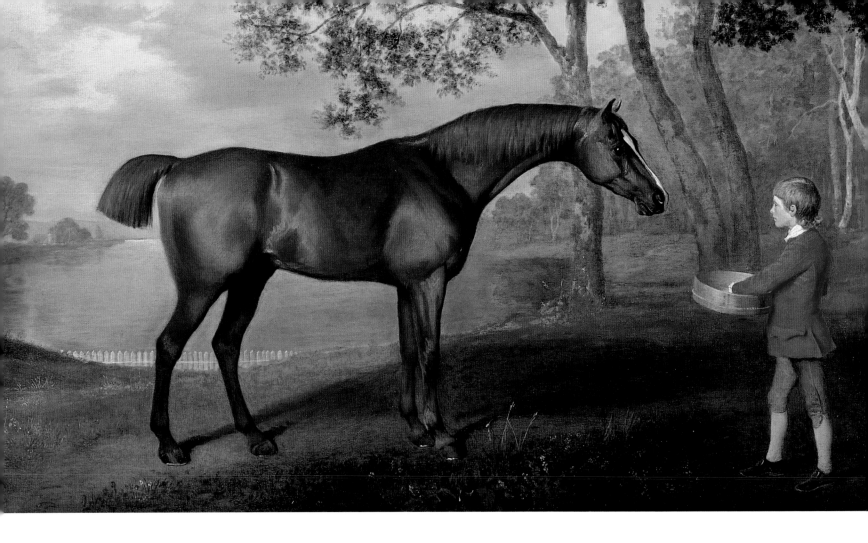

(overleaf)

FIG. 1 Detail of cat. 23, George Stubbs, *Zebra*, 1762–63, oil on canvas, 40½ x 50¼ in. (102.9 x 127.5 cm). Yale Center for British Art, Paul Mellon Collection. B1981.25.617

FIG. 2 Detail of cat. 25, George Stubbs, *Pumpkin with a Stable-lad*, 1774, oil on panel, 31½ x 39¼ in. (80 x 99.5 cm). Yale Center for British Art, Paul Mellon Collection. B2001.2.69

Years earlier, in 1936, at the age of twenty-nine, Mr. Mellon had bought one other English painting, from Knoedler's, in New York. Again, it was a Stubbs, *Pumpkin with a Stable-lad* (fig. 2). This picture always held a warm place in his heart, I suspect because it was the first occasion when he had felt himself able to apply his own taste and judgement in the shadow of his father's renowned collection of Old Masters. Apart from a few desultory purchases, however, it would be another twenty-three years before he looked seriously again at British painting. He attributed the long gap to the fact that he had been doing many other things in the meantime. This was of course true — he got married, had children, went to war — but there were less obvious factors, which we will look at shortly.

Paul Mellon subsequently became the greatest collector of the second half of the twentieth century, and he was certainly the greatest collector of British art from any period. In 1959, aged fifty-two, he started to form a collection of British art that was to prove, in quality, the equal of any of Britain's national collections, as well as the most comprehensive of any such collection held outside the United Kingdom. Within seven years Yale University was able to announce that he would be giving them this still growing collection, which ultimately reached some two thousand paintings, fifty thousand drawings and prints and thirty-five thousand rare books and manuscripts, together with a building to house them, along with endowment funds for maintenance of the building and for academic and curatorial purposes. The Yale Center for British Art opened in 1977. A small selection from its holdings is displayed in this exhibition to celebrate the centenary of Paul Mellon's birth.

Paul Mellon (fig. 3) was the only son of Andrew Mellon (fig. 4), an American of dour Scots-Irish descent and a brilliant city banker from Pittsburgh who had become, with John D. Rockefeller and Henry Ford, one of the three wealthiest men in the United States. The elder Mellon had gone

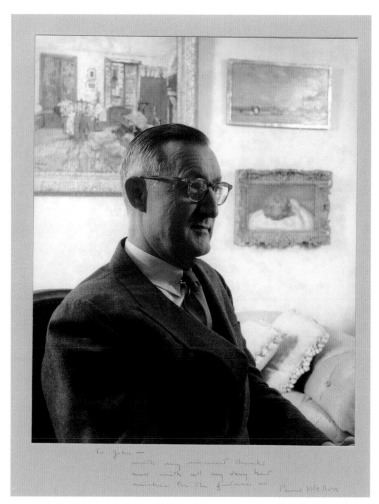

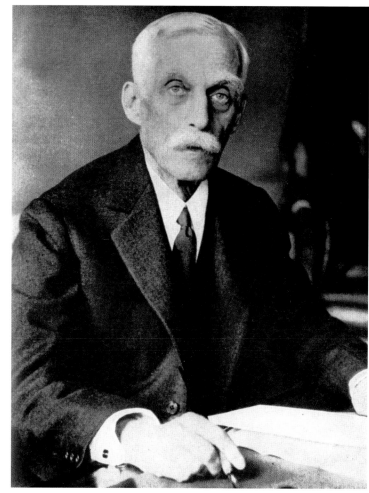

FIG. 3 Paul Mellon, ca. 1963, with an inscription by Mr. Mellon to John Baskett: *To John—with my sincerest thanks and with all my very best wishes for the future—Paul Mellon*

FIG. 4 Andrew Mellon

on in the latter part of his life to serve, first as Secretary of the Treasury under three Presidents, and then, for a short period in London, as Ambassador to the Court of St. James. Paul Mellon's English mother, Nora McMullen, a flighty and lively woman, was the daughter of a Hertfordshire brewer, who had been brought up with eight older brothers. She nourished a deep love of horses and of the countryside.

A number of factors combined to secure Mellon's lasting affection for England, but the first must surely be his baptism in St. George's Chapel at Windsor, burial place of so many kings and queens of England. His parents had brought him on a visit to England as a six-month-old child. One day, when they found themselves in conversation with the Dean of Windsor, his mother rather cannily let it be known that their son had not received baptism. The Dean was horrified and promptly offered to perform the service himself. So it was that the ceremony took place exactly one hundred years ago, on 22 December 1907. In later years Paul Mellon found himself especially vulnerable to offers of painted views of Windsor Castle!

Paul Mellon returned to England in 1913, aged six (fig. 5), following the bitter divorce of his parents the previous year. He and his father, with a nurse, stayed at the Hyde Park Hotel in Knightsbridge and then at a rented elegant eighteenth-century house, Down House (now demolished), by the Thames. Every detail of this holiday remained indelibly fixed in Paul Mellon's mind seventy-five years later when, as an old man, he related his memoir — sailing his toy boat in the Round Pond in Kensington Gardens, watching suffragettes protesting, flags, music, the twenty-five-mile motor car journey (accompanied by several punctures), then the river and all about him the English landscape. He unconsciously absorbed a rather romantic view of pre-First World War England that would be reflected in his choice of paintings later in life. He said, '[That period] had the colour and feeling of childhood itself, a most beautiful and peaceful interlude'.

He attended Yale University where, appropriately, he focused on English studies. It was a period that engendered his interest in literature and poetry rather than in paintings and drawings. His time at Yale coincided with that of a group of legendary scholars and lecturers at the university. Not long after graduating in 1929, he began building up a library, described here in William Reese's essay, that was to include colour-plate books, the renowned libraries of Major J. R. Abbey and William Locke, Americana, botanical and natural history books, a sporting library and a remarkable collection of William Blake material. Yale has every reason to be glad to have had him as a student (he nearly went to Princeton), because he turned out to be one of the most munificent donors and supporters in the history of the university.

Following Yale, Paul Mellon spent two years in England at Cambridge. Although studying history at Clare College, he was, by his own admission, more interested in sport, namely fox hunting and rowing. In fact Mr. Mellon discovered fox hunting in England, and the friendships formed at this time helped to deliver him from a natural shyness that had dogged his earlier life. This period did much to cement his vision of Englishness, a vision that always harboured rather romantic overtones. He reflected the image of Cambridge portrayed in Rupert Brooke's *The Old Vicarage, Grantchester*, when, in his speech delivered at the opening of the exhibition of his English pictures at the Virginia Museum of Fine Arts, in 1963, he said, 'Cambridge I loved, and I loved its grey walls, its grassy quadrangles, St. Mary's bells, its busy, narrow streets, full of men in black gowns, King's Chapel and Choir and candlelight, the coal-fire smell, and walking across the quadrangle in a dressing gown in the rain to take a bath. In the winter it got dark at 3:30, and all winter the wet wind whistled straight across from the North Sea'.

After coming down from Cambridge, Paul Mellon bought a number of sporting and colour-plate books, but as yet showed no interest in buying pictures. This was understandable when one bears in mind that at this period, between 1930 and 1931, his father was negotiating, through agents, with the Bolshevik government of Russia for the purchase of twenty-one masterpieces from

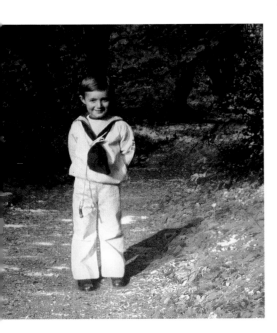

FIG. 5 Paul Mellon at Dartmouth, in England, aged six, 1913

the Hermitage Museum and making other major acquisitions of Old Master paintings with a view to establishing a National Gallery in Washington, D.C. In such circumstances, one could hardly appear, in one's twenties, to be in competition with one's own father!

In late 1933 Paul Mellon met his first wife, Mary Conover, and they got married a little over a year later. Through her, he developed an interest in psychology, and they spent periods in Zurich in 1938 and 1939 at which time Mr. Mellon got to know Dr. Carl Jung. The upshot of this relationship was that in 1945 Paul and Mary Mellon founded the Bollingen Foundation, named after the lakeside village where Jung had built a home. The Foundation published many influential books over the next forty or so years including the 'I Ching' and Joseph Campbell's *The Hero with a Thousand Faces*, and had Jung's works translated into English.

In 1941, Paul Mellon, who always had a penchant for the military life, registered for the draft, even before America entered the war. He underwent cavalry training and was subsequently posted to England, where he joined up with the European Office of Strategic Services (OSS), an operation at that time headed by his brother-in-law, David Bruce.[1] After qualifying as a parachutist he was seconded to the British agency, Special Operations in Europe (SOE), where he trained secret agents, many of them women, who were to be dropped into enemy-occupied France. He told me he always had the greatest admiration for the courage of these people. Later he sailed over to Omaha Beach, three weeks after the initial landing, and served in France, reaching the rank of major (fig. 6).

His wife, Mary, died from an asthmatic attack in 1946, shortly after his return from Europe, and two years later he married his second wife, Rachel (Bunny) Lloyd. By this time his father had been dead for eleven years. Soon after this second marriage, in 1948, Paul Mellon began visiting art dealers in New York and Paris with his new wife, encouraged by Chester Dale, a New York stockbroker who, with his own wife, had formed a remarkable collection of French Impressionist paintings. Dale, who served as President of the National Gallery of Art in Washington, D.C., from 1955 to 1962, subsequently left his pictures to the Gallery. Paul and Bunny Mellon started buying French paintings from Wildenstein, Knoedler's, Sam Salz and Alexandre Rosenberg. In 1958 they made major purchases of French paintings in the Goldschmidt sale at Sotheby's, triggering the rise of the auction houses, an event about which Paul Mellon later had mixed feelings. Their superb collection of French pictures, with the exception of those paintings left to furnish the residences of Paul Mellon's widow and some donated and bequeathed to the Virginia Museum of Fine Arts, are now with the National Gallery of Art, where he had served variously as President, Chairman and Trustee over many years.

In the spring of 1959 Paul Mellon, a keen and accomplished horseman, was staying at the Virginia resort of Hot Springs and taking part in a competition named the Hundred Mile Trail Ride. On the first morning, he had an unexpected visitor at breakfast in the person of Leslie Cheek, then Director of the Virginia Museum, who had driven over to ask him to chair the British and American committees of an exhibition to be called 'Sport and the Horse'. So Mr. Mellon found himself heading a committee of four dukes, five earls, a captain and a major. The honorary patrons were the Queen of England and the President of the United States. Cheek went for the big names. Lord Halifax was to give the address when the exhibition opened, in April 1960, and the catalogue on the British, French and American exhibits was to be written by Basil Taylor (fig. 7), then Librarian at the Royal College of Art. Taylor's fifteen-page introduction described the work of the various artists represented in the exhibition: their understanding of the horse's anatomy, their skills in horse portraiture and their portrayals of hunting and racing scenes. There was a long article on George Stubbs.

Aware of the preparations for this exhibition, Paul Mellon had already made his first move, for in June 1959 he had asked Basil Taylor to have luncheon with him at Claridge's. Both men were quite shy but both must have been aware of the opportunity that lay within their grasp.

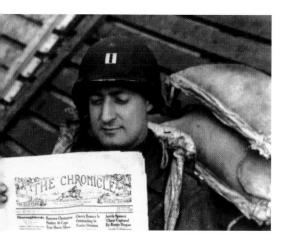

FIG. 6 Paul Mellon on his way to Omaha Beach, 1944

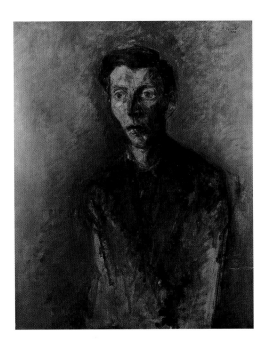

FIG. 7 Gerald Frankl, *Portrait of Basil Taylor*, 1953

They were fully aware that British art was needlessly neglected and undervalued. Taylor was very persuasive in his quiet way, and he had an almost missionary zeal to do something about it. Paul Mellon, too, was strongly attracted by the idea. By the time they were drinking coffee an arrangement had been arrived at whereby Paul Mellon would start to form a collection of British art and Basil Taylor would be his advisor. Taylor was to play a pivotal role for the next nine years. His only caveat, prompted by memories of Bernard Berenson, was that he shouldn't receive any remuneration.

We cannot know for sure what was passing through Paul Mellon's mind at this time. His only comment, when asked, was that these things happened by stages. He wasn't the sort of person to make spontaneous decisions and he must have been giving the matter serious thought for some time before his meeting with Taylor. The 'Sport and the Horse' exhibition may well have been the catalyst, but his father's collecting activity and experiences as a benefactor to the nation were very likely to have been a component.

At the time of Paul Mellon's first purchase, the Stubbs painting in 1936, his father, Andrew Mellon, then in his eighties and approaching the end of his life, was busy planning the creation of the National Gallery of Art, in Washington, D.C. It was an undertaking he had had in mind for a number of years and the Gallery was formally established the following year by joint resolution of Congress. Andrew Mellon had begun to collect Old Master paintings seriously in the 1920s, and it became clear towards the end of that decade that his ultimate objective was to donate his collection to the people of the United States of America, together with a building to house it. As a financial vehicle for this purpose he formed the A. W. Mellon Educational and Charitable Trust.

Unfortunately, the Roosevelt administration, angry at the policies pursued by the earlier Republican government, during which time Andrew Mellon had been Secretary of the Treasury, brought a case against him, citing tax evasion on the part of the Educational and Charitable Trust. After lengthy proceedings, Mellon was exonerated on all counts, but only after his death, in 1937. The eminent journalist Walter Lippmann described the whole affair as 'having the appearance of a low and inept political maneuver'. David Cannadine, in his biography of Andrew Mellon, also described this episode as not being Roosevelt's finest hour.[2]

Perhaps with this event in mind, when offering the building and his collection to the nation, Andrew Mellon made the gift conditional, with the strict stipulation that, although the government, through the Smithsonian Institution, would be responsible for staffing and maintaining the

museum, a self-perpetuating body of privately appointed trustees should always outnumber those trustees appointed through the government. The administration could take the offer on those terms or leave it. Politically, Roosevelt and Congress felt they had no choice but to take it. At the opening ceremony of the National Gallery of Art in 1941, where Paul Mellon represented his father, Roosevelt airily praised Andrew Mellon, comparing 'the richness of his gift with the modesty of his spirit'.[3] There should be little surprise that, as a result of his father's experience, Paul Mellon distanced himself from politics throughout his life. He never sought office, and his dealings concerning the disposition of his collections were all conducted through museum and university bodies.

Paul Mellon had been appointed by his father as a Founder Trustee of the A. W. Mellon Educational and Charitable Trust in 1930, at the age of twenty-three. Andrew Mellon had hardly consulted his shy son at the time. Shy he may have been, but underneath it there was a steely determination. First he was unswerving in his intention, despite his father's wishes, that he would not follow in his father's footsteps and make a life for himself in the Mellon Bank. Second, he resolved to plough his own furrow, although it was not clear to him at the time what this should be. Ironically, Andrew Mellon had faithfully and happily followed *his* father, Thomas Mellon, into the bank, yet Thomas, whose father, also named Andrew, hoped that he would join him on his farm, took the same independent line as Paul, and opted, in his case, for banking and the city life. Although Paul Mellon never knew his grandfather, who died the year after his birth, he said he felt very close to him on this account, and went to the trouble of having his grandfather's memoirs republished.

It would appear that Andrew Mellon never had any great confidence in Paul's abilities, the sort of confidence that any son would wish to enjoy. It is true that sons of high-achieving, dynamic fathers often lead sad, unfulfilled lives, but how this father would have changed his opinion had he lived another sixty years! Yet Paul Mellon could probably have achieved what he did only in the absence of his father, albeit with the inheritance his father had left him. He stated in his memoir, 'I do not know, and I doubt if anyone will ever know, why Father was so seemingly devoid of feeling and so tightly contained in his lifeless, hard shell'. Yet Paul Mellon throughout his life respected his father and had a high regard for his integrity. Further, he adopted a number of his father's approaches to management. He learned from his father about delegating. Like his father he found managers to look after his various interests and when his affairs were going well, he showed tremendous loyalty and just oversaw things in a general way.

After the luncheon with Basil Taylor, things moved forward very rapidly. Paul Mellon consulted John Walker, then Director of the National Gallery of Art, who pointed him towards some London dealers. Walker had himself been considering publishing a series of books on British art, but Paul Mellon dissuaded him from the idea, establishing instead the Paul Mellon Foundation for British Art with the same objective.[4] The Foundation was based in London but was under the financial control for a short time of his Bollingen Foundation, and then of his Old Dominion Foundation in Washington, D.C. Basil Taylor was appointed Director with a salary, thus solving in an acceptable manner the question of his remuneration.

It was at this time that Basil Taylor recommended me to Mr. Mellon as someone who could put his fast growing collection into some sort of order. In 1961 I took two years leave of absence from working as an assistant to my father in the Bond Street art-dealing firm of Colnaghi's, and left London for that period to be his first curator, in Virginia. During my memorable and very enjoyable stay I formed close relationships with both Mr. and Mrs. Mellon and Basil Taylor. Taylor himself was touring the London dealers, establishing relationships with those whom he felt he could trust. The London art world of the early 1960s was very different from that of today. The art trade had not yet recovered from the effects of the Great Depression, followed by the Second World War. Older dealers continued to look back nostalgically to the 1920s. Museums,

for their part, were rather inward-looking institutions. For some inexplicable reason, there had long been indifference, almost approaching hostility, towards our native artists among many scholarly curators, whose interests centred almost entirely on Italian Renaissance art as well as on the continental Northern schools. There was almost a feeling that British art belonged properly to the corridors of country houses. As a result, supply was outpacing demand and prices were modest. It was into this market that Paul Mellon made his debut.

A procedure quickly evolved whereby Basil Taylor examined paintings at the invitation of the London dealers, asking them to send photographs of any he chose as being eligible to Mr. Mellon for his consideration. He would then type a letter to Mr. Mellon on blue airmail paper on his old Olivetti typewriter. The typewriter had seen better days and the print was subject to pitch and roll, and frequently the typing continued off the bottom of the page. The subject matter, too, might best be described as 'stream of consciousness', referring to his observations on the photographs which Mr. Mellon would have received, mixed up with Taylor's thoughts about art as well as gossip and domestic matters. Mr. Mellon, with his breakfast tray, would digest all this. Occasionally Taylor flew over to America to discuss progress.

The selection of pictures and drawings was naturally dependent up to a point on what was appearing on the market at any given time, but Taylor had in mind a comprehensive collection, focusing chiefly on the period between the earlier ministries of Robert Walpole in the eighteenth century and the accession of Queen Victoria in the nineteenth, a period that reflected Mr. Mellon's historical interests. In fact, it was clearly understood from the start that Mr. Mellon would be the final arbiter of what was chosen, although he was always pleased to listen to advice. He had a love of horses, sporting subjects, the English countryside and English topography, portraiture and the exploits of the Englishman abroad — in other words, the historical and literary background of the England he had grown to love. There was a strong linkage in both men's approach towards British art. Notably absent at this point, however, were the full-scale eighteenth-century portraits so much admired by his father's generation. Either he thought they were already fully represented in the United States or they didn't appeal to him — probably a little of both.

Paul Mellon made it clear that, in addition to paintings, Taylor had opened his eyes to the attraction of watercolours and drawings. Drawings were even more plentiful than paintings in the early sixties and presented fewer problems with storage. His holdings in this area were enormously enlarged by the acquisition of collections of watercolours and drawings which had been formed earlier in England by others. Thus, he acquired the Duke, Lowinsky, Martin Hardie, Iolo Williams and Girtin collections, to include many examples by the great names. To these were added many more artists such as Thomas Rowlandson, that great chronicler of the late eighteenth century and Regency periods, who was very much to Paul Mellon's taste.

With the arrival of so many paintings, a logistical problem presented itself concerning where to put them. Paul Mellon had houses in Virginia, Washington, D.C., New York and Cape Cod, but these already contained the earlier purchases of French and American paintings. The solution was found with a house that he had occupied with his first wife on the farm in Virginia. This house, which in any other part of Virginia would have been called a mansion, was euphemistically named 'the Brick House' (fig. 8), located on 'the farm', which itself was a 4,500-acre estate. The house had fallen into disuse when he and his second wife moved to a comfortable farmhouse built for them nearby, so he had it converted into a picture gallery and library, a repository for his collections of paintings, drawings, prints and books.

Mr. Mellon, who was then in his early fifties, took a keen interest in his collections at the same time as in his racing (his classic racehorse 'Mill Reef' won the Epsom Derby in 1971, and his American-trained 'Sea Hero' won the Kentucky Derby in 1993), horse breeding, philanthropy and foundation and museum trusteeships. The collection was growing at an astonishing speed and by

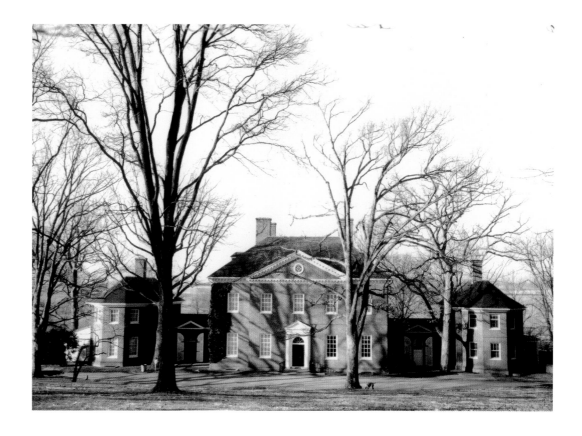

1963 an exhibition was planned to show what had been accomplished to date. The venue was to be the Virginia Museum of Fine Arts, where Paul Mellon was a Trustee. As with *Sport and the Horse*, Taylor was again invited to write the catalogue. The exhibition was entitled *Painting in England, 1700–1850, Collection of Mr. & Mrs. Paul Mellon* and it opened in April of that year with a display of 451 paintings. It was a very festive occasion. In a speech after the opening, Paul Mellon explained his motives for forming the collection: 'I don't believe', he said, 'many motives in life are clear-cut or self-evident. Collecting especially is such a matter of time and chance—intellectual bent, individual temperament, personal taste, available resources, changing fashion—and the psychologists tell us, even of early child-training—and my own motives as a collector seem to myself extremely mixed'.

The following year, 1964, the exhibition was shipped over by sea to be put on show in Britain, at the Royal Academy. Fourteen of the thirty-five paintings in the present exhibition were then on show, and nine of the seventy-eight graphic works, giving some idea of how the collection expanded after this date. The reviews at that time were enthusiastic, and some quite insightful. Terence Mullaly, in a piece headed 'Mellon show arouses delight and dismay', wrote that delight was provided not just by seeing the illustrious names, but also by exploring the byways that revealed beauty where only competence was expected, and he expressed dismay that the British had not, up until then, noticed it for themselves. There is no doubt that the exhibition provided a wake-up call; three years later, in 1967, in an editorial entitled 'Let's blow our own trumpet for a change', Denys Sutton exclaimed, 'British art was neglected for years, except by a few enthusiasts, but, largely thanks to the munificence of Mr. Paul Mellon, it is marching ahead'.

At this time, although having made no public announcement, Paul Mellon had decided that in due course his collection would enter the public domain and that he should build a gallery to house it. Locations were discussed. The National Gallery of Art in Washington was not considered because it was clear that his collection would have to be subsumed into the general collection and that it would be possible to show only a very small part of it at any one time. He owned a large

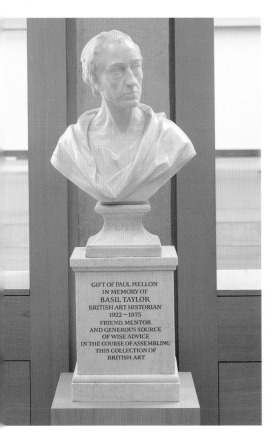

FIG. 9 View of cat. 15, Louis-François Roubiliac, *Alexander Pope*, 1741, marble, 24⅞ in. high (63 cm). Yale Center for British Art, Gift of Paul Mellon in memory of the British art historian Basil Taylor (1922–75). B1993.27

house next to his Washington residence that backed onto the British Embassy, but to use that would entail zoning and parking difficulties. Perhaps with memories of his father's problems with the politicians in changing administrations, he leaned towards a museum in a university environment and, urged on by the then Director of the Yale University Art Gallery, Andrew Ritchie, he chose his alma mater, Yale.

His gift was publicly announced in December 1966. Although there were suggestions from some academics that the collection be used as a teaching instrument, it was appreciated that Paul Mellon had collected the pictures to be hung on the museum's walls primarily to give pleasure to visitors. It was to be another eleven years before the Yale Center for British Art, designed by the architect Louis Kahn, was to open, a story told in Jules Prown's essay in this volume. Taylor resigned his roles both as Paul Mellon's advisor and as Director of the Paul Mellon Foundation for British Art, in 1968, on account of ill health. By default I fell into the advisory role in England insofar that Mr. Mellon asked me to provide advice and act for him in the salerooms. I continued this function, with the help of friends (Dudley Snelgrove, for example, provided invaluable advice on drawings), until I retired in 1990 from the Bond Street art dealership I had established with my brother-in-law, Richard Day, in 1967. Basil Taylor died in 1975.

From 1966 Jules Prown, the first Director of the Center, was largely preoccupied with details of the construction of the museum building. Meantime, after Taylor's departure, the collection in Virginia continued to grow until the Brick House was bursting at the seams. In 1973, Beverly Carter, a good friend and by then Mr. Mellon's curator in Virginia, and I shipped eighty paintings to Pittsburgh, where we hung them in the Mellon Bank. They remained there until the building to house the collection, named the Yale Center for British Art, in New Haven, was completed. Staff at the bank were surprised to find their walls suddenly decorated with English pictures; and later, just when they had got attached to them, they were somewhat dismayed when equally suddenly the works of art were whisked off to Yale. With commendable enterprise the bank began a collection of its own.

At the end of 1975, Jules Prown resigned the directorship in order to return to teaching at the university. Edmund Pillsbury succeeded him as Director, bringing staff numbers up to full complement and overseeing the opening ceremonies in the spring of 1977. Later, in 1981, after Pillsbury had left to become Director of the Kimbell Art Museum in Fort Worth, Texas, Duncan Robinson became Director of the Center, to continue in this role, as he describes in his essay here, for the next fourteen years until 1995, when he returned to England to become Director of the Fitzwilliam Museum at Cambridge and subsequently Master of Magdalene College. Old friends, we all worked in close harmony from either side of the Atlantic. Paul Mellon provided the Yale Center with a generous purchasing grant; sometimes he also funded major purchases recommended by the Center, but after the opening he continued to collect on his own account, in consultation with its directors. With most of his paintings having departed for the Center, he turned his Brick House into a gallery of sporting art. In fact, consultation with the Center was very much a two-way affair and the museum always kept him in close touch with developments, looking forward to his periodic visits, when policy could be discussed. The last purchase he made on his own account, but which he promptly gave to the museum, was in 1990, when he was eighty-three, eight years before his death. It was a fine bust, by Roubiliac, of the poet Alexander Pope (fig. 9). He said in his humourous way that he thought Pope's face in the sculpture bore a striking similarity to that of Basil Taylor.

Paul Mellon's personality was a propitious mixture of his father's shrewd judgment and his mother's romanticism. He was a delightful man whose company and whose conversation were invariably a pleasure to experience. Well read and intelligent, he never patronized or talked down to anyone and always encouraged those in his presence who were of a shy disposition. It was

FIG. 10 Paul Mellon with John Baskett in front of Mr. Mellon's childhood home on Woodland Road in Pittsburgh, ca. 1990

FIG. 11 Paul Mellon with John Baskett at a lawn meet at Oak Spring, 1998

remarkable to meet someone in his position so unspoiled, so self-disciplined and with such well-bred manners. Studiously unostentatious, he had a wonderful sense of humour and a frighteningly good memory. His cheerful disposition and consideration for others led him to have a happy and fulfilling life, and his inspired use of his inheritance resulted in his leaving his fellow countrymen a remarkable legacy for their educational and cultural lives.

Notes

1 After the war the OSS became the CIA.

2 For a detailed account of Andrew Mellon's collecting, see David Cannadine, *Mellon: An American Life* (New York, 2006).

3 Roosevelt can be heard uttering these words on the National Gallery of Art web site, and sounding as if he is reading from a text written by another hand!

4 The Foundation was later reborn in London as an offshoot of Yale University and named the Paul Mellon Centre for Studies in British Art, described here in Brian Allen's essay.

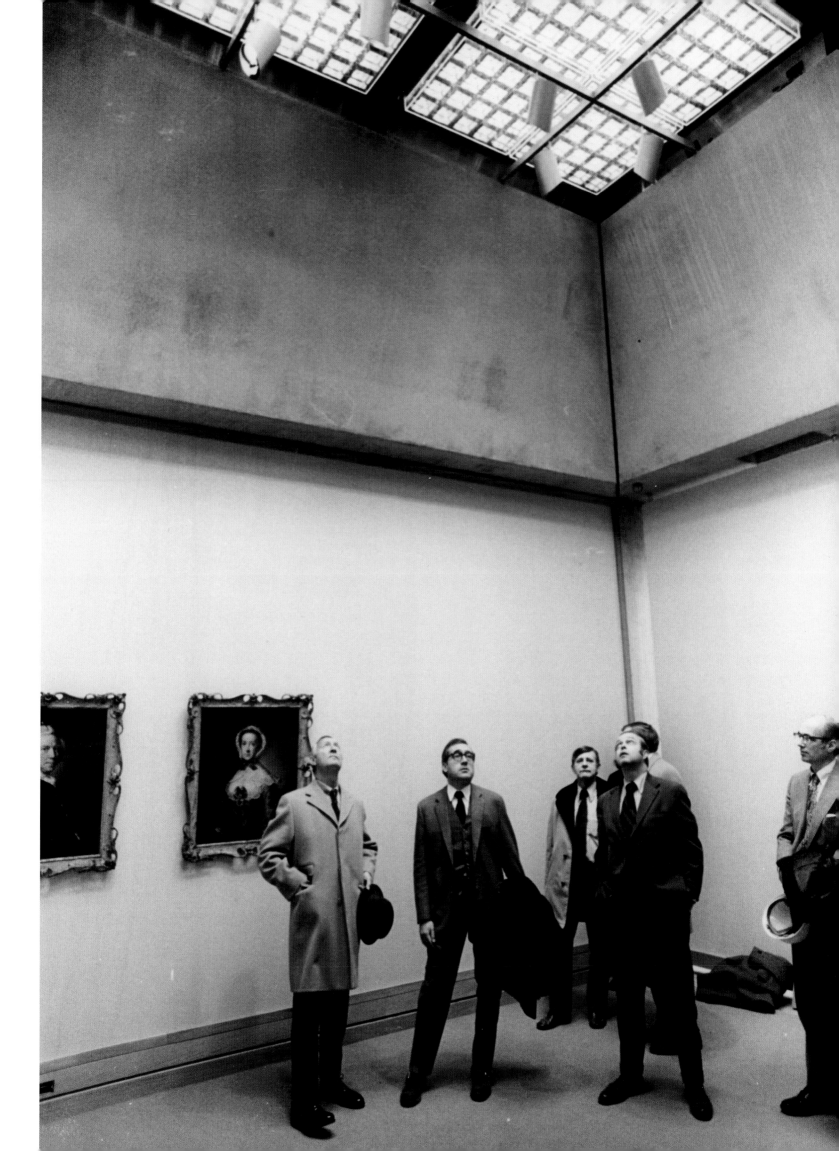

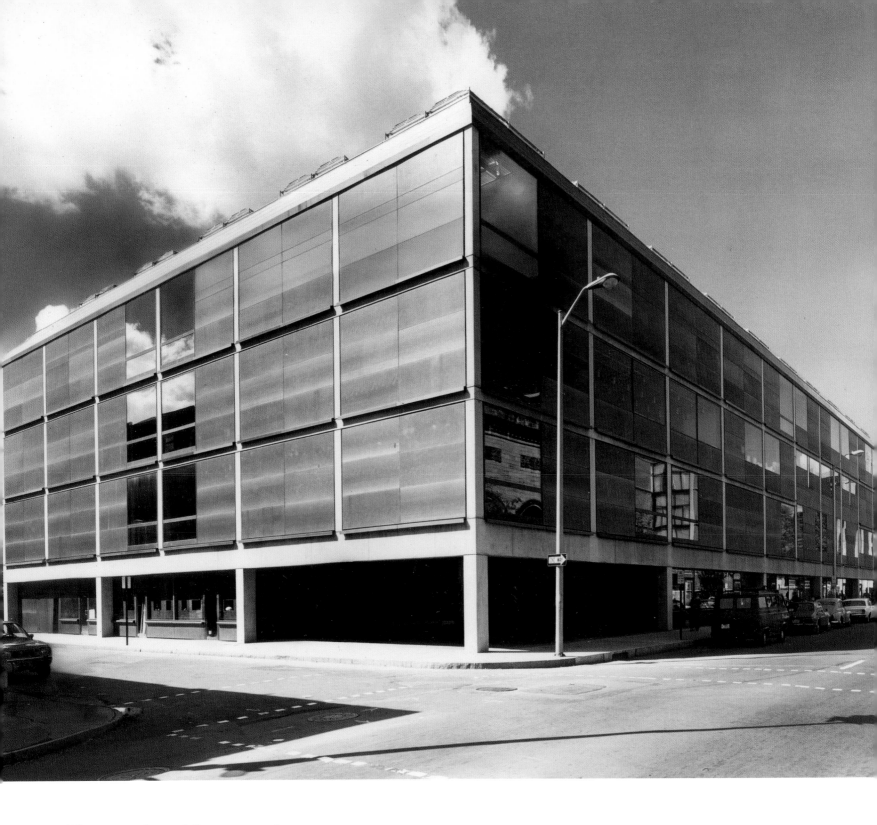

Elegant style and fine proportions.

 —Paul Mellon, on Louis Kahn's Yale Center for British Art

Paul Mellon and the Architecture of the Yale Center for British Art

JULES DAVID PROWN

When I became director of what was then called the Paul Mellon Center for British Art and British Studies in the summer of 1968, the president of Yale, Kingman Brewster, told me that my first job was to recommend an architect. At that time I was an associate professor of the History of Art at Yale, curator of American Art at the Yale University Art Gallery, and a member of the University Committee that had developed the initial proposals for the Center in response to Paul Mellon's gift.

A few days after my appointment, I flew to Virginia to visit Mr. Mellon in Upperville. When I asked him whether he had any particular thoughts or preferences with regard to an architect, he replied that he did not; among contemporary architects, he was most familiar with the work of I. M. Pei, who had designed the Paul Mellon Art Center at Choate Academy and was currently at work on the plan for the East Building of the National Gallery of Art in Washington, D.C., where Mr. Mellon was chairman of the board. This familiarity, however, did not constitute a recommendation. "After all," he said, "I am not going to have to live with the building. Yale will, and Yale should make the choice." But he added that he would like to be kept apprised as the selection process and the development of architectural plans proceeded.

In late September, Paul Mellon and I, along with Edward Larrabee Barnes, who was then campus planning adviser to President Brewster and who later provided me with an introduction to Louis Kahn, visited the "Architecture of Museums" exhibition at the Museum of Modern Art.[1] Subsequently I traveled to see some of the more recently designed art museums, including Pei's Everson Museum of Art in Syracuse and Phillip Johnson's Munson-Proctor-Williams Museum of Art in Utica and Amon Carter Museum in Fort Worth. I was, of course, familiar with Kahn's Yale University Art Gallery and visited some of his other buildings, especially the Richards Medical Research Laboratories in Philadelphia and the Phillips Exeter Academy Library. His current project was the Kimbell Art Museum in Fort Worth, where my friend Ric Brown was director. In late November, Mr. and Mrs. Mellon accompanied me on a return trip to the Kimbell to see the plans and model, as well as to meet with Brown.

The inscription on the wall at the entrance to the Yale Center for British Art (fig. 1), written by Mr. Mellon, reads "THIS CENTER, WITH HIS COLLECTIONS / OF BRITISH ART AND BOOKS, IS THE GIFT OF PAUL MELLON / YALE COLLEGE, CLASS OF 1929." Although he was keenly interested in the architecture of the building, his perspective was shaped by his love for his art and books. A major factor in the choice of an architect would be the ability to create a sympathetic environment for the collection rather than a signature architectural statement. The architecture was to serve the art, not the converse. Early on I went to Washington and Virginia often to meet with Mellon and familiarize myself with the collection, then dispersed among storerooms at the National Gallery; a house on Whitehaven Street, next door to his home, that served as administrative headquarters; and the Brick House on his estate at Upperville, Virginia, where rare books, watercolors, drawings, and sporting paintings were kept.

On these trips I met regularly with Mr. Mellon to discuss not only architecture but such issues as the nature of his collections; the procedures by which works of art were being acquired, primarily in England; the roles of individuals who worked for him in building and caring for the collection in London, Washington, and Upperville; and in particular the function and future of the Paul Mellon Foundation for British Art in London, for which he offered to provide an endowment if Yale would assume responsibility.[2] In the course of these discussions it became clear that as much as he loved art, he had a particular passion for horses. At this time one of his horses, Fort Marcy, won the Washington, D.C. International (twice). After Fort Marcy's final victory, I congratulated Mr. Mellon who told me that the horse would now be retired. In an attempt to indicate that my purview was not limited to art and Yale, and to display my knowledge of the sporting world, I asked him if he was going to put Fort Marcy out to stud. He looked at me incredulously — Fort Marcy was one of the great geldings in racing history.

Having gotten acquainted with the collections, if only in a general way, I developed a preliminary program describing the architectural qualities one would look for. I shared my thoughts with Mr. Mellon, and eventually with Brewster, noting that these criteria would eliminate certain architects. I indicated that I was leaning toward Kahn. Brewster approved of my thinking and of my wish to meet with one or more architects, but said, "I want to know what Paul thinks."[3]

I met Kahn at his office in Philadelphia in early March of 1969, felt we were compatible, and proceeded to set up a meeting with Paul Mellon. Kahn wanted to make his presentation at the Salk Institute in La Jolla, California (fig. 2). In the latter part of April, Mellon flew me and his lawyer and close adviser, Stoddard Stevens, to La Jolla. The following morning we had breakfast with Kahn and Jonas Salk, who spoke about his thoughts as a client in working with Kahn. Salk said that the essence of his building was to express man through what he *is*. I replied that our Center would express man through what he *makes*. Kahn characteristically spoke in poetic abstractions —

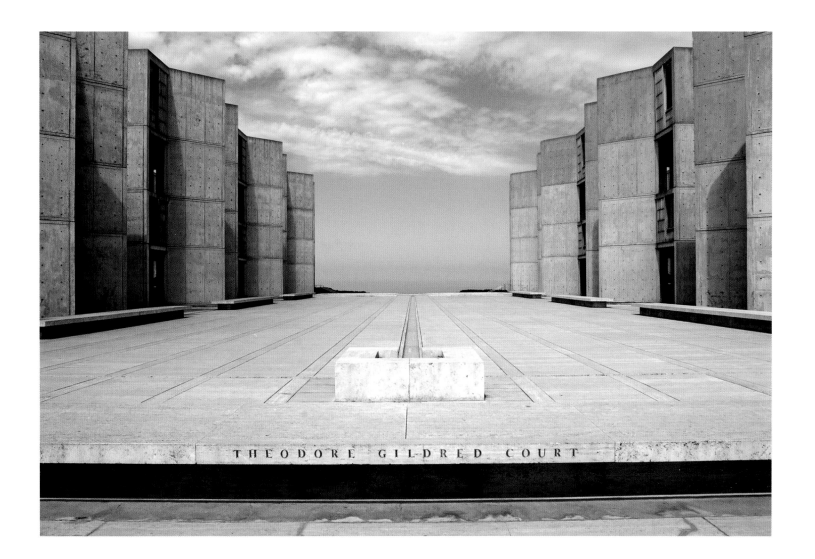

silence and light and thresholds — diagramming his thoughts on paper napkins. As Salk drove us to the Institute after breakfast, Mellon, ever the collector, suddenly expostulated, "I forgot to pick up the napkins."

With Mr. Mellon's approval confirmed, Kahn was officially selected by the Yale Corporation as the architect of the Center, although the announcement of the appointment was deferred until September, when school resumed. During the summer of 1969 my thoughts turned to how the gallery would be installed. I liked the practice at the Fogg, and at other museums where I thought paintings looked particularly well presented, of introducing occasional pieces of fine period furniture against the walls in order to articulate the space. Early in the design process, I went with Kahn to the Phillips Gallery in Washington, D.C., one of my favorite museums and one that also used objects in this way, to indicate certain qualities I was looking for — light, proportions, domestic scale, rooms, outside views. I wrote to Paul Mellon suggesting such a use of objects and received a stern letter in reply, stating that he could not disagree more: "I would be very much against any extraneous material cluttering the various rooms to distract the attention from the objects of art."[4] He felt that the paintings themselves opened up the space. I then realized that he subscribed completely to the prevailing conviction at the National Gallery that decorative arts did not belong in an art gallery devoted to fine art.

During 1970 Kahn's design for a bold, four-story, 150,000-square-foot building took shape.[5] I recall that Kahn at one point asked Mr. Mellon if he had any preferences with regard to material for the facade. He said that he did not, although he allowed that he liked stone. "Stone is nice," Kahn replied.

Paul Mellon looked at plans, sections, and elevations as they came along. He was inclined to be restrained in his generally positive responses. When he did have a concern, he tended to express it not as a statement but as a query. To get approval from the City of New Haven, the Center needed to provide adequate parking. Because the anticipated structure occupied the site fully, parking was to be accommodated on two levels below the building. Mellon asked, "Do you think it is a good idea to have automobiles underneath my paintings"? What he meant, we learned, was "I *don't* think it is a good idea to have automobiles underneath my paintings"!

In mid-January of 1971, he saw the most recent plans and a model (fig. 3) and was informed that a considerable shortfall in funds was anticipated because of inflation and a severe escalation in building costs. In March, Kahn sent Mr. Mellon a complete set of the final drawings and specifications that had gone out for estimate. The following month I sent him a detailed report on the estimated costs we had received for the building, the projected shortfalls, and proposed savings, primarily from a reduction in size, should no additional funding be made available.[6]

The estimated cost had ballooned from $10 million to $17 million. At virtually the same time, the projected cost of the East Building of the National Gallery, which Mellon money was also funding, had escalated even more dramatically. Paul Mellon advised Yale that he had made a generous gift and that the building would have to be built, if possible, from the available funds. Yale determined that this could be accomplished if the projected building was reduced by one-third. Kahn set about producing a new design in response to a revised program and in November 1971 presented updated plans and a new model (fig. 4) at a major meeting in Mr. Mellon's New York office. He later wrote, "I liked the revised plan much better than the original one."[7]

Budgetary considerations now became crucial, and as we proceeded Mr. Mellon was kept informed of how anticipated building costs were being constrained, along with special reports on such things as security and fire suppression. In February 1972 I reported that the New Haven Board of Aldermen had applauded the project at a meeting, and approval seemed assured. A crucial and particularly thorny issue from that time forward was the development of a satisfactory skylight system for the building. In order to test various skylight solutions, a mock-up of a single

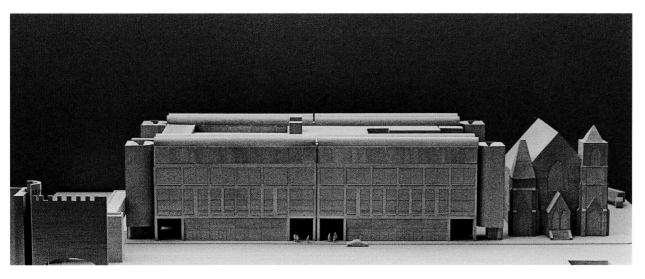

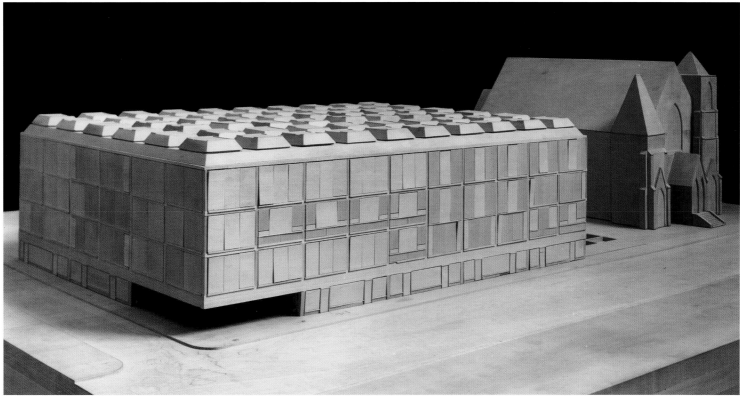

FIG. 3 First project, model, Chapel Street facade. Model housed at the Louis I. Kahn Collection, University of Pennsylvania. Photo: Louis Isadore Kahn Collection, Manuscripts and Archives, Yale University Library

FIG. 4 Second project, model, facades on Chapel and High streets, November 1972. Model housed at the Louis I. Kahn Collection, University of Pennsylvania. Photo: Yale Center for British Art, Department of Rare Books and Manuscripts, YCBA Archives

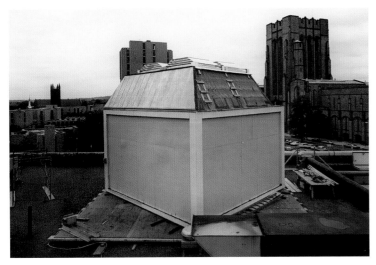

twenty-by-twenty-foot fourth-floor bay was created on the roof of the physical plant building on Ashmun Street (figs. 5, 6).

At the end of September, I flew with Paul Mellon to Fort Worth for the opening of the Kimbell Art Museum, where natural light was an important element in the museum's architectural character (fig. 7). The trip to the Kimbell, I subsequently wrote to him, had made me increasingly aware of the fact "that we are carrying museum theory in the use of natural light a decided step forward in our building," using it actively rather than for "psychological awareness of the existence of the outside world," as at the Kimbell.[8] I also expressed my concern about the use of stainless steel cladding on the building, but said that everyone else at Yale was enthusiastic:

> Lou knows precisely what he is looking for in terms of a non-reflective metallic surface
> and an articulation of that surface by the way in which the metal is bent in both the
> window enframements and the panels themselves, giving what he calls a "graffito" or
> non-planar effect to the facade of the building. I asked him if he had ever seen a metal
> building that he liked, and he conceded that he had not. I have not either. But it is clear
> that what Lou has in mind for the Mellon Center is something that has never been
> achieved before, and despite my reservations, I do believe that both you and Yale would
> be well-advised to go along with him while he develops this very new concept of the
> exterior cladding of a concrete framed building. Before anything becomes final, we will
> see a complete mock-up of it and will have, I hope, confidence in the final result.[9]

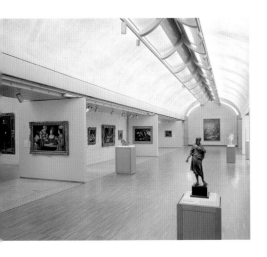

On 1 November 1972 I sent Mr. Mellon a telegram: "One solitary but tough bulldozer appeared on the site this morning. Construction has begun. We are off and running." (I guess I thought a racing metaphor appropriate.) I sent him a construction schedule at the end of the year that anticipated completion by August 1974 and a possible opening in late spring 1975.[10]

It now became routine for Mr. Mellon to make periodic visits to New Haven to meet with us and survey progress on construction of the building. On a typical visit, we might first gather at our Center headquarters, a small old brick town house at 26 High Street; we would then tour the site with Kahn and Brewster, along with Kenneth Froeberg of the Macomber Company, the contractor; Kenneth Borst, Director of Building and Grounds Services at Yale; and others (figs. 8–11). A group lunch at Mory's followed.

The Center was constructed under a negotiated contract, which meant that whenever costs went up as a result of revised estimates or change orders, reductions had to be made in order to stay on budget. Significant cost increases occurred primarily in projected costs for electrical

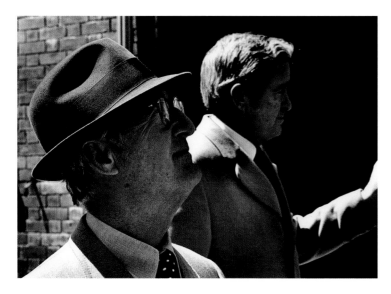

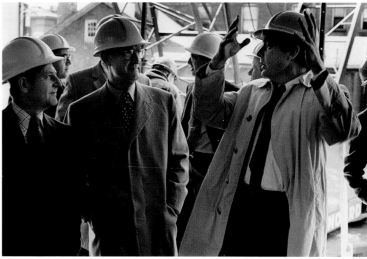

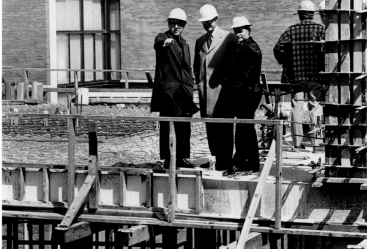

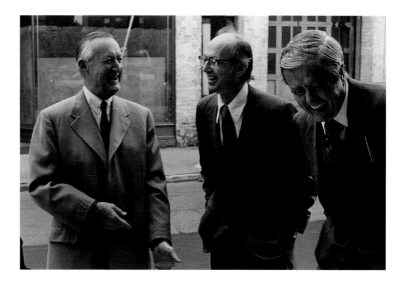

(clockwise from above)

FIG. 8 Paul Mellon and Kingman Brewster, 11 April 1974.
Yale Center for British Art, Department of Rare Books and
Manuscripts, YCBA Archives

FIG. 9 *(Left to right)* Kenneth Froeberg, Paul Mellon, and
Kenneth Borst, 11 April 1974. Louis Isadore Kahn Collection,
Manuscripts and Archives, Yale University Library

FIG. 10 *(Left to right)* Jules Prown, Paul Mellon, and Kenneth
Froeberg, 11 April 1974. Louis Isadore Kahn Collection,
Manuscripts and Archives, Yale University Library

FIG. 11 *(Left to right)* Paul Mellon, Charles Taylor (provost),
Kingman Brewster, 3 October 1974. Louis Isadore Kahn
Collection, Manuscripts and Archives, Yale University Library

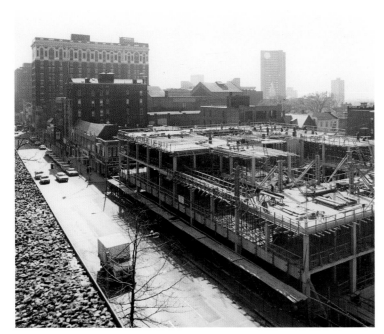
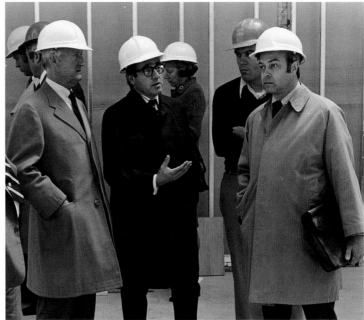

FIG. 12 View of the Center from the Art and Architecture building, 6 March 1974. Louis Isadore Kahn Collection, Manuscripts and Archives, Yale University Library

FIG. 13 *(Left to right)* Paul Mellon, Jules Prown, Hannah Gray (background), Frederick Wales, and Marshall Meyers, 3 October 1974. Louis Isadore Kahn Collection, Manuscripts and Archives, Yale University Library

systems, millwork, and skylights. I reassured Mellon that with the suggestions and thoughts of Froeberg, Borst, and Kahn "we should be able to identify substantial savings which will not alter the character or quality of the building."[11]

At the time of Kahn's sudden death on 17 March 1974, the building had risen to the second floor level (fig. 12). Completing the building as Kahn would have wanted it became a matter of primary importance. Fortunately, Yale had earlier engaged Marshall Meyers, Kahn's project architect at the Kimbell Art Museum who had launched his own practice, to make field decisions when Kahn, who was then traveling extensively to the Mideast and Asia, was not available (fig. 13). Most issues had been resolved with final plans from Kahn in hand, but not all. One unresolved issue was the treatment of the entrance, on the corner of High and Chapel streets. Mellon was concerned about the integrity of the building as art gallery and library. He had at first been taken aback by the suggestion of commercial shops integrated into the first floor of the building. Although he became convinced that this was acceptable, he did not want the commercial aspects to compromise the entrance. Some thought had been given to having doors or windows open directly from the entrance portico into the adjoining shops. Plans did not show such openings, but the City of New Haven "asked that these be put in as a prerequisite for granting approval."[12] Mellon was not in favor of this. The final solution was to have display windows in the entrance portico be used for posters announcing exhibitions (fig. 14).

Mr. and Mrs. Mellon also had a particular interest in what plantings might go in the sunken courtyard between the Center and the Yale Repertory Theater. I conveyed to them Marshall Meyer's reasoning for a single large tree, off center, as per Kahn's final design, rather than a grouping of small trees.[13]

Constant experimentation in the mock-up while the Center was under construction with various means of admitting natural light failed to produce a satisfactory solution. When the building reached its full height, with the problem still not fully resolved, two fourth-floor bays were used for final trials. Some details had already been decided—the external louvers and the division of the roof of each bay into four quadrants beneath Plexiglas domes containing ultraviolet light filtration. The remaining challenge was the "cassette" set into each quadrant opening that would scramble the light and scatter it evenly on the interior wall surfaces. The system that Kahn had been working

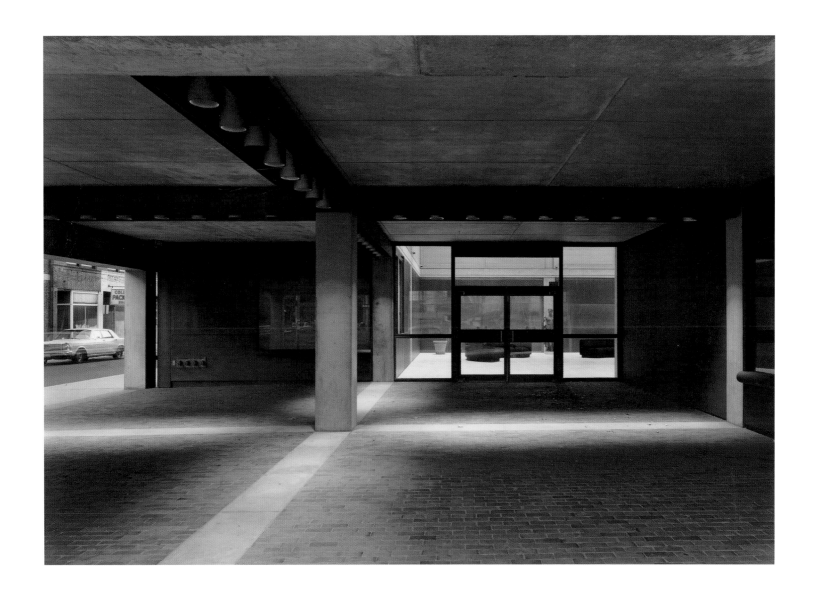

FIG. 14 Entrance portico of the Center, 1977. Louis Isadore Kahn
Collection, Manuscripts and Archives, Yale University Library

on with his lighting consultant, Richard Kelly, several weeks before his death was installed in one bay. It was an attractive, rather crystalline assemblage of what might be described as largish Plexiglas dentils (fig. 15). The other was a somewhat blander cassette assembled by Froeberg from available manufactured elements. The two systems worked equally well in terms of manipulating the light admitted; the Kahn-Kelly system cost one hundred thousand dollars more. A summit meeting to choose between them was held at Yale. Mellon sat at the head of the table and after full discussion it was agreed by all, except me, to go with the Froeberg cassette. It does in fact work perfectly well, and certainly if Kahn had lived, he would have refined his and Kelly's solution, which was, I admit, a bit glitzy.

With the completion of Kahn's building, I decided I would rather use the Center than run it. So I returned to full-time teaching. For me, the building has been a source of constant pleasure, stimulation, and gratification. Mellon's final judgment was that "the building and in particular the interior have been a resounding success."[14]

Notes

EPIGRAPH: Paul Mellon, with John Baskett, *Reflections in a Silver Spoon: A Memoir*, New York, 1992, p. 324.

1 As a graduate student in John Coolidge's Museum Training Course at Harvard eleven years earlier, I had worked with two other students to produce an exhibition of recent museum architecture.

2 The successor institution is the Paul Mellon Centre for Studies in British Art.

3 Yale Center for British Art (YCBA), Archives, Box 1 Folder 12, Jules Prown to Kingman Brewster (copy), 22 Jan. 1969, attached to Kingman Brewster to Jules Prown, 15 Feb. 1969. In my letter I also enclosed a draft of my more formal "preliminary thoughts on architecture," later printed in Jules David Prown, *The Architecture of the Yale Center for British Art* (New Haven, 1977), pp. 12–13.

4 He added, "As for floors, I personally am all for 'wall to wall' carpeting in some un-distracting, neutral color. It can easily be replaced, wears well, is cheaper than polished wooden floors, and is easily maintained. However, I am not pushing this idea." YCBA, Archives, Box 8 Folder 15, Paul Mellon to Jules Prown, 9 Sept. 1969.

5 For a comprehensive account of the building of the Center, see Prown, *Architecture of the Yale Center*. A new edition of this volume with a new preface is due to be published in 2007.

6 YCBA, Archives, Box 8 Folder 16, Jules Prown to Paul Mellon (copy), 13 Apr. 1971.

7 Mellon, *Reflections*, p. 324.

8 Current museum practice had turned against the use of traditional skylights in favor of artificial light that could be completely controlled.

9 YCBA, Archives, Box 8 Folder 17, Jules Prown to Paul Mellon (copy), 2 Oct. 1972.

10 YCBA, Archives, Box 3 Folder 34b, Jules Prown to Paul Mellon. The Center was actually inaugurated on 15 Apr. 1977.

11 YCBA, Archives, Box 3 Folder 33, Jules Prown to Paul Mellon (copy), 5 Oct. 1973.

12 Ibid., Box 8 Folder 19, Jules Prown to Paul Mellon (copy), 17 June 1974.

13 Ibid., Box 9 Folder 7, Jules Prown to Paul Mellon (copy), 15 July 1975.

14 Mellon, *Reflections*, p. 324.

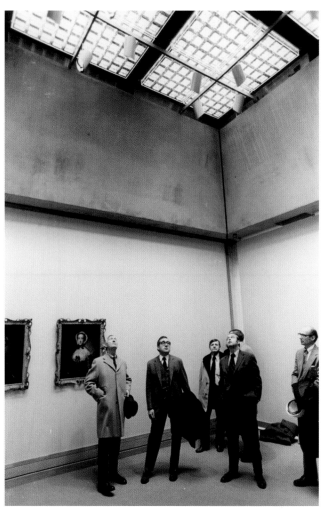

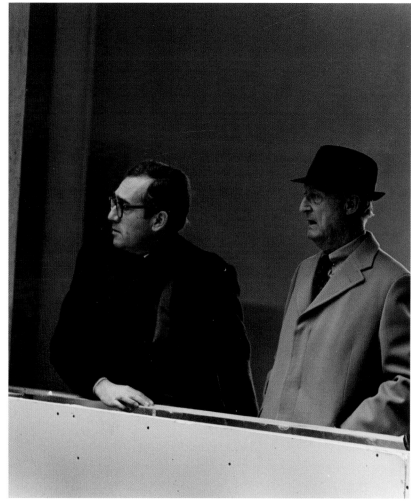

FIG. 15 *(Front, left to right)* Paul Mellon, Jules Prown, Kenneth Froeberg, and Marshall Meyers studying the Kahn-Kelly skylight in the fourth-floor bay, 1 March 1975. Louis Isadore Kahn Collection, Manuscripts and Archives, Yale University Library

FIG. 16 Jules Prown and Paul Mellon on fourth floor, looking out into entrance court, 1 March 1975. Louis Isadore Kahn Collection, Manuscripts and Archives, Yale University Library

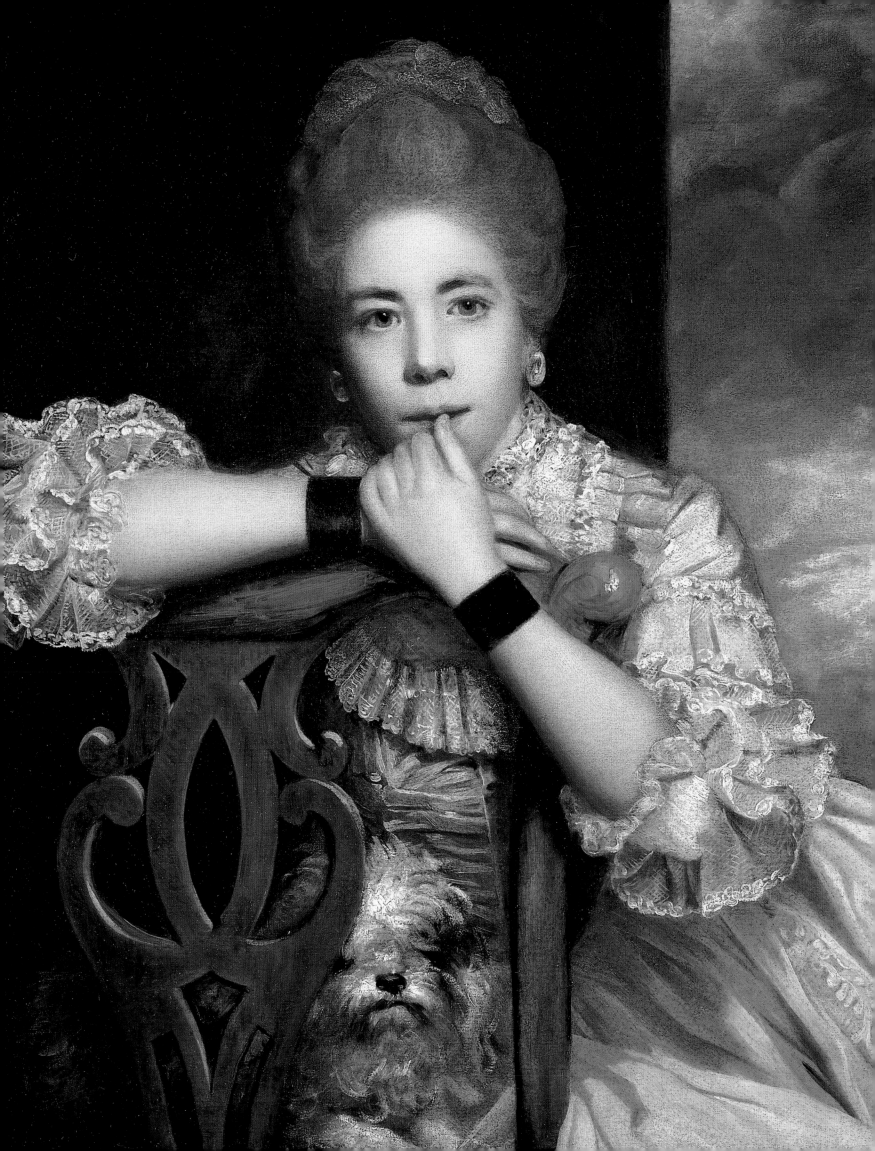

Paul Mellon
and
the Yale Center for British Art

DUNCAN ROBINSON

'. . . not only for scholastic purposes, but for pure enjoyment'

When *Painting in England, 1700 – 1850, from the Collection of Mr. and Mrs. Paul Mellon* was shown at the Royal Academy of Arts in 1964 – 65, Basil Taylor characterised the exhibition as having 'been very much determined by a particular historical sensibility originally stimulated at Yale by a great generation of 18th-century scholars but since then kept continuously alive and on the move. It is indeed the collector's commitment to what these pictures represent in terms of informal human relationships, landscape and country life that gives this group of English pictures its special identity'.[1] In pointing out the preponderance of conversation pieces, intimate landscapes and animal pictures, he made it clear that the exhibition did not present 'a total view of English painting' as much as the personal taste of a private collector for whom English art comprised 'not just the *Duchess of Devonshire*, or the *Age of Innocence*'. The last were Paul Mellon's own words, spoken at the time, and just as he had begun to relish the wider significance of his collection of British art, 'so that expanding the Collection, increasing its breadth and depth, filling in important historical or chronological gaps as well as adding artists and schools in which we were weak, or which we lacked entirely — all seemed part of a logical, deliberate attempt to say to ourselves and to the public — *this* is English Art. . . . let's take it seriously, let's re-evaluate it, let's look at it, let's enjoy it'.[2]

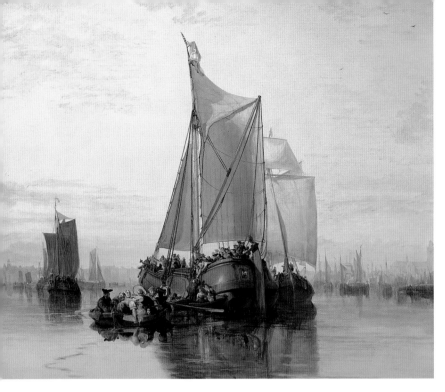
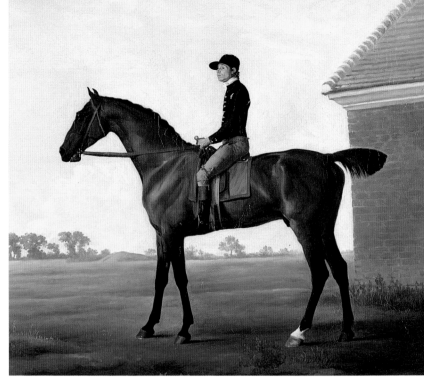

(overleaf)

FIG. 1 Detail of cat. 31, Sir Joshua Reynolds, *Mrs. Abington as Miss Prue in William Congreve's "Love for Love,"* 1771, oil on canvas, 30¼ x 25⅛ in. (76.8 x 63.7 cm). Yale Center for British Art, Paul Mellon Collection. B1977.14.67

FIG. 2 Detail of cat. 90, J. M. W. Turner, *Dort, or Dordrecht, the Dort Packet-boat from Rotterdam Becalmed*, 1818, oil on canvas, 62 x 92 in. (157.5 x 233 cm). Yale Center for British Art, Paul Mellon Collection. B1977.14.77

FIG. 3 Detail of cat. 24, George Stubbs, *Turf, with Jockey Up, at Newmarket*, ca. 1765, oil on canvas, 40⅛ x 50⅛ in. (99.1 x 124.5 cm). Yale Center for British Art, Paul Mellon Collection. B1981.25.621

Once he had decided, after weighing all of the options, to entrust his collection of British art to Yale University and to establish a Center there, Paul Mellon made a conscious decision to widen his horizons as a collector and to acquire works of art which would transform what he had been inclined to think of as his private collection into a public one. 'After having crossed the Rubicon (or more accurately the Quinnipiac) and I had definitely chosen Yale', he explained in his inaugural address for the Center, 'my collecting continued unabated, but informed by a slightly different philosophy. With the University, with education, with public exposure in sight, I tried even harder not only to maintain what I considered the high quality of the collections, but wherever possible to add paintings, drawings and books of greater quality and recognised stature'.[3] As a result, between 1971 and 1981, full-lengths by Van Dyck, Reynolds, Gainsborough and Lawrence were added to the collection, each one a masterpiece of the kind of formal portraiture which Paul Mellon respected rather than loved. On the other hand, he had a particular affection for Reynolds's intimate portrait of *Mrs. Abington as Miss Prue in William Congreve's "Love for Love"* (fig. 1), with its double act of character portrayal, of an attractive and talented actress playing the part of a feckless heroine.

This shift in emphasis, towards what might be described as the more 'classic' taste of his father's generation, was not accompanied by any lessening of interest or focus on the part of the collector. As he reminded the audience at the opening of the Center in 1977, 'it was subsequent to my decision to found the Center that I was able to buy such masterpieces as Turner's *Dort* [fig. 2], Reynolds' *Mrs Abington*, Stubbs' portrait of *Turf*, [fig. 3] and his four great shooting paintings'. In 1969 he wrote to Jules Prown to inform him 'that I would prefer to keep the reins of collecting in my own hands for the foreseeable future, or at least until the collections go to Yale'. Fortunately he persisted in that resolve long after the Center opened; over a period of nearly thirty years he was personally responsible for a succession of spectacular acquisitions, often based on advice from the staff of the Center. As a result the chronological boundaries of the collection were pushed back to the sixteenth and seventeenth centuries and forward into the twentieth century. Purchases made in 1977, that *annus mirabilis* in which the Center opened, included the oil sketch of *Peace Embracing Plenty* (fig. 4), one of Rubens's autograph studies for his ceiling decorations in the Banqueting House at Whitehall. With its bright colours and swirling figures, it shows that master of the European baroque at the height of his powers, composing what was undoubtedly his most

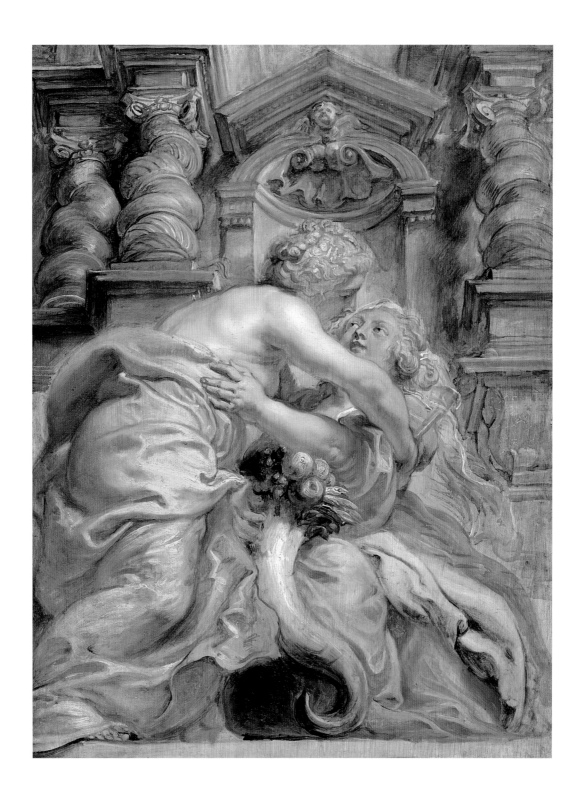

FIG. 4 Peter Paul Rubens, *Peace Embracing Plenty*, 1633–34, oil on panel, 24¾ x 18½ in. (62.9 x 47 cm). Yale Center for British Art, Paul Mellon Collection. B1977.14.70

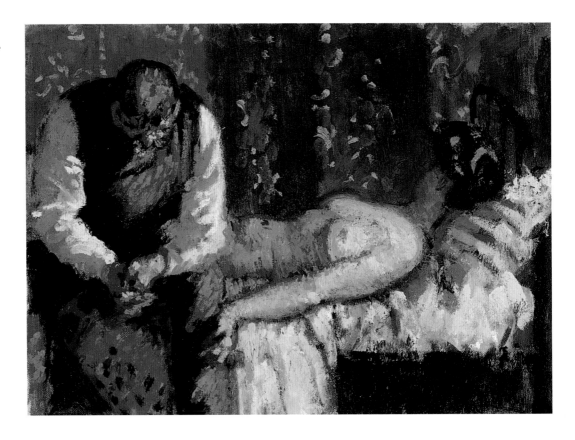

FIG. 5 Walter Sickert, *The Camden Town Murder, or What Shall We Do for the Rent?*, ca. 1908, oil on canvas, 10¹⁄₁₆ x 14 in. (25.6 x 35.6 cm). Yale Center for British Art, Paul Mellon Fund. B1979.37.1

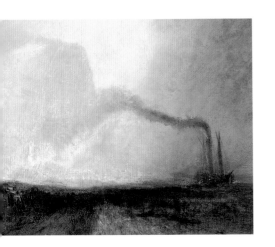

FIG. 6 Detail of cat. 91, J. M. W. Turner, *Staffa, Fingal's Cave*, 1832, oil on canvas, 36 x 48 in. (91.5 x 122 cm). Yale Center for British Art, Paul Mellon Collection. B1978.43.14

important commission for King Charles I. In 1979 the Center purchased two paintings by Walter Sickert, including his *Camden Town Murder, or What Shall We Do for the Rent?* of circa 1908 – 09 (fig. 5). It was a bold step forward, 'expanding the Collection, increasing its breadth and depth', but in ways which were consistent with the donor's own taste. In the 1960s Paul Mellon had acquired a group of paintings and drawings of horse sales by Robert Bevan, which were featured prominently among the loans to an exhibition of the Camden Town Group that Malcolm Cormack, Curator of Paintings at the Center from 1976 to 1991, organised there in 1980.

We debated the issue of chronological limits endlessly. In 1969, Paul Mellon had written to Prown that 'another aspect that worries me is a tendency to slip beyond the original date limits of the collections, i.e. I used to say that the collections should not reach much beyond 1860. I have no intention of going out now and trying to build up, myself, a collection of Pre-Raphaelites. Perhaps you will be able in the future to persuade other donors to do so.' A decade later, knowing of my interest in the twentieth century, he often challenged me to justify adding the art of later periods to those on which he had concentrated, namely the eighteenth and early nineteenth centuries. He allowed that he had acquired works by a whole string of twentieth-century artists, including Gwen John, Barbara Hepworth, Henry Moore, Ben Nicholson and John Skeaping, but in 1981 the destination of their works and those he owned by their contemporaries was far from certain. For his concerns were also practical, about gallery and storage space within the Center, which had been purposely built to house his collection. The solution I proposed was to confine almost all of the temporary exhibitions to the third floor of the Center, and to allow us to install the permanent collection on the second as well as the fourth floor. As always, my ideas were received with the utmost courtesy but, for some considerable time, without a clear indication of the way forward. The answer came not in words, but in action, when in 1985 a consignment of works arrived at the Center, including sculptures by Hepworth and Moore and three paintings by Nicholson. Beyond that, his own generation of British artists, Paul Mellon was not prepared to go. In their works he could discern those English roots he shared with them, that 'Mellon enthusiasm for English life and land-

scape', as Andrew Ritchie put it.[4] Feeling increasingly remote from more contemporary developments, he made it clear, under the terms of his will, that the funds he had provided for acquisitions should be spent on works of art produced within 'the original date limits' of his collection.

When an export license was granted for *Dort* to leave the United Kingdom in 1966, there were murmurs of protest that insufficient efforts had been made to retain this finest example of Turner's respect for seventeenth-century Dutch marine painting. The tide of opinion was beginning to turn in favour of British art, bringing with it a surge in prices on the art market. 'The incurable collector' began to think that he was the victim of his own success.[5] On the other hand, eleven years later, as the Center opened in New Haven, there were no grounds for complaint when Paul Mellon bought *Staffa, Fingal's Cave* (fig. 6) from its English owner; *Staffa* was in all probability the first painting by Turner to have been bought by an American collector, when Colonel James Lenox of New York used the good offices of the American-born painter C. R. Leslie to obtain it from the artist's studio in 1845. A few months after Mr. Mellon purchased *Staffa,* a second Turner with an American provenance was offered directly to the Center in 1977, *Wreckers — Coast of Northumberland, with a Steam-boat Assisting a Ship off Shore* (fig. 7), which had left London for Pittsburgh a year or two before Paul Mellon was born there and more than seventy years before he would be able to add it to his collection.

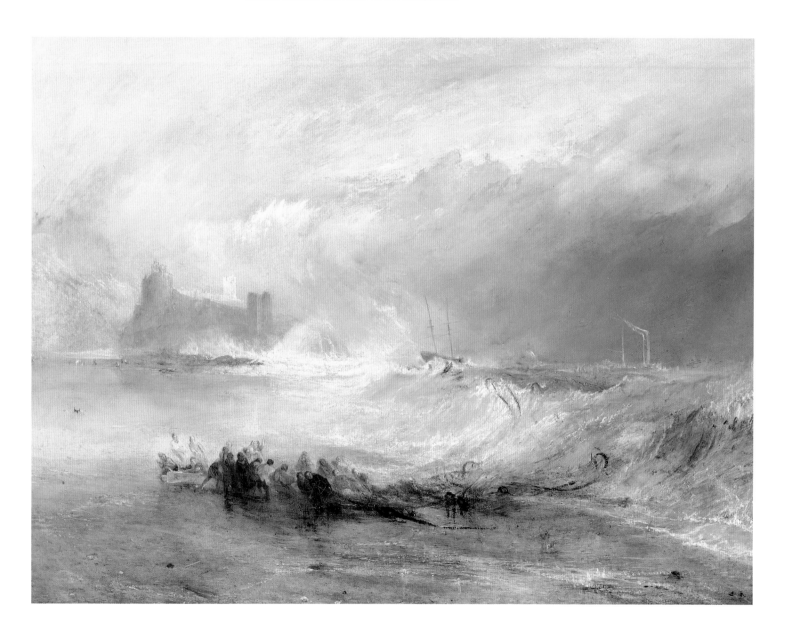

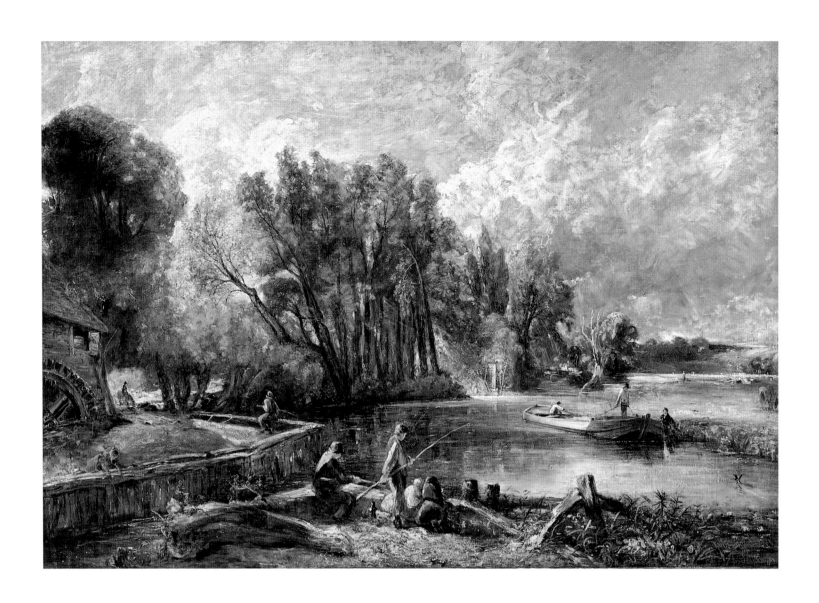

FIG. 8 John Constable, *Stratford Mill,
"The Young Waltonians,"* 1819–20, oil on
canvas, 51½ x 72½ (130.8 x 184.2 cm).
Yale Center for British Art,
Paul Mellon Fund. B1983.18

FIG. 9 Detail of cat. 94, J. M. W. Turner, *The Channel Sketchbook*, ca. 1845, sketchbook with marbled endpapers and eighty-eight leaves of white wove paper, with seventy-four watercolor and twenty-six graphite sketches, sheet size: 3¾ x 6⅜ in. (9.5 x 16.2 cm). Yale Center for British Art, Paul Mellon Collection. B1993.30.118(1–88)

By the time I joined the Center in 1981, Paul Mellon had established a pattern of giving a sum annually to enable the curatorial staff to make purchases for the collection. He had also made it clear that he remained open to suggestions for major acquisitions, which, if made, he might either retain himself, for the time being, or donate immediately. On such occasions he participated fully in the entire process, from approval of the proposal, through the planning of the campaign, to its execution. It is difficult to resist an analogy with field sports, not least because he clearly relished the pursuit of fair game. Constable's full-scale sketch *Stratford Mill, "The Young Waltonians"* (fig. 8) comes to mind as an example. When it came up at auction in 1983 it met with mixed reactions from the experts. Malcolm Cormack and I both went to see it on separate occasions, carefully disguising our enthusiasm for what we believed to be a perfect example of Constable's working methods. We were encouraged by the opinion of Graham Reynolds, the doyen of Constable studies, who led the way towards the reappraisal of the painting and subsequently published it. As always, Paul Mellon thought carefully before committing himself to a bid which, in this case, proved to be more than adequate. After the sale John Baskett told me that he was almost certainly bidding against the reserve. We then obtained an export license in record time, with only token opposition from the government's expert advisor. Whenever we were asked to lend major works from the Paul Mellon Collection to exhibitions abroad, I invariably consulted the donor before reaching a decision. I remember his reaction, a characteristic mixture of amusement and pleasure, when I reported that the Tate Gallery had asked to borrow *Stratford Mill* in order to show it alongside the finished painting, by then in the National Gallery in London, as a highlight of the 1991 Constable exhibition.

Sound judgement, clear sight, a cool head and above all patience: it took all those qualities and more to secure for the collection Turner's pocket-sized *Channel Sketchbook* (fig. 9), filled with studies of sea and skies, in pencil and watercolour, when it came up for sale in 1993. We realised at the time that this was a rare opportunity to obtain one of the last complete sketchbooks by Turner in private hands, and after taking appropriate advice, Paul Mellon decided to make a serious bid for it. In the event it went for more than he bid, to dealers in London who had every intention of re-selling at a still higher price. Months went by, and rumours began to circulate suggesting that if they could not find a single buyer, the owners might be obliged to break the sketchbook up for sale

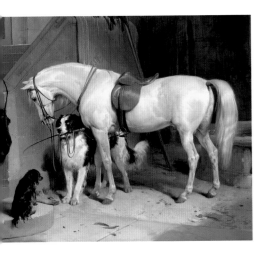

FIG. 10 Detail of cat. 109, Edwin Landseer, *Favourites, the Property of H.R.H. Prince George of Cambridge*, 1834–35, oil on canvas, 40 x 49½ in. (101.6 x 125.7 cm). Yale Center for British Art, Paul Mellon Collection. B2001.2.273

(facing page)
FIG. 11 George Stubbs, *Hyena with a Groom on Newmarket Heath*, ca. 1767, oil on canvas, 40⅛ x 50⅛ in. (101.6 x 126.7 cm). Virginia Museum of Fine Arts, Richmond. The Paul Mellon Collection

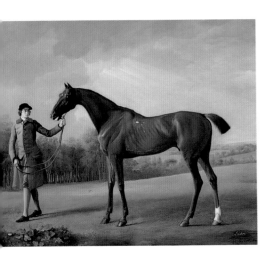

FIG. 12 George Stubbs, *Lustre, Held by a Groom*, ca. 1760–62, oil on canvas, 40⅛ x 50 in. (101.9 x 127 cm). Yale Center for British Art, Paul Mellon Collection. B2001.2.122

as separate leaves. Michael Kitson, then Director of Studies at the Paul Mellon Centre in London, went so far as to write a letter to *The Times* deploring that prospect, a point of view Paul Mellon shared to such an extent that he determined to try again, and to make an offer sufficient to keep the sketchbook intact. Even more surprisingly, he conducted the negotiation himself, on a visit to London, without intermediaries. His pleasure at the outcome, recounted with quiet satisfaction and that inimitable smile, was unforgettable.

In his *Memoir*, Paul Mellon noted that 'as anyone who has started to collect anything knows, it is impossible to stop. While taking a keen interest in what is going on at Yale, I have concentrated on enlarging my collection of sporting paintings, and the gaps on the walls of the Brick House were soon being filled'.[6] In what was, in effect, his private art gallery, the ageing collector took a particular delight in adding paintings such as Landseer's *Favourites, the Property of H.R.H. Prince George of Cambridge* (fig. 10). He did so not only for his personal pleasure, genuine though that was, but also because of his lifelong 'belief that British sporting art has always, blindly and mistakenly, been grossly underrated'.[7] With the final distribution of the paintings, prints and drawings from the Brick House in 1999, it became clear just how perceptive, and prescient, he had been, both in collecting and in allocating these personal favourites.

For more than twenty years, Paul Mellon thought carefully about the destinations of the works of art he owned, and although he regarded the Center as the principal repository for his British art, he reserved a small number of masterpieces for the National Gallery of Art in Washington, D.C., and a larger group, preponderantly sporting art, for the Virginia Museum of Fine Arts in Richmond. I was fortunate to be among the people he consulted, although he always reserved final decisions for himself. I recall that after he bought Stubbs's painting of the racehorse *Hyena* (fig. 11), I rather brashly commented that I looked forward to seeing it in New Haven some day. The reply, which came as a smiling whisper, I took as the gentlest of rebukes, 'So are you suggesting that *Lustre* [fig. 12] should go to Richmond instead?'

It would be misleading to characterise Paul Mellon's relations with the Center as concerned only with the care and growth of his collection there. As Trustee, President and finally Chairman of the National Gallery of Art over a period of forty-seven years, he understood better than anyone the rules and responsibilities of those offices and the practical issues of museum management faced by the staff. He was always careful to distinguish between the two, expecting the institutions he supported to abide by agreed priorities, but leaving implementation fully in the hands of those he tried and trusted. At Yale, he was alarmed by initial reactions to the announcement of his intended gift, proposing the establishment of an interdisciplinary study centre devoted to 'British culture and society within the period 1625–1850, with the Paul Mellon Collection of British Art as the focal point. . . . I would have been saddened', he commented, 'if the only purpose the pictures were going to serve was to replace lecture slides'.[8] Initially, the fledgling Center was named as 'The Paul Mellon Center for British Art and British Studies'. Several years later he explained that he had 'requested the change . . . to the Yale Center for British Art [because] I had the future of the project in mind. . . . I have always hoped that the reputation and excellence of the Center would attract other donors. . . . We all know that a *personally named* institution has much greater difficulty in raising funds than an *institutionally named* one'.[9]

Paul Mellon's proverbial generosity was never profligate. Indeed, there was more of his father's son in him than he would ever have claimed. Shortly before the Center opened in 1977, it became clear that additional funds would be needed to enable it to function effectively. Instead of adding capital to its endowment at that stage, the founder offered to provide recurrent funding for five years, to be calculated on the basis of budgets agreed in advance and revised annually. 'I felt it was the only way to discover the true running costs', he explained, 'information by which I should be able to make a judgment as to how much further endowment I would be willing to give'.[10]

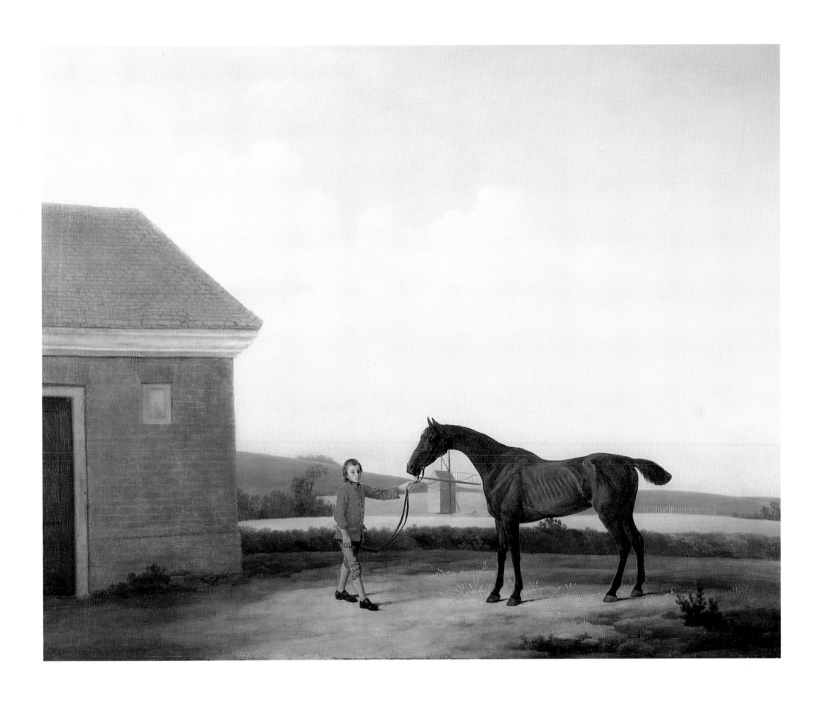

It proved to be an ideal arrangement which suited both parties, and which was extended for the rest of his lifetime. Over that twenty-year period his annual contributions amounted to many millions of dollars, covering not only the running costs of the Center but also the major maintenance of Kahn's landmark building which required re-glazing and re-roofing before the end of the century. Needless to add, at the end of the day he paid dividends on his promise to provide an adequate endowment, a figure he preferred not to name but to recalculate on a regular basis until his death in 1999. That final settlement leaves the Center among the best endowed of all museums and galleries in the United States.

Within months of opening to the public, the Center began to enjoy an international reputation as the most comprehensive collection of British art outside the United Kingdom. Its temporary exhibitions, designed to complement the strengths of the permanent collection, attracted large audiences and commanded reviews in leading international art journals. Ironically, however, its high profile abroad was not matched at home; within the university it was celebrated, but also isolated from the intellectual mainstream as a so-called jewel in the crown. When I joined the staff, it seemed that we needed to reaffirm the principles which lay behind Paul Mellon's commitment to Yale, confirmed by his remarks at the opening of the Center: 'Since a university is a community of scholars, a majority of them young scholars at that, and since within its walls there is, or at least should be, a sharing of interests and a cross-fertilisation of knowledge, it seems to me that the ferment of a university would enliven and stimulate the study of and the enjoyment of these artistic relics of our British inheritance, more vitally and more resourcefully than if they were passively displayed in a non-teaching institution'.[11]

A program to invite visiting scholars to New Haven was already in place, based on the premise that it was important to provide access to the collections for research as well as teaching. By establishing an Academic Advisory Committee, we sought to increase use of the Center by members of the Yale faculty in a wide range of relevant disciplines. Simultaneously, through an increasingly active, volunteer-led docent program, we reached out to schools and special-interest groups. Gradually the Center came to life within the local community, the university and the wider world of scholarship, catering to everyone from third-graders in New Haven schools to graduate students in the History of Art Department at Yale and visiting scholars from abroad.

Two initiatives in particular stand out. In 1985 the Center hosted the first of a series of Institutes, funded by the National Endowment for the Humanities. It focused upon the eighteenth century and enabled twenty scholars from around the United States, junior and senior, representing a broad range of disciplines, to go to Yale for four weeks during the summer to pursue a program of intensive research and discussion. It provided a highly successful model, especially when we overcame the objections of the Endowment to our holding seminars in the evenings; we did so to allow participants to spend the maximum amount of time in the museums and libraries during opening hours. The second initiative was developed jointly with the London Centre. It resulted from the conjunction of an interdisciplinary conference, 'Towards a Modern Art World', organised by Michael Kitson and co-sponsored by the Tate Gallery in 1989, with a series of discussions on both sides of the Atlantic about the need for a serial publication devoted to British art. In due course, the proceedings of the conference initiated *Studies in British Art*, an ongoing series in which seventeen volumes have appeared to date.

In 1984–85, the Center joined forces with the Tate Gallery to organise, in honour of Paul Mellon, a monographic exhibition devoted to the work of George Stubbs. In New Haven it attracted unprecedented audiences. I remember one day in particular when the Library Courtyard was filled at mid-morning by seven- and eight-year-olds crouching on all-fours and roaring in imitation of the painted, over life-sized lion attacking a horse on the wall above them. Later that day a small group of graduate students gathered in the same place for a seminar on images of authority

and oppression in eighteenth-century English art. Finally, in the evening, there was a reception in the courtyard following a public lecture on Stubbs attended by a capacity audience. In a single day, several hundred people of all ages had experienced firsthand, in totally different ways, what Paul Mellon called 'the art experience . . . a meeting place of thoughts and dreams and feelings'.[12] 'My hope has always been', he said, 'that the Center and its contents would attract undergraduate students, advanced scholars, struggling as well as established artists, and lovers of English art in general — not only for scholastic purposes but for pure enjoyment'.[13] Q.E.D.

Notes

1 Basil Taylor, Introduction to *Painting in England, 1700 – 1850, from the Collection of Mr. and Mrs. Paul Mellon*. Royal Academy of Arts, London, Winter Exhibition, 1964 – 65, p. vi.

2 'A Collector Recollects', remarks at the opening of the exhibition *Painting in England, 1700 – 1850: Collection of Mr. and Mrs. Paul Mellon*, at the Virginia Museum of Fine Arts, 20 Apr. 1963.

3 Paul Mellon, 'Remarks about the Development of the Collection', in *Selected Paintings, Drawings and Books*, published for the inauguration of the Yale Center for British Art, 15 Apr. 1977, p. xi.

4 Andrew Carnduff Ritchie, Director of the Yale University Art Gallery, 1957 – 1971, in his preface to *Painting in England, 1700 – 1850, from the Collection of Mr. and Mrs. Paul Mellon*, exhibition catalogue, Yale University Art Gallery, 1965, p. 2.

5 'Some years ago I walked past a shop in New York called The Incurable Collector and remember thinking at the time that the title could equally well be applied to me'. Paul Mellon, with John Baskett, *Reflections in a Silver Spoon: A Memoir* (New York, 1992), p. 293.

6 Ibid., p. 292.

7 Mellon, 'Development of the Collection,' p. xii.

8 Mellon, *Reflections*, p. 323.

9 Paul Mellon, memorandum to President A. Bartlett Giamatti, Yale University, 10 July 1979.

10 Ibid.

11 Mellon, 'Development of the Collection,' p. x.

12 Paul Mellon, from his dedication of the Paul Mellon Center at Choate School, 12 May 1972.

13 Mellon, 'Development of the Collection,' p. xi.

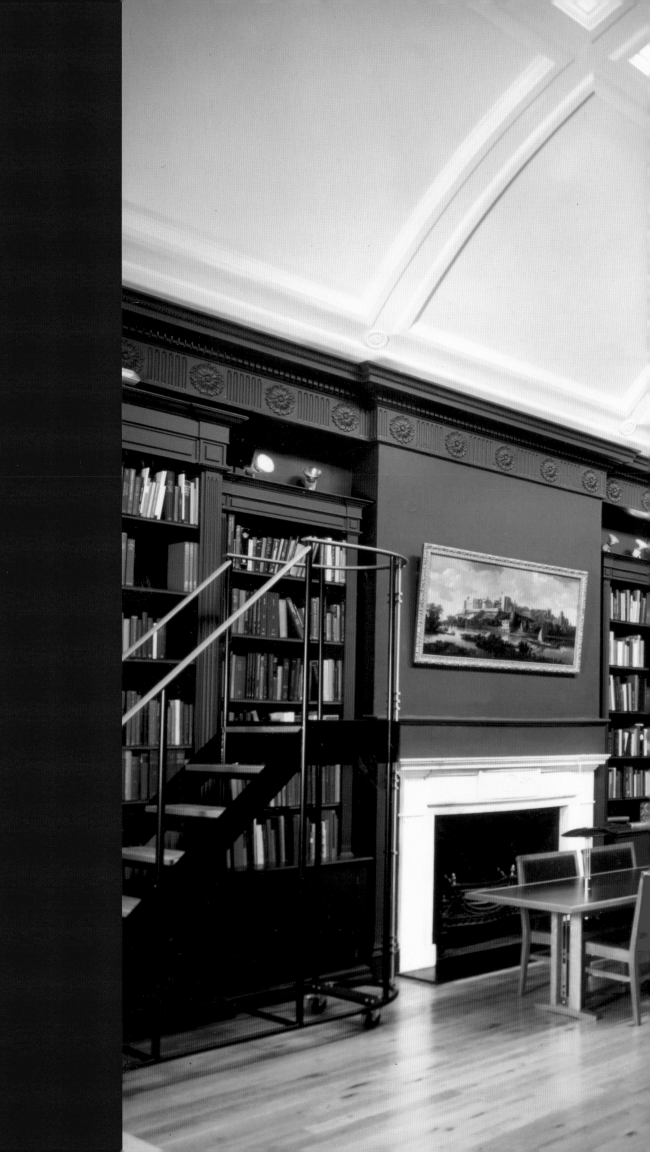

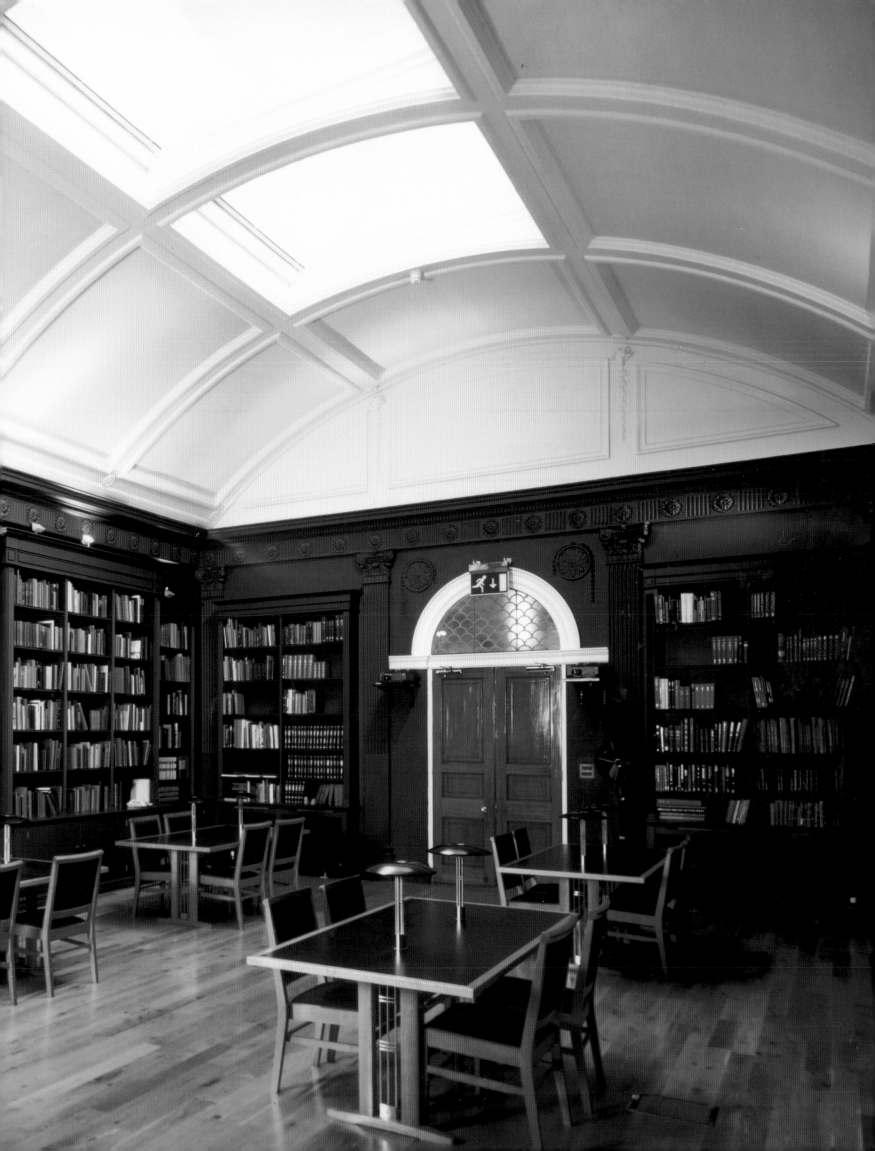

STUDIES IN
BRITISH ART

Marcellus Laroon

ROBERT RAINES

PMF
BA

THE PAUL MELLON
FOUNDATION FOR
BRITISH ART
Routledge & Kegan Paul
Pantheon Books

Paul Mellon and Scholarship in the History of British Art

BRIAN ALLEN

'One of my failings as a collector may be my lack of curiosity about the lives of the artists, their social and political backgrounds and their places in history. I am also little interested in their techniques, their materials, or their methods of working. I sometimes worry about it, but then I say to myself, "Why should I have to?"' These words of Paul Mellon from his autobiography might seem at odds with his extraordinary legacy, but they do emphasise his prime interest in the work of art itself. Although, objectively, and as a result of his education at Yale and Cambridge, Mellon always understood the significance of scholarship, its results usually left him unmoved. 'I find most critical writing, most statements about art, to be totally misleading', he wrote. 'Critical analysis of art is quite different from literary criticism. You can translate Sanskrit into English and analyse the meaning, but when you try to sum up the meaning of [Raphael's] *Alba Madonna* or Cézanne's *Boy in a Red Waistcoat* in words, it all seems to go off the rails'.[1]

By his own admission, most of his decisions in life, whether in collecting or in other areas of interest, resulted from intuition rather than intellectual analysis. This essentially explains why, after he announced the gift of his collection to Yale in December 1966, Paul Mellon was uneasy about the initial report Yale submitted to him in the spring of 1968, which suggested using the proposed new Center for British Art primarily as the focal point for interdisciplinary study devoted to British culture and society between about 1625 and 1850. 'I thought of the Center', he wrote, 'as an ideal institution for the study of British art and only incidentally of British manners and customs, of its history and mores'.[2] His prime objective in giving his collections of British art to Yale was to afford young men and women the opportunity to experience works of art firsthand.[3]

By the time Paul Mellon went to Yale in the mid-1920s, the history of art had, contrary to the situation in Britain, established itself as a respectable academic discipline in the best American universities. Yale had long been renowned for its Anglophilia and was already preeminent in the field of English literary studies. Professor Chauncey Brewster Tinker (1876–1963), who taught Paul Mellon at Yale, was already exploring the relationship between literature and the visual arts in Britain, which culminated in the publication of his Charles Eliot Norton lectures, delivered at Harvard in 1937–38.[4] Yale in the 1920s offered plenty of opportunities for young men like Paul Mellon to foster an interest in the visual arts as well as literature. In addition to Tinker, another of Mr. Mellon's teachers, Frederick Pottle (1897–1987), was making his name as an authority on James Boswell, and the young Frederick Hilles (1900–75) was devoting his professional career to the life of Sir Joshua Reynolds, studies that resulted in his important books *The Letters of Sir Joshua Reynolds*, which appeared in 1929, the year Paul Mellon graduated, and *The Literary Career of Sir Joshua Reynolds*, of 1936. Another Yale affiliate, who later became a friend of Mr. Mellon, Wilmarth Sheldon Lewis (1895–1979), had developed an obsession with another giant of eighteenth-century Britain, Horace Walpole (1717–97). Decades later, this focus would culminate in the publication of the definitive forty-eight-volume edition of Walpole's *Correspondence* by Yale University Press.[5]

It is worth noting that scholarship in British art during Paul Mellon's formative years, and before he began to collect British art seriously, was underdeveloped, which helps one understand more fully his importance in redressing this imbalance. In a fascinating lecture delivered at the inauguration of the Yale Center for British Art on 16 April 1977, Sir Ellis Waterhouse (1905–85), the doyen of historians of British art and from 1970 to 1973 the first director of the Paul Mellon Centre for Studies in British Art in London, reminisced about his long and distinguished career. He noted that, compared to the United States, the state of scholarship in England in the 1920s and 1930s was markedly less professional. In this address to an audience of luminaries, Waterhouse remarked that until the middle of the 1930s the art historian had no serious recognition in England. 'I should confess', he remarked, 'that it is only since the last war that I have myself felt able to use the word "art-historian" in England without a nagging feeling that it was a neologism which might not necessarily be understood!'[6]

Exactly fifty years earlier, in 1927, when Waterhouse first set foot in the United States, Henry E. Huntington (1848–1927) had just died, and the remarkable library and art gallery that bears his name had just opened to the public a dozen miles east of Los Angeles. Given that the discipline of art history had barely reached the west coast of the United States at that time, it is remarkable that so much scholarship in the field of British art would eventually emanate from that idyllic location. The initial impetus for this may have been the arrival in 1932 of the distinguished scholar and curator C. H. Collins Baker (1880–1959), who had left the National Gallery in London for the Huntington. Collins Baker, whom Waterhouse knew well, was 'one of the few English scholars in this field surviving from an earlier generation', and his presence at that pioneering institution, essen-

tially devoted to the display and study of British art and literature, set the tone for the achievements of Robert R. Wark (b. 1927), the Curator of the Huntington art collection from 1956 to 1990.[7]

Unlike today, in pre – Second World War England the Tate Gallery played virtually no role in promoting the study of British art. The situation was barely better at the National Gallery because, according to Waterhouse, the Director, Sir Augustus Daniel (1866 – 1950), 'actually disliked British painting of the eighteenth century'.[8] Although Collins Baker knew a good deal about British painting and published much that is still consulted today, it fell to his young assistant at the National Gallery, Ellis Waterhouse, to make British painting one of his areas of expertise before leaving to become Librarian of the British School in Rome in 1933.[9] At the National Portrait Gallery, the Director, Henry Hake (1892 – 1951), and his colleagues Henry Isherwood Kay (1893 – 1938) and C. K. Adams (1899 – 1971) conducted research on rather more specialist lines. But before the outbreak of war, these efforts were the extent of contributions from the official art establishment in Britain.

It is curious that from the beginning of the twentieth century the study of historic British painting was almost entirely in the hands of the art trade. Much of what was published about British art at that time was, in fact, written by the 'librarians' of London's leading art dealers, usually in the form of elaborate pamphlets produced to sell individual works. These now rather rare and often sumptuous publications are invariably anonymous, undoubtedly written by scholars who were cautious about protecting their anonymity. The leading 'expert' in the field was William Roberts (1862 – 1940), who had begun as second art critic of *The Times* under Humphrey Ward and went on to become the main *Times* critic. His first major work (published jointly with Humphrey Ward by Agnew's in 1904) was a book on George Romney, and there followed books on Sir William Beechey in 1907 and on John Hoppner, written jointly with the dealer William McKay and published by the dealer Colnaghi in 1909. Roberts, like many other experts, would, for five pounds, write certificates of authenticity for any eighteenth-century British picture placed in front of him, though he worked entirely outside the establishment world of the national museums.

Part of an older generation, the enormously prolific Dr. George C. Williamson (1858 – 1942) published numerous pioneering books on such artists as Ozias Humphry (1918), Daniel Gardner (1921) and (with Lady Victoria Manners) Angelica Kauffman (1924). None of these publications has proved reliable, however, and they are characterized by the kind of amateur scholarship in the field that survived in Britain until the Second World War, and indeed beyond. The one figure from this generation whose work has proved durable and who is still widely read and quoted is William T. Whitley (1858 – 1942). Whitley's work remains valid primarily because he based his books, written towards the end of his life, on decades of primary research in archives, newspapers and periodicals and presented in a straightforward chronological narrative an astonishing compendium of new and reliable information in *Artists and Their Friends in England, 1700 – 1799* (2 vols., 1928) and its sequel, *Art in England, 1800 – 1837* (2 vols., 1928, 1930). Apart from Whitley's admirable books, only the annual volumes of the Walpole Society (founded in 1911), which then, as now, had only a few hundred subscribers, produced any serious offerings about British art, and, then, mostly about watercolour painting. Perhaps the exhibitions in the 1930s of the Burlington Fine Arts Club should also be mentioned in this context since this group at least brought to public attention works by then little-known British painters such as Joseph Wright of Derby. Their catalogues, however, can hardly be deemed works of scholarship.

The establishment of the Courtauld Institute in London in 1932, under the directorship of W. G. Constable (1887 – 1976), was undoubtedly a significant moment, because a number of the first Ph.D. theses to emerge from this new body were on eighteenth-century English painters, although they remained unpublished. Another important landmark at this date was the series of

exhibitions held at the London house in Park Lane of Sir Philip Sassoon (1888–1939), Chairman of the National Gallery's trustees, in aid of the Royal Northern Hospital. The exhibition catalogues of Gainsborough in 1936 and Reynolds in 1937, both written by Ellis Waterhouse, were important milestones in the study of eighteenth-century British painting, and it might be argued that the interest in painters like Devis, Zoffany and Wheatley resulted from the first of these loan exhibitions, *English Conversation Pieces*, held in 1930.[10]

Just before the outbreak of the Second World War, in 1939, a new series of monographs on British artists was conceived for the publisher Kegan Paul under the editorship of Herbert Read (1893–1968), who was to become a friend of Paul Mellon, with the aim of including 'all the great English masters and . . . treat[ing] them with thorough and exact scholarship'.[11] The first of these to appear was Andrew Shirley's *Bonington*, in 1940. A volume on Sir Joshua Reynolds, written by Ellis Waterhouse, had actually been completed before the war, but owing to the outbreak of hostilities was not actually published until 1941. Waterhouse's *Reynolds* set an entirely new standard of professional scholarship and connoisseurship in the history of British art by providing a concise and reliable catalogue of the artist's work. It must have been clear that the young author was emerging as the leading figure in the field. After the war, Waterhouse was also commissioned by Nikolaus Pevsner, as the editor of the newly established Pelican History of Art series, to write the volume *Painting in Britain, 1530–1790*, the first in that distinguished series, published in 1953. Further volumes in the English Master Painters series continued to be published after the war: on Hogarth and Lely, by R. B. Beckett; on Richard Wilson, by W. G. Constable; on Thomas Lawrence, by Kenneth Garlick; and on William Etty, by Dennis Farr. Eventually, in the mid-1950s, the series fizzled out. Paradoxically, the proposed volume on George Stubbs by Basil Taylor never appeared, but it brings us rather neatly to the point at which both Basil Taylor and Paul Mellon enter the scene.

Although Paul Mellon had purchased a few British sporting pictures before the 1950s, most of his collecting activity had been confined to acquiring sporting and colour-plate books, such as the magnificent Abbey collection, purchased between 1952 and 1955 (see Reese, this vol. and cats. 128, 141 and 142). Although it seems probable, we do not know if Mr. Mellon, on his regular visits to England in the 1950s, saw the winter exhibitions at the Royal Academy, such as the one devoted to the institution's first hundred years, held in 1951–52, or the exhibition 'British Portraits', held in 1956–57. By that date Paul Mellon had of course been acquiring important nineteenth-century French paintings, but it was the chance meeting with the English art historian Basil Taylor (1922–75) in the spring of 1959 that had such significant bearing on all that followed. Their joint interest in Stubbs and sporting art in general was the happiest of coincidences, for it set in motion a sequence of events that was to have a profound influence on new scholarship in the history of British art.

Basil Taylor had always insisted on not taking any remuneration in return for advising Paul Mellon on his collection of British art, but, late in 1961, when he resigned his position at the Royal College of Art, his continuing refusal to accept payment for his services left him without an income. At about this time it came to Paul Mellon's attention that a lengthy and comprehensive manuscript on the history of watercolour painting in Britain by the deceased Keeper of the Prints and Drawings Department at the Victoria and Albert Museum, Martin Hardie (1875–1952), remained unpublished, essentially because of the prohibitive cost of editing and publication. Because Paul Mellon had just purchased Martin Hardie's own fine collection of English watercolours, he perhaps felt some sense of responsibility towards this project. After lengthy discussions with his friend Herbert Read, who was a director of the publisher Routledge and Kegan Paul, he decided not only to underwrite the overhaul of Hardie's manuscript, which eventually appeared in three volumes, published by Routledge between 1966 and 1968, but also to ask Basil Taylor to

draw to his attention any other writings on British art that faced the same predicament. From this almost accidental beginning, late in 1961, grew the concept of establishing a publishing venture that, to use Paul Mellon's words, 'would promote a wider knowledge and understanding of British art'.[12] A non-profit charitable trust was established, with 'independent self-governing British status and with its own board of trustees, to publish a series to be entitled "Studies in British Art"'.[13] This new project started under the wing of one of Paul Mellon's charitable trusts, the Bollingen Foundation, which he had established with his first wife, Mary, in December 1945, but shortly thereafter it was transferred to the financial control of the Old Dominion Foundation, which Mr. Mellon had established in 1941.[14] The new foundation in London was named the Paul Mellon Foundation for British Art, and Basil Taylor was persuaded to take on the directorship from premises at 38 Bury Street, St. James's.

The Foundation's early activities resulted in a series of short 'supplements' published in *Apollo* magazine beginning in 1964, consisting of brief scholarly notices about previously unpublished works of art. The first of these appeared some months before the first exhibition in England of Paul Mellon's collection, which opened to the public at the Royal Academy on 12 December 1964. When the collection was shown at the Yale University Art Gallery the following year, a three-day conference was held with the aim of bringing together leading scholars in the field to debate British art and to draw attention to areas in need of new research. Basil Taylor described the occasion as 'a most useful, but perhaps a little discouraging occasion, as hour by hour we were being reminded how much we did not know, how much remained to be discovered'.[15]

It is now all too easy to forget that in the 1960s, Britain had remarkably little confidence about the art of its past compared to that of mainland Europe. Denys Sutton (1917–91), the editor of *Apollo*, even went so far as to challenge his readers, in an editorial in June 1967 entitled 'Let's blow our own trumpet for a change', to stop being so diffident. Sutton posed the question, could the French Impressionists 'rival Turner with his poetical blending of delicacy and strength?' He went on to note that 'British art was neglected for years, except by a few enthusiasts, but, largely thanks to the munificence of Mr Paul Mellon, it is marching ahead'.[16]

Sutton's editorial coincided with the publication in 1967 of the Mellon Foundation's first three books: Robert Raines's monograph on *Marcellus Laroon* (fig. 1); Roy Strong's *Hans Holbein at the Court of Henry VIII*; and Oliver Millar's *Zoffany and His Tribuna*. All received the kind of widespread, lengthy reviews and publicity in the national press that would now be inconceivable for academic books. A few months later, in an article published in *Contemporary Review*, Basil Taylor offered a progress report on the Foundation's activities to date, noting that the primary aim of the Foundation was to advance the knowledge, understanding and enjoyment of British painting, sculpture and graphic arts through publications — 'by increasing the authoritative literature of the subject'. It was recognized at the start, wrote Taylor, that 'if such a programme of publishing was to have continuity, ambition and any intellectual drive, the study of British art itself would have to be nourished in other ways. As a contribution to that end', he noted, 'The Foundation has endowed two lectureships, one in British Medieval Art at the University of York and the other in Post-Medieval Art at the University of Leicester'.[17] In addition to offering modest grants to individual scholars for research purposes, financial support for exhibitions was an important part of the Foundation's charge, with exhibitions devoted to Bonington, Wheatley, Brooking, Mortimer, Laroon and Mercier, to name but a few, all receiving significant help.

Basil Taylor argued forcefully that simply by virtue of its creation, the Paul Mellon Foundation asserted that British painting was worthy of intelligent consideration. He was quick to point out, however, that for the student of British art in 1967 'the very fundaments of knowledge are still missing', noting that catalogues raisonnés of most of the greatest British painters, such as Turner and Constable, simply did not exist and that if 'our writers had been as inadequately

FIG. 2 Book jacket, Roy Strong, *The English Icon: Elizabethan and Jacobean Portraiture* (London: The Paul Mellon Foundation for British Art in association with Routledge and Kegan Paul; New York: Pantheon Books, 1969)

published and presented there would surely have been an outcry'.[18] In this interim report Taylor also drew attention to what was to prove to be the Foundation's nemesis, a proposed multivolume dictionary of British art. The dictionary, in its planning stages since the Foundation's inception, was, as Taylor admitted, 'perhaps too ambitious for the present resources of British art scholarship. Time will tell'.[19] It did, and the enormous estimated cost of the dictionary was one of the prime reasons for the Foundation's demise in 1969. In May 1970 a rather indignant editorial entitled 'The Future of the Mellon Foundation' appeared in *The Burlington Magazine*, following the announcement that a newly constituted organization, under the aegis of Yale University, named the Paul Mellon Centre for Studies in British Art, had been established. The editorial noted that at a meeting held in London on 9 December 1969 'to which a number of outside art historians were invited to give their advice, it transpired that the ten or twelve volumes projected would cost nearly £1,400,000', a huge sum for the proposed, rather over-optimistic print run of five thousand copies.[20] This sum was far beyond the means of the new Centre, whose tighter financial controls under Yale's management meant that it was not prepared for such an extravagance. The Foundation had employed a research team for the dictionary that, at its peak, numbered twenty; many young scholars such as the Tate's future director, Sir Nicholas Serota (b. 1946), cut their professional teeth on this venture.

Unfortunately, Basil Taylor's fragile, self-destructive personality and his weakness in managing the Foundation's financial resources were a major factor in the demise of the Paul Mellon Foundation. In his autobiography Mr. Mellon gives a full account of these years, during which Basil Taylor's manic depression tested their friendship to the breaking point.[21] Mr. Mellon regretted that the dictionary never appeared and years later remarked that 'if things had been handled differently and if Basil had had a more equable nature, it might have been possible to overcome the problems'.[22] Taylor resigned as director of the Foundation towards the end of 1968 and thereafter

his mental health deteriorated. He became increasingly isolated from his friends and family and, tragically, committed suicide in 1975. Despite this terrible ending, it should always be remembered that without Basil Taylor's friendship with Paul Mellon, neither the Foundation nor its successor might ever have been created.

By the time Basil Taylor resigned, the planning of the Yale Center was progressing apace, and it was decided, in large part due to Jules Prown, the Center's first Director, that a London office would be highly desirable. It was also clear that the current setup was not running satisfactorily and that both Paul Mellon and Yale University would require significant changes if the organization was to survive. By the time the Foundation closed in 1969, four more books had been published: Benedict Nicolson's *Joseph Wright of Derby, Painter of Light*; a beautiful facsimile of Richard Wilson's Italian Sketchbook, edited by Denys Sutton; Roy Strong's groundbreaking study of sixteenth-century painting, *The English Icon* (fig. 2); and Mary Webster's monograph *Francis Wheatley*. Many more books in preparation under the Foundation were eventually published, sometimes decades later, under the auspices of the London Centre and Yale University Press. There is no doubt, however, that the closure of the Foundation caused, as Ellis Waterhouse rather diplomatically put it, 'considerable bruised feelings'.[23]

The Burlington Magazine, unhappy at the failure of the Foundation, and doubtless expressing the views of many British scholars who feared that this putative 'Golden Age' might founder before it could even begin to flourish, predicted that the new London Centre, by then established with an endowment Paul Mellon had given to Yale, would 'have a tough time standing up to its American counterpart', the Yale Center for British Art. A new director had yet to be appointed, and it was hoped the person chosen would be of 'high standing . . . with a will of iron'.[24] By a stroke of good fortune in the summer of 1970 Professor Ellis Waterhouse was about to retire after eighteen years as Director of the Barber Institute of Fine Arts at the University of Birmingham; Jules Prown shrewdly persuaded him to take the helm of the new Centre until a long-term successor could be found. Waterhouse's international reputation immediately commanded respect in the London art world, and he undoubtedly established the character of the new Centre, in its premises at 20 Bloomsbury Square, a building shared with Yale University Press, then a modest London operation.

In its early years the London Centre was a great deal more modest in its aims than the Foundation had been. To win the confidence of institutions in Britain it was decided that the Centre should be completely disassociated from helping build the Mellon collection because, it should be remembered, when the collection was shown at the Royal Academy in the winter of 1964–65, headlines such as that in the *Daily Telegraph* — 'MELLON SHOW AROUSES DELIGHT AND DISMAY' — reminded the British art establishment and the public just how many good British pictures had left the United Kingdom over the previous five years.[25]

Although the Foundation had been active in building up an archive of black-and-white photographs of British paintings, drawings and engravings during its few brief years of existence, under the directorship of Waterhouse, who had an unrivalled knowledge of British art in both public and private collections, the new Centre made a high priority of photographing works passing through the auction houses and those in private collections. From his early days as a young curator at the National Gallery and later as Director of both the National Gallery of Scotland (1949–52) and the Barber Institute of Fine Arts (1952–70), Waterhouse had always made a practice of establishing photographic archives and recognized the vital importance of photography to the art historian. Thanks to the excellent work of the photographer Douglas Smith (1920–2006), who was employed from 1964 successively by both the Foundation and the Centre until his retirement in 1996, this more targeted approach, compared to the Witt Library's more comprehensive gathering of images, led to the cataloguing in the Centre's archive of tens of thousands of works

of art that might otherwise have gone unrecorded. Waterhouse was Director of the Centre for
less than three years, but in that short time and with the support of Jules Prown at Yale and
a distinguished advisory council comprising leading scholars and museum directors from the
British art world, he rapidly managed to establish the Centre as a viable force and to dispel the
unease that accompanied the Centre's foundation.

Any doubts that the Centre might not continue the Foundation's policy of supporting
scholarly books were dispelled with the publication in October 1971 of Ronald Paulson's magis-
terial two-volume *Hogarth: His Life, Art, and Times* by Yale University Press (fig. 3). This was the
first of the Centre's books published under a new contractual arrangement with Yale University
Press, and the sheer scale of this study (originally planned as a three-volume work) made the
Centre's ambitions clear. Since then, a steady stream of important publications (well over 150 to
date) has appeared under the imprint of the London Centre and Yale University Press. The publi-
cations program was given real impetus in 1973 when John Nicoll (b. 1944), a promising young

FIG. 4 Book jacket, David Mannings and Martin Postle, *Sir Joshua Reynolds: A Complete Catalogue of His Paintings*, 2 vols. (New Haven and London: Published for the Paul Mellon Centre for Studies in British Art by Yale University Press, 2000)

FIG. 5 Book jacket, Martin Butlin and Evelyn Joll, *The Paintings of J. M. W. Turner*, 2 vols. (New Haven and London: Published for the Paul Mellon Centre for Studies in British Art and the Tate Gallery by Yale University Press, 1977)

FIG. 6 Book jacket, Graham Reynolds, *The Later Paintings and Drawings of John Constable*, 2 vols. (New Haven and London: Published for the Paul Mellon Centre for Studies in British Art by Yale University Press, 1984)

publisher who was making a name for himself at Oxford University Press, was persuaded to join the London office of Yale University Press to handle production of its art books.

It is interesting to note that at the end of the 1930s, Ellis Waterhouse wrote rather despairingly in the preface to his monograph on Reynolds that the ideal book on the artist 'would run to about four fat volumes and would record all the sittings and the days of the month of each: it would be a bigger and very much better Graves and Cronin, would need a decade of unremitting labour and would cost the world to produce. Perhaps it may be done in our time'.[26] Although neither he (nor Paul Mellon) lived to see the publication of David Mannings's and Martin Postle's monumental catalogue of Reynolds's paintings in 2000 (fig. 4),[27] Waterhouse was remarkably prescient in his observations about the time and costs involved in that and similar projects.[28] He did, however, live to see the publication of catalogues raisonnés of Turner, Constable, Blake and Whistler (figs. 5, 6), all of which received substantial personal support from Paul Mellon, over and above the Centre's endowment funds.

Since the turn of the century, further catalogues raisonnés of Ramsay, Van Dyck, Stubbs and Holman Hunt have been published, and those for Madox Brown, Wilkie, Bonington, Hogarth, Gainsborough and Sargent are all in preparation. These books have provided a solid base for a new generation of scholars of British art, and with the publication of many more discursive texts and books of essays the changing approaches to the discipline are also reflected in the Centre's publications. The Centre's support of architectural history should also be noted, because the Paul Mellon Foundation had excluded architecture and the applied and decorative arts from its program. Standard reference works such as the third and fourth editions of Howard Colvin's *A Biographical Dictionary of British Architects, 1600–1840* have been published under the Centre's imprint, and groundbreaking works such as Eileen Harris's *The Genius of Robert Adam: His Interiors* and John Cornforth's *Early Georgian Interiors* have set the highest standards in both scholarship and sumptuous presentation.

When Waterhouse retired in 1973, Christopher White (b. 1930) was recruited as the second Director of Studies from his post as Curator of Graphic Arts at the National Gallery in Washington, D.C. White had considerable experience in the museum world and the art trade, having worked for eleven years in the Department of Prints and Drawings at the British Museum before joining the dealers Colnaghi in 1965. Although White was not a specialist in British art, he

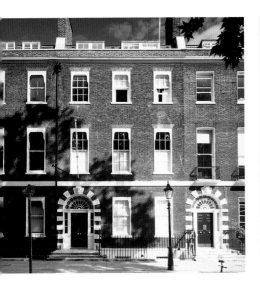

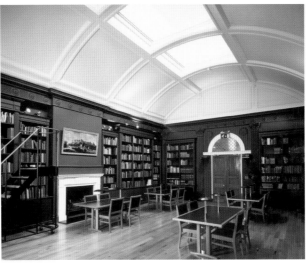

FIG. 7 Exterior, Paul Mellon Centre for Studies in British Art

FIG. 8 Library, Paul Mellon Centre for Studies in British Art

FIG. 9 Seminar room, Paul Mellon Centre for Studies in British Art

was a distinguished and respected figure, and during his twelve years as Director of Studies at the Centre he forged closer links with the sister institution, the Yale Center, after it opened in April 1977. One of his innovations was the introduction of the Yale-in-London program in the summer of 1977. Initially a summer course, it was extended in 1981 to two full semesters abroad that provided opportunities for Yale undergraduates interested in pursuing courses offered by what was then Yale's British Studies Department. This gave the London Centre a definable role in Yale's undergraduate life, and daily life at 20 Bloomsbury Square was enhanced by the presence of lively and intelligent Yale undergraduates. The experience of studying British art during a term in London also enabled them to make greater use of Paul Mellon's collections at the Yale Center on their return to New Haven. Increasingly, too, the London Centre was becoming a base for the stream of Yale graduate students (and from other universities as well) who wished to pursue advanced research in historic British art. The presence of a London base, which made possible introductions to the London art world, has undoubtedly provided a vital point of entry for students at a sometimes isolated stage in their professional existence.

When Christopher White was appointed Director of the Ashmolean Museum at Oxford in 1985, he was succeeded by the Deputy Director of the Courtauld Institute of Art, Michael Kitson (1926–98). Although not a prolific writer, Kitson was a hugely influential figure within academic circles and brought a wealth of experience and authority to the London Centre. The seven years of his directorship were a period of greater engagement and closer academic ties between history of art departments in universities and national museums. As his successor, I began my career at the Centre in 1976 and have been fortunate to be in the post at a time when the Centre's funds have grown significantly as a result of Yale University's careful investment of Paul Mellon's endowment. As a result, not only was the Centre able to move in 1996 to larger premises in Bedford Square (figs. 7–9), but the modest sum available in grant aid from the Centre before 1998 has grown tenfold, resulting in a hugely beneficial impact in the field. The Centre now publishes about fifteen new titles each year, and, through its grant program, offers support to other academic publishers of scholarly books on British art.

A new, expanded fellowship program has provided far greater opportunities for research in British art than ever before. One suspects that when the Centre was founded in 1970, Paul Mellon may have been circumspect about its prospects, given the short and turbulent history of its predecessor, but by the time of his death in 1999 he was able to see that from comparatively modest beginnings the Centre was indeed fulfilling what he and Basil Taylor had first conceived thirty years earlier.

Notes

1 Paul Mellon, with John Baskett, *Reflections in a Silver Spoon: A Memoir* (New York, 1992), p. 294.

2 Ibid., p. 323.

3 For Paul Mellon's own words on this subject, see Robinson, this vol., p. 36, and Mellon, *Reflections*, p. 323.

4 Chauncey B. Tinker, *Painter and Poet: Studies in the Literary Relations of English Painting* (Cambridge, 1938).

5 *Horace Walpole's Correspondence*, ed. W. S. Lewis, 48 vols. (New Haven, 1937–83).

6 Ellis Waterhouse, *British Art and British Studies: Remarks at the Inauguration of the Yale Center for British Art, 16 April 1977* (New Haven, 1979), p. 5.

7 Ibid., p. 7.

8 Ibid., p. 11.

9 Collins Baker's *Lely and the Stuart Portrait Painters*, 2 vols. (London, 1912), remains an authoritative volume.

10 Peter Stansky, *Sassoon: The Worlds of Philip and Sybil* (New Haven, 2003), 196–97.

11 From the series dust jacket text.

12 Mellon, *Reflections*, p. 328.

13 Ibid.

14 Ibid., pp. 171–77, 357.

15 Basil Taylor, 'The Paul Mellon Foundation for British Art: A Report on Progress', *Contemporary Review*, November 1967, p. 267.

16 [Denys Sutton], *Apollo*, June 1967, p. 399.

17 Taylor, 'Report on Progress', p. 264.

18 Ibid., p. 266.

19 Ibid., p. 267.

20 *The Burlington Magazine*, May 1970, p. 267.

21 Mellon, *Reflections*, pp. 329–36.

22 Ibid., p. 332.

23 Waterhouse, *British Art and British Studies*, p. 28.

24 *The Burlington Magazine*, p. 268.

25 *Daily Telegraph*, 11 Dec. 1964.

26 A. Graves and W. V. Cronin, *A History of the Works of Sir Joshua Reynolds*, 4 vols. (London, 1899–1901).

27 David Mannings, *Sir Joshua Reynolds: A Complete Catalogue of His Paintings*, catalogued by Martin Postle, 2 vols. (New Haven, 2000).

28 Ellis K. Waterhouse, *Reynolds* (London, 1941), p. ix.

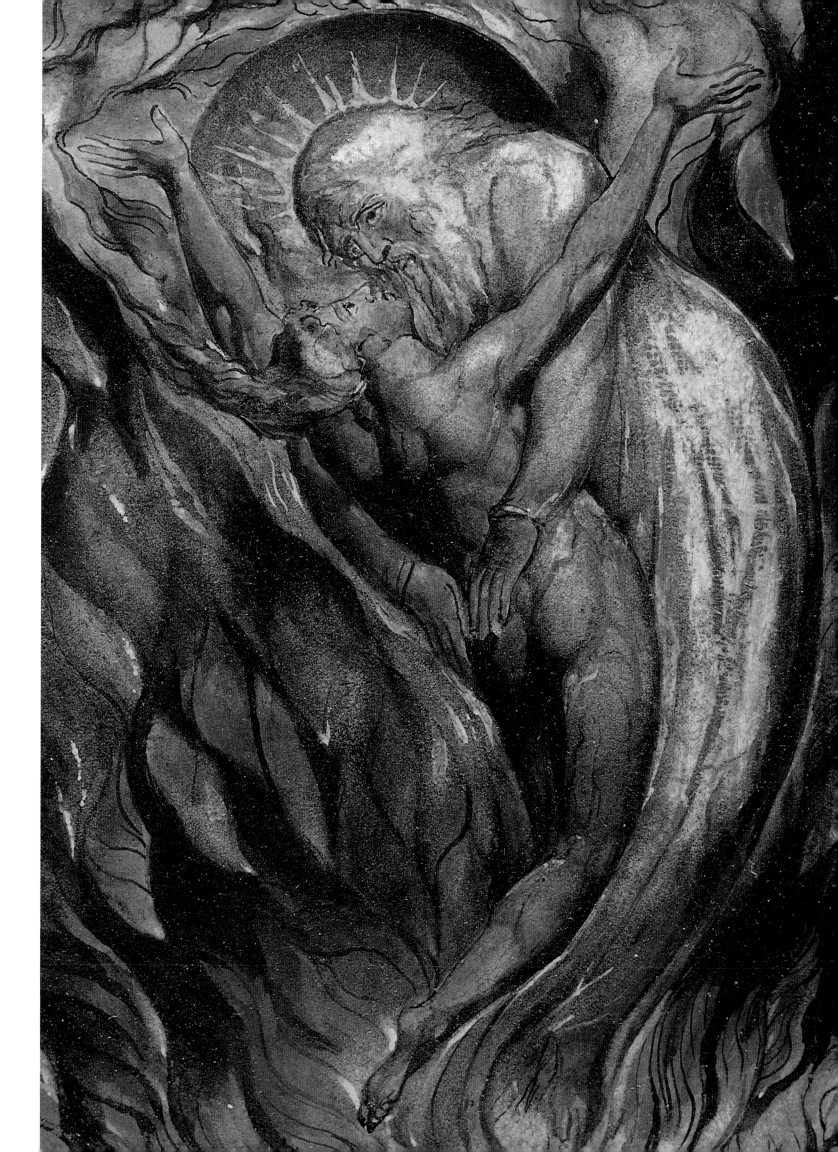

A Series of Eight Plates of

FOX HUNTING

From the

Original Drawings by W. P. HODGES, ESQ.r and Engraved by

M.r HENRY ALKEN.

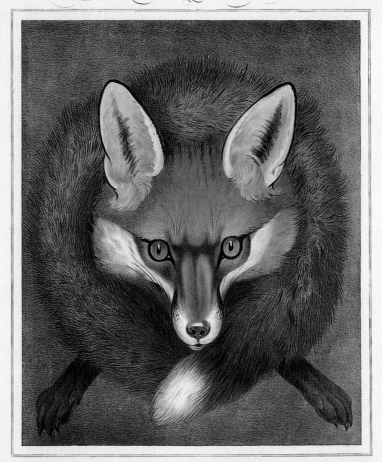

THE SPORTSMAN'S ARMS

DEDICATED BY SPECIAL PERMISSION TO HIS GRACE THE

Duke of Beaufort K.G.

London: Published by THO.s M.c LEAN, 26, Haymarket, Aug 1833

Paul Mellon
as a Book Collector

WILLIAM REESE

Paul Mellon was one of the greatest book collectors of the twentieth century.
This may surprise some, for his achievements as an art collector and his role in the
creation and expansion of two major institutions, the Yale Center for British Art
(YCBA) and the National Gallery of Art, Washington, D.C., have largely overshadowed
his interest in books and manuscripts. Mellon was a serious book collector before he
bought any significant paintings, and there were periods when books were his primary
collecting interest. Over time he pursued a variety of fields, ranging from sporting
books to William Blake, from Americana to early English books, from botany and
natural history to the entire library of John Locke. Most of his books and manuscripts,
numbering more than thirty thousand volumes, were ultimately given to the Center as
a gift or bequest, although important segments went to the Beinecke Rare Book and
Manuscript Library at Yale or to other institutions in England and the United States.
Had Mellon been a book collector alone, he would be celebrated today as one of the
giants in the field. Books and manuscripts were an integral part of his collecting for
much of his life and were closely related to his fine arts activities.[1]

The foundations of Paul Mellon's book collecting were established at Yale. Like many other undergraduates of his era, he was deeply influenced by Chauncey Brewster Tinker, whose course entitled "The Age of Johnson" was vividly illustrated with rare books and manuscripts from Tinker's personal library. Tinker was also Yale's first Keeper of Rare Books. Although Mellon never became a collector of the English classics, like so many others who fell under Tinker's spell, he came to share a love of Blake and even consulted Tinker on his plans for postgraduate study when he briefly considered a teaching career. Several decades later, Mr. Mellon bought a number of books for the Yale Library because Tinker wanted them and went out of his way to lend the university Blake items so that Tinker, who was in ill health, could see them.[2]

Whatever seed was planted, after graduating from Yale in 1929, Paul Mellon's interest in books was primarily as a reader, especially of English sporting fiction, which he absorbed along with English sport during his years at Cambridge. Back in the United States, in May 1936, Mr. Mellon visited the New York store of the bookseller William Gannon and bought his first rare book, Charles B. Newhouse's *The Roadsters Album* (London, 1845). Gannon would have been described at the time as a seller of "books for a gentleman's library": color-plate books, nicely bound sets, and standard rarities, with a specialty in sporting books. Well-known in the trade, though not one of the fanciest dealers, Gannon would act as Mr. Mellon's agent in buying antiquarian books for the next two decades, either bidding for him at auction or finding what his customer wanted in other dealers' stocks.[3]

The collecting bug soon bit hard. It came at a time when Paul Mellon had resolved his differences with his father, when he no longer felt he would be forced to play an active role in the family businesses and was about to move to the farm in Virginia, which would be his home for the rest of his life. Andrew Mellon had never been a book collector or an admirer of country sport; his son now began a passionate pursuit of books that exemplified both for a country gentleman. In February 1937, via Gannon, he was a serious participant in the American Art Association sale of the Dixon collection, one of the greatest collections of works by the sporting illustrator Henry Alken ever to come on the market. Although the country was in the depths of the Depression, a small group of wealthy sporting-book collectors made for bruising competition. Paul Mellon came away with the chief prize (and his first serious rare book), Alken's *The Beaufort Hunt* (London, 1833; fig. 1). Two weeks later, clearly enthused, he bought the double elephant folio Havell edition of Audubon's *The Birds of America* (London, 1828–39).[4]

Mr. Mellon bought numerous books on racing and fox hunting until the summer of 1939, when he and his wife, Mary Conover Mellon, moved to Zurich to study with C. G. Jung, who fascinated them both. Their eight-month sojourn in Switzerland and their dedication to Jung's theories led, in 1945, to the foundation of the Bollingen Foundation and its extraordinary series of publications, including Jung's collected works. The more immediate result, on their return to the United States in 1940, was that Mary Mellon began to collect books and manuscripts on alchemy and the occult, and Paul Mellon began his collection of Blake. In one of his few remarks about book collecting in his memoir, Mellon notes that the works of Blake "have always had a special appeal for me." At the A. Edward Newton sale in April 1941 he bought the Blake watercolor *The Wise and Foolish Virgins* and *The Book of Job* (London, 1825). A few months later he bought his first major Blake printed work, *There Is No Natural Religion* (London, 1788–94). At this point, war intervened, and he joined the army. After his return, Mary Mellon died, in the fall of 1946. There were no significant book purchases from the spring of 1941 to the fall of 1947.[5]

In late 1947, he began to pick up the strands of his book collecting. As they would be all his life, books on sport—especially horses, hunting, and equestrian sports generally—were a constant background to grander acquisitions in other areas. He began to build his Blake collection, acquiring *Songs of Innocence* (London, 1789) from David Randall, of Scribner's rare book department, in

1947; *Europe a Prophecy* (Lambeth, 1794) from the collector Moncure Biddle in 1948; and *Songs of Innocence and of Experience* (London, this copy ca. 1814) and *The Book of Thel* (London, 1789) shortly afterward. Even in the extraordinary postwar book market, when the world seemed awash in great books at laughably low prices, Blake's works were extremely rare.[6] In another direction, Mr. Mellon and his second wife, Rachel Lambert Lloyd Mellon, began to acquire books on botany, horticulture, and natural history. He had already bought some important titles in this area before his remarriage, notably Pierre Joseph Redouté's magnificent color-plate books, *Les Liliacées* (Paris, 1802–16) and *Les Roses* (Paris, 1817–24). These proved to be the foundation of what would become Mrs. Mellon's Oak Spring Garden Library.[7]

Paul Mellon had begun his donations to Yale collections in 1940, providing the funds to buy a magnificent Renaissance chansonnier, a collection of secular songs containing both words and music. Christened the Mellon Chansonnier, it has become one of the most highly used early manuscripts at Yale. Then, in 1949, he made one of his most significant gifts, in a transaction that cemented his warm relationship with his former professor, Tinker, and with the University Librarian, James T. Babb. The James Boswell papers, which had been unearthed and brought to the United States in the 1920s by Colonel Ralph Isham, were a prize the Yale librarians desperately hoped to acquire. Isham had begun their publication, then ceased because of his increasingly difficult financial straits during the Depression. Through every vicissitude, he had held on to the manuscripts, seeking a price then unmatched in English literary collecting. For Tinker, a Boswell scholar who had taught Isham as an undergraduate, only to be beaten out by his student in the initial acquisition of the papers, the matter was intensely personal as well (he had confronted Isham in the lobby of Claridge's after Isham bought them, shaking his fist and admonishing him: "Ralph, you have stolen my mistress!"). More important, the Yale librarians were convinced of the tremendous potential for publication. Paul Mellon came to the rescue through his Old Dominion Foundation, providing most of the funds for the purchase and initial editing. When the first of the diaries, *Boswell's London Journal*, sold almost half a million copies by 1953, he was deeply gratified. From this point on, Babb frequently appealed to him for financial help in acquisitions, while offering bibliographical assistance to Mr. Mellon in his own collecting.[8]

In the latter part of 1951, Paul Mellon became aware that one of the leading scholars of alchemical books and manuscripts, Denis I. Duveen, planned to sell his collection. Mary Mellon had acquired a small group of alchemical material before her death, to which Mr. Mellon now added 126 important manuscripts from Duveen. Over the next decade he purchased another nineteen manuscripts from various sources, as well as numerous printed works on the same themes. His intention seems to have been to build a significant collection in the field as a memorial for Mary; the purchases were made through the Bollingen Foundation. The collection was given to the Yale University Library in 1964, and separate catalogues of the printed books and manuscripts were published in 1968 and 1977, respectively.[9]

Late in 1951 a string of events prompted by the bookselling brilliance of the rare book department of Scribner's—David Randall in New York and John Carter in London—transformed Paul Mellon's collecting. He had been discreet as a buyer, making most of his transactions anonymously through Gannon. Randall, however, knew who Gannon's customer was, since on one occasion in the late 1930s, Gannon was marooned in Boston by a blizzard and was unable to attend an auction where he was to bid on sporting books for Mr. Mellon. He called on Randall to execute the bids, in the process revealing on whose behalf he was acting. Randall was almost certainly aware who had bought his *Songs of Innocence* several years earlier when the 1951 facsimile edition of the only colored copy of Blake's *Jerusalem* (London, 1804–20; fig. 2) drew his attention. The original had belonged for decades to General Archibald Stirling of Keir, as part of one of the finest Blake collections in the British Isles. As Randall noted, "It was not merely a great Blake book, but *the* great

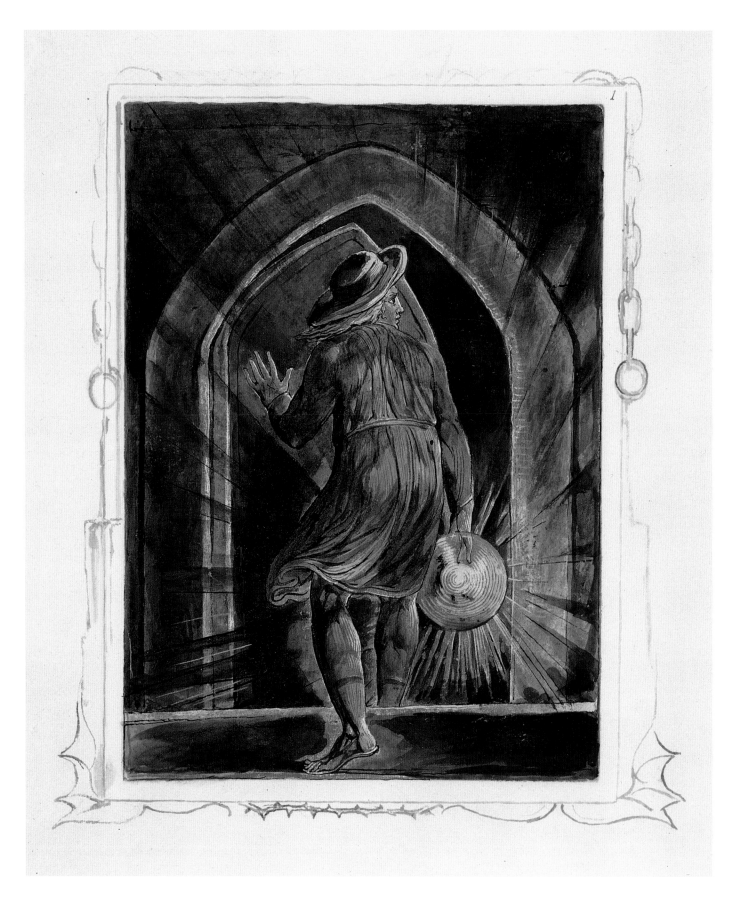

FIG. 2 William Blake (1757–1827), frontispiece from *Jerusalem*
(London, 1804–20), relief etching, printed in orange, with pen
and ink, watercolor, and gold on wove paper. Yale Center for
British Art, Paul Mellon Collection. B1992.8.1(1)

Blake book." At Randall's prompting, Carter approached General Stirling, while he brought the idea of acquiring it to Mr. Mellon via Gannon. Carter successfully purchased the book and five original Blake paintings on his behalf, but the deal fell afoul of the newly established laws controlling the export of cultural treasures. An export license was initially refused, but Carter negotiated a deal by which Mr. Mellon gave one of the paintings to the British nation, the others were sold at bargain prices to public galleries, and in return the book was allowed to be exported. Paul Mellon had acquired his greatest Blake. He almost immediately deposited the book with the Yale Library, and Babb reported that he had shown the volume to Tinker, who was in the hospital, and that seeing it had cheered the patient immensely. Babb wrote that Tinker examined it in silence for some time and then said, "I am smitten down. I never expected to turn the pages of the Stirling copy." Mr. Mellon subsequently loaned many of his Blakes to Yale, and they remained on exhibition in Sterling Library for several years in the 1950s.[10]

While the *Jerusalem* transaction was slowly proceeding, the Scribner's team put an entirely different proposition before him. Carter had been working with the great English collector Major John Roland Abbey, who had formed a magnificent holding of color-plate books illustrated in aquatint and lithography, published between 1770 and 1860. The collector had focused mainly on English books (although some works had been published elsewhere) dealing either with scenes of life in the British Isles or with travel in other parts of the world. Abbey was in the process of compiling a comprehensive catalogue of his collection and hoped to sell segments as he completed the separate sections. The first volume, *Scenery of Great Britain and Ireland in Aquatint and Lithography, 1770–1860*, was already in press. Abbey was a stickler for condition, and many of his books were in the original parts as issued, large paper copies, or had other special features of binding, association, or special coloring. It was an unparalleled collection. Without much hesitation Paul Mellon agreed to buy the first section, and in 1952 the transaction was concluded via Scribner's and Gannon. The second section, *Life in England in Aquatint and Lithography, 1770–1860*, followed in spring 1953, and the final part, *Travel in Aquatint and Lithography, 1770–1860*, in early 1955. Suddenly Paul Mellon had a major library on his hands, with almost two thousand titles, many of them multivolume sets or large folios.[11]

At first he had the Abbey books sent to Oak Spring, his Virginia home, but it quickly became apparent that major construction was needed to shelve them. In fall 1953 they were transferred to the National Gallery of Art, where Mr. Mellon was lent a storage room in the basement. The inadequate shelving, however, collapsed under the weight of the heavy folios. When Tinker visited to see the books in December 1954, he was unhappy to find many of the larger volumes stacked on the floor. In the meantime books were accumulating at home as well. Mr. Mellon had almost immediately started to buy books that fit Abbey's criteria but were not in the collection, especially American travel books, where Abbey was weak. Such acquisitions as William Wells's *Western Scenery; or Land and River, Hill and Dale, in the Mississippi Valley* (Cincinnati, 1851), one of the first American view books published outside the major cities of the East Coast, began to build on the Abbey base. Sporting and botanical books were flowing in. The purchase of the Duke of Gloucester's massive collection of sporting prints in 1956 added to the urgency. Clearly some greater organization was needed.[12]

In December 1956, Paul Mellon wrote Babb asking his advice: "We have always purchased, managed, and cared for these collections ourselves," he said, detailing Blake, sporting, and "Flowers and Gardens" as the three main areas in his Virginia holdings. Now, with Abbey and the other collections growing, he felt he needed professional help. He had also begun plans to transform his former residence, the large brick house that had stood vacant since he and his wife had moved to the Oak Spring farmhouse, into an extensive library space. Babb responded quickly, dispatching a Yale librarian to calculate the number of shelf feet it would take to accommodate Abbey, and

FIG. 3 George Harvey (ca. 1800–1878), "Winter, no. 5: Impeded Travellers in a Pine Forest, Upper Canada," hand-colored aquatint, from *Harvey's Scenes of the Primitive Forest of America* (London, 1841). Yale Center for British Art, Paul Mellon Collection

FIG. 4 Francis Delaram (1589–1627), "Frances, Duchess of Richmond," engraving, from *Generall historie of Virginia*, by John Smith (London, 1624). Yale Center for British Art, Paul Mellon Collection

recommending Willis Van Devanter, a recent Yale graduate with a library degree from Columbia, as a personal librarian. By April 1957, Van Devanter was installed in an office at the National Gallery and was reporting to Babb that the renovation of what came to be known as the Brick House was definitely going ahead.[13]

Having a librarian quickly transformed the pace and scope of Mr. Mellon's collecting. Gannon ceased to be his agent, and books were acquired wherever they became available. The initial expansion he had in mind was building on the Abbey holdings, broadly interpreted. This included any plate books or view books with American scenes, costume books from various parts of the world, and even for a time books on arms and armor, a short-lived interest that added several extraordinary manuscripts on fencing to the collection. As he wrote to Major Abbey himself a few years later, "I am always highly interested in English illustrated books or in fact any beautifully illustrated scenic books." This was a sweeping mandate that was pursued as long as Paul Mellon seriously collected books. Abbey became the central core around which much of the rest of the library was built. Mr. Mellon did not hesitate to purchase variant copies (for example, he eventually owned four copies of one of the great rarities of English and American color-plate books, George Harvey's *Harvey's Scenes of the Primitive Forest of America* [London, 1841; fig. 3], and five copies of the Karl Bodmer atlas to Prince Maximilian von Wied-Neuwied's *Reise in das Innere Nord-America . . .* [Coblenz, 1839–41]). Not surprisingly, dealers on both sides of the Atlantic were quickly aware of the new activity, and offers poured in.[14]

In 1958 the floodgates opened. Succumbing completely to bibliomania, Paul Mellon embarked on five years of intensive book buying that marked the height of his career as a bibliophile. His primary collecting interest over the previous decade, at least in terms of cash outlay, had

been French Impressionist paintings, and by this time the Mellons had one of the most extensive such collections in private hands. His interest in English paintings lay in the future; he did not begin to buy them seriously until 1960. The period 1958–1962 was devoted more to books than to any other area. During this time the Brick House was renovated with the intention of being a library; the extensive remodeling took until spring 1961. In the meantime, books and manuscripts were being acquired at a rapid rate in more and more fields.

Paul Mellon had always had a strong affection for his adopted state of Virginia and in 1953 bought the first book to describe explorations into the western part of the state and over the Blue Ridge, John Lederer's *The Discoveries of John Lederer* . . . (London, 1672). In the summer of 1958, on the 350th anniversary of the founding of the Jamestown colony, the New York dealer John Fleming issued a catalogue entitled *Virginia's Role in American History*. Fleming, the former assistant to the famous bookseller Dr. A. S. W. Rosenbach, had taken over the remains of that dealer's fabulous stock and drew out many treasures accumulated over decades. Mr. Mellon bought the catalogue en bloc, acquiring in one transaction five of the nine promotional tracts issued by the Virginia Company in its early years (including the only copy in private hands of Robert Rich's *Newes from Virginia* [London, 1610]) and a sweeping collection of great rarities, including the manuscript petition from the Virginia House of Burgesses to King George III calling for an end to the slave trade.[15]

With this impressive beginning, he turned to the dealer H. P. Kraus to make his single greatest purchase of material relating to Virginia. Kraus and the French Americana expert Chamonal had purchased, in 1952, the papers of the Comte de Rochambeau, commander of French forces in the American Revolution. The heart of the archive was George Washington's correspondence with Rochambeau, comprising dozens of letters tracing the strategy and conduct of the war in great detail, as well as minutes of the key conferences between the two commanders. There were maps detailing the march of the French army from Connecticut to Virginia, Rochambeau's journal of the Yorktown campaign, Lafayette's letters to Rochambeau reporting on his independent command, correspondence with Admiral de Grasse coordinating naval activity, and the reports of Rochambeau's chief officers. It is a measure of the book market in the 1950s that this archive had remained unsold at $180,000 for six years when Mr. Mellon bought it. In later years he acquired a number of other journals related to the Yorktown campaign.[16]

The Virginia historical purchases and the desire to create an "American Abbey" of illustrated works relating to America firmly established Paul Mellon as an Americana collector from 1958 on. As time passed, a third theme emerged—that of America as part of the larger Atlantic world of English discovery, exploration, and settlement. In this sense the early Virginia material was part of the English emphasis that dominated much of his collecting (fig. 4). Mr. Mellon ultimately assembled several thousand books and manuscripts on Americana and Virginiana. This was the only large segment of his library not to stay intact as a collection after his death, having been divided among the University of Virginia, the Virginia Historical Society, and the Beinecke Library and the Center at Yale.

More major purchases lay in store. In 1959 the English book dealers Lionel and Philip Robinson offered Mr. Mellon the surviving portion of the library of the English philosopher John Locke, which they had on consignment from Locke's collateral descendant, Lord Lovelace. This comprised more than eight hundred volumes, most annotated to some degree by Locke in his neat hand, as well as manuscript material. Paul Mellon purchased the entire collection, gave the manuscripts to Oxford University, and moved the library to the Brick House, where it was installed in a special room designed to re-create Locke's study, with the books arranged in their original shelf order. He had always intended to return the books to England, and in 1977 he gave them to the Bodleian Library at Oxford.[17] Shortly after the Locke purchase, the New Haven dealer Laurence

FIG. 5 Ranulf Higden (d. 1364), woodcut, title page from *Policronicon* (London, 1495). Yale Center for British Art, Paul Mellon Collection

Witten offered Mr. Mellon a staggering collection in another area, early English imprints. Witten had acquired the choice selection of works printed by William Caxton, Wynkyn de Worde (fig. 5), and Richard Pynson, the first three major English printers, assembled by Sir Arthur Howard. The eight Caxtons alone represented what Babb correctly called a nonrepeatable opportunity. Mr. Mellon bought the entire group, a total of thirty titles. Important early imprints were pursued more broadly after this, and over the next eight years the number of Caxtons, and of works by the other pioneering printers, was almost doubled. In 1968 the early English books were the subject of an exhibition at the Grolier Club.[18]

Cartography became yet another new area of interest in 1959. English atlases were a logical extension of illustrated English books, but just as the Americana collections swiftly grew beyond their original conception to include books on early explorations, the atlas holdings quickly expanded in scope as well. The most spectacular addition, in the spring of 1960, was a copy of Johann Blaeu's *Atlas Major* (Amsterdam, 1662), specially colored with magnificent gold highlighting and bound in full red velvet for the Holy Roman Emperor Leopold I. At the same time came a superb copy of Robert Dudley's *Arcano de Mare* (Florence, 1661), the first marine atlas compiled by an Englishman, containing detailed sea charts unrivaled up to that time. The single most spectacular acquisition in this area, also in 1960, was not a book but a pair of celestial and terrestrial globes created about 1522. The terrestrial globe, one of the earliest made, was probably designed by the cosmographer Johann Schöner and incorporates the cartography of Martin Waldseemüller depicting the New World. The designs of the celestial globe were executed by Albrecht Dürer. Known as the "Brixen Globes" because they were originally the property of the Bishop of Brixen, the globes were purchased from Prince Johann II of Liechtenstein by Kraus, who sold them to Mr. Mellon. A number of major atlases were added over the next decade, including virtually all of the important early atlases of England (fig. 6). One of his most notable purchases came in 1964, when he acquired a unique composite atlas assembled around 1680 by the Dutch mapmaker Nicolaes Visscher (fig. 7) bound *en plano*, with none of the maps folded, and extensively highlighted in gold.[19]

FIG. 6 Christopher Saxton (b. 1542[?]), engraved by Remigius Hogenberg (1536–87), hand-colored engraving, frontispiece from *Atlas of the Counties of England and Wales* (London, 1579), cat. 118. Yale Center for British Art, Paul Mellon Collection

FIG. 7 Gerald Valk (1651–1726), "America," hand-colored engraving, with touches of gold, from *Atlas Minor, Sive Geographia Compendiosa, Qua Orbis Terrarum*, by Nicolaes Visscher (Amsterdam: Visscher, 1680). Yale Center for British Art, Paul Mellon Collection

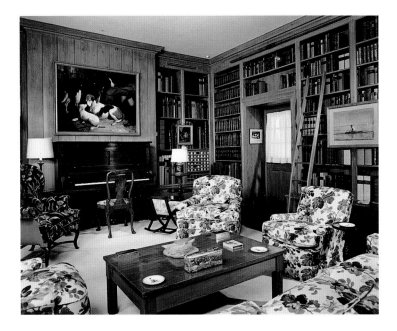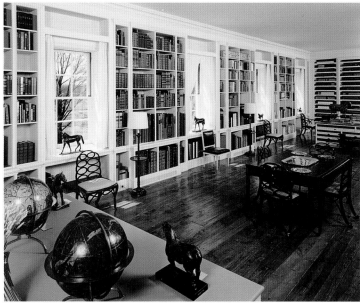

In this prolific period there was a brief interest in the French *livre d'artiste*, perhaps more as a corollary to the Mellons' interest in French painting. Over a few years in the late 1950s and early 1960s he acquired a significant collection of works illustrated by Picasso, Matisse, Bonnard, and Rouault, including Bonnard's original drawings for Verlaine's *Parallèlement* (Paris, 1897). At the same time he added a number of autograph letters by French Impressionist painters.[20]

The Brick House renovation was completed in the summer of 1961, and all of the collections were moved in. The first floor contained two smaller libraries, the Old Library (fig. 8), retained from the original incarnation of the house, where the Americana and atlas collections were housed, and the smaller Locke library next to it. The second floor held the main library, the grand Abbey Room (fig. 9), where Abbey books and additions were shelved. Books were being added in every field: sporting books (which went to the Gothic Library at the Oak Spring house), horticultural and botanical works, Abbey additions, Americana, atlases, and reference books to support both the book and art collections. At this point Paul Mellon was certainly the leading book collector in the United States, but other interests were vying with books for his attention, mainly English paintings, which he had begun to collect the previous year.

In 1962, however, there was no sign of his bibliophily abating. He had already had extensive dealings with Lionel and Philip Robinson, who had achieved a spectacular coup in 1946 by buying, largely sight unseen, all of the remaining book and manuscript collections of Sir Thomas Phillipps, the greatest book collector of the nineteenth century. This extraordinary trove of riches was not fully dispersed for another fifty years, and after 1956 the brothers closed their regular business and, constrained by tax considerations, dealt only with a select group of customers. The Robinsons offered Mr. Mellon "The Robinson Collection of Americana," a group of three hundred books and manuscripts largely carved out of the Phillipps material and designed to appeal to him. The approach was effective, and he acquired in one swoop some of the greatest Americana and English voyage material he ever bought. The most spectacular item was the earliest surviving manuscript map to show the route of Sir Francis Drake's circumnavigation of 1577–80 (cat. 120). Probably executed in 1587, it also illustrates the route of his Caribbean raid of 1585–86. Also present were such treasures as Thomas Cavendish's manuscript account of his last voyage in 1582 (cat. 122); Guy Johnson's manuscript journals and letter books of his career as British agent to the Iroquois during the American Revolution; a unique composite atlas of American maps printed between 1722 and 1766; the first English edition of Jan Linschoten's *His Discours of Voyages into Ye Easte and Weste Indies* (London, 1598), which included both the English maps and the engraved

plates normally found only in the Dutch edition; and Maximilianus Transylvanus's *De Moluccis Insulis* (Cologne, 1523), the first published account of Magellan's circumnavigation. The Robinson purchase alone would have made a major collection.[21]

By 1963 the directions of Mr. Mellon's book collecting were well established, and a steady flow of important acquisitions continued over the next four or five years. There were fewer en bloc purchases, but the rate of accrual was impressive. In the Americana area alone, about one hundred titles a year were added, and purchases of works on various English subjects far outstripped that. Many of the prints and drawings now at the Center, particularly those in albums, were originally acquired as part of the book collections, especially in the sporting material. If there was one unifying theme to all of these collections (excepting some of the early printed books) it was illustration. Paul Mellon remained fascinated with visual images of all kinds, from high art to the panoramas (fig. 10), strip views, and cartoons that enlivened the Abbey collection. Indeed, one of the most appealing aspects of the Mellon book collections is their diversity, ranging from great rarities and formal works to humorous and ephemeral pieces. A good example of this catholic approach is a portfolio of forty drawings by George Francis Lyon (fig. 11), one of the officers on Sir William Parry's expedition to discover a Northwest Passage in 1821–23. Lyon could not use watercolors because of the cold but nonetheless created remarkably evocative sketches in graphite, especially of the Eskimo he lived with through the brutal Arctic winter.[22]

Sporting books always remained a constant in Mr. Mellon's interests. In 1961 he purchased at Sotheby's the *Helmingham Herbal and Bestiary* (cat. 131), an English manuscript of circa 1500 with drawings of real English flowers and trees and a variety of both real and fantastic animals. One of the few American members of the English book-collecting society, the Roxburghe Club, Mr. Mellon in 1988 produced a facsimile of this manuscript as his contribution to the club's tradition of a member presenting fellow members with a work of scholarship based on an item in his collection. In 1967 he bought another great English manuscript, William Twiti's *The craft of venery* (ca. 1450, cat. 125), and in 1969 purchased a capstone, the first edition of Henri de Ferrières's classic work on sport, *Le Liure du Roy Modus et de la Reine Racio* (Chambéry, 1486, cat. 126). Mr. Mellon's sporting drawings, prints, manuscripts, and books are the most thoroughly recorded of any of his collections, through a series of detailed catalogues published between 1978 and 1981.[23]

Paul Mellon developed new areas in the mid to late 1960s. He had always had an interest in works relating to art, such as drawing-instruction manuals. As his interest in British paintings grew in the 1960s, works relating to fine arts were developed much more extensively. One of the most appealing of such books was a copy of the first American art-instruction book, Archibald Robertson's *Elements of the Graphic Arts* (New York, 1802), accompanied by numerous letters and sketches of the artist and his unpublished working material for a second volume (see cat. 135). Like many artists practicing in the United States in the Federal period, Robertson was an Englishman who sought opportunity in the New World. He opened the first American art school, the Columbian Academy of Painting, in 1792. Another appealing example is Edward Luttrell's

An Epitome of Painting . . . , a manuscript compiled in 1683 that gave detailed instructions for painting, drawing, and the new art of mezzotint (cat. 133). Ultimately broad collections of such works, both English and American, took shape. Mr. Mellon also acquired important art history reference tools, such as the collection of some 737 annotated art auction catalogues formed by the 2nd Baron Northwick, one of the major English painting collectors of the early nineteenth century.[24] A small but interesting collection of English fine printing was added, with comprehensive holdings of the Golden Cockerel and Nonesuch Press. Mr. Mellon had an early interest in the Kelmscott Press, buying a copy of the famous Kelmscott Chaucer in 1939 (see cat. 148). In 1970 he purchased a complete set of books from Kelmscott, certainly the most important English fine arts press.[25] An additional area was British architecture, the most obvious gap in his illustrated English books. Beginning in 1966, he made a determined effort to remedy this with the purchase of both printed books and architectural drawings, such as the original Robert Adam designs for Headfort House in County Meath, Ireland, and a comprehensive run of editions of *Vitruvius Britannicus*.[26]

Paul Mellon's attitude toward his book collecting underwent a basic shift concurrent with his decision to create the Yale Center for British Art. He had always planned that the bulk of his book collections would go to Yale and had told Babb as early as 1955 that Abbey and the sporting books were destined to find a home there. But, while his ultimate disposition plans were institutional, he had always collected books in an intensely personal way. Even if an item might fit his collecting criteria and be fairly priced, he simply didn't buy it if it did not appeal to him personally. With more demands on his attention, now largely focused on paintings and the planning of a major cultural institution, acquisitions slowed dramatically, and purchases became oriented toward research materials for the Center. Around 1970 material began to be transferred to the Beinecke Library for storage and cataloguing, and Mr. Mellon increasingly asked Yale scholars to comment on whether items under consideration were of interest before he made a decision to purchase. After the Grolier show in the spring of 1968, no more early English books were added, and the last major work of illustrated Americana, William Birch's *The City of Philadelphia . . . in the Year 1800* (Philadelphia, 1800) was purchased the same year. The departure of Van Devanter in 1973 signaled a final halt to most of Mr. Mellon's book collecting, and the following year books destined for the Center began to be given formally to the university. The one exception was sporting books, which he continued to buy for the rest of his life. His final rare book purchase, in 1993, was *The Citizen and Countryman's Experienced Farrier* (Wilmington, Del., 1764), the first American book on horse care. Although he no longer collected personally, he frequently purchased books and manuscripts for the Center at the request of its curators. For example, in 1968 and 1977, Paul Mellon acquired from Lord Elgin of Broomhall the drawings, watercolors, journals, letters, and other records relating to the expedition undertaken in 1767–73 by James Bruce and the Italian draftsman Luigi Balugani to discover the source of the Nile (fig. 12). In 1987, he made a final such gift: the *Record Books* of the Scottish artist David Roberts, creator of the most spectacular color-plate books on Egypt and the Holy Land, perhaps the best known Abbey titles (see cat. 137).[27]

Paul Mellon's legacy as a book collector remains intact. Most of his book collections were given to the Center between 1974 and his death, in 1999. The Center was also the largest recipient of books from his estate, including all of the sporting books, the remaining atlases, all of the Abbey books and Abbey additions not already transferred, the fine press books, and a substantial part of the Americana collection. The remainder of the Americana was divided among the Beinecke Library, the Virginia Historical Society, and the University of Virginia.[28] All the botanical and horticultural books not already belonging to Mrs. Mellon were willed to her and are now in her Oak Spring Garden Library. Combined with his many gifts to Yale during his lifetime, the book collections at the Yale Center for British Art are an important part of Paul Mellon's vision of making rare books available to scholars within the context of a great university.

FIG. 12 Luigi Balugani (1737–70), formerly attributed to
James Bruce (1730–94), *Carthamus tinctorius (Safflower)*,
watercolor and gouache over graphite. Yale Center for British
Art, Paul Mellon Collection. B1977.14.9100

Notes

1 I am grateful to Elisabeth Fairman and the staff of the Department of Rare Books and Manuscripts of the Yale Center for British Art (YCBA) for their generous assistance in researching this essay. Mellon bought many items as books that are now classed separately by modern curatorial distinctions. For example, most of Mellon's Blake acquisitions, which were bought as books in the book market and treated as such by him, are now housed in the Prints and Drawings Department at the Center (indeed, the featured Blake titles are discussed here in the Fine Arts section of the catalogue; see cats. 69–76).

2 Records of the Yale University Librarian, University Librarian's Correspondence (hereafter cited as ULC), Group 32-C, Series 3, Box 53, Folder 710–12, letter from James Babb to Mellon, 3 Mar. 1953. See Paul Mellon, with John Baskett, *Reflections in a Silver Spoon: A Memoir* (New York, 1992), p. 117.

3 Dealer invoice files (William Gannon), YCBA, invoice from William Gannon, 13 May 1936. Much of the chronology in this essay is taken from databases I created for the appraisal of books in the Mellon estate, which included purchase dates and vendor information, and from the dealer invoice files at the Center. Copies of these databases are in the office of the Curator of Rare Books at the YCBA, as are the dealer invoice files.

4 Dealer invoice files (William Gannon), YCBA, invoices from William Gannon, 6 and 18 Feb. 1937. *The Beaufort Hunt* is now at the Center, and the Audubon volume at the Oak Spring Garden Library. As an interesting comparison of values between 1937 and now, Mellon paid twelve thousand dollars for *The Beaufort Hunt* and eleven thousand dollars for *Birds of America*.

5 Dealer invoice files (William Gannon), YCBA. See Mellon, *Reflections*, pp. 157–82, for a discussion of the Bollingen Foundation, and pp. 284–85 for his remarks on Blake collecting.

6 Dealer invoice files (William Gannon), YCBA, and William Blake inventory files, YCBA. All of the early purchases were made via Gannon as agent.

7 Both titles are now in the Oak Spring Garden Library. They were purchased via Gannon in 1939 and 1947; dealer invoice file (William Gannon), YCBA.

8 The Mellon Chansonnier is MS 91 in the Beinecke Library. It was reproduced in facsimile, with commentary, in Leeman L. Perkins and Howard Garey, eds., *The Mellon Chansonnier* (New Haven, 1979). For Boswell, see Frederick A. Pottle, *Pride and Negligence: The History of the Boswell Papers* (New York, 1982), pp. 181–87. ULC, various letters from Babb to Mellon.

9 *Alchemy and the Occult: A Catalogue of Books and Manuscripts from the Collection of Paul and Mary Mellon Given to the Yale University Library*. The first two volumes, describing the printed books, were edited by Ian MacPhail and appeared in 1968; the second two, compiled by Laurence C. Witten and Richard Pachella, were published in 1977. The volumes were dedicated to Mary Mellon.

10 David A. Randall, *Dukedom Large Enough* (New York, 1969), pp. 91, 132–33; Donald C. Dickinson, *John Carter* (New Castle, Del., 2004), pp. 312–14. ULC, Babb to Mellon, 3 Mar. 1953.

11 Randall, *Dukedom Large Enough*, pp. 89–92. Dealer invoice files (William Gannon), YCBA. Mellon was determined from the beginning that the Abbey collection would stay together, and virtually all of it (with the exception of six titles given to the Pierpont Morgan Library and one title now in the Oak Spring Garden Library) is at the Center.

12 See dealer invoice files (J. R. Abbey), YCBA; in the same file, Martha Tross to N. E. Garver, 7 Aug. 1956, for a history of the Abbey transactions and storage problems.

13 ULC, Mellon to Babb, 14 Dec. 1956; Babb to Mellon, 7 Jan. 1957; Van Devanter to Babb, 30 Apr. 1957.

14 Dealer invoice files (J. R. Abbey), YCBA, Mellon to J. R. Abbey, 24 Oct. 1962.

15 Dealer invoice files (John Fleming), YCBA. The collection also included a second copy of the Lederer, which is now at the Center; the copy acquired in 1953 is at Virginia Historical Society, as is the House of Burgesses petition. Mellon presented the Robert Rich pamphlet to the John Carter Brown Library in honor of J. Carter Brown, giving that library the only complete set of the Virginia Company tracts.

16 H. P. Kraus, *A Rare Book Saga* (New York, 1978), pp. 173–74. Mellon gave the archive to the Beinecke Rare Book and Manuscript Library at Yale in 1992. See Vincent Giroud, *The Road to Yorktown: Maps and Manuscripts from the Archive of General Rochambeau: The Gift of Paul Mellon* (New Haven, 1992), an exhibition at the Beinecke Library immediately after the gift.

17 Dealer invoice files (Lionel and Philip Robinson), YCBA; Mellon, *Reflections*, p. 284.

18 Dealer invoice files (Lawrence Witten), YCBA. The Grolier Club catalogue, *Fifty-five Books Printed Before 1525 Representing the Works of England's First Printers: An Exhibition from the Collection of Paul Mellon* (New York, 1968), was prepared by Willis Van Devanter and provided full bibliographical details of all the books and extensive provenance, including notes that came from Howard's collection and those that came separately from dealers.

19 Kraus, *Rare Book Saga*, p. 338. All of Mellon's atlases and globes are now at the Center. For a detailed discussion of material in the collection, see Elisabeth Fairman, "'Wherin all Trauailers may Vnderstand How to Direct their Voyages,' Maps and Atlases at the Yale Center for British Art from the Bequest of Paul Mellon," *Yale University Library Gazette* 75:3–4 (Apr. 2001): 111–44. Dealer invoice files (Zeitlen, Nebenzahl, Kraus), YCBA.

20 Dealer invoice files (Kraus), YCBA. The French books and manuscripts were left to Mrs. Mellon for her lifetime, after which they will become part of the collections of the National Gallery of Art, Washington, D.C.

21 Dealer invoice files (Lionel and Philip Robinson), YCBA. See A.N.L. Munby, *The Dispersal of the Phillipps Library* (Cambridge, 1960), for the complex story of the Phillipps collection.

22 Dealer invoice files (Maggs Bros.), YCBA.

23 Judy Egerton and Dudley Snelgrove, *Sport in Art and Books: The Paul Mellon Collection: British Sporting and Animal Drawings, c. 1500–1850* (London, 1978); Dudley Snelgrove, *Sport in Art and Books: The Paul Mellon Collection: British Sporting and Animal Prints, 1658–1874* (London, 1981); John Podeschi, *Sport in Art and Books: The Paul Mellon Collection: Books on the Horse and Horsemanship Riding, Hunting, Breeding and Racing, 1400–1941* (London, 1981). The last included material acquired up to 1976. For an overview of the sporting books in the Mellon bequest to the Center, see James B. Cummins, "The Paul Mellon Collection of Sporting Books," *Yale University Library Gazette* 75:3–4 (Apr. 2001): 167–87. See also Elisabeth Fairman, *"The Compleat Horseman": Sporting Books from the Bequest of Paul Mellon*, an exhibition at the Center in 2001.

24 Dealer invoice files (Kennedy Galleries, C. A. Stonehill), YCBA, and office files on the Northwick purchase.

25 Dealer invoice files (Bernard Weinreb), YCBA.

26 Ibid. (House of El Dieff).

27 Ibid. (Old Print Shop, William Reese, Hobhouse Ltd.).

28 After the bequests from the Americana dispersal, the Virginia Historical Society and the Beinecke Library both staged memorial exhibitions with illustrated catalogues. They are Robert H. Strohm, ed., *Treasures Revealed from the Paul Mellon Library of Americana* (Charlottesville, Va., 2001), and George A. Miles and William S. Reese, *America Pictured to the Life: Illustrated Works from the Paul Mellon Bequest* (New Haven, 2002). For an overview of the Americana that went to the Center and the Beinecke Library, see William S. Reese, "Americana in the Paul Mellon Bequest," *Yale University Library Gazette* 75:3–4 (Apr. 2001): 145–66.

Fine Arts

1 **Jacques Le Moyne de Morgues (ca. 1533–88)**

A Young Daughter of the Picts, ca. 1585

Watercolor and gouache, touched with gold, on parchment;
10¼ x 7⁵⁄₁₆ in. (26 x 18.6 cm)
B1981.25.2646

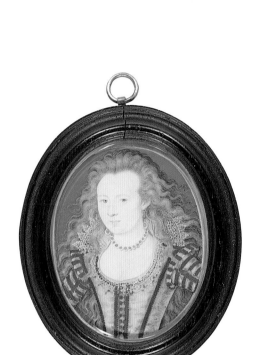

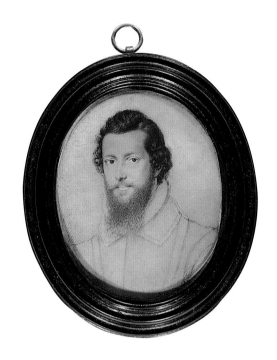

2 **Nicholas Hilliard (1547[?]–1619)**

Portrait of a Lady, ca. 1605–10

Gouache on parchment laid onto card; 2 x 1¹¹⁄₁₆ in. (5.1 x 4.3 cm), oval
B1974.2.51

3 **Isaac Oliver (ca. 1565–1617)**

Robert Devereux, 2nd Earl of Essex, ca. 1596

Gouache and brush and gray ink on parchment laid onto card;
2¹⁄₁₆ x 1¹¹⁄₁₆ in. (5.2 x 4.3 cm), oval
B1974.2.75

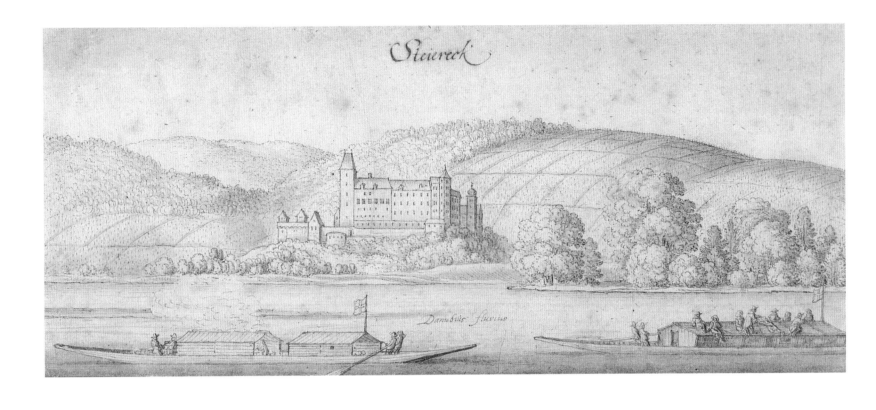

Steiereck

Danubuis fluvius

4 Wenceslaus Hollar (1607[?]–77)

View of Steiereck on the Danube, ca. 1636

Pen and brown ink and blue-gray wash on laid paper;
3¹⁵⁄₁₆ x 9¼ in. (10 x 23.5 cm)
B1977.14.4146

5 **Wenceslaus Hollar (1607[?]–77)**

View of the East Part of Southwark,
Looking Towards Greenwich, ca. 1638

Pen with black and brown ink over graphite on laid paper, with an additional
strip at right, added by the artist; 5⅝ x 12⅛ in. (14.3 x 30.8 cm)
B1977.14.4664

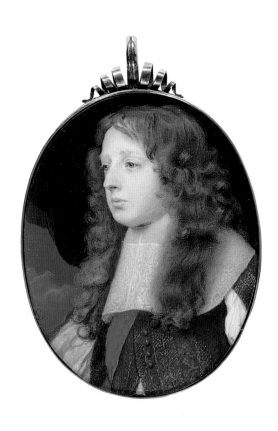

6 **Samuel Cooper (1607/8–72)**

*Charles Stuart, 3rd Duke of Richmond and
6th Duke of Lennox*, ca. 1661–67

Gouache on parchment laid onto card; 2¹¹⁄₁₆ x 2³⁄₁₆ in. (67 x 55 cm), oval
B1974.2.14

7　**Thomas Wyck (1616[?]–1677)**

View of the Waterhouse and Old St. Paul's, London, ca. 1663

Gray wash and graphite on two joined sheets of laid paper;
9 x 13½ in. (22.9 x 34.3 cm)
B1975.4.1446

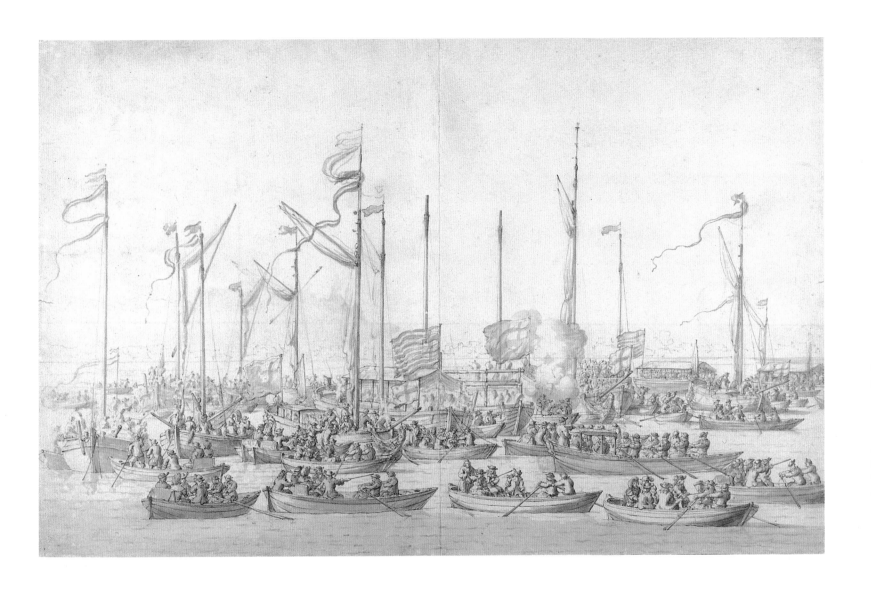

8 **Willem van de Velde the Elder (1611–93)**

Celebration on the Thames near Whitehall, 1685

Pen and brown ink, graphite and gray wash on two joined sheets of laid
paper; 11⅛ x 17⅛ in. (28.3 x 44.1 cm)
B1986.29.496

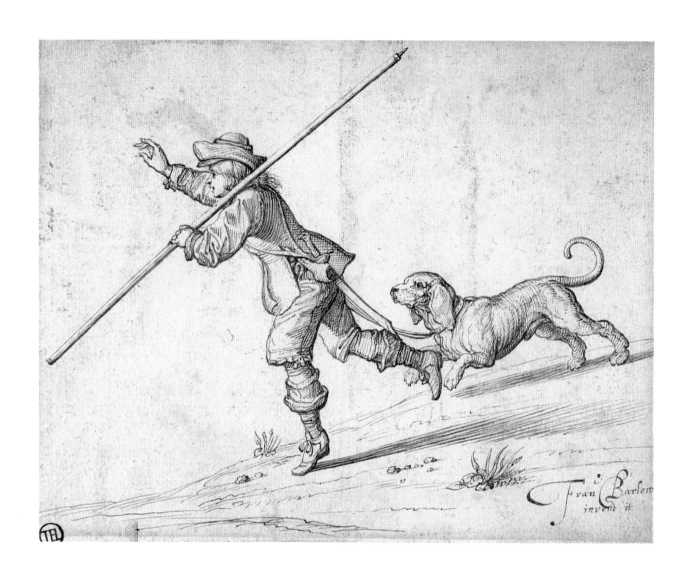

9 **Francis Barlow (1626–1702/4)**

Man Hunting with a Pointed Staff and a Hound, ca. 1645–50

Pen and brown ink on laid paper; 4¹¹⁄₁₆ x 6¹⁄₁₆ in. (11.9 x 15.4 cm)
B1977.14.4144

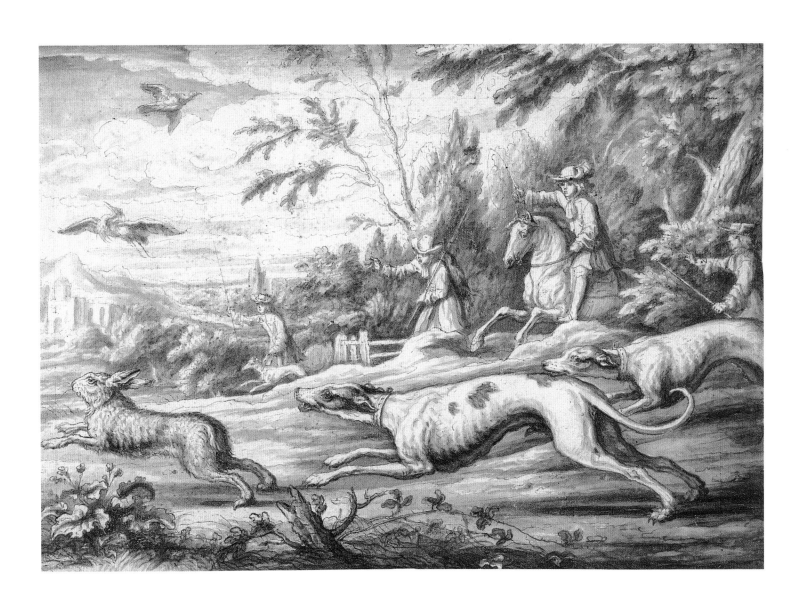

10 Francis Barlow (1626–1702/4)

Hare Hunting, date unknown

Pen, brown ink and gray wash on laid paper;
6⅞ x 9⅞ in. (17.5 x 25.1 cm)
B2001.2.623

11 **Jan Siberechts (1627–ca. 1703)**

Wollaton Hall and Park, Nottinghamshire, 1697

Oil on canvas; 75½ x 54½ in. (191.8 x 138.4 cm)
B1973.1.52

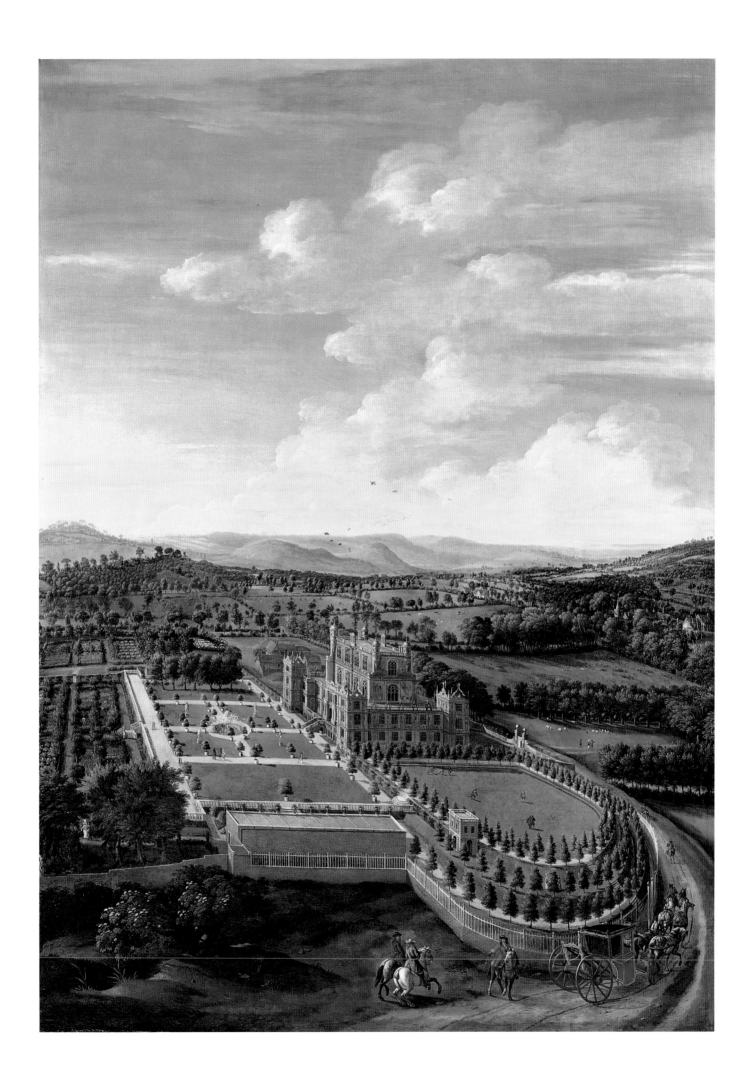

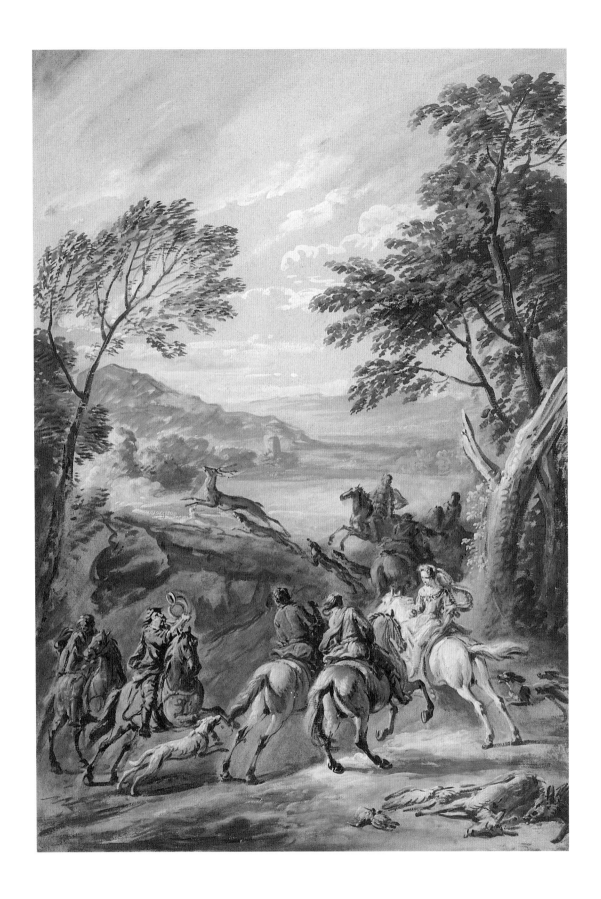

12　**Jan Wyck (ca. 1645/52–1700)**

Stag Hunt, date unknown

Brown wash with gouache on blue laid paper laid down on mount;
18¾ x 12⅞ in. (47.6 x 32.7 cm)
B1977.14.4170

13 **John Wootton (ca. 1682–1764)**

Hounds in a Landscape, date unknown

Gray wash with touches of pen and brown ink and crayon over graphite
on laid paper; 8¾ x 8 in. (22.2 x 20.3 cm)
B2001.2.1382

14 **William Hogarth (1697-1764)**

The Beggar's Opera, 1729

Oil on canvas; 23¼ x 30 in. (59 x 76 cm)
B1981.25.349

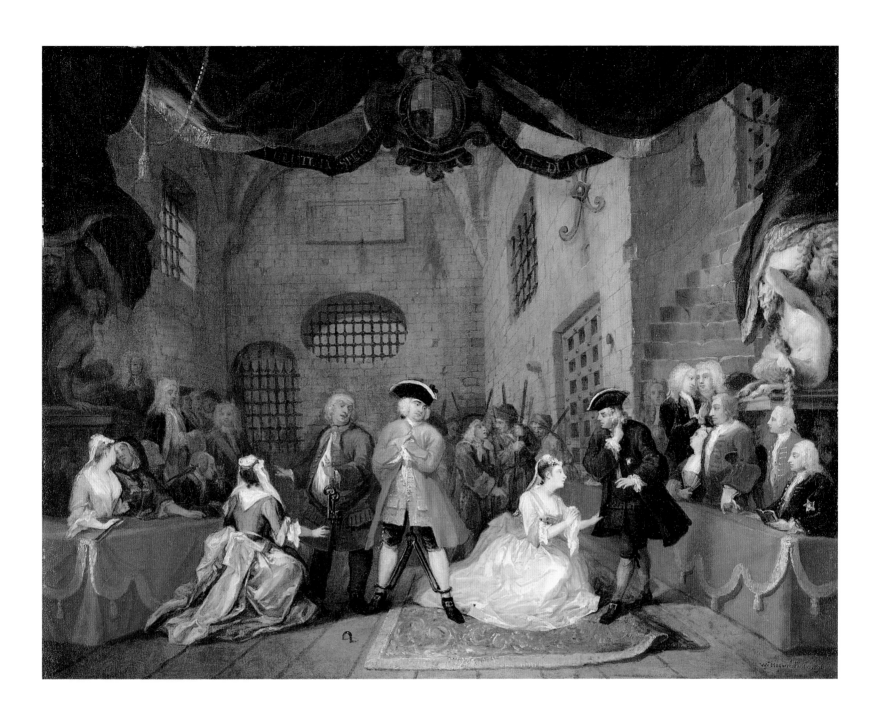

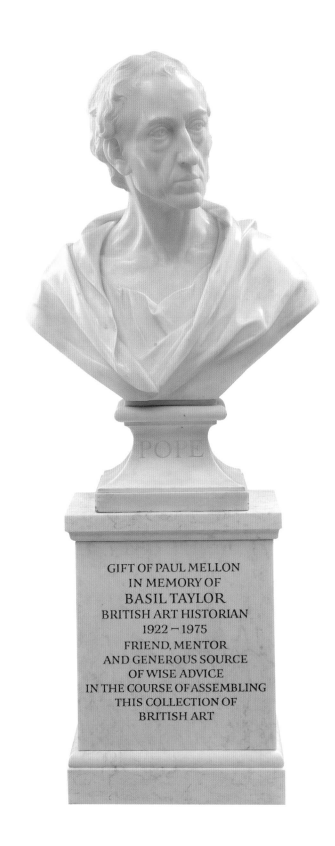

GIFT OF PAUL MELLON
IN MEMORY OF
BASIL TAYLOR
BRITISH ART HISTORIAN
1922 – 1975
FRIEND, MENTOR
AND GENEROUS SOURCE
OF WISE ADVICE
IN THE COURSE OF ASSEMBLING
THIS COLLECTION OF
BRITISH ART

15 **Louis-François Roubiliac (1695–1762)**

Alexander Pope, 1741

Marble; 24⅞ in. high (63 cm)
B1993.27

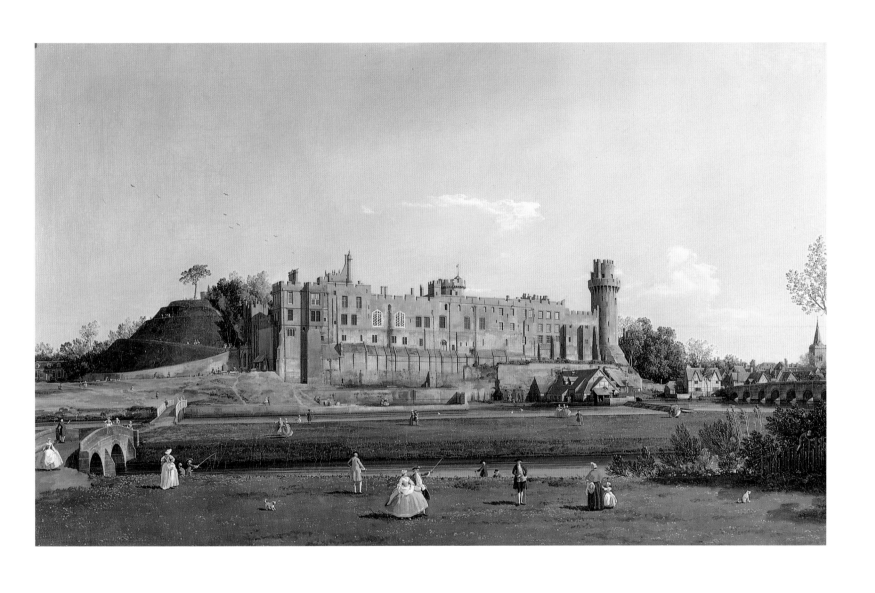

16 Giovanni Antonio Canal, known as **Canaletto**
(1697–1768)

Warwick Castle, ca. 1748–49

Oil on canvas; 28½ x 47³⁄₁₆ in. (72.4 x 119.9 cm)
B1994.18.2

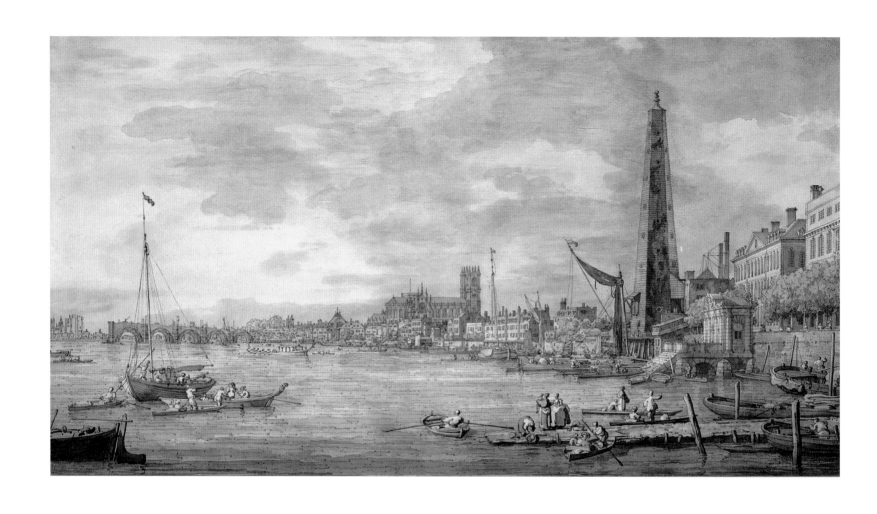

17 **Giovanni Antonio Canal**, known as **Canaletto (1697–1768)**

The City of Westminster from near the York Water Gate,
ca. 1746/47

Pen and brown ink with gray wash on laid paper;
15⅛ x 28⅛ in. (38.4 x 71.4 cm)
B1977.14.4630

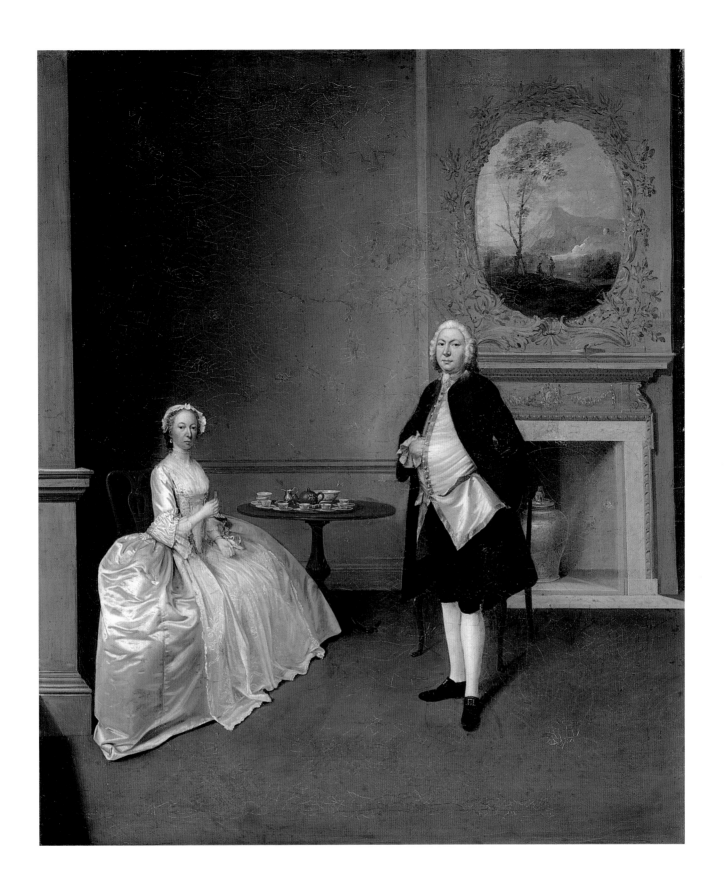

18 **Arthur Devis (1712–87)**

Mr. and Mrs. Hill, ca. 1750–51

Oil on canvas; 30 x 25 in. (76 x 63.5 cm)
B1981.25.226

19 **Richard Wilson (1714–82)**

Rome from the Villa Madama, 1753

Oil on canvas; 37⁹⁄₁₆ x 52½ in. (95.4 x 132.4 cm)
B1977.14.82

20 Richard Wilson (1714–82)

Temple of Minerva Medica, Rome, 1754

Black and white chalk on blue laid paper laid down on original mount;
11¼ x 16½ in. (28.6 x 41.9 cm)
B1977.14.4654

21 **Richard Wilson (1714–82)**

The Arbra Sacra on the Banks of Lake Nemi, ca. 1754–56

Black chalk with white chalk on gray laid paper; 15¼ x 22 in. (38.7 x 55.9 cm)
B1977.14.4655

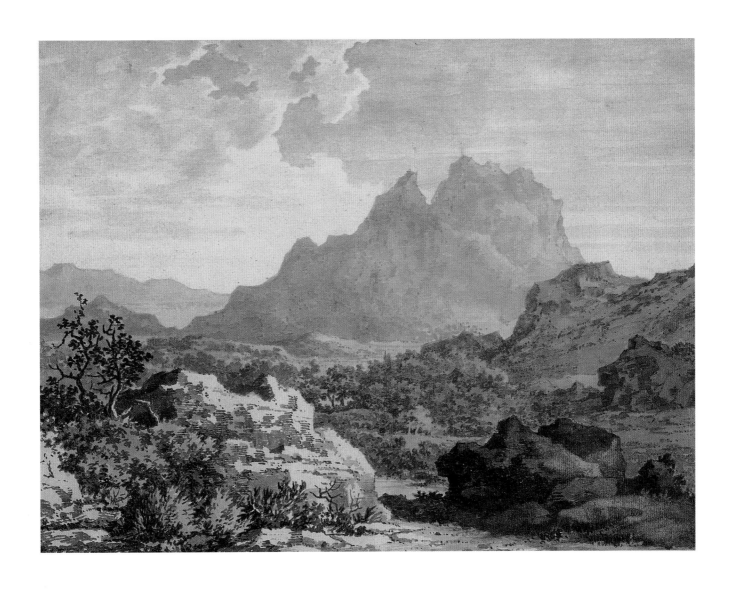

22 **Alexander Cozens (ca. 1717–86)**

Mountainous Landscape, ca. 1780

Gray and brown wash on laid paper prepared with pale brown wash,
laid down on a contemporary mount; 9½ x 12½ in. (24.1 x 31.8 cm)
B1975.4.1480

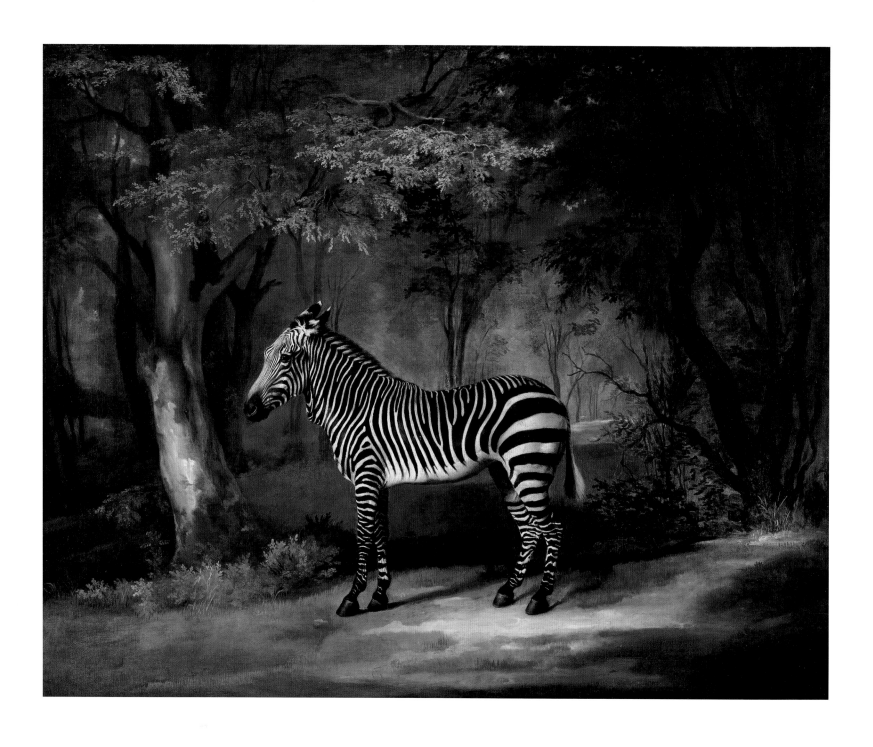

23 George Stubbs (1724–1806)

Zebra, 1762–63

Oil on canvas; 40½ x 50¼ in. (103 x 127.5 cm)
B1981.25.617

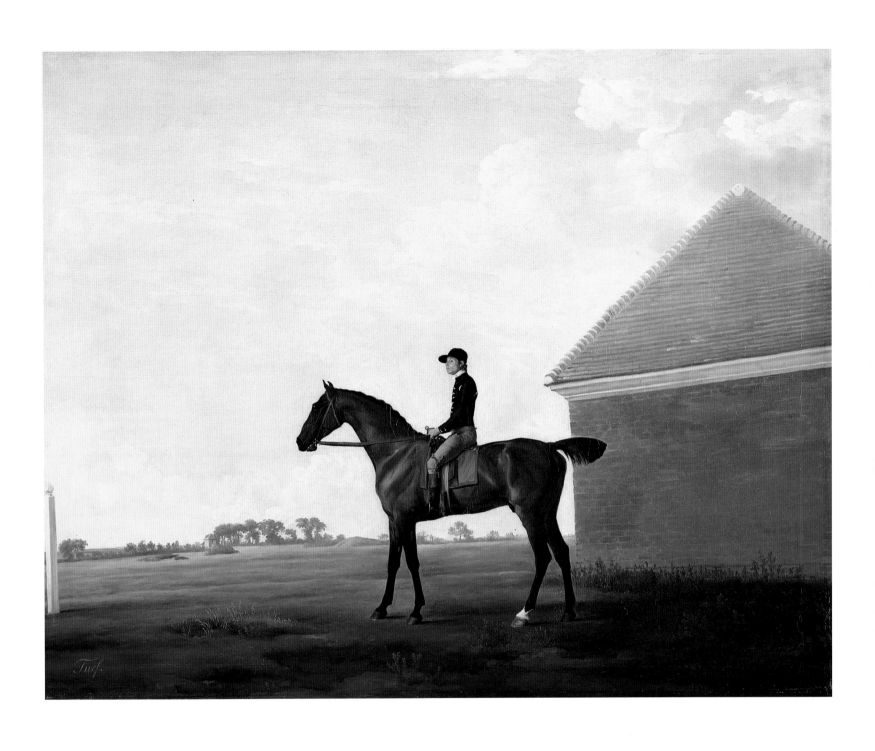

24 George Stubbs (1724–1806)

Turf, with Jockey Up, at Newmarket, ca. 1765

Oil on canvas; 40⅛ x 50⅛ in. (99.1 x 124.5 cm)
B1981.25.621

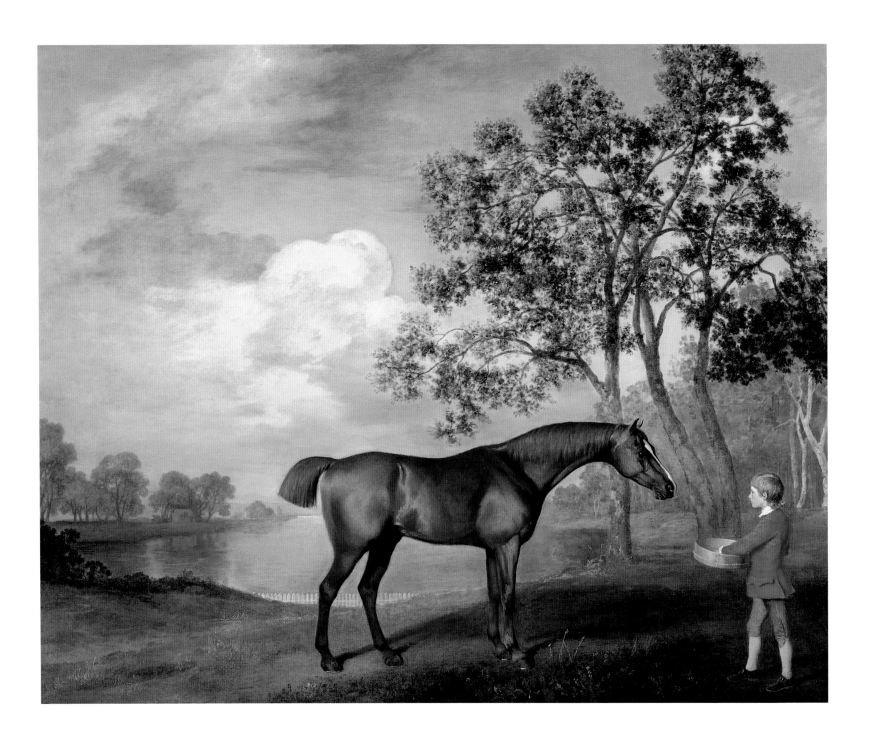

25 George Stubbs (1724–1806)

Pumpkin with a Stable-lad, 1774

Oil on panel; 31½ x 39¼ in. (80 x 99.5 cm)
B2001.2.69

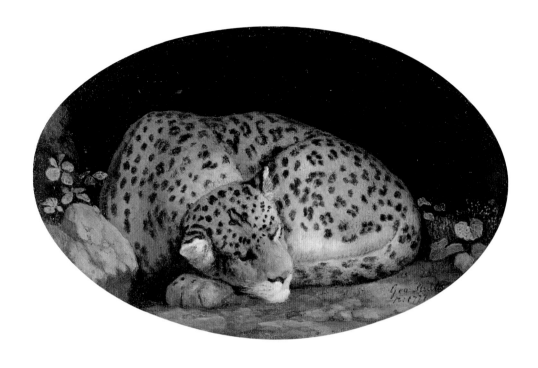

26 George Stubbs (1724–1806)

Sleeping Leopard, 1777

Enamel on Wedgwood biscuit earthenware (Queen's Ware);
4¼ x 6⅝ in. (10.8 x 16.8 cm), oval
B2001.2.209

27 **George Stubbs (1724–1806)**

Study for the Self-portrait in Enamel, 1781

Graphite on wove paper, squared; 12 x 9⅛ in. (30.5 x 23.2 cm)
B2001.2.1262

28 George Stubbs (1724–1806)

Study for *A Comparative Anatomical Exposition of the Structure of the Human Body with That of a Tiger and a Common Fowl: Human Figure, Anterior View, Final Stage of Dissection*, 1795–1806

Graphite on heavy wove paper; 21¼ x 15⅞ in. (54 x 40.3 cm)
B1980.1.21

29 George Stubbs (1724–1806)

Study for *A Comparative Anatomical Exposition of
the Structure of the Human Body with That of a Tiger and
a Common Fowl: Tiger, Lateral View, with Skin and Tissue
Removed*, 1795–1806

Graphite on heavy wove paper; 16 x 21⅛ in. (40.6 x 53.7 cm)
B1980.1.9

30 George Stubbs (1724–1806)

Study for *A Comparative Anatomical Exposition of the Structure of the Human Body with That of a Tiger and a Common Fowl: Fowl Skeleton, Lateral View*, 1795–1806

Graphite on heavy wove paper; 21¼ x 16 in. (54 x 40.6 cm)
B1980.1.5

31 **Sir Joshua Reynolds (1723–92)**

Mrs. Abington as Miss Prue in William Congreve's
"Love for Love," 1771

Oil on canvas; 30¼ x 25⅛ in. (76.8 x 63.7 cm)
B1977.14.67

32 Paul Sandby (1731–1809)

The Norman Gate and Deputy Governor's House, ca. 1765

Gouache on laid paper; 15⅛ x 21¼ in. (38.4 x 54 cm)
B1981.25.2691

33 Paul Sandby (1731–1809)

*Northeast View of Wakefield Lodge in Whittlebury Forest,
Northamptonshire*, 1767

Watercolor with pen and gray ink and touches of gold paint over
graphite on laid paper, laid down on a contemporary mount;
16¾ x 33½ in. (42.5 x 85.1 cm)
B1977.14.4648

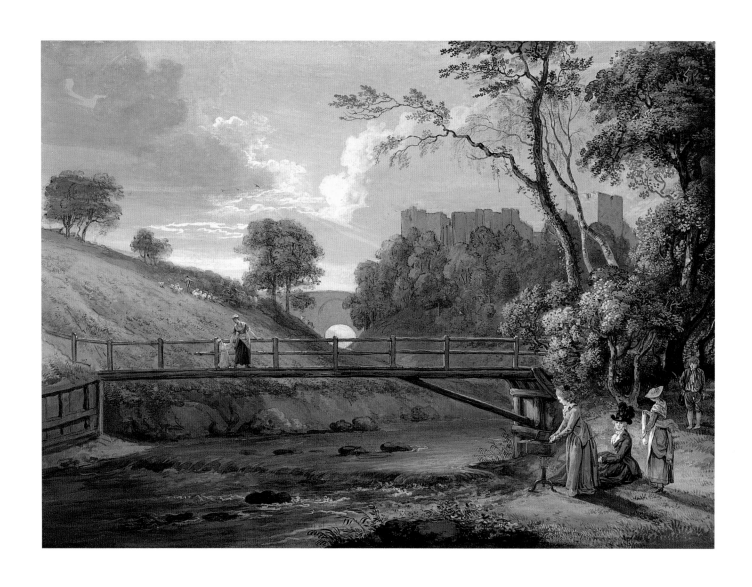

34 Paul Sandby (1731–1809)

Roslin Castle, Midlothian, ca. 1780

Gouache on laid paper mounted onto board;
18 x 24¾ in. (45.7 x 62.9 cm)
B1975.4.1877

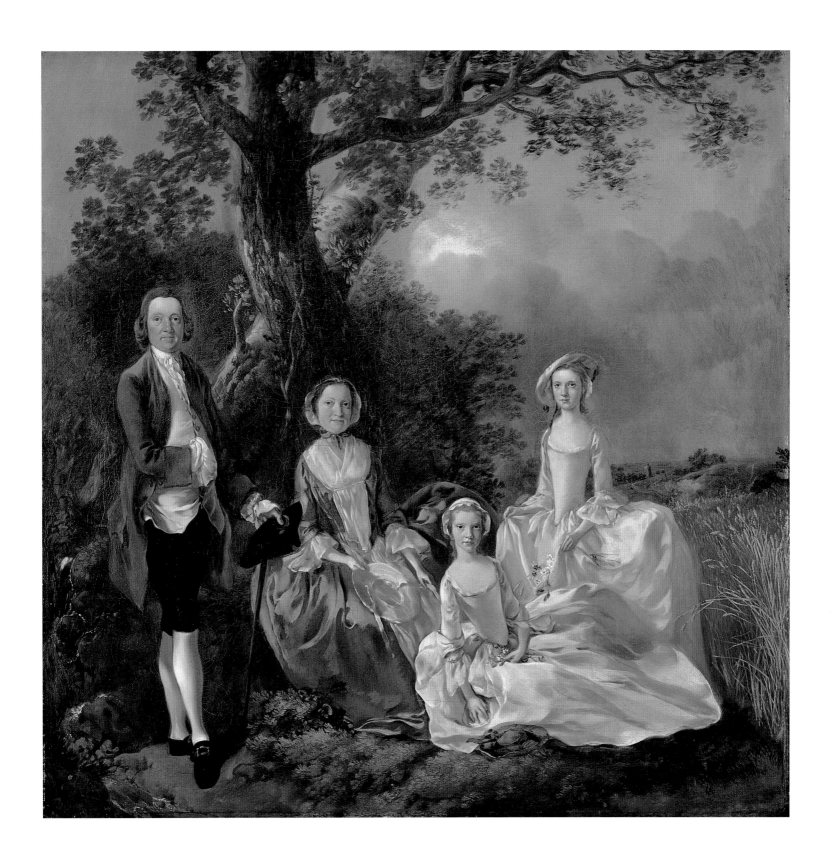

35 Thomas Gainsborough (1727–88)

The Gravenor Family, ca. 1754

Oil on canvas; 35½ x 35½ in. (90.2 x 90.2 cm)
B1977.14.56

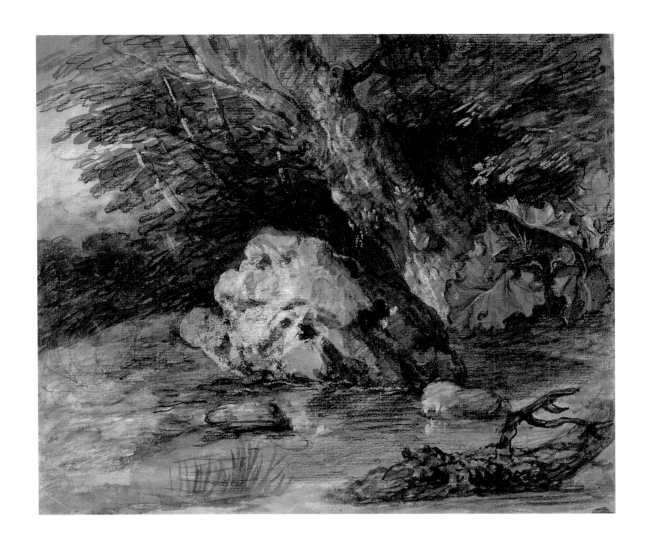

36 **Thomas Gainsborough (1727–88)**

A Woodland Pool with Rocks and Plants, ca. 1765–70

Watercolor, black chalk, and oil paint, with gum, on laid paper;
9 x 11⅜ in. (22.9 x 28.9 cm)
B1975.4.1198

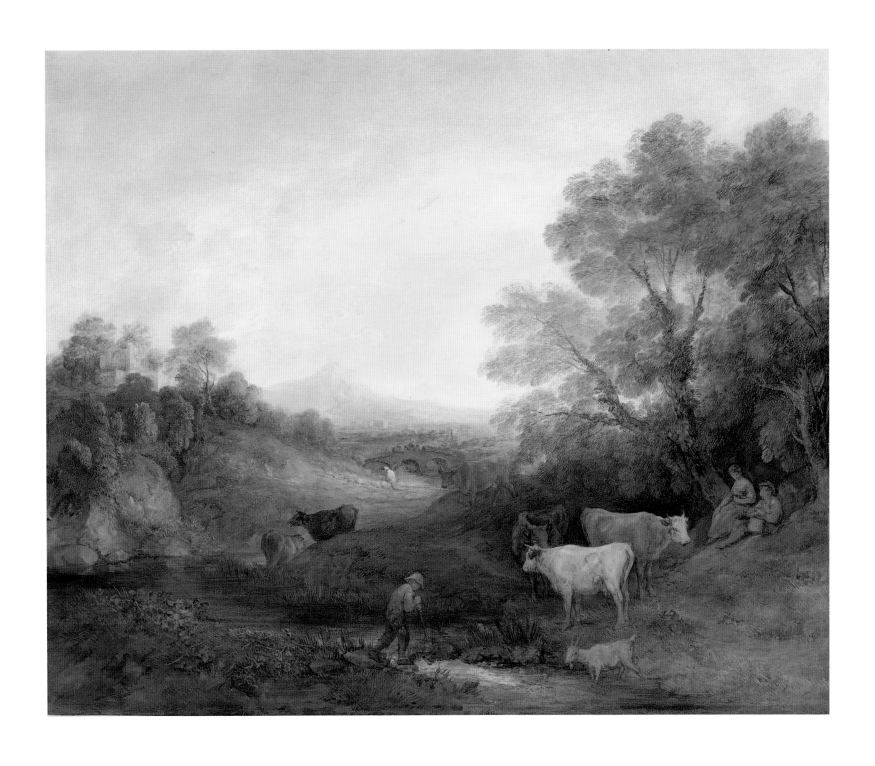

37 Thomas Gainsborough (1727–88)

Landscape with Cattle, 1772–74

Oil on canvas; 47¼ x 57¼ in. (120 x 145.5 cm)
B1981.25.305

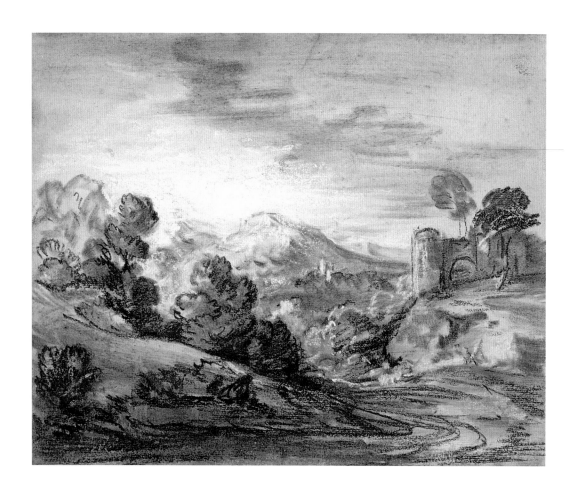

38 **Thomas Gainsborough (1727–88)**

Wooded Landscape with Castle, ca. 1785–88

Black chalk and stump with white chalk, on blue-gray laid paper;
10⅜ x 12¹³⁄₁₆ in. (26.4 x 32.5 cm)
B1975.4.1520

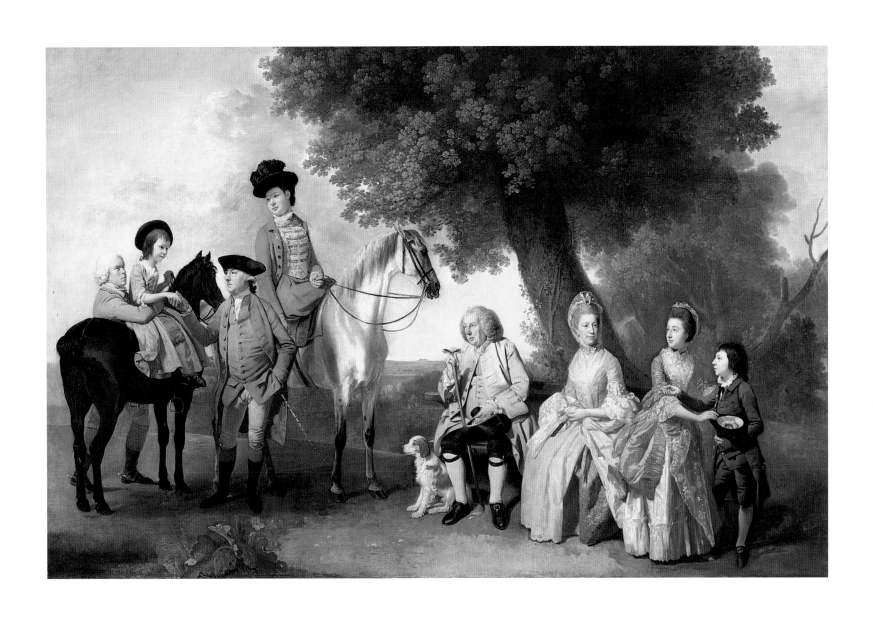

39 Johan Joseph Zoffany (1733–1810)

The Drummond Family, ca. 1769

Oil on canvas; 41½ x 63 in. (104 x 160 cm)
B1977.14.86

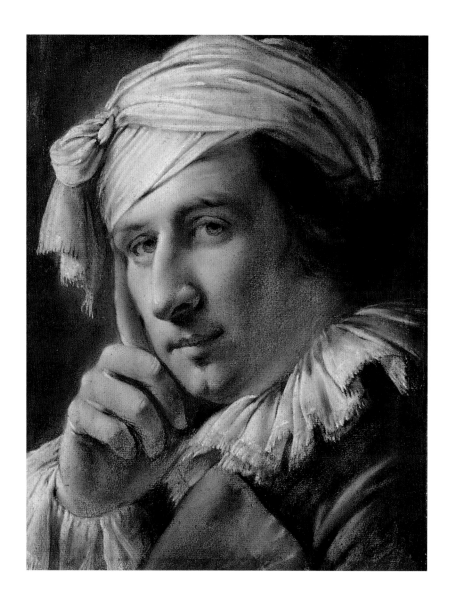

40 Joseph Wright of Derby (1734–97)

Portrait of a Man, ca. 1768

Black, white, and brown chalk and charcoal on laid paper;
14¼ x 11¾ in. (36.2 x 29.8 cm)
B1977.14.6320

41 Joseph Wright of Derby (1734–97)

An Academy by Lamplight, ca. 1768–69

Oil on canvas; 50 x 39⅜ in. (127 x 101.2 cm)
B1973.1.66

42 Jonathan Skelton (ca. 1735–59)

Harbledown, a Village near Canterbury, 1757

Watercolor with pen and gray ink over graphite on laid paper,
laid down on contemporary mount; 8 x 21⅛ in. (20.3 x 53.7 cm)
B1975.4.1956

43 **Benjamin West (1738–1820)**

The Artist and His Family, ca. 1772

Oil on canvas; 20½ x 26¼ in. (52 x 66.5 cm)
B1981.25.674

44 Francis Towne (1739–1816)

Ambleside, 1786

Watercolor with pen and brown and gray ink over graphite
on laid paper; 9¼ x 6⅛ in. (23.5 x 15.6 cm)
B1977.14.4147

45 John Smart (1741/2–1811)

Colonel James Stevenson, 1796

Gouache and watercolor on ivory; 3 x 2½ in. (7.6 x 6.4 cm), oval
B1974.2.99

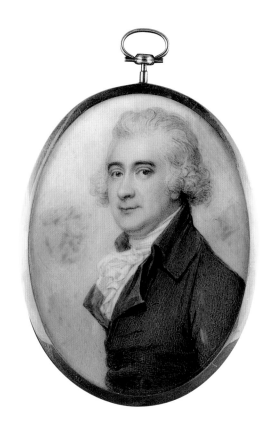

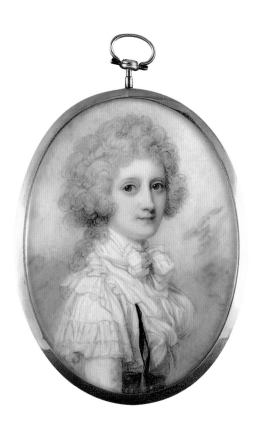

46 **Richard Cosway (1742–1821)**

Elizabeth, Countess of Hopetoun, 1789

Watercolor and gouache on ivory; 3 x 2⁵⁄₁₆ in. (7.6 x 5.9 cm), oval
B1974.2.18

47 **Richard Cosway (1742–1821)**

James Hope, 3rd Earl of Hopetoun, 1789

Watercolor and gouache on ivory; 3 x 2⁵⁄₁₆ in. (7.6 x 5.9 cm), oval
B1974.2.19

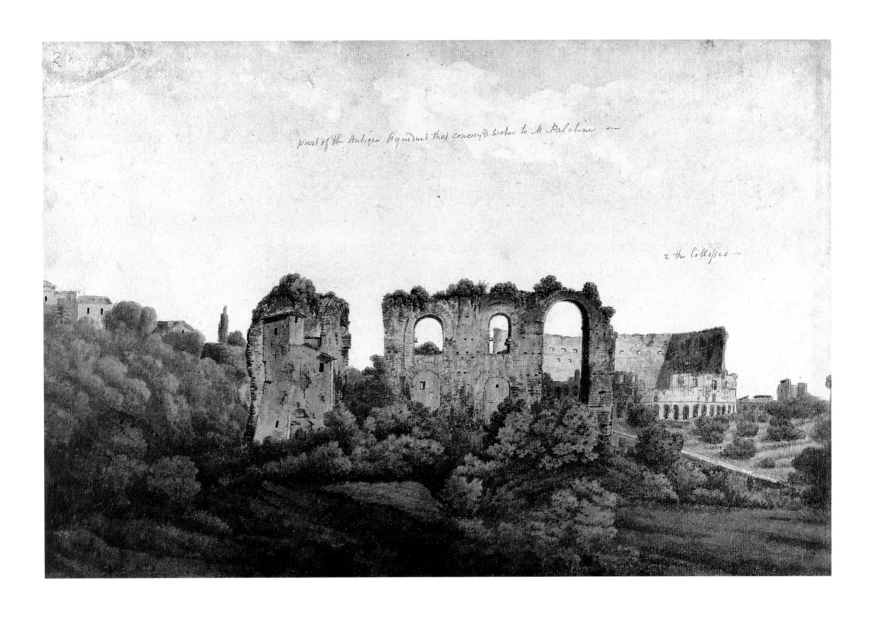

part of the Antique Aqueduct that convey'd water to M. Palatine

2 the Collosseo

48 Thomas Jones (1742–1803)

The Claudean Aqueduct and Colosseum, 1778

Watercolor over graphite with gum on laid paper;
10¾ x 16¼ in. (27.3 x 41.3 cm)
B1981.25.2637

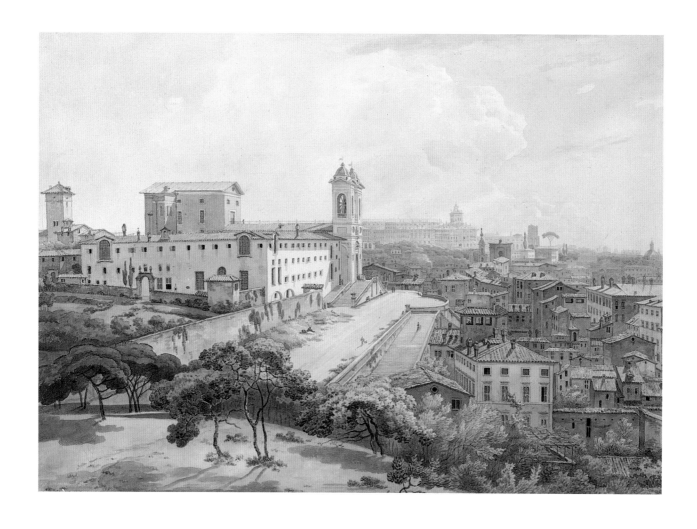

49 **William Pars (1742–82)**

A View of Rome Taken from the Pincio, 1776

Watercolor over graphite on laid paper; 15⅛ x 21⅛ in. (38.4 x 53.7 cm)
B1977.14.4704

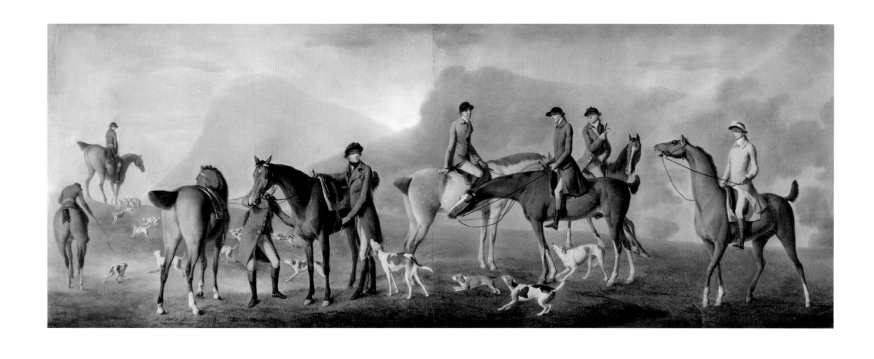

50 Robert Healy (1743–71)

Tom Conolly of Castletown Hunting with His Friends, 1769

Pastel, chalks, and gouache on two joined sheets of laid paper;
20¼ x 53½ in. (51.4 x 135.9 cm)
B2001.2.880

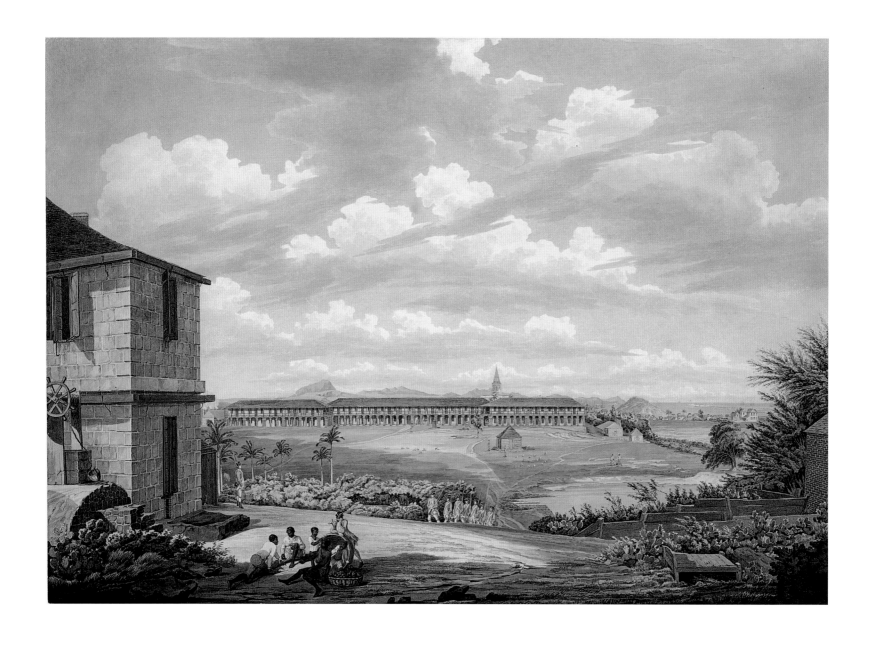

51 Thomas Hearne (1744–1817)

A View on the Island of Antigua: The English Barracks and
St. John's Church Seen from the Hospital, ca. 1775–76

Watercolor with pen and gray ink over graphite on laid paper laid down on
card; 20¼ x 29 in. (51.4 x 73.7 cm)
B1993.30.78

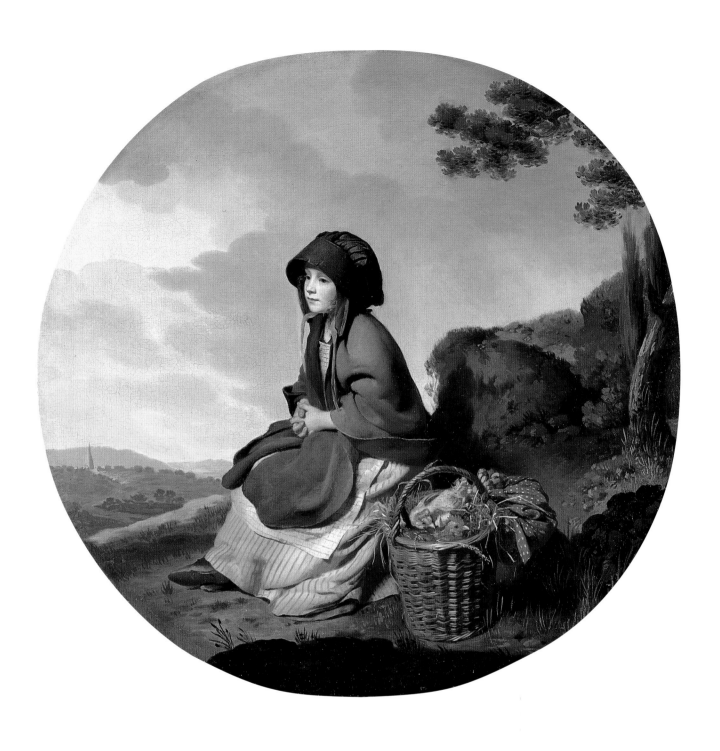

52 Henry Walton (1746–1813)

The Market Girl, also known as *The Silver Age*, ca. 1776–77

Oil on canvas; 22 x 22 in. (55.9 x 55.9 cm), circular
B1981.25.650

53 Francis Wheatley (1747–1801)

The Browne Family, ca. 1778

Oil on canvas; 27 ¾ x 35 in. (70.5 x 88.9 cm)
B1981.25.675

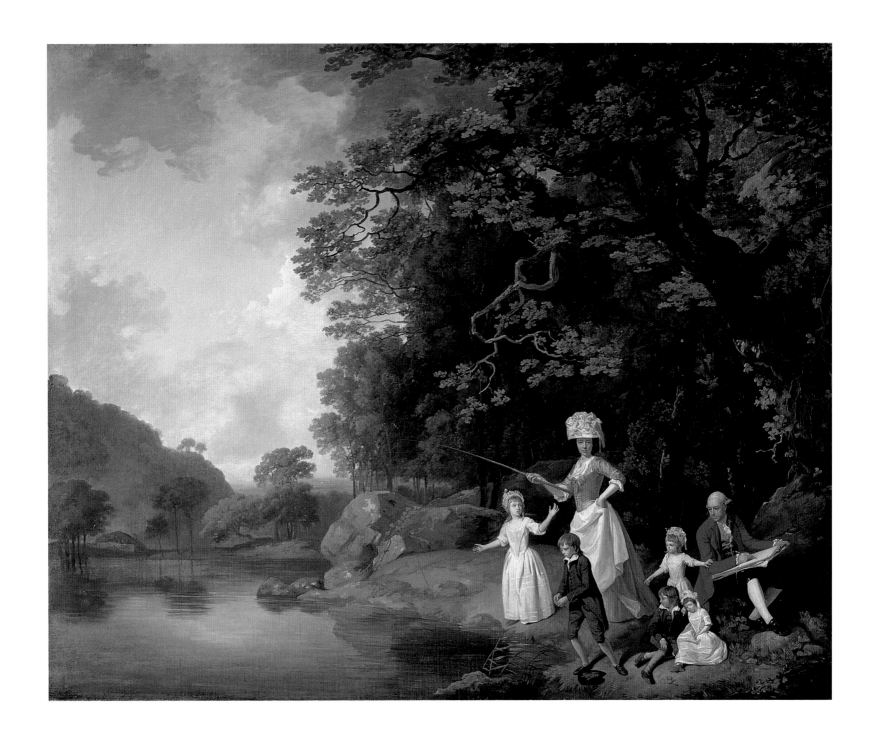

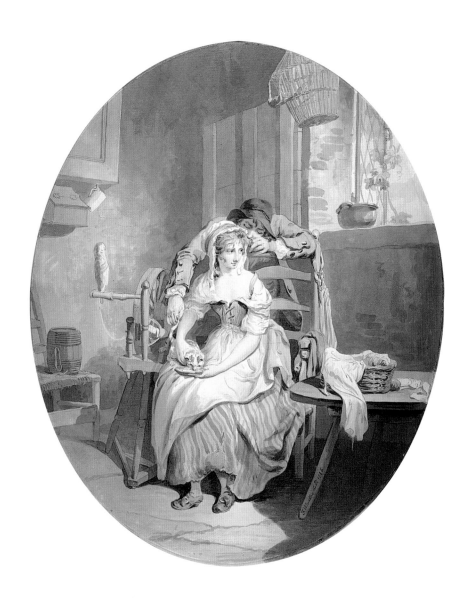

54 **Francis Wheatley (1747–1801)**

The Rustic Lover, 1786

Watercolor with pen with black ink, over graphite, on laid paper, laid down
on card; 17 x 13¾ in. (43.2 x 34.9 cm), oval
B1977.14.6315

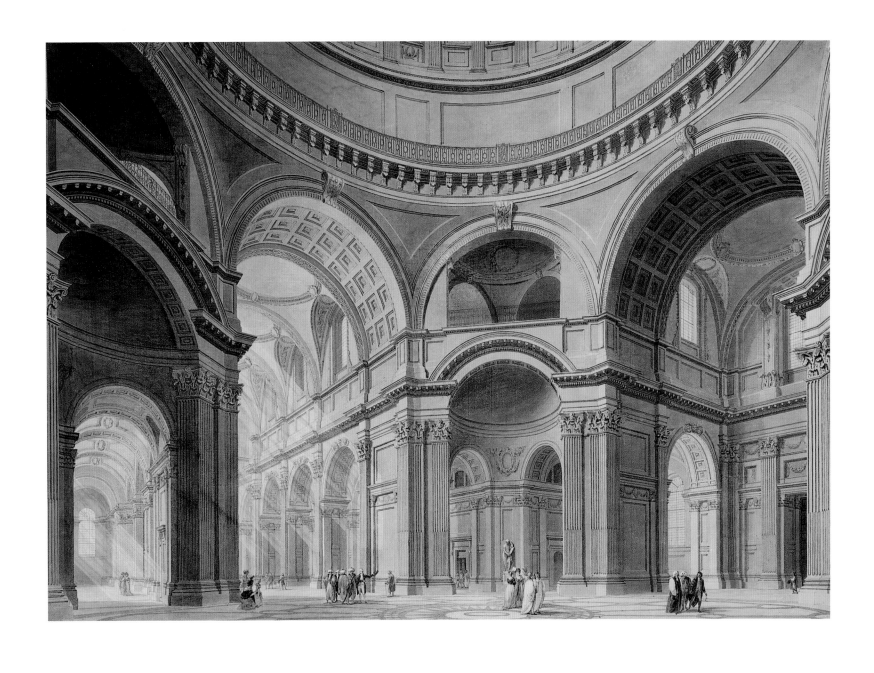

55 Thomas Malton (1751/2–1804)

Interior of St. Paul's Cathedral, ca. 1792

Watercolor with pen and ink over graphite on laid paper laid down on card;
26¼ x 36⅛ in. (66.7 x 91.8 cm)
B1977.14.6220

56 John Brown (1749–87)

The Geographers, date unknown

Pen and ink and gray wash on laid paper;
7³⁄₁₆ x 10¹⁄₁₆ in. (18.3 x 25.6 cm)
B1977.14.4152

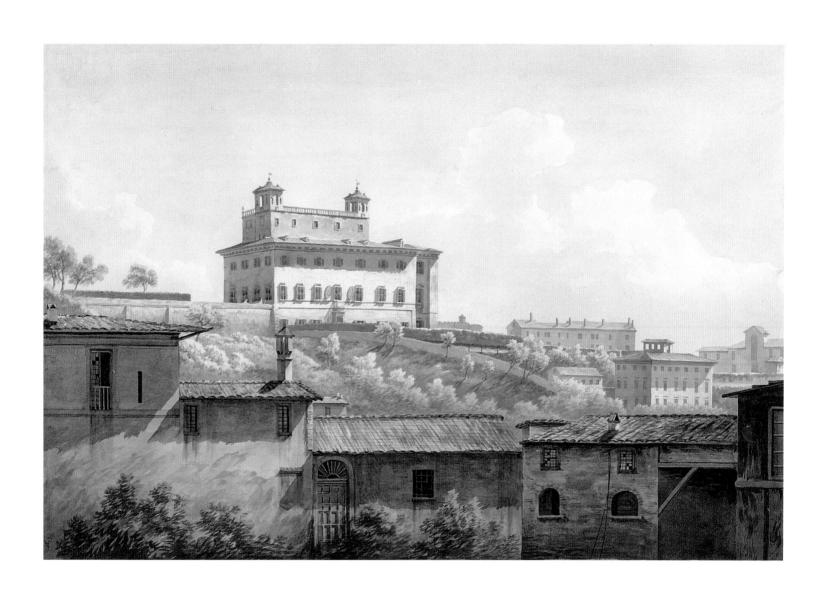

57 John "Warwick" Smith (1749–1831)

The Villa Medici, Rome, 1784

Watercolor over graphite on laid paper, on contemporary mount;
13⅝ x 20¼ in. (34.6 x 51.4 cm)
B1977.14.4699

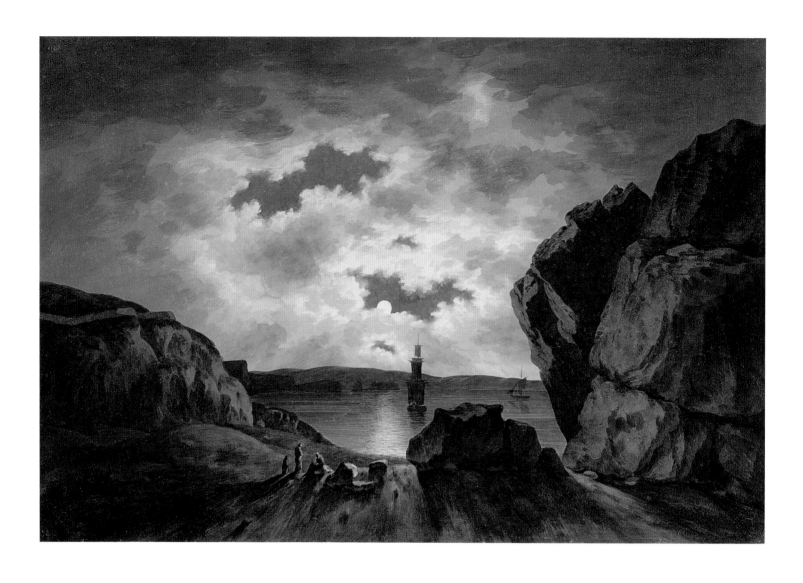

58 John "Warwick" Smith (1749–1831)

Bay Scene in Moonlight, 1787

Watercolor over graphite with scratching out on wove paper;
13⅜ x 20 in. (34 x 50.8 cm)
B1977.14.4383

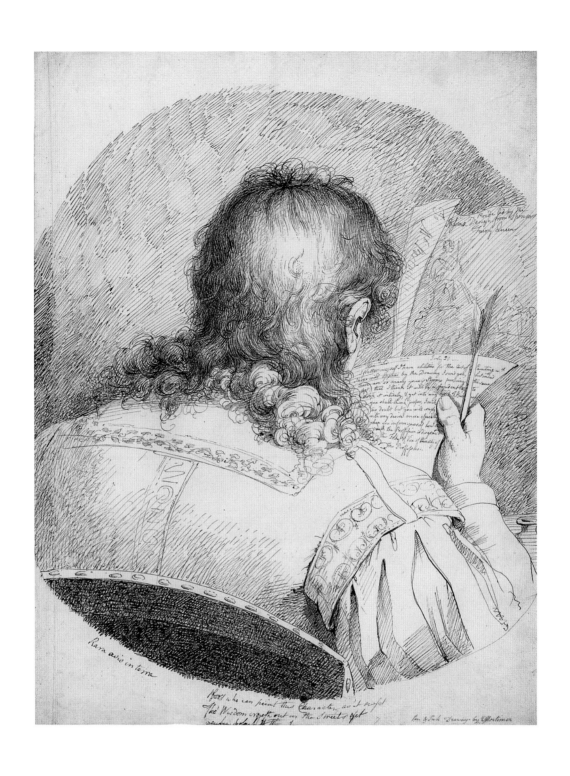

59 James Jefferys (1751–84)

Self-portrait, ca. 1771–75

Pen and brown ink on wove paper;
21¼ x 16¼ in. (54 x 41.3 cm)
B1977.14.6227

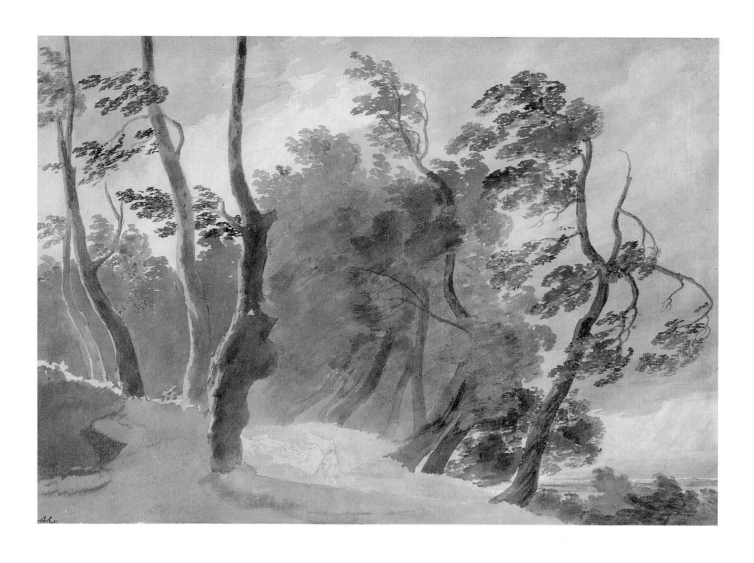

60 John Robert Cozens (1752–97)

Galleria di Sopra, Albano, ca. 1778

Watercolor and graphite on wove paper laid down on
contemporary mount; 14¼ x 20¹³⁄₁₆ in. (36.2 x 52.9 cm)
B1975.4.1904

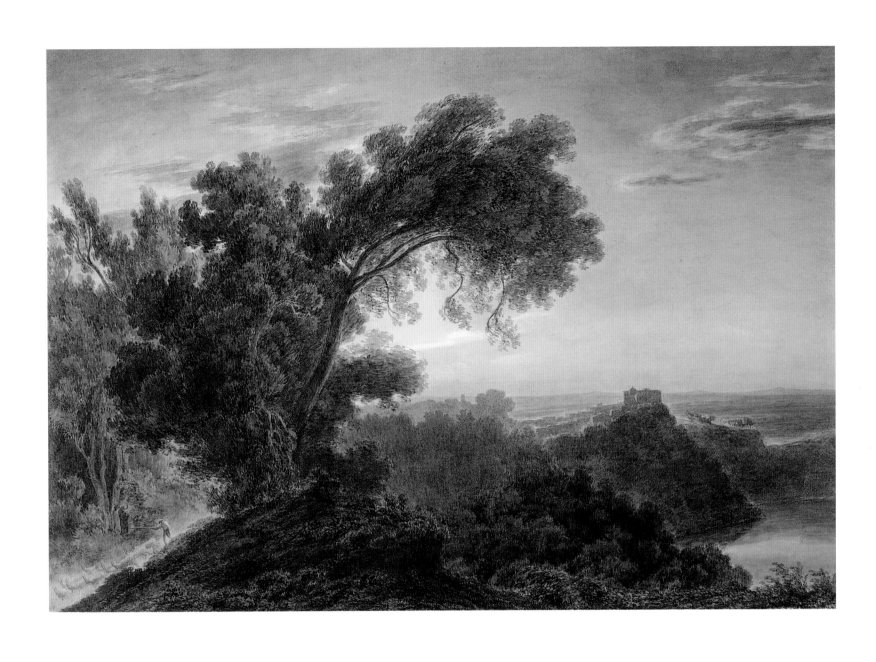

61 John Robert Cozens (1752–97)

The Lake of Albano and Castel Gandolfo, ca. 1779

Watercolor over graphite on wove paper; 17 x 24¼ in. (43.2 x 61.6 cm)
B1977.14.4635

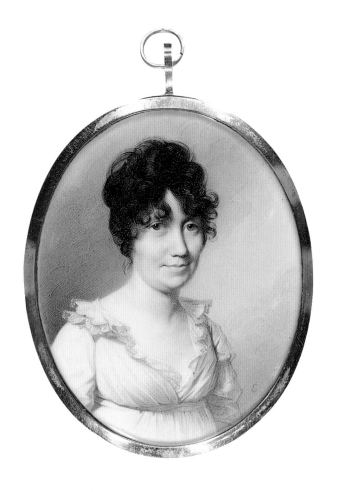

62 **George Engleheart (1750–1829)**

A Lady of the Blunt Family, ca. 1795–1800

Watercolor and gouache on ivory; 3⅜ x 2⅞ in. (8.6 x 7.3 cm), oval
B1974.2.38

63 John Flaxman (1755–1826)

The Creation of the Heavens, ca. 1790–94

Pen and gray ink and gray wash on laid paper;
9³⁄₁₆ x 9⅞ in. (23.3 x 25.1 cm)
B1981.25.2586

65 Thomas Rowlandson (1756–1827)

Georgiana, Duchess of Devonshire, Her Sister Harriet,
Viscountess Duncannon (later Countess of Bessborough)
and a Musician, 1790

Watercolor with pen and ink over graphite on laid paper,
laid down on contemporary mount; 19⅝ x 16⅞ in. (49.8 x 42.9 cm)
B1975.3.141

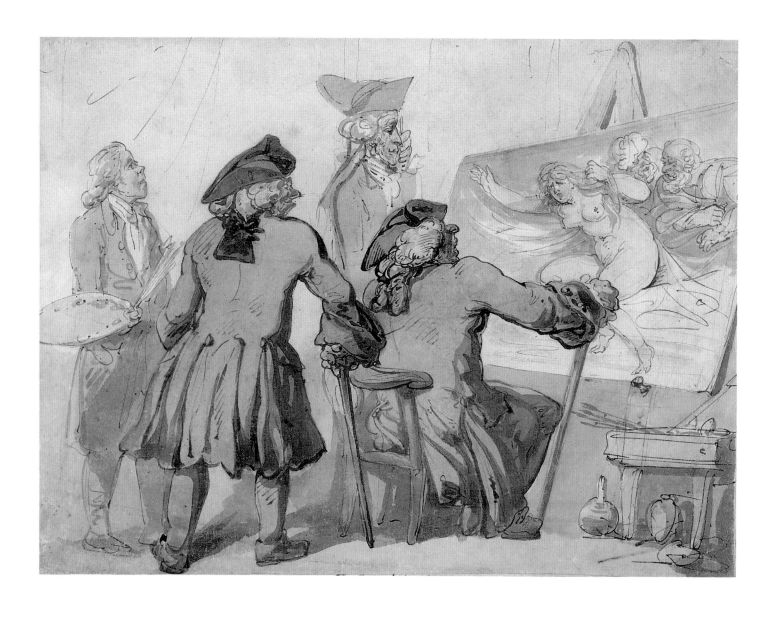

66 **Thomas Rowlandson (1756–1827)**

The Connoisseurs, ca. 1790

Watercolor with pen and ink over graphite on wove paper,
laid down on contemporary mount; 9⅜ x 12½ in. (23.8 x 31.8 cm)
B1975.3.106

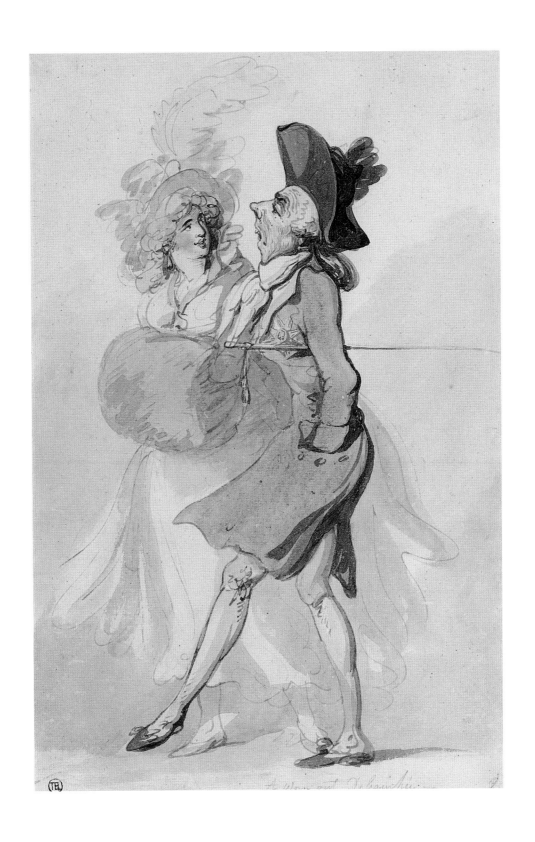

67 Thomas Rowlandson (1756–1827)

A Worn-out Debauchee, ca. 1790–95

Watercolor with pen and ink and watercolor over graphite, on laid paper;
12⅛ x 8¼ in. (30.8 x 21 cm)
B1975.3.100

68 Thomas Rowlandson (1756–1827)

The Exhibition Stare-case, Somerset House, ca. 1800

Watercolor with pen and ink over graphite on wove paper;
17½ x 11¹¹⁄₁₆ in. (44.5 x 29.7 cm)
B1981.25.2893

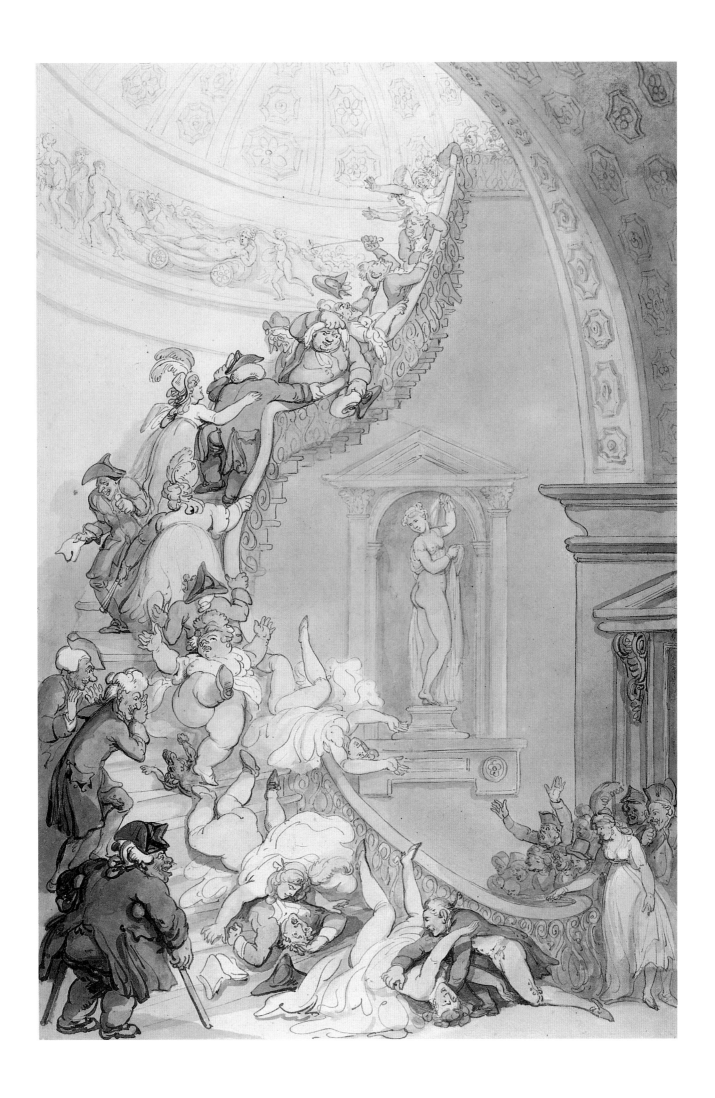

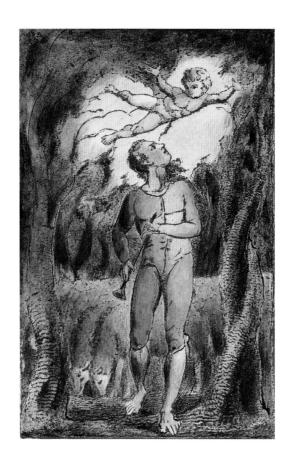

69 **William Blake (1757–1827)**

Songs of Innocence and of Experience, 1795

Fifty-four relief etchings printed in dark brown ink,
with pen and ink and watercolor on fifty-four leaves;
spine: 7½ in. (9.1 cm); sheets: 7⅛ x 5 in. (8.1 x 12.7 cm)
B1992.8.13 (1–54)

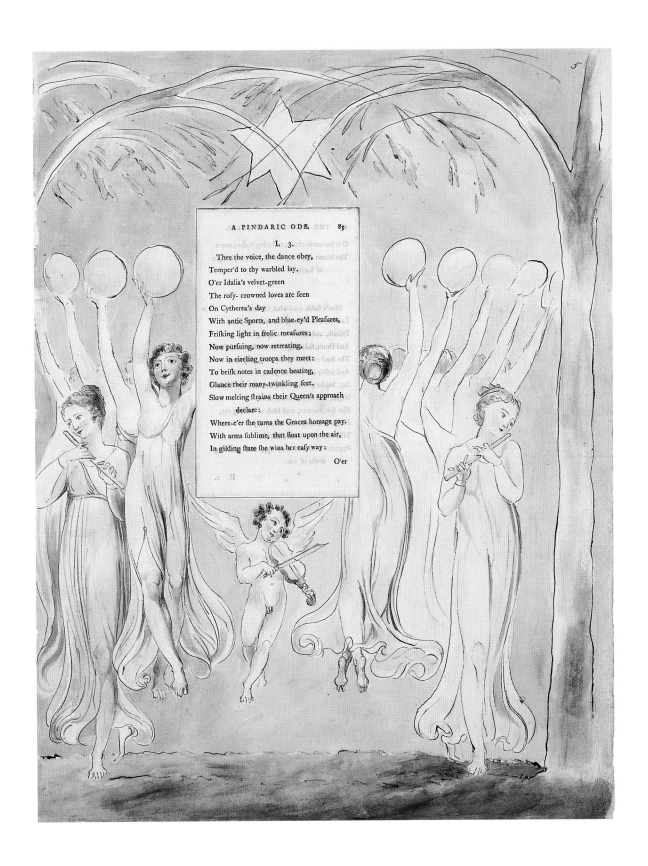

The letterpress inset reads:

A PINDARIC ODE. 85

I. 3.

Thee the voice, the dance obey,
Temper'd to thy warbled lay.
O'er Idalia's velvet-green
The rosy- crowned loves are seen
On Cythera's day
With antic Sports, and blue-ey'd Pleasures,
Frisking light in frolic measures;
Now pursuing, now retreating,
Now in circling troops they meet:
To brisk notes in cadence beating,
Glance their many-twinkling feet.
Slow melting strains their Queen's approach
declare:
Where-e'er she turns the Graces homage pay.
With arms sublime, that float upon the air,
In gilding state she wins her easy way:
O'er

II. 1.

70 William Blake (1757–1827)

The Progress of Poesy. A Pindaric Ode. "On Cythera's day,"
from *Illustrations to the Poems of Thomas Gray*, 1797–98

Watercolor with pen and black ink over graphite on wove paper with
letterpress inset; 16½ x 12¾ in. (41.9 x 32.4 cm)
B1992.8.11 (23 recto)

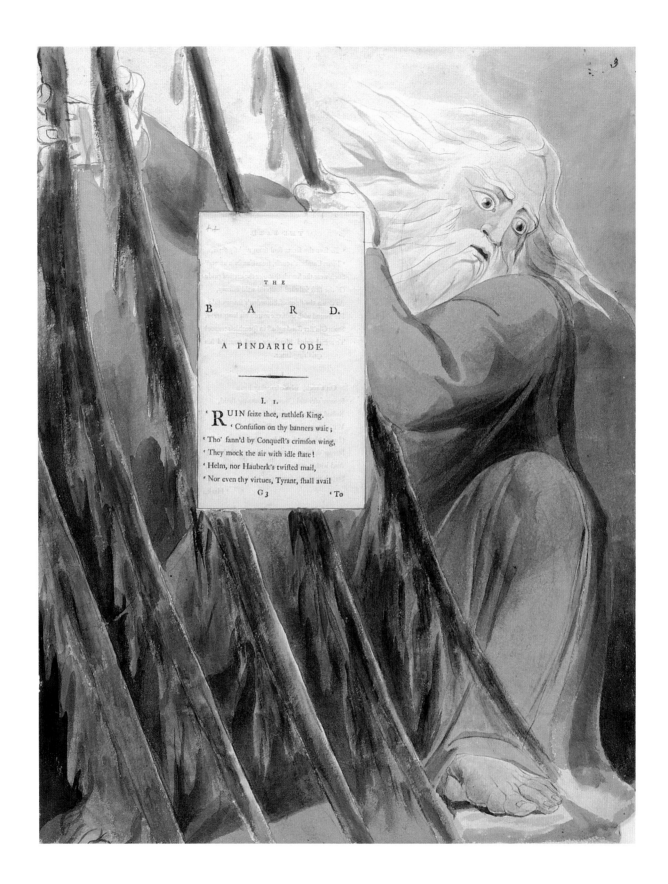

The letterpress inset reads:

THE

B A R D.

A PINDARIC ODE.

I. 1.

'RUIN feize thee, ruthlefs King.
 'Confufion on thy banners wait;
'Tho' fann'd by Conqueft's crimfon wing,
'They mock the air with idle ftate!
'Helm, nor Hauberk's twifted mail,
'Nor even thy virtues, Tyrant, fhall avail

G 3 'To

71 William Blake (1757–1827)

*The Bard. A Pindaric Ode. "And weave with bloody hands
the tissue of thy line," from Illustrations to the Poems of
Thomas Gray, 1797–98*

Watercolor with pen and black ink over graphite on wove paper with
letterpress inset; 16½ x 12¾ in. (41.9 x 32.4 cm)
B1992.8.11 (28 recto)

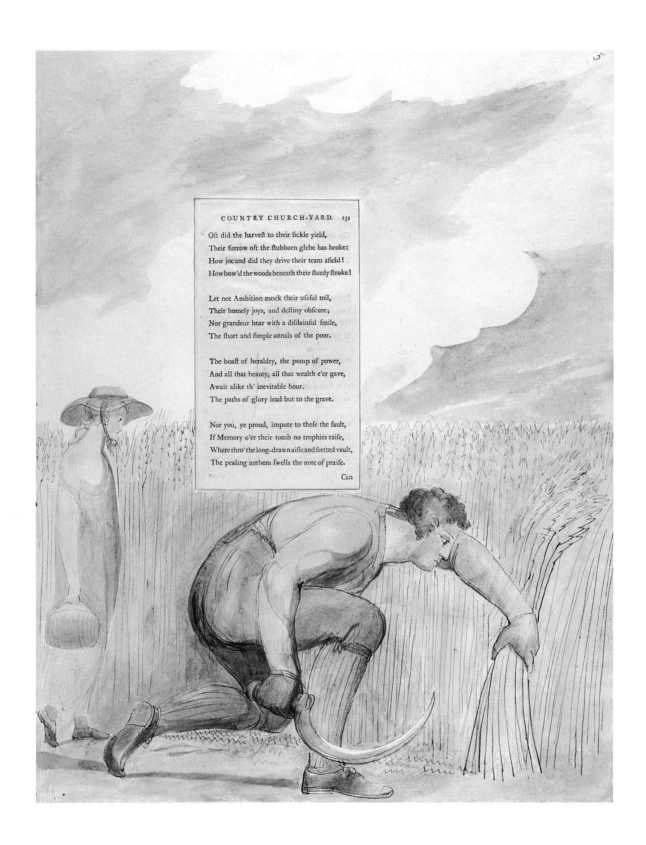

COUNTRY CHURCH-YARD. 151

Oft did the harveft to their fickle yield,
Their furrow oft the ftubborn glebe has broke:
How jocund did they drive their team afield!
How bow'd the woods beneath their fturdy ftroke!

Let not Ambition mock their ufeful toil,
Their homely joys, and deftiny obfcure;
Nor grandeur hear with a difdainful fmile,
The fhort and fimple annals of the poor.

The boaft of heraldry, the pomp of power,
And all that beauty, all that wealth e'er gave,
Await alike th' inevitable hour.
The paths of glory lead but to the grave.

Nor you, ye proud, impute to thefe the fault,
If Memory o'er their tomb no trophies raife,
Where thro' the long-drawn aifle and fretted vault,
The pealing anthem fwells the note of praife.

Can

72 William Blake (1757–1827)

Elegy Written in a Country Churchyard. "Oft did the harvest to their sickle yield," from *Illustrations to the Poems of Thomas Gray,* 1797–98

Watercolor with pen and black ink over graphite on wove paper with letterpress inset; 16½ x 12¾ in. (41.9 x 32.4 cm)
B1992.8.11 (55 recto)

73 **William Blake (1757–1827)**

The Horse, ca. 1805

Tempera with pen and black ink on gesso priming on a copper engraving
plate; 4³⁄₁₆ x 2⁵⁄₈ in. (10.7 x 6.7 cm)
B2001.2.34

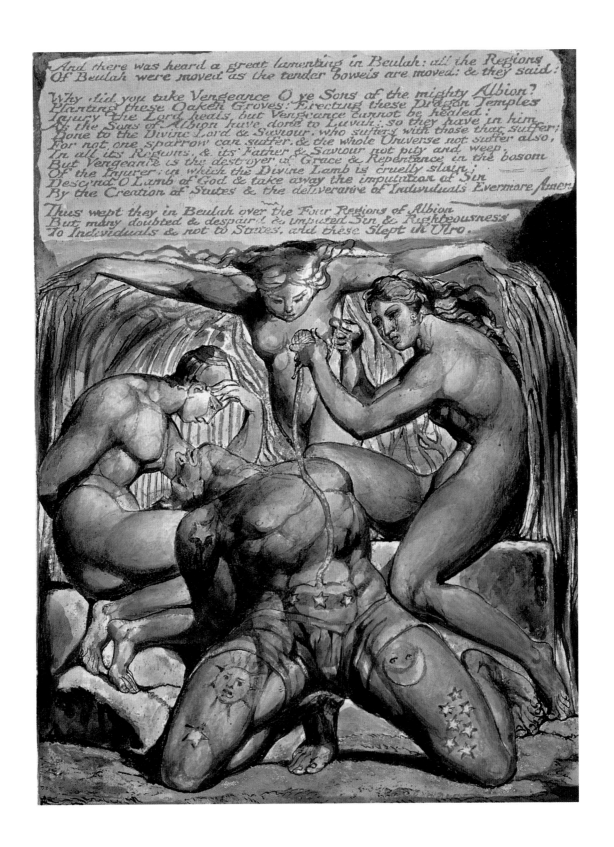

74 William Blake (1757–1827)

Plate 25: *"And there was heard a great lamenting in Beulah,"*
from *Jerusalem: The Emanation of the Giant Albion,* 1804–20

Relief etching printed in orange, with pen and ink, watercolor, and gold on
wove paper; 13½ x 10⅜ in. (34.3 x 26.4 cm)
B1992.8.1 (25)

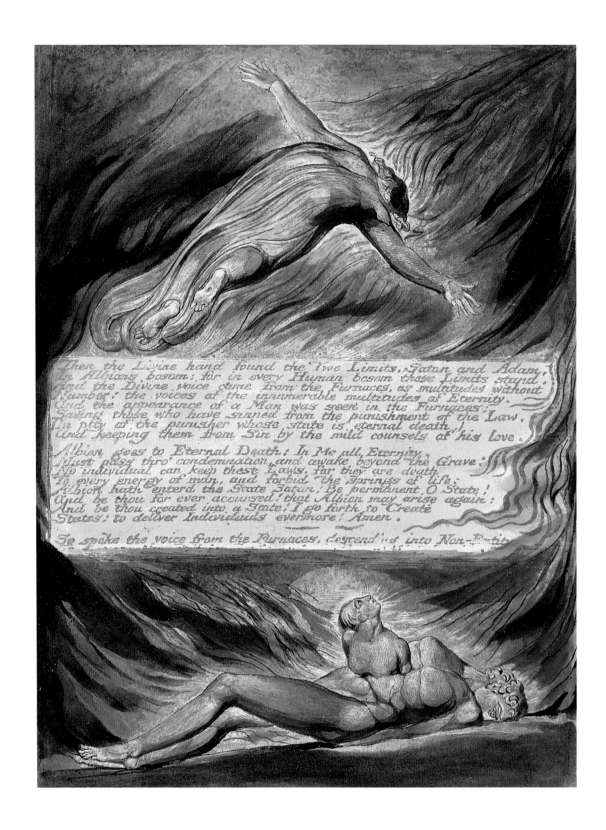

75 William Blake (1757–1827)

Plate 35: *"Then the Divine hand found the Two limits,
Satan and Adam,"* from *Jerusalem: The Emanation of the
Giant Albion*, 1804–20

Relief etching printed in orange, with pen and ink, and watercolor on wove
paper; 13½ x 10⅜ in. (34.3 x 26.4 cm)
B1992.8.1 (35)

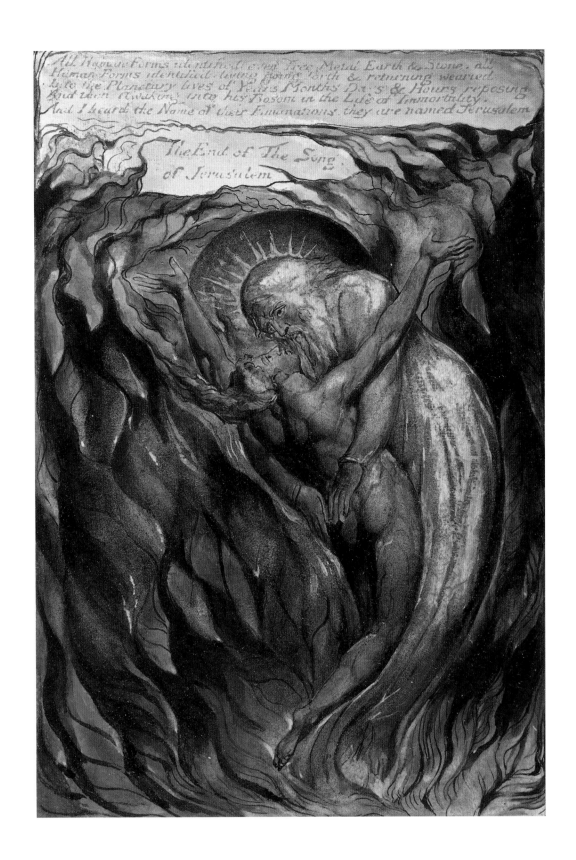

76 William Blake (1757–1827)

Plate 99: *"All Human Forms identified even Tree Metal Earth & Stone,"* from *Jerusalem: The Emanation of the Giant Albion*, 1804–20

Relief etching printed in orange, with pen and ink, and watercolor on wove paper; 13½ x 10⅜ in. (34.3 x 26.4 cm)
B1992.8.1 (99)

77 Adam Buck (1759–1833)

The Artist and His Family, 1813

Watercolor and graphite with gum and scraping out on card;
17½ x 16½ in. (44.5 x 41.9 cm)
B1977.14.6109

78 Edward Francis Burney (1760–1848)

The Triumph of Music, also known as *The Glee Club*, ca. 1815

Watercolor with pen and black ink over graphite on wove paper;
12⅛ x 18⅛ in. (30.8 x 46 cm)
B1975.4.1467

79 Edward Dayes (1763–1804)

Queen Square, London, 1786

Watercolor with pen and black ink over graphite on wove paper
with line and wash border; image: 14½ x 20⅞ in. (36.8 x 53 cm);
sheet: 17⅛ x 23½ in. (43.5 x 59.7 cm)
B1977.14.4639

80 **William Alexander (1767–1816)**

City of Lin Tsin, Shantung,
with a View of the Grand Canal, 1795

Watercolor over graphite on laid paper; 11¼ x 17⅜ in. (28.6 x 44.1 cm)
B1975.4.1450

81 **Ben Marshall (1768–1835)**

*Muly Moloch, a Chestnut Colt Being Rubbed Down on
Newmarket Heath, with Portraits of Trotter, Hardy,
and Thompson to the Left*, 1803

Oil on canvas; 40 x 50 in. (101.6 x 127 cm)
B2001.2.212

82 Robert Hills (1769–1844)

A Village Snow Scene, 1819

Watercolor and gouache with scraping out over graphite
on heavy wove paper;
12⅝ x 16¾ in. (32.1 x 42.5 cm)
B1977.14.4907

83 **Sir Thomas Lawrence (1769–1830)**

George James Welbore Agar-Ellis,
later 1st Lord Dover, ca. 1823–24

Oil on canvas; 36 x 29 in. (91.4 x 73.7 cm)
B1981.25.411

84 **James Ward (1769–1859)**

Eagle, A Celebrated Stallion, 1809

Oil on canvas; 35¾ x 48 in. (90.8 x 122 cm)
B1981.25.655

85 Thomas Girtin (1775–1802)

The Abbey Mill, Knaresborough, ca. 1801

Watercolor, touched with gouache, with some scratching out, over graphite on heavy laid paper; 12⅝ x 20⅝ in. (32.1 x 52.4 cm)
B1975.4.1925

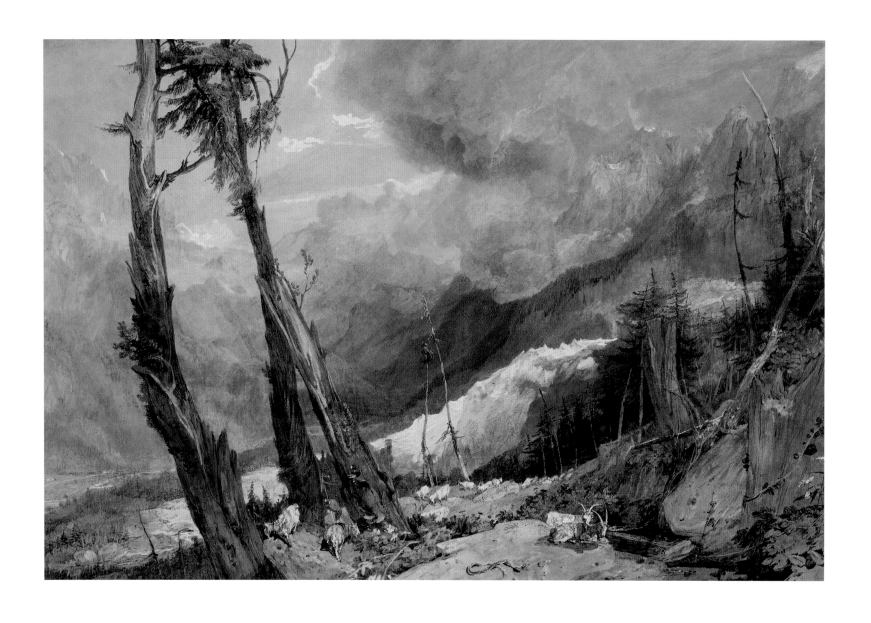

86 Joseph Mallord William Turner (1775–1851)

Mer de Glace, in the Valley of Chamouni, Switzerland, 1803

Watercolor over graphite with scraping out and stopping out on wove paper
laid down on board; 27¼ x 40¾ in. (69.2 x 103.5 cm)
B1977.14.4650

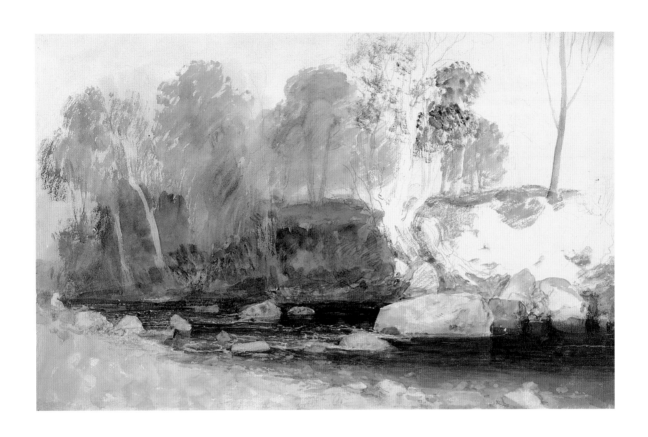

87 Joseph Mallord William Turner (1775–1851)

On the Washburn, ca. 1815

Watercolor and graphite with scratching out on wove paper;
11¼ x 18 in. (28.6 x 45.7 cm)
B1975.4.1620

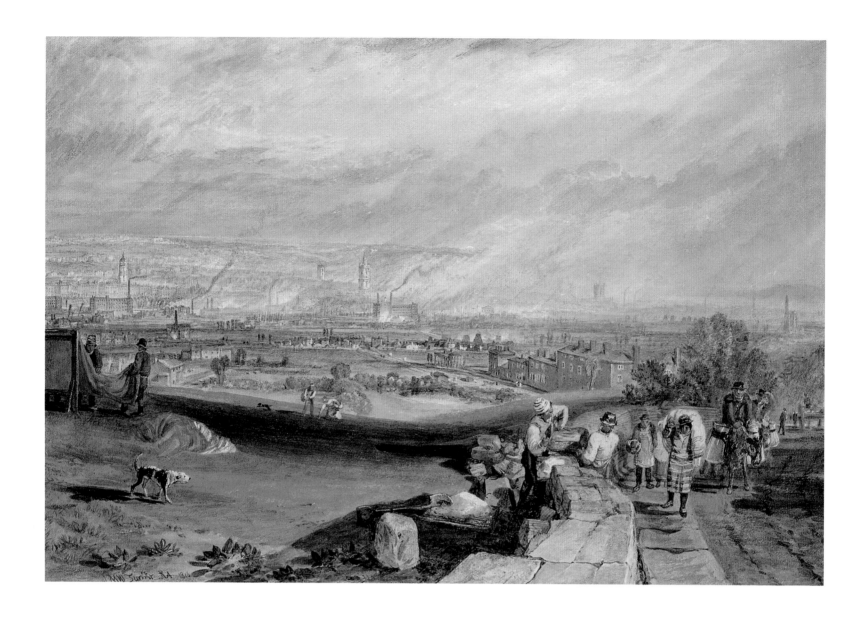

88 Joseph Mallord William Turner (1775–1851)

Leeds, 1816

Watercolor with scraping out on wove paper; 11½ x 17 in. (29.2 x 43.2 cm)
B1981.25.2704

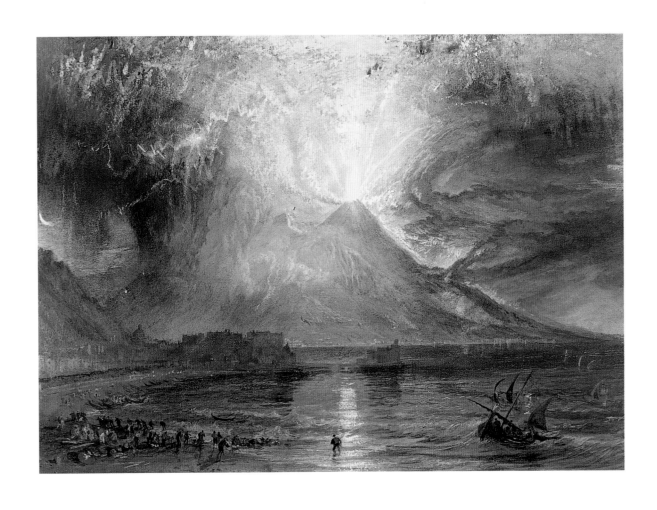

89 Joseph Mallord William Turner (1775–1851)

Vesuvius in Eruption, ca. 1817–20

Watercolor with gum and scraping out on wove paper laid down on card;
11¼ x 15⅝ in. (28.6 x 39.7 cm)
B1975.4.1857

90 Joseph Mallord William Turner (1775–1851)

Dort, or Dordrecht, the Dort Packet-boat from Rotterdam Becalmed, 1818

Oil on canvas; 62 x 92 in. (157.5 x 233 cm)
B1977.14.77

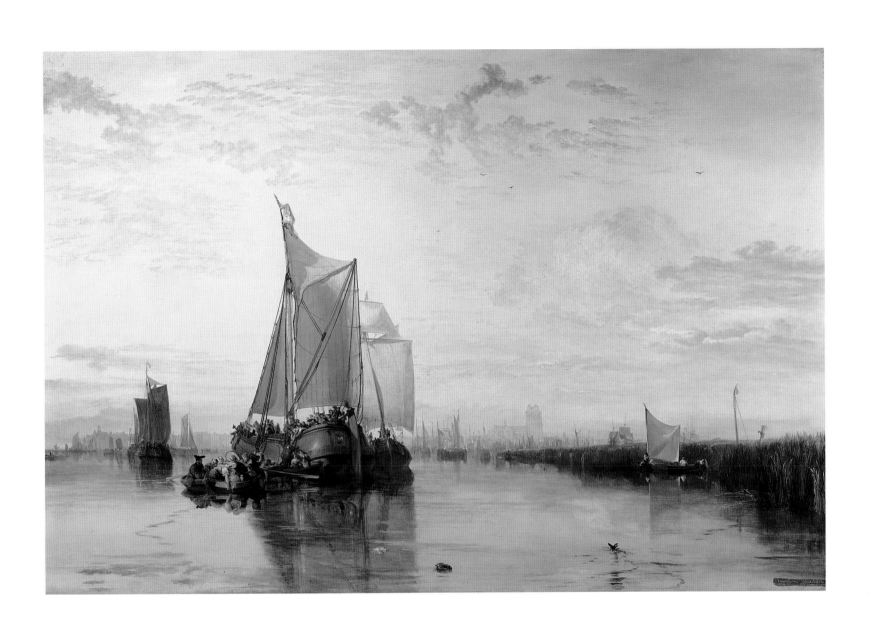

91 **Joseph Mallord William Turner (1775–1851)**

Staffa, Fingal's Cave, 1832

Oil on canvas; 36 x 48 in. (91.5 x 122 cm)
B1978.43.14

92 Joseph Mallord William Turner (1775-1851)

Venice, the Mouth of the Grand Canal, 1840

Watercolor on wove paper; 8⅝ x 12½ in. (21.9 x 31.8 cm)
B1977.14.4652

93 Joseph Mallord William Turner (1775–1851)

A Paddle-steamer in a Storm, ca. 1840

Watercolor over graphite with scratching out on wove paper;
9⅛ x 11⅜ in. (23.2 x 28.9 cm)
B1977.14.4717

94 Joseph Mallord William Turner (1775–1851)

The Channel Sketchbook, ca. 1845

Sketchbook with marbled endpapers and eighty-eight leaves of white wove
paper, with seventy-four watercolor and twenty-six graphite sketches;
sheet size: 3¾ x 6⅜ in. (9.5 x 16.2 cm)
B1993.30.118 (1–88)

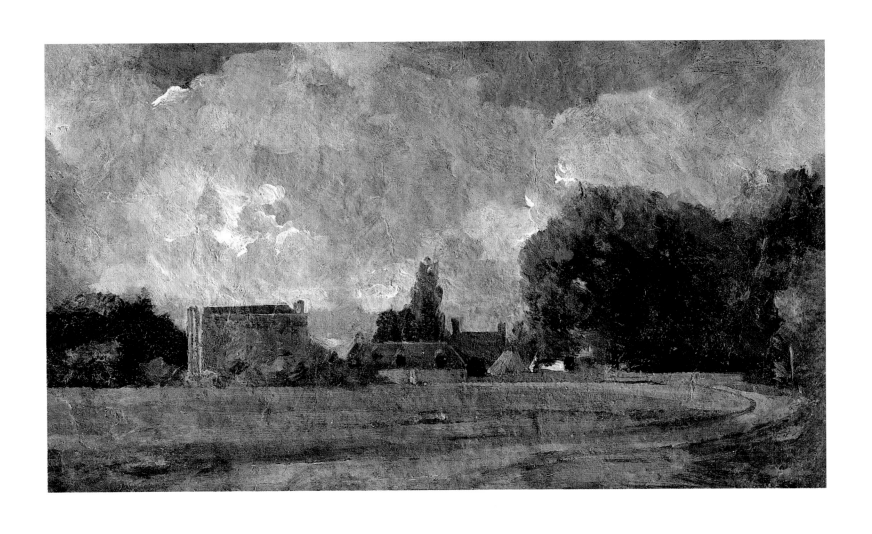

95 John Constable (1776–1837)

*Golding Constable's House, East Bergholt: The Artist's
Birthplace (Landscape with Village and Trees)*, ca. 1809

Oil on canvas; 5¾ x 10 in. (14.6 x 25.4 cm)
B2001.2.105

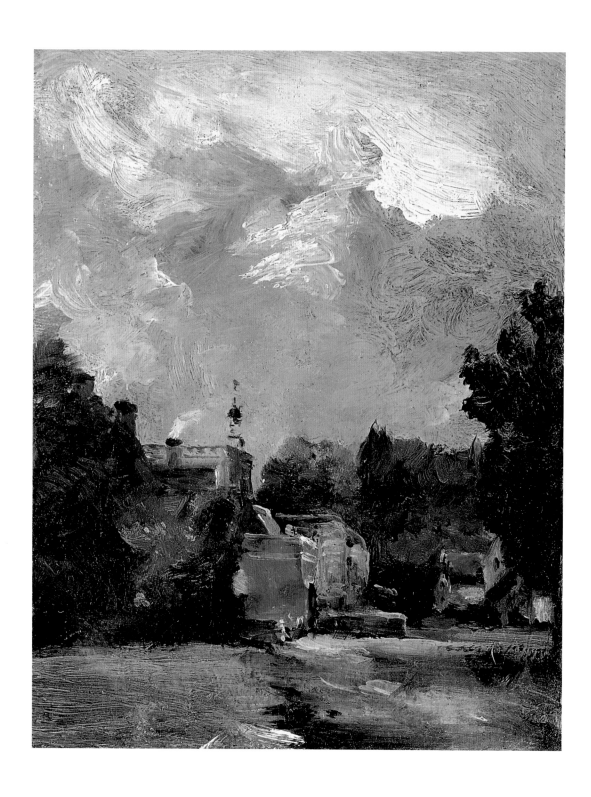

96 John Constable (1776–1837)

East Bergholt Church, 1809

Oil on paper, laid on panel; 7⅞ x 6¼ in. (20.2 x 15.7 cm)
B2001.2.237

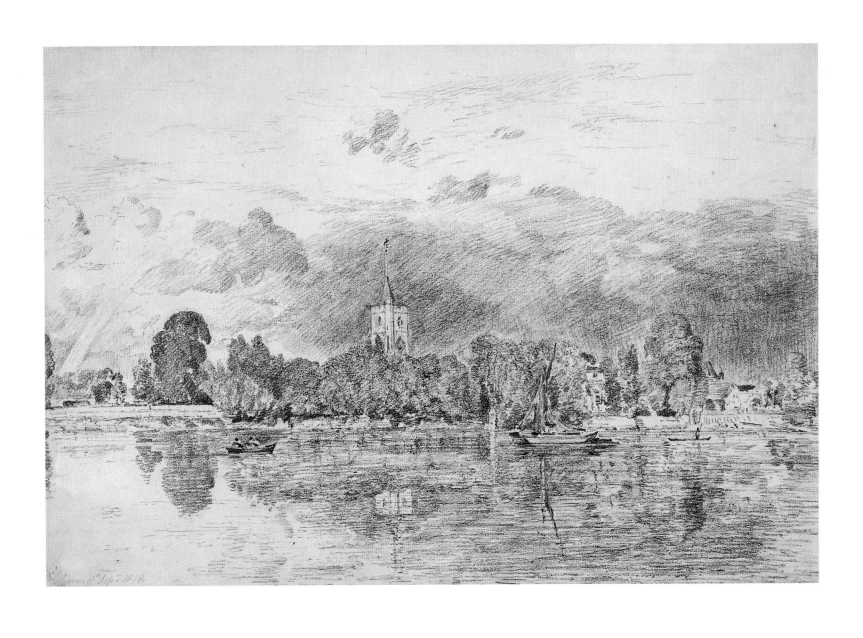

97 John Constable (1776–1837)

Fulham Church from Across the River, 1818

Graphite on wove paper; 11⅝ x 17½ in. (29.5 x 44.5 cm)
B1977.14.4632

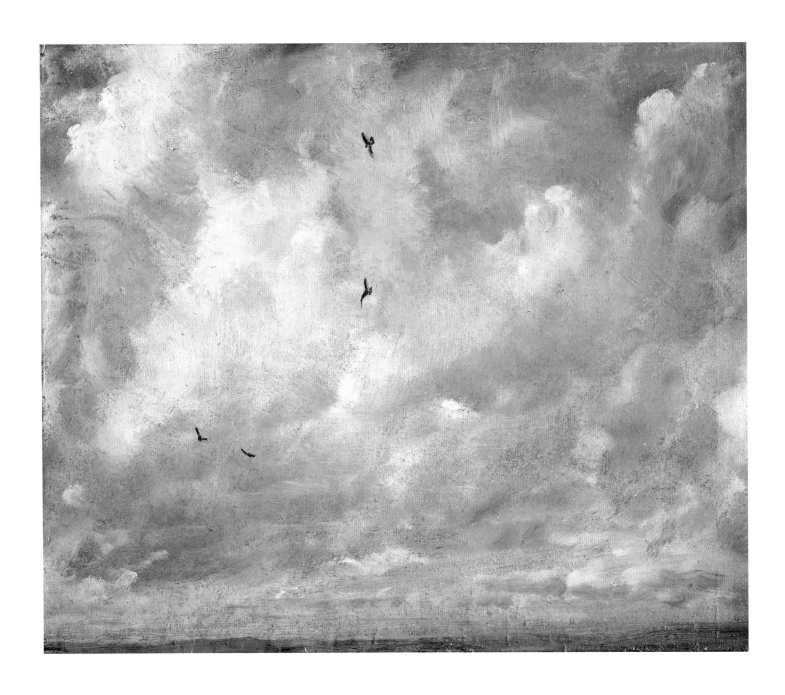

98 John Constable (1776–1837)

Cloud Study, 1821

Oil on paper, laid on board; 9¾ x 11⅞ in. (24.8 x 30.2 cm)
B1981.25.155

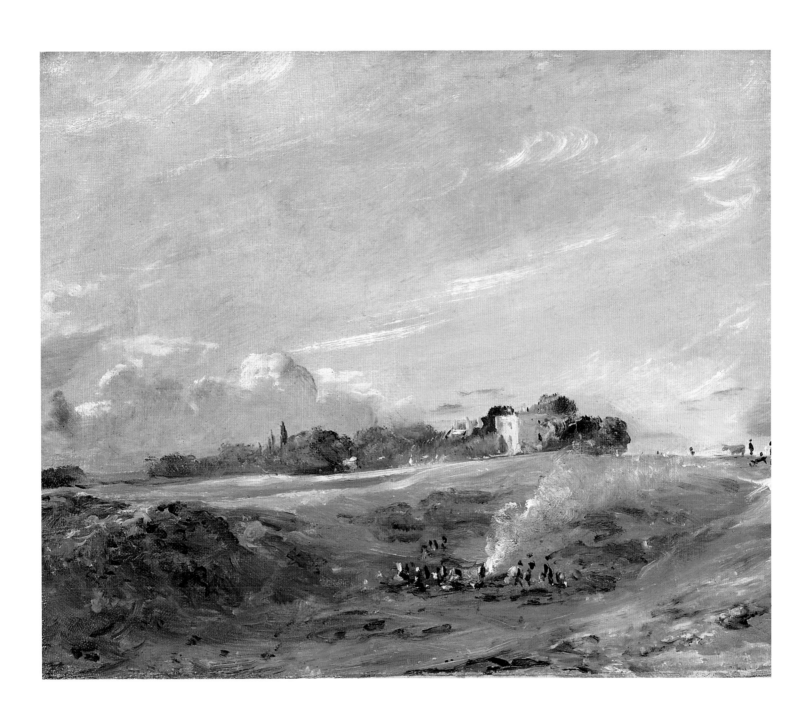

99 John Constable (1776–1837)

Hampstead Heath, with a Bonfire, ca. 1822

Oil on canvas; 10⅝ x 12⅝ in. (27 x 32.1 cm)
B2001.2.241

100 **John Constable (1776–1837)**

Hadleigh Castle, The Mouth of the Thames—
Morning After a Stormy Night, 1829

Oil on canvas; 48 x 64¾ in. (121.9 x 164.5 cm)
B1977.14.42

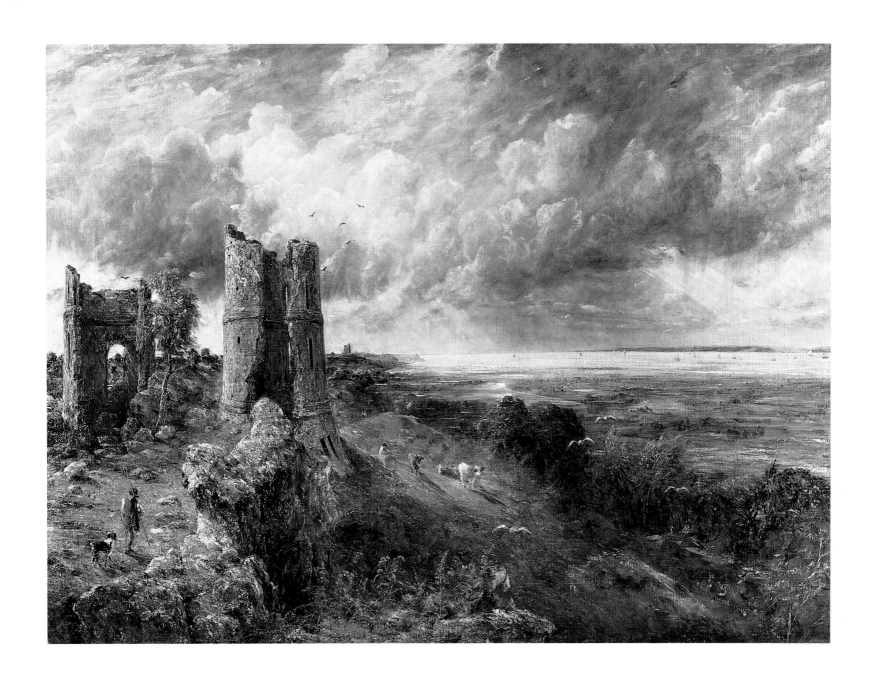

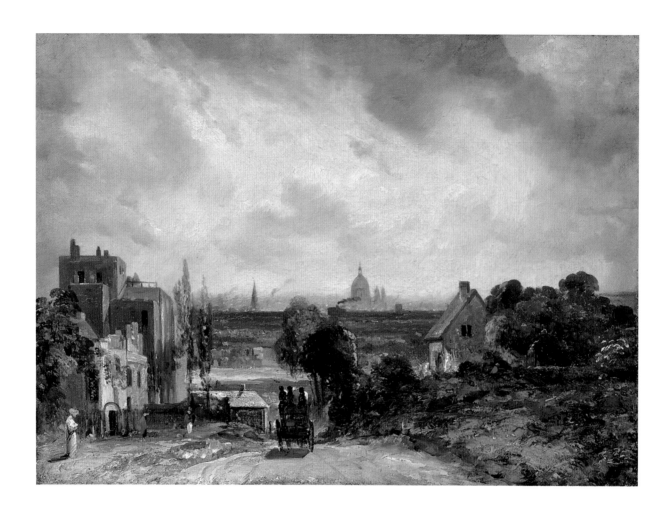

101 **John Constable (1776–1837)**

Sir Richard Steele's Cottage, Hampstead, ca. 1831–32

Oil on canvas; 8¼ x 11¼ in. (21 x 28.6 cm)
B2001.2.25

102 John Sell Cotman (1782–1842)

In Rokeby Park, ca. 1805

Watercolor over graphite on laid paper;
12⅞ x 9 in. (32.7 x 22.9 cm)
B1977. 14. 4671

103 **George Fennel Robson (1788–1833)**

Loch Coruisk, Isle of Skye—Dawn, ca. 1826–32

Watercolor, gouache, scraping out, and gum on wove paper laid down
on card; 17¾ x 25¾ in. (45.1 x 65.4 cm)
B1977.14.6254

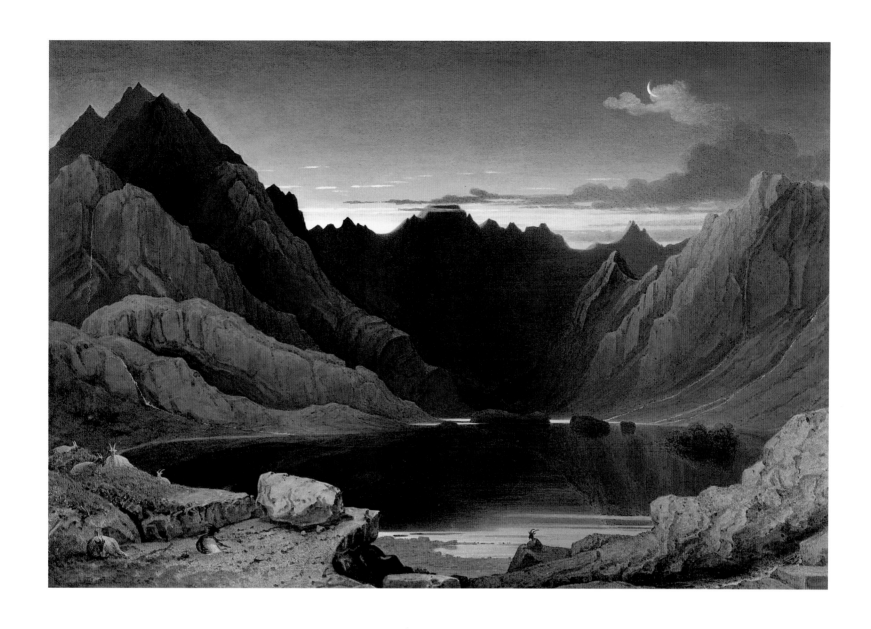

104 **William Turner of Oxford (1789–1862)**

Donati's Comet, 1859

Watercolor and gouache over graphite on wove paper;
10⅛ x 14⅜ in. (25.7 x 36.6 cm)
B1975.4.1767

105 John Linnell (1792–1882)

Shepherd Boy, also known as *Shepherd Boy Playing a Flute*, 1831

Oil on panel; 9 x 6½ in. (22.9 x 16.5 cm)
B1981.25.420

106 **Robert Burnard (1800–1876)**

John Gubbins Newton and His Sister, Mary Newton, ca. 1833

Oil on canvas; 92½ x 56½ in. (235 x 143.5 cm)
B2001.2.66

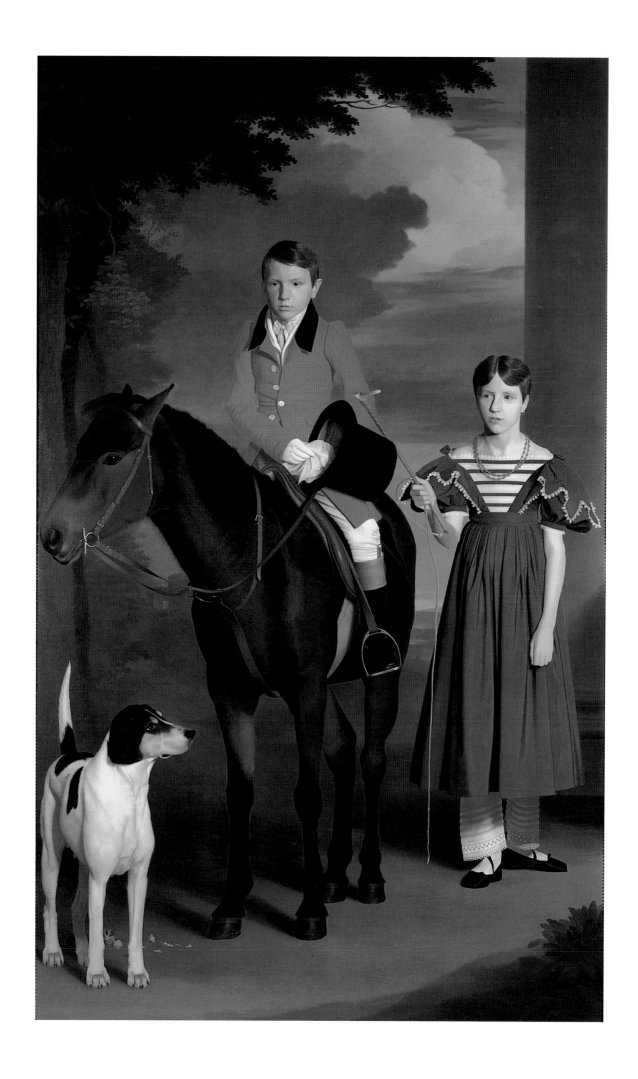

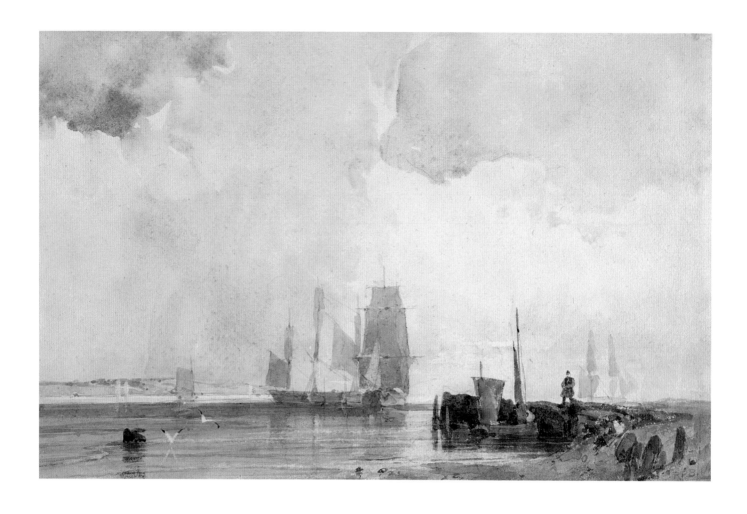

107 Richard Parkes Bonington (1802–28)

Shipping in an Estuary, Probably near Quilleboeuf,
ca. 1825–26

Watercolor over graphite with scratching out on wove paper;
5¾ x 9 in. (14.5 x 22.9 cm)
B1981.25.2398

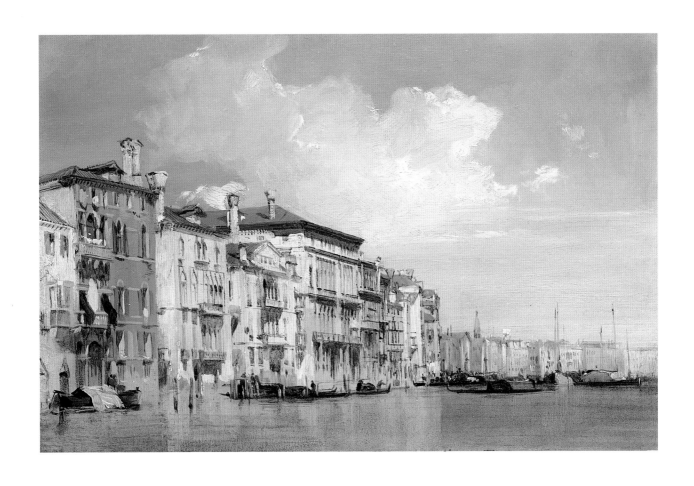

108 Richard Parkes Bonington (1802–28)

Grand Canal, Venice, 1826

Oil on millboard; 9¼ x 13¾ in. (23.5 x 34.9 cm)
B1981.25.56

109 **Sir Edwin Landseer (1802–73)**

Favourites, the Property of H.R.H. Prince George of
Cambridge, 1834–35

Oil on canvas; 40 x 49½ in. (101.6 x 125.7 cm)
B2001.2.273

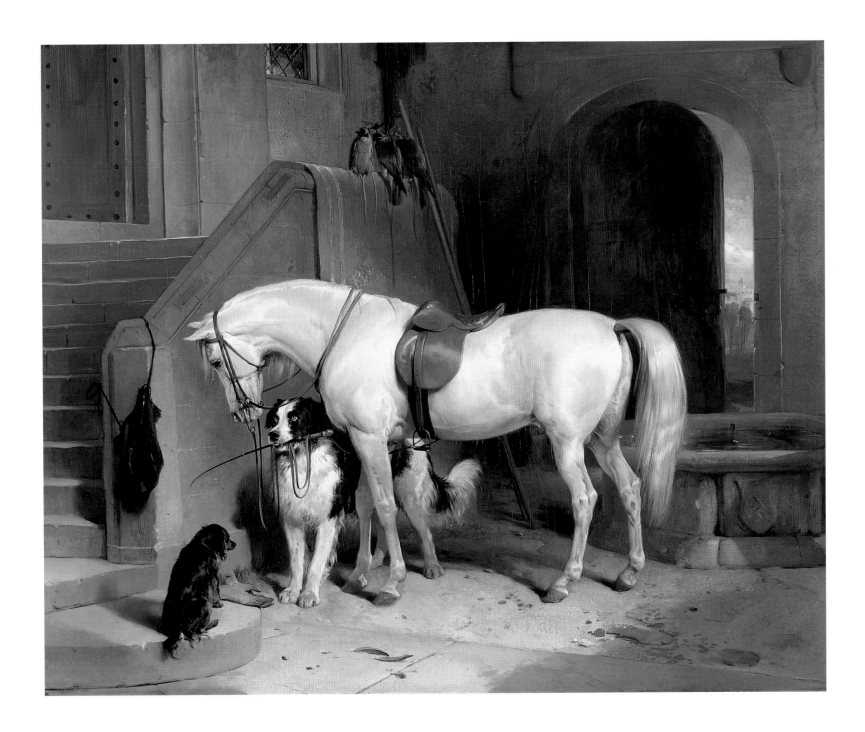

110 **Thomas Shotter Boys (1803–74)**

L'Institut de France, Paris, 1830

Watercolor over graphite on wove paper;
13¹⁵⁄₁₆ x 10½ in. (35.4 x 26.7 cm)
B1975.4.1460

111 **John Frederick Lewis (1804–76)**

A Frank Encampment in the Desert of Mount Sinai,
1842 — The Convent of St. Catherine in the Distance, 1856

Watercolor and gouache over graphite on wove paper laid down
on board; 26¼ x 53½ in. (66.7 x 135.9 cm)
B1977.14.143

112 **Samuel Palmer (1805-81)**

A Moonlight Scene with a Winding River, ca. 1827

Black and brown wash, gouache, and gum on wove paper;
10½ x 7⅛ in. (26.7 x 18.1 cm)
B1977.14.4643

113 Samuel Palmer (1805–81)

The Weald of Kent, ca. 1833–34

Watercolor, gouache, and pen and Indian ink on heavy wove paper;
7⅜ x 10¾ in. (18.7 x 27.3 cm)
B1977.14.65

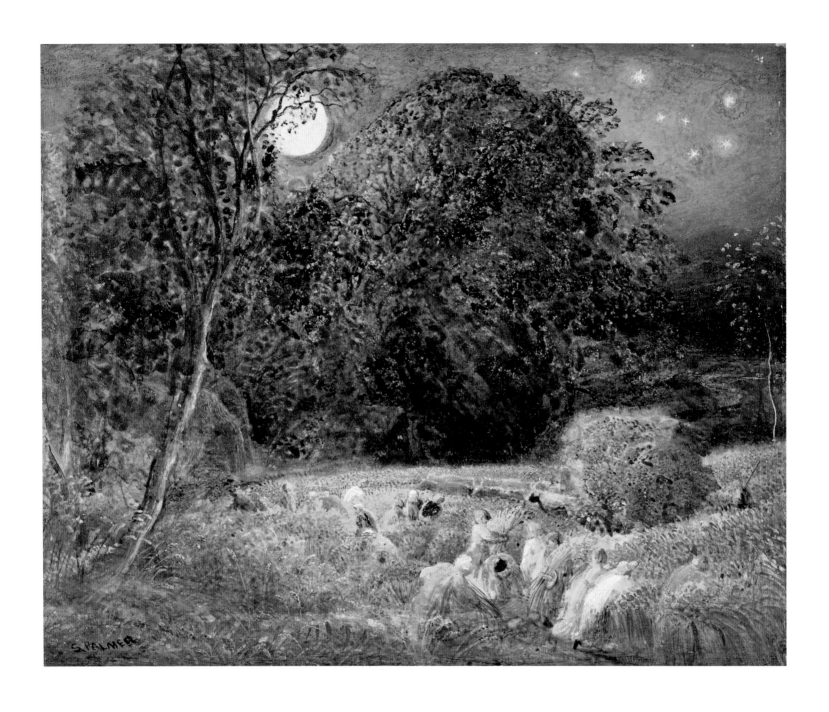

114 **Samuel Palmer (1805–81)**

The Harvest Moon, ca. 1833

Oil and tempera with graphite on paper laid on panel;
8¾ x 11 in. (22.2 x 27.7 cm)
B1977.14.65

115 Richard Dadd (1817–86)

Death of Abimelech at Thebez, 1855

Watercolor over graphite on wove paper;
14⅛ x 10⅛ in. (35.9 x 25.8 cm)
B1981.25.2574

116 **Sir Alfred Munnings (1878–1959)**

Paul Mellon on Dublin, 1933

Oil on canvas; 31 x 37½ in. (78.7 x 95.3 cm)
B2001.2.230

...tio expeditionis nauticæ, Francisci Draci Angli, equitis
...quinq naubus probe instructis, ex occidentali Angliæ par...
...soluens, tertio post decimo Decembris Anº M.D.LXXVII,
... ambitum circumnauigans, unica tentu naui reliqua (alijs
flamma correptis) redux factus, sexto supra Vigesimo Sep: 1580.

G.R

CIRCVLVS ARCTICVS

META Incog-
nita

Terra Noba

NOVA
FRAN
CIA

Hug nabi ad
...ctus Franc..
Druc Job moun...
frigoris usu in
reuersus est

Japan

Noua Albyon sic a Francisco Draco equite
dicta, eiusdē inuentore, Anº 1579, qui bis ab in-
colis eode die Regiæ Maiestatis nomine, dia-
demate coronatus est

VIRGINEA
Colonia ducta in
hanc continentis
partem a Gualte-
ro Ranlee
equite 158...

A M E
NOVA HIS-
PANIA
R I
C A
D A

California

Culiacan

MAR DEL

NOORT. CAN

TROPICVS

Mexico
Acapulco

IVCA
TAN
Cartagena

Car-
tagena

CA
RI
BANA

210 220 230 240 250 260 270 280 290 300 310 320 330 340 350

ÆQVI:

MAR DEL
ZVR

Tumbes

PE
R
V

Lima

Cusco
Arica

PA
R
I
A

BRA
SIL
IA

TROPICVS

Chile

RV
NA

CA
CHILI

Mucho

Terra
Gigan-
tum

Rio de Plata

Fretu Iuliano

ELIZABETHA

CIRCV

Kubu Bachia

...dore Matir

...ce a Rege Molucensium
...admittente et quatuor na...
...portu introbectus est, ve...
...in delineatio...

Cum omnes fere hanc partem australem conti-
nente esse putent, pro certo sciant insulas esse ea-
rũ australissimam ELIZABETHAM
dictam esse, a Francisco Draco eiusdē inbento
re...

ME

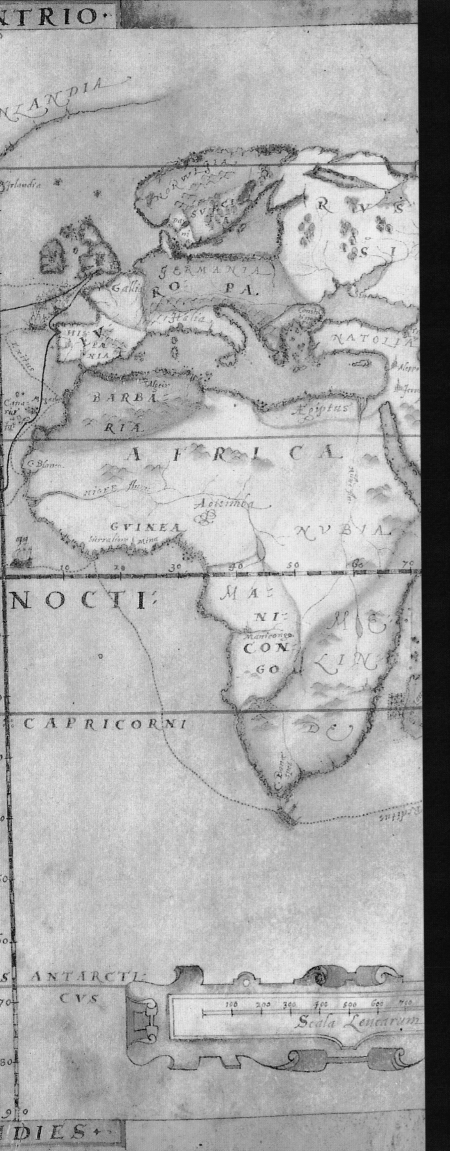

Book Arts

117 **Claudius Ptolemy (ca. 100–168)**

"Tabvla Prima Evropae," from *Geographie opus nouissima traductione e Grecorum archetypis castigatissime pressum*

Compiled by Martin Waldseemüller (ca. 1475–1522)
Strasbourg, Johann Schott, 1513
Colored woodcut
Binding (closed): 18 x 12¾ in. (45.7 x 32.3 cm)

22 | 23 | 24 | 24 | 26 | 2A | 28 | 29 | 30 | 31 | 32

ΡΑΝVS DVECALLEDONIVS.

hile Infula

63

62

Orchades Infule não XXX

dumna infula

g.lanis

61

epidium
Cornes
Carnones
Epidy
Caledonia
filua
uolas
finus
Curnaui
glabna
memo
finus
Cantre
Caledonia
Ripalin fla
lugi
tumaua Taíma
Virõmagi
ncis
uictoria
glabna
deuana
Vernicõ
nes
Tazali
ortua
finus

60

49

48

Saxonü infula

Albis fl

47

uifurgis fl

46

Cõuennos

45

uidrus
fluuis

44

MAGNE GERMANE PARS.

43

CELTOGALATIAE BELGICAE PARS.
Renus
flu9

42

22 | 23 | 24 | 24 | 26 | 2A | 28 | 29 | 30 | 31 | 32 | 33

118 **Christopher Saxton (b. 1542[?])**

Frontispiece, with portrait of Queen Elizabeth engraved by
Remigius Hogenberg (1536–87), from *Atlas of the Counties
of England and Wales*

London, 1579
Engraving
Binding (closed): 16¾ x 11⅝ in. (42.5 x 29.5 cm)

119 **Richard Hakluyt (1552[?]–1616)**
Leaves ¶3v–¶4r from his *Divers voyages touching*
the discouerie of America, and the Ilands adiacent
vnto the same, made first of all by our Englishmen,
and afterward by the Frenchmen and Britons

London, Thomas VVoodcocke, 1582
Letterpress, with pen and ink
Binding (closed): 7⅛ x 5⅞ in. (18.1 x 14.9 cm)

120 *Vera descriptio expeditionis nauticæ, Francisci Draci Angli, cognitis aurati, qui quinque navibus probe instructis, ex occidentali Anglia parte anchoras soluens, tertio post decimo Decembris Anº M.D.XXXVII, terraru[m] orbis ambitum circumnauigans, unica tentu navi reliqua (alijs fluctibus, alijs flamina correptis) redux factus, sexto supra Vigesimo Sep: 1580* (A True description of the naval expedition of Francis Drake, Englishman & Knight, who with five ships departed from the western part of England on 13 December 1577, circumnavigated the globe and returned on 26 September 1580 with one ship remaining, the others having been destroyed by waves or fire), ca. 1587

Pen and ink and watercolor on parchment
9⅜ x 17¾ in. (23.8 x 45 cm)

ANDIA·

TARTA
RIA

A S I A.

SIA

EVRO PA.

GERMANIA

ITALIA

NATOLIA

Arme
nia

Turchestan

PERSIA

CHINA

HISPA
NIA

BARBA
RIA.

Aegiptus

ARA

ARABIA

AFRICA.

GVINEA

NVBIA

NOCTI

MA
NI
CON
GO

ALIS

ORIENS·

CAPRICORNI

ANTARCTI
CVS

Scala Leucarum

Quem miseri super iacente scopulo nabis
illiso latere quassatus 20 horarii spatio, at
tandem auxilio divino servata, ipsa desertitis
indicat

121 **Baptista Boazio (fl. 1588–1606)**

The Famouse West Indian voyadge made by the Englishe
Fleete of 23 shippes and Barkes wherin weare gotten
the Townes of St. Iago, Sto. Domingo, Cartagena, and
St Avgvstines, the same beinge begon from Plimmouth
in the Moneth of September 1585 and ended at Portesmouth
in Iulie 1586

London [?], 1589
Hand-colored engraving
16½ x 21⅞ in. (42 x 55.6 cm)

2

122 **Thomas Cavendish (1560–92)**

Leaves 1v–2r from *Account of the Last Voyage
of Thomas Cavendish*, 1592

Manuscript, in pen and ink
Binding (closed): 7⅝ x 5⅝ in. (19.4 x 14.3 cm)

XIX.
Die Statt Secota.

ES seind die Stätte/ so mit keinē Pfälen vmb-
ringet/ gemeiniglichen lustiger als die andern/ wie diese
Figur/ so die Statt Secota genennet wirdt/ rechte con-
trafactur auffweiset. Dañ daselbst sind hin vnd her Häu-
ser vnd Gärten/ wie der Buchstab E. bezeichnet/ in welche
wächst das Tabaco/ von ihnen Vppowoc genennet. Es
seind auch vmb dieselben Wälde/ in welchen sie Hirsche fangen. So seind auch
daselbst Ecker/ darinn sie ihr Korn sähen. Auff den Eckern bawen sie ein ge-
rüst/ vnd darauff ein Häußlein oder Hütten/ welches sie nach art eines hal-
ben Circkels bedecken/ wie der Buchstab F. bedeutet. In diesem bestellen sie
ein Wächter/ dann es seind allda so viel Vögel vnd Thier/ daß/ so ferrn sie nit
fleissig wacheten/ der Samen in kurtzer zeit auffgefressen würde/ dessen wegē
muß der Wächter ohn vnterlaß ruffen/ vnd ein geschr machen. Den Samē
aber sähen sie auff eine solche ordnung/ welche der Buchstab H. außweiset/
sonst würde das eine gewächs durch das ander erstickt/ vnnd das Korn/ wie
sichs gebürt/ nicht reiff werden/ dann seine Bletter sind so groß als die Blet-
ter deß grossen Rors/ wie am Buchstaben G. zu sehen. Sie haben auch einen
sonderlichen Platz/ mit C. gezeichnet/ auff welchen/ wann sie mit ihren Nach-
bawren allda zusammen kommen/ ihre järliche hohe Fest (davon in der ach-
tzehenden Figuren geredt ist worden) begehen. Darnach gehen sie auff einen
ort/ durch den Buchstaben D. bedeutet/ vnd halten daselbst ihre Gastereyen.
Gegen vber haben sie einen runden Boden/ mit dem Buchstaben B. bezeich-
net/ dahin sich ihr Jargeitliches Gebett zu thun/ versamlen. Nicht ferrn
von diesen ist ein weites Gebäw/ mit A. gezeichnet/ in welchem der grossen
HerrnBegräbnusse sind/ wie auß der zwey vnd zwantzigsten Figuren erschei-
nen wirdt. Sie haben auch Gärten/ in welchen sie eine Frucht/ einem Apffel
oder Pfeben gleichförmig/ ziehen/ durch den Buchstaben J. bezeichnet. So
haben sie gleicher weise einen ort/ durch K. angedeutet/ auff welchen sie zu zei-
ten ihrer hohen Feste ein Fewer anzünden. Draussen/ nicht ferrn von der
Statt/ haben sie ein fliessendes Wasser/ durch L. angedeutet/ auß welchem sie
Wasser schöpffen. Es machen sich derwegen diese Leut/ mit gar keinem Geitz
beladen/ lustig vnd frölich. Vnd nach dem sie ihre grosse Fest bey Nacht bege-
hen vnd halten/ derohwegen legen sie helle vnd liechte Fewer an/ zum er-
sten darumb/ daß sie nicht im finstern strauchlen/ zum andern/
daß sie ihre frewde vnter einander zu
versehen geben.

123 **Theodor de Bry (1528–98)**

"Die Statt Secota" ("The Towne of Secota"), from
*Wunderbarliche doch warhafftige Erklärung, von der
Gelegenheit und Sitten der Wilden in Virginia* (A Briefe
and True Report of the New Found Land of Virginia),
by Thomas Hariot, *Grand Voyages*, pt. 1.

Frankfurt, Johann Wechel for T. de Bry, 1600 (2nd ed.)
Letterpress, with engraving
Binding (closed): 14⅛ x 9⅝ in. (35.8 x 24.4 cm)

124 Henri de Ferrières (fl. 1377)
Leaves 13v–14r from *Le Livre du Roy Modus
et de la Royne Racio*

France, ca. 1420
Manuscript, in pen and ink, with watercolor and gouache
and touched with gold, on parchment
Binding (closed): 12³⁄₁₆ x 9⅝ in. (30.9 x 24.4 cm)

125 William Twiti (d. 1328)

Leaves 36v–37r from *The craft of venery*

England, ca. 1450
Manuscript, in pen and ink
Binding (closed): 9 x 6⅜ in. (22.8 x 16.2 cm)

fi comme il appartiét Et fe les chiens le treuuét fi ozes grans abaitz et
grant chaffe et grant noife de huer Et de coner et de renforcer la chaffe
des chiens du hardonner pour qu̲oy la chaffe eft fi grant et la noife telle

quon nentendroit mie dieu tonner Et quant bient fur le tart que les be
ftes font pourmenees x que les chiens du hardoner chaffent to̲ au buif
fon Adonc̲ques ozes a la haie crier crier chiens abaier et chaffer cozs
et trompettes fonner et les aultres huer fi endroit terres le meilleur d̲
duit des chiens qui xeult eftre Et quant le buiffon eft bon de beftes on e̲
prent grant foifon Et endroit de moy ie vy le roy charles qui fut filz au
beau roy phelippe q̲ chaffa en la foreft de bertelly en bng buiffon appelle
laboule gueralde ou il print-bi.xx beftes noires en bng iour fans les
emblees · Et fe il bient aux leureirs ceulx qui tiennét les leureirs les
doiuent laiffer aller quant ilz font paffes apres le cul Et retiens que a
loups on doit laiffier le leureir a lencotre et es cerfz aux couftes et aux
fanglier au cul pour troys caufes La premiere eft que fe tu ne laiffe al
ler tes leureirs a lencontre du loup fach̲es que le lup dōnes grant aua̲
taige de eflongner les leureirs et quant on laiffe aller a lencôtre y re
tourne et baudril par quoy les leureirs la prochent fi eft aua̲taige pour

eur · Item et quant au cerfz fe tu laiffe aller tes leureirs a lencontre il
eft fi royde de puiffance et hault fur iambes x fi fort de foy que a paine la
procheront Et pource doit on laiffer aller au cofte Au fanglier et a noy
tez beftez qui laifferoit aller a lencontre au fanglier par efpecial il farze
ftes et les atend et fi côme il vient ilz biennent-il les decoppe pource laf
fe len aller apres le cul car auffi font ce beftes que pozes et trupes qui ne
font mye touft Ainfi vous auons d̲rduit et deuife le d̲eduit royal
Aprentis demande ce on fait ainfi tous buiffons pour toutes
autres beftes Modus dift nennil fe ne font pour les cerfz
pour les loups Efquieulx chappitres tous fera dift et monftre
par raifon aulcuns exemples qui font bien a retenir Qui veult prêdre
les loups a buiffoner le tâps eft la fin du moys de feureir et eft le têps
ilz font departy de geftoire et de challeur pour quoy ilz font familieux
Car tant come ilz font en geftoire ilz menguent pou ou neant x pour lez
a femblez a bng buiffon ou lon les veult prandre et deftrâdre leur fault
donner a menger en cefte maniere Tu dois regarder es boys ou loupz
hantet ou buiffons fors des boys et ceft pais au quel il aift eaue dedas
ainfi comme bng mare ou flacte ou il puiffant boyre Puis prenes bne

e ij

126 **Henri de Ferrières (fl. 1377)**

Leaves e1v–e2r from *Le Liure du Roy Modus
 et de la Reine Racio*

Chambéry, France, Anthoine Neyret, 1486
Letterpress, with woodcuts
Binding (closed): 10 ¼ x 7 ½ in. (26 x 19 cm)

Ther be bestys of the chace: of the swete fewte. And they be the Bucke. the Doo. the Beere. ther Reynd the Elke. the SpytarD. the Otre. and the Martron.

Ther be bestis of the chace of the stynkyng fewte And thay be the Roobucke. and the Roo. the Fulmard. the Fychis. the Baude. the Graye. the Foxe. the Squyrell. the Whitrat. the Sot. and the Pulcatte.

The namys of diuerse maner houndis

Theis be the namys of houndes. First ther is a Grehothnd a Bastard. a Mengrell. a Mastyfe. a Lemor. a Spaynell. Rachys. Kenettys. Teroures. Bocheris houndes. Myddyng dogges. Tryndeltaples. and Pryckerid curris. and smale ladies popis that bere a way the fleis and dyueris smale fawtis.

The propreteis of a goode Grehound

A Grehound shuld be hedid like a Snake. and neckyd like a Drake. Foted like a Kat. Tayled like a Rat. Syded lyke a Teme. Chyned like a Beme.

The first yere he most lerne to fede The secund yere to feld to hym lede. The .iij. yere he is felow lyke. The .iiij. yere ther is noon sike The .v. yere he is good Inough The .vi. yere he shall hold the plough The .vij. yere he Will availe: grete bittchys for to assaple The .viij. yere lickladill. The .ix. yere carsagdyll. And whan he is com

The propretees of a goode hors

A Goode hors shuld haue .xv. propretees. and condicions. iij. of a man. iij. of a Woman. iij. of a fox iij. of an haare. and .iij. of an asse.
Off a man bolde prowde and hardy.
Off a Woman fayre bresstid fayre of here & esy to lip vppon.
Off a fox a fayre tayle short eris with a goode trot.
Off an haare a grete eygh a dry hede. and well rennyng
Off an asse a bigge chyne a flatte lege. and goode houe.

Well trauelid Women ner Well trauelid hors Wer neu goode

Arise erly. serue god deuouteli. and the world besily do thy werke Wiseli. yeue thyn almesse secretly Go by the way sadly. Answere the peple demurely. Go to thi mete apetideli. Sit ther at discretely Of thi tonge be not to liberali. Arise therfrom temparly. Goo to thi soper soberly. And to thy bedde merely. Be in thyn Inne Iocundly. Plese thy loue duly. And slepe surely.

Werke wele theys .iiii. thynges

Ther be .iiij. thynges principall to be dred of euy wise man The first is the curse of oure holy fader the pope. The secunde is thindignacion of a prince. Quia indignacio regis vel principis mors est. The thridde is the fauor or the Witt of a Juge. The .iiij. is Sclaunder & the mutacion of a cominalte.

127 **Dame Juliana Berners (b. ca. 1388)**
Leaves f4v–f5r from *The Boke of St. Albans*, also known as
The Book of Hawking, Hunting, and the Blasing of Arms

St. Albans, Schoolmaster Printer, 1486
Letterpress, with rubrication
Binding (closed): 11¼ x 8⅜ in. (28.5 x 21.3 cm)

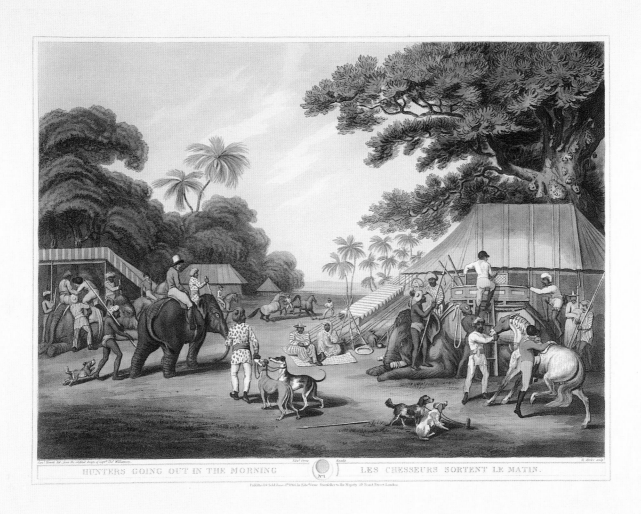

HUNTERS GOING OUT IN THE MORNING LES CHESSEURS SORTENT LE MATIN.

128 **Captain Thomas Williamson (fl. 1778–89)**

"Hunters Going Out in the Morning," by Henri
Merke, after Thomas Williamson and Samuel Howitt
(1765[?]–1822), from *Oriental Field Sports, Being a
Complete, Detailed, and Accurate Description of the
Wild Sports of the East, and Exhibiting in a Novel and
Interesting Manner the Natural History of the Elephant,
the Rhinoceros, the Tiger . . . the Whole Interspersed with
a Variety of Original, Authentic, and Curious Anecdotes*

London, Edward Orme, 1805–7
Hand-colored aquatint
19 x 24 in. (48.2 x 61 cm)

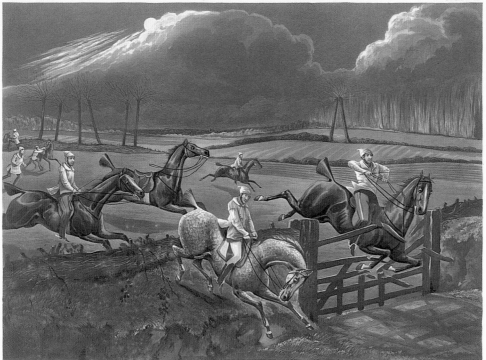

129 **Henry Thomas Alken (1784–1851)**

"The Last Field near Nacton Heath," by J. Harris, after
Henry Thomas Alken, from *The First Steeple Chase on
Record, or, The Night Riders of Nacton*

London, Ackermann, 1839
Hand-colored aquatint
17⁹⁄₁₆ x 23⅞ in. (43.6 x 60.6 cm)

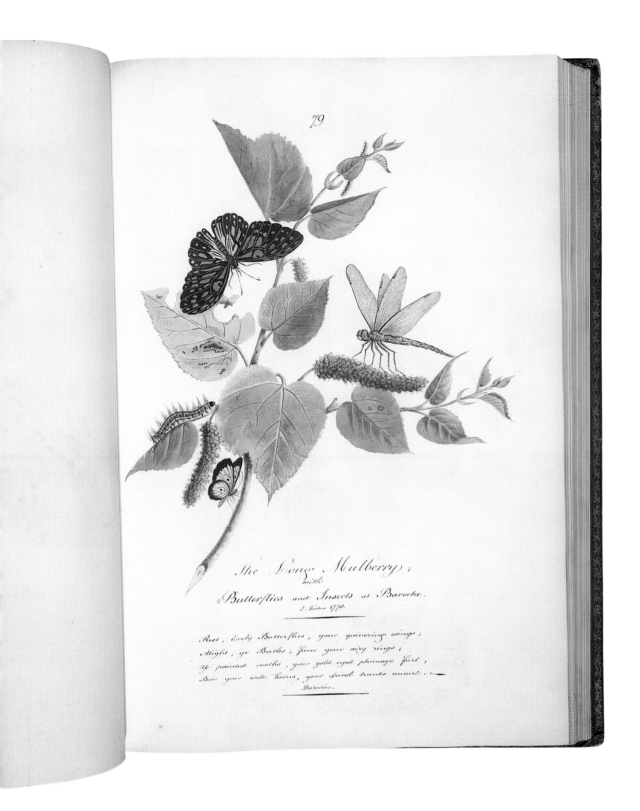

130 James Forbes (1749–1819)

"The Long Mulberry, with Butterflies and Insects at Baroche," from
*A Description of the Purgunna of Baroche, with the Animal and Vegetable
Productions in this Part of Guzerat Province*, vol. 10 (1778) of Forbes's
*A Voyage from England to Bombay, with Descriptions in Asia, Africa, and
South America, 1776–1784* (vols. 1–13 of his *Descriptive Letters and Drawings,
Presented to Elizabeth Forbes*, 1800)

Pen and ink and watercolor
Binding (closed): 21¼ x 15 in. (54 x 38 cm)

131 Leaves 17v–18r from *Helmingham Herbal and Bestiary*

England, ca. 1500
Gouache and watercolor, with pen and ink, on parchment
Binding (closed): 17¾ x 12³⁄₁₆ in. (45.1 x 31 cm)

A griffon. A grehond.

Ahors. A hair.

132 **Alexander Marshal (ca. 1620–82)**

St. George and the Dragon, inlaid to size and bound in
vol. 3 of *Anecdotes of Painting in England, with
some Account of the Principal Artists, and Incidental
Notes on Other Arts,* by Horace Walpole (1717–97),
Strawberry-Hill, 1762–71 [i.e., 1780], 4 vols.

Watercolor, gouache, and pen and ink
Binding (closed): 17½ x 12 in. (44.4 x 30.4 cm)

Observe alwaies in Laying your Print upon the
glass that you lay itt even free from cockling or
from Bladders and where you se itt Bladders be
sure to work itt close to the glass with your thumb
else twill appear in shineing spotts.

have a Care also you lay not your turpentine
too thick nor streaky but all over even wch you
may effect by holding itt nere the fire and lett
itt run all over alike

Butt if you hold itt too nere the fire twill
Crack ye glass.

This short direction is sufficient if by
your practice you endeavour to performe it
you will bring itt to more perfeccon
find out more Rules and tricks then I am
able to insert for this is but a Trick
itt self though now in great use amongst
all persons of Quality and may be improved
beyond immagination.

The true way of Laying a
Ground on a Copper Plate for working in Mezzo
Tinto

This Art was first invented by Prince Rupert
and improved by Mr Vailant to whome the Prince
taught itt tis effected thus

you must have a Roule of good steel well temperd
and gett itt Cutt by a File Cutter indifferent
fine, and chequer waies, be sure that ye Roule
be true turnd and even cutt, and then putt
itt into such a frame as the Bookbinders
roules are putt in, which they fillett their
books with, then Tip your Copper plate in som
Cement on a Board and sett ye handle of
your Roule agt your shoulder and guide itt
with your hands and by often going over
your plate you effect of ground
Note that your plate must be well polished
before you lay a ground on itt And then
tis no art but pure Labour and patience
perfects this work ye oftner you goe over itt

133 **Edward Luttrell (fl. 1680–1724)**

Pages 44–45 from *An Epitome of Painting Containing Breife
Directions for Drawing Painting Limning and Cryoons wth the
choicest Receipts for preparing the Colours for Limning and Cryoons,
Likewise Directions for Painting on Glass as tis now in use amongst
all persons of Quality. And Lastly How to lay the Ground, and work
in Mezzo Tinto*, 1683

Manuscript, in pen and ink
Binding (closed): 9⅝ x 7⅜ in. (24.5 x 18.8 cm)

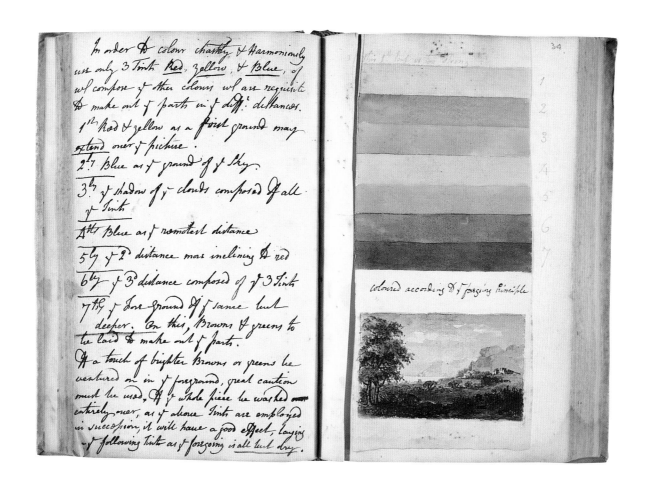

134 William Gilpin (1724–1804)

Leaves 33v–34r (with color chart laid in) from *Hints
to form the taste & regulate ye judgment in sketching
Landscape*, ca. 1790

Manuscript, in pen and ink, with watercolor
Binding (closed): 8⅜ x 5¾ in. (21.3 x 14.5 cm)

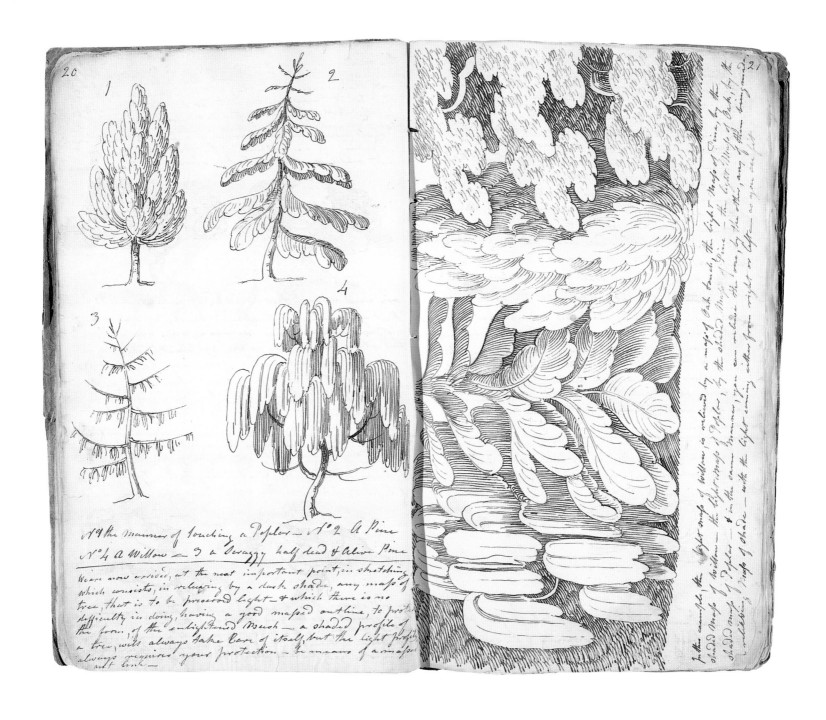

135 **Archibald Robertson (1765–1835)**
Pages 20–21 from "On the Art of Sketching,"
in a manuscript of an unpublished sequel to Robertson's
Elements of the Graphic Arts

New York, 1801
Manuscript, in pen and ink
Binding (closed): 16 1/16 x 10 in. (40.8 x 25.5 cm)

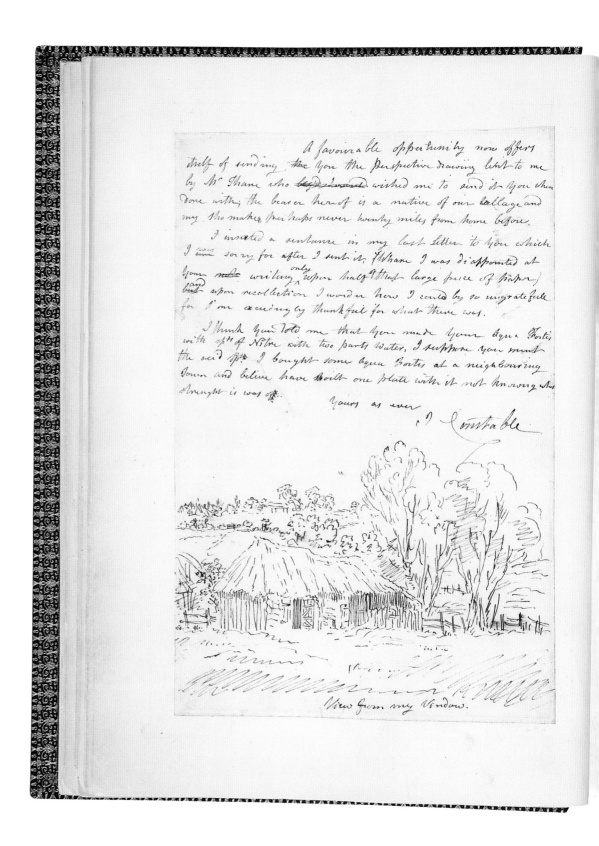

136 **John Constable (1776–1837)**

Autograph letter from Constable to John Thomas Smith
(1766–1833), dated between 16 January and 23 March 1797,
inlaid to size and bound in *Memoirs of the Life of John
Constable*, by Charles Robert Leslie (1794–1859), London,
James Carpenter, 1843

Manuscript, in pen and ink
Binding (closed): 14⅛ x 11 in. (35.7 x 28 cm)

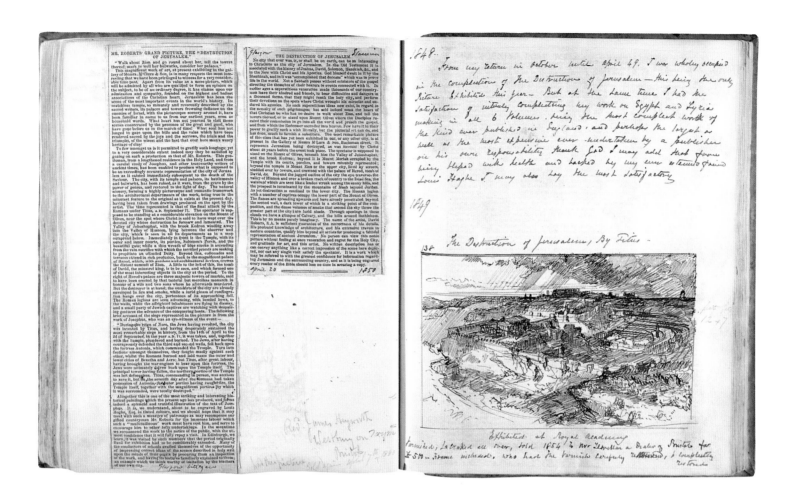

137 David Roberts (1796–1864)

Pages 125v–126r, showing sketch of Roberts's painting
Destruction of Jerusalem by Titus, from vol. 1 of his
Record Books, 1817–64

Manuscript, in pen and ink, with newspaper clippings
Binding (closed): 9⅜ x 7⅝ in. (23.8 x 19.4 cm)

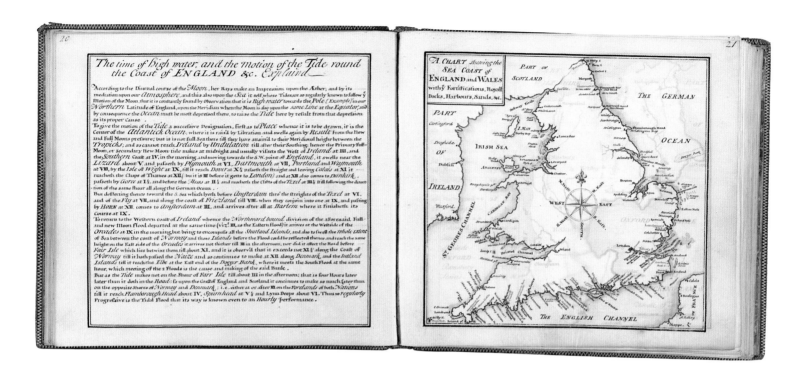

138 Thomas Badeslade (fl. 1712–42)

"A Chart Showing the Sea Coast of England and Wales,"
from *A Compleat Sett of Mapps of England and Wales in
General, and of Each County in Particular, Accurately
Projected in a New Method and All of Them Original
Drawings: Most Humbly Inscribed to His Majesty King
George by Francis Negus, Commissioner for Executing the
Master of the Horse to His Majesty,* 1724

Manuscript, in pen and ink and watercolor, on parchment
Binding (closed): 6⅝ x 7⅝ in. (16.9 x 19.4 cm)

139 **Sarah Sophia Banks (1744–1818)**

"Weighing a Fish after a Haul," by William Brand,
from vol. 1 of *Sir Joseph Banks's Fishery Book of the River
Witham in Lincolnshire*, 1784–96, 2 vols.

Manuscript, in pen and ink, with gouache and watercolor
Binding (closed): 8⅜ x 5⁵⁄₁₆ in. (21.2 x 13.4 cm)

140 A. Cooper

"Bishop's Wood," from

Journal of a Tour Down the Wye, 1786

Manuscript, in pen and ink, with watercolor
Binding (closed): 10⁹⁄₁₆ x 8⅜ in. (26.8 x 21.2 cm)

141 **Samuel Ireland (d. 1800)**

"Hop Ground near Maidstone, 1791," bound in *Picturesque Views, on the River Medway, from the Nore to the Vicinity of its Source in Sussex: with Observations on the Public Buildings and other Works of Art in its Neighbourhood,* London, T. and J. Egerton, 1793

Watercolor and graphite, with pen and ink
Binding (closed): 13⁹⁄₁₆ x 9⅞ in. (34.4 x 25 cm)

Hop ground near Maidstone. 1791.

142 Richard Colt Hoare (1758-1838)

"Tintern Abbey," bound in vol. 2 of *Historical Tour Through Monmouthshire*, by William Coxe (1747–1828), London, T. Cadell, 1801

Watercolor, with pen and ink and graphite
Binding (closed): 21¾ x 15⅜ in. (55.2 x 39 cm)

143 **William Caxton (ca. 1422–91)**
Leaves C5v–C6r from *Hier begynneth the book callid the myrrour of the worlde*, Westminster, William Caxton, 1481

Letterpress, with woodcuts
Binding (closed): 11½ x 8¼ in. (29.2 x 21 cm)

Thou art a squyer and he is a knyght
But god forbede for his blysful myght
But a clerk coude do as gentyl a dede
As wel as ony of you it is no drede
Syre I releee the thy thousande pounde
As now thou were cropen out of the grounde
Ne neuer or now ne haddist knowen me
For sire I wol not take a peny of the
For al my craft ne for al my trauaylle
Thou hast wel payde for my vytaylle
It is ynow farewel and haue good day
And tooke hys hors & forth he goth hys way
Lordynges thys question than axe I yow
Whyche was the most fre as thynkyth yow
Now telyth me er that ye further wende
I can nomore my tale is at an ende

Here endyth the frankeleyns tale
And folowyth the prologe of the wif of Bathe

Experience though none auctorite
Were in thys world is right ynow for me
To speke of woo that is in mariage
For lordis syn I twelue yere was of age
Thanked be god that is eternal alyue
Husbondis at the cherche dore haue I had fyue
If I so ofte myght haue weddid be
And alle were worthy men in her degre
But me was told not longe a go ywys
That sith cryst wente neuer but onys
To weddynge in the Cane of galilee
That by the same ensaumpyl taught he me
That I ne weddid sholde be but onys
Lo herke a sharp worde for the nonys
Besyde a welle Jhesus god and man
Spak in repreef of the samaritan
Thou hast had fyue husbondis sayde he
And that ilke man that now hath the
Is not thy husbonde thus he sayd certeyn
What he mente therby I can not sayn
But that I aske why that the fyfth man
Was not husbonde to the samaritan
How many myght she haue in mariage
Yet herde I neuer tellen in myn age
Of thys noumbre very dyffynycioun
Men mowe deme and glose vp a doun
But wel I woot expresse wythouten lye
That god bad vs wexe and multiplye
That gentyl text can I wel vnderstonde
Eke wel I woot he sayd that myn husbonde
Sholde leue fader and moder and take to me
But of noumbre no mencion made he
Of bygamye or of Octogamye
Why sholde men speke of it velonye
Lo here the wyse kyng dan Salamon
I trow he hadde wyues mo than on
As wolde to god it leefful were to me
To haue refresshynge half so ofte as he

144 **Geoffrey Chaucer (ca. 1343–1400)**
Leaves q6v–q7r, with woodcut of the "Wife of Bath,"
from *The Canterbury Tales*, Westminster, William
Caxton, 1483

Letterpress, with woodcut
Binding (closed): 10 x 7⁵⁄₁₆ in. (25.4 x 18.5 cm)

145 **Sebastian Brant (1458–1521)**
Leaves I6v–K1r, with woodcut illustrating "Overbearing Pride," from *This present Boke named the Shyp of folys of the worlde was translated ī the college of saynt mary Otery in the counte of Devonshyre: out of Laten, Frenche, and Doche into Englysshe tonge*, London, Richarde Pynson, 1509

Letterpress, with woodcut
Binding (closed): 11⅜ x 8 in. (28.8 x 20.3 cm)

ODE VI.

IN CASSIVM SEVERVM.

QVID immerentes hofpites vexas,
canis,
Ignavus adverfum lupos?
Quin huc inanes, fi potes, ver-
tis minas,
Et me remorfurum petis?
Nam, qualis aut Moloffus, aut fulvus Lacon, 5
Amica vis paftoribus,
Agam per altas aure fublata nives,
Quæcunque praecedet fera.
Tu, cum timenda voce complefti nemus,
Projectum odoraris cibum. 10
Cave, cave: namque in malos afperrimus
Parata tollo cornua;

Qualis Lycambae fpretus infido gener,
Aut acer hoftis Bupalo.
An, fi quis atro dente me petiverit, 15
Inultus ut flebo puer?

146 Horace (65–8 BCE)

Pages 230–31 from vol. 1 of *Quinti Horatii Flacci Opera*,
London, John Pine, 1733–37

Engraving
Binding (closed): 9¼ x 6 in. (23.4 x 15.2 cm)

147 Henry Noel Humphreys (1810-79)
Pages 52 – [53] from *The Art of Illumination
and Missal Painting: A Guide to Modern Illuminators
Illustrated by a Series of Specimens*, London,
H. G. Bohn, 1849

Letterpress, with watercolor and gouache
Binding (closed): 7½ x 5⅜ in. (19 x 13.6 cm)

148 Geoffrey Chaucer (ca. 1343–1400)
Frontispiece and title page, with designs by
Edward Burne-Jones (1833–98) and William Morris
(1834–96), from *The Works of Geoffrey Chaucer*,
Hammersmith, Kelmscott Press, 1896

Letterpress, with wood engraving
Binding (closed): 17 1/16 x 12 in. (43.3 x 30.4 cm)

The tendre croppes, and the yonge sonne
Hath in the Ram his halfe cours yronne,
And smale foweles maken melodye,
That slepen al the nyght with open eye,
So priketh hem nature in hir corages;
Thanne longen folk to goon on pilgrimages,
And palmeres for to seken straunge strondes,
To ferne halwes, kowthe in sondry londes;
And specially, from every shires ende
Of Engelond, to Caunterbury they wende,
The hooly blisful martir for to seke,
That hem hath holpen whan that they were
seeke.

BIFIL that in that seson on a day,
In Southwerk at the Tabard as
I lay,
Redy to wenden on my pilgrym-
age
To Caunterbury with ful devout

THAT Aprille with his shoures soote
The droghte of March hath perced to the roote,
And bathed every veyne in swich licour,
Of which vertu engendred is the flour;
Whan Zephirus eek with his swete breeth
Inspired hath in every holt and heeth

corage,
At nyght were come into that hostelrye
Wel nyne and twenty in a compaignye,
Of sondry folk, by aventure yfalle
In felaweshipe, and pilgrimes were they alle,
That toward Caunterbury wolden ryde.

Catalogue: Fine Arts

A NOTE TO THE READER
The first section of the catalogue (cat. nos. 1–116) comprises the fine arts: drawings, watercolors, paintings, and sculpture.

AUTHORS

CA Cassandra Albinson
LF Lisa Ford
GF Gillian Forrester
MH Matthew Hargraves
EH Eleanor Hughes
JMA Julia Marciari Alexander
MO Morna O'Neill
SR Stéphane Roy
AT Angus Trumble
SW Scott Wilcox

Jacques Le Moyne de Morgues (ca. 1533–88)

Jacques Le Moyne de Morgues, a French Huguenot artist, achieved new fame in the nineteenth and twentieth centuries as an early modern botanical and ethnographical artist. His earliest known works were a set of drawings, now lost, of the Timucuan Indians, done for the 1564–65 expedition to Florida led by René Goulaine de Laudonnière. Le Moyne was enlisted to draw maps of the coast, the towns, and topography, as well as native dwellings and other features of interest. His personal narrative of the ill-starred expedition, which included a rebellion against Laudonnière's leadership, near starvation, the massacre of the French forces by the Spanish, and Le Moyne's escape and return to France, forms a lively, and at times harrowing, story.

Richard Hakluyt mentioned Le Moyne's Florida drawings, which were supplemented by observations on the Timucuan Indians, in the introduction to the 1587 English translation of Laudonnière's account of his voyages. Theodor de Bry later acquired some of Le Moyne's drawings, engravings of which appeared in his edition of Thomas Hariot's *Briefe and True Report of the New Found Land of Virginia*.

Le Moyne moved to England circa 1580, "for religion," and lived in St. Anne's parish in Blackfriars with his wife, Jeane, until his death. During this period he added "de Morgues" to his name, and the inscription "de morogues" on one of his botanical watercolors is presumed to be his autograph. He acquired important patrons such as Sir Walter Raleigh, who funded the publication of his Florida narrative, and Lady Mary Sidney, mother of Philip Sidney, to whom he dedicated *La Clef des champs*, an herbal he published in 1586. *La Clef* includes many images that correspond to an album of more than fifty beautifully colored drawings of plants and insects, attributed to Le Moyne in 1922. Since then, nearly one hundred further botanical drawings have been attributed to Le Moyne, though some of his drawings continue as the object of debate.

Selected Literature: Bennett, 1968; Hulton, 1977; Le Moyne de Morgues, 1984. LF

1

A Young Daughter of the Picts, ca. 1585
Watercolor and gouache, touched with gold, on parchment; 10 ¼ x 7 ⁵⁄₁₆ in. (26 x 18.6 cm)

PROVENANCE: F. G. Huth, sold, Sotheby's, 6 July 1967 (12); H. P. Kraus; bt Paul Mellon, 1968
SELECTED EXHIBITIONS: PML, *English Drawings*, 1972, no. 1; YCBA, *Wilde Americk*, 2001, no. 31
B1981.25.2646

This colorful miniature apparently served as the model for an engraving for plate III of the section on Picts and ancient Britons in Theodor de Bry's publication of Thomas Hariot's *Briefe and True Report of the New Found Land of Virginia*, published in 1590 (see cat. 123).

Originally attributed to the artist John White, whose drawings from the Virginia expedition were also featured in the de Bry volume, *Young Daughter* was not reattributed to Le Moyne until after its acquisition by Paul Mellon in 1967. The Pictish illustrations were intended to remind readers that early natives of the British Isles existed in a savage state similar to natives in the Americas.

Young Daughter was the second miniature attributed to Le Moyne from his drawings of early indigenous peoples, most of which are now known only through engravings. The first miniature identified as his work, and the only one from Le Moyne's drawings of Timucuan Indians, is *Laudonnière and King Athore*, which was featured in part 2 of de Bry's *America* and is in the James Hazen Hyde collection of the New York Public Library.

The drawing is a harmonious embodiment of Le Moyne's two known subject areas, ethnological drawings and botanicals. The colorfully ornamented body of the young woman, with her high waist, full thighs, and long hair rippling in waves to her hips, evokes his drawings of the Timucuan women, who also tattooed their bodies through a process Le Moyne describes in his Florida observations. Her botanical tattoos, such as the cornflowers on her waist and wrists, and the heartsease on her waist, calves, and hips, also bear comparison with Le Moyne's existing botanical illustrations. In addition, Le Moyne decorates her with species newly introduced to Western Europe, thus signaling his botanical sensibilities and knowledge, though rendering her slightly anachronistic. LF

Nicholas Hilliard (1547[?]–1619)

Nicholas Hilliard, miniature painter and goldsmith, was born into a family of goldsmiths in Exeter. He in turn was apprenticed to the London goldsmith and jeweler Robert Brandon, whose clients included Queen Elizabeth. Hilliard completed his apprenticeship in 1569 and quickly acquired steady work at court, but his fame grew as a limner rather than a jeweler. His first miniature of Queen Elizabeth is dated 1572. By 1584, he was apparently the primary limner to the queen and that same year received a coveted commission to design the new Great Seal.

There is no evidence that Hilliard had any formal training as an artist. In his work *A treatise concerning the arte of limning*, Hilliard mentions Dürer and Holbein as influences and states: "Holbeans maner of Limning I haue euer Imitated, and howld it for the best" (Hilliard, *Arte of Limning*, p. 68). During his years in London, Hilliard had ample opportunity to examine Holbein's miniatures as well as those of Lucas Hornebolte and Levina Teerlinc, limners working in or around the Tudor court, the latter of which may have given Hilliard advice or instruction. Hilliard himself took several pupils, including Isaac Oliver, whose pattern miniature of Robert Devereux, 2nd Earl of Essex, is also in the Center's collection.

Despite his royal patronage, Hilliard struggled financially, owing to the meager sums given him by Elizabeth; even the annuity arranged for him by Robert Cecil, Lord Burghley, did not solve his problems. Nevertheless, on Elizabeth's death, Hilliard continued to serve James I as the King's Limner until his own death.

Selected Literature: Walpole, *Anecdotes of Painting*; Auerbach, 1961; Reynolds, 1971; Hilliard, *Arte of Limning*; Edmond, 1983; Stainton and White, 1987. LF

2

Portrait of a Lady, ca. 1605–10
Gouache on parchment laid onto card; 2 x 1 ¹¹⁄₁₆ in.
(5.1 x 4.3 cm), oval

PROVENANCE: Lady Isabella Scott; from whom
purchased by Horace Walpole, Strawberry Hill, sold,
10 May 1842 (15); bt 13th Earl of Derby, by descent
until 1971, sold, Christie's, 8 June 1971 (77); bt Fry;
bt Paul Mellon, 1971
SELECTED EXHIBITIONS: South Kensington, *Special
Exhibition*, 1862, no. 2221; South Kensington,
Portrait Miniatures, 1865, no. 1812; BFAC, *Portrait
Miniatures*, 1889, no. 1; V&A, *Hilliard and Oliver*,
1947, no. 97; RA, *British Portraits*, 1956–57, no. 633;
YCBA, *English Portrait Drawings*, 1979–80, no. 1; BM,
Drawing in England, 1987, no. 1
SELECTED LITERATURE: "The Earl of Derby's
Miniatures," 1958, pp. 44–46; Auerbach, 1961,
pp. 1–48; Hilliard, *Arte of Limning*; Murdoch,
Murrell, and Noon, 1981, pp. 62–68
B1974.2.51

The identities of both the sitter and artist for this mini-
ature, who were traditionally thought to be Elizabeth,
daughter of James I and later Queen of Bohemia, and
Isaac Oliver, respectively, were debated and revised in
the twentieth century. Graham Reynolds reattributed
the work to Nicholas Hilliard in 1947, a revision that
remains unchallenged, and Erna Auerbach unequivo-
cally stated that comparison of this portrait with those
authenticated as Princess Elizabeth make the original
identification unsupportable. The miniature of the
princess by Isaac Oliver, in the Center's collection, also
offers a markedly different image. Indeed, the brightly
colored gown, open stance, and flowing, seemingly
wind-tossed hair of the sitter give a life and vividness to
the work that differs markedly from most other minia-
tures identified as Princess Elizabeth, which show her
in stiff formal splendor, with her hair dressed high on
her head.

Reynolds places *Portrait of a Lady* among a
series of portraits of women with loose, flowing hair
done by Hilliard circa 1605–10, which both he and
Auerbach count as some of the artist's finest work in
his later years. This miniature, and the pattern minia-
ture of Robert Devereux, 2nd Earl of Essex, by
Hilliard's talented pupil Isaac Oliver (see cat. 3), both
passed from Horace Walpole's splendid collection to
that of the 13th Earl of Derby. LF

Isaac Oliver (ca. 1565–1617)

Isaac Oliver, miniature painter, was the son of a gold-
smith, Pierre Olivier, a French Huguenot refugee who
moved to London with his wife and young son circa
1568. Details of Oliver's early life are few, but Nicholas
Hilliard may have come to know the Oliver family
during Hilliard's childhood exile in Geneva a decade
earlier, an acquaintance that perhaps prompted the

young Isaac's apprenticeship to Hilliard. Oliver's
earliest known work, of an anonymous woman, is
dated 1587, when he was likely nearing the end of his
apprenticeship; by the mid-1590s he was his former
master's chief rival, a status confirmed by his appoint-
ment in 1605 as limner to Anne of Denmark, queen of
James I. His growing renown is suggested by a com-
mission from Robert Devereux, 2nd Earl of Essex, for
the unfinished pattern miniature now in the Center's
collection, of which numerous and variable copies
exist in modern collections. His second marriage, to
Sara Gheeraerts, also brought him into close contact
with the court painters John de Critz and Marcus
Gheeraerts the younger, whose full-length "Cádiz"
portrait of Essex set the pattern for many later depic-
tions of the earl. Although such connections undoubt-
edly helped establish him among the ranks of the
fashionable painters, Oliver's talent is unquestionable.
His varying styles of representation and aesthetics
range from classical motifs to purely late Elizabethan
court traditions, and he is credited with producing
works that respond directly to the sensibilities of his
sitters. His eldest son, Peter, also became an accom-
plished miniaturist and artist and is represented in the
Center's collection by several works, including a mini-
ature of Charles I when he was still Prince of Wales.

Selected Literature: Reynolds, 1971; Murdoch,
Murrell, and Noon, 1981; Edmond, 1983; *ODNB*. LF

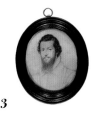

3

Robert Devereux, 2nd Earl of Essex, ca. 1596
Gouache and brush and gray ink on parchment laid
onto card; 2 ¹⁄₁₆ x 1 ¹¹⁄₁₆ in. (5.2 x 4.3 cm), oval

PROVENANCE: Sir Robert Worseley; Frances, Lady
Worseley; Horace Walpole, Strawberry Hill, sold,
10 May 1842 (45); bt 13th Earl of Derby, by descent
until 1971, sold, Christie's, 8 June 1971 (81); bt Fry;
bt Paul Mellon, 1971
SELECTED EXHIBITIONS: South Kensington, *Special
Exhibition*, 1862, no. 2227; South Kensington,
Portrait Miniatures, 1865, no. 1818; BFAC, *Portrait
Miniatures*, 1889, case 20, no. 7; YCBA, *English
Portrait Drawings*, 1979–80, no. 2; V&A, *Hilliard and
Oliver*, 1947, no. 150; Edinburgh, *British Portrait
Miniatures*, 1965, no. 27
SELECTED LITERATURE: "The Earl of Derby's
Miniatures," 1958, pp. 44–46; Auerbach, 1961, p. 6;
Reynolds, 1971; Strong, 1983, pp. 105–6
B1974.2.75

This portrait, likely done from life, of Robert Devereux,
2nd Earl of Essex (1566–1601), appears to have been
deliberately left unfinished. The painstaking execu-
tion of the face, hair, and beard and the shadowy
sketching of the upper body suggest that it was painted
as a pattern for replication. That its purpose was well
served is testified to by several existing versions in

museum and private collections, including the Royal
Collection, the Victoria and Albert Museum, London,
and the National Portrait Gallery, London.

It is not surprising that the Earl of Essex com-
missioned such a work. Essex's ambitions centered
on renown as a soldier and leader in the Protestant
cause and as a spiritual successor to Sir Philip Sidney.
Elizabeth's favor brought him into court circles after
1587 as master of the horse and her preferred com-
panion. His insistence on pursuing his ideals, how-
ever, often in defiance of politic behavior, brought
Essex into disfavor with the queen more than once,
and his ambitions to rival the Cecil family in political
leadership also created tensions. In these struggles,
Essex frequently utilized the public forum to circulate
his ideas and strengthen his position, issuing printed
and manuscript propaganda. His portraits, over his
lifetime, also suggest the conscious molding of an
image of strength and prowess, and later of states-
manlike qualities. At approximately the time Oliver
created this miniature, Essex was seeking to become
Elizabeth's chief councillor, the better to promote the
cause of Protestant war. The dating of the miniature
to a time when Essex was still promoting his triumph
over the Spanish in the Cádiz expedition and before
his fall from grace in 1598 is suggested by his distinc-
tive beard, which features in Marcus Gheeraerts's
Cádiz portrait, and the ribbon of the garter, combined
with a sober doublet and fancy collar. Such a combi-
nation reminds the viewer of the earl's martial leader-
ship, while presenting a somber yet courtly mien and
dress suitable to a political leader. LF

Wenceslaus Hollar (1607[?]–77)

Wenceslaus Hollar was originally intended by his
family to study law, but his own inclination was
toward drawing, and in his early twenties he was
apprenticed to Matthäus Merian the elder, a noted
cartographic engraver in Frankfurt. He became profi-
cient at perspective views; allegedly, his prospect of
the city of Prague brought him to the attention of the
Earl of Arundel in 1636, when that nobleman was
traveling through Cologne on an embassy to Emperor
Ferdinand II, and "being pleas'd with his Drawings
and Representation of those Towns he had an
Intention to visit in his Embassy, he took him along
with him" (Vertue, 1745, p. 123). Hollar returned to
England with Arundel and began a lengthy career
of recording Arundel's impressive art collection,
engraving portraits, and producing views of London
and its buildings, including the *Long View of London
from Bankside*.

The Earl of Arundel fled England for Flanders
during the Civil War, whereas Hollar enlisted with the
royal army, was captured, and became a prisoner of war.
After escaping, Hollar joined Arundel in Antwerp
and continued his work on the art collection.

Arundel died in 1646, and Hollar remained in
Antwerp. Vertue writes that Hollar, never sufficiently
well off to publish independently or support himself,
always worked for print sellers or publishers. He
returned to England by 1652, seeking better opportu-
nities, and produced engravings for Dugdale's volumes
on St. Paul's and Warwickshire. He profited little
from his apparently enormous output (Pennington's
catalogue lists nearly two thousand items) and was

Wenceslaus Hollar
Samuel Cooper
Thomas Wyck
Willem van de Velde the Elder

said to be so poor in his last days that he had to beg his creditors not to take his bed until after he had died. Hollar's widow sold many of his works to the collector and physician Sir Hans Sloane.

Selected Literature: Vertue, 1745; Hind, 1922; Pennington, 1982; Tindall, 2002. LF

4

View of Steiereck on the Danube, ca. 1636
Pen and brown ink and blue-gray wash on laid paper;
3 $^{15}/_{16}$ x 9 ¼ in. (10 x 23.5 cm)

PROVENANCE: George Salting; Sir Harry Baldwin; John Baskett, 1970; bt Paul Mellon, 1970
SELECTED EXHIBITIONS: PML, *English Drawings,* 1972, no. 5
SELECTED LITERATURE: Griffiths and Kesnerova, 1983; Godfrey, 1994
B1977.14.4146

This tranquil scene was drawn in 1636 when Hollar was traveling with the Earl of Arundel's embassy to the imperial court of Ferdinand II. Steiereck, now called Steyregg, is a few miles east of Linz, on the Danube, en route to Vienna. The barges in the foreground flying the flag of St. George, which are featured in many of Hollar's drawings of the journey, are part of the English ambassador's flotilla.

Hollar's drawings of the Arundel embassy trip cover more than one hundred sheets. These drawings may have been intended as illustrations for the journal published by William Crowe, Arundel's secretary, recounting the embassy's travels, but they were not included in the 1637 publication. Hollar is here serving as an expedition artist, as he did again much later when he was appointed by Charles II to go to Tangiers with Lord Henry Howard to take views of the town and fortifications. In a letter to Charles requesting an appointment for this expedition, Hollar signed himself "his Majesties Scenographer." LF

5

View of the East Part of Southwark, Looking Towards Greenwich, ca. 1638
Pen with black and brown ink over graphite on laid paper, with an additional strip at right, added by the artist; 5 ⅝ x 12 ⅛ in. (14.3 x 30.8 cm)

PROVENANCE: J. A. Williams; Patrick Allan Fraser, sold, Sotheby's, 10 June 1931 (147[?]); Iolo A. Williams; Colnaghi, 1964; bt Paul Mellon, 1964
SELECTED EXHIBITIONS: Colnaghi-Yale, *English*

Drawings, 1964–65, no. 2; YCBA, *English Landscape,* 1977, no. 2; YCBA, *Gilded Scenes,* 1985, p. 52; BM, *Drawing in England,* 1987, no. 68; YCBA, *Hollar,* 1994, no. 63
SELECTED LITERATURE: Vertue, 1745, pp. 121–36; Hind, 1922, pp. 44–47; Pennington, 1982, pp. 175–76; Tindall, 2002
B1977.14.4664

This view looking east across the roofs of Southwark, toward a faintly penciled background suggesting the distant environs of Greenwich and Eltham, was a study for Hollar's *Long View of London from Bankside,* published in 1647 in Antwerp. The jumble of London houses is punctuated by the square tower of St. Olave's Church, on the left, and a similar, smaller tower to the right, identified as St. George's, Southwark. The bend in the Thames toward Greenwich is filled with boats, while the Tower of London is roughly sketched in pencil on the opposite bank.

This study was for sheets 6 and 7, the right-hand sections of the *Long View.* The Center's collection also includes the study for sheets 2 and 3, *A View from St. Mary's, Southwark, Looking Towards Westminster.* Hollar apparently made these sketches before fleeing England for Antwerp in 1644 and used them as the basis for the engraving he produced there. A. M. Hind speculated that the present study was done from the tower of St. Mary Overie (now Southwark Cathedral), the location named in the title of the study for sheets 2 and 3. Working from this sketch, Hollar depicts a markedly different perspective in the final engraving, in which the viewpoint swings sharply to the left, looking more directly toward the Tower of London and eliminating the view toward Eltham and the top of the Thames bend. The construction of St. Olave's Church tower also changes in the engraving, to a centered cupola and two sets of windows. LF

Samuel Cooper (1607/8–72)

Samuel Cooper was arguably the most talented painter working in England during the Interregnum. The details of his life before 1642, the date of his first signed works, are fragmentary; his early biographers, Richard Graham and Bainbrigg Buckeridge, report that from a young age he lived and trained with his uncle, the renowned miniaturist John Hoskins the elder, who worked successfully at the court of James I and his son Charles I (Graham, 1695, p. 338, and Buckeridge, 1706, p. 409). Apparently working for a broad clientele from around 1635, Cooper's reputation for excellent craftsmanship and personal charm—he was reported to be a talented linguist and lutenist (Vertue, *Note Books,* vol. 2, p. 130)—led him to have steady employment throughout the years of the Civil War and Interregnum. His sketch from life of Oliver Cromwell (in the collection of the Duke of Buccleuch) served as the model for the Protector's most famous portraits, but, unlike those works that took it as a model, and despite its small size, Cooper's sketch is certainly among the most insightful portraits of the seventeenth century.

As was the case for most of the best painters working in England during the turbulent 1640s and 1650s, Samuel Cooper immediately found himself inundated with commissions at court after the Restoration of Charles II in 1660. He was appointed King's Limner in 1663. Although his portraits of Charles II and his brother, James, Duke of York (later James II), are not among his

best, many of his portraits from the first decade of the Restoration sensitively capture not only the particular allure of his sitters' beauty but also the outright glamour of the hard-edged world that was the Restoration court. By his death in 1672, Cooper, "commonly stil'd Vandyck in little" (Buckeridge, 1706, p. 409), had gained international fame as a portrait painter, and his works were actively sought after by foreign collectors and connoisseurs.

Selected Literature: Buckeridge, 1706, pp. 409–11; Graham, 1695, pp. 227–355; Foskett, 1974; Noon, 1979–80; *ODNB*. JMA

6

Charles Stuart, 3rd Duke of Richmond and 6th Duke of Lennox, ca. 1661–67
Gouache on parchment laid onto card;
2 11/16 x 2 3/16 in. (67 x 55 cm), oval
Signed, lower left: *SC* in monogram; verso of locket engraved: *Prince Rupert*

PROVENANCE: Colnaghi, 1971; bt Paul Mellon, 1971
SELECTED EXHIBITIONS: YCBA, *English Portrait Drawings*, 1979–80, no. 8
B1974.2.14

Cooper's talent for portraying likeness is supremely demonstrated in this exquisite miniature. Long misidentified, the sitter was correctly identified as Charles Stuart, 3rd Duke of Richmond and 6th Duke of Lennox (1639–72), by Patrick Noon (Noon, 1979–80, pp. 8–9). Noon recognized the close physical resemblance between the sitter in this work and that of Richmond in a full-length portrait painted by Sir Peter Lely (ca. 1661; North Carolina Museum of Art, Raleigh). Close—almost exact—correspondence between a number of Cooper miniatures and large-scale oil portraits by Lely strongly suggests that the two artists (who lived near each other in Covent Garden) collaborated after the mid-1650s. Although the precise nature of their artistic partnership remains uncertain, it seems most likely that Lely turned to Cooper's portraits—many of which remained unfinished in his studio until his death (they were probably used by the miniaturist to make replicas)—in the creation of his full-scale oil portraits. In fact, among these unfinished works in his studio was a portrait of Richmond with "the face finished and the rest in sketch only" (Foskett, 1974, pp. 63–65). The present miniature, fully finished and signed in monogram, is certainly not that referred to above, but it may be a replica of this lost unfinished work.

Painted probably around 1661, when Richmond was made Gentleman of the Bedchamber and Knight of the Order of the Garter, this portrait depicts him at the height of his career at court. Unfortunately, he did not live up to his political or military promise and is mainly remembered for his profligate love affairs. In 1667 he eloped with Frances Teresa Stuart

(1647/8–1702), a choice of bride that proved perilous. His elopement with the well-known object of the king's—apparently unrequited—desire led to the couple's immediate banishment from court; they were allowed to return only after she recovered from a near-fatal case of smallpox. Notorious for his dissolute lifestyle, Richmond died in 1672, at the age of thirty-three, leaving his beautiful bride with a vast fortune and her freedom. JMA

Thomas Wyck (1616[?]–77)
Thomas Wyck (Wijck) was born near Haarlem, but the exact date of his birth remains uncertain. A pupil of Pieter van Laer (known to Italians as Il Bamboccio and famous for his painting of everyday life), Wyck traveled to Italy around 1640, visiting Rome and presumably Naples. In 1642 he returned to the Netherlands, where he enrolled in Haarlem's Guild of St. Luke. In the following years, he painted landscapes with a definite Italianate touch, drawing on his Roman and Neapolitan visual repertoire. He traveled to England in 1663. During his stay in the English capital, he painted mostly views of London from the Thames. Wyck's arrival in the city, a few years before the Great Fire of 1666, could not have happened at a more auspicious time; as a landscape artist, he recorded views of a bustling and changing metropolis. In his *Anecdotes of Painting in England*, Horace Walpole (following George Vertue) mentions that Lord Burlington had from Wyck "a long prospect of London and the Thames, taken from Southwark, before the fire, and exhibiting the great mansions of the nobility then on the Strand" (Walpole, *Anecdotes of Painting*, vol. 3, p. 143); Vertue considered this view one of the best he knew (Vertue, *Note Books*, vol. 5, p. 43). In the 1670s, Wyck appears to have regularly traveled between London and Haarlem, where he died in 1677. He was survived by his son, Jan Wyck, an artist well-respected in England.

Selected Literature: Walpole, *Anecdotes of Painting*, vol. 3, pp. 142–43; Grant, 1957–61, vol. 1, p. 46; *Dictionary of Art*. SR

7

View of the Waterhouse and Old St. Paul's, London, ca. 1663
Gray wash and graphite on two joined sheets of laid paper; 9 x 13 1/2 in. (22.9 x 34.3 cm)

PROVENANCE: Horace Walpole [?]; Dr. H. Wellesley [?]; Gardner; Major Sir Edward Feetham Coates; Lady Celia Milnes Coates, sold, Christie's, 23 Nov. 1971 (137); John Baskett; bt Paul Mellon, 1971
SELECTED EXHIBITIONS: PML, *English Drawings*, 1972, no. 7; YCBA, *English Landscape*, 1977, no. 5
B1975.4.1446

The present drawing, believed to have been in Horace Walpole's collection at Strawberry Hill, was made shortly after Wyck's arrival in London in 1663 (the pagoda-shaped water house shown here was demolished in 1664). In the distance, at the right of the composition, is Old St. Paul's, which would soon be consumed in the Great Fire of 1666. Wyck's use of gray wash, a technique he is credited with popularizing—if not introducing—among English artists, gives this view contrasts and shadows.

Wyck's English compositions, like those of Claesz Janz. Visscher and Wenceslaus Hollar, are witness to a changing urban landscape. Apart from their own artistic merits and aesthetic qualities, these works have historical significance. Wyck has recorded vistas of a city that was undergoing—or about to see—major transformations. The Great Fire was a defining moment for all Londoners, artists included: for those fortunate enough to have been spared its destruction, the event gave a temporal standpoint from which it became possible to designate a *before* and *after* cityscape. Wyck's particular interest in this event and its aftermath is demonstrated by several of his works, such as a *View of London Before the Great Fire* (collection of the Duke of Devonshire), a drawing showing the Newgate Prison surrounded by plumes of smoke (Paul Mellon Collection, YCBA), and sketches depicting the Ruins of Old St Paul's (Wakefield Collection and Bodleian Library). SR

Willem van de Velde the Elder (1611–93)
Willem van de Velde was primarily a draftsman, best known for his highly detailed and precise *penschilderingen* ("paintings" drawn with pen and black pigment on a white ground). During the first and second Anglo-Dutch Wars, he frequently witnessed the movements and battles of the Dutch navy from a galliot, which was under orders to "take him ahead, astern or with the fleet or in such a manner as he may judge expedient for him to make his drawings" (Robinson, 1990, p. xiv). Van de Velde made thousands of these drawings "by way of journal," which he used as the basis for the penschilderingen.

In the winter of 1672–73, van de Velde immigrated to London, perhaps in response to the proclamation by Charles II inviting Dutch people to settle in England; it has been suggested that he did so to escape his estranged wife's lawyers or his mistress's husband. Whatever the reason, he left behind a country threatened by invasion from French troops by land and the English by sea and gripped by an economic depression that made finding patronage difficult.

In England, van de Velde and his son, also named Willem, were given the use of a large house and a studio in the Queen's House at Greenwich. In 1674 Charles II arranged a salary "of One Hundred pounds per annum unto William Vandeveld the elder for taking and making off Draughts of Sea Fights, and the like Salary of One Hundred pounds per annum unto William Vandeveld the younger for putting the said Draughts into Colours for Our particular use" (Robinson, 1990, p. xiv). In this manner, the van de Veldes produced paintings and tapestry designs of the battles of the Third Anglo-Dutch War, royal visits to the fleet, ship launches, and processions for the court, wealthy merchants, and naval patrons. Their work set the standard for subsequent maritime painting in Britain.

Willem van de Velde the Elder
Francis Barlow
Jan Siberechts
Jan Wyck

Selected Literature: Buckeridge, 1706, pp. 472–73; Robinson, 1958; Boymans-van Beuningen, 1979; Cordingly, 1982; Robinson, 1990. EH

8

Celebration on the Thames near Whitehall, 1685
Pen and brown ink, graphite and gray wash on two joined sheets of laid paper; 11 ⅛ x 17 ⅛ in. (28.3 x 44.1 cm)

PROVENANCE: Colnaghi, 1963; bt Paul Mellon, 1963
SELECTED EXHIBITIONS: Colnaghi, *English Drawings and Watercolours*, 1963, no. 26
B1986.29.496

The coronation of James II took place on 23 April 1685. Owing to "the wearisomeness that the Fatigue of those Glorious Processions and stately Ceremonies of the Coronations had bred in their Majesties," the fireworks display planned for that evening had to be postponed until the next day, when "between five and six [o'clock] London seem'd to have disembogued and emptied its Inhabitants into the Boats and on the Shoars of the Thames" (Lowman, 1685, p. 1).

This drawing is part of a series of four views showing the crowds of spectators gathering on the river and the decorated pontoon stationed opposite Whitehall Palace from which the fireworks were launched. The first view (now in the collection of the Boymans-van Beuningen Museum in Rotterdam) is inscribed "No. 1" and looks upstream; the third and fourth views (both numbered, in the Boymans-van Beuningen and National Maritime Museum, respectively) look downstream from a position farther upriver. In this drawing the dimensions, the cropping of the vessels on the far right, and the direction in which the oarsmen are rowing suggest that it was originally the left-hand panel of the second view (now in the collection of the National Maritime Museum), which is taken from directly opposite the pontoon, perhaps from Whitehall itself.

Celebration on the Thames demonstrates not only van de Velde's expertise in drawing various types of vessels, including ceremonial barges, wherries, and East India Company vessels (identifiable by their striped flags), but also his persuasiveness in depicting the human figure in miniature. EH

Francis Barlow (1626–1702/4)
Francis Barlow is among the first native British artists specializing in animal and sporting subjects, genres that in future years would be closely associated with British customs and culture. Little is known of Barlow's early life. He presumably studied under the portraitist William Shepherd (or Sheppard). Shortly after being given his freedom from the Painter-Stainers' Company (1649–50), he illustrated Edward Benlowe's *Theophila, Or Love Sacrificed, a Divine Poem* (1652). By 1656, at age thirty, Barlow is described as "the famous painter of fowle,

Beastes & Birds" by John Evelyn (*Diary*, 16 Feb. 1656). Barlow considered himself "no professed Graver or Etcher, but a Well-wisher to the Art of Painting," as he mentioned in his first major accomplishment, the publication of *Aesop's Fables, With His Life in English, French & Latin* (1666). As a draftsman, he produced many designs for book illustrations, some of which were engraved by eminent artists in this field, such as William Faithorne and Simon Gribelin. Wenceslaus Hollar, one of his most renowned contemporaries, etched Barlow's drawings for *Severall Wayes of Hunting, Hawking, and Fishing According to the English Manner* (1671). His best-known work was produced in connection with Richard Blome's *Gentleman's Recreation* (1686), a compendium on the various forms of sporting. Barlow's etchings enjoyed some popularity on the Continent (*Livre de plusieurs animaux inventez par Barlou*, Paris, Chez de Poilly, ca. 1670; *Nouvaux livre d'oyseaux dessinée au naturel*, Amsterdam, J. Gole, 17[??]) and into the eighteenth century, through the publications of Robert Sayer. Although he secured the patronage of a number of members of the aristocracy over his lifetime, Barlow nonetheless died a poor man (according to Vertue) in 1704. His *fortune critique* as the father of sporting art, however, is undeniable.

Selected Literature: Evelyn, *Diary*, vol. 3, p. 166–67; Vertue, *Note Books*, vol. 2, pp. 135–36; Walpole, *Anecdotes of Painting*, vol. 2, pp. 140–41; Shaw Sparrow, 1922, pp. 21–51; Hodnett, 1978; *Dictionary of Art; ODNB.* SR

9

Man Hunting with a Pointed Staff and a Hound, ca. 1645–50
Pen and brown ink on laid paper; 4 ¹¹⁄₁₆ x 6 ¹⁄₁₆ in. (11.9 x 15.4 cm)
Signed, lower right: *Franᶜ Barlow invent it*

PROVENANCE: T. E. Lowinsky; J. Lowinsky, to 1963; bt Paul Mellon, 1963
SELECTED EXHIBITIONS: BM, *Drawing in England*, 1987, no. 102
SELECTED LITERATURE: Ayrton, 1946, p. 21; Egerton and Snelgrove, 1978, p. 20, no. 2
B1977.14.4144

Many features of this drawing suggest that it was meant to be engraved. The cross-hatching and emphatic outlines are unmistakably reminiscent of preparatory sketches for the engraver. The expression "invent it" (from the Latin *invenit*, i.e., "has invented") specifically refers to the convention of prints as well. Judging from the vignette-like design of this drawing, similar in format and inspiration to an equestrian subject in the Blofeld collection (background lacking), this piece may have been destined to be part of a sourcebook or design manual for artists. The overly emphatic signature, with its exaggerated festooning, is perhaps indicative of a work produced in Barlow's early career. Indeed, comparison with *David*

Slaying the Lion (British Museum, London) suggests that the drawing dates to the late 1640s.

The exact subject of this composition is uncertain; the title was not given by the artist himself. It has sometimes been referred to as "otter hunting," although this has been convincingly contested (Egerton and Snelgrove, 1978, p. 20; Stainton and White, 1987, p. 142). Barlow designed an *Otter Hunting* (etched by Yeates) for Blome's compendium in which two-pointed prongs are used by hunters; furthermore, the hounds usually required for this type of hunting do not resemble those appearing in this sheet. SR

10

Hare Hunting, date unknown
Pen, brown ink and gray wash on laid paper;
6 ⅞ x 9 ⅞ in. (17.5 x 25.1 cm)

PROVENANCE: L. G. Duke; Colnaghi, 1961; bt Paul Mellon, 1961
SELECTED EXHIBITIONS: PML, *English Drawings*, 1972, no. 8; BM, *Drawing in England*, 1987, no. 109
SELECTED LITERATURE: Shaw Sparrow, 1933; Shaw Sparrow, 1936, p. 38; Macaulay, 1942, p. 27; Woodward, 1951, p. 48; Whinney and Millar, 1957, p. 279; Egerton and Snelgrove, 1978, pp. 19–20, no. 1
B2001.2.623

This drawing offers a salient contrast, both in technique and composition, to Barlow's *Man Hunting with a Pointed Staff and a Hound*. The use of wash gives this boisterous composition nuance and substance; its tonal gradations made it well suited for James Collins to make a mezzotint after this drawing. Barlow's distinctive penciling, with its nervous baroque delineations, aptly renders foliage and the animals' furriness. Equally distinctive is Barlow's staging of the action, where the whole surface is used. The artist's apparent reluctance to leave empty spaces often amounted, in many of his works, to an odd assemblage of birds and animals, as if one were contemplating a curiosity cabinet. Yet, in the present drawing, a great sense of coherence and movement emerges as the emphasis is given to the chase rather than to the catch; the action, hemmed in an imaginary Italianate landscape (distant ruins, bell tower, etc.), flows effortlessly from an enclosed woody space out to an open field.

Although undated, this drawing shares many features of one of Barlow's compositions for his Aesop's Fable 41, *The Hares and Storm* (1666). The rising heron is found elsewhere in Barlow's oeuvre (*Herons*, undated drawing, Tate, London; *Animals in landscape*, undated drawing, Ashmolean Museum, Oxford; *Hares and Storm*, undated drawing, British Museum, London). This motif demonstrates his skills at integrating drawings of birds and animals, done from life, into more formal compositions. SR

Jan Siberechts (1627–ca. 1703)

Jan Siberechts was among the earliest painters in Britain to look to the great estates of England for subject matter, and, indeed, Ellis Waterhouse claimed him as "the father of British landscape" (Waterhouse, 1994, p. 118). The son of a sculptor, Siberechts was born in Antwerp, where he trained and was made a master of the Guild of St. Luke in 1648. He spent his early career primarily as a painter of rural landscapes; in these works he largely conformed to the conventions of Flemish landscape painting but displayed his ability to capture the idiosyncrasies of place. According to early biographers, his talent attracted the eye of the English nobleman George Villiers, 2nd Duke of Buckingham, when the latter was sent by King Charles II on a diplomatic mission to the court of Louis XIV at Versailles in July 1670. At Buckingham's behest, the artist left the Continent and went to England (probably around 1672), where he worked on the painted interiors at Cliveden, the duke's country residence in Buckinghamshire (Buckeridge, 1706, p. 466; Walpole, *Anecdotes of Painting*, vol. 3, p. 102). Siberechts secured his fame in the wake of this first commission (the most famous painting from his English period is certainly his view of Longleat House, Wiltshire, from 1678, now in the Government Art Collection, UK). Often conforming to a conventional bird's-eye format, Siberechts's English works manage, nevertheless, to capture the vitality, individuality, and beauty of their subjects: the houses, estates, and interests—personal and political—of those for whom he painted.

Selected Literature: Buckeridge, 1706, p. 466; Fokker, 1931; Walpole, *Anecdotes of Painting*, vol. 3, p. 102; Waterhouse, 1994. JMA

11

Wollaton Hall and Park, Nottinghamshire, 1697
Oil on canvas; 75 ½ x 54 ½ in. (191.8 x 138.4 cm)
Signed and dated, lower left: *J. Siberechts 1697*

PROVENANCE: Sir Thomas Willoughby, 1st Baron Middleton, by descent to Mrs. H. L. Birkin; Sotheby's, 11 July 1962 (18); bt Colnaghi; bt Paul Mellon, 1962
SELECTED EXHIBITIONS: YCBA, *Pursuit of Happiness*, 1977, no. 136; YCBA, *Country Houses*, 1979, no. 3; AGNSW, *Eden*, 1998, no. 7; YCBA, *Great British Paintings*, 2001, no. 6
SELECTED LITERATURE: Harris, 1979, pp. 47, 74, no. 70; Friedman, 1989; Grindle, 1999, pp. 95–109
B1973.1.52

Wollaton Hall, built between 1580 and 1588 and one of the most spectacular achievements of Elizabethan architecture, was the primary country seat of the family of Sir Francis Willoughby (1546/7–96). Sir Francis commissioned Robert Smythson to create this show-

piece as a crown upon the very lands—rich in coal—that comprised the foundation of his family's fortune. One of his contemporaries remarked that Sir Francis had "out of ostentation to show his riches, built at vast charges a very stately house, both for the splendid appearance and curious workmanship of it" (Camden, 1695, p. 482). The most notable feature of Sir Francis's house was the "Prospect Room," located in the double-tiered central roof tower. Accessible only via dark narrow staircases in its corner walls, this capacious, light-filled room—with no designated function other than enjoyment—floated above the house and landscape and provided those inside with an unimpeded view of every aspect of the font and fruits of the Willoughby wealth (Friedman, 1989, pp. 149–51).

From his characteristic bird's-eye view, the painter surveys the magnificent house and extensive property and carefully depicts not only the glories of the Hall's unusual architecture—with its four-corner tower design, extensive tracery glazing, and raised Prospect Room—but also the daily workings and pleasures of life at Wollaton. Siberechts's patron, Sir Francis's great-great-grandson Sir Thomas Willoughby, 1st Baron Middleton, and his elder sister Cassandra, mistress of the house, made significant interior improvements to the Elizabethan structure, and Sir Thomas commissioned a number of views of the house and estate from the painter in the 1690s. Siberechts's portrait not surprisingly emphasizes these recent changes, including: the newly laid-out, fashionable formal gardens; the bleaching field; the garden of specimens planned and gathered together by Sir Thomas; the newly planted "wilderness"; and a neatly tended bowling green. A sumptuous record of place, this prospect is, most of all, a visual hymn to the harmonious accord of God, Nature, and Man found at Wollaton. JMA

Jan Wyck (ca. 1645/52–1700)

Born in Haarlem, Jan Wyck (or Wijck) was the son (and pupil) of Thomas Wyck. A marriage certificate suggests he was born circa 1645, but a mezzotint portrait by John Faber II (made after a painting by Sir Godfrey Kneller) sets his birth date on 29 October 1652. Sometime in the early 1670s, Wyck moved to England with his father. His presence in London is first recorded in June 1674, when he appeared before the court of the Painter-Stainers' Company in London and "vowed" to pay both his own and his father's quarterly fees (*ODNB*).

In his *Essay Towards an English School of Painting* published in 1706, Bainbrigg Buckeridge described Wyck as a "Dutch Battel-Painter of grate note" (George Vertue would later use the same words). He indeed painted a number of military scenes, such as the Battle of the Boyne and the Siege at Namur, works of sizable dimensions that displayed "a great deal of Fire," in the literal as well as the figurative sense (Buckeridge, 1706, pp. 479–80). According to Vertue, his talent was such that it may well have put an end to the career of his fellow battle painter Dirck Stoop (Vertue, *Note Books*). Wyck is perhaps best known today as a painter of landscapes, hunting scenes, and equestrian figures (a genre he popularized). His hunting pieces were "in grate Esteem among our Country-Gentry, for whom he often drew Horses and Dogs by the Life" (Buckeridge, 1706, p. 480). His achievement in this field earned

Jan Wyck
John Wootton
William Hogarth
Louis-François Roubiliac

him a commission, along with his famous contemporary Francis Barlow, for a series of drawings for Richard Blome's *Gentleman's Recreation* (London, 1686). Unlike his father, Jan Wyck apparently never returned to the Netherlands; he died in Mortlake in 1700. Among Wyck's probable pupils was John Wootton, whose work is sometimes reminiscent of his master's. Through Wootton, Wyck's legacy was carried forward well into the eighteenth century.

Selected Literature: Buckeridge, 1706; Vertue, *Note Books*, vol. 4, p. 152; Walpole, *Anecdotes of Painting*, vol. 3, pp. 143–44; *Dictionary of Art*; Gibson, 2000; *ODNB*. SR

12

Stag Hunt, date unknown
Brown wash with gouache on blue laid paper laid down on mount; 18 ¾ x 12 ⅞ in. (47.6 x 32.7 cm)

PROVENANCE: R. Willett, 1808, sold 1846[?]; William Esdaile; E. Horsman Coles; F. R. Meatyard; A. P. Oppé; A. and D. Oppé; S. Gahlin, 1965; bt Paul Mellon, 1965
SELECTED EXHIBITIONS: RA, *Paul Oppé Collection*, 1958, no. 410; BM, *Drawing in England*, 1987, no. 162
SELECTED LITERATURE: Egerton and Snelgrove, 1978, no. 3
B1977.14.4170

A vivacious chase swirling uphill, a lady riding side-saddle, the noble profile of the stag and the pursuing hounds: every element in *Stag Hunt* has been infused with elegance. This work epitomizes a shift occurring in the social practice of hunting. Whereas Francis Barlow depicts hunting mostly as a physical and strenuous activity, Wyck shows it as a fashionable pastime. In fact, the present scene may have less to do with "hunting" than with "sporting," associated with recreation and amusement. Sporting embodied politeness and refinement. It was believed that nobility could be attained through horsemanship, closely associated with the ancient glory of chivalry. Given that sporting required vast open spaces, the representation of landscape in works of art quickly became a pretext to show prosperity. Sporting scenes such as this one were also seen as a celebration of country life; for opulent residents of large seventeenth- and eighteenth-century metropolises, being able to live outside the city was perceived as beneficial to health and as a sign of wealth.

This composition is a fine example of Wyck's ability to merge the genres of landscape and hunting scenes. Unlike most sporting painters, as an author once judiciously observed, Wyck "contrived really to make pictures for the connoisseur without disappointing the sportsman" (Grant, 1957, p. 46). SR

John Wootton (ca. 1682–1764)

Born in Snitterfield, Warwickshire, John Wootton presumably studied with Jan Wyck. Both artists were patronized by the Beaufort and Coventry families. At Wyck's death, Wootton established himself in London, where he attained a great deal of respectability and success. Although he has since fallen into relative obscurity, Wootton was once a celebrated figure in the art world. His name is closely associated with the nascent professionalization of art-making in England: he was a subscriber to the newly founded Academy of Painting and Drawing in 1711 and elected a steward of the Virtuosi Club of St. Luke's in 1717.

Reflecting on Wootton's career, Horace Walpole said of the artist that he "was a very capital master in the branch of his profession to which he principally devoted himself, and by which he was peculiarly qualified to please in this country; I mean, by painting horses and dogs, which he both drew and coloured with consummate skill, fire and truth" (Walpole, *Anecdotes of Painting*, vol. 4, p. 58). Indeed he was steadily in unison with his patrons' social aspirations, traveling to their estates in the country, painting their property, horses, and hounds. As a result Wootton was never short of commissions. "In great vogue & favour with many persons of ye greatest quality" (Vertue, *Note Books*, vol. 3, p. 34), he was able to secure the patronage of eminent members of the aristocracy, among them Edward Harley, 2nd Earl of Oxford and noted patron of arts and letters. For Wootton, fame and wealth came hand in hand, and "by his assiduous application & the prudent management of his affairs rais'd his reputation & fortune to a great height" (Vertue, *Note Books*, vol. 3, p. 34). His talent in the field of animal portraiture was such that his horse portraits are said to have reached prices as high as those for human portraits by Sir Godfrey Kneller. Wootton, who was later admired by Edwin Landseer and A. J. Munnings (Shaw Sparrow, 1922, p. 90), is recognized as a pivotal figure in the history of English landscape and sporting scenes, two genres that he elevated to a new level.

Selected Literature: Vertue, *Note Books*, vol. 3, p. 34; Walpole, *Anecdotes of Painting*, vol. 4, pp. 158–59; Shaw Sparrow, 1922, pp. 89–113; Kendall, 1932–33; Deuchar, 1982; Meyer, 1984; *Dictionary of Art*; *ODNB*. SR

13

Hounds in a Landscape, date unknown
Gray wash with touches of pen and brown ink and crayon over graphite on laid paper; 8 ¾ x 8 in. (22.2 x 20.3 cm)

PROVENANCE: John Baskett, 1970; bt Paul Mellon, 1970
SELECTED EXHIBITIONS: PML, *English Drawings*, 1972, no. 12
SELECTED LITERATURE: Meyer, 1984, pp. 77–78; Allen and Dukelskaya, 1996, p. 166; Dukelskaya and Moore, 2002, pp. 299–300
B2001.2.1382

John Wootton excelled in classical landscapes and sporting scenes, some on canvases of large proportions. The present drawing, though modest in size, represents an important hunting subgenre for Wootton: group portraits of hounds. Early in his career, Wootton painted numerous pictures in which hounds took center stage and humans played little or no role; for instance, *Hounds and a Magpie* (ca. 1716, Hermitage), formerly in Sir Robert Walpole's collection, which was sold to Catherine the Great.

Stylistically, this drawing bears some resemblance to *Althorp Hounds and the Magpie* (collection of the Earl Spencer), a fact emphasized by the *trompe de chasse* (hunting horn) suspended from a branch. A painting in the Yale Center for British Art, *Releasing the Hounds* (ca. 1740–50, B2001.2.290), offers even more striking compositional correspondence. Although dissimilar in size and techniques, they complete each other in that they represent different stages of hunting ritual—a theme that Wootton fully exploited in a set of four hunting scenes, from the gathering prior to the hunt up to the kill, known today through engravings by Bernard Baron dated 1726. It is difficult, in the present case, to know with certainty if the scene takes place before or after the hunt (no spoil is shown). The hounds, as Wootton captured them, are at rest among themselves, almost as if they were interacting. While some of Wootton's studies denote a careful attention to hounds' morphology (see, for instance, a sketch attributed to Wootton in The Huntington Library, Art Collections, and Botanical Gardens, San Marino, Calif.), the artist seems here less concerned with physiological minutiae than with psychological perceptiveness. Wootton's masterly appreciation of canine pantomime, where postures and inflexions appear capable of conveying emotions, results in a very refined conversation piece. This makes Wootton a predecessor, in every respect, of George Stubbs's fine pictorial and psychological interpretation of animal character. SR

William Hogarth (1697–1764)

In the decades spanning the mid-eighteenth century, William Hogarth's activities as printmaker, painter, theorist, philanthropist, promoter of British art, and founder of an art academy touched on and expanded nearly every aspect of artistic enterprise and production. He was the son of a schoolmaster and author whose scheme to run a Latin-speaking coffeehouse landed the family in debtor's prison, an experience that would inform Hogarth's later subject matter and perhaps inspire his pugnacious self-assertiveness in the pursuit of financial independence.

Like other artists of his generation, Hogarth received very little formal training. He broke off his apprenticeship to the silver engraver Ellis Gamble in 1720 to set up his own shop, producing his first independent satirical print the following year. Hogarth initially made his name painting conversation pieces, group portraits displaying the private theater of polite society. In the 1730s he began publishing the engraved pictorial narratives he termed "modern moral subjects"; to protect them from piracy he initiated an act of Parliament that would vest artists with the copyright of engravings and prohibit unauthorized copies. In 1735 he founded an academy in St. Martin's Lane based on democratic principles in contrast to the rigidly hierarchical arrangement of continental academies. During the same decade he forged connections with a number of new charitable institutions for which he painted historical subjects allied to themes of charity and healing, in part to demonstrate the ability of British artists to produce works on a level with their European counterparts, and in part to elevate his own standing from caricaturist to "Comic History Painter." Toward the end of his career, increasingly embittered by the reception of his aesthetic treatise *The Analysis of Beauty* (1753) and of his further attempts at history painting, Hogarth became preoccupied with political and personal feuds.

Selected Literature: Paulson, 1971; Bindman, 1980; Paulson, 1992–93; Hogarth, *Analysis of Beauty*; Uglow, 1997; Hallett, 2001. EH

14

The Beggar's Opera, 1729
Oil on canvas; 23 ¼ x 30 in. (59 x 76 cm)
Signed and dated in lower right-hand corner:
Wm: Hogarth: Fecit: 1729

PROVENANCE: Painted for John Rich; bt by the 4th Duke of Leeds at the Rich sale, 1762, by descent to the 11th Duke of Leeds, sold, Sotheby's, 14 June 1961 (10); bt Agnew; bt Paul Mellon, 1962
SELECTED EXHIBITIONS: Grosvenor, *Centenary*, 1885, no. 25; Tate, *British Painting in the Eighteenth Century*, 1957–58, no. 28; Munich, *The Age of Rococo*, 1958, no. 96; VMFA, *Painting in England*, 1963, no. 213; RA, *Painting in England*, 1964–65, no. 22; VMFA, *Hogarth*, 1967, no. 6; NGA, *Hogarth*, 1971, no. 4; YCBA, *Among the Whores and Thieves*, 1997, no. 11; AGNSW, *Eden*, 1998, no. 8; YCBA, *Great British Paintings*, 2001, no. 7
SELECTED LITERATURE: Oppé, 1948, pp. 32–33; Antal, 1962, pp. 65–67; Paulson, 1971, vol. 1, pp. 180–95; Bindman, 1980, pp. 32–36; Walker, 1986, pp. 363–80; Uglow, 1997, pp. 136–42; Hallett, 2001, pp. 44–54
B1981.25.349

John Gay's ballad opera, with music arranged by Johann Pepusch, was first produced by John Rich at the Lincoln's Inn Fields Theatre in January 1728. *The Beggar's Opera* was an unprecedented success, running for sixty-two performances in its first season and inspiring the pun that it had made Rich gay, and Gay rich. With its English ballad interludes and its setting in London's criminal underworld, the play challenged the vogue for Italian opera that Hogarth had satirized in his earliest engravings.

Hogarth's painting depicts the climax of the play, set in Newgate Prison. Macheath, a gentlemanly highwayman bigamist, stands in chains at center stage. His two wives, Polly Peachum and Lucy Lockit, make appeals to their fathers, thieftaker and jailer, respectively, to perjure themselves in support of Macheath. Hogarth painted five versions of the scene; this is the last and marks the culmination of his rapid development as a painter.

The painting is set in an ambiguous space, part prison and part stage, which situates the interplay of reality and fiction suggested in the Latin motto that appears on the banner over the stage: "Veluti in speculum" (as in a mirror). The figures seated in boxes at the sides of the stage, occupying what were considered to be the best seats in the house, are recognizable portraits. Of particular note are John Gay, the shadowy figure at the foot of the staircase, and John Rich, standing immediately in front of Gay. In the foreground, Lavinia Fenton, the actress playing Polly Peachum, meets the gaze of the enthralled Lord Bolton; at the end of the season he would install her as his mistress, and they would remain together until his death in 1754.

The Beggar's Opera was Hogarth's first major success as a painter and set the stage thematically and compositionally for the modern moral subjects he would begin to produce in the following decade. EH

Louis-François Roubiliac (1695–1762)

The French expatriate Louis-François Roubiliac elevated sculpture in Britain much as Anthony Van Dyck permanently transformed the art of painting by his presence at court a hundred years earlier. Although Roubiliac's parents both came from merchant families in Lyons with good connections to the silk industry, went on to forge close links to the Huguenot community in London, and got married in 1735 in a Huguenot church, historians have proven remarkably reluctant to identify Roubiliac as a Huguenot, or indeed a Protestant. Having spent some time working in Dresden at the court of Augustus I, "the Strong," the elector-king of Saxony, by 1731 Roubiliac had abandoned what might have become a southward trajectory from a studentship at the Académie Royale in Paris to the Académie Française at the Villa Medici in Rome—the path that led from one to the other was well worn. Instead he settled permanently in London.

At first Roubiliac worked for the comparatively workmanlike sculptors Thomas Carter and Henry Cheere, moved rapidly through successive stages of subcontracting and collaboration, and finally established himself with an independent studio. His reputation was built on a series of fine, increasingly ambitious portrait busts and statues of "worthies," or great men of the age, including Sir Isaac Newton (1732, Royal Society, London), William Hogarth (ca. 1741, National Portrait Gallery, London), Francis Hayman, Alexander Pope (ca. 1750 and 1741, both Paul Mellon Collection, YCBA), and George Frederick Handel (ca. 1738, Victoria & Albert Museum, London)—a whole statue that was created for Jonathan Tyers's pleasure gardens at Vauxhall.

Larger, more prestigious, and more expensive church monuments grew out of Roubiliac's portrait practice, first at Worcester Cathedral—the tomb of Bishop John Hough (1744–47)—and then in Westminster Abbey, where Roubiliac raised a monument to John Campbell, 2nd Duke of Argyll, in 1749; to General George Wade the following year; and subsequently to Major-General James Fleming (1754) and Sir Peter Warren (1757), among other senior officers and veterans of the brutal Jacobite campaign of 1745.

Louis-François Roubiliac
Canaletto
Arthur Devis

Roubiliac's most important late works include a full-length, life-size marble sculpture of the Bard commissioned in 1757 by the actor-manager and playwright David Garrick for his "Grateful Temple to Shakespeare," and the tomb of Handel in Westminster Abbey.

Roubiliac, who apparently never lost his charming French accent, was personable, well-liked, and physically small: his friends called him "Little Roubiliac." Unlike Van Dyck, whose reputation never declined in subsequent periods, Roubiliac and his work went out of fashion during the period when Neoclassicism transformed, then dominated, the sculpture studios of London.

Selected Literature: Esdaile, 1928; Bindman and Baker, 1995; Baker, 2001; *ODNB*. AT

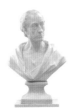

15

Alexander Pope, 1741
Marble, 24 ⅞ in. high (63 cm)
Signed and dated, beneath the right shoulder: *Anno Dom. MDCCXLI. L. F. Roubiliac Sc[ulp]it. ad vivum.* Inscribed, beneath the left shoulder: *ALEXr. POPE Nat[u]s. LONDINI, die 8°. junii anno MDCLXXXVIII [sic]. Obiit in vico Twickenham prope Urbem, die 8°. maii MDCCXLIV.*

PROVENANCE: Henry St. John, 1st Viscount Bolingbroke; Joseph Browne, Shepton Mallet, Somerset, bt James Bindley; "Mr. Sotheby," Wellington Street, 5 Mar. 1819 (243); Watson Taylor; Erlestone Mansion, Wiltshire, 24 July 1832, (163), bt Sir Robert Peel; sold with Peel heirlooms by Robinson & Fisher, 10–11 May 1900 (142); bt Thomas Agnew & Sons, for 5th Earl of Rosebery, by descent; sold, Sotheby's, 5 July 1990 (57); bt John Baskett; bt Paul Mellon, 1990
SELECTED EXHIBITIONS: BI, 1820, no. 45; V&A, *Rococo*, 1984, no. S5
SELECTED LITERATURE: Vertue, *Note Books*, vol. 3, p. 105; Esdaile, 1928, pp. 47–50; Wimsatt, 1965, pp. 244–47; Whinney, 1971, p. 218
B1993.27

The English poet, man of letters, satirist, wit, translator of Homer, and editor of Shakespeare, Alexander Pope (1688–1744) was one of the greatest figures of the Enlightenment. Largely self-educated, Pope was also one of the first English poets to generate a comfortable income from nondramatic writing. His brilliance was such that he came to dominate the world of English poetry and letters in the first half of the eighteenth century in a manner to which no subsequent poet could reasonably aspire or possibly emulate. The fluency and elegance of his poetic writing were matched by the originality and sharpness of his intellect. Pope was a Catholic, a friend of Jonathan Swift, a keen gardener, and a neighbor, at Twickenham, of the traveler and diarist Lady Mary Wortley Montagu.

Pope's fame was such that he was also one of the most frequently portrayed men of the age. Wimsatt catalogued more than sixty portraits, many of which exist in multiple versions, and still others reappear from time to time. There are portraits of Pope by Godfrey Kneller, Jonathan Richardson the elder, Jervas, Hoare of Bath, and Van Loo. And there are busts by Michael Rysbrack and four marble versions of the present work, which in due course spawned sets of four successfully marketed library busts of Shakespeare, Milton, Dryden, and Pope, based on the original terracotta modello (1738, Barber Institute of Arts at the University of Birmingham) by Louis-François Roubiliac.

This fine version, which was given to the Center by Paul Mellon, was possibly commissioned by the author, Tory politician, and diplomat Viscount Bolingbroke (1678–1751) and was subsequently owned by two prime ministers. It is not clear whether it was one of the two marble busts of Pope that were listed as "marble head" and "marble bust" in the sculptor's studio sale of 1762. The socle is modern. The other three versions are at Temple Newsam House, Leeds; the Fitzwilliam collection at Minton, Peterborough; and the Shipley Art Gallery, Gateshead. George Vertue thought Roubiliac's busts of "Mr. Pope more like than any other sculptor has done I think" (Vertue, *Note Books*), and Reynolds told Malone that the sculptor had described Pope's appearance during the sittings "as that of a person who had been much afflicted with the headache, and that he should have known the fact from the contracted appearance of the skin above the eyebrows, though he had not otherwise been apprized of it" (Wimsatt, 1965, p. 229). AT

Giovanni Antonio Canal, known as Canaletto (1697–1768)

The Venetian artist Giovanni Antonio Canal spent nearly ten years of his career working in England. Canaletto's fame was established in his native Venice, where his early views of that city combined limpid light effects, a mastery of perspective, and a unique style of rendering figures as a series of lively dots and dashes. English travelers on the Grand Tour were ravenous consumers of his work; many aristocratic families acquired major pictures (and sometimes sets of pictures). The War of Austrian Succession (1741), however, severely restricted the number of visitors to Venice and destroyed Canaletto's business. When his patrons could not reach him, Canaletto decided to go to them: he arrived in London in 1746. The artist was soon busy producing images of the metropolis and surrounding country houses. His vision defined topographical representations of town and country in England for the better part of a century, and his work was a major spur to native artists such as Samuel Scott and William Marlow.

Canaletto enjoyed great success in England, but his reputation began to flag near the end of his decade-long stay. William Hogarth's circle was hostile to foreign artists in England, and, as George Vertue recorded, there were whispered rumors that Canaletto's English pictures did not live up to those he had produced in Venice. Some even suggested that Canaletto employed studio assistants rather than painting pictures himself or that perhaps he was "not the veritable Canalletti of Venice" but rather an imposter (Vertue, *Note Books*, vol. 3, p. 149). In response to this criticism, Canaletto painted several pictures on speculation and displayed them in his studio for public viewing. Returning to Venice sometime in the mid-1750s, the artist resumed painting views of his native city. He died of fever in 1768.

Selected Literature: Constable, 1976; Liversidge and Farrington, 1993; Links, 1994; Beddington, 2006. CA

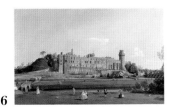

16

Warwick Castle, ca. 1748–49
Oil on canvas; 28 ½ x 47 ⁷⁄₁₆ in. (72.4 x 119.9 cm)

PROVENANCE: Commissioned by Francis Greville
(8th Baron Brooke, later 1st Earl of Warwick); his son,
George Greville, 2nd Earl of Warwick; Sir James
Peachy, 1st Baron Selsey, by descent; Frederick Bower,
sold, Christie's, 12 Feb. 1906 (50); bt Ashworth; Miss
F. Batty; 1929 Agnew; 1930, sold by Leggatt to John
Jacob Astor, 1930, by descent to 1980; sold to Samuel
T. Fee, through Agnew; bt Paul Mellon, 1985
SELECTED EXHIBITIONS: AGNSW, *Eden*, 1998, no. 23;
YCBA, *Canaletto*, 2006, no. 44
SELECTED LITERATURE: Constable, 1976, no. 444;
Jacques, 1979, pp. 474–76; Baetjer and Links, 1989,
pp. 11–12, 61, 238, 240, 242; Buttery, 1992; Links,
1994, p. 168
B1994.18.2

Warwick Castle is one of a pair of imaginary "before"
and "after" pictures commissioned by the wealthy
young aristocrat Francis Greville, Lord Brooke (the
other picture is in the Museo Thyssen-Bornemisza
Collection, Madrid). The exercise of creating these
two paintings drew on the talents of imaginative pro-
jection that Canaletto had honed in his *capricci*, or
fantastical representations of ruined buildings and
crumbling tombs.

When Lord Brooke returned from his Grand
Tour, he decided that Warwick Castle, his ancestoral
home, needed to be brought up to the standards of
the fashion of the eighteenth century. His first two
interventions, the gleaming white Gothic-style win-
dows on the second story of the castle and the new
Gothic porch on the left side of the building, are
clearly indicated in the Center's painting. Next to the
porch we see a listing lean-to shed with tools stacked
against it, an indication of the building site that
Warwick would soon become. Workers toil on the
beginning stages of the massive landscaping of the
castle park that Brooke had commissioned from
Lancelot "Capability" Brown, the renowned landscape
designer. In the Thyssen-Bornemisza picture this area
is shown planted with picturesque groupings of trees,
as the artist imagined it would appear after the imple-
mentation of Brown's design. The two pictures also
diverge in the depiction of Castle Meadow, the area in
the foreground crisscrossed by the river Avon. In the
Center's picture, elegant couples, gentlemen fishing,
and a nursemaid with an infant enjoy the meadow at
their leisure. The mill along the river and the young
boys scrambling over a fence in the right corner of the
painting are reminders of the intense relationship
between the town of Warwick and the castle. In the
Thyssen-Bornemisza picture the mill is gone,
replaced by a private pleasure barge, and the number
of figures on the lawn is truncated. The park of
Warwick Castle would be a private retreat rather than
a public promenade after Brooke's remodeling.
Canaletto's appealing paintings were instrumental in

this process of renovation and reimagination, and
Brooke commissioned a total of five paintings of
Warwick Castle from the artist. CA

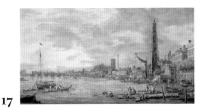

17

*The City of Westminster from near the York Water
Gate*, ca. 1746/47
Pen and brown ink with gray wash on laid paper;
15 ⅛ x 28 ⅛ in. (38.4 x 71.4 cm)

PROVENANCE: R. P. Roupell, sold, Christie's, 12 July
1887 (734); J. P. Heseltine, sold, Sotheby's, 28 May
1935 (136); bt Ellis & Smith; Montagu Bernard;
Colnaghi, 1961; bt Paul Mellon, 1961
SELECTED EXHIBITIONS: YCBA, *Sandby*, 1985, no. 9;
Birmingham, *Canaletto & England*, 1993–94, no. 18;
YCBA, *Line of Beauty*, 2001, no. 131; YCBA, *Canaletto*,
2006, no. 13
SELECTED LITERATURE: Constable, 1962, vol. 1,
pp. 94, 141; Kingzett, 1980–82, p. 54; Links, 1994,
p. 165
B1977.14.4630

Canaletto, who had primarily been known for his
paintings, began to devote himself seriously to drawing
and etching after the beginning of the War of Austrian
Succession. By the time he moved to London, in 1746,
his drawings were prized by collectors as works of art
in their own right.

Westminster Bridge, which can be seen in the left
background, was one of Canaletto's favorite motifs dur-
ing his time in London. Built between 1739 and 1750
(with construction delayed by the collapse of a pier in
1747), the bridge was in a much more advanced state of
completion at the time Canaletto was in London than
he indicates in this drawing. This inaccuracy hardly
seems to matter, however. Throughout his career
Canaletto had evinced an interest in portraying build-
ings and scenery at moments of change or accretion.
Here, the uncompleted Westminster Bridge functions
analogously to the fanciful ruins in his earlier
Venetian works. The picturesque qualities of the
foreground structures were clearly of equal interest to
him. The massive wooden water tower, crowned with
a finial, distributed water to outlying areas of London.
York Watergate (the marble structure at the foot of
the tower), fashioned to resemble a baroque temple,
was the riverside entrance to the gardens of the
demolished York House. In these forms, Canaletto
found buildings that echoed the campaniles and
canal-side churches of his native Venice. CA

Arthur Devis (1712–87)

Arthur Devis trained in the studio of the topographical
painter and portraitist Peter Tillemans, where he
learned the intricacies of glazes and gained practical
experience painting both figures and landscape. Along
with Hogarth, Devis was one of the earliest English
artists to specialize in the conversation piece. This
genre is defined as a group portrait of family members
or friends in either an interior or a landscape setting,
and it met a new demand on the part of gentry and
middle-class patrons for smaller, more informal pic-
tures. It is difficult to reconstruct a full picture of
Devis's career as a painter; no records from his studio
seem to have survived, and he did not begin to exhibit
his work until the age of forty-nine, when he showed
a painting at the Free Society of Artists in 1761.
When Lord John Cavendish learned that he was to
be painted by Devis he wrote, "I understand his
[Devis's] pictures are all of a sort: they are whole
lengths of about two feet long; and the person is
always represented in a genteel attitude, either leaning
against a pillar, or standing by a flowerpot, or leading
an Italian greyhound in a string, or in some other
such ingenious posture" (Waterhouse, 1994, p. 194).
However, despite his overdependence on etiquette
manuals for the postures of his sitters, Devis's formula
of stiffly posed figures represented in detailed cos-
tumes was immensely popular with members of the
Tory gentry, who saw their aspirations depicted in
Devis's careful compositions.

Selected Literature: D'Oench, 1979; D'Oench,
1980. CA

18

Mr. and Mrs. Hill, ca. 1750–51
Oil on canvas; 30 x 25 in. (76 x 63.5 cm)

PROVENANCE: Frank Partridge and Sons, 1957; Amyas
Phillips, Hitchin Ltd., by 1958; John Mitchell and
Sons, 1961; bt Paul Mellon, 1961
SELECTED EXHIBITIONS: VMFA, *Painting in England*,
1963, no. 229; RA, *Painting in England*, 1964–65,
no. 201; YUAG, *Painting in England*, 1965, no. 72;
YCBA, *The Conversation Piece*, 1980, no. 23
SELECTED LITERATURE: D'Oench, 1979, p. 94
B1981.25.226

Arthur Devis was the most prolific painter of conver-
sation pieces, having produced more than three hun-
dred in various standard sizes, such as this, mostly for
members of the largely Tory landed gentry and pro-
fessional classes. The genre did not appeal so much
to Whig grandees. Although he studied and perfected
many of the techniques of the Dutch Old Masters,
Devis was uneasy drawing from the live model, pos-
sibly because of his training as a miniature painter.
He relied on a small wooden lay figure or mannequin
that he kept in the studio and, when necessary,
dressed it in miniature costumes.

In this two-figure conversation piece, Mr. and Mrs. Hill pose in the corner of a room which, though sparsely decorated, contains a large oval Italianate landscape painting mounted as an overmantel and a Chinese vase in the fireplace—it must be summer. Seven exquisitely painted cups and saucers on the tea table indicate that five guests are expected, while Mr. Hill has placed his book (octavo) on the mantelpiece. His pose reflects nearly contemporaneous rules for gentlemen as set out in etiquette manuals. This does not necessarily suggest that Mr. Hill was trying especially hard, nor that Devis felt it necessary to underline the point. Nevertheless, Mr. Hill's right-angled feet, and the position of his hand in his waistcoat, are what François Nivelon's *Rudiments of Genteel Behavior* (1737) recommended.

It is tempting to identify the sitters as the Tory lawyer and eccentric George Hill (ca. 1716–1808) and his wife, Anna Barbara, daughter and heir of Thomas Medlycote of Cottingham, Northamptonshire. AT

Richard Wilson (1714–82)

The son of a Welsh clergyman, Richard Wilson was apprenticed to a minor London portrait painter, Thomas Wright, in 1729. Following his apprenticeship, Wilson worked mainly as a portraitist in London until his departure for Italy in 1750. According to Joseph Farington, who was the artist's pupil in the early 1760s, Wilson traveled to Italy to advance his career in portraiture. Encouraged by the landscape painters Francesco Zuccarelli and Claude-Joseph Vernet, however, he gave up portraiture for landscape. Established in Rome, Wilson sketched the Italian countryside and the remains of antiquity, painted views for Grand Tourists, and built a repertoire of Italian subjects on which he would draw for later landscape paintings. Leaving Rome in 1756, he made his way back to London by late 1757.

The decade of the 1760s was a period of professional and artistic success for Wilson. He was a founding member of the Society of Artists in 1760 and then joined the breakaway group that formed the Royal Academy in 1768. Although later criticized by Sir Joshua Reynolds (Reynolds, *Discourses*, pp. 255–56), Wilson's *Destruction of the Children of Niobe* (Paul Mellon Collection, YCBA), which was shown at the first Society of Artists exhibition in 1760, was a milestone in the creation of grand-manner historical landscape painting. His views of the classical landscape of Italy as well as his views of British scenery cast in the forms of classical landscape were popular and influential.

In the 1770s Wilson's popularity declined and his health deteriorated, exacerbated by a drinking problem. In 1776 he was given the sinecure of Royal Academy Librarian. In 1781 relatives took him back to Wales, where he died the following year. Although he ended his life in poverty and obscurity, Wilson's achievement was recognized by a later generation. In his lectures on the history of landscape painting in 1836, John Constable credited Wilson with "opening the way to the genuine principles of Landscape in England" (Leslie, 1843, p. 146).

Selected Literature: Constable, 1953; Solkin, 1982. SW

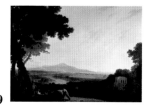

19

Rome from the Villa Madama, 1753
Oil on canvas; 37 ⁹⁄₁₆ x 52 ½ in. (95.4 x 132.4 cm)
Signed in monogram and dated lower left: *RW 1753*

PROVENANCE: 2nd Earl of Dartmouth, by descent to Lady Templemore; John Baskett; 1974; bt Paul Mellon, 1974
SELECTED EXHIBITIONS: Manchester, *Art Treasures*, 1857, no. 29; Birmingham, *Wilson*, 1948–49, no. 16; Munich, *Englische Malerei*, 1979–80, no. 92; YCBA, *Classic Ground*, 1981, no. 53; Tate, *Wilson*, 1982–83, no. 67; AGNSW, *Eden*, 1998, no. 24
SELECTED LITERATURE: Ford, 1952, pp. 311–12; Constable, 1953, p. 218
B1977.14.82

Rome from the Villa Madama is one of two oil paintings of Rome commissioned by William Legge, 2nd Earl of Dartmouth, who made the Grand Tour in 1752–53, during Wilson's sojourn there. The other is *Rome from the Janiculum* (Tate, London). In the Center's painting, the city is seen from the slopes of Monte Mario, to the north-west of Rome, traditionally the first view of the city seen by pilgrims arriving from the north. To the right, in shadow, is the loggia of the Villa Madama, built by Pope Clement VII from designs by Raphael.

Wilson's painting closely echoes a painting of the same view by Jan Frans van Bloemen, known as *l'Orizzonte*, whose importance as a model for Wilson's landscape painting in his early years in Rome has been pointed out by David Solkin (Solkin, 1982, pp. 184–85). Yet the more profound influence of Claude Lorrain is already much in evidence in the eloquent massing of forms and the subtle movement from areas of rich shadow into a luminous distance. While Wilson's later landscapes would show a more sensitive grasp of naturalistic detail and a more ambitious range of motifs and emotive effects, the Roman views he painted for Dartmouth and others during his stay in the city are unmatched in their coolly glowing light and sense of timeless tranquility. SW

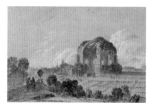

20

Temple of Minerva Medica, Rome, 1754
Black and white chalk on blue laid paper laid down on original mount; 11 ¼ x 16 ½ in. (28.6 x 41.9 cm)
Signed and dated in black chalk on mount, lower left: *R. Wilson f. 1754;* inscribed on mount in pen and brown ink, lower center: *T. of Minerva|Medica;* and in black chalk, lower right: *No. 19*

PROVENANCE: Drawn for 2nd Earl of Dartmouth, by descent to the 8th Earl; Agnew; bt Paul Mellon, 1961

SELECTED EXHIBITIONS: Birmingham, *Wilson*, 1948–49, no. 87; PML, *English Drawings*, 1972, no. 25; YCBA, *English Landscape*, 1977, no. 16; YCBA, *Classic Ground*, 1981, no. 73, YCBA, *Line of Beauty*, 2001, no. 98
SELECTED LITERATURE: Ford, 1948, p. 345; Ford, 1951, no. 55; Constable, 1953, no. 88b
B1977.14.4654

Over the course of his stay in Italy, Wilson developed into a draftsman of great subtlety and delicacy. One of the crowning achievements of his years there is the series of sixty-eight finished landscape drawings, which Lord Dartmouth commissioned from Wilson following his two oil paintings of Rome. Of the drawings, twenty-some are known today. The *Temple of Minerva Medica* is one of two from the set now in the Yale Center for British Art. Because of the statue of Minerva found within it, the fourth-century ruin was thought to be a temple to the goddess, though it is now believed to have been a nymphaeum, or fountain structure, in the Gardens of Licinius. The dome visible in Wilson's drawing collapsed in 1828. While Wilson's drawings for Dartmouth are topographical in that they depict actual views in Rome and its environs, his choice of media—black and white chalk on blue paper—reflects not the standard practice of the topographical draftsman, which would have been pen and ink with watercolor, but the techniques employed at the Académie Française in Rome, redolent of the traditions of Old Master drawing. sw

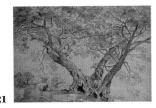

21

The Arbra Sacra on the Banks of Lake Nemi, ca. 1754–56
Black chalk with white chalk on gray laid paper; 15 ¼ x 22 in. (38.7 x 55.9 cm)
Collector's stamp of the Earl of Warwick, lower right (Lugt 2600)

PROVENANCE: George Guy, 4th Earl of Warwick; Mrs. Arthur Clifton; Agnew, 1964; bt Paul Mellon, 1964
SELECTED EXHIBITIONS: PML, *English Drawings*, 1972, no. 26; YCBA, *English Landscape*, 1977, no. 18; Munich, *Englische Malerei*, 1979–80, no. 104; Tate, *Wilson*, 1982–83, no. 52; YCBA, *Sandby*, 1985, no. 15; YCBA, *Line of Beauty*, 2001, no. 99
B1977.14.4655

Similar to the Dartmouth series in date and in the sensitivity of its draftsmanship is Wilson's drawing of a plane tree on the banks of Lake Nemi in the Alban Hills south of Rome. Known as the Speculum Dianae (Mirror of Diana), Lake Nemi was revered by eighteenth-century travelers for its association with the Roman goddess of the hunt. The tree in Wilson's drawing is presumably the one mentioned by his pupil Thomas Jones, when he visited Nemi in April 1778: "All went to make sketches about the Lake of

Nemi—particularly a large *Plane* tree call'd the Arbor Santa, which has a hollow within that I believe w'd contain about a dozen persons & I was told that my Old Master *Willson* when in this Country made use of it as a Study to paint in" (Jones, *Memoirs*, p. 58). sw

Alexander Cozens (ca. 1717–86)

Born in Russia to English émigrés, Alexander Cozens was sent to England for schooling at the age of ten and returned to live in Russia in the early 1740s. By 1746 he was in Rome, where in addition to sketching the city and studying its art, he networked with some of the leading artists of the day. On settling in London he found employment as a drawing master tutoring private pupils, ultimately holding an official position at Eton College from 1763. Between 1759 and his death he worked on at least five treatises on art, ranging from practical advice to ambitious explorations of aesthetics, though not all found their way into print. His pupil William Beckford admired his grand theories of nature and representation, calling him "almost as full of Systems as the Universe" (Oppé, 1952, p. 34). His pupils were discouraged from sketching nature and urged to produce compositions of ideal landscapes instead. Over time he developed a blot method to produce imaginary landscapes, a process that required laying fluid washes onto paper until a landscape slowly emerged in an almost accidental way. The technique was easily misunderstood and earned him the unfortunate nickname "dingy digit." This method was, however, used by his pupils as well as professionals such as Joseph Wright of Derby and John "Warwick" Smith. In his final years Cozens regularly stayed with Beckford at Fonthill, in Wiltshire, where he was described as "creeping about like a domestic Animal" (Oppé, 1952, p. 36). Beckford had reason to value his loyal "pet," for Cozens was acting as go-between in his illicit love affair with the young William Courtney, which would soon destroy Beckford's reputation (Mowl, 1998, p. 126). Cozens was dismissed as a charlatan after his death, and his work rapidly fell into obscurity. MH
Selected Literature: Sloan, 1986.

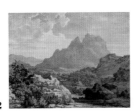

22

Mountainous Landscape, ca. 1780
Gray and brown wash on laid paper prepared with pale brown wash, laid down on a contemporary mount; 9 ½ x 12 ½ in. (24.1 x 31.8 cm)

PROVENANCE: John Baskett, 1971; bt Paul Mellon, 1971
SELECTED EXHIBITIONS: PML, *English Drawings*, 1972, no. 27; YCBA, *English Landscape*, 1977, no. 22; YCBA, *Cozens*, 1980, no. 23; YCBA, *Oil on Water*, 1986, no. 16; YCBA, *Line of Beauty*, 2001, no. 45
B1975.4.1480

In the 1770s Cozens developed a treatise on landscape painting titled *The Various Species of Landscape Composition, in Nature*. Although the text is lost, we know he intended to argue that landscape compositions could convey feelings and ideas simply through the arrangement of forms. According to this theory, ideal landscapes could carry serious moral messages of the kind traditionally reserved to history painting (Rosenthal, 1993, p. 20). Although *Mountainous Landscape* does not match any of the designs in *The Various Species*, it is a purely imaginary composition that contains various stock elements found in Cozens's classification of landscape scenery. The ideas Cozens associated with such landscapes could be esoteric, but here the barren mountain rising suddenly from a fertile plane evokes the awesome power of the sublime. He undoubtedly appreciated Edmund Burke's *Philosophical Enquiry into the Origin of Our Ideas of the Sublime and Beautiful* (1757), which had argued that viewing awesome prospects like mountains inspired a thrilling sense of terror; Cozens concurred, believing that mountain prospects inspired "surprise, terror, superstition, silence, melancholy, power, strength" (Sloan, 1986, p. 56). One of Cozens's pupils noted in 1781 that "he has for several years exhibited to the public, pictures of landscapes; attempting to perform them in the third degree of taste, that is the sublime" (unknown author, 1781, cited in Whitley, 1928, vol. 2, p. 319). The exclusion of color from Cozens's palette further distances this drawing from imitation of nature by forcing the viewer to focus on the landscape's formal properties. Similarly it is entirely devoid of human life, giving the landscape a universal significance rather than tying it to any particular time or place. Although Cozens earned a reputation as a blotter, his technique for finished drawings was a carefully controlled blend of fluid washes and hatched strokes, an approach perhaps influenced by the work of the English-based French engraver François Vivares (Wilton, *Cozens*, 1980, p. 9). MH

George Stubbs (1724–1806)

Although his achievements were prodigious, and his working life long and professionally rewarding, we know relatively little about George Stubbs. He was born in Liverpool, the son of a currier and leather seller. He was briefly a pupil or assistant to the local artist Hamlet Winstanley and copied pictures in the collection of the Earl of Derby at Knowsley Hall, near Liverpool. In the mid-1740s, Stubbs was established as a portrait painter in York but also undertook systematic anatomical dissections and provided illustrations for John Burton's *Essay Towards a Complete New System of Midwifery* (1751).

Stubbs went to Italy in 1754 and, on his return, retreated with his common-law wife Mary Spencer—he may have been married earlier (to a Miss Townly?)—to an isolated farmhouse at Horkstow in Lincolnshire, where he dissected horses and assembled meticulous drawings from which he planned to produce a volume of engravings. Largely on the basis of these drawings, from 1760, in London, Stubbs achieved success with portraits of thoroughbred racehorses and other sporting subjects that he executed for the prime minister, the Marquess of Rockingham, the Duke of Richmond, Lord Brooke, and their Whig racing associates.

In the mid-1760s, following the successful publication of his *The Anatomy of the Horse* (1766), Stubbs was elected to the committee of the Society of Artists, later serving also as treasurer (1769) and president (1772). During this period he was associated with the Scottish men of science and medicine William and John Hunter, for whom he executed a series of portraits of exotic animals, including the zebra (see cat. 23). He was elected an associate of the Royal Academy in 1780, and full membership followed the next year. His later years were occupied by large projects, first to document the history of the turf from 1750 in a series of paintings that were eventually exhibited at the Turf Gallery in 1794 and engraved by his son George Townly Stubbs. Finally, in 1795, Stubbs commenced work on his ambitious *Comparative Anatomical Exposition of the Structure of the Human Body with That of a Tiger and a Common Fowl* (see cats. 28–30). He died in 1806 at the age of eighty-one.

"Nobody suspects Mr. Stubs [*sic*] of painting anything but horses & lions, or dogs & tigers," wrote his business associate Josiah Wedgwood in 1780, not without sympathy (Tattersall, 1974, p. 118). Yet in his lifetime the horse was as much a problem for Stubbs's reputation as it was the cornerstone of his artistic practice. He did much to make it so. Although Stubbs was the Vesalius of the horse, a brilliant anatomist, and painted some of the greatest equine portraits that exist, within the rapidly evolving institutional framework of the London art world he had to fight to rise above the label of "horse painter."

Yet to some degree Stubbs's artistic reputation still remains comfortably mounted on horseback. His fondness for the exquisitely sensitive "horse-and-boy" rubbing-down subjects is a Houyhnhnm counterbalance to the Yahoo aspect of his remarkable "horse-and-lion" theme, to which he returned again and again after painting the first and largest version for the London dining room of Lord Rockingham (1765, Paul Mellon Collection, YCBA). That family of compositions, in which a horse is stalked, frightened, or attacked and devoured by a lion, has almost come to symbolize the totality of the Romantic imagination, or at least to evoke the latent violence of wild nature and the sublime.

Selected Literature: Egerton, 1976; Blake, 2005. AT

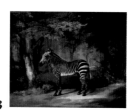

23

Zebra, 1762–63
Oil on canvas; 40 ½ x 50 ¼ in. (103 x 127.5 cm)

PROVENANCE: The artist's sale, 27 May 1807 (88); Sir Walter Gilbey, sold, Christie's, 25 May 1891 (348); bt Capt. M. Fitzgerald; Vokins; Sir Walter Gilbey, sold, Christie's, 12 Mar. 1910 (147); bt Agnew; W. Lockett Agnew, sold, Christie's, 15 June 1923 (58); bt Smith; S. Ben Simon, sold, Sotheby's, 16 May 1928 (130); bt Leggatt; Ackerman; A. K. Macomber; M. A. Hall; J. B. Donnelly, sold, Harrod's, 19 Oct. 1960 (278); Colnaghi; bt Paul Mellon, 1960

SELECTED EXHIBITIONS: SA, 1763 (121); VMFA, *Painting in England*, 1963 , no. 315; RA, *Painting in England*, 1964–65, no. 267; YUAG, *Painting in England*, 1965, no. 179; Tate, *Stubbs*, 1984–85, no. 77; AGNSW, *Eden*, 1998, no. 42
SELECTED LITERATURE: Egerton, 1984, p. 112
B1981.25.617

This is one of the earliest in a long series of paintings of exotic animals, many of which Stubbs produced for his friends William and John Hunter, the Scottish anatomists and men of science. Stubbs may have met John Hunter in connection with the procurement of cadavers that the older, more socially established, and more medically experienced William dissected for his pupils and other interested people in the basement of his London town house. We do not know why Stubbs painted Queen Charlotte's zebra, or African "she-ass," nor why the painting was still in his studio at his death, but it has long been presumed that access to the animal was arranged by William Hunter, who served regularly as accoucheur to the queen.

This was in fact the first zebra to be seen in England. It was brought from South Africa in 1762 by Sir Thomas Adams, the commanding officer of H.M.S. *Terpsichore*, as a gift from the governor for young Queen Charlotte. Two live specimens were dispatched from the Cape of Good Hope in what Malcolm Warner has described as "Noah's-ark fashion," but only the female survived the voyage. As soon as she reached London, the zebra was installed in the menagerie at Buckingham House (Buckingham Palace) and became an instant celebrity. "The Queen's she-ass," wrote one observer, "was pestered with visits, and had all her hours employed from morning to night in satisfying the curiosity of the public. She had a sentinel and guard placed at the door of her stable. . . . The crowds that resorted to the Asinine palace were exceeding great," (MacClintock, 1992, p. 4). In fact, she also inspired a number of rude songs—including this one that circulated in broadsheets:

Ye Bucks and ye Jemmies who amble the Park,
Whose Hearts and whose Heads are as lightsome
 as Cork,
Through *Buckingham Gate*, as to *Chelsea* you pass,
Without Fee or Reward, you may see the Q—'s A—.
See the Q—'s A—. See the Q—'s A—,
 Without Fee or Reward, &c.
(The QUEEN'S ASS. A NEW HUMOROUS ALLEGORICAL SONG . . . By H. Howard, To the Tune of *Stick a Pin There.* Broadsheet, British Museum)

Stubbs's grasp of the anatomical differences between zebras and horses is, of course, masterly, and in the present work the backward direction of the ears, the dewlap on the underside of the neck or the front, and the "gridiron" pattern of the stripes on the nether regions, immediately above the tail—all these are exactly consistent with zoological verisimilitude and, in fact, identify the present animal as the smallest of three subspecies of zebra, the Cape Mountain. "The Queen's Ass" survived until 3 April 1773, perhaps in spite of sharing its accommodation in due course with an elephant and being moved to the Tower of London. AT

24

Turf, with Jockey Up, at Newmarket, ca. 1765
Oil on canvas; 40 ⅛ x 50 ⅛ in. (99.1 x 124.5 cm)
Inscribed, lower left: *Turf*

PROVENANCE: Painted for Frederick St. John, 2nd
Viscount Bolingbroke, by descent to the 6th Viscount,
sold, Christie's, 10 Dec. 1943 (49); bt Ellis & Smith;
Walter Hutchinson, sold, Christie's, 20 July 1951 (126);
bt Leggatt; Ivor Grosvenor, 2nd Viscount Wimborne,
by descent to the 3rd Viscount Wimborne; Somerville
& Simpson; bt Paul Mellon, 1976
SELECTED EXHIBITIONS: Hutchinson House, *Sports
and Pastimes*, 1948, no. 111; Tate, *Stubbs*, 1984–85,
no. 57; AGNSW, *Eden*, 1998, no. 43
SELECTED LITERATURE: Egerton, 1984, p. 87
B1981.25.621

This racehorse portrait was painted for one of Stubbs's
best early patrons, the young Whig aristocrat Frederick
St. John, 2nd Viscount ("Bully") Bolingbroke. Lord
Bolingbroke, who inherited the title in 1751 from the
childless half-brother of his father, owned some of the
most successful racehorses of the day, including the
famous Gimcrack. Turf raced mostly at Newmarket,
and the high point of his career was beating King
Herod in a match for a thousand guineas on 4 April
1766. He was retired lame the following year. The alert,
if somewhat nonchalant, jockey wears Bolingbroke's
colors, but his identity is unknown. AT

25

Pumpkin with a Stable-lad, 1774
Oil on panel; 31 ½ x 39 ¼ in. (80 x 99.5 cm)
Signed and dated, lower right: *Geo : Stubbs
pinxit/1774*

PROVENANCE: Thomas Foley, 1st Baron Foley, by
descent to the 7th Lord Foley, probably sold,
Castiglione & Scott, 16 Oct. 1919 (564);
D. H. Carstairs; Knoedler's; bt Paul Mellon, 1936
SELECTED EXHIBITIONS: VMFA, *Sport and the Horse*,
1960, no. 20; Ackermann, *Racehorses*, 1962, no. 5;
VMFA, *Painting in England*, 1963 (274); RA, *Painting
in England*, 1964–65, no. 274; YUAG, *Painting in
England*, 1965, no. 186; YCBA, *Paul Mellon Bequest*;
2001, p. 81
SELECTED LITERATURE: Millar, 1969, p. 186; Taylor,
1971, p. 210
B2001.2.69

This was the first British painting purchased by Mr.
Mellon and his first wife, Mary. They bought it
together in 1936 from Knoedler's in New York City.
"It was my very first purchase of a painting," Mr.
Mellon recalled later, "and could be said to be the
impetus toward my later, some might say gluttonous,
forays into the sporting art field" (Mellon, 1992,
pp. 280–81). Until the end of Paul Mellon's life,
Pumpkin remained one of his favorite paintings.

By Match'em out of Old Squirt Mare, the chest-
nut Pumpkin was foaled in 1769. In twenty-four starts
he won sixteen races, many of them at Newmarket,
altogether worth 6,090 guineas and nine hogsheads
of claret. In 1772, in his first race, Pumpkin beat the
favorite, Denmark, by half a neck. It was thought to be
one of the finest races ever run on English turf. He
went on to win a long series of matches in the subse-
quent three seasons. Pumpkin's owner was the 2nd
Baron Foley, who commissioned Stubbs's portrait.
Lord Foley was a member of the Jockey Club, a racing
crony of Charles James Fox, and the Presbyterian heir
to an iron and coal fortune.

Stubbs's rendition of the stable lad, who is pre-
sumably about nine or ten years old, is exquisitely
sensitive, conveying seriousness and responsibility as
much as boyish charm: he holds a sieve, from which
he feeds his charge. Stubbs painted three other por-
traits of Pumpkin, each with the jockey William
South in Foley's blue-and-white racing colors (at
Ascott House [National Trust]; with H.M. the
Queen; and with the Earl of Halifax), but the warmth
of the stable lad's rose-red jacket and the unusual
glimpse of white paling fence beyond the dip in the
middle distance are typical of Stubbs's supremely
inventive approach to the composition and coloring
of his portraits of thoroughbred racehorses. AT

26

Sleeping Leopard, 1777
Enamel on Wedgwood biscuit earthenware (Queen's
Ware); 4 ¼ x 6 ⅝ in. (10.8 x 16.8 cm), oval
Signed and dated, lower right: *Geo. Stubbs/pi : 1777*.
Impressed: WEDGWOOD

PROVENANCE: Possibly the work referred to in the
artist's sale as "sleeping tiger" 26 May 1807 (64); bt
(at that sale[?]) William Hoare, certainly by ca. 1820,
by descent to Janet Faurschou; bt Paul Mellon, 1974
SELECTED LITERATURE: Tattersall, 1974
B2001.2.209

Crucially important as the earliest recorded example
of Stubbs's work in enamel on earthenware supports
that were made and then fired in Josiah Wedgwood's
factory, this work predates Stubbs's more ambitious
compositions for larger-scale Wedgwood ceramic
plaques or "canvases." The position of the Wedgwood
stamp, moreover, strongly suggests that the oval plaque
was cut with a grinder from the bottom of a Queen's

Ware plate and that Stubbs created the present work
as an experiment with which to demonstrate (maybe
to the manufacturer) the possibility and promise of
painting in enamel on Wedgwood earthenware.

In the 1770s distinctions among the various spe-
cies of big cat were still rather vague, and the English
word *tiger* was frequently used as a generic term to
describe them all except lions. This is why the pres-
ent work has plausibly been identified with the refer-
ence to a "sleeping tiger" in the artist's posthumous
sale of 26 May 1807, despite the unequivocal spots.

Paul Mellon loved this little painting and kept it
on the desk in his study in the house he kept on East
Seventeenth Street in New York City. AT

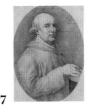

27

Study for the Self-portrait in Enamel, 1781
Graphite on wove paper, squared; 12 x 9 ⅛ in.
(30.5 x 23.2 cm)
Signed, lower right: *George Stubbs*

PROVENANCE: H. S. Reitlinger; Alistair Matthews; Ian
Fleming-Williams; bt Paul Mellon, 1962
SELECTED EXHIBITIONS: VMFA, *Painting in England*,
1963, no. 332; PML, *English Drawings*, 1972 (31); Tate,
Stubbs and Wedgwood, 1974, no. 29; Tate, *Stubbs*,
1984–85, no. 3; YCBA, *Line of Beauty*, 2001, no. 150
SELECTED LITERATURE: Taylor, 1965, pp. 3–4; Warner
and Blake, 2004, p. 200
B2001.2.1262

This highly finished drawing is a preparatory study,
squared up for transfer, for the self-portrait that
Stubbs executed in 1781 on a Wedgwood oval plaque
(National Portrait Gallery, London), probably for Mrs.
Thorold, the wife of his good friend John Thorold
of the Inner Temple—so said Ozias Humphry, who
remains one of the very few, and far from wholly reli-
able, sources of biographical information about
Stubbs. Although it was for many years identified as a
portrait not of Stubbs but of Wedgwood, the final
version of the plaque was correctly identified by Basil
Taylor in 1965. It conforms to what we know about
other preparatory drawings for Stubbs's Wedgwood
plaques. The technique of generating a composition
for firing in enamel seems to have required a high
degree of artistic decision-making in advance and a
good deal of finish even prior to beginning work on
the earthenware support. A number of Stubbs's other
squared-up drawings were recorded in the artist's
posthumous 1807 studio sale, but relatively few have
been traced.

To commemorate the centenary of the birth of
the late Paul Mellon, the Yale Center for British Art
recently purchased at auction in London one of a
small group of other self-portraits by Stubbs: an
exquisite, small oval painting of head and shoulders
in oil on copper. This much earlier work serves as a
valuable reminder that the oval format, and within it

George Stubbs
Sir Joshua Reynolds
Paul Sandby

the three-quarter attitude facing the right, were firmly established both in the artist's view of himself and in the mind-set of other artists, including Ozias Humphry and William Craft, who both portrayed Stubbs in almost identical formats. AT

Studies for *A Comparative Anatomical Exposition of the Structure of the Human Body with That of a Tiger and a Common Fowl*, 1795–1806 (nos. 28–30*)

28

Human Figure, Anterior View, Final Stage of Dissection
Graphite on heavy wove paper; 21 ¼ x 15 ⅞ in.
(54 x 40.3 cm)
B1980.1.21

29

Tiger, Lateral View, with Skin and Tissue Removed
Graphite on heavy wove paper; 16 x 21 ⅛ in.
(40.6 x 53.7 cm)
B1980.1.9

30

Fowl Skeleton, Lateral View
Graphite on heavy wove paper; 21 ¼ x 16 in.
(54 x 40.6 cm)
B1980.1.5

PROVENANCE: Mary Spencer, sold, Phillips, 30 Apr. 1817; bt Richard Wroughton [?], sold, Sotheby's, 3 Apr. 1822 (1636); bt "G."; Thomas Bell; Dr. John Green; by whom presented to the Worcester Public Library, 1863; bt Paul Mellon, 1980
SELECTED EXHIBITIONS: Arts Council, *Stubbs*, 1958, no. 11; Tate, *Stubbs*, 1984–85, no. 142; YCBA, *Stubbs*, 1999, nos. 77, 84, 89; Hall & Knight, *Fearful Symmetry*, 2000, nos. 42, 47

Much of what we know about the watersheds in the life of George Stubbs relates to his mostly systematic study

of anatomy, beginning at the age of eight—according to Ozias Humphry—when a Dr. Holt set him the task of drawing bones. Evidently Stubbs proceeded to the study of anatomical dissection in York and was good at it. Dissections for Dr. John Burton's *Essay Towards a Complete New System of Midwifery* (1751) were carried out in York on deceased pregnant women and fetuses, one of which was "conceal'd in a Garret," apparently not obtained as a result of execution and therefore illegal. These incidents were evidently sufficient grounds upon which to refer in writing to Stubbs as an artist "of vile renown." The work of dissecting horses that Stubbs undertook with the assistance of the long-suffering Mary Spencer in an isolated farmhouse in Lincolnshire led to the production of a series of spectacular finished drawings that a little later, in London, provided prospective horse-mad patrons with a highly effective demonstration of his talents as a draftsman. Stubbs taught himself how to engrave plates after his own finished drawings, from which were printed deluxe copies of the magnum opus of the middle part of his career, *The Anatomy of the Horse* (1766). The book was a tremendous success. Stubbs hoped that it would not only be useful to artists but also contribute to the advancement of scientific knowledge (with its nearly fifty thousand words of detailed anatomical text). Presumably it was Stubbs's work in anatomy that brought him into contact with John Hunter, upon whom his more socially elevated brother, William Hunter, the surgeon and accoucheur to the queen, relied for the procurement of corpses. Stubbs's work in anatomy was potentially dangerous, and in any case hair-raising.

Begun when Stubbs was seventy-one years old, the *Comparative Anatomical Exposition* reflected ideas about certain fundamental structural characteristics that were thought to be shared by all living things. The point of the exercise was not to compare like with like but, by applying empirical techniques of observation and analysis, to discover among radically dissimilar creatures—in this case man, fowl, and tiger—the reassuring bedrock of fundamental similarities. The project was enormously ambitious: Stubbs projected sixty elaborately engraved plates with accompanying explanatory letterpress in both English and French editions—a valuable reminder that to some extent Stubbs's reputation as a man of science flourished not just in England but abroad as well. Although he managed to complete all the preparatory drawings, barely half of the plates were engraved and published by the time Stubbs died in 1806.

It is possible that the model for Stubbs's tiger in the *Comparative Anatomical Exposition* was in fact a leopard (Doherty, 1974, p. 131). AT

Sir Joshua Reynolds (1723–92)

There has never been a time when Joshua Reynolds was not regarded as one of the great men of the Enlightenment in England and a portrait and history painter of tremendous versatility, inventiveness, originality, and ambition.

Reynolds was the seventh of the ten or eleven children of a schoolmaster and his wife, both of whose families were abundant with Church of England clergymen. Showing prodigious talent as a boy, he was apprenticed for four years to the London portrait painter Thomas Hudson of Lincoln's Inn Fields, before establishing a burgeoning portrait practice in London and Plymouth. In 1749–50 Reynolds traveled to Italy and France by way of Spain and Morocco. In Rome he copied the Old Masters, for eighteen months scouring the city's churches

and princely art collections and working his way back across the Continent, similarly absorbing a host of artistic exempla. Upon his return to London, Reynolds resumed his portrait practice and achieved rapid commercial and critical success, although the failure of some of his experiments with certain fugitive pigments and varnishes was soon apparent.

Beginning in 1760, when he leased a large house at 47 Leicester Square, Reynolds exhibited with the Society of Artists but eventually distanced himself from the squabbles that increasingly divided the members from their committee. He also hesitated before accepting the invitation to become the first President of a rival "Academy" that was founded in 1768 with patronage of King George III. As President, Reynolds was knighted in April 1769, an honor that was not without precedent but that signaled Reynolds's certain preeminence in the institutional art world of London. In the *Discourses* he delivered as President, Reynolds set out the principles to which a great national school of art should adhere, ennobled by poetry and eloquence, intellectual dignity, and the purity of the so-called great style of Michelangelo, Raphael, and the Florentine-Roman tradition of *disegno*.

In the 1770s and 1780s, Reynolds's portrait subjects included most of the great men and women of the age: his own good friend Dr. Samuel Johnson, the king and queen, Sir Joseph Banks, James Boswell, Oliver Goldsmith, David Garrick, and others. He created a sideline in imaginative portrait studies of children, known as "fancy pictures," and also experimented with history painting. As Reynolds aged, he showed an increasing awareness of and interest in Dutch art and continued to be showered with honors, both domestic and foreign. In old age, the deafness he blamed on a chill he said he caught in the Sistine Chapel got worse (but that, like his harelip, was probably hereditary); in addition, his eyesight deteriorated. Although he was immensely self-important, and to that extent personally vain, in his marvelous self-portraits Reynolds freely acknowledged the existence of all three maladies, most obviously the harelip, but also his ear trumpet and spectacles, while other artists in their portraits of him rarely acknowledged their existence. After his death in 1792, Reynolds's body was attended by ten pallbearers, among whom were three dukes, two marquesses, three earls, and a cortège of ninety-one carriages.

Selected Literature: Northcote, 1815; Wendorf, 1996; *ODNB*. AT

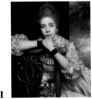

31

Mrs. Abington as Miss Prue in William Congreve's "Love for Love," 1771
Oil on canvas; 30 ¼ x 25 ⅛ in. (76.8 x 63.7 cm)

PROVENANCE: John Parker, 2nd Baron Boringdon (later 1st Earl of Morley) by 1813, by descent to Albert

Edmund Parker, 3rd Earl of Morley; sold privately, 1877, to Sir Charles Henry Mills, Bart.; bt Agnew; bt Paul Mellon, 1972
SELECTED EXHIBITIONS: RA, 1771, no. 161; BI, *Reynolds*, 1813, no. 103; South Kensington, *National Portraits*, 1867, no. 601; RA, *Old Masters*, 1876, no. 31; Grosvenor, *Reynolds*, 1883, no. 7; Park Lane, *Reynolds*, 1937, no. 56; Birmingham, *Reynolds*, 1961, no. 50; RA, *Reynolds*, 1986, no. 78; AGNSW, *Eden*, 1998, no. 35; Tate, *Reynolds*, 2005, no. 54
SELECTED LITERATURE: Mannings and Postle, 2000, pp. 55–56
B1977.14.67

The actress Frances (Fanny) Barton, better known as Mrs. Abington, was one of the most popular stars of the London stage. She grew up in the slums near Drury Lane; sold flowers in Covent Garden (where she was called "Nosegay Fan"); worked for a French milliner in Cockspur Street; and was employed by the cook and future comedian Robert Baddeley, who gave Fanny her first big break. She married James Abington, one of the king's trumpeters, and became a star in the Drury Lane Company, managed by the actor-manager David Garrick. She created the role of Lady Teazle in Richard Brinsley Sheridan's *The School for Scandal* (1777). In this portrait, Reynolds (an admirer) portrays Mrs. Abington in one of her most successful roles, that of the young ingénue Miss Prue in William Congreve's somewhat dated 1694 comedy *Love for Love*. She played that part for the first time in December 1769, and the sittings for this portrait took place either in December or in March and April 1771.

Showing her in character (and adopting what was then taken to be a suggestive, or at least unrefined, pose—unthinkable for a lady—and exploiting as a strategically positioned fascinator the Hepplewhite chairback upon which she rests her arms), the work is both a portrait of unusual directness and candor, her thumb coyly hovering on the lower lip, and a "historical" picture, whose associations went beyond the subject's likeness, which Horace Walpole thought "easy and very like" (Mannings and Postle, 2000, p. 56).

Reynolds painted at least half a dozen portraits of Mrs. Abington in 1771 and two further paintings that must correspond to surviving notes in Reynolds's appointment books for 1773 and 1780. The latter of these, which is untraced, showed the actress in character once again, this time in the role of Roxalana, the English slave in Isaac Bickerstaff's play *The Sultan*, which was first performed in 1775 in Drury Lane. In that drama, "the playful, unequal, coquettish Roxalana," wrote Sir Uvedale Price, "full of sudden turns and caprices, is opposed to the beautiful, tender, and constant Elvira; and the effects of irritation, to those of softness and languor" (Graves and Cronin, 1899–1901, vol. 1, p. 5). AT

Paul Sandby (1731–1809)

A notable figure of British art, Paul Sandby combined industry with consistency in the ebullient and fast-changing English art scene of the second half of the eighteenth century. Baptized in Nottingham in 1731, he was first employed, as was his elder brother Thomas, by the Board of Ordnance at the Military Drawing Office, located in the Tower of London. Following the Battle of Culloden, he was sent to the

Highlands as a draftsman for the Military Survey (1747[?]). He spent five years in Scotland strengthening his skills as a topographer and then settled in London in the early 1750s, earning a living as a drawing master.

Sandby's work began to be part of the cultural landscape in the 1760s as he frequently contributed work to the Society of Artists' exhibition. He also participated in almost every annual exhibition of the Royal Academy, of which he was a founding member (1768). The same year, he was appointed Drawing Master at the Woolwich Royal Military Academy, a position he kept until 1796. Sandby's later years were less successful. With fewer students to teach and his work failing to sell, he struggled financially. Although he had once been a pioneer in the field of watercolor and the medium of aquatint, Sandby saw his style and technique challenged by young artists; the fresh and painterly works of artists such as Thomas Girtin and J. M. W. Turner made Sandby's minutely delineated watercolors look outdated. Yet, as a new century began, Paul Sandby's reputation as the "father of English watercolors" remained unchallenged.

Selected Literature: Oppé, 1947; Wilton, 1977; Robertson, 1985; Herrmann, 1986; Robertson, 1987; *ODNB*. SR

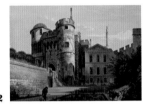

32

The Norman Gate and Deputy Governor's House, ca. 1765
Gouache on laid paper; 15 ⅛ x 21 ¼ in. (38.4 x 54 cm)

PROVENANCE: Sir Richard Frederick Molyneux, by whom presented to HRH the Princess Royal; 7th Earl of Harewood, sold, Christie's, 13 July 1965 (170); bt Colnaghi; bt Paul Mellon, 1965
SELECTED EXHIBITIONS: PML, *English Drawings*, 1972, no. 38; YCBA, *Sandby*, 1985, no. 83
SELECTED LITERATURE: Borenius, 1936, no. 427; Oppé, 1947, no. 13; Robertson, 1987, vol. 1, p. 227; Roberts, 1995, fig. 12.1
B1981.25.2691

From the 1750s to the very last years of his life, Paul Sandby made frequent visits to Windsor. His elder brother, Thomas, served as a draftsman to the Duke of Cumberland in the early 1740s and was appointed Deputy Ranger of Windsor Great Park in 1747. This family connection, paired with a growing public interest in the castle—featured in travel guides—certainly explains why Sandby produced such a considerable number of Windsor views during his career.

After collaborating with his brother on a set of eight engraved views of Windsor Great Park in the mid-1750s, Sandby pushed further his pictorial exploration of the castle, depicting it from every possible vantage point and at various angles. He exhibited eight views of Windsor Castle at the Society of Artists between 1763 and 1768. The present work, made around that time, is part of a set of four views of the

castle in gouache in the Paul Mellon Collection (YCBA). Sandby's Windsor subjects enjoyed great popularity, and he made several copies in gouache, watercolors, and oils, illustrating his versatility in multiple media. One such copy is a later version of the *Norman Gate* in the Royal Library, dated 1780, and of comparable dimensions (Oppé, 1947, nos. 13, p. 22). As is often the case with these replications, Sandby made some minor changes, such as removing the figures on the right and slightly modifying the garden's shape. These views, taken altogether, provide vivid and charming architectural records of Windsor and its vicinity. They also suggest the extent to which, as an author quipped, "Windsor was Sandby's bread and butter" (Robertson, 1987, p. 227). SR

M. A. Rooker for *A Collection of Landscapes*, published in London in 1777. Other versions of the lodge were made the next year for the *Copperplate Magazine*, to which Sandby contributed many designs. These endeavors are telling of the artist's condition: by hanging his work on the walls of the Society of Artists, Sandby most likely hoped to attract private and wealthy patrons wishing to have their own estates depicted in a similar fashion; by providing designs to publishers, he could make a decent living while courting a larger public. SR

34

33

Northeast View of Wakefield Lodge in Whittlebury Forest, Northamptonshire, 1767
Watercolor with pen and gray ink and touches of gold paint over graphite on laid paper, laid down on a contemporary mount; 16¾ x 33½ in. (42.5 x 85.1 cm)
In gold paint, lower left: *P. Sandby 1767;* inscribed on mount in gold paint: *North West View of Wakefield Lodge in Whittlebury Forest*

PROVENANCE: The Dowager Lady Hillingdon; Agnew, 1967; bt Paul Mellon, 1967
SELECTED EXHIBITIONS: SA, 1767, no. 272; PML, *English Drawings*, 1972, no. 41; YCBA, *Sandby*, 1985, no. 77, YCBA, *Line of Beauty*, 2001, no. 136
SELECTED LITERATURE: Binney, 1973
B1977.14.4648

Located in Whittlebury Forest, Wakefield Lodge was an imposing hunting lodge designed by William Kent for the 2nd Duke of Grafton. Its completion was overseen by the 3rd Duke of Grafton (short-lived prime minister from 14 October 1768 to 28 January 1770) who continuously increased the size of the estate.

Having been trained as a topographer, Sandby felt particularly at ease with estate portraiture. He chose to depict Wakefield lodge from a distance rather than at close range, thereby displaying the property in its wider setting. As is often the case in Sandby's oeuvre, the artist peppered his composition with references to estate life. The grazing horses remind the viewer that the majestic 250-acre park was host to the Wakefield Lawn Races, while the wary herd of stags is evocative of the Grafton Hunt. Sandby's artistic aspirations never prevented him from adding a touch of lightness: one cannot help noticing a raggedy couple surreptitiously bundling wood and hiding behind a tree as a phaeton approaches, making this an exquisite scene of rustic burlesque.

Although not as frequently depicted by Sandby as Windsor views, Wakefield Lodge was the subject of some repetitions as well. The present work was one of two Wakefields exhibited at the Society of Artists in 1767. Sandby also produced two watercolors from different viewpoints that were later engraved by

Roslin Castle, Midlothian, ca. 1780
Gouache on laid paper mounted onto board; 18 x 24¾ in. (45.7 x 62.9 cm)

PROVENANCE: William Sandby; Herbert Peake; Mrs. Mew; Christie's, 7 July 1959 (152); Agnew, 1960; bt Paul Mellon, 1960
SELECTED EXHIBITIONS: PML, *English Drawings*, 1972, no. 39; YCBA, *Sandby*, 1985, no. 109; YCBA, *Fairest Isle*, 1989, no. 147; YCBA, *Line of Beauty*, 2001, no. 138
SELECTED LITERATURE: Andrews, 1989, p. 208; Hemming, 1989, p. 41; Andrews, 1999, p. 117
B1975.4.1877

Located about eight miles southwest of Edinburgh, Roslin Castle was built in the fourteenth century; it was damaged to a great extent after being besieged in the sixteenth and seventeenth centuries. Its ruins, on a cliff overlooking the North Esk River, were celebrated by poets and immortalized by artists. The "beautifully wild and awfully sublime" vista also attracted numerous visitors (White, 1977, no. 40). Despite its title, Sandby's composition is more likely a reflection of his contemporaries' longing for such views rather than an attempt to render the castle accurately. A new cultural practice seems to be unfolding here: the taste for picturesque touring, a broadened social experience inherited from the once-dominating and exclusive practice of the Italian Grand Tour.

This cultural phenomenon is personified by the figures appearing on the right in Sandby's work. A drawing entitled *Lady Frances Scott and Lady Elliott*—dated 1780—in the Paul Mellon Collection (YCBA) reveals the identity of two of these women. Lady Scott, an amateur artist of some repute (she was known to Horace Walpole), can be seen sketching a view with the help of a camera obscura. The design of this optical device was of disarming simplicity: after entering through a small opening in front of the box, light would hit a mirror placed at an angle, projecting the image onto a glass surface on which was laid a sheet, allowing its user to draw the outlines. Known since antiquity and used by many artists (Sandby included), the camera obscura was extremely popular with amateur artists and travelers anxious to keep visual journals of their quests for local color in the countryside. SR

Thomas Gainsborough (1727–88)

As a child Thomas Gainsborough forged parental notes excusing him from school in order to go out drawing in the countryside. This mischievous streak of rebellion and his dedication to the depiction of the English landscape were the artist's signature characteristics throughout his life. From early in his career, Gainsborough exhibited a singular touch in his paintings and drawings, an ability to bind his whole composition together with harmonious and lively brushwork. The artist's talents were equally suited to portraiture, genre scenes, and landscape, although throughout his life Gainsborough preferred the latter.

Leaving home at age thirteen, Gainsborough moved to London, where he is believed to have studied at the St. Martin's Lane Academy. The young artist was greatly influenced by Hubert-François Gravelot, Francis Hayman, and William Hogarth, imbibing their particular version of the rococo as translated for an English audience. With a wife and family to support, Gainsborough returned to his native Sudbury, Suffolk, where he painted portraits for money and landscapes for pleasure. He most succinctly combined these two genres in the famous *Mr. and Mrs. Andrews* (about 1750; National Gallery, London). Moving to the prosperous port town of Ipswich, Gainsborugh put aside these small-scale conversation pieces in favor of head-and-shoulders portraits. Seeking a larger market of potential clients, in 1759 Gainsborough moved again, this time to the fashionable resort of Bath. There he began to produce masterful full-length portraits such as *Mary, Countess Howe* (1763–64; Kenwood House, London). In the *Harvest Wagon* of 1767 (Barber Institute, University of Birmingham) the rural figures that had peopled Gainsborough's Suffolk landscapes are placed at center stage, a foretaste of the artist's highly original fancy pictures of cottagers and woodcutters. His pure landscapes from this period reflect his study of Old Master paintings by Claude Lorrain and others in collections near Bath.

A founding member of the Royal Academy, Gainsborough was already well-known and appreciated by the London art-viewing public when he relocated to the capital in 1774. Some of his best portraits were painted during this period, including the ravishing *Mrs. Richard Brinsley Sheridan* (1785; National Gallery of Art, Washington, D.C.); his landscapes from the London period are equally skilled and self-assured. They lost some of the accidental and haphazard charm of his earlier productions, but in return they gained a glowing light and calm ethereality. Gainsborough's representations of the landscape (both painted and drawn) became more schematic and abstract, depicting ruined castles, aqueducts, and bridges more Italian than English in appearance. This imaginative component of his art came to fruition in his fancy pictures, which are indicative of the streak of experimentation that runs through all of Gainsborough's art.

Selected Literature: Waterhouse, 1958; Hayes, 1971; Hayes and Stainton, 1983; Asfour and Williamson, 1999; Rosenthal, 1999. CA

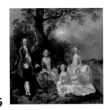

35

The Gravenor Family, ca. 1754
Oil on canvas; 35 ½ x 35 ½ in. (90.2 x 90.2 cm)

PROVENANCE: By descent in the Gravenor family to Major J. Townshend; Sotheby's, 19 July 1972 (41); Colnaghi; Nigel Broackes; Colnaghi; bt Paul Mellon, 1977
SELECTED EXHIBITIONS: YCBA, *The Conversation Piece*, 1980, no. 55; Tate, *Manners and Morals*, 1987–88, no. 153; Grand Palais, *Gainsborough*, 1981, no. 3; AGNSW, *Eden*, 1998, no. 15; YCBA, *Great British Paintings*, 2001, no. 13; Tate, *Gainsborough*, 2002, no. 20
SELECTED LITERATURE: Hayes, 1975, no. 11; Jones, 1997, pp. 19–26; Rosenthal, 1999, p. 127; Vaughan, 2002, pp. 53–56; Belsey, 2002, p. 51
B1977.14.56

This charming group portrait was painted in the provincial port city of Ipswich, where the young Gainsborough labored in relative obscurity early in his career. John Gravenor, a local apothecary and politician, his wife, Ann, and their two daughters are shown as if resting during a pleasant walk in the country. Gainsborough has chosen a square canvas, an unusual format that indicates that the portrait may have been intended to serve as an overmantel.

The square shape of the picture support lends *The Gravenor Family* an insularity and formal harmony. This sense of enclosure within the landscape is accentuated by the wheat and the intertwined trees (symbols of the Gravenors' matrimonial harmony). The seated younger daughter leans in toward her mother, and Gainsborough's vivid brushstrokes in the storm clouds on the right further envelop the family in their natural setting. Although the sitters look out toward the viewer, rather than conversing among themselves, they are a remarkably coherent family group.

The writer Philip Thicknesse described visiting Gainsborough's studio in Ipswich around the time the artist was working on the portrait of the Gravenors. According to Thicknesse, there were "several portraits truly drawn, perfectly like, but stiffly painted." Also on view were landscapes, which gave Gainsborough "infinite delight" and which Thicknesse deemed far superior to the artist's portraits (Thicknesse, 1788, p. 10). In the portrait of John and Ann Gravenor and their daughters the figures are indeed "stiffly painted," but they charm nonetheless. CA

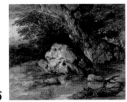

36

A Woodland Pool with Rocks and Plants, ca. 1765–70
Watercolor, black chalk, and oil paint, with gum, on laid paper; 9 x 11 ⅜ in. (22.9 x 28.9 cm)

PROVENANCE: David Rolt; Colnaghi, 1962; bt Paul Mellon, 1962
SELECTED EXHIBITIONS: VMFA, *Painting in England*, 1963, no. 58; PML, *English Drawings*, 1972, no. 37; YCBA, *English Landscape*, 1977, no. 25; Tate, *Gainsborough*, 1980–81, no. 22; Grand Palais, *Gainsborough*, 1981, no. 94; NGA, *Gainsborough Drawings*, 1983–84, no. 48; YCBA, *Oil on Water*, 1986, no. 25; YCBA, *Line of Beauty*, 2001, no. 48
SELECTED LITERATURE: Hayes, 1971, no. 311, pp. 180–81
B1975.4.1198

This may well be a drawing of one of the so-called foregrounds in miniature that Gainsborough constructed out of stones, mosses, and mirrors in his Bath studio. He assembled and then sketched these miniature tabletop landscapes as a means of composing the feathery trees, gnarled stumps, rocky outcroppings, and pools of water that appear in his landscapes, portraits, and genre scenes. Gainsborough was also, however, devoted to the practice of drawing the motif directly from nature. The painter Ozias Humphry, a neighbor of Gainsborough's in Bath, recalled that the two artists would often take afternoon sketching excursions into the countryside (Hayes and Stainton, 1983, p. 9).

Whatever the mechanics of the creation of this drawing, it demonstrates a change in style and technique that evolved during his Bath period. Previously, the artist had drawn mostly with pencils. In the 1760s the ever-inventive and experimental Gainsborough began to make mixed-media drawings with watercolor, chalk, oil paint, and gum arabic, among other things. Combining these materials allowed him to achieve dramatic chiaroscuro and texture in his works on paper. Here, he emphasizes the rock in the middle distance, touching it with white paint and a dash of acidic green suggestive of moss or lichen in tone and texture. CA

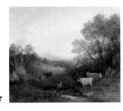

37

Landscape with Cattle, 1772–74
Oil on canvas; 47 ¼ x 57 ¼ in. (120 x 145.5 cm)

PROVENANCE: J. Longe, 1856; sold, Christie's, 19 May 1866 (38); bt Agnew for John Heugh; sold, Christie's,

10 May 1878 (239); bt Agnew; J. S. Morgan, 1885, by descent to G. Morgan; bt Knoedler, ca. 1916; Colonel Robert L. Montgomery, by descent to Alexander Montgomery; Wildenstein; Agnew; bt Paul Mellon, 1966
SELECTED EXHIBITIONS: Grosvenor, *Centenary*, 1885, no. 129; Tate, *Gainsborough*, 1980–81, no. 114; Grand Palais, *Gainsborough*, 1981, no. 46; AGNSW, *Eden*, 1998, no. 28; YCBA, *Sensation and Sensibility*, 2005
SELECTED LITERATURE: Hayes, 1975, no. 83; Hayes, 1982, no. 108; Cormack, 1991, p. 114; Brenneman, 1995–96, pp. 38–39; Asfour and Williamson, 1999, p. 189; Trumble and Wilcox, 2005, p. 58
B1981.25.305

Gainsborough's landscapes from his late Bath period are highly structured, although they radiate a sense of ease and naturalness. After years of creating what appeared to be fresh and unmediated visions of the English landscape, in the early 1770s Gainsborough began to paint and draw formally composed meditations on the idyll of rustic life, consciously mimicking the landscape precepts of the seventeenth-century painter Claude Lorrain. Hence, in this painting, our eye moves from the darker foreground figures shaded by a grove of trees and follows the winding river and arching bridge in the middle distance out to a background featuring a town bathed in a glowing evening light.

A drawing related to *Landscape with Cattle* in the collection of the Yale Center for British Art suggests that Gainsborough carefully worked out some of his paintings at this time through the medium of drawing, experimenting with minute compositional shifts that would have a great impact on the nature of the finished work. The three cows are grouped more statically in the Center's drawing than in the finished painting. It is generally thought that Gainsborough produced only rough sketches for his paintings, preferring to work out compositions as he painted. However, the fact that he had only recently begun painting landscapes of this kind, which would have demanded a more rigorous working method, argues for the supposition that the Center's drawing preceded *Landscape with Cattle*. CA

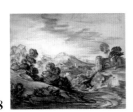

38

Wooded Landscape with Castle, ca. 1785–88
Black chalk and stump with white chalk, on blue-gray laid paper; 10 ⅜ x 12 ¹³/₁₆ in. (26.4 x 32.5 cm)

PROVENANCE: Sotheby's, 15 Apr. 1953 (6); bt Colnaghi; William Selkirk, sold, Sotheby's, 3 May 1961(87); bt Colnaghi; bt Paul Mellon, 1961
SELECTED EXHIBITIONS: NGA, *English Drawings*, 1962, no. 34; YCBA, *English Landscape*, 1977, no. 34; YCBA, *Cozens*, 1980, no. 154; Tate, *Gainsborough*, 1980–81, no. 50; Grand Palais, *Gainsborough*, 1981, no. 114; NGA, *Gainsborough Drawings*, 1983–84, no. 90
SELECTED LITERATURE: Hayes, 1971, no. 806
B1975.4.1520

This drawing dates from the last years of Gainsborough's life when, owing to continued skirmishes with the Hanging Committee, he refused to exhibit his works at the Royal Academy. His paintings and drawings (as well as the innovative oil paintings on glass that the artist was creating during this period) became more generalized than before; examples such as the present drawing sometimes come closer to suggesting rather than truly representing forms, and they are often set in an imaginary world of picturesque castles and winding roads. In some areas of this drawing the black and white chalk has been blended and softened with the artist's fingertips, or perhaps with a coil of felt or leather known as a stump. The only color in the composition is the blue paper support, which has faded to gray in the sky, making the mass of white clouds above the distant mountain stand out more brightly. This use of blue paper harkens back to the earliest days of Gainsborough's career, when he adopted this habit from his first teacher, the French draftsman Gravelot. CA

Johan Joseph Zoffany (1733–1810)

Born near Frankfurt am Main in Germany, Johan Zoffany was raised in the lower ranks of the court of the Prince of Thurn und Taxis. As an ambitious young art student he went to Rome in 1750, arriving at the moment when many British artists had joined the expatriate colony, including Joshua Reynolds, Gavin Hamilton, Thomas Patch, Richard Wilson, William Chambers, and others. There he studied from the live model under Anton Raphael Mengs, came into contact with the incipient world of Neoclassicism, and then returned to Germany, where he later became court painter to the Elector of Trier.

Marriage and a dowry provided Zoffany with the means to escape the stultifying atmosphere of a provincial German baroque micro-court. In 1760 the Zoffanys traveled to London. At first he provided decorative scenes on clock faces for Stephen Rimbault, the clock maker, and draperies for an irritatingly less talented fellow artist, Benjamin Wilson. Zoffany was lucky to be discovered by the great actor-impresario David Garrick, who himself commissioned, and led others to commission, a great number of theatrical portraits "in character" and subject pictures that today form a remarkable porthole into the blossoming world of the London stage in the third quarter of the eighteenth century. Through Garrick, Zoffany gained access to the circle of the prime minister, the Earl of Bute, and the Scottish noblemen and bankers who surrounded him. For them he produced numerous fine conversation pieces, adapting his semi-rococo German manner to this supremely indigenous genre of English group portraiture with particular élan.

From Lord Bute it was but a short distance to the youthful King George III and Queen Charlotte, with whom Zoffany could speak German—his English was appalling—and at whose command he eventually traveled to Florence. There he painted for the queen his remarkable view of the Tribuna in the Uffizi, replete with clusters of English Grand Tourists. In 1771, displaying not for the first time an inclination to wanderlust or at least restlessness, Zoffany arranged to accompany Sir Joseph Banks on Cook's second circumnavigation but withdrew because of a dispute over the cramped nature of his living quarters aboard the *Resolution*. In 1783, restless once more, Zoffany sailed for India, where he was immediately taken up by Governor-General Warren Hastings. He lived and worked in India for five

years, captivated by the subcontinent and its various communities of princes and occupiers. He made a fortune there and eventually returned to London, where he continued to paint Indian subjects but gradually declined, through self-quotation and dotage, to senility. In 1811 Frau Zoffany sold her husband's collection of Oriental armor and curiosities, together with the contents of his studio— his books, prints, and mementos.

Selected Literature: Webster, 1977; Pressly, 1999; *ODNB*. AT

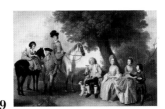

39

The Drummond Family, ca. 1769
Oil on canvas; 41 ½ x 63 in. (104 x 160 cm)

PROVENANCE: Andrew Drummond[?]; his son John Drummond, by descent to 1959; Leggatt Bros., 1959; Agnew, 1959; Ackerman and Johnson, 1962; bt Paul Mellon, 1962
SELECTED EXHIBITIONS: Park Lane, *Conversation Pieces*, 1930; VMFA, *Painting in England*, 1963, no. 298; RA, *Painting in England*, 1964–65, no. 205; YUAG, *Painting in England*, 1965, no. 238; NPG, *Treasures and Curiosities*, 1968
SELECTED LITERATURE: Manners and Williamson, 1920; Williamson, 1931, p. 16; Sitwell, 1937, pp. 38, 59
B1977.14.86

This ambitious group portrait shows three generations of the family of the Scottish goldsmith and banker Andrew Drummond (1688–1769), a widower. The date of Mr. Drummond's death, in 1769, has generally been taken to indicate a *terminus ante quem* for the painting, but it is not entirely certain that his inclusion in the family group, sitting with his dog and somewhat isolated in the middle, was not a commemorative gesture of reverent piety postmortem. In 1766 Zoffany had painted an oval single-figure portrait of Andrew Drummond that obviously provided him with the model for this part of the composition. In both, he took care to include Dr. Drummond's expensive snuffbox, his splendid malacca cane with a gold crutch handle, and, most important, the dog (seated this time on the garden seat). The cane and snuffbox are still owned by Drummonds Bank.

Mr. Drummond's son, one of the members of Parliament for Thetford, John Drummond (1723–74), stands to the left with his son and daughter, their ponies, and a groom. John Drummond's aristocratic wife, Lady Charlotte (née Beauclerk, the family of the dukes of St. Albans), and their two other children complete the right-hand side of the composition. Andrew Drummond's bank was particularly well patronized by artists, including Thomas Gainsborough, the sculptor Henry Cheere, the plasterer Joseph Rose, the architects Sir William Chambers and Henry Holland, and the landscape gardener Lancelot "Capability" Brown. Zoffany himself opened an account at the

bank in 1765. Later, members of the Drummond family were crown contractors for the payment of British troops during the American War of Independence. AT

Joseph Wright of Derby (1734–97)

Joseph Wright of Derby was one of the most unconventional British artists of the eighteenth century. He is best remembered for his remarkable series of "candlelight" paintings, many of which he exhibited in London at the Society of Artists. It was in response to his highly original and virtuoso handling of artificial light penetrating gloom that the critic of the *Gazetteer* made the slightly puzzled assessment that "Mr. Wright, of Derby, is a very great and uncommon genius in a peculiar way" (23 May 1768). For, as Judy Egerton has observed, the source of light, "a candle, sometimes a lamp, later fire in a forge—is usually concealed but could be observed to throw powerful shadows over faces, stuffs, and objects, altering perceptions of color itself as objects receded from light" (*ODNB*). These pictures are sophisticated essays in optics.

Wright was the son of an attorney. Apart from two relatively brief periods of apprenticeship in the London studio of Thomas Hudson, Wright's early career as a portrait painter unfolded in his native Derby, and in the Midlands generally. Gaining steadily in confidence and skill, he began to experiment with the candlelight paintings in the early 1760s, and his apparently effortless portrayal in them of technical and scientific equipment probably reflects Wright's acquaintanceship with Erasmus Darwin, Josiah Wedgwood, and other men of science and industry in the Midlands. His greatest paintings from this period, *The Philosopher Giving a Lecture on the Orrery* (1766, Derby Museum and Art Gallery) and *Experiment on a Bird in the Air Pump* (1768, Tate, London), established Wright's reputation in London, largely owing to the circulation of engravings. He nonetheless stayed in Derby.

Wright was nearly forty when he departed for Italy in 1773, far older than many artists who undertook the Grand Tour as young students. Perhaps because of this, Wright's response to what he saw during his two years in Rome and Naples was highly idiosyncratic. Partly shaped by his passion for, and mastery of, strong light, penumbra, and nocturnal effects, he was attracted to the subjects of Roman fireworks, of deep-hewn grottoes near Salerno, south of Naples, and of Mount Vesuvius, which conveniently erupted in October 1774. These subjects equipped Wright with subject matter for studio pictures over the next twenty years. On his return to England, and after dallying briefly in Bath, where he hoped to fill the shoes of the recently departed Thomas Gainsborough, Wright once again exhibited his strong homing instinct and at length returned to Derby, where he worked the rest of his life.

The Yale Center for British Art owns a fine collection of paintings by Wright, representing most phases of his career: as a sometimes tentative portrait painter; as a Grand Tourist and highly original painter of Italianate landscape; as a painter of unusual literary subjects, to which he was increasingly drawn in his later years, and of current events—preferably pyrotechnic—such as the defense of Gibraltar; and, finally, as a painter not of the rich soil of Suffolk (as in Constable) but of the hard rocks and escarpments of his native

Derbyshire. He suffered from debilitating bouts of depression but loved music and played the flute.

Selected literature: Nicolson, 1968; Egerton, 1990; Jones, 1990; Solkin, 1993; Daniels, 1999; Hargraves, 2006. AT

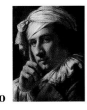

40

Portrait of a Man, ca. 1768
Black, white, and brown chalk and charcoal on laid paper; 14 ¼ x 11 ¾ in. (36.2 x 29.8 cm)

PROVENANCE: Mortimer Brandt; bt Paul Mellon, 1965
SELECTED EXHIBITIONS: NGA, *Wright of Derby*, 1969–70, no. 1; YCBA, *English Portrait Drawings*, 1979–80, no. 72; YCBA, *Line of Beauty*, 2001, no. 12
SELECTED LITERATURE: Nicolson, 1968, vol. 1, pp. 38, 229
B1977.14.6320

This portrait belongs to a relatively small group of monochrome drawings that Wright executed in the late 1760s and early 1770s in chalk. Despite the friability and dryness of the medium, the effects of light achieved here have much in common with the most adventurous oil paintings in which Wright pursued the study of highly complex effects of natural and artificial light in gloom: either natural gloom, as in the penumbra of twilight or the pitch darkness of night, or the gloom of interrupted or banished daylight. The consensus of opinion is that these drawings demonstrate Wright's interest in, not to say indebtedness to, the medium of mezzotint, which had been used in May 1768 by William Pether to reproduce Wright's somewhat sensational, recent *The Philosopher Giving a Lecture on the Orrery*, the first such reproductive print to be published after a work by Wright, and therefore, for any artist, a moment laden with professional and personal promise. But Wright had easy access to a plentiful supply of other models in mezzotint for life-sized portrait heads.

When Paul Mellon bought the present drawing, it was thought to be a self-portrait and was published as such several times. However, it bears only a vague and superficial resemblance to securely documented self-portraits by Wright (ten in number) and indeed differs from them in several respects, namely, the cleft chin and the nose, which is much larger than Wright's and decidedly hooked by comparison. Instead, Gillian Forrester has raised the possibility that this is a portrait of the artist's good friend Peter Perez Burdett. Wright had painted Burdett and his wife in 1765, and Burdett reappears as a model in several of Wright's subject pictures, including the *Orrery* and *Three Persons Viewing the Gladiator by Candle-Light* (1765, private collection). The presence of fancy costume in this portrait, particularly the "Van Dyck" collar and cuff, which are also conspicuous in Wright's *Academy by Lamplight* (cat. 41), of around 1768, is consistent with David Solkin's suggestion that in the latter work

"we are dealing with the projection of an imagined ideal as opposed to a portrayal grounded in reality" (Solkin, 1993, p. 242). Wright's methods and recurring preoccupations defy easy categorization, however, and a form of dress that elsewhere conjures something of the formality and performance of masquerade here frames a portrait head of startling, disarming intimacy, and Rembrandtesque warmth. AT

41

An Academy by Lamplight, ca. 1768–69
Oil on canvas; 50 x 39 ⅜ in. (127 x 101.2 cm)

PROVENANCE: Peniston Lamb, 1st Baron Melbourne (later 1st Viscount Melbourne), by descent to George Buxton Browne, who presented the painting to the British Association for the Advancement of Science, 1919; Royal College of Surgeons, London; Gooden and Fox, 1964; bt Paul Mellon, 1973
SELECTED EXHIBITIONS: SA, 1769, no. 197; AGNSW, *Eden*, 1998, no. 17; Louvre, *D'Après l'antique*, 2000–01, no. 153
SELECTED LITERATURE: Nicolson, 1968, no. 189; Haskell and Penny, 1981, p. 281; Solkin, 1993, pp. 239–46; Hargraves, 2006, p. 97
B1973.1.66

The academy students, each suggesting a different stage in the awakening of artistic genius, are gathered around a copy of the famous Hellenistic sculpture *Nymph with a Shell* (Louvre), which was widely known through casts and reproductions. But while Wright alludes to an artistic exemplum, he has also grounded his subject in fact. Art students were regularly given the exercise of drawing sculpture in lamplight and candlelight. Showing the sculpture as though warmed into life by the glow of the candles, Wright pays homage to the transformative, enlivening, even magical powers of light. He may also be gently alluding to the famous classical legend of Pygmalion, King of Cyprus, who carved a statue of Venus, the goddess of love, and in so doing fell in love with it. In answer to his prayers, the goddess herself inhabited the statue and made it come alive.

Somewhat more prosaically, it has recently been shown that this painting and its companion, *Philosopher by Lamplight* (Derby Museum and Art Gallery), which Wright exhibited with the Society of Artists at Spring Gardens in May and early June 1769, offered a terse commentary upon the recent establishment of the Royal Academy under the presidency of Sir Joshua Reynolds. In the context of contemporaneous art-world politics, the *Philosopher by Lamplight* was "at once both a learned reworking of Salvator Rosa for the connoisseurs, and perhaps also a fitting warning to the new RAs about the transience of earthly glory," while the Academy formed a kind of "critique of the hierarchical structure of the new RA by contrasting it with an ideal democratic school with clear allusions to the now defunct St. Martin's Lane Academy" (Hargraves, 2006, p. 97). JMA and AT

Jonathan Skelton (ca. 1735–59)

Of Jonathan Skelton's early life, little is known. He remained an obscure figure during the 150 years that followed his death. His name—and his place within British art—was unexpectedly revived in the 1909 sale of the Blofield collection, in which there were no fewer than eighty-four watercolors from his hand. His early work has been stylistically linked to that of George Lambert, who enjoyed a considerable reputation in Britain as a pioneer of English landscape painting (and who presumably was Skelton's teacher). Although no records document the English portion of Skelton's life, the dates inscribed on some of his drawings give clues as to his whereabouts: Croydon in 1754, London in 1755 and 1757, and Rochester and Canterbury in 1757. He went to Italy in 1758, where he produced most of his oeuvre. The last years of his life are better known, detailed by the letters he wrote from Italy to his patron, William Herring of Croydon. From this correspondence, which forms an invaluable source of information about artistic life in mid-century Rome, we learn that he frequently drew and painted outside of the studio. He was among the very first British watercolorists to depict the Italian landscape en plein air. He died in Rome, in his mid-twenties, from a duodenal ulcer.

Selected Literature: Ford, 1960; Pierce, 1960; White, 1977, p. 28; *Dictionary of Art*; Lyles and Hamlyn, 1997, pp. 100–103. SR

42

Harbledown, a Village near Canterbury, 1757
Watercolor with pen and gray ink over graphite on laid paper, laid down on contemporary mount; 8 x 21 ⅛ in. (20.3 x 53.7 cm)
In pen and black ink, on verso: *Harbledown Hospital J. Skelton 1757*; in pen and black ink, on mount, now detached: *Harbledown, A village near Canterbury/ J: Skelton 1757/N: B: Drawn immediately after a heavy Summer-Shower*

PROVENANCE: T. C. A. Blofield, to 1909; George Thorne-Drury; Mrs. S. M. Cowles, sold, Sotheby's, 13 July 1966 (10); bt Colnaghi; bt Paul Mellon, 1966
SELECTED EXHIBITIONS: Victoria, *British Watercolour Drawings*, 1971, no. 38; PML, *English Drawings*, 1972, no. 43; AFA, *British Watercolors*, 1985–86, no. 33; YCBA, *Line of Beauty*, 2001, no. 133
SELECTED LITERATURE: Pierce, 1960, no. 28
B1975.4.1956

This watercolor was made shortly before Skelton's trip to Italy, from which he was never to return. It belongs to a set of eight views of Canterbury and its vicinity, of which four are in the Paul Mellon Collection (YCBA). Harbledown was the last village that pilgrims encountered before arriving at the ancient cathedral city of Canterbury, one and a half miles away. From atop the hill on which Harbledown is located ("Bobbe up-and-down" as the village was once referred to by Chaucer in

his *Canterbury Tales*), pilgrims would have an unimpeded view of the cathedral. The road at the forefront of Skelton's composition is known today as the old Pilgrims Way, linking London to Canterbury. Hardly recognizable amid its densely wooded surroundings is the church of St. Nicholas, or "Harbledown hospital" (the subject is given by Skelton himself on the sheet's verso), still referred to nine hundred years later by locals as "The Leper Church," or leper's hospital. This lazaret, with its adjoining almshouses (many of which have not survived), was a mandatory stop for early kings en route to Canterbury.

Harbledown perfectly demonstrates Skelton's mastery in color variations. His inclination toward the observation of nature is suggested by an inscription on the old mount which reads: "Harbledown, A village near Canterbury/J: Skelton 1757/N: B: Drawn immediately after a heavy Summer-Shower." His use of the method of "tinted drawing," a technique that consisted of adding washes of colors over penciled outlines, is precise without being rigid; a full spectrum of greens and browns is exploited to effectively convey a damp atmosphere. As with other compositions in the Canterbury series, the artist represented Harbledown in a panoramic format in which the sense of depth is suggested by a wandering path. SR

Benjamin West (1738–1820)

The story that Benjamin West learned to mix colors from the local Indians in his native Pennsylvania may well be apocryphal; he was likely taught the rudiments of painting by journeymen artists in Philadelphia. The obscurity of his origins cannot be exaggerated, however, and West's life and career is one of the great success stories of the eighteenth century. Born to Quaker parents, West was the first American artist to travel to Italy, where he quickly established himself as a leading talent. During what was intended to be a short stay in London, West exhibited two of his neoclassical paintings to great acclaim and decided to settle permanently there. Success after success followed, and the artist excelled at two different genres: history painting and religious painting. His history paintings encompassed everything from Roman legends—*Agrippina Landing at Brundisium with the Ashes of Germanicus* (1768, Yale University Art Gallery, New Haven)—to nearly contemporary events, such as the *Death of General Wolfe* (1770, National Gallery of Canada, Ottawa). The artist's large religious scenes were some of the most sensational works in this genre exhibited at the Royal Academy. West's public acclaim and string of honors (Historical Painter to the King, Surveyor of the King's Pictures, President of the Royal Academy) were unmatched by his contemporaries. He was also a leading educator and advocate for young American artists in London, single-handedly founding a native school of ambitious history painters and portraitists.

Selected Literature: Erffa and Staley, 1986; Staley, 1989. CA

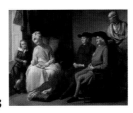

43

The Artist and His Family, ca. 1772
Oil on canvas; 20 ½ x 26 ¼ in. (52 x 66.5 cm)
Signed and dated (very faintly), lower left: *B. West, 1770/72[?]*

PROVENANCE: By descent in the family of Raphael West to Aubyn Margary; Agnew; bt Paul Mellon, 1964
SELECTED EXHIBITIONS: RA, 1777, no. 367; BI, 1833, no. 28; RA, *Bicentenary Exhibition*, 1968–69, no. 50; YCBA, *The Conversation Piece*, 1980, no. 60; AGNSW, *Eden*, 1998, no. 18
SELECTED LITERATURE: Leslie, 1855, pp. 292–93; Erffa and Staley, 1986, no. 546; Nemerov, 1998, p. 13; Prown, 2002; Lovell, 2005, pp. 156–58, 160, 166
B1981.25.674

Despite its small size—it measures less than twenty-seven inches across—Benjamin West's *The Artist and His Family* is a forceful statement of personal and professional ambition. The "neat little scene of domestic happiness," as it was called by the *Morning Chronicle* (25 April 1777) was probably painted with the express purpose of serving as a modello for an engraving published by Boydell in 1779. Dedicated to Catherine the Great, Empress of Russia, the print—as well as the lofty references to religious art in *The Artist and His Family*—indicates the scope of West's ambitions to be known internationally as a history and portrait painter through the calling card of this seemingly modest family picture.

The painting marks two generative events: the birth of West's second child and the reunion of the American and British members of the West family. After Benjamin West settled in London, his English-born father, John, returned from America for the first time in nearly fifty years. There, John met his long-lost son Thomas, shown as a man of fifty-six seated next to his white-haired father. This earlier reunion between John and Thomas—both practicing Quakers, as indicated by their costume—is echoed in the 1772 gathering, in which grandfather and uncle call to see the newest member of the West family.

Jules Prown has referred to *The Artist and His Family* as "a nativity in Hammersmith," denoting the sacred aura that infuses this domestic scene, probably painted at the artist's villa near the Thames in Hammersmith (Prown, 2002, p. 117). Betsy West, cradling her child in her lap, is a secular Madonna, visited by two magi in the forms of John and Thomas West. The artist, dressed in a lavender gown and holding his palette and maulstick as markers of his profession, echoes the marginalized physical placement of Joseph in traditional Nativity scenes. CA

Francis Towne (1739–1816)

One of the most distinctive watercolor stylists of the late eighteenth and early nineteenth centuries, Francis Towne is known today almost exclusively for his watercolors. For much of his career, however, he downplayed their importance, staking his claim to recognition on his oil paintings. Trained as a coach painter in London, Towne moved in the early 1760s to Exeter, which remained his base of operations for most of his life. Although he became a popular drawing teacher there, he sought recognition as an artist in London. He exhibited at the Society of Artists and the Free Society of Artists and made successive attempts, without success, to be elected to the Royal Academy. In 1780 he traveled to Italy, working in Rome with William Pars and John "Warwick" Smith and visiting Naples in the company of Thomas Jones. He returned through Switzerland with Smith in 1781, producing a series of powerful watercolors of alpine subjects. Towne's limited success with his oil paintings, combined with the rising popularity of watercolor painting in the early years of the nineteenth century, seems to have led Towne to rethink his attitude to his own watercolors. He mounted a one-man exhibition of his watercolors in London in 1805, but this was neither a popular nor a critical success. Disappointed by the lack of recognition in his lifetime and with an eye to posterity, he deposited his Italian watercolors in the British Museum. It was only with his rediscovery by A. P. Oppé in the 1920s that Towne secured a valued place in the history of British watercolor painting.

Selected Literature: Oppé, 1920; Bury, 1962; Wilcox, 1997. SW

44

Ambleside, 1786
Watercolor with pen and brown and gray ink over graphite on laid paper; 9 ¼ x 6 ⅛ in. (23.5 x 15.6 cm)
Signed and dated in pen and brown ink, lower left: *F Towne./delt 1786/No. 2*; inscribed verso, in graphite: *Morning light from the right hand*, and in ink: *No. 2 Ambleside August 7th 1786*; inscribed on verso of artist's mount (now removed): *Ambleside/drawn on the spot by/Francis Towne/August 7th 1786*

PROVENANCE: J. F. L. Wright; bt Paul Mellon, 1967
SELECTED EXHIBITIONS: AFA, *British Watercolors*, 1985–86, no. 14; Tate, *Towne*, 1997–98, no. 46
B1977.14.4147

Although the Reverend William Gilpin, the great popularizer of picturesque travel, toured the Lake District in 1772, he did not publish his observations on the tour until 1786. By that date, the Lakes had already attracted a number of writers and artists who found in its scenery native equivalents to the landscapes of Claude Lorrain, Gaspard Dughet, and Salvator Rosa. George Barrett, Philippe Jacques de

Francis Towne
John Smart
Richard Cosway
Thomas Jones

Loutherbourg, Thomas Hearne, and Thomas Gainsborough had visited the area, and Joseph Farington had actually lived and worked in Keswick from 1775 to 1781. Thomas West's *Guide to the Lakes*, first published in 1778, had gone through several editions. Thus Gilpin's publication of *Observations, Relative Chiefly to Picturesque Beauty, Made in the Year 1772, on Several Parts of England; Particularly the Mountains, and Lakes of Cumberland and Westmoreland* only confirmed and enhanced an existing appreciation of Lakeland scenery both as a subject for artists and as an object of Picturesque touring.

Perhaps spurred by Gilpin's newly published volume, Towne traveled north in the company of John Merivale and James White, two friends from Exeter, in early August. They reached the village of Ambleside, situated near the head of Lake Windermere, on August 7, the date Towne inscribed on the verso of this watercolor. Using Ambleside as the base for much of their touring, they spent two weeks in Lakes, possibly cutting short their visit because of bad weather (Wilcox, 1997, p. 107).

This watercolor, the second in the carefully numbered sequence of drawings Towne produced during the trip, shows the view looking north from Ambleside to Rydal, Grasmere, and Keswick. The artist's inscription on the drawing's original mount indicated that the watercolor was "drawn on the spot," but this would refer only to the underlying pencil outlines. These outlines were later reinforced in pen and ink: a fine line in gray ink in the distant mountains, a heavier line in brown ink in the nearer trees and buildings. Over these outlines Towne has laid flat washes of color. While the effect is formal and decorative, Tim Wilcox has argued that Towne's method of working up his watercolors was intended to emphasize their origin as sketches (Wilcox, 1997, pp. 13–15), which would seem to be supported by the additional notations on the verso about the time of day and fall of light. Towne exhibited no watercolors from the tour, nor any other Lake District subjects, until his one-man show of 1805. sw

John Smart (1741/2–1811)

Despite the celebrated miniaturist's great fame, the date and circumstances of John Smart's birth remain obscure, and the only record of his training is his enrollment at William Shipley's Drawing School in 1755, when he was approximately fourteen. In the same year, the ambitious young artist demonstrated his prodigious talents by exhibiting a drawing in the first annual Society of Arts competition, for which he was awarded second prize (Richard Cosway, who was more or less the same age, was the winner). In the succeeding three years, Smart went on to take first prize. His first miniature is dated 1760, and thereafter he rapidly established a successful practice in Soho. Unlike his contemporary George Engleheart, who worked directly from life, Smart would make detailed sketches of his sitters before painting their likenesses in watercolor on ivory; he also made delicate portrait drawings in graphite and watercolor wash.

Smart's meticulous portraits were considered remarkable by his contemporaries, both for their astonishingly "exactness," as his fellow-miniaturist Ozias Humphry termed it, and for their lack of flattery. Smart's refinement and skill as a colorist clearly were appealing to his wealthy middle-class clientele, however, and by 1798 he was commanding twenty-five guineas for a

portrait. He was also an established figure in the art world and became President of the Society of Artists in 1778. Between 1785 and 1795 he worked in Madras. On his return to London in 1795, Smart reestablished his practice, and despite having lived with or married three women, and having produced several children, on his death he left nearly nine thousand pounds. Not all his contemporaries applauded his success, however; the landscape painter Thomas Jones noted in his *Memoirs* that "however eminent he was in his profession . . . he was a man of the most vulgar manners, grossly sensual, and greedy of Money to an extreme" (Jones, *Memoirs*, p. 73).

Selected Literature: Foskett, 1964; *ODNB*. GF

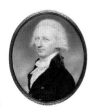

45

Colonel James Stevenson, 1796
Gouache and watercolor on ivory; 3 x 2 ½ in. (7.6 x 6.4 cm), oval
Inscribed, lower left: *JS 1796*, and on back of case: *JIS* [?] in monogram

PROVENANCE: Sotheby's, 1 June 1970 (83); bt Fry; bt Paul Mellon, 1970
B1974.2.99

Smart's restrained and meticulous style of portraiture seems to have been particularly appealing to men, and he received a considerable number of commissions from military officers. In 1785, capitalizing on the commercial opportunities offered by the British presence in India, he set up a portrait studio in Madras, where his sitters included members of the British army as well as famous local figures including the Nawab of Arcot and the captive sons of Tippoo Sultan. Smart may have met James Stevenson in Madras, though this miniature is dated 1796, the year after the artist's return to London. The toughness implicit in Smart's austere portrait, mitigated only by the hint of a sardonic smile, is borne out by the sitter's military career. Stevenson was second in command to Arthur Wellesley, later the Duke of Wellington, during Wellesley's campaign against the Marathas in India in 1802–3. He played an important role in the decisive Battle of Assaye on 24 September 1803, which Wellesley's troops won against considerable odds and with enormous casualties. GF

Richard Cosway (1742–1821)

Richard Cosway reinvented the genre of the miniature from one of modest dimensions and ambitions to a form of public art for an age of sentimentality and showmanship. The son of a provincial schoolteacher, Cosway came to London at age twelve and rapidly established himself as one of the most talented students at William Shipley's Drawing School. He exhibited oil portraits, miniatures, and drawings at both the Free Society of Artists and the Society of Artists in the 1760s, before being admitted to the newly formed Royal Academy Schools. Elected Royal Academician in 1771, a rare

honor for a miniature painter, Cosway is represented in the right foreground of Johan Zoffany's group portrait of the Royal Academy members attending a life drawing class (1772; Royal Collection), his cane resting jauntily on the belly of a plaster torso of Venus.

The year 1780 was a watershed for the artist. He married Maria Hadfield, a talented artist in her own right, and the couple established one of the most fashionable salons of the Regency period. In that same year, Cosway painted his first portrait miniature of George IV, when he was Prince of Wales. A great favorite of the prince, Cosway was given permission to sign his works "Primarius Pictor Serenissimi Walliae Principis" (Principal Painter to His Royal Highness the Prince of Wales). Cosway's miniatures, according to the essayist William Hazlitt, "were not merely fashionable—they were fashion itself," indicating the extent to which portraiture of the period determined standards of beauty and grace (Hazlitt, *Complete Works*, vol. 12, p. 96). Cosway also painted tinted or stained portrait drawings of equal skill and fashionable appeal. After 1808 Cosway fell out of favor with the Prince of Wales, and his marriage collapsed soon afterward.

Selected Literature: Lloyd, 1995; Reynolds, 1998, pp. 127–29. CA

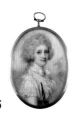

46

Elizabeth, Countess of Hopetoun, 1789
Watercolor and gouache on ivory; 3 x 2 ⁵/₁₆ in. (7.6 x 5.9 cm), oval
Inscribed, in pen and brown ink, on a label attached to the back: *Eliza/Countess of Hopetoun/R ᵈᵘˢ Cosway R.A./Primarius Pictor/Serenissimi Walliae/Principus/Pinxit/1789*
B1974.2.18

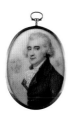

47

James Hope, 3rd Earl of Hopetoun, 1789
Watercolor and gouache on ivory; 3 x 2 ⁵/₁₆ in. (7.6 x 5.9 cm), oval
Inscribed, in pen and brown ink, on a label attached to the back: *James/Earl of Hopetoun/R ᵈᵘˢ Cosway R.A./Primarius Pictor/Serenissimi Walliae/Principis/Pinxit/1789*
B1974.2.19

PROVENANCE: A. P. Cunliffe, sold, Sotheby's, 20 Nov. 1945 (37); bt Sydney; Christie's, 18 Feb. 1969 (118); bt Fry; bt Paul Mellon, 1969

SELECTED EXHIBITIONS: YCBA, *English Portrait Drawings*, 1979–80, nos. 52, 53; SNPG, *Cosway*, 1995, nos. 67 and 68; YCBA, *Line of Beauty*, 2001, nos. 19, 20

Cosway used his signature method of sticking closely to the tone of the ivory support in these portraits of the Earl and Countess of Hopetoun (1741–1816 and 1750–93, respectively). He limited his palette to blue, gray, white, and black, with pink highlights on the cheeks and lips, and the colors were made as transparent as possible before application. They seem to float on the ivory background, which is visible in sections of the countess's gown that are untouched by watercolor or gouache. Although the faces are rendered with delicate strokes of paint, Cosway freely applied his signature blue in the background.

The Earl and Countess of Hopetoun were acquainted with the Cosways at least three years before these portrait miniatures were painted. In 1786 their daughter Eliza recorded having seen an "excessively handsome" miniature of the Prince of Wales at the Cosways' home and studio (*Troubled Life*, 2000, p. 7). What prompted the Hopes to sit for Cosway in 1789, particularly in the somewhat unusual format of a pair of pendant miniature portraits, is not known. By this date Eliza had died, after a long and painful illness, and it is likely that the black ribbon pinned to the countess's gown is a memorial to her daughter. In letters to her husband during Eliza's last days, the countess lamented "those repeated bleedings" that had been advised by the doctors, imploring "May the Almighty forgive me for allowing her to be reduced in that manner" (*Troubled Life*, 2000, p. 8). Cosway executed one of his pencil and watercolor portraits of the countess with two of her other daughters (ca. 1790; National Gallery of Scotland, Edinburgh). One of the girls gestures to an angel in the sky, no doubt meant to represent either Eliza or her sister Jamima, who had died at age three. CA

Thomas Jones (1742–1803)

The son of a Welsh landowner, Thomas Jones studied at Jesus College, Oxford, before moving to London to pursue a career as a painter. He trained for a year at William Shipley's Drawing School and for two years in the studio of his fellow Welshman Richard Wilson. By the late 1760s he was successfully exhibiting and selling grand historical landscape paintings in Wilson's manner. For his personal pleasure rather than public consumption, Jones also began to paint small plein-air oil studies of his native Radnorshire. He continued this practice of making private oil sketches outdoors during his stay in Italy between 1776 and 1783.

Jones is chiefly known today for these remarkably modern-looking oil sketches of Italy and for his memoirs, with their lively and informative insider's account of life in the British artistic community in Rome. The memoirs, however, were not published in their entirety until 1951; similarly, the oil sketches, which remained in Jones's family, were virtually unknown until a group of them came on the market in 1954.

Already familiar with the beauties of the Italian landscape from his studies with Wilson, Jones proclaimed Italy "Magick Land." He became part of a convivial group of young British artists based in

Rome, including William Pars, John Robert Cozens, Francis Towne, and John "Warwick" Smith. Jones visited Naples in 1778–79 and again from 1780 to 1782, when he painted many of his most striking oil studies. Although he had some success in Rome selling large oil landscapes to visiting Grand Tourists, the prospects for making a living from his art had dimmed by the time of his second stay in Naples. Returning to London in late 1783, Jones continued to struggle to make a living as an artist. When he inherited the family estate of Pencerrig in 1787, he moved back to Wales and his professional career ended.

Selected Literature: Jones, *Memoirs*; Edwards, 1970; Gowing, 1986; Hawcroft, 1988; Sumner and Smith, 2003. SW

48

The Claudean Aqueduct and Colosseum, 1778
Watercolor over graphite with gum on laid paper; 10 ¾ x 16 ¼ in. (27.3 x 41.3 cm)
Inscribed in graphite, upper right: 2; upper center: *part of the Antique Aqueduct that convey'd water to M. Palatine-/May 1778* [partly erased]/2 *the Collosseo*- and lower right: *vineyard*

PROVENANCE: By descent in artist's family to Canon J. H. Adams, sold, Sotheby's, 27 Nov. 1975 (90); John Baskett; bt Paul Mellon, 1975
SELECTED EXHIBITIONS: Marble Hill, *Jones*, 1970, no. 38; YCBA, *Classic Ground*, 1981, no. 68; YCBA, *Presences of Nature*, 1982, no. 3:14; YCBA, *Line of Beauty*, 2001, no. 101; NMGW, *Jones*, 2003–4, no. 90
B1981.25.2637

Like the oil sketches on which his modern reputation largely rests, Jones's watercolors were meant not for sale or public display but for his personal amusement and reference. In his memoirs Jones recorded "making some Drawings in the garden belonging to the English colledge upon Mount Palatine" on 21 May 1778 (Jones, *Memoirs*, p. 72). This watercolor, together with another of a similar view in a private collection (Sumner and Smith, 2003, no. 89), were presumably the drawings made that day. At least Jones would have done the graphite underdrawing on the Palatine. The actual working up of his drawings in watercolor, quite highly finished for sketches done outdoors, may have taken place later. Despite the popular modern conception of Jones as a plein-air artist, derived from his oil sketches, it seems likely that the drawings were not finished on the spot. As Greg Smith has suggested, Jones's standard practice was probably to draw on site with graphite and add watercolor later (Sumner and Smith, 2003, pp. 185–99). Although the watercolors may lack the plein-air immediacy of the oil sketches—and we may question whether some of the oil sketches may also be less spontaneous creations than they appear—they, nonetheless, have an undeniable sensitivity and delicate beauty. SW

William Pars (1742–82)

One of the most widely traveled and influential of eighteenth-century British draftsmen, William Pars produced groundbreaking watercolor views of Greece, Asia Minor, and the Alps. A London native, he studied at William Shipley's Drawing School and later taught there. In the early 1760s he worked as a portrait painter, exhibiting with the Society of Artists. In 1764 the Society of Dilettanti, an association of gentlemen formed to promote the appreciation of ancient art, commissioned Pars to accompany Richard Chandler and Nicolas Revett's expedition to record the classical antiquities of Asia Minor. In 1769, the society published Pars's watercolors from the expedition as illustrations to Chandler's account, under the title *Ionian Antiquities.* That same year, seven of Pars's views in Greece were exhibited at the Royal Academy, and the following year he was elected Associate Academician. Images from Pars's stock of drawings of Greece were subsequently aquatinted by Paul Sandby (1776) and used as illustrations in Stuart and Revett's *Antiquities of Athens* (1789).

Pars accompanied one of the Dilettanti, Henry Temple, the 2nd Viscount Palmerston, on tours of Switzerland in 1769 and of Ireland and the Lake District in 1771. Alpine views derived from the Swiss tour were engraved and exhibited at the Royal Academy in 1771. For another of the Dilettanti, Horace Walpole, Pars produced views of Strawberry Hill, used to illustrate Walpole's published description of his home in 1784.

In 1775 Pars, who had first visited Rome as part of Palmerston's entourage six years earlier, obtained the Society of Dilettanti's first award to an artist for study in Rome. Although the grant was to cover three years, Pars remained in Rome for the last seven years of his life, at the heart of a community of visiting British watercolorists that included John "Warwick" Smith, Francis Towne, and Pars's friend and housemate Thomas Jones.

Selected Literature: Wilton, *Pars*, 1979. sw

49

A View of Rome Taken from the Pincio, 1776
Watercolor over graphite on laid paper; 15 ⅛ x 21 ⅛ in. (38.4 x 53.7 cm)
Signed and dated in pen and black ink, lower left: *WPars Rome 1776*

PROVENANCE: Rimell; T. Girtin, ca. 1907; Tom Girtin; John Baskett; bt Paul Mellon, 1970
SELECTED EXHIBITIONS: PML, *English Drawings*, 1972, no. 50; YCBA, *English Landscape*, 1977, no. 50; YCBA, *Line of Beauty*, 2001, no. 100
B1977.14.4704

According to Thomas Jones, Pars took advantage of the study grant offered by the Society of Dilettanti to escape England in the company of the wife of the miniaturist Samuel Smart, with whom he was having an affair. They arrived in Rome on 25 December 1775 and took lodgings near the Via del Babuino. His companion died of consumption in 1778; Pars died four years later as the result of having caught cold while sketching at Tivoli.

Pars's watercolor, painted early in his stay in the city, shows the view from the Pincian Hill, not far from his lodgings, looking toward the church of Trinità dei Monti and the top of the Spanish Steps. Rising behind is the Palazzo del Quirinale, the papal summer residence. It was in the streets around the Piazza di Spagna that British artists and indeed many visiting artists from across northern Europe congregated. Pars masterfully gradates his watercolor tones not only to establish distance but to give an almost palpable sense of the heat and haze hanging over the city and the shimmer of sunlight on the tiled rooftops. sw

Robert Healy (1743–71)

The son of a successful architect and decorator, Robert Healy studied at the Dublin Society's Drawing Schools under the pastel painter Robert West. The School's curriculum in the late eighteenth century did not include oil painting, and, like his fellow student Hugh Douglas Hamilton, Healy specialized in pastel and chalk drawings, producing portraits and animal subjects for wealthy and aristocratic patrons. Healy exhibited at the Dublin Society of Artists in 1766 and 1767, but his promising career was cut short when he died at the age of twenty-eight, having contracted a cold while sketching cattle outdoors on the estate of Lord Mornington at Dangan, County Meath, in the summer of 1771.

Little is known about Healy's career, and the twenty-five works securely attributed to him are distinctive drawings in grisaille, that is, a subtle blend of monochrome and color pigments. Desmond Guinness has suggested that Healy and his brother William, who was also an artist, may have been color-blind; however, drawing in grisaille seems to have been a component of the curriculum at the Dublin Society Drawing Schools. Healy also may have been influenced by the monochrome chalk portrait heads and mezzotints made by the Irish artist Thomas Frye. The Schools also trained mezzotint engravers, producing some of the most important practitioners of the medium in the eighteenth century. Their work may have inspired Healy to produce his subtly modulated grisaille drawings. This affinity did not go unnoticed during his lifetime: the pseudonymous Dublin critic Anthony Pasquin observed that they were "proverbial for their exquisite softness;—they look like fine proof prints of the most capital mezzotinto engravings" (Pasquin, 1796, p. 18). An anonymous article on the Healy family in the *Public Monitor or the New Freeman's Journal*, written two years after Robert's death, characterized him as "the young deceased Healy, so much esteemed by the Nobility for his great Ability in Drawing, as none could excell him" (27 March 1773) .

Selected Literature: Guinness, 1982, pp. 84–85; Crookshank, 1994. GF

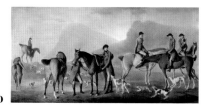

50

Tom Conolly of Castletown Hunting with His Friends, 1769
Pastel, chalks, and gouache on two joined sheets of laid paper; 20 ¼ x 53 ½ in. (51.4 x 135.9 cm)
Signed and dated, lower left: *R Healy delin^t 1769*

PROVENANCE: The Conolly family, by descent to Lord Carew; bt Hon. Desmond Guinness, sold, Christie's, 15 July 1983 (10); John Baskett; bt Paul Mellon, 1983
SELECTED EXHIBITIONS: Dublin, *Irish Portraits*, 1969, no. 76; YCBA, *Line of Beauty*, 2001, no. 92
SELECTED LITERATURE: Guinness, 1982, pp. 84–85; Crookshank, 1994, pp. 63–64
B2001.2.880

In his memoirs the Irish actor John O'Keefe recalled that his friend Healy "excelled at drawing in chalks, portraits, etc., but his chief forte was horses which he delineated so admirably that he got plenty of employment from those who had hunters, mares, or Ladies palfreys" (O'Keefe, 1826, vol. 1, p. 28). The only known evidence of Healy's work in this genre, however, is a remarkable series of eight drawings made for the Conollys of Castletown in the late 1760s. Castletown, in County Kildare, was built in the 1720s by the wealthy Whig politician William Conolly. At his death in 1729 the Palladian mansion was still unfinished but, when his great-nephew Tom and his wife, Louisa, settled on the estate in 1759, they undertook an extensive program of renovations. Castletown was renowned for its informal hospitality, and in 1768–69 Healy chronicled the traditional recreations of hunting, shooting, and skating enjoyed by the Anglo-Irish aristocracy.

The centerpiece of the series is this work, which Paul Mellon purchased when the drawings were sold in 1983 and bequeathed to the Center. Made on two sheets of paper, this ambitious and refined drawing, with its friezelike composition and attenuated forms, has close affinities with the work of George Stubbs. Louisa Conolly's brother, Charles Lennox, 3rd Duke of Richmond, was an important early patron of Stubbs, and Healy may have visited Richmond's collection at Goodwood House. In any case, he probably would have known Stubbs's engravings, which he might have seen in Louisa Conolly's print room at Castletown. GF

Thomas Hearne (1744–1817)
Born in Gloucestershire, Thomas Hearne, though apprenticed to a London pastry cook, showed considerable artistic talent and in 1763 and 1764 was awarded prizes for drawings by the Society of Arts. Between 1765 and 1771 he was indentured to the eminent line engraver William Woollett but continued to exhibit landscape and architectural drawings. When his apprenticeship came to an end, he chose to pursue a career as a draftsman. In 1771, Hearne met Sir George Beaumont, who was to become an important patron; that same year he accepted a commission to work as a draftsman for Sir Ralph Payne, Governor-General of the Leewards Islands.

After his return to England in 1775, Hearne never went abroad again, perhaps traumatized by his experience of colonial life. He did, however, travel extensively in Britain with Beaumont, producing an ambitious series of drawings that were engraved by William Byrne and published as *The Antiquities of Great Britain* between 1778 and 1781. Conservative in his politics, Hearne was a staunch supporter of the Church of England and the monarchy, and his drawings of the landscape and topography of the Caribbean and Britain subtly reinforce a sense of social and political order. Hearne's watercolors are extremely refined, mirroring his personality (shortly before his death, Beaumont wrote of him, "Hearne has risen daily in my esteem; a man of purer integrity does not exist" [Hardie, 1967–68, vol. 1, p. 173]). Toward the end of his career, his style of tinted drawing had become unfashionable, but Hearne trenchantly resisted making concessions to modern artistic developments, declaring in 1809 that "there is now an established false taste and the public mind is so vitiated that works simple and pure would not be relished," and denouncing the sky in one of Turner's oil paintings as the work of a "Mad man" (Morris 1989, p. 137). After 1793 Hearne ceased exhibiting his works, and in his later years he was supported by a few loyal patrons, notably Thomas Monro, who also paid for his funeral in 1817.

Selected Literature: Morris and Milner, 1985; Morris, 1989. GF

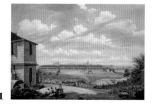

51

A View on the Island of Antigua: The English Barracks and St. John's Church Seen from the Hospital, ca. 1775–76
Watercolor with pen and gray ink over graphite on laid paper laid down on card; 20 ¼ x 29 in. (51.4 x 73.7 cm)

PROVENANCE: Ralph Payne, 1st Baron Lavington, sold, Jabert, 5 July 1810 (15); Squire Gallery; Walker's Galleries, 1951; bt Ray Livingston Murphy; Christie's, 19 Nov. 1985 (38); bt Paul Mellon, 1985
SELECTED EXHIBITIONS: YCBA, *Line of Beauty*, 2001, no. 77
SELECTED LITERATURE: Morris and Milner, 1985, pp. 24, 37; Morris, 1989, pp. 9–13
B1993.30.78

In 1771 Hearne began working for Sir Ralph Payne, the recently appointed Governor-General of the Leeward Islands, a group of sugar colonies consisting of Antigua, Nevis, St. Christopher's (now St. Kitts), and Montserrat. Hearne spent three and a half years making working drawings and, after his return to England in 1775, produced twenty large and highly finished watercolors for Payne, of which only eight are now known. This watercolor depicts St. John's at Antigua, the traditional center of government for the Leewards, where Payne had taken up residence, despite owning a large sugar estate on St. Christopher's. After a major slave insurrection in Antigua in 1736, the colonial government had petitioned successfully to have a regiment stationed there, but the white West Indians living on the island remained in constant fear both of another slave revolt and of a French attack from nearby Guadeloupe and Martinique.

One of Hearne's watercolors is a vivid depiction of a hurricane that devastated Antigua on the night of 30 August 1772. The Center's watercolor shows the newly rebuilt barracks and hospital and the renovated courthouse, as well as members of the 60th Royal American Regiment at exercise. The drawing functions as a pendant to Hearne's image of the hurricane; if the violence of the storm is read as metaphor for insurrection and political instability, then Hearne's panoptic view reinforces the message that Antigua was a well-governed and orderly colonial possession. Eliding the conventions of the military survey and the picturesque landscape, Hearne meticulously delineates the pristine and substantial government buildings, placing the spire of St. John's church strategically at the center of the composition. He also includes discreet allusions to the sugar industry, showing, on the right, cane fields devoid of laborers, and behind, a sugar factory with a smoking chimney. Completing Hearne's account of the social hierarchy, and drawing on the stereotype of the indolent slave, is the group in the foreground, consisting of a free soldier probably of mixed race, two slave children playing in a barrel, two men playing a game of chance, who appear from their dress to be domestic slaves, and a field slave, flanked by a cornucopia of fruit. GF

Henry Walton (1746–1813)
Henry Walton, the son of a Norfolk farmer, turned to art as a profession at the relatively advanced age of nineteen. According to his friend Dawson Turner, "when sent to London in his youth with a very different destination, he showed so decided a turn for painting as to induce his friends to place him under [Johan] Zoffany, then honored with the especial patronage of George III" (Turner, 1840, p. 20). Walton enrolled at the Society of Artists academy in Maiden Lane in 1770, and one year later, having established himself as a painter of miniatures and portraits in oil, he became a member. During the same year he married Elizabeth Rust, also a miniature painter, who would exhibit at the Royal Academy as an honorary member. Walton was elected director of the Society of Artists in 1772.

In 1776 Walton began exhibiting genre scenes at the Royal Academy, but after his unsuccessful application to become an academician in 1778, he exhibited his last painting there in 1779 and retired to an estate he had purchased in Norfolk. There he continued to paint portraits and collaborated on sporting scenes with the painters Sawrey Gilpin and George Barrett. During the following decades his practice as a picture dealer became arguably more significant than his activities as an artist. He studied and purchased art in exhibitions and sales in London and Paris, with the result that "there was scarcely a picture of note in this country, with the history of which

he was unacquainted" (Turner, 1840, p. 20). He advised and sold to several major collectors, including Lord Fitzwilliam, whose collection formed the basis of the Fitzwilliam Museum. According to Turner, Walton was a "respectable artist and very worthy man. . . . There was in him a singular bonhomie, united to much shrewdness, with a vivacity sure to please, and a knowledge of art and a fund of anecdotes connected with it, equally sure to interest and to instruct" (Turner, 1840, p. 21).

Selected Literature: Turner, 1840, pp. 20–21; Bell, 1998–99; Evans, 2002. EH

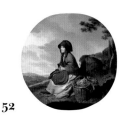

52

The Market Girl, also known as *The Silver Age*, ca. 1776–77
Oil on canvas; 22 x 22 in. (55.9 x 55.9 cm), circular

PROVENANCE: James Hughes Anderson, 1879; R. W. Nutt, 1881; Sotheby's, 19 Oct. 1949; bt Leslie Godden; Gooden and Fox; bt Paul Mellon, 1962
SELECTED EXHIBITIONS: RA, 1777; Blairman, *Walton*, 1946, no. 6; VMFA, *Painting in England*, 1963, no. 263; RA, *Painting in England*, 1964–65, no. 223; YUAG, *Painting in England*, 1965, no. 207
SELECTED LITERATURE: Bell, 1998–99, pp. 42, 44, 75
B1981.25.650

Although this painting is more commonly known as *The Silver Age*, it was first exhibited at the Royal Academy in 1777 as *The Market Girl*. It has been suggested that in his travels to Paris Walton may have become acquainted with Chardin, whose influence can be perceived in the scale, composition, and tranquil mood of the scene. The genre paintings that Walton exhibited in the mid-1770s certainly constituted a shift away from his early portraits in style and subject matter. The model may be one of Walton's nieces, who posed for several of his genre scenes.

The publisher Valentine Green assigned the alternate title when he published an engraving after this work paired with another, after a painting by Benjamin West (probably *A Domestic Scene*, RA 1776, no. 321), as *The Silver Age* and *The Golden Age*, respectively. In Ovid's *Metamorphoses*, the Golden Age was one of "immortal spring" during which the earth

> . . . yet guiltless of the plough,
> And unprovok'd, did fruitful stores allow.

During the Silver Age, spring "was but a season of the year":

> Then ploughs, for seed, the fruitful
> furrows broke,
> And oxen labour'd first beneath the yoke.
> (Ovid, *Metamorphoses*, p. 5)

The classical metaphor is not entirely apt, not least because *The Golden Age* depicts a view, through a door-

way, of a man plowing a field. Green, however, may have intended a more general association concerning the passage of time and innocence. The sleeping baby in the foreground of West's composition, blissfully unaware of the world's travails, could be taken as a younger incarnation of the market girl, bundled against the cold, whose basket of chickens signals her participation in an agricultural economy. EH

Francis Wheatley (1747–1801)

Francis Wheatley's career was shaped by the changing currents of the London art world in the late eighteenth century. As a mature artist Wheatley painted pictures specifically intended for the rapidly expanding print market, establishing a particularly fruitful relationship with the publisher John Boydell. Wheatley's subject matter from this period—sentimental genre scenes of rustic life, sometimes with a teasing undercurrent of sexuality—played on urban viewers' idealized understanding of the countryside as more innocent and desirable than the metropolis. This dichotomy between London and the country defined both Wheatley's age and his art.

The son of a London tailor, Wheatley studied at William Shipley's Drawing School and also at the Royal Academy Schools. His early professional and social life centered around his painting studio near Covent Garden, where he specialized in conversation pieces set against landscape backgrounds. But Wheatley was a mercurial individual, a gambler, a spendthrift, and a ladies' man. In 1779 he ran off to Dublin with the wife of a fellow artist. There, he painted a series of watercolors of the annual peasant fairs held in the Irish countryside, which marked a change in subject matter for the artist. At the end of 1783, fleeing from creditors, Wheatley returned to London, where he worked directly for the print market and was elected to the Royal Academy in 1791. Between 1792 and 1795 Wheatley exhibited fourteen paintings of London street vendors at the Academy's annual exhibition. Published in printed form as *The Cries of London*, this became one of the most successful graphic series of the eighteenth century. Despite this, the artist died deeply in debt.

Selected Literature: Webster, 1965; Webster, 1970. CA

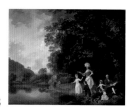

53

The Browne Family, ca. 1778
Oil on canvas; 27 ¾ x 35 in. (70.5 x 88.9 cm)

PROVENANCE: By descent to William Meredith Browne; sold, Sotheby's, 14 June 1939 (146); Agnew; Sir Austen Harris; Peter Harris; Agnew; bt Paul Mellon, 1962
SELECTED EXHIBITIONS: VMFA, *Painting in England*, 1963, no. 264; RA, *Painting in England*, 1964–65, no. 220; Leeds, *Wheatley*, 1965, no. 97; YUAG, *Painting in England*, 1965, no. 220; YCBA, *Pursuit of Happiness*, 1977, no. 1; YCBA, *Pleasures and Pastimes*, 1990, no. 16; AGNSW, *Eden*, 1998, no. 19; YCBA, *Wheatley*, 2005

SELECTED LITERATURE: Webster, 1970, p. 23 and no. 27; Praz, 1971, no. 143; Egerton, 1978, no. 133

B1981.25.675

In this portrait of George and Mary Browne and their five eldest children, Francis Wheatley has turned the conventions of the conversation piece upside down. The Browne family engage in the fashionable pursuits dictated by eighteenth-century ideals of polite behavior, but with a twist. It is Mr. Browne, Principal Clerk of the Westminster Fire Office insurance company, who serenely sketches by the lakeside, a traditionally female activity in conversation pieces. His wife, hitching up her skirt to reveal a bright pink petticoat, has confidently cast out her line and snared a catch, which her son George unhooks for her. Mrs. Browne's confident stance—hand on hip—is a variation on the pose made famous by Anthony Van Dyck in his dashing male portraits. This reversal of traditional gender roles adds a layer of narrative interest missing from so many conversation pieces, in which the sitters are arranged in a monotonous friezelike manner. The Brownes are pushed to the right side of the canvas; more than half of the picture surface is given over to the depiction of the landscape that these Londoners temporarily inhabit. In the distance we see a humble thatched dwelling, suggestive of the cottagers and peasants who would become Wheatley's dominant subject matter later in his career. CA

54

The Rustic Lover, 1786
Watercolor with pen with black ink, over graphite, on laid paper, laid down on card; 17 x 13 ¾ in. (43.2 x 34.9 cm), oval
Signed and dated, on the leg of the table: *Fr. Wheatley delt. 1786*

PROVENANCE: J. A. Pierpont Morgan; Agnew; bt Paul Mellon, 1961
SELECTED EXHIBITIONS: NGA, *English Drawings*, 1962, no. 97; YCBA, *The Exhibition Watercolor*, 1981, no. 3; YCBA, *Wheatley*, 2005
SELECTED LITERATURE: Roberts, 1910, p. 47; Webster, 1970, p. 164

B1977.14.6315

This watercolor was made as a study for the print *The Rustic Lover*, published in 1787. During his time in Dublin, Wheatley began to paint scenes of peasant life, and upon returning to London he concentrated on this genre. Here he uses his signature technique from the 1780s: a pen outline is filled in with washes of softly hued pastel watercolor.

The Rustic Lover is difficult to locate within debates about the representation of the peasant in eighteenth-century British art. On the one hand, Wheatley seems to suggest that his lower-class figures are morally compromised. The young girl's dress is slipping off her shoulder as she turns to listen to the seductive words being whispered into her ear. However, the bird (a well-known symbol for female virtue) has not yet escaped from its protective cage. Here, and in other representations of peasants, Wheatley masters a delicate balancing act between lascivious humor and innocence. His female protagonist teeters on the brink of moral failure without falling into debauchery. This tension explains the popularity of images such as The *Rustic Lover*, as well as Wheatley's later series *The Cries of London*. CA

Thomas Malton (1751/2–1804)
Thomas Malton and his brother, James Malton, both architectural draftsmen and artists, received their earliest education from their father, also named Thomas Malton. The elder Malton was a cabinetmaker, draftsman, and popular author of primers such as *The Royal Road to Geometry, or, An Easy and Familiar Introduction to the Mathematics* (1774) and *A complete treatise on perspective in theory and practice, on the principles of Dr. Brook Taylor* (1775). The younger Thomas Malton studied at the Royal Academy Schools from 1773. He showed early promise, winning a Premium from the Society of Arts in 1774 and a gold medal for theater design from the Royal Academy Schools in 1782. He exhibited regularly at the Academy from 1773 to 1803, living and working in London except for a brief period in 1790 when he joined his father in Dublin, where the elder Malton had moved to escape creditors. Although membership in the Academy and success as an architect eluded Malton, his understanding of architecture is evident in his topographical prints, such as his masterwork *A Picturesque Tour Through the Cities of London and Westminster* (1792) and *Picturesque Views of Oxford* (1802). As a drawing master, he specialized in perspective. Thomas Girtin and J. M. W. Turner studied with him; Turner would refer to Malton's work during his 1811 lectures on perspective at the Royal Academy (Davies, 1992, pp. 71–72). Malton's skill with perspective also served him well as a theater designer. He worked for Drury Lane in 1780–81 and at Covent Garden from 1790 until 1794. Critics praised his ingenious set designs, commemorated in doggerel verse by Thomas Bellamy in his *London Theatres* (1795):

> Judicious Malton! Thy receding scene
> Of architectural beauty so deceives
> The eye of Admiration, that we ask—
> "Is this majestic view *unreal* ALL?"
> The rising column, and the stately arch
> Can ne'er be picture *thus!* 'tis not in art"
> (Quoted in *ODNB*)

Selected Literature: Davies, 1992; *ODNB*. MO

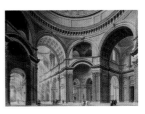

55

Interior of St. Paul's Cathedral, ca. 1792
Watercolor with pen and ink over graphite on laid paper laid down on card; 26 ¼ x 36 ⅛ in. (66.7 x 91.8 cm)

PROVENANCE: The Architectural Association; bt John Baskett; bt Paul Mellon, 1973
SELECTED EXHIBITIONS: RA, 1797, no. 709; YCBA, *Line of Beauty*, 2001, no. 129

B1977.14.6220

Throughout his career, Thomas Malton specialized in topographical views and perspective drawings such as this view of St. Paul's Cathedral. The prominent role of architects in the establishment of the Royal Academy in 1768 brought new attention to architectural drawing and the vital role of the draftsman in translating plans and elevations into perspectival renderings. Trained at the Royal Academy, Malton was highly skilled in the mathematical complexities and optical accommodations required for perspective drawings, providing some illustrations for his father's treatise on perspective. He hoped to be elected an associate of the Royal Academy as an architect. He never executed a building and having the misfortune to stand for election at the same time as John Soane, was rejected by the Academy. In a bid to establish his credentials as an artist and gain acceptance to the Academy as a painter, Malton turned his eye to the city around him, publishing the aquatint series *A Picturesque Tour Through the Cities of London and Westminster*, exhibiting watercolors in tandem with this project. This view of St. Paul's was one of a suite of views of the cathedral exhibited at the Royal Academy in 1797; the aquatint version followed in 1798. Malton admired Wren's design, devoting eight plates to St. Paul's and commenting: "The dome is a stupendous work, that cannot be viewed without surprize and delight, as the happiest and boldest production of architecture in England" (Malton, 1792, p. 68). He also probably appreciated the challenges presented to his skills by Wren's design. To convey the vast grandeur of the structure, which acts as classical basilica, tourist attraction, and society promenade, he deployed the convention known as *scena per angolo* to construct perspective along one or more diagonals rather than along a central axis. MO

John Brown (1749–87)
Born in Edinburgh, John Brown studied at the Trustees' Academy and moved to London in 1769. In the same year, he traveled to Italy with the artist David Erskine to join his close friend and fellow Scot Alexander Runciman, who was a distinguished history painter. In Rome, Brown was introduced to influential artists and connoisseurs by Erskine's cousin Charles, who held an important post at the Vatican, and he acted as a draftsman for the antiquaries Sir William Young and Charles Townley on their

John Brown
John "Warwick" Smith
James Jefferys

travels in Italy and Sicily. Brown stayed in Italy for twelve years, but only one large drawing survives from his time there, a precisely delineated view of the Basilica of Maxentius, apparently influenced by Piranesi's enigmatic views of Roman ruins, which provides a clear indication of Brown's considerable powers as a draftsman as well as his imaginative capabilities. In Rome Brown also became friendly with Henry Fuseli and evidently shared the Swiss artist's preoccupation with the uncanny, since he produced a number of drawings of fantastic and sinister genre scenes, whose subjects contrive to be deeply compelling but utterly elusive, including *The Geographers.*

Brown was highly regarded by his contemporaries for both his artistic facility and his erudition; in his introduction to Brown's *Letters on the Italian Opera* (1789), his friend and patron James Burnett, Lord Monboddo, noted that the artist "was not only known as an exquisite draughtsman, he was also a good philosopher, a sound scholar and endowed with a just and refined taste in all the liberal and polite arts and a man of consummate worth and integrity" (p. iii). Although his contemporaries record that Brown worked in oils and watercolors, none of these works seems to have survived. From his return to Edinburgh in 1781 to his death six years later, Brown appears to have focused on portrait drawings and miniatures, notably a large group of life-size pencil portraits of members of the Society of Antiquaries in Scotland.

Selected Literature: Pressly, 1979, pp. 54–63. GF

56

The Geographers, date unknown
Pen and ink and gray wash on laid paper;
7 ³⁄₁₆ x 10 ¹⁄₁₆ in. (18.3 x 25.6 cm)
Inscribed in graphite, lower right: *John Brown Romae*,
and in top right corner: *61;* on verso in graphite:
J Brown del!.
Verso: graphite sketch of a seated man reading a book

PROVENANCE: William Young Ottley, sold, T. Philipe, 20 June 1814 (1621); Sir Thomas Lawrence, sold, Christie's, 17 June 1830 (105); bt Knowles; Lady North; Leon Suzor, by 1952; Faerber & Maison; bt Paul Mellon, 1965
SELECTED EXHIBITIONS: MC, *Collections parisiennes*, 1950, no. 94; PML, *English Drawings*, 1972, no. 59; YCBA, *Fuseli Circle*, 1979, no. 61; LACMA, *Visions of Antiquity*, 1993–94, no. 7; YCBA, *Line of Beauty*, 2001, no. 58
B1977.14.4152

The subject of this enigmatic and atmospheric drawing has never been identified; it was untitled by the artist, and *The Geographers* is a later appellation. The composition is indeed dominated by the shadow of the globe looming menacingly over the foreground, but the volume over which the young men pore so intently is depicted as a tabula rasa rather than a map or travel book, and the spaces being charted are more likely those of the dark recesses of the imagination than actual geographical

sites. Originally a sheet in one of Brown's Roman sketchbooks, the drawing suggests something of the intense intellectual climate he experienced there and reflects the preoccupation with supernatural and uncanny themes explored by Henry Fuseli and his circle.

The drawing also demonstrates Brown's fascination with physiognomy, a theoretical system dating back to the Renaissance and based on the premise that facial expressions were an index to human personality. Brown may have become interested in the subject through his association with Fuseli, who made several drawings for Johann Kasper Lavater's influential treatise *Essays on Physiognomy, Calculated to Extend the Knowledge and the Love of Mankind.* The young man seated nearest the viewer in Brown's drawing has a classical profile—in physiognomonic terms, indicative of nobility of character—whereas the hooked noses and scowling expressions of the standing men hint at their villainous nature. Brown, who made numerous drawings of heads, was described by the amateur artist and connoisseur William Young Ottley as having "a peculiar talent in delineating the human physiognomy which he prosecuted with utmost diligence and perseverance, frequently following a remarkable character day after day until he completely succeeded in obtaining his resemblance and character" (Ottley, 1814, lot 1621).

The Geographers has a distinguished provenance; it belonged to Ottley, who studied briefly with Brown and purchased the contents of the artist's studio after his death, and was subsequently owned by Sir Thomas Lawrence. GF

John "Warwick" Smith (1749–1831)

The son of a gardener to the Gilpin family in Cumberland, John "Warwick" Smith studied with the animal painter Sawrey Gilpin and accompanied the Reverend William Gilpin on sketching tours in the 1770s. With the financial backing of George Greville, 2nd Earl of Warwick, Smith traveled to Italy in 1776. There he worked with William Pars, Thomas Jones, and Francis Towne. Within this group he developed the watercolor practice of working directly in color, without monochrome underpainting, an innovation for which he was later given much credit. Smith traveled home through the Alps with Towne in 1781.

On his return to England, Smith established himself in Warwick. Although Italian subjects continued to be a staple of his watercolor production, he made sketching expeditions in Wales, Scotland, and the Lake District. He contributed illustrations to various topographical publications; his *Select Views in Great Britain* appeared in 1784 and 1785 and *Select Views in Italy* between 1792 and 1799. Once considered a pioneering practitioner of the art of watercolor, by the time the Society of Painters in Water-Colours was founded, in 1804, Smith's work seemed old-fashioned. Yet he was respected as an elder statesman of the art; he was elected a member of the Society in 1805 and served as its President in 1814, 1817, and 1818.

Selected Literature: *ODNB.* SW

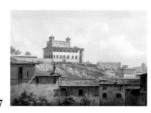

57

The Villa Medici, Rome, 1784
Watercolor over graphite on laid paper, on contemporary mount; 13 ⅝ x 20 ¼ in. (34.6 x 51.4 cm)
Signed in monogram and dated lower left: *JS 1784;*
inscribed on the back of the mount: *Villa Medici at Rome, from the Strada Babourni*

PROVENANCE: Iolo A. Williams, his family to 1970;
bt Paul Mellon, 1970
SELECTED EXHIBITIONS: PML, *English Drawings*, 1972,
no. 56; YCBA, *English Landscape*, 1977, no. 63; Speed,
British Watercolors, 1977, no. 22; YCBA, *Oil on Water*,
1986, no. 58
B1977.14.4699

This watercolor, painted by Smith when he was back
in London, shows the Villa Medici from the Via
del Babuino, the street in which Smith was living in
1780. The villa was built for Cardinal Ricci da
Montepulciano between 1564 and 1574 and was
bought by Cardinal Ferdinando de' Medici in 1576.
Still owned by the Medici at the time of Smith's
Roman visit, it was purchased by Napoleon in 1803
and became the home of the Académie Française.

An undated watercolor version, acquired from
the artist by the Earl of Warwick in 1781, is in the
British Museum. In all but a few minor details, the
Yale version replicates the earlier watercolor exactly.
Another version of the composition in oils on paper
by Thomas Jones is in the collection of the Yale
Center for British Art. Its misunderstanding of the
villa's architecture suggests that it was copied from
Smith, probably from the watercolor now in the
British Museum, several details of which (not present
in the Yale version) it reproduces. sw

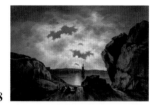

58

Bay Scene in Moonlight, 1787
Watercolor over graphite with scratching out on wove
paper; 13 ⅜ x 20 in. (34 x 50.8 cm)
Signed and dated lower right: *J. Smith 1787*

PROVENANCE: Earl of Warwick; Colnaghi, 1967; bt
Paul Mellon, 1967
SELECTED EXHIBITIONS: YCBA, *Presences of Nature*,
1982, no. 2:1; YCBA, *Masters of the Sea*, 1987, no. 48;
YCBA, *Line of Beauty*, 2001, no. 74
B1977.14.4383

Celebrated in his own time as one of the great innovators in the development of a national school of watercolor painting, Smith in his *Bay Scene in Moonlight*
produced one of the very few nocturnes in eighteenth-century watercolor painting. Earlier examples
are the various views by Paul Sandby of Windsor
Castle on rejoicing night (three versions in the Royal
Library). More likely models for Smith's evocative
nocturne are the paintings (and the prints after the
paintings) of moonlight coastal scenes by the French
landscape and marine painter Claude Joseph Vernet,
which were often part of a set of landscapes or seascapes illustrating the times of day. The solemn stillness of Smith's watercolor, however, seems to have
less in common with the night pieces of Vernet than
with the later Romantic paintings of the coast in
moonlight by Caspar David Friedrich. sw

James Jefferys (1751–84)

Born in Maidstone, the son of a portraitist and coach
builder, James Jefferys was apprenticed to the celebrated London line engraver William Woollett in
1771 and attended classes at the Royal Academy
Schools between 1772 and 1775. At Woollett's studio
he met the historical painter, draftsman, and printmaker John Hamilton Mortimer, who would become
such an important role model that it is often difficult
to distinguish between the two artists' works. Jefferys
exhibited historical drawings at the Royal Academy
and the Society of Arts and in 1774 was awarded the
Society's gold palette for his drawing, *Deluge*. The
following year, Jefferys won one of the first traveling
scholarships awarded by the Society of Dilettanti,
which enabled him to study in Rome for three years.

Soon after Jefferys's arrival in Rome, on
7 October 1775, the painter and art dealer Alexander
Day mentioned in a letter to Ozias Humphry that he
had seen a drawing by the young artist, which "had
infinite merit" (Ozias Humphry, MS correspondence,
Royal Academy, London, HU/2/16). Little other evidence of Jefferys's activities in Rome has survived,
however, excepting accounts of a turbulent love affair,
and the promising artist seems to have become something of a dilettante himself. According to Edward
Edwards, Jefferys remained in Rome for four years,
though there is no documentary evidence of when he
returned to England. His next recorded artistic activity was an album of illustrations to Chaucer, made in
1781. Two years later he exhibited his painting *Scene
at Gibraltar*, the only work he was to show at the
Royal Academy after his return from Rome. Jefferys's
career ended abruptly when he died of a fever in
1784. His drawings have often been attributed to J. H.
Mortimer or to James Barry, who was also an important influence, to the detriment of his critical reputation, but Timothy Clifford and Susan Legouix's discovery of signed drawings by Jefferys in the Maidstone
Museum and Art Gallery in the 1970s has helped
clarify some of these complex issues of attribution.
Selected Literature: Clifford and Legouix, 1976;
Sunderland, 1977. GF

59

Self-Portrait, ca. 1771–75
Pen and brown ink on wove paper; 21 ¼ x 16 ¼ in.
(54 x 41.3 cm)
Inscribed in artist's hand in pen and brown ink, lower
left: *rara avis in terra*, and lower center: *But <for>
who can paint this Character as it ought/Tho'
Wisdom cryeth out in the Streets yet/. . .*; and within
the design area: *Hon'd Sir July 26/I flatter myself I
have abilities for the Art of Painting wch/I hope will
appear by the drawing I send you, but indeed/there are
so many young Persons pursuing the same/Art, that I
think it will be a prudent Step to/drop it intirely, &
get into any kind of Business/you shall think, proper. I
make/no doubt but you will comply/with my desire
more especially/when you inform yourself how/much
the Proffession is disgrac'd/by the Folly and Vice of
many of the Proffessors . . . ;* and within the design
area: *To Mr Brinchl[?ey]* and *Pride led by the/Passions
a Design from Spensers/Faery Queen;* in a later hand
in pen and brown ink, lower right: *Pen & Ink
Drawing by Mortimer*

PROVENANCE: John Newington Hughes [?]; George
Hilder Libbis, by descent to Nell Hilder Libbis, sold,
Sotheby's, 13 Mar. 1969 (67); John Baskett; bt Paul
Mellon, 1969
SELECTED EXHIBITIONS: PML, *English Drawings*, 1972,
no. 46; YCBA, *Fuseli Circle*, 1979, no. 83; YCBA, *English
Portrait Drawings*, 1979–80, no. 71; YCBA, *Line of
Beauty*, 2001, no. 149
SELECTED LITERATURE: Sunderland, 1970, pp. 326,
528 (as Mortimer); Clark et. al., 1972, no. 195 (as
Mortimer); Sunderland, 1977, pp. 279–80, nos. 77,
78; Rogers, 1993, p. 54
B1977.14.6227

This drawing is one of a pair that were traditionally
considered to be self-portraits by John Hamilton
Mortimer, to whom Jefferys was close. In 1977, however, John Sunderland suggested persuasively that
they were both of and by Jefferys, evidencing the age
of the sitter (Mortimer was some ten years older), the
close stylistic affinities with Jefferys's known work, and,
most significantly, the clear reference of the drawing
in the background to *Pride Led by the Passions*
(Maidstone Museum and Art Gallery), a drawing firmly
attributed to Jefferys. Sunderland's identification of
sitter and maker is now accepted.

The drawings depict front and back views of the
artist, like two sides of a coin, and present contrasting
aspects of the artistic life: disaffection and creativity.
In the Center's drawing, Jefferys, wearing seventeenth-century costume and with romantically disheveled
hair, holds a letter, apparently addressed to his godfather and early patron John Brenchley, in which he
threatens to renounce his chosen profession. The
inscription in the lower margin, "Rara avis in terra,"
meaning "a rare bird on the earth," is a quotation
from the Roman satiric poet Juvenal, alluding, though

James Jefferys
John Robert Cozens
George Engleheart
John Flaxman

perhaps not unironically, to Jefferys's exceptional gifts and special status as a creative artist.

The companion drawing, now in the National Portrait Gallery, London, shows the youthful genius with *porte-crayon* in hand, momentarily pausing from his labors on a drawing of the Massacre of the Innocents to confront his audience (which presumably might include his "Professors," whose "Folly and Vice" he castigates in the inscription on the Center's drawing) with his intense stare.

Although Jefferys's portrayal of himself as a young misunderstood genius is very beguiling, there is clearly a strong element of posturing in these self-portraits, as Jefferys's career in fact began extremely well. The artist did not live to fulfill his youthful promise, however (in this respect his self-portraits seem to have been somewhat prophetic), and he died in London at the age of thirty-two, allegedly having wasted his considerable talents through dissipation. GF

John Robert Cozens (1752–97)

A nervous breakdown in 1794 put an end to John Robert Cozens's career. By then he had worked long enough to revolutionize British watercolor painting, turning it from a utilitarian art form into a serious branch of painting in its own right. He had, naturally, trained with his father, Alexander Cozens. In 1776 he served the young Richard Payne Knight as draftsman on his Grand Tour, sketching the landscapes they saw in Switzerland and Italy. When Payne Knight returned to England, Cozens stayed behind in Rome, joining the expatriate community of British artists then living in the city. On his return to London in 1779, he worked his sketches up into finished watercolors, presenting a portfolio of them to Knight. Their success led to requests for replicas from a small circle of connoisseurs, one of whom was the young William Beckford.

Cozens's fortunes were tied to Beckford for the next stage of his career. In 1782 Beckford set off for Italy traveling like a prince, with an entourage that included Cozens as his draftsman. Cozens remained in Italy until 1783, and once back in England he produced almost one hundred watercolors for Beckford as well as variants for other collectors. His work for this series introduced into watercolor a new depth and consistency of tone and a technique of coloring in layered washes similar to oil glazes that transformed topographical views into affective landscape visions. During his final illness he was treated by Dr. Thomas Monro, a specialist in mental disorders as well as a keen watercolor collector and patron. His collection of Cozens's drawings proved a decisive influence on the next generation of landscape artists such as Thomas Girtin and J. M. W. Turner. Constable, another admirer, put Cozens's achievement succinctly: "He was the greatest genius that ever touched landscape" (Leslie, 1843, p. 99).

Selected Literature: Sloan, 1986. MH

60

Galleria di Sopra, Albano, ca. 1778
Watercolor and graphite on wove paper laid down on contemporary mount; 14 ¼ x 20 ¹³⁄₁₆ in. (36.2 x 52.9 cm)
Inscribed lower left in a later hand: *AC*

PROVENANCE: Manning Galleries, to 1966; bt Paul Mellon, 1966
SELECTED EXHIBITIONS: Victoria, *British Watercolour Drawings,* 1971, no. 10; YCBA, *English Landscape,* 1977, no. 74; YCBA, *Cozens,* 1980, no. 92; Denver, *Glorious Nature,* 1993–94, no. 37
SELECTED LITERATURE: Sloan, 1986, p. 132
B1975.4.1904

When in Rome, Cozens bought himself an ass to enable him to tour the city's environs more easily. Lake Albano was a short ride from Rome and an essential stopping place for any traveler visiting Italy. Perched above this volcanic lake stands Castel Gandolfo, where Pope Urban VIII (1568–1644) built a small palace as an occasional retreat from Rome. To facilitate transport between the palace and the neighboring town of Albano, Urban began the Galleria di Sopra, a winding, tree-lined road that offered occasional views of Lake Albano, on one side, and of the Roman Campagna, on the other. In 1778 the 4th Earl of Bristol thought "a more romantic spot cannot be seen" and marveled at the "oldest and most venerable oaks, as well as chestnuts, that I ever saw" lining the road (Oppé, 1952, p. 135). Sketches Cozens made on the spot provided the basis of a number of drawings of the Galleria di Sopra, most being variants of what was essentially the same design. This unfinished drawing is, however, unique, both in focusing on the road itself, rather than the prospect of the Campagna, and in showing an approaching storm. Here a pair of goatherds hurries along the road to escape the oncoming tempest seen blowing in from the right, the trees already buffeted by advance winds. The emphasis on human vulnerability in the face of the forces of nature suggests a depth of meaning that puts this work beyond mere topography and reveals a debt to his father's theory of the intellectual potential of landscape painting. The lack of finish also displays Cozens's innovative handling of watercolor: in some areas he uses gray underwashes, whereas in others he applies pure pigment in layers directly onto the white paper, giving the green leaves of the right-hand tree a jewel-like intensity of color. MH

61

The Lake of Albano and Castel Gandolfo, ca. 1779
Watercolor over graphite on wove paper; 17 x 24 ¼ in.
(43.2 x 61.6 cm)

PROVENANCE: C. Morland Agnew; C. Gerald Agnew;
D. Martin Agnew; Agnew; bt Paul Mellon, 1967
SELECTED EXHIBITIONS: PML, *English Drawings*, 1972,
no. 60; YCBA, *English Landscape*, 1977, no. 73; YCBA,
Cozens, 1980, no. 93; YCBA, *Line of Beauty*, 2001, no. 103
SELECTED LITERATURE: Bell and Girtin, 1935, no.
147 v; Hawcroft, 1971, p. 19
B1977.14.4635

Eighteenth-century popes used Castel Gandolfo as
an occasional retreat from Rome, mainly in the spring
and autumn. Cozens's view of Lake Albano is taken
from the Galleria di Sopra and captures the land-
scape at dusk, the papal villa silhouetted dramatically
against the twilit sky. To the left, a solitary goatherd
drives his flock home along the Galleria before dark-
ness falls. To British Grand Tourists, this view evoked
the very beginnings of Rome, in that Castel Gandolfo
was believed to occupy the site of Alba Longa, the
birthplace of Romulus and Remus (Northall, 1766, p.
378). When Thomas Jones visited in 1776 and walked
from Castel Gandolfo to Lake Nemi nearby, he
admired the landscape in eulogistic terms:

> This walk considered with respect to its classick
> locality, the Awful marks of the most tremendous
> Convulsions of nature in the remotest Ages, the
> antient and modern Specimens of Art, and the
> various extensive & delightful prospects it com-
> mands is, to the Scholar, naturalist, Antiquarian
> and Artist, without doubt, the most pleasing and
> interesting in the Whole World. (Jones, *Memoirs*,
> p. 55)

That this region held such an array of cultural asso-
ciations explains the exceptional popularity of the
design; there are at least eleven surviving versions of
this watercolor from Cozens's hand, each one slightly
different in atmosphere and mood. In this example
the mood is pastoral and the inclusion of the goat-
herd evokes the landscapes of Claude or the poetry of
Virgil's *Eclogues*. At the same time his archaic pres-
ence hints at what Protestant Englanders saw as the
unenlightened and backward state of modern papal
Rome. Surveying the decayed and uncultivated state
of the Roman suburbs, compared to supposed
English prosperity, William Beckford concluded they
proved "how completely the papal government con-
trives to make its subjects miserable" (Beckford,
Dreams, p. 190). MH

George Engleheart (1750–1829)

The son of a German plaster modeler, George
Engleheart enrolled at the Royal Academy Schools
on 3 November 1769, giving his age erroneously as
sixteen. Engleheart may have cherished ambitions of
becoming a landscape painter. He studied first with
the successful but impecunious George Barrett, but
probably influenced by the negative example of
Barrett's perpetually precarious financial situation, he
subsequently transferred to Sir Joshua Reynolds's
studio, where he worked as an assistant between 1773
and 1776. Engleheart exhibited miniatures at the
Royal Academy from 1773, and after leaving
Reynolds's studio rapidly established himself as a
highly successful miniaturist, working from premises
in London owned by his father. By 1776, the
upwardly mobile Engleheart had already had three
sittings from George III and in the same year set up
his own studio in fashionable Mayfair.

Engleheart worked primarily on ivory supports,
though he also occasionally made full-length colored
drawings and experimented with enamels. An artist of
extraordinary facility, he worked from life without mak-
ing preliminary studies, producing more than 4,850
miniatures during his forty-year career; his fee books,
which survive in a private collection, testify to the
consistency of his output. Engleheart's miniatures are
distinctive both for the extremely fine quality of their
draftsmanship and for their austerity. The restrained
and dignified demeanor with which Engleheart
endowed his sitters seems to have been particularly
appealing to George III, who awarded him the
appointment of Miniature Painter to the King in 1789,
whereas the Prince of Wales and his entourage evi-
dently found the more flamboyant and flattering like-
nesses produced by Engleheart's chief competitor,
Richard Cosway, more to their taste. After an extraor-
dinarily productive and lucrative career, Engleheart
sensibly retired in 1813 to his country home in
Middlesex and thereafter painted only portraits of his
family and friends, which included William Blake,
George Romney, and the poet William Hayley.

Selected Literature: Williamson and Engleheart,
1902; *ODNB*. GF

62

A Lady of the Blunt Family, ca. 1795–1800
Watercolor and gouache on ivory; 3 ⅜ x 2 ⅞ in.
(8.6 x 7.3 cm), oval
Inscribed in brown, lower right: *E*; in pen and
black ink, on a paper label attached to back:
Miss Blunt | Property of | Mrs. H. Grafton; in pen
and black ink, on a paper label attached to back:
Edward Fletcher

PROVENANCE: Mrs. H. Grafton; Edward Fletcher;
Col. E. W. Fletcher, sold, Christie's, 28 Oct. 1970
(88); bt Fry; bt Paul Mellon, 1970
SELECTED EXHIBITIONS: YCBA, *English Portrait
Drawings*, 1979–80, no. 56; YCBA, *Line of Beauty*,
2001, no. 22
B1974.2.38

The portrait miniature is associated particularly with
the sixteenth and seventeenth centuries, but this dis-
tinctive form of drawing retained its appeal through-
out the eighteenth century and indeed increased in
popularity as a middle-class clientele for portraits
evolved. Although portrait miniatures were exhibited
publicly later in the century (at the Royal Academy
they were prominently displayed around the fireplace
in the Great Room), they were generally, though not
invariably, intended for private rather than public use.
Usually commissioned to commemorate births, mar-
riages, friendships, love affairs, or dynastic relation-
ships—though sometimes made as copies of large-
scale portraits—these tiny delicate likenesses were
often housed in specially crafted cases made of pre-
cious materials and either worn as jewelry or stored
in cabinets with other images of loved ones.

As Jean-Jacques Rousseau's concept of "natural"
and close family relationships became increasingly
influential toward the end of the century, this most
private form of portraiture, like the family conversa-
tion piece, gained in popularity. Because of the inher-
ently personal and private nature of miniatures, the
identities of sitters have often been lost over the centu-
ries, particularly when the objects have left the origi-
nal owners and entered museum collections; this
sense of loss adds a particular resonance and poi-
gnancy to these commemorative images. The exact
identity of the sitter of this exquisite miniature is
uncertain, but the inscription records that it repre-
sents a "Miss Blunt." According to his fee books,
George Engleheart painted fifteen miniatures of
members of the family of Sir Charles William Blunt
between 1785 and 1812; on the basis of style and cos-
tume, the miniature can be dated to circa 1795–1800,
and it most likely depicts Blunt's third daughter,
Elizabeth (d. 1839), who married her second cousin
Sir Charles Burrell Blunt in 1801 and is recorded in
Engleheart's fee book as having sat for the artist in
1796 and 1800. GF

John Flaxman (1755–1826)

The writer William Hazlitt described John Flaxman
as "a profound mystic," one of a number of artists who
"relieve the literalness of their professional studies by
voluntary excursions into the regions of the preter-
natural, pass their time between sleeping and waking,
and whose ideas are like a stormy night, with the
clouds driven rapidly across, and the blue sky and
stars gleaming between!" (Bindman, 1976, p. 19). This
quotation encompasses the two sides of Flaxman's
production as an artist: the literalness of his book
illustrations and his industrial design work for
Wedgwood and the silversmiths Rundell, Bridge and
Rundell, and his more mystical drawings and tomb
designs, which take faith and redemption as their
subject matter.

Flaxman, the son of a London sculptor and
plaster-cast maker, was trained in his father's studio.
First exhibiting wax and plaster models at the Free
Society of Artists in London, in 1771 the younger
Flaxman won a silver medal at the Royal Academy
exhibition. He became best known for *The Apotheosis
of Homer* (1786, British Museum, London), a relief
commissioned by the Wedgwood pottery factory.
Flaxman also had great success as a designer of tomb
sculptures and by 1787 had saved enough money to

pay for a sojourn in Rome. The most path-breaking works from Flaxman's seven-year period in Italy were the drawings commissioned to illustrate Dante's *Divine Comedy* and Homer's *Iliad* and *Odyssey*. These outline illustrations made Flaxman one of the most famous artists in Europe. Returning to England as an international celebrity, he sculpted important civic monuments and delicate tomb figures that can be seen in numerous churches. He was appointed the first professor of sculpture at the Royal Academy in 1810.

Selected Literature: Bindman, 1979; Irwin, 1979; Symmons, 1984. CA

63

The Creation of the Heavens, ca. 1790–94
Pen and gray ink and gray wash on laid paper;
9 ³⁄₁₆ x 9 ⅞ in. (23.3 x 25.1 cm)

PROVENANCE: Christopher Powney and Heim Gallery, 1976; bt Paul Mellon, 1976
SELECTED EXHIBITIONS: Heim, *John Flaxman*, 1976, no. 24; YCBA, *Fuseli Circle*, 1979, no. 135; YCBA, *Romantic Vision*, 1995–96; YCBA, *Visionary Company*, 1997; YCBA, *Line of Beauty*, 2001, no. 34
SELECTED LITERATURE: Irwin, 1979, pp. 108–9
B1981.25.2586

Despite his reputation as an artist who took his principal inspiration from the ancient world, Flaxman argued in his lectures to the Royal Academy that "there are more suitable artistic subjects to be found in the Old and New Testaments than in pagan mythology" (Bindman, 1979, p. 31). *The Creation of the Heavens* is an example of Flaxman's lesser-known series of biblical drawings. In this dramatic composition the aggregate mass of God and his angels flies upward, cutting a diagonal swath across the darkened paper. Sidestepping the problem of representing the Creator's visage, Flaxman depicts God and the angels from behind, their forms simplified into a few strokes of watercolor. Stars or planets are suggested by the spots of untouched white paper surrounded by the dark watercolor wash in the background.

Locating this undated drawing within Flaxman's career is difficult. During his sojourn in Rome we know that he spent time drawing illustrations for *Pilgrim's Progress* and also biblical subject matter such as *Enoch Raised to Heaven* (1792, British Museum, London). Influenced by the Renaissance art in the Italian capital, Flaxman is clearly indebted in this drawing to Michelangelo's *Creation of the Sun, Moon, and Planets* in the Sistine Chapel. Scholars have also noted, however, the similarity between *The Creation of the Heavens* and plates from William Blake's *The First Book of Urizen* (1794). It might therefore make sense to date the drawing to after Flaxman's return to London in 1794, the same year that *Urizen* appeared. CA

Thomas Rowlandson (1756–1827)

When Thomas Rowlandson suffered spectacular losses at the gaming table, he would pick up his pencil and declare: "I have played the fool, but here is my resource" (*Gentleman's Magazine*, June 1827, p. 564). Rowlandson's gambling habit explains his prodigious output of drawings, book illustrations, etchings, and aquatints. His father, William, had been equally unsuccessful managing money. His silk and wool business collapsed in 1759, shortly after Thomas's birth. Consequently, Rowlandson grew up with his wealthy uncle and aunt.

After a respectable schooling in Soho, he underwent rigorous academic training between 1772 and 1778 at the Royal Academy Schools and at the Duke of Richmond's sculpture gallery, run by the Society of Artists. The society was right to require a letter guaranteeing his "good behaver [*sic*] on admission," because his conduct at the Academy Schools was allegedly wayward (J. Rowlandson to William Thomson, 25 Nov. 1772, SA/39/52, Society of Artists Papers, Royal Academy, London). Apparently he and his comrades delighted in shooting peas at the life models as soon as the Keeper's back was turned (Angelo, *Reminiscences*, vol. 1, p. 202). Although he began exhibiting small portrait drawings in the Academy's exhibitions, he soon found commercial success with the satirical designs of extraordinarily vibrant draftsmanship for which he became best known. In 1789 his widowed aunt died, leaving him around fifteen hundred pounds and all her effects. Thomas gradually frittered away this inheritance by carousing with such friends as the actor Jack Bannister and the artists Henry Wigstead and George Morland—hence the need to keep working. Technically, his traditional stained drawings did not change over time, for he made no concessions to the new developments in watercolor practice. Analysis of his pigments shows, however, that he used only the finest colors available to him (Hayes, 1972, p. 35). His obituarist remarked, "No other artist of the past or present school, perhaps, ever expressed so much as Rowlandson with so little effort, or with so evident an appearance of the absence of labour" (*Gentleman's Magazine*, June 1827, p. 565). MH

64

An Audience Watching a Play at Drury Lane, ca. 1785
Watercolor with pen and black ink over graphite on laid paper; 9 ⅜ x 14 ⅜ in. (23.8 x 36.5 cm)

PROVENANCE: John Baskett; bt Paul Mellon, 1976
SELECTED EXHIBITIONS: YCBA, *Rowlandson Drawings*, 1977–78, no. 5; YCBA, *Pleasures and Pastimes*, 1990, no. 118; YCBA, *Line of Beauty*, 2001, no. 88
SELECTED LITERATURE: Baskett and Snelgrove, 1977, p. 61
B1977.14.149

Rowlandson's portrayal of an audience at the theater captures the culture of display and spectatorship that lay at the heart of eighteenth-century social life

(Brewer, 1995, p. 348). Few of these spectators have actually come to watch the play. Instead they are busy studying one another and being scrutinized by figures in the surrounding boxes. Because light levels in auditoriums were not dimmed during performances, London's crowded theaters provided an ideal venue for this sport of seeing and being seen. Rowlandson was himself a regular habitué of the playhouse; his friend Jack Bannister was a leading comic actor who regularly performed at Drury Lane. Although this scene has been identified as the remodeled Drury Lane that opened in 1775, the architecture does not quite tally, making this a more generic scene of London theater life. These theatergoers occupy the first gallery level of the auditorium, a zone reserved for the polite middling orders of society. Here young gallants try their luck with the seated ladies, a practice described in a contemporary epilogue that was often delivered from the stage to close a night's entertainment. Thomas King ("Bucks Have at Ye All," 1768) described the gallery as "The *Middle Row*, whose keener Views of Bliss Are chiefly centr'd in a fav'rite Miss; A set of jovial *Bucks* who there resort, flushed from the Tavern—reeling ripe for Sport—Whisp'ring soft Nonsense in the fair One's Ear, And wholly ignorant—what passes *here*" (Pedicord, 1980, p. 247). By dispensing with a clear narrative, Rowlandson allows for an endless range of possible plots for this human drama in the theater, something he may have learned from studying French painting on trips to France. Such open-endedness infuses the scene with an erotic charge and invites the viewer to become a fellow gallery lounger, flirting with the surrounding company in a playful exchange of glances. MH

rest of his career. He also emerged as a political caricaturist during the fraught campaign over the Westminster Election. At the center of the campaign were Georgiana, Duchess of Devonshire (1757–1806), and her sister, Harriet, Lady Duncannon (1761–1821). Together they secured the election of Charles James Fox by persuading dithering voters to support their candidate—to the consternation of George III. "Neither entreaties nor promises were spared. In some instances even personal caresses were said to have been permitted, in order to prevail on the surly or inflexible" (Wraxall, 1836, vol. 1, p. 11). Here Rowlandson returns to portraiture six years after the notorious election to depict the two sisters relaxing together on a sofa with a musical score and a serenading guitarist. The matching white dresses, flowing lines, and gentle incline of heads suggest a harmonious relationship, underscored by the metaphor of musical harmony. Georgiana, on the left, was perhaps the most admired and reviled woman of her age, by turns Whig political hostess and fashion icon, novelist, and gambler. The latter vice she passed on to Harriet, who "however inferior to the duchess in elegance of mind and in personal beauty, equalled her in sisterly love" (Wraxall, 1836, vol. 1, p.8). Rowlandson's drawing reflects the fact that, in 1790, the only consolation the sisters had was in each other's company: that year, Georgiana moved to France to escape recriminations over her role in the Regency Crisis, and Harriet's husband had discovered her liaison with the playwright and politician Richard Brinsley Sheridan. Ironically, the first recorded owner of this drawing was George, 5th Duke of Gordon, son of the Tory hostess Jane, Duchess of Gordon, Georgiana's chief political rival. MH

As Archibald Alison put it, echoing earlier authors, the "fine arts are . . . addressed to the imagination, and the pleasures they afford, are described . . . as the Pleasures of the Imagination" (Alison, 1790, p. 1). In this instance three connoisseurs pay a visit to an artist's studio to judge his latest offering: a historical painting of Susanna and the Elders. While the artist gazes at the ceiling in a pose of studied nonchalance, they study his unfinished canvas. But rather than enjoy the pleasures of the imagination, these connoisseurs are content to stop at the pleasures of the flesh. Like latter-day Elders, they lust over the nude Susanna, just as their forebears had in the apocryphal addition to the Book of Daniel. One viewer seats himself within a few inches of the easel to gawk at her body, his desiccated companion peers through an eyeglass and licks his lips, and a third smirks gleefully from a greater distance. Typically for Rowlandson the humor lies in the incongruous juxtaposition of contrasts: the beauty of Susanna and the ugliness of the connoisseurs; Susanna's innocence and the connoisseurs' lust; her youth and their age. The heart of the satire, however, is found in the men's hands, which grasp their walking sticks and eyeglasses with desperate tension. Ironically when it comes to enjoying real women, Rowlandson suggests these impotent old lechers will be forced to confine themselves to the pleasures of the imagination. MH

67

A Worn-out Debauchee, ca. 1790–95
Watercolor with pen and ink and watercolor over graphite, on laid paper; 12 ⅛ x 8 ¼ in. (30.8 x 21 cm)
Inscribed lower right: *A Worn-out Debauchée*

PROVENANCE: Lady Dorothy Nevill; T. E. Lowinsky; Justin Lowinsky, to 1963; Colnaghi; bt Paul Mellon, 1963
SELECTED EXHIBITIONS: PML, *English Drawings*, 1972, no. 70; YCBA, *Rowlandson Drawings*, 1977–78, no. 37; Tate, *James Gillray*, 2001, no. 207
SELECTED LITERATURE: Baskett and Snelgrove, 1977, no. 162; Ribeiro, 1989, p. 132
B1975.3.100

By tradition Rowlandson's sprightly drawing of a decrepit bon vivant is a caricature of William Douglas, 4th Duke of Queensbury (1725–1810), or "Old Q," as he was popularly known. As the most famous rake of the later eighteenth century, his amorous exploits were the stuff of legend. The sexual appetites of this lifelong bachelor were prodigious and, according to one who knew him in his final years, "he pursued pleasure under every shape; with as much ardour at fourscore as he had done at twenty" (Wraxall, 1836, vol. 2, p. 160). Rumor had it he was even drawing up plans to build a seraglio onto his house at Richmond (Robinson, 1895, p. 203). Rowlandson exploits Queensbury's voraciousness to the full, allowing him

65

Georgiana, Duchess of Devonshire, Her Sister Harriet, Viscountess Duncannon (later Countess of Bessborough) and a Musician, 1790
Watercolor with pen and ink over graphite on laid paper, laid down on contemporary mount; 19 ⅝ x 16 ⅞ in. (49.8 x 42.9 cm)
Signed and dated lower left: *Rowlandson—1790*

PROVENANCE: George, 5th Duke of Gordon, by descent to William Brodie of Brodie; Agnew, 1962; bt Paul Mellon, 1963
SELECTED EXHIBITIONS: YCBA, *Pursuit of Happiness*, 1977, no. 66; YCBA, *Rowlandson Drawings*, 1977–78, no. 23; Frick, *Rowlandson*, 1990, no. 47; YCBA, *Line of Beauty*, 2001, no. 7
SELECTED LITERATURE: Hayes, 1972, pp. 138–39; Baskett and Snelgrove, 1977, p. 65; Sutton, 1977, pp. 282–83; Ribeiro, 1984, p. 125
B1975.3.141

For Rowlandson, 1784 was an annus mirabilis. That year the portraits he exhibited at the Royal Academy gave way to the comic drawings that dominated the

66

The Connoisseurs, ca. 1790
Watercolor with pen and ink over graphite on wove paper, laid down on contemporary mount; 9 ⅜ x 12 ½ in. (23.8 x 31.8 cm)
Inscribed in ink, below at center: *The Connoisseurs*

PROVENANCE: L. S. Deglatigny; C. R. Rudolph; Colnaghi, 1963; bt Paul Mellon, 1963
SELECTED EXHIBITIONS: Colnaghi-Yale, *English Drawings*, 1964–65, no. 26; YCBA, *Rowlandson Drawings*, 1977–78, no. 37; NGA, *Berenson*, 1979, no. 66
SELECTED LITERATURE: Paulson, 1972, pp. 83–84; Brewer, 1997, pp. 279–81
B1975.3.106

Like many of his fellow artists, Rowlandson continually mocked the foibles of connoisseurs in a variety of ways over the course of his career. Around the time he made this drawing, the eighteenth-century culture of connoisseurship had received a major boost, as art flowed more freely than ever in the wake of the French Revolution (Bermingham, 1995, p. 503).

to revel in the incongruous union of the eager young mistress and her geriatric lover. He is shown, as one wag described him in 1794, "insatiate yet with Jolly's sport . . . ogling and hobbling down St James's Street" (Thomas Mathias as cited in Godfrey, 2001, p. 222). Sadly for Queensbury, Rowlandson's caricature was right on the mark, for by this time "his person had then become a ruin" (Wraxall, 1836, vol. 2, p. 160). One eye had failed, his hearing was going, and he had lost nearly all his teeth. But despite his physical frailty he still cut a dashing figure. In this drawing Rowlandson portrays the old duke as an irrepressible dandy, his Star of the Thistle prominently displayed on his fashionably tight-fitting clothes (Ribeiro, 1989, p. 132). As one friend noted, in later life "even his figure, though emaciated, still remained elegant" (Wraxall, 1836, vol. 2, p. 160). Rowlandson inscribed the drawing in his own hand, describing Queensbury as a "Debauchee." In eighteenth-century parlance the "debauchee" was wholly abandoned to the pursuit of sensual pleasure, inhabiting a totally different league of immorality from the merely occasional, or accidental, debaucher. MH

68

The Exhibition Stare-case, Somerset House, ca. 1800
Watercolor with pen and ink over graphite on wove paper; 17 ½ x 11 ¹¹⁄₁₆ in. (44.5 x 29.7 cm)

PROVENANCE: H. Minto Wilson; Spink & Son; bt Paul Mellon, 1980
SELECTED EXHIBITIONS: V&A, *English Caricature*, 1984, no. 90; Tate, *James Gillray*, 2001, no. 51
SELECTED LITERATURE: Hayes, 1990, p. 172; Paulson, 1996, pp. 235–36; Craske, 1997, p. 190; Vaughan, *British Painting*, 1999, p. 108
B1981.25.2893

Dr. Johnson thought the acid test of fitness was climbing to the top of the exhibition staircase at Somerset House without stopping (Samuel Johnson to William Heberden, 13 Oct. 1784, in Redford, 1994, p. 418). This stairway was designed by Sir William Chambers and led the way to the Great Room, where the Royal Academy held its annual exhibitions. Although the Academy promoted them as "easy and convenient," the stairs became notorious (Baretti, 1781, p. 15). Owing to the cramped site, Chambers squeezed three continuous flights of stairs into a semicircular space. The unhappy result was a vertiginous staircase, the final flight of which was the steepest and narrowest. While Chambers hoped to make climbing the staircase a metaphor for the ascent of Parnassus, Rowlandson depicts an angry altercation at the top of the stairs and a rampant dog wreaking havoc lower down. To the horror of some onlookers and delight of others, the ladies trip and tumble headlong down the stairs, their skirts flying. The right-hand niche is occupied by a smiling Callipygian Venus, the goddess who admires her own beautiful posterior. By joking about the kind of beauties the exhibition visitors really want to see, Rowlandson also mocks the elevated pretensions of the Academy itself. In this satire, Rowlandson demonstrates the superior appeal of real bodies as opposed to the idealized works of art on view upstairs. Not only does this allude to Hogarth's famous dictum "who but a bigot, even to the antiques, will say that he has not seen faces and necks, hands and arms in living women that even the Grecian Venus doth but coarsely imitate," but the composition also embodies Hogarth's famously anti-academic "Line of Beauty" (Hogarth, *Analysis of Beauty*, p. 66) Unsurprisingly, some have detected Rowlandson borrowing from Last Judgment imagery in these chaotic, tumbling figures (Sitwell, 1937, p. 15). Rather than a dignified ascent of Parnassus, as Chambers intended, Rowlandson suggests a comic equivalent of the descent into hell. MH

William Blake (1757–1827)

One of the most original minds in both British art and poetry, William Blake in his great illuminated books integrated both poetic text and visual imagery in a rich and complex whole. He was apprenticed to the engraver James Basire between 1772 and 1779, but his early ambitions as an artist extended beyond the realm of reproductive engraving. In the 1780s Blake began exhibiting watercolors at the Royal Academy and toward the end of the decade developed the novel method of relief etching that he would employ in his illuminated books. *Songs of Innocence* (1789) was followed by longer narrative poems such as *America: A Prophecy* (1793), *Europe: A Prophecy* (1794), and *The Book of Los* (1795), in which he responded to his revolutionary times. In these and other prophetic books such as *The First Book of Urizen* (1794), he developed an elaborate personal mythology derived from the Bible, Greek mythology, Eastern religions, and the ancient history and legends of Britain.

Although Blake sold few copies of any of his illuminated books, he was able to make a living from the occasional commercial engraving project. The most ambitious of these was the publication of an illustrated edition of Edward Young's *Night Thoughts*. Blake produced 537 watercolors for the project (British Museum, London), of which only forty-three were published before the project collapsed. More significant in terms of sustaining Blake was the patronage of Thomas Butts and William Hayley. Butts, a government clerk, commissioned Blake to create a series of tempera paintings and watercolors illustrating the Bible. The poet Hayley employed Blake at Felpham in Sussex from 1800 to 1803.

On his return to London from Felpham, Blake embarked on two major prophetic books, *Milton a Poem* and *Jerusalem*. In 1809 an attempt to reach out to the public with an exhibition of his work was a humiliating failure. Blake's later years were lightened by the friendship and patronage of the artist John Linnell, who met Blake in 1819. Linnell commissioned Blake to engrave a set of illustrations to the Book of Job, based on watercolors Blake had painted for Butts, and a set of illustrations of Dante's *Divine Comedy*, for which Blake completed 102 watercolors and seven engravings before his death.

Selected Literature: Paley, 1970; Bindman, 1977; Viscomi, 1993; Bentley, 2001; Blake Archive. SW

69

Songs of Innocence and of Experience, 1795
Fifty-four relief etchings printed in dark brown
ink, with pen and ink and watercolor on fifty-four
leaves; spine: 7 ½ in. (9.1 cm); sheets: 7 ⅛ x 5 in.
(8.1 x 12.7 cm)
Shown: Frontispiece and title page

PROVENANCE: Henry Little; Alfred G. Gray;
Sotheby's, 15 Dec. 1926 (613); bt Walter T.
Spencer; Cortandt F. Bishop; American Art
Association–Anderson Galleries, 5 Apr. 1938
(279); Charles Sessler; Moncure Biddle;
Thomas Gannon; bt Paul Mellon, 1948
SELECTED EXHIBITIONS: YCBA, *Human Form
Divine*, 1997
SELECTED LITERATURE: Keynes and Wolf, 1953,
copy L; Bentley, 1977, copy L
B1992.8.13 (1–54)

Blake claimed that his method of relief etching, which
allowed him to create text and image together in the
same process on the same copper plate, had come to
him in a vision of his dead brother, Robert. Using an
acid-resistant varnish, Blake could draw and write on
the plate. When etched in an acid bath, image and
text, protected by the varnish, would be left standing
in relief. The areas in relief would then be inked and
printed. Assisted by his wife, Catherine, Blake would
then strengthen the printed lines with pen and ink
and color the images with watercolor. Although
labor-intensive, the entire process of production was
controlled by Blake without the compromises of
working with a commercial publisher.

 In 1788 Blake made his first experiments with
relief etching to produce illustrated texts, *All
Religions Are One* and *There Is No Natural Religion*.
A year later he used the process to create *Songs of
Innocence*, his first illuminated book of poetry.
Couched in the form of a book for children, the sim-
plicity of Blake's lyrics and of the charming designs in
which they are embedded are deceptive. The *Songs*
are profound meditations on the human condition,
and the richness and complexity of Blake's vision
became more fully apparent with his production of a
companion volume, *Songs of Experience*, in 1794. The
following year he combined the two books under the
title *Songs of Innocence and of Experience*.

 Blake produced none of his illuminated books in
large editions; indeed, each copy was unique, with
variations in coloring and even in the order of plates.
The twenty-six known copies of *Songs of Innocence*,
four *Songs of Experience*, and twenty-four *Songs of
Innocence and of Experience* (a figure that also
includes separately issued copies of *Innocence* and
Experience that were later combined by collectors or
dealers) were among Blake's best sellers. SW

Illustrations to the Poems of Thomas Gray, 1797–98
(nos. 70–72)

70

*The Progress of Poesy. A Pindaric Ode. "On
Cythera's day"*
Watercolor with pen and black ink over graphite on
wove paper with letterpress inset; 16 ½ x 12 ¾ in.
(41.9 x 32.4 cm)
Inscribed in black ink, upper left: 5

PROVENANCE: Ann Flaxman, 1798; her husband, John
Flaxman, sold, Christie's, 1 July 1828 (85); bt Clarke
for William Beckford; Beckford's daughter, Susan,
Duchess of Hamilton, by descent to Sir Douglas
Douglas-Hamilton, 14th Duke of Hamilton; bt Paul
Mellon, 1966
SELECTED EXHIBITIONS: YCBA, *Human Form
Divine*, 1997
SELECTED LITERATURE: Keynes, 1971, p. 53; Tayler,
1971, p. 85; Butlin, 1981, no. 335 *45;* Vaughan, 1996,
pp. 68–69
B1992.8.11 (23 recto)

71

*The Bard. A Pindaric Ode. "And weave with bloody
hands the tissue of thy line"*
Watercolor with pen and black ink over graphite on
wove paper with letterpress inset; 16 ½ x 12 ¾ in.
(41.9 x 32.4 cm)
Inscribed in black ink, upper right: 3

PROVENANCE: see cat. 70
SELECTED EXHIBITIONS: YCBA, *Human Form
Divine*, 1997
SELECTED LITERATURE: Keynes, 1971, p. 57; Tayler,
1971, pp. 95–96; Butlin, 1981, no. 335 *55;* Vaughan,
1996, pp. 74–77
B1992.8.11 (28 recto)

72

*Elegy Written in a Country Churchyard. "Oft did the
harvest to their sickle yield"*

Watercolor with pen and black ink over graphite on
wove paper with letterpress inset; 16 ½ x 12 ¾ in.
(41.9 x 32.4 cm)
Inscribed in black ink, upper right: 5

PROVENANCE: see cat. 70
SELECTED EXHIBITIONS: YCBA, *Blake*, 1982–83, no.
63f; YCBA, *Human Form Divine*, 1997
SELECTED LITERATURE: Keynes, 1971, p. 69; Tayler,
1971, pp. 133–34; Butlin, 1981, no. 335 *109;* Vaughan,
1996, p. 111
B1992.8.11 (55 recto)

In about 1795 the London bookseller Richard Edwards
commissioned William Blake to provide illustrations
for a deluxe edition of Edward Young's *Night
Thoughts*. A standard edition of the poem was taken
apart and the pages mounted on large sheets of paper
on which Blake drew and colored his designs. Blake
created 537 illustrations on 269 sheets (now in the
British Museum, London), only a fraction of which
were actually published. With the model of Blake's
watercolors for *Night Thoughts* in mind, Blake's
friend John Flaxman commissioned a set of water-
color illustrations of the poems of Thomas Gray as a
birthday gift for his wife, Ann, known as Nancy.
Again the pages of a standard edition of the poems
were mounted on large sheets, perhaps left over from
the earlier project, on which Blake created his water-
color illustrations. Unlike his illustrations to *Night
Thoughts*, these 116 watercolors on fifty-eight sheets
(all now in the Paul Mellon Collection, YCBA) were
never intended for publication.

 On each of the pages of text Blake marked with a
graphite "X" the lines that he intended to illustrate.
The three pages displayed here convey something of
the range and variety of Blake's responses to Gray's
poetry. The image of Cythera's day, from Gray's ode
celebrating the poet's calling, is light and exuberant.
Cythera, one of the Ionian Islands, was the center of a
cult of Aphrodite. A group of levitating young devotees
of the goddess of love dance and play instruments
beneath a six-pointed star.

 "The Bard" was a seminal text of Romantic
nationalism. Based on the traditional account of the
killing of the Celtic minstrel-poets by Edward I after
his conquest of Wales, the poem is the lament of the
lone surviving bard and his curse on Edward and his
descendants. Blake himself identified with the bard,
writing in the Introduction to the *Songs of Experience*:
"Hear the voice of the Bard!" For the opening of
Gray's poem, Blake produced one of the most power-
ful designs in the set. Departing from his standard
practice, he chose to illustrate a line later in the poem.
He marked a double "X" in the upper left of the let-
terpress page, which corresponds to the similarly
marked line, "And weave with bloody hands the tis-
sue of thy line," several pages further on. The figure
of the bard plucks the bloody strands from which he
will weave Edward's fate. The strands at the same time
suggest the harp with which the bard traditionally
accompanied his songs.

 While Gray's most celebrated poem, "Elegy in a
Country Churchyard," gave little scope to the more
extravagant side of the artist's visual imagination,
Blake did create a sequence of images that enhance
the quiet poignancy of the poet's meditation. The
compact figure of the reaper, with its coiled energy,

William Blake
Adam Buck
Edward Francis Burney

forcefully evokes the former vitality of those "rude fore-fathers" who lie buried in the churchyard. sw

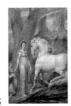

73

The Horse, ca. 1805
Tempera with pen and black ink on gesso priming on a copper engraving plate; 4 ³⁄₁₆ x 2 ⅝ in. (10.7 x 6.7 cm)

PROVENANCE: George Blamire; sold, Christie's, 7 and 9 Nov. 1863 (138); bt H. G. Bohn; Upholland College, Wigan; sold, Christie's, 27 Oct. 1961 (43); bt Colnaghi; bt Paul Mellon, 1962
SELECTED EXHIBITIONS: Arts Council, *British Painting*, 1951, no. 9; VMFA, *Painting in England*, 1963, no. 382; YCBA, *Blake*, 1982–83, no. 89; YCBA, *Human Form Divine*, 1997
SELECTED LITERATURE: Butlin, 1981, no. 366
B2001.2.34

It was through John Flaxman that Blake secured the patronage of the popular poet William Hayley. Between 1800 and 1803 Blake lived in Felpham, Sussex, working on projects for Hayley. The relationship between the two poets was not an easy one. Although Hayley's employment provided much-needed financial assistance, he encouraged Blake to put aside his more imaginative work, leading Blake to describe Hayley as "corporeal friend and spiritual enemy" (Bindman, 1977, p. 132).

In 1802 Blake produced fourteen engravings to illustrate an edition of Hayley's *Ballads*. A few years later, after Blake had returned to London from Felpham, he made new plates for a small-format edition of the *Ballads*. On 25 April 1805 he wrote to Hayley: "The prints, five in number, I have engaged to finish by 28th May. They are to be as highly finished as I can do them." In the same letter he mentioned, "Of these five I am making little high finished pictures, the size the engravings are to be, and I am hard at it to accomplish in time what I intend." This tempera, which reproduces at the same size the illustration for "The Horse," may be one of these "little high finished pictures." The only other known candidate is a sepia drawing for "The Eagle" (Pierpont Morgan Library, New York). Blake's tempera illustrates a mother calmly facing down a runaway horse who threatens her fearful child. Blake was particularly pleased with this design, and when he thought the print might be omitted from the *Ballads*, he wrote to Hayley to argue for its inclusion as "one of my best; I know it has cost me immense labour" (Butlin, 1981, no. 366). sw

Jerusalem: The Emanation of the Giant Albion, 1804–20 (nos. 74–76)

74

Plate 25: *"And there was heard a great lamenting in Beulah"*
Relief etching printed in orange, with pen and ink, watercolor, and gold on wove paper; 13 ½ x 10 ⅜ in. (34.3 x 26.4 cm)

PROVENANCE: Catharine Blake; Frederick Tatham, from ca. 1831; George Blamire; Christie's, 6 Nov. 1863 (213); bt Daniels; William Fuller Maitland, to 1876; Christie's, 1 June 1887 (225); bt Quaritich; bt Gen. Archibald Stirling of Keir, ca. 1893; his son, Col. William Stirling; Thomas Gannon; bt Paul Mellon, 1952
SELECTED EXHIBITIONS: YCBA, *Blake*, 1982–83, no. 99e; YCBA, *Human Form Divine*, 1997; Tate, *Blake*, 2000, no. 303
SELECTED LITERATURE: Keynes and Wolf, 1953, copy E; Bentley, 1977, copy E; Erdman, 1974, p. 304; Paley, 1991, pp. 168–69
B1992.8.1 (25)

75

Plate 35: *"Then the Divine hand found the Two limits, Satan and Adam"*
Relief etching printed in orange, with pen and ink, and watercolor on wove paper; 13 ½ x 10 ⅜ in. (34.3 x 26.4 cm)

PROVENANCE: see cat. 74
SELECTED EXHIBITIONS: YCBA, *Blake*, 1982–83, no. 99j; YCBA, *Human Form Divine*, 1997; Tate, *Blake*, 2000, no. 303
SELECTED LITERATURE: Keynes and Wolf, 1953, copy E; Bentley, 1977, copy E; Erdman, 1974, p. 310; Paley, 1991, pp. 185–86
B1992.8.1 (35)

76

Plate 99: *"All Human Forms identified even Tree Metal Earth & Stone"*

Relief etching printed in orange, with pen and ink, and watercolor on wove paper; 13 ½ x 10 ⅜ in. (34.3 x 26.4 cm)

PROVENANCE: see cat. 74
SELECTED EXHIBITIONS: YCBA, *Blake*, 1982–83, no. 99q; YCBA, *Human Form Divine*, 1997; Tate, *Blake*, 2000, no. 303
SELECTED LITERATURE: Keynes and Wolf, 1953, copy E; Bentley, 1977, copy E; Erdman, 1974, p. 378; Paley, 1991, p. 296
B1992.8.1 (99)

In April 1827, a few months before his death, Blake wrote to his friend George Cumberland: "The last work I produced is a Poem entitled Jerusalem the Emanation of the Giant Albion. . . . One I have finished. It contains 100 plates but it is not likely that I shall get a Customer for it." *Jerusalem* was the culmination of Blake's series of great prophetic books, and he had been at work on it from 1804 on, the date on the title page. Of the five known complete copies of the book, four are printed in black ink and uncolored; the copy to which Blake refers as "finished" is the Mellon copy, printed in red-orange ink and lavishly hand-colored in watercolor with touches of gold paint. At Blake's death, this deluxe copy passed to his widow, Catherine, from whom it was obtained by Frederick Tatham, who, in a twenty-four-page biographical sketch of Blake in manuscript that he attached to the copy, described it as containing "some of the most noble conceptions possible to the mind of man" (leaf 5v).

The poem, divided into four chapters, tells of the fall of man, represented by Albion, and his ultimate redemption. Of the three plates exhibited here, the first is the final image of the first chapter. It shows the fallen Albion being disemboweled. In a plate depicting the birth of Eve, the figure of the Creator and Savior (bearing the stigmata) hovers above. The third exhibited plate is the penultimate plate of the book, which ends the narrative in an image of the union of contraries in the form of Jehovah (or Christ taking on the patriarchal appearance of Jehovah) embracing an androgynous Jerusalem. Redemption is achieved through reconciliation. SW

Adam Buck (1759–1833)
Adam Buck was a pioneer of the small, full-length watercolor portrait on card, a popular format during the Regency period. Probably self-taught, Buck left his native Ireland in 1795. He established a studio and school in London that attracted a fashionable clientele. In 1811 Buck issued a prospectus for a folio of prints after Greek vases in English private collections. Although the project did not come to fruition, the 157 surviving pen and ink drawings provide invaluable information on eighteenth-century collecting (Trinity College, Dublin). For the most part, however, Buck's study of the antique was put to the service of creating stylized scenes of motherhood and domesticity. In 1795 the critic and satirist Anthony Pasquin noted that Buck "appears to study the antique more rigorously than any of our emerging artists; and by that means he will imbibe a chastity of thinking, which may eventually lead him to the personification of

apparent beauty" (Pasquin, 1796, p. 41). Combining the craze for Neoclassicism with the emerging fashion for more intimate and natural modes of child rearing, these images were disseminated in printed form and as designs for china and furniture decoration.

Selected Literature: Strickland, 1969; *ODNB*. CA

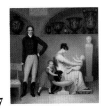

77

The Artist and His Family, 1813
Watercolor and graphite with gum and scraping out on card; 17 ½ x 16 ½ in. (44.5 x 41.9 cm)
Signed and dated, in pen and gray ink, on the base of the herm: *Adam Buck/1813*

PROVENANCE: Mrs. A. M. Salomons, sold, Sotheby's, 1933 (208); bt Hare; D. H. Farr [?]; M. R. Schweitzer, 1966; bt Paul Mellon, 1966
SELECTED EXHIBITIONS: RA, 1814, no. 481; SBA, 1829, no. 58; YCBA, *Fifty Beautiful Drawings*, 1977, no. 25; YCBA, *English Portrait Drawings*, 1979–80, no. 101; YCBA, *The Exhibition Watercolor*, 1981, no. 12
SELECTED LITERATURE: Jenkins, 1988, pp. 448–57; Darvall, 1989, pp. 775–76
B1977.14.6109

This interior, featuring decorative niches inspired by subterranean Roman sepulchres and *klismos* chairs copied from Greek pottery, is a reminder of the somber mood of the particular moment of highly stylized Neoclassical taste in England. The stark setting is appropriate because this portrait represents the artist Adam Buck, his wife, and two of their sons in the presence of a herm (or bust on a plain shaft), which probably depicts a deceased member of the family. Ian Jenkins has traced a convincing narrative of mourning and rebirth in the iconography of the Greek vases on display, in keeping with the melancholy inclusion of the herm. The loving interaction between mother and baby, as well as the rambunctious antics of the elder child (who playfully dips a cat into an ancient vase), however, are strategies of representation familiar from Buck's sentimental genre scenes. Melding the somber and the joyful, Buck succeeded in creating a picture that is a celebration of the continuation of family, as well as a memorial to a member lost along the way. CA

Edward Francis Burney (1760–1848)
Edward Francis Burney was the cousin of the novelist Fanny Burney (Madame d'Arblay) and the nephew of the eminent musicologist Dr. Charles Burney. Edward, who has been described by Patricia Crown as "almost pathologically diffident and retiring," was best known as a prolific illustrator and designer, specializations that may have suited his temperament better than genres requiring a greater degree of self-promotion and exposure (Crown, 1980, p. 435). He studied at the

Royal Academy from 1777 and exhibited a handful of portraits and illustrative "sketches" there between 1780 and 1803. His book illustrations included contributions to John Bell's second edition of Shakespeare (1784–88), David Hume's *History of England* (1806), Milton's *Paradise Lost* (1808), and the 1810 edition of Alexander Pope's translation of the *Iliad*. He also illustrated a textbook of natural history and wrote his own illustrated scientific adventure story, *Q.Q. es'Qre*. Burney appears to have been an inveterate recorder of contemporary artistic life, particularly during his early career; his drawings of the Royal Academy exhibition of 1784 and Philippe de Loutherbourg's *Eidophusikon*, a miniature mechanical theater, are rare records of ephemeral metropolitan activities. His combination of Hogarthian humor with a consistently elegant and subtle manner of depiction make Burney a singular figure among artists of the period.

Selected Literature: Crown, 1977; Crown 1980; Crown, 1982. EH

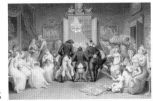

78

The Triumph of Music, also known as *The Glee Club*, ca. 1815
Watercolor with pen and black ink over graphite on wove paper; 12 ⅛ x 18 ⅛ in. (30.8 x 46 cm)

PROVENANCE: Anon. sale, Christie's, 22 June 1962 (31); bt Colnaghi; bt Paul Mellon, 1962
SELECTED EXHIBITIONS: VMFA, *Painting in England*, 1963, no. 434; Colnaghi-Yale, *English Drawings*, 1964–65, no. 30; PML, *English Drawings*, 1972, no. 81; AFA, *British Watercolors*, 1985–86, no. 41; YCBA, *Pleasures and Pastimes*, 1990, no. 1; Villa Hügel, *Metropole London*, 1992, no. 575
SELECTED LITERATURE: Crown, 1980, pp. 435–72
B1975.4.1467

This drawing, also known as *The Glee Club*, appears to be part of a coherent group along with *The Waltz*, *The Elegant Establishment for Young Ladies* (both Victoria & Albert Museum, London), and *Amateurs of Tye-Wig Music* (Paul Mellon Collection, YCBA). All four pictures are of similar format and finish and are linked by their musical theme. Although no printed version has yet been identified, it is possible that Burney may have intended to publish them, but they may also have been created for the amusement of his private circle.

The Triumph of Music depicts the type of musical group to which the Burney family belonged, a group of gentlemen (and sometimes ladies) who met to sing, eat, and drink together. Specifically, it refers to types of songs popular during the period; the numerous inscriptions are the titles of catches, canons, glees, and rounds. Glees in particular are characterized by their double, sometimes obscene meanings and the repetition of words or fragments of words. Here, the

Edward Francis Burney
Edward Dayes
William Alexander
Ben Marshall

formal attributes of the picture echo the structures of glee and canon singing: the figures of the three old women on the right, for example, are repeated in the three young women on the left, and salacious visual puns abound. The tall, thin man on the left may be a self-portrait. EH

Edward Dayes (1763–1804)

The career of Edward Dayes was particularly marked by a disparity between the works he produced from artistic ambition and those he made from financial necessity. He is primarily known for his topographical oil paintings and watercolors, over sixty of which were exhibited at the Royal Academy and the Society of Artists. Although these were the mainstay of his livelihood, Dayes supplemented his income with more diverse artistic activities: he worked on Thomas Barker's panorama, made designs for small decorative engravings, colored aquatints, and painted backgrounds for other artists. Having trained at the Royal Academy Schools, however, Dayes aspired to become a history painter. His diary for 1798 shows that he could complete a commissioned view in three or four days but spent weeks at a time on a single historical subject. He also had unrealized ambitions to be elected a Royal Academician and, perhaps in support of his candidacy, published a series of essays on painting in the *Philosophical Magazine*. In these he espoused a philosophy similar to that of Reynolds in its insistence on a set of aesthetic standards oriented primarily toward the production of history painting. His library likewise reflected a desire for literary achievement; it contained works on aesthetic theory, philosophy, and classics in translation as well as more standard works of polite literature and manuals on painting and perspective (Dayes, *Works*).

Dayes's aspirations were never realized, however, in part because of the failure of his historical subjects, and in part because younger artists, such as J. M. W. Turner and Dayes's own pupil, Thomas Girtin, were developing new ways of depicting landscape, placing greater emphasis on painterly surface effects and the subjectivity of the artist. Dayes's topographical landscapes, with their reliance on outline and relatively muted colors, were effectively outmoded (Kriz, 1997, pp. 21–29). He committed suicide in 1804.

Selected Literature: Dayes, *Works*, 1971; Kriz, 1997, pp. 2–3, 21–32. EH

79

Queen Square, London, 1786
Watercolor with pen and black ink over graphite on wove paper with line and wash border; image: 14 ½ x 20 ⅞ in. (36.8 x 53 cm); sheet: 17 ⅛ x 23 ½ in. (43.5 x 59.7 cm)
Signed and dated in pen and black ink, lower left: *E Dayes/1786*

PROVENANCE: Agnew, 1968; bt Paul Mellon, 1968
SELECTED EXHIBITIONS: RA, 1787, no. 582; PML, *English Drawings*, 1972, no. 82; YCBA, *The Exhibition Watercolor*, 1981, no. 13; YCBA, *Presences of Nature*, 1982, no. 6.2; RA, *Great Age of British Watercolours*, 1993, no. 106; YCBA, *Line of Beauty*, 2001, no. 140
SELECTED LITERATURE: Barker and Jackson, 1990, p. 60; Longstaffe-Gowan, 2001, p. 211
B1977.14.4639

Queen Square is one of a series of four views of London squares that Dayes produced at the outset of his professional career. He exhibited views of Queen Square and Bloomsbury Square at the Royal Academy in 1787; these, along with his views of Hanover and Cavendish Squares, were engraved in 1787 and 1789. Queen Square, first laid out in the early eighteenth century, is located just east of Russell Square and was distinguished for its open prospect of the countryside, looking toward Hampstead and Highgate to the north. The other squares depicted by Dayes also date from an early period of London square building. The variety of the buildings and the established gardens in these older squares may have appealed more strongly to a picturesque sensibility than the architectural uniformity of newer squares such as Bedford Square (begun in 1776).

All four of Dayes's views suggest social tensions underlying the ordered, placid appearance of the squares, which in reality had a reputation for violent crime, particularly robbery, and were seen as potential sites for the gathering of disruptive crowds; as recently as 1780, foot patrols had been stationed in Queen Square during the Gordon Riots (Longstaffe-Gowan, 2001, p. 205). A range of social types populates these images: high and low intermingle in the public spaces while genteel couples stroll within the safety of the fenced-off gardens. A seven-foot lead statue of Queen Charlotte, erected in 1775 by one of the square's residents, presides over this scene (Blackwood, 1989, p. 44). In the foreground, a fashionably dressed couple is accosted simultaneously by a beggar boy and a flower seller with a child strapped to her back, while a butcher returning from a delivery looks on in amusement. Distracted by and dismissive of their supplicants, the couple heads straight for a pile of horse droppings. EH

William Alexander (1767–1816)

William Alexander was a member of the "Monro Academy," the group of artists including J. M. W. Turner and Thomas Girtin who enjoyed the patronage of the physician and collector Dr. Thomas Monro in the 1790s. After training at the Royal Academy Schools, Alexander's first (and defining) commission came in 1792, when he was hired as official draftsman for Lord Macartney's embassy to China. The embassy was in part an attempt to establish direct contact with the Chinese imperial court in the hopes of creating interest in British manufactured goods and thereby offsetting the trade deficit caused by British demand for Chinese goods, particularly tea and silk. The embassy failed to win trading commissions, and Alexander, to his great disappointment, was left behind in Beijing when Macartney traveled north to Jehol for his meeting with the emperor: "To have been within 50 miles of that stupendous monument of human labour, the famous Great Wall, and not to have seen that which might have been

the boast of a man's grandson, as Dr. Johnson has said, I have to regret forever" (Legouix, 1980, p.11).

Despite this setback, Alexander was able to use the sketches he had made in China to produce and exhibit finished watercolors at the Royal Academy. He later found employment as the first Master of Landscape Drawing at the Royal Military College (a position that John Constable had been offered but turned down) and spent his vacations drawing the Egyptian antiquities at the British Museum until 1808, when he was hired as the museum's Assistant Keeper in the Department of Antiquities, which eventually led to his post as Keeper of Prints and Drawings.

Selected Literature: Legouix, 1980; Legouix and Conner, 1981; Wood, 1994. EH

80

City of Lin Tsin, Shantung, with a View of the Grand Canal, 1795
Watercolor over graphite on laid paper; 11 ¼ x 17 ⅜ in. (28.6 x 44.1 cm)
Signed and dated in brown ink, lower right:
W Alexander 95; inscribed in graphite, verso:
Lin Tsin, from canal

PROVENANCE: Direct descent through artist's family; Spink, 1964; bt Paul Mellon, 1964
SELECTED EXHIBITIONS: PML, *English Drawings*, 1972, no. 83; YCBA, *English Landscape*, 1977, no. 94; YCBA, *Line of Beauty*, 2001, no. 82
SELECTED LITERATURE: Legouix, 1980, p. 66; Legouix and Conner, 1981, p. 36
B1975.4.1450

On 22 October 1793, Alexander noted in his journal, "At noon we passed the Pagoda of Linsing of 9 stories, about 120 ft. in height. Tis a striking object being detached from any town and stands about 20 yards from the waters edge" (Legouix and Conner, 1981, p. 36). The pagoda at Lin-Ching-Shih stood at the point where the Eu-Ho River intersects with the Grand Canal. Alexander saw and sketched it from the junk in which he traveled up the Eu-Ho and along the entire length of the Grand Canal, from Beijing to Hangchow. Although he had little opportunity for excursions beyond the riverbanks, the month-long voyage provided him with plentiful opportunity to observe waterside life. Alexander made a number of drawings of the Chinese people who gathered to watch the Europeans passing and used these sketches to populate his finished watercolors. This watercolor is one of five versions of the scene that Alexander produced on his return to England and may be the one that was exhibited at the Royal Academy in 1796 under the title "Pagoda near Lin-tchin-four" (no. 690). A view of the pagoda, along with several dozen other views by Alexander, was engraved as an illustration to Sir George Staunton's official account of the voyage in 1797. EH

Ben Marshall (1768–1835)

Even in the mid-twentieth century, by which time sporting pictures in general and horse paintings in particular were once again hugely fashionable, English critical opinion had to remind itself that lately there had been "a disposition to regard Marshall as a genuine painter, and not a studio-prop of horsy snobs. This is much overdue" (Shaw Sparrow, 1929). In fact, Ben Marshall was, between George Stubbs and Alfred Munnings, the most brilliant chronicler of the turf, and of turf people, that England produced in the nineteenth century.

A native of Leicestershire, Marshall was the youngest of five sons. He was discovered by his local member of Parliament and in 1791 was sent, newly married and armed with a letter of introduction, to seek a place in the London studio of Lemuel Francis Abbott; shortly thereafter the older portrait painter descended into mental illness and insanity. From 1795 until 1810 the couple resided at 23 Beaumont Street, Marylebone, Marshall having prospered owing to the early success of his portraits of thoroughbred racehorses. In 1792 he had been commissioned to paint the Prince of Wales's horse Escape and was soon afterward engaged to give painting lessons to the prince's eldest sister, the Princess Royal (known to the royal family as "Royal"). Much profitable employment resulted from his presence at court, and in 1800 he was elected to the Royal Academy. For thirty years he received commissions for paintings from the *Sporting Magazine*, which published more than sixty plates and reproductions. For the same paper he also wrote ebullient, sometimes scurrilous racing journalism under the pseudonym "Observator." By 1812, the standard price for one of Marshall's forty-by-fifty-inch horse paintings was fifty guineas, a large sum; that same year the family moved to the outskirts of Norfolk so as to be within easy reach of Newmarket, such was his overriding passion for racing and his dependence upon it for his artistic practice.

Marshall suffered a series of personal tragedies, the first being the death of his mother during his infancy. In 1819 the mail coach on which he was traveling to Leeds overturned, leaving him with broken legs and back and head injuries. A final catastrophe occurred in 1834, when he witnessed the death of his younger daughter, Elizabeth, who died from severe burns when her dress caught fire in the hearth. This tragedy was said to have hastened Ben Marshall's decline and death the following year.

Selected Literature: Shaw Sparrow, 1929. AT

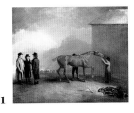

81

Muly Moloch, a Chestnut Colt Being Rubbed Down on Newmarket Heath, with Portraits of Trotter, Hardy, and Thompson to the Left, 1803
Oil on canvas; 40 x 50 in. (101.6 x 127 cm)

PROVENANCE: William Henry Vane, 3rd Earl of Darlington; Captain Forester; Ackermann, 1966; bt Paul Mellon, 1966
SELECTED EXHIBITIONS: YCBA, *Paul Mellon Bequest*, 2001, p. 84
SELECTED LITERATURE: Shaw Sparrow, 1929, pp. 52–53
B2001.2.212

This is one of two paintings that Marshall painted for Lord Darlington, whose busy stud was at Raby Castle, near Durham in the north of England. The other picture, formerly in the collection of Lord Barnard, is a portrait of another of Lord Darlington's thoroughbred racehorses, the champion Haphazard. Muly Moloch was foaled in 1798. His sire was John Bull (by the famous Herod, a descendant of the Byerly Turk), who won the Derby in 1792. Muly Moloch's dam was a mare called Mistletoe, the daughter of Pot-8-os (also known as 'Pot-"oooooooo"-s,' the winner of thirty races and the sire of three Derby winners). Muly won seven out of thirteen races from 1800 to 1803 and competed against some of the strongest horses of his generation. He did well in 1801 but in 1802 was overtaken and humiliated by Quiz, first in August at York, then again the following month in the St. Leger at Doncaster. Although Muly had begun as a favorite, odds were rapidly readjusted, and in 1803 the horse was given a long break from racing. He was defeated again in October, when Lord Darlington attempted a comeback at Newmarket, after which Muly was retired to stud.

The painting records with considerable verity the restlessness of the horse, whose heart is still racing after the contest and for whom the brushing, scraping, and rubbing down are disturbing. The horse blanket and drench bottle (probably port or brandy, administered before the race) are clearly shown in the foreground. The stable lad's name was Tod, and the three onlookers are Hardy, the trainer (gesturing with emphasis); Thompson, the head gardener at Raby Castle; and Trotter, an elderly tenant of Lord Darlington's and an enthusiastic connoisseur of the turf. Marshall was particularly skillful at the characterization of his rich patrons' tenants and servants, as Stubbs was before him. The task of creating affectionate but plausible portraits of men such as this, with whom the squire shared a love and enthusiasm for sport but whose social position was unambiguously inferior to and indeed dependent upon his, created a delicate problem of decorum for artists whose own social and professional situation brought them approximately into the range of positions to which servants aspired and in which tenants to some extent felt secure; but it also required them to see servants, tenants and farmworkers, gamekeepers, and stable lads through the eyes and with the instincts, sympathy, and imagination of the squire.

The name Moloch appears in Leviticus, the second Book of Kings, and the prophet Jeremiah as the name of an idolatrous Canaanite god of fire. The affectionate use of the bucolic prefix Muly implies stubbornness and earthy persistence, underlying the hot color, theatricality, and flamboyance of the Hebrew name. AT

Robert Hills (1769–1844)

Robert Hills began his artistic training with John Alexander Gresse before entering the Royal Academy Schools in 1788. He focused on watercolor and soon became renowned for his animal studies. With W. H. Pyne, James Ward, J. C. Nattes, and James Green, Hills formed the Sketching Society, for the purpose of observing landscape and figures from life. On their annual sketching trips, Hills engaged in an almost obsessive study of animal anatomy. He recalled that he spent a day stalking a deer "like a sportsman sighting his game" (Baskett and Snelgrove, 1972, no. 87). So expert were his depictions that he drew deer and cattle in the work of other artists such as George Fennel Robson, William Andrews Nesfield, and George Barrett Junior. He issued his *Etchings of Quadropeds* (*sic*) as a series from 1798 to 1815, as well as *Cattle in Groups* (1808) as a source book of animal imagery for other artists, similar to his friend W. H. Pyne's *Artistic and Picturesque Groups for the Embellishment of Landscape* (1817). Even after the Sketching Society disbanded in 1806, Hills continued sketching tours throughout his life, traveling throughout Britain and, later, the Low Countries shortly after the Battle of Waterloo. He published *Sketches in Flanders and Holland: with some account of a tour through parts of those countries, shortly after the battle of Waterloo* in 1816. He was a founding member of the Society of Painters in Water-Colours in 1804 and its first secretary.

Selected Literature: Long, 1923; *ODNB*. MO

82

A Village Snow Scene, 1819
Watercolor and gouache with scraping out over graphite on heavy wove paper; 12 ⅝ x 16 ¾ in. (32.1 x 42.5 cm)

PROVENANCE: Meatyard; T. Girtin, 1922; Tom Girtin; bt John Baskett; bt Paul Mellon, 1970
SELECTED EXHIBITIONS: Tokyo, *Institute of Art Research*, 1929, no. 42; Sheffield, *Girtin Collection*, 1953, no. 62; Leeds, *Early English Water Colours*, 1958, no. 65; RA, *Girtin Collection*, 1962, no. 59; PML, *English Drawings*, 1972, no. 87; YCBA, *The Exhibition Watercolor*, 1981, p. 48; RA, *Great Age of British Watercolours*, 1993, no. 166; YCBA, *Toil and Plenty*, 1993–94, no. 62
SELECTED LITERATURE: Binyon, 1933, p. 83; Hardie, 1967–68, vol. 2, p. 140
B1977.14.4907

Although he lived and worked in London throughout his career, Hills specialized in scenes of rural life. He painted at least three versions of this view of village life in winter (others are in the Spooner Collection, Courtauld Institute of Art, London, and in a private collection). The work is a combination of the real and the ideal, inspired in part by a seventeenth-century Flemish painting *A Barn in Winter* (Royal Collection, UK), then attributed to Peter Paul Rubens, which Hills

saw when it was exhibited at the British Institution in 1819. At the same time, Hills was committed to studying figures from life. As his friend W. H. Pyne observed in his *Rustic Figures in Imitation of Chalk* (1817), "To become acquainted with the true rustic character, the student must go to nature, and view this class of people in their occupations" (p. ii). The figures in *A Village Snow Scene* portray these dual aspects as villagers seek shelter from a snowstorm in a barn. Hills delineates each person's costume and the details of their setting, from the distinctive shape of a woman's bonnet to the structural support of the barn that offers shelter. As Christiana Payne notes, village life continues during the storm: two blacksmiths work on the left and cattle are driven down the road (Payne, 1993, p. 155). Yet the figures remain types rather than individuals, their faces expressionless or obscured. The snow becomes the subject of the work: Hills render the bright white areas by leaving the paper untouched, a gesture that lends both texture and depth to the blankets of snow that cover the rooftops. He achieved the glimmering effect of falling snow by scraping out each snowflake. MO

Sir Thomas Lawrence (1769–1830)

Through a combination of prodigious talent and dogged ambition, Thomas Lawrence became one of the most lauded (and imitated) artists in Europe. His portraits were startlingly modern and yet grounded in historical forms. Their air of bravura virtuosity—stemming from the artist's use of unrestrained brushwork, sinuous lines, and brilliant colors—belies their rigorous underpinnings in the form of chalk drawings executed on the canvas.

The son of a provincial innkeeper, the young Lawrence was enlisted to draw pastel portraits of his father's customers. A patron offered to send Lawrence to study in Italy, but his father, perhaps afraid of losing a source of income, refused, and Lawrence did not travel outside of his native country until middle age. Moving to London at eighteen, he first gained real public attention at the Royal Academy of 1790, where he exhibited portraits of the actress Elizabeth Farren (1789–90; Metropolitan Museum of Art, New York) and Queen Charlotte (1789–90; National Gallery, London). He quickly became the preferred chronicler of fashionable London society with performances such as the mesmerizing *Arthur Atherley* (1792; Los Angeles County Museum of Art). Lawrence was named Painter-in-Ordinary to the King in 1792 and, later, President of the Royal Academy.

Lawrence's temperament was a cruel mixture of workaholic and procrastinator. From early in his career patrons complained of waiting months, and sometimes years, for the promised painting. By the early nineteenth century his personal affairs were in great disarray: Lawrence owed more than twenty thousand pounds in debts, many stemming from his voracious collecting of Old Master drawings. Yet during this time he painted some of his most important works, including a series of multifigure compositions such as *Sir Francis Baring, Bt, John Baring, and Charles Wall* (1807; private collection) that rescued the group portrait in England from the stiffness of the small-scale conversation piece. Sometime in 1814 it was decided that Lawrence should paint a gallery of portraits of the heroes of the Napoleonic Wars for the Waterloo Chamber at Windsor Castle; this project consumed much of his time until his death six-

teen years later, although Lawrence continued to paint the famous and fashionable of London society. Always a tactile and sensual painter, Lawrence's work fell rapidly out of favor during the Victorian period, but he is today appreciated as one of the most technically proficient and imaginative portraitists of the British school.

Selected Literature: Garlick, 1964; Garlick, 1989; Levey, 1979; Levey, 2005. CA

83

George James Welbore Agar-Ellis, later 1st Lord Dover, ca. 1823–24
Oil on canvas; 36 x 29 in. (91.4 x 73.7 cm)

PROVENANCE: By family descent to Lord Annaly, 1948; Matthiessen Ltd., London; F. H. Pearson; Mrs. F. H. Pearson; Newhouse Galleries, New York; bt Paul Mellon, 1966
SELECTED EXHIBITIONS: BI, 1825, no. 46; YCBA, *Sir Thomas Lawrence*, 1993, no. 2
SELECTED LITERATURE: Garlick, 1989, no. 13
B1981.25.411

This elegant portrait is a testament to the relationship of mutual respect and friendship between the artist and his subject, George James Welbore Agar-Ellis (1797–1833). Agar-Ellis, a politician and art lover, had persuaded the British government to purchase the Angerstein collection of paintings (which Lawrence had effectively curated) as the nucleus for the National Gallery. Lawrence and Agar-Ellis established a firm friendship based on mutual regard, and the artist was later commissioned to paint Agar-Ellis's wife and young son in a charming double portrait (1827–28; private collection). Agar-Ellis served as one of Lawrence's pallbearers.

The virtuosity of this portrait can in part be explained by the extraordinary amount of time and labor that Lawrence invested in it. Twelve sittings are recorded in Agar-Ellis's diary between October 1823 and May 1824, several lasting for three or more hours (Northamptonshire Records Office, Annaly of Holdenby Collection, ref. X1384). The sitter's handsome features are complimented by a masterfully painted costume of velvet and fur, referred to in Agar-Ellis's diary as a "crimson =Titian-like pelisse," which Lawrence had personally selected for the portrait. The face is painted smoothly in comparison with the slash of blue ribbon and the bristling fur. A second white highlight glimmers in Agar-Ellis's right pupil, a trick that Lawrence used to suggest the glassy moisture of the human eye with remarkable fidelity.

Considered the consummate portrayer of female beauty, Lawrence here delineates an equally compelling vision of masculinity. The portrait—a study in soft curves, beginning with the sitter's mop of brown curls and his delicately crimped pinky finger and extending through his relaxed posture—proves that

Lawrence's penchant for sinuous torsos and sloping shoulders was not reserved for his female sitters. CA

James Ward (1769–1859)

At the height of his long career, James Ward was known as the "Mammoth of animal painters," but he was much else besides. Today he is remembered as a major artist in the British Romantic tradition, and his masterpiece *Gordale Scar* (1812–14; Tate, London) remains a powerful manifestation of the taste for the sublime and of Regency gigantism.

Born in London, Ward emerged from much-resented poverty and mastered the reproductive art of mezzotinting. He was taught by the artist John Raphael Smith and by his own brother, William Ward (1766–1826). He switched to oil painting in about 1790—assisted by his brother-in-law George Morland, who had also been a pupil of Smith. Ward's early paintings of rustic subject matter strongly reflect the influence of the older, more extroverted Morland.

From 1798 or 1799, Ward painted about two hundred portraits of British livestock for the newly established Board of Agriculture, an important documentary project that was underwritten by Messrs. Boydell the printers. This ambitious task, which relates to the rapid development of animal husbandry, agronomy, and bloodstock in this period, took Ward all over the English countryside. His love of roads, brooks, trees, pasture, birds, and animals (wild and domestic), as well as village life and the activities of the rural laborer, are all reflected in the hundreds of drawings he made on his travels.

In 1807, Ward began to paint portraits of thoroughbred racehorses. At the same time, he studied the representation of horses in low relief on the Parthenon frieze (the Elgin Marbles), as well as the limited supply of Old Master paintings in London. He was especially fascinated by Peter Paul Rubens and Anthony Van Dyck, to whom he turned for solutions to difficult compositional, coloring, and other technical problems.

Elected an Associate of the Royal Academy in 1807, and then granted full membership in 1811, Ward strove ever more ambitiously to escape the label of "animal painter" and to attain the higher rank he felt he deserved. This desire to be lauded as a fully fledged history painter, rather than merely recognized, was never realized—despite a great deal of effort expended upon such ventures as the doomed *Waterloo Allegory* (1815–20). Perhaps for that reason Ward's struggle with "history" haunted him for years, until his retirement in 1830. He continued to work well into his eighties, but in 1855 he suffered a stroke and died four years later.

Selected Literature: Beckett, 1985; Nygren, 1976. AT

84

Eagle, A Celebrated Stallion, 1809
Oil on canvas; 35 ¾ x 48 in. (90.8 x 122 cm)
Signed and dated in monogram, lower left: *JWARD 1809*

PROVENANCE: Purchased from the artist by Thomas Garle, Oct. 13, 1820; Christie's, 14 May 1862 (80), bt (John[?]) Garle, by descent to Mrs. L. Garle; F. T. Sabin, 1960; bt Paul Mellon, 1960
SELECTED EXHIBITIONS: RA, 1810, no. 211; Arts Council, *James Ward*, 1960; VMFA, *Painting in England*, 1963, no. 354; RA, *Painting in England*, 1964–65, no. 286; YUAG, *Painting in England*, 1965, no. 211; YCBA, *Pursuit of Happiness*, 1977, no. 148; YCBA, *The Art of James Ward*, 2004
SELECTED LITERATURE: *Sporting Magazine*, Mar. 1811, p. 265; *Sporting Magazine*, Nov. 1826, p. 2; Grundy, 1909, no. 386; Walker, 1972, p. 78; Egerton, 1978, pp. 212–14
B1981.25.655

Eagle, A Celebrated Stallion is one of the finest of Ward's portraits of thoroughbred racehorses and exhibits his remarkable ability to create an accurate physical portrait of a particular animal. At the same time, he evokes a transcendent Romantic type—suggesting the latent power of a barely tamed creature, full of drive, dash, and tension, whose swollen veins and flaring nostrils to some extent conjure up the elemental forces of nature itself.

Having dwelled for years in the shadow cast by the great equine painters, George Stubbs and his contemporary, the slightly younger Sawrey Gilpin, Ward was obviously aware that his portraits of horses would inevitably be compared with theirs. It was not until 1809, shortly after Stubbs and Gilpin had died, that Ward felt comfortable venturing into the subgenre, his mastery of which is demonstrated in *Eagle*.

Eagle and Ward's other great racehorse paintings differ from Stubbs's in that the essential ingredient of human control—jockeys, grooms, attendants, owners, which to some extent defined the very purpose of the thoroughbred—is conspicuously absent. Neither is there much evidence of the mounting yard, finishing post, or rubbing-down house. Instead, the noble creature exists on its own, standing in a landscape that is laden with potential drama.

Eagle, celebrated for his strength and speed, was a prize-winning bay colt by Volunteer out of a mare by High Flyer and a descendant of Old Partner. He was eventually exported to Virginia, where he influenced the development of American bloodstock. Eagle's owner, Thomas Hornby Morland, used an engraving after Ward's portrait as the frontispiece for his influential treatise *The Genealogy of the English Race Horse* (1810). AT

Thomas Girtin (1775–1802)

Born in 1775, the son of a south London brush maker, Thomas Girtin was apprenticed at the age of fourteen to the topographical draftsman Edward Dayes, under whose tutelage he colored prints and made watercolors using the traditional method of drawing graphite outlines, laying in shadows in gray, and applying light watercolor pigments. Girtin also made drawings from sketches of medieval architecture by the antiquary James Moore, and his 1794 debut at the Royal Academy, a watercolor of Ely Cathedral, was derived from one of Moore's drawings. Moore also introduced Girtin to his circle of fellow antiquarians and took the young artist on his first sketching tour in 1794, to the Midlands. The brilliant and ambitious Girtin evidently tired of the restrictions of his seven-year apprenticeship, and it seems likely that he extricated himself from Dayes prematurely in order to pursue an independent career as a landscape artist.

For several years, beginning in 1794 Girtin, together with his exact contemporary and friend J. M. W. Turner, spent evenings at the so-called "Academy" of Dr. Thomas Monro, who hired aspiring artists to make copies of drawings in his collection by artists including John Robert Cozens and Canaletto. Monro lobbied for Girtin's admission to the Royal Academy Schools, but he never attended, either because his skills were thought insufficient or because he had deemed the Academy's training inappropriate for his particular purposes. Unlike Turner, Girtin made few efforts to establish himself at the Academy, delaying his unsuccessful campaign for Associate status until 1801, when he exhibited his only oil painting, *Bolton Bridge* (now untraced). Girtin developed his own distinctive watercolor technique, abandoning the traditional practice of monochrome underpainting and, instead, building up rich tonality through a complex layering of washes, often using roughly textured papers. Girtin's efforts to establish himself as a watercolorist were highly successful, and he rapidly acquired a large group of influential and supportive patrons. His extraordinary career ended abruptly, however, with his death from asthma in 1802, when he was only twenty-seven, provoking Turner's celebrated if apocryphal testimony, "If Tom Girtin had lived, I would have starved."

Selected Literature: Girtin and Loshak, 1954; Morris, 1986; Smith et al., 2002. GF

85

The Abbey Mill, Knaresborough, ca. 1801
Watercolor, touched with gouache, with some scratching out, over graphite on heavy laid paper; 12 ⅝ x 20 ⅝ in. (32.1 x 52.4 cm)
Inscribed on verso in graphite: *Mr. Reynolds Poland St. Soho No. [46?]*

PROVENANCE: S. W. Reynolds [?]; E. K. Greg; J. C. Butterwick; Sir George Davies; Lady Davies; her daughter, Mrs. Streatfield; Agnew; Sir William Worsley; Agnew, 1971; bt Paul Mellon, 1971

SELECTED EXHIBITIONS: YCBA, *Presences of Nature*, 1982, no. 5:11; YCBA, *Girtin*, 1986, no. 83; YCBA, *Oil on Water*, 1986, no. 30; Harewood, *Girtin*, 1999, no. 27
SELECTED LITERATURE: Girtin and Loshak, 1954, no. 437 (2)
B1975.4.1925

In the fall of 1796 Girtin made his first independent sketching tour, visiting York, Ripon, and Durham and traveling up the Northumbrian coast via Lindisfarne to Jedburgh, on the Scottish borders. The sketching tour was a key element of his artistic practice, as it was for Turner, who traced a similar itinerary with Girtin's advice the following year. Girtin seems to have developed a deep affinity for the north of England. The panoramic views he produced after his first tour mark a decisive break with his early practice, derived from his master, Edward Dayes, of depicting close-up views of ruins; they also signal a radical shift in his palette to stronger colors. Girtin revisited Yorkshire on a number of occasions, having acquired several important patrons there, notably Edward Lascelles, who owned the Harewood estate and who acquired eighteen works by the artist.

Lascelles was also one of Turner's early patrons, but in 1799, the art-world insider Joseph Farington recorded in his diary that "Mr. Lascelles as well as Lady Sutherland are disposed to set up Girtin against Turner, who they say effects his purpose by industry—the former more genius—Turner finishes too much" (Farington, *Diary*, vol. 4, p. 1154). While one might take issue with Lascelles's judgment in relation to Turner, Girtin's Yorkshire watercolors are indisputably virtuoso masterpieces of atmosphere and poetry, though his lack of finish also provoked charges of slovenliness from less enthusiastic viewers. Lascelles hired Girtin as a drawing master and reportedly set aside a room at Harewood permanently for the artist's visits. This watercolor is one of a number of views of the Priory Mill, which stands on the left bank of the river Nidd, a mile downstream from Knaresbrough Castle and some ten miles from Harewood. Girtin, notoriously, relied on fugitive pigments, in particular indigo, for his spectacular effects, and many of his watercolors have faded appallingly; this vivid watercolor, however, is remarkably fresh and suggests why Girtin's patrons found his work so compelling. GF

Joseph Mallord William Turner (1775–1851)

Described by John Ruskin as "the man who beyond all doubt is the greatest of the age; greatest in faculty of the imagination, in every branch of scenic knowledge; at once the painter and poet of the day," the landscape and history painter Joseph Mallord William Turner was born in London in 1775, the son of a Covent Garden barber and wig maker (Ruskin, *Works*, vol. 35, p. 305). The precocious Turner began his artistic career at a young age and was admitted to the Royal Academy Schools in 1789, when he was only fourteen. He was elected an Academician in 1802, at the age of twenty-seven, and four years later was appointed Professor of Perspective. Turner went on to become the most celebrated British artist of his time (arguably, of all time), and his work continues to exert an enduring influence, in both North America and Europe.

While establishing himself as a painter in oils, Turner also developed his skills in watercolor and

rapidly demonstrated extraordinary technical virtuosity in both media. He first received commissions to produce designs for topographical engravings in 1793 and worked for print publishers until almost the end of his life, undertaking regular sketching tours in Britain and continental Europe to gather material. Habitually secretive about his methods, on rare occasions he permitted a privileged few to see him at work on his watercolors, and he would also provide his fellow artists with a rare show of his dazzling painterly skills at the Royal Academy's Varnishing Days.

An artist of almost megalomaniacal ambition, Turner vied with his Old Masterly predecessors and contemporaries alike, always striving to gain acceptance for his chosen genre of landscape. Despite a lack of formal education, he read voraciously and, as John Constable observed, had a "wonderful range of mind" (Constable, *Correspondence*, vol. 2, p. 13). Turner was astonishingly productive, characteristically attributing his success simply to "damned hard work" (Ruskin, *Works*, vol. 13, p. 536). The Yale Center for British Art alone owns fifteen paintings, some seventy drawings, and one sketchbook by the industrious artist, as well as many impressions of the more than eight hundred prints made in Turner's lifetime from his designs.

Selected Literature: Butlin and Joll, 1984; Gage, 1987; Bailey, 1997; Venning, 2003. GF

86

Mer de Glace, in the Valley of Chamouni, Switzerland, 1803
Watercolor over graphite with scraping out and stopping out on wove paper laid down on board; 27 ¼ x 40 ¾ in. (69.2 x 103.5 cm)

PROVENANCE: Walter Ramsden Fawkes, by descent until 1961; Agnew; bt Paul Mellon, 1961
SELECTED EXHIBITIONS: RA, 1803, no. 396; London, *Fawkes*, 1819, no. 24; PML, *English Drawings*, 1972, no. 98; YCBA, *English Landscape*, 1977, no. 125; YCBA, *Turner and the Sublime*, 1980–81, no. 24; Tate/RA, *Turner*, 1974, no. 65; RA, *Great Age of British Watercolours*, 1993, no. 282
SELECTED LITERATURE: Wilton, *Turner*, 1979, p. 341, no. 365; Shanes, 2000, pp. 687–94
B1977.14.4650

Between 1799 and 1815, the wars with Napoleon made recreational travel on the Continent more or less impossible, with the exception of a period of less than a year following the 1802 Treaty of Amiens. Turner took advantage of the temporary cessation of hostilities to make his first trip to the Continent, spending three months traveling through France and Switzerland and making more than five hundred sketches. On his return, he dismantled two of his sketchbooks and mounted over a hundred of the

most highly finished drawings in an album to show prospective patrons. This proved to be an effective strategy, as Turner received numerous commissions for finished watercolors of Alpine views from collectors, including Walter Fawkes, who was to become one of the artist's closest friends and most supportive patrons, and who owned this drawing.

The watercolor has traditionally been identified with one of Turner's 1803 Royal Academy submissions, entitled *Glacier and Source of the Arveron, Going Up to the Mer de Glace,* but Eric Shanes has recently suggested that the exhibited work was a watercolor formerly owned by Fawkes and now in the National Gallery of Wales, Cardiff (Wilton, *Turner,* 1979, no. 376) and that Turner made the present drawing for Fawkes around 1814. Both watercolors were included in an exhibition Fawkes held at his London house in 1819. Shanes has painstakingly examined the catalogue and contemporary representations of the installation, noting that the Center's drawing was exhibited as *Mer de Glace, in the Valley of Chamouni, Switzerland,* whereas the Cardiff drawing bore the title *Source de l'Arveron, Valley of Chamouni.* Neither title corresponds exactly to the Royal Academy submission; moreover, the Cardiff drawing, which is smaller and considerably less ambitious in technical terms, seems a less likely candidate for exhibition at the Academy than the spectacular Yale watercolor.

In the absence of conclusive documentary evidence, much of this argument depends on technical and stylistic issues. Although Shanes's suggestion that an 1803 dating for this highly sophisticated watercolor is too early may be persuasive, it is not inconceivable that Turner could have produced it at that moment in his career, and a dating of 1814 seems somewhat late. Shanes's thesis is extremely thought provoking, however, and merits more detailed discussion than this catalogue entry permits. GF

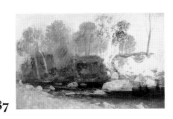

87

On the Washburn, ca. 1815
Watercolor and graphite with scratching out on wove paper; 11 ¼ x 18 in. (28.6 x 45.7 cm)

PROVENANCE: John Edward Taylor, by whom given to Frank Short; his daughter, Dorothea Short, sold, Christie's, 9 Nov. 1971 (120); bt John Baskett; bt Paul Mellon, 1971
SELECTED EXHIBITIONS: YCBA, *English Landscape,* 1977, no. 134; YCBA, *Presences of Nature,* 1982, no. 4:31
SELECTED LITERATURE: Wilton, *Turner,* 1979, p. 361, no. 539; Hill, 1984, pp. 11–22; Lyles, 1988
B1975.4.1620

Turner first visited Yorkshire in 1797. The initial impetus for the trip seems to have been the commission by his patron Edward Lascelles for a series of views of Harewood, the estate situated between

Leeds and Harrogate; Turner also made an extensive and meticulously planned sketching tour of the north of England and Scottish borders, filling his sketchbooks with drawings to which he was to refer throughout his career. Around this time Turner met the Yorkshire landowner, politician, and collector Walter Ramsden Fawkes, and the two men became close friends. Turner first visited Fawkes's estate, Farnley Hall, in 1808; a popular houseguest, he returned almost every year until Fawkes's death in 1825, and both the estate and the family came to have a deep personal significance for him. Fawkes was one of Turner's most active patrons, acquiring seven oils and more than two hundred watercolors, many of them commissions; this outstanding collection is now mostly dispersed, and several of Fawkes's Turners are now owned by the Center (see cats. 86, 89, and 90).

A keen natural historian, Fawkes commissioned Turner to contribute watercolors to his *Ornithological Collection,* which consisted of five volumes of drawings of birds and their eggs. Turner also made a group of watercolors recording the interiors and exteriors of Farnley Hall and chronicling everyday activities on the estate. These delightful drawings provide a vivid and intimate portrait of Farnley's domestic life, as well as a valuable record of Fawkes's installation of his collection. An inveterate angler, Turner spent many pleasurable hours while at Farnley on the Washburn river, waiting for a catch and meditating on the landscape. This vivid drawing is a study for a finished watercolor, which is also in the Center's collection (Wilton, *Turner,* 1979, no. 540). The present sheet originally belonged to the *Large Farnley Sketchbook* (Tate, London) and was acquired by John Edward Taylor, who began to collect Turner's watercolors in the 1860s and who had a taste, radical at that time, for the artist's sketches. GF

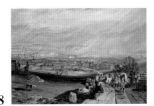

88

Leeds, 1816
Watercolor with scraping out on wove paper; 11 ½ x 17 in. (29.2 x 43.2 cm)
Inscribed, lower left: *JMW Turner RA 1816*

PROVENANCE: John Allnutt, sold, Christie's, 18 June 1863 (166); bt Vokins; John Knowles, sold, Christie's, 5 June 1880 (484); bt Fine Art Society; Christie's, 22 July 1882 (65); bt McLean; Mrs. Lee; A. G. Turner; his son, J. G. Turner; Agnew, 1962; bt Paul Mellon, 1962
SELECTED EXHIBITIONS: Manchester, *Art Treasures,* 1857, no. 312; Colnaghi-Yale, *English Drawings,* 1964–65, no. 37; PML, *English Drawings,* 1972, no. 102; Tate/RA, *Turner,* 1974, no. 186; YCBA, *English Landscape,* 1977, no. 136
SELECTED LITERATURE: Rawlinson, 1908–13, vol. 2, p. 407, no. 833; Wilton, *Turner,* 1979, p. 362, no. 544; Daniels, 1986; Daniels, 1993, pp. 116–24
B1981.25.2704

Of all the British landscape artists of the Romantic period, Turner was the most fascinated by modernity, and many of his images chronicle technological advances. While touring Yorkshire in 1816 to gather material for Thomas Dunham Whitaker's *The History of Yorkshire*, Turner visited Leeds, the hub of the nation's wool and flax industries, and made meticulous graphite sketches of the city, which he elaborated into this watercolor on his return to London. Turner's remarkable drawing celebrates the economic success and resilience of Leeds—and by extension, that of Britain—in the immediate aftermath of the wars with Napoleon. As Stephen Daniels has noted in his penetrating analysis of the watercolor, to which this entry is indebted, Turner's image is a complex and richly allusive portrayal of a rapidly developing industrial city, an amalgam of sources rather than a straightforward topographical record (Daniels, 1986, 1993).

The watercolor, which depicts the city from Beeston Hill, about a mile and half south of the city, draws on the conventions of the prospect or panorama, a well-established genre for representing urban development and prosperity. Daniels has suggested convincingly that Turner used two eighteenth-century sources, Samuel Buck's 1720 engraved prospect of Leeds and an allegorical poem by John Dyer, *The Fleece*, which details the processes of wool manufacture and offers a vision of Britain united through labor. With similar patriotic intention, though perhaps not without ambivalence, Turner mapped the smoky industrial landscape of Leeds, placing John Marshall's flax mill at the center of his composition and carefully differentiating its figures' occupations—tentermen hanging cloth to dry, masons, milk carriers, and a millworker carrying a roll of cloth. It is likely that Turner intended *Leeds* to be engraved for Whitaker's publication, but it was not included, perhaps because its industrial subject matter was considered unsuitable for this somewhat conservative publication. The watercolor was published in 1823, translated, appropriately, into the modern medium of lithography. GF

SELECTED LITERATURE: Wilton, *Turner*, 1979, p. 381, no. 697; Powell, 1987, pp. 79–82; Hamilton, 1998, pp. 115–25
B1975.4.1857

The eighteenth-century fascination with volcanoes, and Vesuvius in particular, deepened in the nineteenth century, fuelled by the eruptions of Vesuvius in 1794, 1807, 1819, and 1822. Turner was alert to both the intellectual and aesthetic possibilities that the evolving discipline of geology offered; he cultivated friendships with pioneering geologists, including John MacCulloch and Charles Stokes, and his sketchbooks contain detailed records of geological phenomena.

During the second decade of the nineteenth century Turner, a keen proponent of the Sublime, had his own burst of volcanic activity. In 1815 he exhibited his canvas *The Eruption of the Souffrier Mountains, in the Island of St Vincent* (Butlin and Joll, 1984, no. 132); two years later the print publisher W. B. Cooke commissioned Turner to make companion watercolors of Vesuvius, showing the volcano in eruption and repose (Wilton, *Turner*, 1979, nos. 698–99). This watercolor, the third of the group and the most spectacular, would also have been made around the same time as Cooke's drawings, if the inscription on the back, which is not in Turner's hand, is correct.

Turner did not visit Italy until 1819, and he may have based the Vesuvius drawings on the work of another draftsman, most likely James Hakewill, whose sketches Turner used for a group of watercolors commissioned as designs for Hakewill's publication *Picturesque Tour of Italy*. Although the Center's Vesuvius drawing was neither exhibited nor engraved, its extremely high degree of finish suggests that Turner had made it for a specific purpose, perhaps as a commission. Although Turner's patron Walter Fawkes (see also cats. 86 and 90) owned the watercolor, it was not included in Fawkes's exhibition of his collection at his London house in 1819, which featured his outstanding holdings of Turner's work. The work was probably acquired by Fawkes (and possibly even made) sometime later. GF

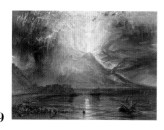

89

Vesuvius in Eruption, ca. 1817–20
Watercolor with gum and scraping out on wove paper laid down on card; 11 ¼ x 15 ⅝ in. (28.6 x 39.7 cm)
Inscribed on verso: *Mount Vesuvius in Eruption J M W Turner RA 1817*

PROVENANCE: Walter Fawkes, until 1890; W. Newall, sold, Christie's, 30 June 1922 (75); Sir Robert Hadfield, sold, Christie's, 19 Jan. 1945 (109); Brian Hamilton, sold, Sotheby's, 22 Nov. 1961 (48); Colnaghi; bt Paul Mellon, 1961
SELECTED EXHIBITIONS: Leeds, *Exhibition of Paintings*, 1839, no. 80; Guildhall, *Turner*, 1899, no. 145; VMFA, *Painting in England*, 1963, no. 142; PML, *English Drawings*, 1972, no. 103; Tate/RA, *Turner*, 1974, no. 184

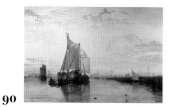

90

Dort, or Dordrecht, the Dort Packet-boat from Rotterdam Becalmed, 1818
Oil on canvas; 62 x 92 in. (157.5 x 233 cm)
Signed and dated, lower right on log: *J M W Turner RA 1818 Dort*

PROVENANCE: Bt Walter Fawkes, 1818, by family descent; Christie's, 2 July 1937 (61); sold on behalf of Major le G. G. W. Horton-Fawkes by Agnew to Paul Mellon, 1966
SELECTED EXHIBITIONS: RA, 1818, no. 166; Whitechapel, *Turner*, 1953, no. 79; NGA, *Turner*, 1968–69, no. 10; Mauritshuis and Tate, *Shock of Recognition*, 1970–71, no. 44

SELECTED LITERATURE: Cormack, 1983; Butlin and Joll, 1984, p. 102, no. 137; Bachrach, 1994, pp. 17–18; Hamilton, 2001
B1977.14.77

In 1817, in the aftermath of the Napoleonic Wars, Turner visited the Netherlands for the first time. He spent just a day and a half in Dordrecht (known locally as Dort), making numerous pencil sketches, and exhibited this luminous view of the city from the north at the Royal Academy in 1818. Turner, who often indulged in playful rivalry with his fellow artists, may have been stimulated by Augustus Wall Callcott's homage to the Dutch Old Masters, *The Pool of London* (Bowood Settlement, Wiltshire), exhibited to acclaim at the Royal Academy in 1816. Described by the *Morning Chronicle* in May 1818 as "one of the most magnificent pictures ever exhibited," *Dort* was immediately acquired by Turner's patron Walter Fawkes (see cats. 86 and 89). The price was five hundred guineas, a huge sum, though as James Hamilton has recently noted, it is likely that Turner was never paid, since Fawkes was in chronic debt, and Turner had himself lent him three thousand pounds (Hamilton, 2001). The painting hung in the Drawing Room at Farnley Hall until 1966, when it was purchased by Paul Mellon.

Although Turner did not visit the Netherlands until he was over forty, he was familiar with important Dutch Old Master paintings in British collections from early in his career, and his first Royal Academy submission, *Fishermen at Sea* (Tate, London), testifies to his admiration for Rembrandt. *Dort* pays tribute to one of Turner's most formative Dutch influences, Aelbert Cuyp; the motif of the packet boat is directly borrowed from Cuyp's *Maas at Dordrecht* (National Gallery of Art, Washington, D.C.), which was exhibited at the British Institution in 1815. *Dort* is as much a personal artistic statement as an homage to an Old Master, however; its contrast of cool and warm colors and bright chromatic scale (a contemporary viewer told the diarist Joseph Farington that "it almost puts your eyes out" [Farington, *Diary*, vol. 15, p. 5191]) mark the emergence of Turner the colorist and anticipate the brilliance of his work of the 1820s. GF

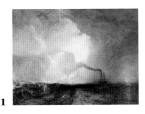

91

Staffa, Fingal's Cave, 1832
Oil on canvas; 36 x 48 in. (91.5 x 122 cm)

PROVENANCE: Bt from the artist, by C. R. Leslie for James Lenox, 1845; given to the Lenox Library (later New York Public Library); sold, Parke Bernet, New York, 17 Oct. 1956 (39); bt Agnew; from whom bt the Hon. Gavin Astor; from whom bt Paul Mellon, 1977
SELECTED EXHIBITIONS: RA, 1832, no. 453; Toronto and Ottawa, *Turner*, 1951, no. 18; Dresden and Berlin, *Turner*, 1972, no. 17; Tate/RA, *Turner*, 1974, no. 490; MMA, *Empire City*, 2000, no. 49

SELECTED LITERATURE: Holcomb, 1972; Lockspeiser, 1973; Gage, 1975; Butlin and Joll, 1984, pp. 198–99, no. 347; Klonk, 1997; Rodner, 1997, pp. 66–70
B1978.43.14

J. M. W. Turner had an affinity with the Scottish landscape, inspired by his deep admiration for the work of Sir Walter Scott. In 1831 he was commissioned by the Edinburgh publisher Robert Cadell to produce illustrations for an edition of Scott's *Poetical Works*. After a memorable stay at Abbotsford with the ailing writer, who was to die the following year, Turner traveled north to Tobermory, where he boarded a steamer bound for the remote island of Staffa. Described by Scott as "one of the most extraordinary places I ever beheld," Staffa was celebrated for its purplish-gray basaltic formations and enigmatic cavernous spaces; Fingal's Cave, named for the Ossianic hero, was a particular object of pilgrimage for the Romantic tourist. According to Turner's much later account, he was caught in a wild storm; upon his return to London, he commemorated his memorable voyage, choosing the moment when the sun "getting through the horizon, burst through the rain-cloud, angry" to create an extraordinarily compelling enactment of an encounter between man, symbolized by the steamship, and the unbridled forces of nature (Turner, *Correspondence*, p. 209).

In the spring of 1832 Turner exhibited *Staffa* to critical acclaim; by coincidence, Felix Mendelssohn's *Isles of Fingal* (later retitled *Die Hebriden*) was first performed in London on 14 May of that year, though to a considerably cooler reception. *Staffa* remained in Turner's studio until 1845, when it was purchased by C. R. Leslie for five hundred pounds, on behalf of the New York collector Colonel James Lenox and thus became the first painting by Turner to be sent to America. Lenox was initially displeased with his purchase, complaining that it looked "indistinct," but Turner recommended wiping the surface of the painting, suspecting that the varnish had bloomed during its transit across the Atlantic (Butlin and Joll, 1984, p. 199). This simple solution seems to have satisfied Lenox, who went on to acquire Turner's *Fort Vimieux* (private collection), though he was unsuccessful in persuading the recalcitrant artist to sell him the *Fighting Temeraire* (National Gallery, London), despite offering the then astronomic sum of five thousand pounds. GF

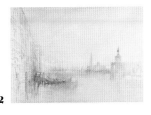

92

Venice, the Mouth of the Grand Canal, 1840
Watercolor on wove paper; 8 ⅝ x 12 ½ in.
(21.9 x 31.8 cm)

PROVENANCE: Rt. Hon. W. H. Smith; Sir Joseph Beecham, sold, Christie's, 4 May 1917 (155); Walter H. Jones; Gilbert Davis; Colnaghi, 1966; bt Paul Mellon 1966

SELECTED EXHIBITIONS: Victoria, *British Watercolour Drawings*, 1971, no. 44; PML, *English Drawings*, 1972, no. 108; YCBA, *English Landscape*, 1977, no. 150; Grand Palais, *Turner*, 1983, no. 238; YCBA, *Lear*, 2000, no. 202; Tate, *Turner and Venice*, 2003–4, no. 111
SELECTED LITERATURE: Wilton, *Turner*, 1979, p. 463, no. 1360; Warrell, 2003, p. 171
B1977.14.4652

Turner's dazzling paintings and watercolors of Venice are among his most celebrated works, and his vision continues to shape our perception of the city today. Turner first visited Venice in 1819, stopping there to draw intensively for a few days en route to Rome. In a state of economic decline in the aftermath of Napoleonic occupation, the former maritime empire was rarely visited by artists at this period, though Lord Byron lived there intermittently between 1817 and 1820, and Turner's visit may have been in part inspired by the publication in 1818 of the evocative fourth canto of Byron's *Childe Harold's Pilgrimage*.

Later characterized by John Ruskin as "a ghost upon the sands of the sea, so weak, so quiet, bereft of all but her loveliness," Venice, with its seductive combination of evanescent luminosity, rich literary and artistic associations, and decaying grandeur, was an ideal subject for Turner, whose major preoccupations were the rise and fall of civilizations and the depiction of light (as he later remarked to Ruskin, "Atmosphere is my style" [Ruskin, *Works*, vol. 9, p. 17]). Yet, paradoxically, the "Glorious City in the Sea" was slow to captivate Turner's imagination; after returning to England in 1820, he produced just one unfinished canvas of the Rialto and, aside from a few watercolors, did not turn his attention to the city again until 1833, when he exhibited two Venetian subjects at the Royal Academy. Turner returned later that year, and again in 1840, compulsively drawing (his three brief visits yielded over a thousand sketches), and produced Venetian canvasses and watercolors steadily between 1833 and the late 1840s.

Turner was a virtuoso watercolorist, and the medium was particularly well suited to capturing Venice's elusive and volatile atmospheric conditions. As Ian Warrell has demonstrated (2003, p. 171), this view of San Giorgio Maggiore and the Dogana is a sheet from the widely dispersed "Storm" sketchbook in use during Turner's 1840 visit, which contained a series of finished watercolors charting the progress of a dramatic thunderstorm over Venice. As Warrell conjectures convincingly, Turner probably made the watercolors immediately on his return to the Europa Hotel after being caught in the storm. GF

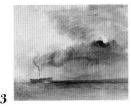

93

A Paddle-steamer in a Storm, ca. 1840
Watercolor over graphite with scratching out on wove paper; 9 ⅛ x 11 ⅜ in. (23.2 x 28.9 cm)

Joseph Mallord William Turner
John Constable

PROVENANCE: Thomas Greenwood, sold, Christie's, 12 Mar. 1875 (267); bt Agnew for James Houldsworth, by descent to Col. J. F. H. Houldsworth; Sotheby's, 28 Nov. 1974 (118); bt John Baskett; bt Paul Mellon, 1974
SELECTED EXHIBITIONS: YCBA, *English Landscape*, 1977, no. 144; YCBA, *Turner and the Sublime*, 1980–81, no. 113; Canberra and Melbourne, *Turner*, 1996, no. 85; YCBA, *Behold, the Sea Itself*, 2003
SELECTED LITERATURE: Wilton, *Turner*, 1979, p. 478, no. 1484; Wilton, *Turner*, 1980, p. 183, no. 113; Egerton, 1995, p. 65; Rodner, 1997, pp. 73–74; Taft, 2001
B1977.14.4717

Turner was deeply interested in modern technology and particularly fascinated by steamboats, which appealed to him for both aesthetic and practical reasons. First introduced in Britain in 1801, the steamboat was established as a form of public transportation in 1812 and rapidly became widespread. Turner made frequent sketching tours in Britain and on the Continent, and the development of steam navigation enabled him to travel more widely and rapidly. The artist was often exercised by the problem of depicting "the wavy air, as some call the wind," as he noted in one of his sketchbooks; the black smoke produced by steamboats, however, enabled Turner to track the movement of air currents in addition to offering a vehicle for articulating a new poetics of modernity (Taft, 2001). The steamship recurred frequently in Turner's work from the early 1820s, often apparently celebrating technological progress, though appearing sinister or even demonic, and sometimes pitted against the forces of nature. Critics were initially skeptical about the appropriateness of steamboats as a subject for art, but by 1836 a writer in the *Quarterly Review* was praising Turner for introducing "a new instance of the beautiful" (Rodner, 1997, p. 45).

In this drawing the steamer is shown sailing heroically in a menacing storm, the extremity of the weather underscored by Turner's bravura use of scratching out to denote the flash of lightning and the foam under the steamer's paddles. Both the date and the subject of this bold and atmospheric watercolor are uncertain. Andrew Wilton has plausibly suggested that the location is the Lake of Lucerne (Wilton, *Turner*, 1980, p. 183); Judy Egerton has less convincingly connected the drawing to Turner's 1830 visit to Staffa (see cat. 91), and a third possibility is that the drawing is a view of the Lagoon and relates to his 1840 stay in Venice. Technically, the watercolor is similar to Turner's work of the early 1840s, and this dating seems most likely. GF

94

The Channel Sketchbook, ca. 1845
Sketchbook with marbled endpapers and eighty-eight leaves of white wove paper, with seventy-four watercolor and twenty-six graphite sketches; sheet size: 3 ¾ x 6 ⅜ in. (9.5 x 16.2 cm)

PROVENANCE: Sophia Caroline Booth; her son, John Pound; Lawrence W. Hodson, by descent; sold,

Sotheby's, 10 July 1986 (37); bt Paul Mellon, 1986
SELECTED EXHIBITIONS: YCBA, *Behold, the Sea Itself*, 2003
SELECTED LITERATURE: Wilton, 1986; Wilton, 2001
B1993.30.118 (1–88)

A compulsive draftsman, Turner invariably traveled with a sketchbook. On his death, he left in his studio 290 sketchbooks, which formed a significant part of his bequest to the British nation (now housed at Tate, London). Just five sketchbooks outside of the Turner Bequest are recorded, including this one, which Turner seems to have used in the mid-1840s, when he was living mostly in Chelsea with a widow named Sophia Booth; it apparently remained with Mrs. Booth after his death in 1851. Bound in red leather, and in immaculate condition, the pocket-sized sketchbook, which still bears the label of the London stationer Pillsworth, contains vivid drawings in watercolor and graphite of the sea, shore, and sky, some obviously recording observations made on the spot and others more likely drawn from Turner's imagination, such as his sketches of whale hunts.

The date and location of the views depicted remain uncertain, but the dates of June 9 and July 24 are inscribed on two of the sketches, and Andrew Wilton (1986, p. 9) has suggested convincingly that Turner may have used the sketchbook along the British coast near Folkestone and possibly at Boulogne in the summer of 1845. Turner, who typically drew with great speed and economy, seems to have worked through the sketchbook in one direction, making watercolor drawings on the right-hand leaves, and then to have turned it upside down, working from back to front. The sketchbook contains a sequence of thirteen graphite drawings, annotated with color notes, which apparently record the progress of a single sunset over the sea. According to John Ruskin, who inventoried the Turner Bequest, this was Turner's "last sketchbook"; it seems unlikely that Turner would have abandoned a lifetime's habit of drawing out of doors during the last five years of his life, despite his failing health, but if this is indeed the last, it is a compelling testament to the artist's insatiable curiosity about the world and his penetrating powers of observation (Wilton, 1986, p. 9). GF

John Constable (1776–1837)
Like J. M. W. Turner, John Constable was one of the greatest English landscape painters of the nineteenth century. Born in East Bergholt, Suffolk, he entered the Royal Academy Schools in London in 1799. Through sources as various as rustic engravings, the paintings of Claude Lorrain, the Dutch Old Masters, and Gainsborough—but perhaps most of all through his attachment to the region of Suffolk—Constable formed a highly personal eye for the English picturesque landscape, as quiet and unpretentious as Turner's was frequently wild and colossal. Though unassuming, Constable was tenacious. Money troubles prevented his marriage for seven years, but the engagement lasted. Critical success was elusive but finally came. He was disappointed not to be elected to the Royal Academy before 1829, but by that time his most famous picture, *The Hay Wain* (1821; National Gallery, London), had created a sensation in France.

Constable's awareness of the rural calendar as well as of current developments in agriculture is evident in his studies of the Stour Valley, while his interest in the systematic study of meteorology drove him toward the

unique cloud studies, which, from 1819 on, he made each summer near his rented house in Hampstead. To Constable the sky was the most crucial determinant of the character of a landcape. He wrote: "If the Sky is *obtrusive*—(as mine are) it is bad, but if they are *evaded* (as mine are not) it is worse.... It will be difficult to name a class of Landscape, in which the sky is not the '*key note*,' the *standard of 'Scale*,' and chief '*Organ of sentiment*.'... The sky is the '*source of light*' in nature—and governs every thing" (Constable, *Correspondence*, vol. 6, pp. 76–77). If Turner's skies held in balance the drama of void and energy, Constable's embraced the logical movement of plain clouds, and discovered great poetry in that.

The essential unpretentiousness of Constable's vision of the English landscape is summed up in his famous remark in the same letter to his friend John Fisher (23 Oct. 1821): "The sound of water escaping from Mill-dams . . . willows, old rotten Banks, slimy posts, & brickwork. . . . They made me a painter (& I am gratefull)" (Constable, *Correspondence*, vol. 6, pp. 76–77).

Selected Literature: Leslie, 1843; Rosenthal, 1983; Cormack, 1986. AT

95

Golding Constable's House, East Bergholt: The Artist's Birthplace (Landscape with Village and Trees), ca. 1809
Oil on canvas; 5 ¾ x 10 in. (14.6 x 25.4 cm)

PROVENANCE: The artist's daughter, Isabel Constable; Mrs. G. S. Curtis; Oscar and Peter Johnson; bt Paul Mellon, 1964
SELECTED LITERATURE: Reynolds, 1996, p. 149
B2001.2.105

Constable's father was a prosperous corn merchant and owned water mills in the Stour Valley at Flatford, Dedham, and East Bergholt, close to the large family house over which he presided, the rear view of which this sketch records. (The stand of trees and the lone poplar, on the right, and the sprightly little cupola make it clear that we are looking at the back of the house.) The church of East Bergholt (see cat. 96) would be visible here if the margin of the present composition were extended farther to the left. Constable in fact produced at least one other view of his birthplace in which he included the church, thereby gathering into the composition the symbolic presence of the two crucial components of the rural polity—the rector and the squire. As well, Constable painted views from the rear windows of East Bergholt House, in effect directing his gaze back out toward the ground from which this and related views of the back of the house were taken. AT

96

East Bergholt Church, 1809
Oil on paper, laid on panel; 7 ⅞ x 6 ¼ in. (20.2 x 15.7 cm)
Inscribed, verso: *Oct. 10th 1809*

PROVENANCE: By family descent to Hugh Constable; Leggatt, 1899; Sir Michael Sadler by 1913; N. L. Hamilton by 1950; John Baskett; bt Paul Mellon, 1980
SELECTED EXHIBITIONS: Salander-O'Reilly, *Constable*, 1988; Tate, *Constable*, 1991, no. 27; YCBA, *Paul Mellon Bequest*, 2001, p. 28
SELECTED LITERATURE: Hoozee, 1979, no. 69; Reynolds, 1996, p. 135, no. 09.39
B2001.2.237

Contrary to the wording of the title by which it is now generally known, this exquisitely fresh oil study directs the eye of the viewer north along Church Street in the village of East Bergholt, from a position slightly adjacent to the village green, barely one hundred yards from Constable's birthplace, East Bergholt House. In the middle ground, a red-brick shop partially obscures the tower that in the sixteenth century was added to the side of the medieval church facing the street, but never completed. Stands of trees that surround the church and partially obscure the peculiarities of its hybrid form also prevented Constable from finding an unobstructed vantage point from which to record a view of the whole building. Constable's maternal grandfather had been rector of East Bergholt church. When Constable was growing up, he worshiped there with his family on Sundays and walked past the church on his way to and from Dedham Grammar School. At that time, the sundial on the porch carried the elementary Latin inscription "Ut umbra sic vita" (Life is like [a] shadow). AT

97

Fulham Church from Across the River, 1818
Graphite on wove paper; 11 ⅝ x 17 ½ in. (29.5 x 44.5 cm)
Inscribed and dated, lower left: *Fulham 8th. Sep.ʳ 1818*

PROVENANCE: Sir Charles Russell; Fine Art Society, 1961; bt Paul Mellon, 1961
SELECTED EXHIBITIONS: YCBA, *English Landscape*, 1977

SELECTED LITERATURE: Day, 1975, no. 59; White, 1977, pp. 87–88; Hoozee, 1979, no. D15; Rhyne, 1981, p. 134, no. 28
B1977.14.4632

This view beyond trees of the square tower of All Saints' Parish Church at Fulham was taken from the south bank of the Thames, a little way upstream from Putney Bridge and Fulham Palace, the summer residence of the Bishop of London, and a little way downstream from Hammersmith. At that reach of the Thames, and in this position, the viewer's eye is, in fact, directed due east, and the position of a partially obscured sun indicates that the time of day is therefore morning. On September 8, Constable made the trip from London to Putney Heath to visit his wife, Maria, who had been staying with her sister, Louisa Bicknell. Several other drawings he made on the same day are known, including a view of the semaphore on Putney Heath (The Fitzwilliam Museum, Cambridge), a windmill at Barnes (private collection), and a view of Richmond Bridge, farther upstream, that Constable drew the next day (September 9). All of them appear to have been removed from the same sketchbook, and all amply demonstrate the mastery with which Constable extracted atmospheric and textural effects of astounding subtlety from the medium of lead pencil, unembellished with ink, wash, or any other addition or effect. AT

98

Cloud Study, 1821
Oil on paper, laid on board; 9 ¾ x 11 ⅞ in. (24.8 x 30.2 cm)
Inscribed, verso: *Sep.r 28. 1821/Noon—looking. North. West./Windy from the S.W./large bright clouds flying rather fast/very stormy night followed*

PROVENANCE: The artist's son, Lionel Constable; Pierre Bordeaux-Groult; bt Paul Mellon, 1965
SELECTED EXHIBITIONS: Grosvenor, *Century of British Art*, 1889, no. 238; NGA, *Constable*, 1969, no. 43; Tate, *Constable*, 1991, no. 121; Denver, *Glorious Nature*, 1993–94, no. 58
SELECTED LITERATURE: Reynolds, 1984, p. 83, no. 21.57; Thornes, 1999, p. 238; Herrmann, 2000, p. 129
B1981.25.155

Constable's cloud studies represent perhaps one of the most original and surprising aspects of his evolving approach to the art of landscape painting. This exquisite example is in several respects unusual. Unlike numbers of other bona fide cloud studies—the product of hours of plein-air work on Hampstead Heath in 1821 and 1822, together with gradually lengthening sets of notes in which Constable recorded on each the weather conditions, topographical orientation, and the time of day—a narrow strip of "landscape" is

John Constable
John Sell Cotman

clearly indicated along the bottom margin of the panel, and birds wheel and swoop in what is in effect a foreground that elsewhere consists entirely of void and energy, the intangible space held in by clouds scudding far overhead.

Michael Rosenthal has noted the congruence of the larger Romanticism of Constable's strong feeling for skies and also the regulation of light in the landscape by the predictable behavior and motion of specific kinds of cloud, with lines from "Prelude VI," by Wordsworth, that appear to reflect a comparable and quintessentially Romantic outlook:

> The unfettered clouds and regions of
> the Heavens,
> Tumult and peace, the darkness and the light—
> Were all like workings of one mind, the features
> Of the same face, blossoms upon one tree:
> Characters of the great Apocalypse,
> The types and symbols of Eternity.
>
> (cited in Rosenthal, 1983, p. 167) AT

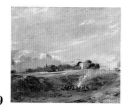

99

Hampstead Heath, with a Bonfire, ca. 1822
Oil on canvas; 10 ⅝ x 12 ⅝ in. (27 x 32.1 cm)

PROVENANCE: Ella Mackinnon, née Constable; Ernest Alfred Colquhoun; Edgar Edmond Colquhoun; Ernest Patrick Colquhoun; John Baskett; bt Paul Mellon. 1981
SELECTED LITERATURE: Reynolds, 1984, pp. 110–11
B2001.2.241

Constable's paintings of Hampstead Heath from approximately 1819 on represent a radical departure from the kind of landscape exemplified by views in the Stour Valley, where the artist felt literally and figuratively at home. The uncultivated, elevated heath, exposed and windy, an aerie from which to gaze at the great and equally unagricultural metropolis below, was a place of sand and gravel pits, a place of relative desolation, of sticks and gorse, of burning off, a condition of land, it was feared, to which cultivated pasture might easily revert should it be left fallow or abandoned, a primitive condition from which it is not difficult to imagine Constable lifting his gaze to trace and observe the casting of broad shadows over the heath's uneven contours by clouds scudding overhead. For it was this landscape, not so much the farms of Suffolk, that first inspired Constable's sustained study of the weather and the building of a repertoire of skies from which to borrow in the larger studio landscapes. AT

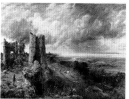

100

Hadleigh Castle, The Mouth of the Thames—Morning After a Stormy Night, 1829
Oil on canvas; 48 x 64 ¾ in. (121.9 x 164.5 cm)

PROVENANCE: Artist's sale, Foster's, 15–16 May 1838; Tiffin; Hogarth; Christie's, 13 June 1851 (46); Louis Huth by 1863 and at least until 1888; American private collection until 1960; Agnew; bt Paul Mellon, 1961
SELECTED EXHIBITIONS: RA, 1829, no. 322; Grosvenor, 1888, no. 7; VMFA, *Painting in England*, 1963, no. 113; RA, *Painting in England*, 1964–65, no. 68; YUAG, *Painting in England*, 1965, no. 32; YCBA, *Presences of Nature*, 1983, no. 3:30; AGNSW, *Eden*, 1998, no. 59; YCBA, *Great British Paintings*, 2001, no. 48; Tate, *Constable*, 2006, no. 57
SELECTED LITERATURE: Cormack, 1986, pp. 36–40; Reynolds, 1984, no. 29.1; Rosenthal, 1983, pp. 214–18; Thornes, 1999, pp. 136–41; Lambert, 2005, p. 102
B1977.14.42

In the famous letter of 23 October 1821 to his friend Archdeacon Fisher, John Constable reported: "I have not been Idle and have made more particular and general study than I have ever done in one summer, but I am most anxious to get into my London painting room, for I do not consider myself at work without I am before a six foot canvas" (Constable, *Correspondence*, p. 76). To some extent, the scale of Constable's great "six-footer" landscape paintings reflected both his high aspirations for landscape in general, and his desire for professional recognition and financial security. Yet *Hadleigh Castle*, which comes relatively late in the sequence of six-footers, in 1829, is among his least characteristic landscape views on a grand scale. Compared with *The White Horse* (1819; Frick Collection, New York), *Stratford Mill*, *The Hay Wain* (1820 and 1821; both National Gallery, London), and other paintings, each with its determined avoidance of heroic elements of the picturesque, each with its affectionate embrace of the seemingly commonplace features of rural life, *Hadleigh Castle* stands apart. The foreground vantage point is elevated and offers no convenient path into the difficult topography that descends toward the river flats to the right. The ruined castle clings to a rocky escarpment that winds into the distance and separates shepherd and cowherd and, presumably, their flock and herd. On the right, the Thames estuary opens out to the east, creating an immense, flat, gleaming distance beneath lowering clouds and theatrical slanting rays of morning sunlight. It is a landscape of revelation, not of domesticity.

Constable had visited Hadleigh in the summer of 1814 and in a letter to his wife, Maria, described the place as "a ruin of a castle which from its situation is really a fine place—it commands a view of the Kent hills, the Nore [the stretch of water beyond the mouth of the Thames] and the North Foreland & looking many miles to sea" (Constable, *Correspondence*, vol. 2, p. 127). He drew the place in his sketchbook (Victoria & Albert Museum, London) and appears not to have considered the subject again until fourteen years later, when, in about 1828, he worked up a small oil sketch (Paul

Mellon Collection, YCBA) and embarked upon the present composition (1829), by way of his accustomed, full-scale six-foot study (ca. 1828–29; Tate, London). He may have been prompted toward the unusually dramatic subject, with its hints at decay and regeneration, by the death from tuberculosis of his beloved wife in November 1828, but it seems that his election, at long last, in February 1829 to full membership of the Royal Academy may also have led Constable to consider the advantages of exhibiting a subject more conventionally picturesque and heroic than might otherwise have attracted him. These two immense changes in his working and personal life obviously went hand in hand. With leaden tact, Sir Thomas Lawrence, the President, had told Constable that he should consider himself lucky to have been elected to the Academy at all, since he had been competing against several talented history painters. Constable's status as an "R.A." therefore had the effect of raising the stakes, and *Hadleigh Castle* may well reflect his desire to adjust his manner of landscape painting in view of the expectations arising from this new professional challenge, made twice as difficult by the grief he suffered after the death of Maria. To some extent he remained desolate and depressed for the rest of his life—he called himself a ruin of a man. While dwelling on the decay of the medieval building in its pastoral setting and causing the Thames estuary to shine under grand shafts of light, Constable perhaps also alludes to the ancient Christian metaphor of death: all his boats point downstream and, receding, sail out to sea. AT

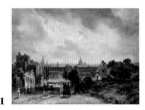

101

Sir Richard Steele's Cottage, Hampstead, ca. 1831–32
Oil on canvas; 8 ¼ x 11 ¼ in. (21 x 28.6 cm)

PROVENANCE: Charles Golding Constable; Mrs. A. M. Constable; Christie's, 11 July 1887 (69); bt Agnew; Daniel, 1889; Thomas James Barrett, 1912–16; Sir R. Leicester Harmsworth, 1916–37; Sir H. Harmsworth, 1937–52; Gooden & Fox; bt Paul Mellon, 1962
SELECTED EXHIBITIONS: Probably RA, 1832; South Kensington, 1880–83, no. 5; Grosvenor, *Century of British Art*, 1889; Wildenstein, *Constable*, 1937, no. 63; Manchester, 1956; RA, *Painting in England*, 1964–65, no. 83; YUAG, *Painting in England*, 1965, no. 46; NGA, *Constable*, 1969, no. 63; YCBA, *Paul Mellon Bequest*, 2001, p. 35
SELECTED LITERATURE: Wilenski, 1960, p. 16; Taylor, 1963, p. 84; Baskett, 1966, p. 82; Reynolds, 1984, p. 235
B2001.2.25

From 1821 on, John and Maria Constable lived with their growing family in the village of Hampstead, which was situated on high ground overlooking London from the northwest. The present view south-

east, along what was then known as Hampstead Road (now Haverstock Hill), is not far from the present Chalk Farm underground railway station. The eponymous cottage on the right was so named because the improvident early eighteenth-century Anglo-Irish essayist and playwright—his real name was Isaac Bickerstaff—for a time took refuge there from his creditors. It had previously been the residence of the dramatist and wit Sir Charles Sedley. The cottage was demolished in 1867. The site is commemorated not by the pub called the Sir Richard Steele, which is farther up the hill, but by Steele's Road, for which the site made way. St. Paul's Cathedral and the city of London are clearly visible on the horizon. In fact this view was largely the same as the Constables' from their leased house at 6 Well Walk. "Our little drawing room," boasted Constable in a letter to his friend John Fisher, "commands a view unequalled in all of Europe [Constable never traveled outside England!] —from Westminster Abbey to Gravesend—the doom [*sic*] of St. Paul's in the Air realizes Michael Angelo's Idea on seeing that of the Pantheon: 'I will build such a thing in the Sky' " (27 August 1827, Constable, *Correspondence*, vol. 6, p. 231). The painting was engraved in mezzotint in 1845 by David Lucas. AT

John Sell Cotman (1782–1842)

John Sell Cotman's present reputation as one of the greatest masters of nineteenth-century watercolor art was secured only in the twentieth century and is based largely on the watercolors he painted over a period of roughly five years, between about 1805 and 1810. In his lifetime, recognition beyond the provincial confines of his native Norfolk was limited, and posthumous appreciation of the breadth and variety of the art he produced throughout his career is still overshadowed by his great early watercolors.

In 1798 Cotman moved from Norwich to London, where he joined the circle of young artists around Dr. Thomas Monro and became a leading figure of the Sketching Society. Tours of Wales in 1800 and 1802 and of Yorkshire and County Durham in the following three years provided subject matter for his watercolors. After failing to be elected to the Society of Painters in Water-Colours in 1806, he returned to Norwich, where he set up as a drawing master and began exhibiting both watercolors and oils with the Norwich Society of Artists. In 1811 he moved to Great Yarmouth under the patronage of Dawson Turner, a banker and antiquary, producing a succession of architectural and antiquarian publications of Norfolk and Normandy.

Cotman returned to Norwich in 1823 and resumed exhibiting in London, becoming an Associate of the Society of Painters in Water-Colours in 1825. He served as President of the Norwich Society of Artists in 1833, the year the society disbanded. The following year he moved to London to become drawing master at King's College School and remained in London until the end of his life.

Selected Literature: Kitson, 1937; Moore, 1982; Rajnai, 1982; Hill, 2005. SW

102

In Rokeby Park, ca. 1805
Watercolor over graphite on laid paper; 12 ⅞ x 9 in. (32.7 x 22.9 cm)

PROVENANCE: Acquired from the artist by Francis Gibson, by descent in the Fry family; Agnew, 1971; bt Paul Mellon, 1971
SELECTED EXHIBITIONS: Tate, *Cotman*, 1922, no. 22; VMFA, *Painting in England*, 1963, no. 196; Colnaghi-Yale, *English Drawings*, 1964–65, no. 50; PML, *English Drawings*, 1972, no. 122; YCBA, *English Landscape*, 1977, no. 174; V&A, *Cotman*, 1982–83, no. 35
SELECTED LITERATURE: Kitson, 1937, p. 83; Rajnai and Allthorpe-Guyton, 1979, p. 61; Hill, 2005, pp. 125–26
B1977. 14. 4671

Watercolors from Cotman's stay in Yorkshire and County Durham in the summer of 1805 have been widely considered not only the high point of his work as a watercolorist but also some of the most strikingly original watercolors of the British School. Indeed, Laurence Binyon described them as "the most perfect examples of pure watercolour ever painted in Europe" (Binyon, 1931, p. 132). Cotman first visited Yorkshire in the summer of 1803, traveling north with an introduction to the Cholmeley family at Brandsby Hall, near York. Cotman became a great favorite of the Cholmeleys and returned to Brandsby the following two summers. After his visit there in July 1805, he proceeded to Rokeby Park, the home of John Morritt, an antiquarian and book collector, whose wife received drawing lessons from Cotman. He spent six weeks sketching in the area.

Although the publication in 1813 of Sir Walter Scott's poem about the English Civil War, titled *Rokeby*, drew international attention to the area between the rivers Tees and Greta, at the time of Cotman's visit, it was not yet an object of picturesque tourism. In a letter to Dawson Turner of 30 November 1805, Cotman wrote that his "chief study has been colouring from Nature, many of which [studies] are close copies of that fickle Dame, consequently valuable on that account" (Hill, 2005, p. 145). Whether *In Rokeby Park* is one of these studies painted from nature has been the subject of much debate. David Hill, in his recent detailed study of Cotman's work in the north, suggests that it most likely is (Hill, 2005, pp. 125–26). Perhaps because they were lacking in conventionally picturesque qualities, *In Rokeby Park* and its companion drawings from the visit to Rokeby did not find immediate purchasers. The watercolor remained in the artist's possession for years, until it was acquired by Francis Gibson, a banker, who became Cotman's patron in his later years. SW

George Fennel Robson (1788–1833)

Born in Durham, George Fennel Robson went to London about 1804, desirous of becoming a landscape painter. He visited Scotland for the first time in 1810, carrying with him a volume of Sir Walter Scott's poems. Responding to the vogue for the Highlands engendered by Scott's poetry and fiction and providing a visual counterpart to Scott's literary evocations of the Scottish landscape, Robson became particularly associated with the mountain scenery of Scotland. He first exhibited views of the Highlands at the Associated Artists in Water Colours from 1810 to 1812. After the demise of the Associated Artists, he became a lifelong member of the Society of Painters in Water-Colours and a prolific contributor to its exhibitions. He served as its President in 1820. His *Scenery of the Grampians*, forty outlines in soft ground etching, was published in 1814 and republished as hand-colored aquatints in 1819. He was a frequent collaborator with Robert Hills, who often provided the animals in Robson's landscapes.

Selected Literature: *ODNB*. SW

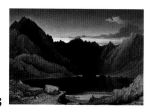

103

Loch Coruisk, Isle of Skye—Dawn, ca. 1826–32
Watercolor, gouache, scraping out, and gum on wove paper laid down on card; 17 ¾ x 25 ¾ in.
(45.1 x 65.4 cm)

PROVENANCE: Fine Art Society, 1972; bt Paul Mellon, 1972
SELECTED EXHIBITIONS: YCBA, *The Exhibition Watercolor*, 1981, no. 62; YCBA, *Presences of Nature*, 1982, no. 1:22; YCBA, *Fairest Isle*, 1989, no. 145; Villa Hügel, *Metropole London*, 1992, no. 254
B1977.14.6254

This dramatic watercolor is presumably one of the six views of Loch Coruisk that Robson exhibited at the Society of Painters in Water-Colours between 1826 and 1832. The watercolor shown in 1826, probably the one in the Victoria & Albert Museum, which is similar in composition to the version here, was accompanied by a poetic tag from Sir Walter Scott's *Lord of the Isles:*

> Stranger! If e'er thine ardent step hath traced
> The northern realms of ancient Caledon,
> Where the proud Queen of Wilderness
> hath placed
> By lake and cataract her lonely throne . . .
> (canto 4, lines 1–4)

Although critical of Robson's drawing, color, finish, and compositional sense, John Ruskin, in *Modern Painters I*, commended the sensitivity of the artist's depiction of mountains in a passage that almost seems to been written with this watercolor of Loch Coruisk in mind:

> They are serious and quiet in the highest degree, certain qualities of atmosphere and texture in them

have never been excelled, and certain facts of mountain scenery never but by them expressed; as for instance, the stillness and depth of the mountain tarns, with the reversed imagery of their darkness signed across by the soft lines of faintly touching winds; the solemn flush of the brown fern and glowing heath under evening light; the purple mass of mountains far removed, seen against clear still twilight. (Ruskin, *Works*, vol. 3, p. 193) SW

William Turner of Oxford (1789–1862)

Born in Oxfordshire in 1789, William Turner of Oxford (as he is invariably called, in order to distinguish him from his contemporary J. M. W. Turner) was the first pupil of the landscape artist John Varley. With Varley's encouragement, Turner, along with his contemporaries John Linnell, William Mulready, and William Henry Hunt, sketched regularly out of doors, a practice that became central to Turner's work. Turner showed great early promise (Varley was recorded as having spoken "violently" of his pupil's precocious talents [Farington, *Diary*, vol. 9, p. 3209]); he exhibited for the first time at the Royal Academy in 1807, and the following year became the youngest Associate of the Society of Painters in Water-Colours. In 1810 a critic writing in *Ackermann's Repository of the Arts, Literature and Commerce* opined, "It is not flattery to say that he has outstripped his master" (July 1810, p. 432).

Around 1812 Turner returned to Oxfordshire, making his living primarily by teaching, though he continued to exhibit watercolors, and, occasionally, oil paintings, of rural subjects executed in a hyperrealist style using saturated colors, which eschew any references to modernity. Turner undertook summer sketching tours, which included visits to the Lake District, Wales, the Peak District, and the Wye Valley; from the early 1820s he made regular trips to the New Forest and the South Downs and in 1838 undertook a long tour to the north of Scotland and the Western Isles, which was to provide him with raw material for the remainder of his career. Generally deemed to have failed to fulfill his youthful promise, Turner is often categorized as a producer of unoriginal and conservative though pleasing landscapes (John Ruskin's characterization of his "quiet and simple earnestness, and the tender feeling" is typical [Ruskin, *Works*, vol. 3, p. 472]); however, the minute detail and intense coloration of his work, which anticipate that of the Pre-Raphaelites, could be regarded as avant-garde.

Selected Literature: Wilcox and Titterington, 1984. GF

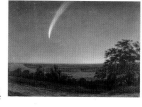

104

Donati's Comet, 1859
Watercolor and gouache over graphite on wove paper; 10 ⅛ x 14 ⅜ in. (25.7 x 36.6 cm)
Signed lower right: *W. Turner/Oxford*

PROVENANCE: Colnaghi, 1965; bt Paul Mellon, 1965
SELECTED EXHIBITIONS: SPWC, 1859, no. 264; YCBA, *English Landscape*, 1977, no. 194; YCBA, *The Exhibition Watercolor*, 1981, no. 65
SELECTED LITERATURE: Olson, 1985; Olson and Pasachoff, 1998, pp. 232–33; Bayard, 1981, pp. 69–70, no. 65
B1975.4.1767

Donati's Comet made its first and only documented appearance in 1858. Discovered on 2 June of that year by the astronomer Giovanni Battista Donati, by mid-August the comet was visible to the naked eye and remained so until December. An extraordinary spectacle by all accounts, the comet inspired numerous works of art, notably William Dyce's haunting meditation on time, *Pegwell Bay: A Recollection of 5th October 1858* (Tate, London). A close observer of natural phenomena, William Turner of Oxford often worked out of doors and inscribed his sketches with the date and time of their execution and remarks about the meteorological conditions. Turner exhibited this drawing at the Society of Painters in Water-Colours in 1859 with the title *Near Oxford—Half-past 7 o'clock, P.M., Oct. 5, 1858*; however, for all its apparent immediacy, the watercolor is not an accurate representation of the comet as it would have appeared on that night (Olson and Pasachoff, 1998, pp. 232–33). On 5 October the comet was at its most brilliant (the *Annual Register* reported that "the population of the western world was probably out of doors gazing on the phenomenon"), passing over the huge and very bright star Arcturus at 7:11 PM, with its twin secondary plasma tails visible, but neither the star nor its tails are depicted in Turner's watercolor.

Although the specificity implied in its title may seem somewhat spurious, Turner's image is nonetheless deeply compelling, contriving to suggest both ephemerality and timelessness and inspiring reflection on humankind's relationship to the natural world. Turner habitually used a combination of watercolor and gouache to give his works their striking density, but Jane Bayard has suggested that his technique of using numerous small touches to build up the sky of *Donati's Comet* may have been influenced by J. F. Lewis's monumental watercolor *Frank Encampment* (see cat. 111), which was exhibited to acclaim three years earlier (Bayard, 1981, p. 70). GF

John Linnell (1792–1882)

John Linnell was a precocious talent. The son of a frame maker and picture dealer, he learned to paint by copying works for his father. His father's business put him in regular contact with leading artists from a young age, including Benjamin West, David Wilkie, Benjamin Robert Haydon, and Sir George Beaumont. Linnell entered the Royal Academy Schools in 1805 (he would leave in 1811) and began his studies with the artist John Varley. Specializing in portraits and landscape studies, Linnell flourished in the art world. Indeed, he was in demand as a portraitist until he gave up that genre in 1847. His close friendship with Cornelius Varley, the brother of his former teacher, had an impact on both his life and his art: Linnell converted to the Baptist faith and focused his attention on landscape painting, influenced by the work of such natural theologians as William Paley, who drew

parallels between the study of nature and the worship of God. Linnell met William Blake in 1818, and they exchanged views on art and religion. He was instrumental in securing important commissions for the older artist, including *Illustrations of the Book of Job* (1825). Linnell was an important influence on Samuel Palmer, introducing him to Blake as the younger artist developed his own visionary mode of landscape painting. A rift developed, however, as Linnell encouraged Palmer to study from nature. A nonconformist by nature, Linnell flirted with Quakerism in the 1830s before renouncing organized religion in 1848. From the 1840s on, Linnell devoted himself to landscape painting and the location of the divine in nature, producing idyllic scenes of agriculture, often tinged with biblical overtones, until his death in 1882. A lifelong Londoner, he retreated to a farm in Redhill, Surrey, in 1851 to immerse himself in the pastoral.

Selected Literature: Story, 1892; Crouan, 1982; Linnell, 1994; *ODNB*. MO

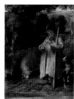

105

Shepherd Boy, also known as *Shepherd Boy Playing a Flute*, 1831
Oil on panel; 9 x 6 ½ in. (22.9 x 16.5 cm)

PROVENANCE: Mrs. Florence Donald; L. J. Drew, Esq.; Colnaghi; bt Paul Mellon, 1962
SELECTED EXHIBITIONS: VMFA, *Painting in England*, 1963, no. 294; Fitzwilliam, *John Linnell*, 1982, n. 68; YCBA, *Toil and Plenty*, 1993–94, no. 19
SELECTED LITERATURE: Lister, 1989, no. 47
B1981.25.420

John Linnell purchased a copy of Robert Bloomfield's *The Farmer's Boy: A Rural Poem* (1800) around 1815 (Story, 1982, p. 79). A self-taught "Peasant Poet," Bloomfield was also known as "The Suffolk Poet" for his commemoration of agricultural life in that area. He acknowledged the tedium and anxiety of living off the land in the story of Giles, the farmer's boy, and his various labors throughout the seasons. In summer, for example,

> The Farmer's life displays in every part
> A moral lesson to the sensual heart
> Though in the lap of Plenty, thoughtful still,
> He looks beyond the present good or ill.
> (Wickett and Duval, 1971, p. 80)

The poem cycle celebrates a rural community and the sense of the divine spirit that pervaded its pursuits. As Linnell turned away from organized religion and toward a sacred conception of landscape, he would have appreciated this sentiment. His 1830 painting *The Farmer Boy*, exhibited at the Royal Academy, commemorates this connection to Bloomfield. *The Shepherd Boy* is thought to be a smaller replica of this earlier work, likewise inspired

by Bloomfield and the motto of *The Farmer's Boy*, taken from Alexander Pope's poem "Summer—The Second Pastoral; or Alexis" (1709): "a Shepherd's boy, he seeks no better name." The child gently engages the viewer, looking up as he plays the fipple flute, an instrument similar to a recorder.

The humble origins of the shepherd boy and his humility parallel the pastoral identity of Christ as a "shepherd of men." Linnell's close relationship with Samuel Palmer in this period motivated this exploration. In 1828 and 1829, Linnell and George Richmond visited Palmer at Shoreham in Kent, where the younger artist was engaged in his own visionary experiments with landscape painting. Linnell maintained this symbiotic relationship among landscape study, artistic practice, and religious belief throughout his career. MO

Robert Burnard (1800–1876)

Robert Burnard was born in 1799 or 1800 in Laneast, about six miles from Launceston, in Cornwall. He was the son of Richard Parnell Burnard and his wife, Elizabeth (née Westlake). We do not know Richard Burnard's profession, nor do we know anything about Robert Burnard's childhood. A later source tells us that Robert was self-taught and that in adult life he lived and worked as a portrait painter in Francis Street, Truro. Burnard married Jane Chapman on 8 October 1822 at Altarnun, near Laneast. Both Jane and Charles, the oldest of their four children, died in 1831. The following year Burnard married his second wife, Elizabeth (née Stodden), and in due course they had another ten children.

In late August 1839, the rapidly multiplying Burnards applied for and were granted assisted free passage to the new colony of South Australia. On 29 October, they sailed from Plymouth aboard the *Java*. That four-month voyage was notorious: the ship was terribly overcrowded, and between thirty and fifty of the 464 passengers died of malnutrition, starvation, or disease by the time the *Java* limped into Port Adelaide on 6 February 1840. There was a near mutiny of the crew, and the ship was long remembered as "the floating coffin" (Trumble, 2004, p. 86, note 10). A Royal Commission and an inquiry conducted by the South Australian medical board, to which Robert Burnard gave evidence, both censured the ship's master, Captain Alexander Duthie, and the two doctors on board. Payment was ultimately withheld from the owners, Scott & Co. of London, who escaped prosecution. The Burnards were lucky. With six children they eventually settled in the Adelaide suburb of Plympton, surrounded by Cornish neighbors. In partnership with his eldest son, Burnard set up a house-painting business that evolved into Burnard & Draysey, Painters, Plumbers, Glaziers, and Paper Hangers, of Pirie Street, which is listed in two Adelaide directories printed in 1856. Robert Burnard died in Adelaide on 13 April 1876 and lies buried in the West Terrace Cemetery. Only three paintings have so far been traced from the artist's Cornish period.

Selected Literature: Warner, 2001; Trumble, 2004. AT

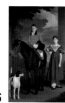

106

John Gubbins Newton and His Sister, Mary Newton,
ca. 1833
Oil on canvas; 92 ½ x 56 ½ in. (235 x 143.5 cm)
Signed, upper left: *R. Burnard Pinxit*

PROVENANCE: John Newton, by descent to John Ashford,
sold with the Millaton estate in 1924 and again in 1955;
bt J. Andrews; Cyril Staal; Jeremy Maas, 1961; bt Paul
Mellon, 1961
SELECTED EXHIBITIONS: VMFA, *Painting in England*,
1963, no. 283; RA, *Painting in England*, 1964–65,
no. 254; YCBA, *Paul Mellon Bequest*, 2001, p. 61
SELECTED LITERATURE: Taylor, 1963, p. 276; Maas, 1969,
p. 75; Egerton, 1978, pp. 284–89; Trumble, 2004
B2001.2.66

These children were the only son and daughter of John
Newton and his wife, Charity (née Gubbins), who lived
at Millaton House at Bridestowe, in Devon. Based on
the birth dates of the Newton children (John, in 1826,
and Mary, in 1823), the picture cannot have been painted
before 1833. Although much is known about the sitters
and their wealthy parents, until recently there were no
clues in the provenance to help answer the question of
attribution. In 1963, Basil Taylor attributed the picture
to the expatriate Swiss animal painter Jacques-Laurent
Agasse (1767–1849), noting that "before settling in
England in 1800, Agasse studied under David and the
strong clarity of his forms and the closely integrated
organization of his design [i.e., of the Newton portrait]
derive as much perhaps from that source as from the
Swiss tradition to which he obviously belongs." Only
these, or sources equally distant from Cornwall, were
sufficient to account for the "mesmeric force" of the
painting's realism, its "clarity and precision of detail."
The picture did not seem English enough. "It stands
quite apart from the romantic bravura and exaggerated
expressiveness of the typical portraiture of its time,
dominated as that was by the style and spirit of Sir
Thomas Lawrence" (Taylor, 1963, p. 276).

In 1978 Egerton devised an ingenious and, in many
ways, better argument, linking this somewhat isolated
West Country subject with the Scottish portrait and
history painter John Zephaniah Bell (1793–1883).
Echoing Taylor's thoughts about Agasse, Egerton cited
in Bell's favour the "clarity, strong lines and quasi-heroic
composition [that] link it rather with the portraiture of
David and his pupils, presupposing some continental
training in the artist" (Egerton, 1978, pp. 286–87). But,
in this case, notwithstanding her own view that the por-
trait "stands quite apart from the typical British portrai-
ture of its time," Egerton based her attribution on the
Newton painting's close resemblance to an 1829 father-
and-daughter portrait by Bell, *David Ogilvy, 9th Earl of
Airlie, and His Daughter, Clementina, Aged Nine* (Earl
and Countess of Airlie, Cortachy Castle, Kirriemuir,
Angus), further suggesting that the Newton portrait
might have been painted in London (Egerton, 1978,
pp. 286–87). This would account for Bell's otherwise
conspicuous lack of West Country clientele.

Both hypotheses turned out to be wrong. In prepa-
ration for the 2001 exhibition *The Paul Mellon Bequest:
Treasures of a Lifetime*, the Newton portrait was cleaned
by the paintings conservator Lance Mayer, who discov-
ered the signature of Robert Burnard lurking in the foli-
age in the upper left corner. This is the only surviving
portrait that has been securely ascribed to Burnard from
the period prior to his immigration to South Australia,
though its sophistication surely suggests that others may
yet be identified. AT

Richard Parkes Bonington (1802–28)

Although his entire artistic career spanned just a decade
and his career as an oil painter lasted for less than five
years, Richard Parkes Bonington's bravura painting style
in both watercolors and oils was immensely influential
in both Britain and France. The son of a sometime
painter and drawing master in Nottingham, Bonington
immigrated with his family to Calais in 1817. There his
father attempted to establish a lace-making business, and
the young Bonington took lessons from Louis Francia, a
French watercolorist who had just returned to Calais
after years of working in London. When the family
moved to Paris in 1818, Bonington entered the studio of
the academic painter Baron Antoine-Jean Gros but
quickly abandoned academic training to paint water-
color landscapes and to work for print publishers.

In 1824 Bonington began painting marine and
coastal subjects in oils. His exhibited work at the Paris
Salon that year—the year in which British artists such as
John Constable and Thomas Lawrence were celebrated
at the Salon—attracted favorable attention and garnered
Bonington a gold medal. In the summer of 1825 he vis-
ited London together with a group of young French
artists, including Eugène Delacroix, with whom he
would later share a studio in Paris. The following year
Bonington exhibited in London for the first time, and
traveled in Switzerland and northern Italy. Two years
later he died of tuberculosis in London, where his par-
ents had taken him in hope of a cure.

Selected Literature: Pointon, 1985; Noon, 1991;
Duffy, 2003. SW

107

Shipping in an Estuary, Probably near Quilleboeuf,
ca. 1825–26
Watercolor over graphite with scratching out on wove
paper; 5 ¾ x 9 in. (14.5 x 22.9 cm)
Signed lower right: *RPB*

PROVENANCE: Madame Henri Leroux, sold, Sotheby's,
21 Mar. 1974 (114); bt John Baskett; bt Paul Mellon, 1974
SELECTED EXHIBITIONS: YCBA, *English Landscape*, 1977,
no. 206; YCBA, *Masters of the Sea*, 1987, no. 86; YCBA,
Bonington, 1991–92, no. 80
B1981.25.2398

Throughout his brief career, coastal landscape would be a mainstay of Bonington's work in both watercolors and oils. His affinity for such subjects presumably dates from his period of study with Louis Francia in Calais in 1817. Francia had fled to England as a youthful refugee from the French Revolution and become part of the circle of Thomas Girtin in London. When he met Bonington, he had just returned to his native Calais and was beginning to establish himself as a drawing master and marine painter. Francia would undoubtedly have transmitted to his young pupil an awareness of British watercolor practice and a taste for naturalistic coastal scenes, both of which were novelties in France.

In the autumn of 1821, while still in the atelier of Baron Gros, Bonington embarked on his first extensive sketching tour, traveling through Normandy and producing watercolors of the coast. He would leave Gros's studio by the end of 1822. He spent most of 1824 based in Dunkerque, and though he was back in Paris in 1825, he was again sketching along the Channel coast with his artist friend Eugène Isabey in the autumn of that year. This watercolor probably derives from that time. Although the inscription on an old mount (now removed) gave the date as 1818, this is clearly a work of Bonington's maturity, remarkably assured in its elegant and fluid use of the medium. sw

108

Grand Canal, Venice, 1826
Oil on millboard; 9 ¼ x 13 ¾ in. (23.5 x 34.9 cm)

PROVENANCE: Agnew and Zanetti, Manchester, 1828–35; Percy Moore Turner, by 1936; R. A. Peto; Mrs. Rosemary Peto; sold, Christie's, 18 June 1971 (108); bt Paul Mellon, 1971
SELECTED EXHIBITIONS: YCBA, *Bonington*, 1991–92, no. 96
B1981.25.56

Bonington left Paris for Italy with his friend and pupil Charles Rivet, later Baron Rivet, on 4 April 1826. They traveled quickly through France and Switzerland, arriving in Milan on 11 April. Bonington was eager to press on, for, as Rivet noted, he "thinks only of Venice" (Noon, 1991, p. 56). Reaching Verona on 18 April, they arrived in Venice a few days later and stayed there until the end of May. Bonington sketched incessantly in graphite, watercolor, and oils. These sketches provided subject matter for much of his finished art in the remaining months of his life. From Venice the two friends went on to Padua, Florence, Pisa, Lerici, Genoa, and Turin, never lingering in any one place. Rivet was back in Paris by 20 June, though Bonington may have done some further traveling on his own in Switzerland.

In 1825 Bonington had begun sketching en plein air in oils on small millboards, which he discovered

during his trip to London. He seems to have brought back about two dozen such sketches on millboard from Italy (Noon, 1991, pp. 59–60). This oil sketch shows the north side of the Grand Canal near its entrance, looking towards the Bacino di San Marco. While Bonington has deftly captured the brilliant shimmering light on the water and the facades of the palazzi, topographical accuracy was clearly not a priority. He has elided the famous Palazzo Gritti-Pisani from the succession of buildings lining the canal. sw

Sir Edwin Landseer (1802–73)

Edwin Landseer enjoyed tremendous success as a prodigiously talented painter of animals and was the greatest of George Stubbs's nineteenth-century successors. That the following famous remark was uttered at the Court of Queen Victoria by the King of Portugal is a measure of the high standing to which Landseer rose, despite the colossal nervous breakdown he suffered in 1840: "Oh, Mr. Landseer, I am delighted to make your acquaintance; I am so fond of *beasts!*"

His father, John Landseer, was a distinguished engraver who arranged for his three sons to be trained as artists in the studio of the initially demanding, later envious, and finally resentful and embittered Benjamin Robert Haydon, from whom young Edwin learned the value of the systematic study of animal anatomy. Landseer prospered in the Royal Academy Schools (where C. R. Leslie remembered him as "a pretty little curly-haired boy") and benefited from the wise neglect of Henry Fuseli (Leslie, 1860, vol. 1, p. 39). Landseer made an immediate and lasting impact with his portraits of dogs—Fuseli is reputed to have asked "Where is my little *dog boy*?"—and early success came as a result of the loyal patronage of the Duke and Duchess of Bedford (Leslie, 1860, vol. 1, p. 39). (The artist is believed to have had an affair with the duchess.) Landseer established himself in society and moved with ease between great houses such as Chatsworth and Goodwood, in the process getting to know such great literary figures as John Keats, Leigh Hunt, and, in 1824, on his first visit to Scotland, Sir Walter Scott. Scotland created in Landseer a passion for wild landscape, hunting, coursing, fishing, and the great outdoors; by this time, as Lord Tankerville recalled, he was "a little, strongly built man, very like a pocket Hercules or Puck in 'The Midsummer Night's Dream'" (Leslie, 1860, vol. 1, p. 39). Queen Victoria and Prince Albert were loyal patrons.

Landseer's early works included grand historical subjects, which were enriched by his aptitude for animal painting, most notably *The Hunting of Chevy Chase* (1825–26) and other related medieval subjects for Woburn Abbey, the seat of the Bedfords. But he also produced fairly conventional genre paintings, such as *The Cat's Paw* (1824; Dr. Roger L. Anderson), the gruesome monkey-and-kitten subject, and the immensely popular bereft dog painting, *The Old Shepherd's Chief Mourner* (1837; Victoria & Albert Museum, London). Later pictures elevate both the standing of the animal protagonists and the antidomestic theatricality of the grand, usually Scottish highland setting, which is often keyed in pungent title choices, as in *The Monarch of the Glen* (1851; Diageo, on loan to the National Museums of Scotland), for

example—a title that to some extent was doomed to be scorned by later generations who were so thoroughly out of sympathy with the unapologetic, anthropomorphizing swagger and profound sentimentality of the subject matter. Landseer cultivated Charles Dickens, William Powell Frith, and John Everett Millais—all much younger. He was knighted in 1850, and his professional life culminated with the design and construction of the four enormous bronze lions for Nelson's column. Landseer was buried near Reynolds, Lawrence, and Turner in St. Paul's Cathedral, and on the day of his funeral huge wreathes were hung from the fangs of the lions in Trafalgar Square.

Selected Literature: Ormond, 1981; *ODNB*. AT

109

Favourites, the Property of H.R.H. Prince George of Cambridge, 1834–35
Oil on canvas; 40 x 49 ½ in. (101.6 x 125.7 cm)

PROVENANCE: Prince George William Frederick Charles of Cambridge (later 2nd Duke of Cambridge), sold, Christie's, 11 June 1904 (25); bt Gooden and Fox; "a family trust"; Christie's, 21 Nov. 1986 (29); bt John Baskett; Paul Mellon, 1986
SELECTED EXHIBITIONS: RA, 1835, no. 303
SELECTED LITERATURE: Graves, 1874, p. 18
B2001.2.273

At the time he commissioned from Landseer this portrait of his gray Arabian stallion Selim, his Newfoundland dog Nelson, his King Charles spaniel Flora, and his peregrine falcons, seen here hooded and ready to be put through their paces at Windsor, the sixteen-year-old Prince George of Cambridge was of considerable dynastic importance. His uncle and aunt, King William IV and Queen Adelaide, with whom he spent long periods at court at Windsor, were childless, and even though Prince George's father, Adolphus, Duke of Cambridge, who acted as his brother's viceroy in the tiny German kingdom of Hanover, was the tenth child and seventh son of George III and Queen Charlotte, there were few legitimate male grandchildren of George III. Apart from his cousin Princess Victoria of Kent, heir presumptive to the throne, who, though tiny, was not particularly delicate, relatively few steps separated the young man from the throne of England. An alternative idea that was seriously entertained by King William was that Prince George would make a splendid husband and consort for Princess Victoria. They were almost exactly the same age, but in due course neither relished the prospect of marriage to the other.

Owing to Salic laws of succession in continental Europe (that is, the mandatory inheritance of the throne by the nearest male heir), after the accession of Queen Victoria in 1837, the crowns of Britain and Hanover were separated almost 125 years after they

were first united under King George I. Thenceforth, Ernest, Duke of Cumberland, another of the new queen's many Hanoverian uncles, reigned as King of Hanover. With no further need for a viceroy in Hanover, the Cambridge family returned to England, and Prince George joined the British army, enjoying a distinguished career and eventually retiring with the rank of field marshal and commander-in-chief. Conforming to the manners of the previous generation, in 1840 Prince George contracted a morganatic marriage to an actress, Louisa, Miss Fairbrother, for whom he provided a house in Queen Street, Mayfair, where she settled comfortably as "Mrs. Fitzgeorge" and produced three sons.

This painting was engraved by W. Giller in 1841 and lithographed by Lafosse. AT

Thomas Shotter Boys (1803–74)

After an apprenticeship to the London engraver George Cooke from 1817 to 1823, Thomas Shotter Boys moved to Paris, where British engravers were much in demand. There he was befriended by Richard Parkes Bonington, under whose influence he took up watercolor painting. The 1830s represented the high point of Boys's artistic career. The technique of his watercolors, exhibited at the Paris Salons and in London at the New Society of Painters in Water Colours, was at its most assured. He also mastered lithography, producing in 1839 one of the great lithographic publications of the century, *Picturesque Architecture in Paris, Ghent, Rouen, etc.*, a collection of twenty-six chromolithographs after his own watercolors. This was followed in 1842 by *Original Views of London as It Is.*

Boys returned to London in 1837. He was elected an Associate of the New Society of Painters in Water Colours in 1840, becoming a full member the following year. He continued to exhibit with the society until his death, but by mid-century the quality of his work had deteriorated and his critical and financial fortunes had begun a long and irreversible decline.

Selected Literature: Roundell, 1974. SW

110

L'Institut de France, Paris, 1830
Watercolor over graphite on wove paper;
13 ¹⁵/₁₆ x 10 ½ in. (35.4 x 26.7 cm)
Signed and dated lower center in brown ink:
Thomas Boys/1830

PROVENANCE: C. R. N. Routh; Agnew, 1962; bt Paul Mellon, 1962
SELECTED EXHIBITIONS: VMFA, *Painting in England*, 1963, no. 196; Colnaghi-Yale, *English Drawings*, 1964–65, no. 50; PML, *English Drawings*, 1972, no. 137; YCBA, *English Landscape*, 1977, no. 209
SELECTED LITERATURE: Roundell, 1974, p. 78
B1975. 4.1460

Boys's work in watercolor was closely modeled on that of his friend and mentor Richard Parkes Bonington; indeed, many of Boys's early watercolors either copy works by Bonington or adopt the same subjects. Such is the case with this watercolor, which presents the Institut de France from almost the same vantage point as a watercolor by Bonington now in the British Museum. Bonington's watercolor probably dates from the last year of his life, a time when he and Boys were frequently working together. Boys's watercolor is not, however, a simple copy. The angle at which Boys presents the famous building by Le Vau has shifted slightly, the foreground incident on the Quai Conti is different, and most significantly Boys includes the Pont Royal, which Bonington had inexplicably omitted. Although Boys took over many elements of Bonington's virtuosic watercolor style, there is in Boys's handling a crispness and precision, if also a hardness, not evident in Bonington's more sensitively atmospheric use of the medium. SW

John Frederick Lewis (1804–76)

John Frederick Lewis's first training as an artist came from his father, the engraver Frederick Christian Lewis. Early friendship with the Landseer family of artists, especially Edwin and his brother Thomas, broadened his artistic circle; like Edwin Landseer, Lewis focused on animals early in his career. He studied live specimens and dissected cadavers as a studio assistant to Thomas Lawrence in the early 1820s. Lewis exhibited these works at the Royal Academy and British Institution. Lewis changed directions in 1827, focusing on watercolor and genre scenes inspired by his travels. He was a peripathetic artist in the following decades, traveling first in Britain and Europe in the 1820s and 1830s, most notably to Spain in 1832–33, and returning to London periodically to exhibit works at the Society of Painters in Water-Colours, the Royal Academy, and the British Institution. In 1837 he left Britain once again for Paris, Italy, and travels throughout the Mediterranean, including Greece and Turkey, before heading to Cairo in 1841. He stayed in Egypt for a decade, and his work there seems to embody the conflicting demands of Orientalist fantasy and Victorian reality. He produced idealized scenes of native life in a meticulously detailed style, both of which would become his hallmarks. Visiting the artist in Cairo in 1844, William Makepeace Thackeray observed "a languid lotus-eater" who lived like a native (W. M. Thackeray, *Notes of a Journey from Cornhill to Gran Cairo*, 1846, pp. 282–91). Yet Lewis socialized with a number of eminent Englishmen during his time in Egypt, including Viscount Castlereagh and Sir John Gardner Wilkinson. When he returned to England in 1851 with his English wife, he soon after retired to Walton-on-Thames, Surrey. Lewis embraced John Ruskin's suggestion that he try oil painting and resigned as President of the Society of Painters in Water-Colours in 1858. From his pastoral hamlet, he produced, to great acclaim, scenes of Egyptian life that he exhibited widely and regularly until his death in 1876.

Selected Literature: *Art Journal*, 1858; *Art Journal*, 1876; Davies and Long, 1925–26; Stokes, 1929; Lewis, 1978; *ODNB*. MO

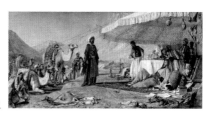

111

A Frank Encampment in the Desert of Mount Sinai, 1842—The Convent of St. Catherine in the Distance, 1856
Watercolor and gouache over graphite on wove paper laid down on board; 26 ¼ x 53 ½ in. (66.7 x 135.9 cm)

PROVENANCE: H. Wallis, 1857; George R. Burnett, sold, 16 Mar. 1872 (137); Gilbert Winter Moss, sold, 28 Apr. 1900 (102); anon. sale, 17 May 1912 (50); C. D. Rudd, sold, 2 May 1919 (38); Fiona Campbell-Blair, sold, Sotheby's, 4 Apr. 1968 (76); R. T. Laughton, sold, Sotheby's, 14 Apr. 1976 (68); Fine Art Society; John Baskett; bt Paul Mellon, 1976
SELECTED EXHIBITIONS: SPWC, 1856, no. 134; Manchester, *Royal Jubilee*, 1887; Laing, *Lewis*, 1971, no. 74; YCBA, *The Exhibition Watercolor*, 1981, no. 80; YCBA, *First Decade*, 1986, no. 102; NGA, *Orientalists*, 1984, pp. 180–81, no. 67; YCBA, *Lear*, 2000, no.186
SELECTED LITERATURE: Ruskin, *Works*, vol. 14, pp. 73–78; *Art Journal*, 1856, p. 176; Davies and Long, 1925–26, pp. 35–36, 39–40; Bendiner, 1979, pp. 213–33; Weeks, 2004, pp. 240–48; Schoenherr, 2005, p. 107
B1977.14.143

After a decade of living and working in Cairo, John Frederick Lewis returned to London in 1851. He established himself as the preeminent interpreter of life in the East, painting genre scenes that played upon Western notions of Oriental luxury set amid bazaars, harems, desert landscapes, and mosques. He rendered each of these subjects in a style characterized by one contemporary critic as "marvelous in minute manipulation" (*Art Journal*, 1876, p. 176). Lewis's sharp style blurs boundaries in this meeting between East and West. A local term for anything European, the Frank of the *Frank Encampment* was Frederick William Robert Stewart, Viscount Castelreagh, author of *Diary of a Journey to Damascus* (1847). He left Cairo for Damascus in May 1842 and spent five days at Mount Sinai. Castelreagh commissioned a portrait of his party from Lewis, and although Lewis sketched some of the sitters before their departure (see Schoenherr, 2005, p. 107), it is unclear if *A Frank Encampment* was the picture commissioned in 1842 or if Lewis even observed the group at Mount Sinai. Castelreagh wears native dress and adopts a languid posture, recumbent amid a bevy of accoutrements—some "Eastern," such as the hookah, some "Western," such as tea, books, furniture, newspapers, and even a bottle of Harvey's Sherry. In contrast, the local sheik Hussein of Gebel Tor (the Arabic name for Mount Sinai) stands erect, his serious, and perhaps dubious, expression directed towards the bloated lord whom he has agreed to guide across the desert. The monumental Monastery of St. Catherine in the distance serves as an appropriate backdrop for this encounter, a site of Christian pilgrimage and an active mosque. Emily Weeks observed in this work the "fragility of borders and the

falseness of boundaries" that challenge the binary of East and West (Weeks, 2004, p. 240). Lewis exhibited the work at the Society of Painters in Water-Colours in 1856. When John Ruskin visited the exhibition, he singled out this work for his highest praise, "I have no hesitation in ranking it among the most *wonderful* pictures in the world" (Ruskin, *Works*, vol. 14, p. 73). MO

Samuel Palmer (1805–81)

Although little known and largely overlooked in his lifetime, the landscape drawings and paintings that Samuel Palmer created as a young artist have been celebrated since the early twentieth century as some of the most intensely individual creations of the Romantic age. These works, invariably described as visionary, have overshadowed his later achievements, yet an intensity and poetry are evident in his responses to nature throughout his career.

The son of a London bookseller, Palmer was largely self-taught as an artist. His earliest works are competent but conventional. In 1822 he met John Linnell, who encouraged him to study the works of Dürer, Michelangelo, and Bonasone and introduced him to William Blake. Palmer became the leading figure in a group of young fellow enthusiasts for Blake who called themselves the Ancients. Blake's influence, together with the study of early Renaissance prints, helped shape Palmer's archaizing and intensely stylized drawings and paintings of the 1820s. From 1826 to 1833 he lived in the Kentish village of Shoreham, during which time he produced his most visionary landscapes.

At the urging of Linnell and in recognition of the need to make a living by his art, Palmer adopted a more naturalistic style. In 1837 he married Linnell's daughter Hannah, and, after a few years in Italy, he returned to London and set up as a drawing master. In 1843 he was elected an Associate of the Society of Painters in Water-Colour, becoming a full member in 1854. Although initially his exhibited work attracted little notice, he was later recognized as a brilliant colorist and a foremost exponent of poetic landscape. He took up etching, becoming a member of the Etching Club in 1850. His late landscapes, both the watercolors and the etchings, based on subjects from Milton and Virgil, are among his most inspired creations.

Selected Literature: Palmer, 1892; Grigson, 1947; Lister, 1974; Vaughan et al., 2005. SW

112

A Moonlight Scene with a Winding River, ca. 1827
Black and brown wash, gouache, and gum on wove paper; 10 ½ x 7 ⅛ in. (26.7 x 18.1 cm)
Inscribed on verso: *From the collection of A. H. Palmer—3863 24th Avenue West—Vancouver. BC./Exhibited at Victoria and Albert Museum Oct. 1926 to Feb 1927—*

at the Palmer exhibition/Number 60 in the official Catalogue./Sold at Christie March 4th 1929–Collector's stamp, upper right: TEL (Thomas E. Lowinsky, Lugt 2420a)

PROVENANCE: A. H. Palmer; Christie's, 4 Mar. 1929 (60); bt Thomas E. Lowinsky; Justin Lowinsky, to 1963; Colnaghi; bt Paul Mellon, 1963
SELECTED EXHIBITIONS: V&A, *Palmer*, 1926, no. 60; Colnaghi-Yale, *English Drawings*, 1964–65, no. 19; PML, *English Drawings*, 1972, no. 139; YCBA, *English Landscape*, 1977, no. 216; Speed, *British Watercolors*, 1977, no. 68; BM, *Palmer*, 2005–6, no. 83
SELECTED LITERATURE: Grigson, 1947, no. 55; Grigson, 1960, no. 30; Lister, 1988, no. 73
B1977.14.4643

The years that Palmer spent in Shoreham were the happiest and most creative of his life. Palmer had first visited the village in Kent, southeast of London, in 1824, and stayed there with the Ancients periodically over the next few years. In 1828, his father, retired from bookselling, rented a house in Shoreham, and Palmer moved in with him. Money left him by his grandfather allowed Palmer to pursue his art without concern for making a living.

Throughout his years in Shoreham, Palmer produced monochrome drawings in black and brown ink and watercolor that he referred to as his "blacks." Indebted to Blake's wood engraved *Illustrations to Robert Thornton's Pastorals of Virgil* (1821) for their simple forms of landscape, figures, and animals and for their crepuscular atmosphere, these drawings frequently depicted moonlit scenes that perhaps reflect the nocturnal wanderings of the Ancients in the countryside around Shoreham.

A Moonlight Scene with a Winding River is one of the more densely worked up of these "blacks," with a heavy admixture of opaque white paint. The landscape seems to pulsate with life. On the left is a cottage or mill; on the right, a sheepfold. The palm tree on the right adds an exotic element perhaps deriving from a print by Dürer or Schongauer; it has been suggested that it may be a symbol of the Christian's victory over death (Lister, 1988, no. 73) or a punning reference on the artist's name (White, 1977, p. 120). SW

113

The Weald of Kent, ca. 1833–34
Watercolor, gouache, and pen and Indian ink on heavy wove paper; 7 ⅜ x 10 ¾ in. (18.7 x 27.3 cm)

PROVENANCE: John Giles; Christie's, 2 Feb. 1881 (612); Richard Sisley; Mrs. John Richmond; Eardley Knollys, sold, Sotheby's, 30 Nov. 1960 (63); bt Agnew; bt Paul Mellon, 1960
SELECTED EXHIBITIONS: Tate, *Blake*, 1913–14, no. 132; V&A, *Palmer*, 1926, no. 132; NGA, *English Drawings*, 1962, no. 46; VMFA, *Painting in England*, 1963,

no. 189; YCBA, *English Landscape*, 1977, no. 221; BM, *Palmer*, 2005–6, no. 83
SELECTED LITERATURE: Grigson, 1947, pp. 94, 111, no. 132; Lister, 1988, no. 172
B1977.14.65

The present watercolor is one of three related views of the Weald of Kent that Palmer produced probably in the summer of 1833 or 1834. The other two are *The Timber Wain* (Paul Mellon Collection, YCBA) and *The Golden Valley* (Michael and Judy Steinhardt Collection, New York). Both *The Weald of Kent* and *The Timber Wain* enclose almost the same distant prospect within the trunk and branches of a massive oak. This view has recently been identified as Underriver as seen from Carter's Hill (Vaughan et al., 2005, p. 155).

In 1832 Palmer purchased a house in London and over the next few years spent less time in Shoreham. In *The Weald of Kent* and its two companion watercolors, the artist seems to be looking back from a distance on the Kentish countryside and taking leave of the intimate pastoral landscape that had heretofore been the heart of his artistic life. SW

114

The Harvest Moon, ca. 1833
Oil and tempera with graphite on paper laid on panel;
8 ¾ x 11 in. (22.2 x 27.7 cm)
Signed lower left: *S. Palmer*

PROVENANCE: A. H. Palmer; Christie's, 20 Mar. 1909 (84); bt Eyre; Christie's, 23 June 1972 (65); John Baskett; bt Paul Mellon, 1972
SELECTED EXHIBITIONS: RA, 1833, no. 64; YCBA, *Toil and Plenty*, 1993–94, no. 20; BM, *Palmer*, 2005–6, no. 81
SELECTED LITERATURE: Palmer, 1892, pp. 46–47; Grigson, 1947, pp. 93, 186, no. 129; Lister, 1988, no. 168
B1977.14.65

Alfred Herbert Palmer, the artist's son and biographer, who owned *The Harvest Moon*, described it as a typical example "full of Shoreham sentiment" and "not without some of the accompanying peculiarities." He went on to comment, "There is nothing out of place in the laden wagon with its team of oxen, or in the harvest labourers, for their dress proclaims them labourers of long ago" (Palmer, 1892, pp. 46–47). Christiana Payne has countered the suggestion that the subject may be anachronistic or may be intended to evoke an earlier time, by noting that oxen continued to be used in parts of Britain throughout the nineteenth century and that the smocks worn by the harvesters were standard dress in the period.

Although the depiction of harvesting by moonlight seems characteristic of Palmer in the Shoreham period and undoubtedly contributes to the visionary intensity of the scene, Payne also indicates that workers continuing

into the night to bring in the harvest had a basis in actual agricultural practice. What does seem fanciful is the crowding of the workers, men and women together, with no open space to set the sheaves—artistic license to emphasize the bounty of the harvest (Payne, 1993, p. 102). SW

Richard Dadd (1817–86)

Richard Dadd began drawing when he was about thirteen, inspired by the landscapes and seascapes of his native Kent. In 1837 he entered the Royal Academy Schools, where he met and befriended William Powell Frith, Augustus Leopold Egg, and his future brother-in-law, John "Spanish" Phillip. Considered by his contemporaries to be one of the most promising artists of his generation, he won critical acclaim for the fairy paintings that he began exhibiting in 1841.

In 1842 Dadd was employed as artist and companion to Sir Thomas Phillips, a Welsh lawyer and former mayor of Newport, on a tour of Europe and the Near and Middle East. While on the journey Dadd began to show the first signs of severe mental disturbance, including delusions that he was under the power of the Egyptian god Osiris. He returned to England in May 1843 and resumed work, but in August, believing his father to be the devil in disguise, he stabbed him to death. Dadd fled to France and was arrested after attempting a second murder; after ten months in a French asylum he was extradited to England, where he was declared insane and committed to the state criminal lunatic asylum, part of Bethlem Hospital in London. He would remain institutionalized for the rest of his life.

For the next forty-two years, Dadd continued to paint highly detailed, often dreamlike landscapes, seascapes, and historical, literary, and biblical subjects in watercolor and oil, drawn in part from at least one sketchbook, his imagination, and an extraordinary visual memory. He died of consumption in Broadmoor Hospital.

Selected Literature: Greysmith, 1973; Allderidge, *Late Richard Dadd*, 1974; Allderidge, *Richard Dadd*, 1974. EH

115

Death of Abimelech at Thebez, 1855
Watercolor over graphite on wove paper;
14 ⅛ x 10 ⅛ in. (35.9 x 25.8 cm)
Signed and dated above drawing in ink: *Death of Abimelech at Thebez—Draw thy sword and slay me, that men say not of me. A Woman slew him—Judges IX. vLIV—by Richard Dadd Bethlehem Hospital London/August 28th/1855*

PROVENANCE: Sir Charles Hood, sold, Christie's, 28 Mar. 1870 (303); bt White; Sir Osbert Sitwell, 1949, by whom bequeathed to Sir Sacheverell Sitwell, sold, Sotheby's, 15 July 1976 (21); bt John Baskett; bt Paul Mellon, 1976

SELECTED EXHIBITIONS: Leicester, *Victorian Romantics*, 1949, no.33; Tate, *Dadd*, 1974–75, no. 150
SELECTED LITERATURE: Greysmith, 1973, pp.79, 177
B1981.25.2574

Death of Abimelech at Thebez is one of the biblical subjects Dadd painted while in Bethlem Hospital. It illustrates an episode from the Book of Judges in which the wicked king Abimelech, having killed his seventy brothers and the entire population of Sechem, besieges the city of Thebez. Receiving his mortal wound at the hand of a woman who throws a piece of millstone from the ramparts, Abimelech commands his armor bearer to dispatch him.

Dadd's painting shows Abimelech receiving the coup de grâce on a chaotic field of battle. Although some elements are certainly the products of Dadd's inventive powers, such as the ruffs worn around the shins of some of the soldiers, others may have been informed by the sketches he made while traveling in the Middle East. The frieze-like arrangement of figures in a shallow compositional space is typical of Dadd's work. It has been argued that the disposition of arms, legs, and spears owes something to Jacques-Louis David's *Oath of the Horatii*, which Dadd knew and on which he drew in other paintings, such as *The Flight Out of Egypt*, painted in 1849–50 (Tate, London). EH

Sir Alfred Munnings (1878–1959)

Alfred Munnings was to the painting of horses and field sports in the Edwardian period and its aftermath what John Singer Sargent was to the art of portraiture. Like Gainsborough and Constable, Munnings was a native of Suffolk, and he trained as an apprentice in commercial art at Page Brothers, a Norwich firm of lithographers. He took evening classes in watercolor at the Norwich School of Art. In 1899 he was blinded in his right eye in an accident involving a thorn bush. In 1903 he spent time in Paris at the Atelier Julian and throughout the first decade of the new century traveled widely throughout England, returning frequently to East Anglia. There he was much preoccupied, as was his near contemporary Augustus John, with the picturesque, bohemian life of gypsies—their ponies, caravans, encampments, and way of life.

In 1911 Munnings settled in the artists' colony of Newlyn, in Cornwall, and the following year married the brewing heiress and manic depressive Florence Carter-Wood, whose first suicide attempt took place on their honeymoon. Munnings's first solo exhibition took place in 1913 at the Leicester Gallery in London, and the following year Florence succeeded in taking her own life. Munnings was at first prevented by partial blindness from enlisting in the army at the outbreak of war with Germany in August 1914, but the grim conditions of 1917 enabled him to serve in the army as a "strapper," testing horses for mange. In 1918 Munnings was assigned by the Ministry of Information to artistic work with the Canadian Cavalry Brigade on war memorials.

In 1919 an associateship of the Royal Academy and an equestrian portrait of the brother of Queen Mary, the Earl of Athlone, a future governor-general

of South Africa, reflected Munnings's burgeoning social cachet as a painter of swagger portraits in the postwar environment and were measures of his professional success. Financial security also came, thanks to his dealers' shrewd marketing of chromolithographic prints after his most popular and successful paintings. In 1921 he painted an equestrian portrait of the golden-haired Prince of Wales, who more than any other subject secured Munnings's reputation as the preeminent portrait painter in London and, in fact, reestablished the equestrian, specifically the hunting, portrait as the smartest mode of society portraiture, particularly for modern women of rank.

Munnings's professional and commercial success was crowned in 1944 by his election as President of the Royal Academy and a knighthood. He shared with the prime minister, Sir Winston Churchill, an entrenched distrust of modernism in art and design, though this partly obscured the adventurous spirit with which he pursued genuinely Bohemian subjects as a young man thirty years earlier. His favorite painters were George Stubbs and John Constable, and in old age he donated funds for the purchase of Gainsborough's birthplace. Munnings painted the present queen with her horse Auriole in 1955 and the following year was given a major retrospective exhibition at the Royal Academy. He died in 1959 at the age of eighty.

Selected Literature: Booth, 1986; Peralta-Ramos, 2000. AT

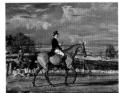

116

Paul Mellon on Dublin, 1933
Oil on canvas; 31 x 37 ½ in. (78.7 x 95.3 cm)
Signed, lower right: *A. J. Munnings*

PROVENANCE: Commissioned by Paul Mellon, spring 1933
SELECTED EXHIBITIONS: NMR, *Munnings*, 2000
SELECTED LITERATURE: Booth, 1986, p. 189; Mellon, 1992, p. 229; Peralta-Ramos, 2000, pp. 49–50
B2001.2.230

Paul Mellon acquired his lifelong love of country pursuits at Cambridge in 1930, and it was to encourage his interest in quintessentially English field sports that his mother, herself a keen horsewoman, presented him with the big Irish bay stallion called Dublin. In his memoirs, Mr. Mellon described Dublin as his favorite among the many hunters he had owned over a period of sixty years. "He pulled a bit," wrote Mr. Mellon, "and was strong as a locomotive, but although a so-called three-quarter-bred, he had enough foot and staying power not to disgrace me in several point-to-points. He could have jumped the Eiffel Tower. I think it was Dublin more than anything else who assured my lifelong addiction to hunting. He

had huge quarters and a wonderful long front, and his eye had the 'look of eagles'" (Mellon, 1992, p. 228).

In many respects, Munnings was a natural choice of artist for this commission because he had an established Anglo-American clientele, was himself passionate about foxhunting, and had painted similar open-air action portraits of the Prince of Wales, the Princess Royal, and members of the English aristocracy. Mr. Mellon recalled bringing Munnings by train to the farm near Eastleach, in Gloucestershire, where Dublin was boarded, so that sketches could be made. Munnings returned there several times on his own, presumably feeling freer to go about his business unobserved. He chose, however, to execute the portrait of his young patron in the comfort of his studio in Chelsea. The result is the best surviving portrait of Paul Mellon, one that conveys not merely the sitter's passion for sport but also his natural grace and elegance.

Mr. Mellon's companions in the background could belong to any of the three packs with whom he rode in Gloucestershire at this date: the Duke of Beaufort's hounds, the Vale of White Horse Hunt (VWH Bathurst and Cricklade), and the Cotswold. AT

Catalogue: Book Arts

A NOTE TO THE READER
The second section of the catalogue (cat. nos. 117–48) is devoted to the book arts, including maps and manuscripts. Entries in this section are organized under six thematic groupings: Early Mapping and Exploration, Sporting Books and Manuscripts, The Natural World, Artists and the Teaching of Art, Touring through Britain, and The Illustrated Book.

AUTHOR
Elisabeth Fairman

Early Mapping and Exploration

Most of the rare books and manuscripts in Paul Mellon's possession at the time of his death in February 1999 were bequeathed to Yale University. The majority — nearly five thousand titles or seventy-five hundred volumes — were given to the Yale Center for British Art. The bequest significantly augmented the Center's existing holdings of nearly thirty thousand titles, most of which were given by Mellon at the time of the museum's opening, in 1977. The bequest encompassed a wide range of subjects that reflected his many interests: his important collection of sporting books, a complete set of Kelmscott Press and other private-press books, and many illustrated and color-plate books on a variety of subjects. It also included a small but select group of eighty or so rare maps and atlases, most dating from the sixteenth and seventeenth centuries and ranging from globes and world atlases to large-scale town books and estate plans, all of which demonstrate Paul Mellon's interest in early discovery, exploration, and cartography. These works are among the Center's greatest treasures; a select few are described here.

117

Claudius Ptolemy (ca. 100–168)
Geographie opus nouissima traductione e Grecorum archetypis castigatissime pressum
Compiled by Martin Waldseemüller (ca. 1475–1522)
Strasbourg, Johann Schott, 1513
Letterpress, with woodcuts

PROVENANCE: Weinreb and Douwma; bt Paul Mellon, 1968
SELECTED EXHIBITIONS: YCBA, *Wilde Americk*, 2001
SELECTED LITERATURE: Shirley, 1999

The Greek astronomer Claudius Ptolemy wrote works on physics, mathematics, optics, and geography and produced the data for creating maps of the world as it was known about 150 AD. None of his maps survived, however, and his work was lost to the West until the Renaissance. Scholars in the fifteenth century re-created Ptolemy's maps using his instructions in *Geographia* for projecting a sphere onto a flat piece of paper using a system of gridlines. The first printed version of *Geographia* with re-created maps was published in Bologna in 1477. Ptolemy's atlases influenced world geography until well into the sixteenth century. The earliest Ptolemy atlas in Paul Mellon's collection (Rome, 1508) includes a world map by Johannes Ruysch, one of the first to show the discoveries of the New World and to mark part of the Americas.

The most important edition was published in Strasbourg in 1513, compiled under the supervision of geographer Martin Waldseemüller between 1505 and 1507. Two new maps are included, described as being compiled from information provided by "the

Admiral" — believed to be Columbus himself. The map of "terre nova" is the first printed map devoted solely to the New World to appear in an atlas.

Paul Mellon's copy of the atlas contains two versions of the woodcut map of the British Isles, entitled "Tabvla Prima Evropae." The first version of the map is the one usually found in the atlas, printed in black and hand-colored, but the second is extremely rare. Indeed, only two other copies of this version have been traced thus far. One was acquired as a loose map by the British Library in 1996; the other is in a private European collection. The Center's copy of the rare version is printed in two colors, brown and black, and is clearly a proof copy — many of the inscriptions are misspelled and text is missing. However, it was also an experiment in color printing at a time when printing maps in more than one color was highly unusual.

118

Christopher Saxton (b. 1542 [?])
Atlas of the Counties of England and Wales
London, 1579
Letterpress, with engravings

PROVENANCE: Mildmay Fane, 2nd Earl of Westmorland; Charles Fane, 3rd Earl of Westmorland; Sotheby's, 13–14 July 1887 (1006), bt Quaritch; Henry Yates Thompson; Hermann Marx; Henry Stevens, Son & Stiles; bt Paul Mellon, 1966
SELECTED LITERATURE: Skelton, 1978; Evans and Lawrence, 1979; Cain, 2001; Fairman, 2001

The earliest national atlas produced by any country is the collection of county maps of England and Wales first published by Christopher Saxton in 1579. Under the authority of Queen Elizabeth I and financed by Sir Thomas Seckford, Saxton spent about nine years surveying and sketching maps from a vantage point upon a "towre Castle highe place or hill" (Order of Assistance for Saxton's Survey, 10 July 1576, PRO, Privy Council Register 2:11). His maps were engraved between 1574 and 1578 with elaborate decoration by the finest Flemish and English engravers. Saxton added an engraved frontispiece portrait of Queen Elizabeth I, a printed index of the maps, and a general map of England and Wales (the earliest map of the two countries printed in Britain). He began selling the collection of maps as an atlas in 1579.

Impressions of the frontispiece showing the queen, produced by the Flemish engraver Remigius Hogenberg, are found in two states. The copy shown here has the portrait in the first state, which is so scarce that only six other impressions are recorded. Alterations must have been made in 1579, after very few copies had been pulled. It shows Elizabeth's dress with heavy ornamentation and a rather hard horizontal line across her lap. It has been conjectured that the queen was dissatisfied with her portrayal and suggested the changes in her costume. The second state of the engraving appears in

most of the one hundred or so surviving copies of the atlas (as it does in the one given earlier to the Center by Paul Mellon).

The atlas as a whole is also a very early issue; there may be as few as two or three surviving copies with all the points—the bibliographic and the cartographic attributes—called for (i.e., the portrait as described above, the index of maps typeset in "setting B," and both the maps of Northamptonshire and Norfolk in state I [see Skelton, 1978, pp. 11–12, and Evans and Lawrence, 1979, pp. 25–34, for more detailed information]). It was formerly owned by Mildmay Fane, 2nd Earl of Westmorland (1602–66), probably best known for his friendship with the poet Robert Herrick, who dedicated several poems to him. Fane wrote poetry himself; three verses appear in his handwriting in the atlas (two of which were previously unknown).

119

Richard Hakluyt (1552[?]–1616)
Divers voyages touching the discouerie of America, and the Ilands adiacent vnto the same, made first of all by our Englishmen, and afterward by the Frenchmen and Britons
London, Thomas VVoodcocke, 1582
Letterpress, with woodcuts

PROVENANCE: Christopher Fulthorpe; William Jekells; H. C. L. Morris; Lionel and Philip Robinson; bt Paul Mellon, 1962
SELECTED EXHIBITIONS: YCBA, *Wilde Americk*, 2001

Richard Hakluyt, although not an explorer himself, was enormously influential in promoting English exploration and colonization of the New World. His first book, a compilation of sixteenth-century voyages, is the earliest English work to refer to any part of what is now the United States.

Hakluyt describes John Cabot's landing in Newfoundland in 1497. On the strength of this voyage, and of Cabot's second, in which he vanished without a trace, Hakluyt deemed "that part of North America which is from Florida to 67 degrees northward" to be English, a description that helped the British lay claim to the American mainland. This northern limit of 67° N is the Arctic Circle, midway in the Davis Strait, but English settlements began much farther south. The English were slow to explore and colonize the New World, and it was not until the end of the sixteenth century that they began to establish a foothold on the North American continent, when Sir Walter Raleigh received a patent from Queen Elizabeth I to finance and settle a colony on the coast of present-day North Carolina.

120

Vera descriptio expeditionis nauticæ, Francisci Draci Angli, cognitis aurati, qui quinque navibus probe instructis, ex occidentali Anglia parte anchoras soluens, tertio post decimo Decembris Anº M.D.XXXVII, terraru[m] orbis ambitum circumnauigans, unica tentu navi reliqua (alijs fluctibus, alijs flamina correptis) redux factus, sexto supra Vigesimo Sep: 1580 (A True description of the naval expedition of Francis Drake, Englishman & Knight, who with five ships departed from the western part of England on 13 December 1577, circumnavigated the globe and returned on 26 September 1580, with one ship remaining, the others having been destroyed by waves or fire), ca. 1587
Pen and ink and watercolor on parchment

PROVENANCE: Sir Thomas Phillipps; Lionel and Philip Robinson; bt Paul Mellon, 1962
SELECTED EXHIBITIONS: PML, *Drake*, 1988; YCBA, *Wilde Americk*, 2001
SELECTED LITERATURE: Thrower, 1984

Sir Francis Drake (1540[?]–1586) made two important discoveries during his circumnavigation. First, he showed that the Strait of Magellan did not, as was commonly believed, divide South America from a southern continent called Terra Australis, but was actually one of many such channels separating a group of islands from South America. Drake thus revealed a new passage to the Pacific. He claimed the southernmost island of the Tierra del Fuego archipelago for Queen Elizabeth I, naming it "Elizabetha" after her. The map shows the island marked with the flag of St. George. Drake's second important discovery was the land to the north of California, which he named Nova Albion (after an ancient name for England) and also claimed for Queen Elizabeth. The general depiction of northwest America on the map is one of the most accurate delineations of the area until after 1700.

When Drake returned to England in 1581, he gave Queen Elizabeth I a large manuscript map of his travels. It was known to have been hanging at Whitehall Palace in 1625, when it was described by Samuel Purchas, and is presumed to have been destroyed in the fire that burned the palace in 1698. The map shown here is a close copy of that manuscript and is the earliest extant to mark the route of Drake's circumnavigation. This map was probably drawn around 1587 in that it not only tracks the route of Drake's ship the *Golden Hind* on its circumnavigation of the world in 1577–80 (the light brown line) but also illustrates the route and activities of his Caribbean voyage of 1585–86 (the dark brown line).

The insets illustrate Drake's reception in the Moluccas (the Spice Islands) and the grounding of the *Golden Hind* on a reef in the Celebes. The line running north to south at the center of the map is marked off to indicate latitude; a similar line intersecting at right angles shows longitude.

121

Baptista Boazio (fl. 1588–1606)
The Famouse West Indian voyadge made by the Englishe Fleete of 23 shippes and Barkes wherin weare gotten the Townes of St. Iago, Sto. Domingo, Cartagena, and St Avgvstines, the same beinge begon from Plimmouth in the Moneth of September 1585 and ended at Portesmouth in Iulie 1586
London [?], 1589
Hand-colored engraving

PROVENANCE: Hatchards; bt Paul Mellon, 1961
SELECTED EXHIBITIONS: YCBA, *Wilde Americk*, 2001

Queen Elizabeth I sent Sir Francis Drake, along with twenty-five ships, on a mission to irritate the Spanish in America and to upset as much as possible the hostile preparations Spain was making to invade England. The map traces Drake's route from the Cape Verde Islands to Santo Domingo, Cartagena, and St. Augustine during 1585–86. After capturing St. Augustine, Drake sailed northward to Virginia to check on the English colonists who had put ashore at Roanoke Island some ten months earlier. Finding them in dire circumstances, he took the survivors—including the writer and scientist Thomas Hariot and the artist John White—back to England, at their request. White brought back the first drawings of Native Americans (now in the British Museum), which were later engraved and published by Theodor de Bry for his edition of Hariot's *Briefe and True Report of the New Found Land of Virginia* (1590; see cat. 123). It is White's illustration of the trigger-fish, called here "Sea Connye," that appears on the map.

Baptista Boazio was an Italian cartographer who worked in London from about 1585 to 1603, primarily as a compiler of regional maps. Besides this large map, he produced four separate plans of the cities visited by Drake (also in Mellon's collection and now at the Center), meant for inclusion in Walter Bigges's account of Drake's raids on Spanish America, published in 1588. The general map was most likely neither meant for inclusion in that work nor in any other printed account. It is extremely rare, and probably fewer than a dozen copies survive.

122

123

Thomas Cavendish (1560–92)
Account of the Last Voyage of Thomas Cavendish, 1592
Manuscript, in pen and ink

PROVENANCE: Tristram Gorges; Reverend Joseph
Hunter; Sir Thomas Phillipps (MS 25851); Lionel and
Philip Robinson; bt Paul Mellon, 1962
SELECTED EXHIBITIONS: YCBA, *Wilde Americk*, 2001
SELECTED LITERATURE: Quinn, 1975

The Mellon bequest included this remarkable manuscript
by the navigator Sir Thomas Cavendish, best known as
the second Englishman to lead a voyage around the
world, after Sir Francis Drake. Cavendish had squan-
dered the fortune he made on his circumnavigation and
in an attempt to regain his wealth undertook a second
such voyage, which ended in disaster. Departing from
Plymouth in August 1591, he reached the Straits of
Magellan by March 1592 but was unable to pass through
because of stormy weather. After two months, his crew
rebelled; they were almost out of food, "as smale A por-
tion, as euer men were At in the seaes" (fol. 34), and
forced Cavendish to abandon the expedition.

The manuscript, entirely in Cavendish's hand, is
his personal testament and account of that last voyage. It
was written in the mid-Atlantic shortly before he died at
sea, brokenhearted and in despair, toward the end of
1592. He addressed the work to his friend and executor,
Tristram Gorges: "now I am growne so weake & fainte
as I am scarce able to holde the penn in my hande"
(fol. 32). Cavendish decided, if they reached Ascension
Island, "to haue there ended my vnfortunate lief"
(fol. 36). It sounds as though he had decided to commit
suicide. The island could not be found, however, and
the ship finally turned toward home. Cavendish died
shortly afterward from unknown causes and was buried
at sea. His crew sailed on, likely obtaining food and
water in the Azores. Further details of the voyage home
are not known, but the ship, the *Galleon Leicester*, was
first heard of again in Portsmouth in March 1593.

A copy of the manuscript came into the possession
of the writer Samuel Purchas (possibly through the aus-
pices of Richard Hakluyt) and was published in his
Pilgrimes (1625), although Purchas suppressed the most
"passionate speeches of Master Candish [*sic*] against
some private persons" (vol. 4, p. 1191).

Theodor de Bry (1528–98)
*Wunderbarliche doch warhafftige Erklärung, Von der
Gelegenheit und Sitten der Wilden in Virginia* (A Briefe
and True Report of the New Found Land of Virginia),
by Thomas Hariot, *Grand Voyages*, pt. 1
Frankfurt, Johann Wechel for T. de Bry, 1600 (2nd ed.)
Letterpress, with engravings

PROVENANCE: Mary Cecil Frankland, 16th Baroness
Zouche; Sotheby's, 9 Nov. 1920 (90), bt Quaritch;
Henry Stevens; Sotheby's, 6 Apr. 1964 (672),
bt Paul Mellon
SELECTED EXHIBITIONS: YCBA, *Wilde Americk*, 2001
SELECTED LITERATURE: Quinn, 1955; Bucher, 1981;
Hulton, 1984

In 1584, Sir Walter Raleigh received a patent from
Queen Elizabeth I to finance and settle a colony on the
coast of present-day North Carolina. Among those who
chose to accompany this first attempt were Raleigh's
Oxford tutor, Thomas Hariot, and an artist named John
White. Hariot was to study the customs of the native
population and describe the new land's geographical
features. White, who served as governor of the later, ill-
fated settlement at Roanoke, was to draw and paint what
he saw and to act as surveyor. After Hariot and White
returned to England in 1586 with Sir Francis Drake,
Richard Hakluyt persuaded the Frankfurt engraver
Theodor de Bry to reprint Hariot's report, originally
published as a pamphlet in 1588.

De Bry first published Hariot's *Briefe and True
Report of the New Found Land of Virginia* in 1590, as the
initial volume in his series of illustrated travel accounts.
Issued simultaneously in German, Latin, French, and
English, it was illustrated with engravings of White's
drawings. His portrayals of Indians were instrumental in
fixing the European image of America; they were copied
countless times for the next two hundred years and used
to illustrate other accounts of the New World. The view
of the village of Secotan (near the present Outer Banks of
North Carolina) shows the Indian habitations and
records their crops of maize, tobacco, sunflowers, and
pumpkins. Although most of the illustrations in the vol-
ume are after John White, there are several engravings
after watercolors by Jacques Le Moyne de Morgues
(ca. 1533–88). These depict early inhabitants of Britain,
including a "yonge dowgter of the Pictes" (see cat. 1
for a discussion of the original watercolor).

Sporting Books and Manuscripts

Most of the sporting works in the Department of Rare Books and Manuscripts came to the Center after Paul Mellon's death in 1999. Nearly two thousand books and manuscripts in his bequest belonged to his important collection of works on sport. They reflect his lifelong interest in the thoroughbred horse, particularly the animal's evolution under domestication as well as its character, physiology, and employment on the racecourse and in the field. The collection includes works on the anatomy, breeding, acquisition, care, and management of horses; on horsemanship and horse racing; and on the hunting of fox, hare, and stag. Although the focus is on the horse as an animal of noble recreation, the working horse is not neglected. There are wonderful, often humorous, books on coaching and early road transportation. Most of the works in the sporting collection are British, but there are important Italian and French (and even a few American) classics as well; they range in date from the early fifteenth to the mid-twentieth century.

124

Henri de Ferrières (fl. 1377)
Le Livre du Roy Modus et de la Royne Racio
France, ca. 1420
Manuscript, in pen and ink, with watercolor and gouache and touched with gold, on parchment

PROVENANCE: Lemoignon; Evelyn Philip Shirley; A. S. W. Rosenbach, 1937; John Fleming; bt Paul Mellon, 1958
SELECTED EXHIBITIONS: YCBA, *Compleat Horseman*, 2001
SELECTED LITERATURE: Podeschi, 1981, no. 1; Brun, 2006

This extraordinary manuscript is a copy of the greatest medieval book on sport, used by all subsequent English and continental writers on the chase. The author of *Le Livre du Roy Modus et de la Royne Racio* (The Book of King Method and Queen Reason) is now usually credited to a Norman, Henri de Ferrières. Composed between 1354 and 1376, the full text of the work is divided into two parts: the first deals with the chase, and the second is an allegorical discussion of the animals of the hunt. This manuscript consists of only the first part and is missing about ten leaves from the beginning (which did not prevent the legendary rare book dealer and collector A. S. W. Rosenbach from writing on the front flyleaf: "A marvelous manuscript! The only great sporting epic of this early period ever to be brought to America"). One of the few copies on parchment, it is also one of the earliest to survive, dating from around 1420. It includes thirty-four watercolor drawings depicting the hunting of deer, hare, boar, and birds by means of hounds, bows,

traps, snares, and falcons; the illustrations are invaluable as sources of information on the manners, customs, and costumes of the chase of the period.

125

William Twiti (d. 1328)
The craft of venery (with chess problems, a treatise on heraldry, and other miscellaneous texts)
England, ca. 1450
Manuscript, in pen and ink

PROVENANCE: John Porter; Thomas Mellynton; Anthony Reston; Thomas Hodgett; Sir William Dethick; Sir Edward Coke; Bishop Percy of Dromore; George Baker; Sir Thomas Phillipps (MS 12086); Lionel and Philip Robinson; Sotheby's, 28 Nov. 1967 (107), bt Paul Mellon
SELECTED EXHIBITIONS: YCBA, *Compleat Horseman*, 2001
SELECTED LITERATURE: Danielsson, 1977; Podeschi, 1981, no. 3; Brun, 2006

The manuscript contains a number of texts on a wide range of secular subjects. Most of it is handwritten by John Porter, a member of Parliament for the city of Worcester, around 1450. It includes one of the two known Middle English translations of William Twiti's *Art de vénerie* (The pursuit of four-footed game). The huntsman for Edward II, King of England from 1284 to 1327, Twiti wrote his treatise originally in Anglo-Norman French early in the fourteenth century. It is considered the first work on hunting to be written in England and an important source for later writers (parts of it appear in *The Boke of St. Albans* of 1486 [see cat. 127]). Like Henri de Ferrières's *Le Livre du Roy Modus et de la Royne Racio* (see cats. 124 and 126), Twiti's treatise takes the form of a dialogue in which the huntsman answers questions put to him by his apprentice.

The Mellon manuscript also includes one of two known manuscripts of one of the earliest works on heraldry composed in England, in Latin, and the earlier of two known manuscripts of chess problems, with forty diagrams and a text in Middle English. It also has a number of interesting miscellaneous texts, including two menus of official banquets held by the City of London (the first a Lenten breakfast on 14 March 1453, consisting of eleven fish dishes, including eel, lamprey, conger, sturgeon, and smelt, and ending with baked quinces); sayings from the Bible; a brief chronicle of English history from 1066 to 1447, in Latin; and a short treatise on the plague, in English.

126

Henri de Ferrières (fl. 1377)
Le Liure du Roy Modus et de la Reine Racio
Chambéry, France, Anthoine Neyret, 1486
Letterpress, with woodcuts

PROVENANCE: A. de Vuillent; H. P. Kraus; bt Paul Mellon, 1969
SELECTED EXHIBITIONS: YCBA, *Compleat Horseman*, 2001
SELECTED LITERATURE: Podeschi, 1981, no. 5; Brun, 2006

This is the very rare first printed edition (the editio princeps) of *Le Livre du Roy Modus et de la Royne Racio*, the first printed French book dealing with the hunt. It includes explicit directions for hunting all sorts of game animals, as well as chapters on falconry and bird snaring. The work is in the form of a dialogue in which Roy Modus (King Method) replies to questions about hunting from his apprentices. He divides prey into two groups, according to certain criteria. Five animals are classified as sweet (*douce*) and four as stinking (*puant*). The sweet ones—the stag, the hind, the fallow and roe deer, and the hare—do not have a foul odor, their pelts have a pleasing (amiable) color, either blond or tawny, and they do not bite. The four stinking animals bite; they include the boar, the wolf, the fox, and the otter.

The fifty-four woodcuts of hunting subjects are all based on drawings that appeared in earlier manuscripts of the work (see cat. 124). The left-hand page of the opening shown in the Gallery of Works illustrates a method of taking wild boar in which the animal is driven into an enclosure by setting up nets and placing beaters and hounds at strategic points. The right-hand page shows a stag that has been shot with an arrow.

127

128

Dame Juliana Berners (b. ca. 1388)
The Boke of St. Albans, also known as *The Book of
Hawking, Hunting, and the Blasing of Arms*
St. Albans, Schoolmaster Printer, 1486
Letterpress, with woodcuts

PROVENANCE: Popham of Littlecote; Richard Bennett;
John Pierpont Morgan; H. P. Kraus; Thomas Gannon;
bt Paul Mellon, 1954
SELECTED EXHIBITIONS: Grolier, *Fifty-five Books*, 1968,
no. 54; YCBA, *Color Printing*, 1978, no. 1; YCBA, *Compleat
Horseman*, 2001
SELECTED LITERATURE: Podeschi, 1981, no. 4

Legend has it that Dame Juliana Berners spent her youth
at the court of Henry IV, where she took part in the
favorite sports of her day. She acquired a fair knowledge
of hunting, hawking, and fishing and wrote about various
sports and other matters of interest to a fifteenth-century
gentleman. Her observations were published in a work
called *The Boke of St. Albans*, named after the anonymous
"schoolmaster" printer who set up a press at St. Albans,
Hertfordshire, in 1479. It is now generally accepted that
Berners was not responsible for the entire work, prob-
ably having contributed only a few observations to the
sections on hunting and hawking.

The *Boke of St. Albans* comprises four treatises—on
hawking, hunting, the rules for forming coats of arms,
and "the blasyng of armys" (the last an explication of
existing heraldic devices)—and is considered to be the
first book on hunting to be printed in Britain. It also
includes what is thought to be the earliest printed
description in English of the properties of a good horse.
Fifteen are listed, "iii of a man, iii of a woman, iii of a fox,
iii of an hare and iii of an asse" (leaf f5r):

> Off a man boolde prowde and hardy.
> Off a woman fayre brestid faire of here & and esy
> to lip [i.e., leap upon].
> Off a fox a faire tayle short eris ears with a
> goode trot.
> Off an hare a grete eygh a dry hede and
> well rennyng.
> Off an asse a bigge chyne a flatte lege, and
> goode hove.

Beasts of the chase are described in rhymed couplets
and most of the information is culled from William
Twiti's treatise on venery (see cat. 125). The greyhound
(used for hunting hare, deer, fox, and small game
because of its keen eyesight and great speed) "shulde be
heded like a Snake and necked like a Drake, Footed like
a Kat, Tayled like a Rat."

The *Boke of St. Albans* is also important as the first
British work to contain illustrations printed in more than
one color, issued barely five years after the first illus-
trated book of any kind was printed in England (William
Caxton's *Myrrour of the Worlde*, 1481; see cat. 143).

Captain Thomas Williamson (fl. 1778-89)
*Oriental Field Sports, Being a Complete, Detailed, and
Accurate Description of the Wild Sports of the East, and
Exhibiting in a Novel and Interesting Manner the
Natural History of the Elephant, the Rhinoceros, the
Tiger . . . the Whole Interspersed with a Variety of
Original, Authentic, and Curious Anecdotes*
London, Edward Orme, 1805–7
Letterpress, with hand-colored aquatints

PROVENANCE: John Roland Abbey; bt Paul Mellon, 1965
SELECTED EXHIBITIONS: YCBA, *Compleat
Horseman*, 2001
SELECTED LITERATURE: Abbey, *Travel*, 1972, no. 427;
Podeschi, 1981, no. 88

Edward Orme, "Printseller to His Majesty," issued
Captain Thomas Williamson's *Oriental Field Sports* in
twelve monthly parts at a guinea each, beginning in 1805.
It is considered among the most beautiful and important
color-plate books ever produced. Williamson, who served
for twenty years in Bengal, provided the descriptive text
and rough drawings, which were then redrawn by Samuel
Howitt (1765[?]-1822) and engraved by Henri Merke
and others. Copies in original wrappers are extremely
rare, and the excellent condition of this set is extraordi-
nary. The cover of each wrapper has a tiger lying on a
rock drawn by Howitt; the vignette appears to have been
printed in oil colors by some sort of stencil process.
Howitt's original drawing for the scene was owned by
Mellon and is now in the Center's collections.

The hand-colored aquatints illustrate the *"Wild
Sports of the East . . . the whole interspersed with a variety
of original, authentic and curious anecdotes, which ren-
der the work replete with information and amusement."*
Williamson states in the preface that "it is not merely to
the Sportsman, that this Work is addressed. It is offered
to the Public as depicting the Manners, Customs,
Scenery, and Costume of a territory, now intimately
blended with the British Empire" (pt. 1, p. [1]).

129

Henry Thomas Alken (1785–1851)
The First Steeple Chase on Record, or, The Night Riders of Nacton
London, Ackermann, 1839
Hand-colored aquatints

PROVENANCE: Henry C. Taylor; Thomas Gannon; bt Paul Mellon, 1939
SELECTED LITERATURE: Siltzer, 1979, pp. 53–55, 63; Snelgrove, 1981, no. 70

Henry Alken was one of the most important—and prolific—sporting artists of the early nineteenth century. He was a particular favorite of Paul Mellon, and the Center's collections include many of Alken's illustrated books, prints, drawings, and paintings. *The First Steeple Chase on Record, or, The Night Riders of Nacton* was one of the most popular of all of Alken's sets of sporting prints. According to Frank Siltzer, "They have been reproduced in every size, shade and form, and there can be but few towns in England where they are not exposed in some curiosity or antique shop for the gaze of the passer-by" (Siltzer, 1979, p. 54). However, Mellon's set—the original issue of 1839 in the printed buff wrappers and the rare sheet of letterpress with the account of the race—is an extraordinary copy and cannot be compared to any of the reissues. Plate 3, showing the moonlit last field near Nacton Heath, is represented in its rare first state showing the wrong sort of shadow cast by the five-barred gate. In later issues, the shadow has been altered and made less bright.

The original story "An Inquiry into the Origin of Steeple-Chases, With an Authentic Account of the Earliest Steeple-Chase on Record," by Sidney Cooper, was published in the January 1839 issue of *The Sporting Review*. The author describes the sporting event that took place in 1803 when some officers of a cavalry regiment quartered at Ipswich were battling boredom one evening. One suddenly proposed to race his gray horse four miles across country against any of his fellow officers who were willing; it was decided that they should wear nightshirts over their uniforms, "whereby we shall not only see each other better, but also ourselves remain unknown to vulgar eyes" (p. 51).

The Natural World

Paul Mellon had been interested in natural history from at least 1937, when he purchased the double elephant edition of John Audubon's *Birds of America* (London, 1828–39); further, in 1939 and 1947 he acquired two of Pierre Joseph Redouté's color-plate books (see Reese, this vol, pp. 58–9). Although many of those early acquisitions remain with his wife, Rachel Lambert Lloyd Mellon, as part of her remarkable Oak Spring Garden Library at Upperville, Virginia, a number of important works of natural history have made their way to the Center. One of the most significant is the archival collection related to James Bruce (1730–94), a Scottish diplomat and explorer who, between 1767 and 1773, attempted to discover the source of the Nile in Abyssinia (now Ethiopia and Eritrea). He was accompanied by a talented Italian draftsman, Luigi Balugani, who recorded the flora and fauna of the region in beautifully rendered watercolors (see Reese, this vol., fig. 13). The collection of drawings has been well described (Hulton, 1991), though the cataloguing of the correspondence and other papers is ongoing.

The exquisitely drawn pattern book of plants and animals known as the *Helmingham Herbal and Bestiary*, completed around 1500, is one of the great treasures in the Center's Department of Rare Books and Manuscripts and was one of Paul Mellon's favorite books. Some five years after he acquired the Helmingham manuscript in 1961, he purchased twenty manuscript volumes composed by the naturalist and travel writer James Forbes (1749–1819) for his daughter. Thirteen of the volumes are devoted to Forbes's voyage from "England to Bombay," with hundreds of detailed natural history drawings depicting plants and animals of India.

130

James Forbes (1749–1819)
A Voyage from England to Bombay, with Descriptions in Asia, Africa, and South America, 1766–1784 (vols. 1–13 of Forbes's *Descriptive Letters and Drawings, Presented to Elizabeth Forbes*, 1800)
Manuscript, in pen and ink, with watercolor and gouache

PROVENANCE: Elizabeth Forbes; St. Mary's College, Oscott, Birmingham; Sotheby's, 7 Nov. 1966 (273), bt Paul Mellon
SELECTED LITERATURE: Rohatgi, 1997; Almeida and Gilpin, 2005

After spending almost twenty years in India working for the East India Company, James Forbes returned to England in 1784. He had kept a daily journal in India, where he recorded the fauna, flora, landscape, buildings, and people of Bombay and the surrounding area, eventually filling 150 folio volumes with his drawings

and observations. They served as the basis for his illustrated *Oriental Memoirs*, published in 1813–15, but do not seem to have survived. It appears likely that he dismantled them, copying text as he needed, and cutting out drawings and watercolors, either for an engraver to copy for publication or for remounting in other volumes, such as the set he presented to his daughter Elizabeth on her twelfth birthday.

That set consists of excerpts both from letters he sent to his family in England and from other writers on natural history, illustrated by almost 520 watercolors, most depicting plants and animals of India. These drawings have been produced with almost scientific precision and help explain Forbes's reputation as one of India's leading amateur naturalists of the period. Some of them have been cut and mounted from another source—probably one of his earlier notebooks—while others must have been copied from his original sketches, such as the full-page drawing illustrating the mulberry, with butterflies and other insects. Forbes notes some basic facts about the plant: "In Hindoostan, we have not the large rich Mulberry common in England. . . . Ours grows on a much larger tree than the former, with a rich foliage, the fruit sweet and luscious, hanging like caterpillars on the branches, long and thin, varying in color of red, white, and brown" (letter 65, 1 June 1778, vol. 10, p. 16). At the bottom of his drawing, Forbes includes an excerpt from *The Botanic Garden*, the famous poem written in 1792 by Erasmus Darwin, Charles Darwin's grandfather.

131

Helmingham Herbal and Bestiary
England, ca. 1500
Gouache and watercolor, with pen and ink, on parchment

PROVENANCE: Tollemache family, Helmingham Hall, Suffolk; Sotheby's, 6 June 1961 (15), bt Paul Mellon
SELECTED EXHIBITIONS: YCBA, *Compleat Horseman*, 2001
SELECTED LITERATURE: Barker, 1988

The manuscript gives a remarkable picture of English knowledge of natural history in the Tudor period. Paul Mellon wrote about it in the preface to the facsimile printed for his fellow members of the Roxburghe Club:

> Although very much an amateur bookman and a far cry from even an elementary botanist, my interest in this manuscript was originally aroused more by the beasts of the Bestiary than the flowers, herbs or trees of the Herbal. It has been my wife, a professional in the fields of horticulture and silviculture, who has shared with me her enthusiasm for the floral and arborial drawings. . . . Far from a treatise on sport (one would be hard pressed to come upon many of

these beasts while hunting!) this picture-book is nonetheless an aesthetically delightful rendering of what in fifteenth-century England was known about the inhabitants of her fields and woodlands, or what was imagined about the denizens of far-away lands. Whether it might often have been in the hands of children for study or entertainment, whether it guided the artisan in the limning of fabric or painted surfaces, and whether or not it was derived from earlier continental models, I see it simply as a charmingly natural and a thoroughly English work. I have also been impressed by the stark simplicity and directness of the drawing and colouring of the objects, as though there were a mysterious aesthetic kinship between these fifteenth-century artists or designers and our own twentieth-century artists. (Barker, 1988, p. xiii)

The *Herbal* consists of ninety-five drawings of flowers and trees, all common species found in Britain. The *Bestiary* includes forty-nine drawings of animals and birds, with many fabulous creatures such as an alde (a purple hound with three-pointed tail and yellow claws), bonacon (a pink horse with yellow horns), koketrice (half rooster, half serpent) and a honicorn (unicorn). Real animals, drawn either from direct observation or as imagined from traveler's reports (occasionally with imaginary attributes), include the ape, hyena, bear, badger, beaver, ibex, rat, and leopard.

Artists and the Teaching of Art

Probably the greatest strength of the collection of rare books and manuscripts at the Center is the material relating to British art, artists, and the making and teaching of art in all media—most of which comes from Paul Mellon's original collections. The works date from the sixteenth century through the nineteenth; they range from both printed and manuscript art-historical treatises and instruction manuals to artists' letters and journals, both published and unpublished. The rare books and manuscripts dovetail very neatly with the rest of the Paul Mellon's collections of British paintings, sculpture, prints, and drawings that now reside at the Center.

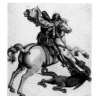

132

Alexander Marshal (ca. 1620–82)
St. George and the Dragon, inlaid to size and bound in vol. 3 of *Anecdotes of Painting in England, with Some Account of the Principal Artists, and Incidental Notes on Other Arts*, by Horace Walpole (1717–97), Strawberry-Hill, 1762–71 [i.e., 1780], 4 vols.
Watercolor, gouache, and pen and ink

PROVENANCE: Sir James Winter Lake, 1779; Sotheby's, 1 Aug. 1978 (28), bt Paul Mellon
SELECTED LITERATURE: Griffiths, 1998; Leith-Ross, 2000; Sloan, 2000

The extra-illustrated, or "Grangerized," set of Walpole's *Anecdotes* (the set also includes Walpole's *Catalogue of Engravers*, 2nd ed., 1765) was owned by Sir James Winter Lake, a book and print collector (and governor of the Hudson's Bay Company from 1799 to 1807). Walpole's text has been trimmed and "inlaid to size" onto larger sheets of paper in order to accommodate the addition of numerous illustrations of different sizes on the interleaved blank pages. The practice of adding extra prints, drawings, manuscripts, and ephemera to topographical and biographical printed works had been fashionable since James Granger published his *Biographical History of England* (1769) with extra blank pages so owners could easily add material.

While most of the 150 or so extra-illustrations are engravings, two drawings by Alexander Marshal have been bound in next to Walpole's text on the artist. Marshal, perhaps better known as a painter of flowers and insects, also produced copies of biblical and religious works by Old Masters. His drawing of *St. George and the Dragon* is a copy of a painting by Raphael. That painting, now in the National Gallery in Washington, D.C., had been supposedly commissioned by the Duke of Urbino in 1505 as a gift for Henry VII, who had made the duke a Knight of the Order of the Garter. By 1627, the painting was owned by William Herbert, the 3rd Earl of Pembroke, but it was in the royal collections by 1639/40. It is conceivable that Marshal saw the original, but as his drawing reverses the image in the painting and changes the color of St. George's cloak and the dragon,

it is more likely that Marshal is copying one of the several engravings after the painting known to have been produced in the 1620s (Griffiths, 1998, pp. 79–81). Marshal had a collection of Old Master prints (Sloan, 2000, p. 71), although it is not known whether he owned a copy of *St. George and the Dragon*.

133

Edward Luttrell (fl. 1680–1724)
An Epitome of Painting Containing Breife Directions for Drawing Painting Limning and Cryoons wᵗʰ the choicest Receipts for preparing the Colours for Limning and Cryoons Likewise Directions for Painting on Glass as tis now in use amongst all persons of Quality. And Lastly How to lay the Ground, and work in Mezzo Tinto, 1683
Manuscript, in pen and ink

PROVENANCE: Dorothy Luttrell; Sir Thomas Phillipps; Lionel and Philip Robinson; Sotheby's, 29 June 1965 (178), bt Paul Mellon
SELECTED LITERATURE: *ODNB*

The manuscript is dedicated by Edward Luttrell "to his much Honored and Most Ingenuous Kinswoman Maddam Dorothy Luttrell." Luttrell gives precise instructions, with the occasional diagram, for the various branches of art mentioned in the title. He emphasizes in his preface that he does not "designe to make a Rhetorical Preamble concerning Painting for that is out of my Sphear, Butt to Discover to you in the Plainest terms first the Difficulty of itt and then the Ready way to Attaine itt" (p. [v]). Sometimes he recommends where a particular item of equipment may be obtained, as in the important section on Mezzo Tinto: "You may have severall of them 'a Roule of good steel' made some finer and some Courser by one Haines a file Cutter att the two Crowns in ye Little Minories" (p. 45).

Luttrell was one of the earliest mezzotint engravers and a friend of the diarist John Evelyn. Evelyn also knew Prince Rupert, to whom he refers in his diary as having shown him "with his owne hands the new way of graving called mezzo tinto." Indeed, the first mention of mezzotint engraving in English was in Evelyn's *Sculptura, or, The History and Art of Chalcography and Engraving in Copper*, published in 1662 (and in the Center's collections). But although "mezzo tinto" is mentioned on the title page, and a mezzotint portrait by Prince Rupert is included in the small book, Evelyn deliberately kept his description "ænigmatical" lest the method be cheapened by popularity. Luttrell's description is likely the earliest detailed account in English.

134

William Gilpin (1724–1804)
Hints to form the taste & regulate ye judgment in sketching Landscape, ca. 1790
Manuscript, in pen and ink, with watercolor

PROVENANCE: Charles J. Sawyer; bt Paul Mellon, 1966
SELECTED LITERATURE: Barbier, 1963; Guentner, 1993; Sloan, 2000, pp. 159–61

From 1768 to 1776 the writer and artist William Gilpin embarked on a series of excursions through Britain, recording his impressions in notebooks and later publishing them as picturesque tours, "in which writing and illustrations complement one another to sing the praises of nature" (Barbier, 1963, p. 41). Gilpin often circulated his unpublished work among friends. The manuscript here is an early draft of at least part of his *Three Essays* (published in 1792), in which he discusses the nature of picturesque beauty, picturesque travel, and the sketching of landscape. The published text of the last part, on the depiction of landscape, clearly has its origin in the manuscript here.

Gilpin begins his manuscript with these words:

> Tho' neatness and smoothness are essential Features of Beauty in real objects, yet alone they never please in representation & consequently form no part of the beauty which we properly call picturesque, or capable of being illustrated by painting. The rugged outline, & the rough surface essential to the picturesque, form the essential point of difference between it and the beautiful.

He suggests that "in order to colour chastely & harmoniously" one should only use "3 tints: red, yellow & blue." The manuscript includes a color chart of the recommended tints, below which he has painted a small landscape.

135

Archibald Robertson (1765–1835)
Manuscript of an unpublished sequel to Robertson's *Elements of the Graphic Arts*, New York, 1801
Manuscript, in pen and ink

PROVENANCE: Kennedy Galleries; bt Paul Mellon, 1963
SELECTED EXHIBITIONS: Beinecke, *America Pictured*, 2002, no. 77
SELECTED LITERATURE: Nygren, 1986; Davis, 1992, pp. 186–98

Archibald Robertson, miniature and portrait painter, grew up in Aberdeen and trained in that city, as well as in Edinburgh and London before immigrating to New York in 1791. He and his brother Alexander opened the Columbian Academy of Painting in New York City the following year, one of the first schools of art in the United States. Archibald Robertson compiled an art instruction manual for his students and issued it as *Elements of the Graphic Arts* in 1802. That work, directed toward the amateur artist, is one of the earliest drawing manuals to be published in the United States. In it he promotes the works of the aesthetician Reverend William Gilpin, who popularized the concept of the picturesque in his books on travel through Britain.

Paul Mellon owned two manuscript volumes by Archibald Robertson, both now at the Center. The first volume consists of a manuscript version of *Elements of the Graphic Arts*, dated 1803 on the fly-leaf, and includes letters from Archibald to his other brother, Dr. Andrew Robertson, who had remained in London. One of those letters details Archibald's "mode of painting Miniatures," including the preparation of the ivories and other materials, the grinding of pigments, the pose of the sitter, colors, and the use of gum arabic. It may not be coincidental that Andrew Robertson gave up practicing medicine about this time to become an important miniature painter. The second manuscript volume is in two parts and appears to be an unpublished sequel to Archibald's earlier published manual. The first part, "On the Art of Sketching," includes instructions on how to draw with a pen and is accompanied by numerous diagrams and examples. In the second part, entitled "On Drawing with Watercolours," Robertson illustrates various types of shading, with a wet and a dry brush, and gives detailed instructions on how to draw trees.

136

John Constable (1776–1837)
Autograph letter from Constable to John Thomas Smith (1766–1833), written between 16 January and 23 March 1797, inlaid to size and bound in *Memoirs of the Life of John Constable* by Charles Robert Leslie (1794–1859), London, James Carpenter, 1843
Manuscript, in pen and ink

PROVENANCE: Charles Robert Leslie; Nora G. Dunlop; E. W. Hennelle; Arthur Hamilton Lee, 1st Viscount Lee of Fareham; William George Constable; bt Paul Mellon, 1967
SELECTED LITERATURE: Constable, *Discourses*; Constable, 1975, pp. 292–94; Rhyne, 1981, pt. 1, pp. 125, 129, 131, 138–39; Rhyne, 1981, pt. 2, pp. 413–15; Fleming-Williams, 1990

John Constable first met the printmaker and draftsman John Thomas Smith in the summer of 1796. Smith had evidently given young Constable some instructions in a previous letter on the technique of etching. Constable writes here: "I think You told me that You made Your Aqua Fortis with spts of Nitre with two parts Water, I suppose You ment the acid spts. I bought some Aqua Fortis at a neighbouring Town and belive have spoilt one plate with it not knowng what strength it was of." The letter ends with a sketch of the view looking northeast from one of the windows at the back of Constable's family home in East Bergholt, Suffolk.

The letter is bound in a remarkable extra-illustrated copy of Charles Robert Leslie's biography of John Constable, first published in 1843. Leslie (1794–1859), a genre painter and author, evidently prepared this copy around 1851 for Nora G. Dunlop, the wife of his patron, James Dunlop. Besides a number of original letters by Constable, the volume includes two drawings by the artist, as well as eight now attributed to his son Lionel Bicknell Constable (1828–87). In addition to the prints by David Lucas after John Constable, published as part of Leslie's original *Memoirs*, there are thirty-eight prints by various other artists and engravers, as well as drawings and letters by John Thomas Smith, Joseph Farington, Francis Danby, Thomas Stothard, John Flaxman, and Richard Wilson. Also bound in is a letter of 11 February 1846 from the artist Ramsay Richard Reinagle to William Henry Ince, stating that he is enclosing a brief sketch of his life—present here—and noting that "Mr. Constable was taught by me the whole Art of Painting. When his Father, who was a rich Miller at Bergholt in Suffolk, dismissed him his house for loving the Art as a profession, I received him into my house for 6 months, & furnished him every thing he wanted—even money."

1823; panorama and scene painting in London; and notes of a visit to France with John Wilson in 1824.

Roberts describes the sketches as an "inventory of the works I have at various times produced and by which I lay claim to my title as a Painter." A typical entry is the opening from the first volume (see Gallery of Works), illustrated with his sketch of one of his largest and most ambitious works, *The Destruction of Jerusalem by Titus*, a painting on which he worked from 1847 to 1849. It was the only work he exhibited at the Royal Academy, in 1849. Roberts notes that the painting was sold in 1854 to "Mr. Lllewellyn, a dealer of Bristol, for £500, frame included, who had the varnish carefully & completely restored." The painting eventually sold at Christie's in 1961; it remains in a private collection today.

In the text above the sketch, Roberts refers to the completion of the last two volumes of the set of lithographs of the Holy Land, begun seven years earlier. The monumental project was, as Roberts writes, "the largest as well as the most expensive ever undertaken by a publisher on his own responsibility—thank God I may add that from being helped with health and backed by my ever esteemed friend Louis Haghe I may also say the most satisfactory." These lithographs are still considered to constitute one of the most important ventures of nineteenth-century publishing.

137

David Roberts (1796–1864)
Record Books, 1817–64, 2 vols.
Manuscript, in pen and ink, with newspaper clippings

PROVENANCE: From the artist to his daughter Christine and her husband, Henry Bicknell; by family descent to Hobhouse Limited; bt Paul Mellon, 1987
SELECTED EXHIBITIONS: Barbican, *David Roberts*, 1986, no. 220
SELECTED LITERATURE: Ballantine, 1866; Abbey, *Travel*, 1972, no. 385; Sim, 1984; ODNB

Almost entirely in the artist's hand, Roberts's record books contain reminiscences of his early career, travels, and colleagues (including Clarkson Stanfield and William Leighton Leitch), along with 250 vignette sketches of major compositions painted throughout his life. It includes press clippings; annotations by Roberts himself and his biographer, James Ballantine, on prices, purchasers, and the history of the paintings; Roberts's election to the Society of British Artists in

The majority of the color-plate books collected by Major John Roland Abbey, and purchased as a whole by Paul Mellon between 1952 and 1955, consisted of nearly six hundred works related to travel through Britain. That part of the Abbey collection was significantly augmented by Mellon, who added hundreds of titles from 1955 to 1977, when the Yale Center for British Art opened. The British landscape—and touring through it—had always been of keen interest to Paul Mellon, as reflected in the books and manuscripts he owned. Recollecting summers long past as a child in England before World War I, he wrote in the foreword to one of the Center's first publications:

> I remember huge dark trees in rolling parks, herds of small friendly deer, flotillas of white swans on the Thames, dappled tan cows in soft green fields, the grey mass of Windsor Castle towering in the distance against a background of huge golden summer clouds; soldiers in scarlet and bright metal, drums and bugles, troops of grey horses; laughing ladies in white with gay parasols, men in impeccable white flannels and striped blazers, and always behind them and behind everything the grass was green, green, green. Of course, there were ominous happenings, the awesome talk of grownups, gathering clouds, then as now. . . . But somehow at this great distance it all melts into a sunny and imperturbable English summer landscape. There seemed to be a tranquility in those days that has never again been found, and a quietness as detached from life as the memory itself. (YCBA, 1977, p. vi)

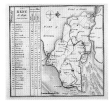

138

Thomas Badeslade, fl. 1712–42
A Compleat Sett of Mapps of England and Wales in General, and of Each County in Particular, Accurately Projected in a New Method and All of Them Original Drawings. Most Humbly Inscribed to His Majesty King George. By Francis Negus, Commissioner for Executing the Master of the Horse to His Majesty, 1724
Manuscript, in pen and ink and watercolor, on parchment

PROVENANCE: John F. Fleming; bt Paul Mellon, 1970
SELECTED EXHIBITIONS: YCBA, *Wilde Americk*, 2001

Thomas Badeslade, an engineer and surveyor, drew this remarkably beautiful series of English county maps in 1724. According to the title page, Francis Negus (1670–1732) intended to present the work to the king for a planned royal tour of the country. Negus, a former soldier and courtier, served under William III in Flanders before succeeding his father-in-law as a

member of Parliament for Ipswich in 1717. That same year he was appointed to a prestigious court position as Commissioner for Executing the Office of the Master of the Horse. Although it appears he would have had the opportunity to present the atlas to the king, there is no evidence that he ever did. Certainly the tour never took place.

The thirty-nine county maps are based on surveys published by Herman Moll, a Dutch cartographer who had moved to England in 1680. Badeslade's drawings were later engraved by William Henry Toms and published in 1742 under the title *Chorographia Britanniae* (also in Mellon's collections and now at the Center). Mellon's manuscript is most likely the "pocket book" mentioned on that work's title page, "first drawn and compiled . . . by order and for the use of His late Majesty King George I." Toms's work was a considerable success, perhaps one of the two or three bestselling county atlases published in the eighteenth century. It was the first county atlas to be truly pocket size and immediately found a substantial and hitherto unexploited market.

139

Sarah Sophia Banks (1744–1818)
Sir Joseph Banks's Fishery Book of the River Witham in Lincolnshire, 1784–96, 2 vols.
Manuscript, in pen and ink, with gouache and watercolor

PROVENANCE: Sarah Sophia Banks; Sir Wyndham Knatchbull; Sotheby's, 13 Mar. 1886 (974), bt Edward Stanhope; Richard Philip Stanhope; Lady Beryl Stanhope (Gilbert); Sotheby's, 22 July 1918 (8), bt William A. Cragg; Sotheby's, 28 July 1932 (537); Marlborough Rare Books; bt Paul Mellon, 1967
SELECTED EXHIBITIONS: YCBA, *Compleat Horseman*, 2001
SELECTED LITERATURE: Carter, 1987, p. 277

The manuscript describes the fishing parties held between 1784 and 1796 on the river Witham in Lincolnshire by Sir Joseph Banks (1743–1820), the renowned botanist and President of the Royal Society, together with his family, friends, and neighbors. The text was written by Sir Joseph's sister Sarah Sophia Banks, an avid collector of coins, medals, and printed ephemera (her collection of over twenty thousand items is now in the British Museum). The maps and drawings are mainly the work of William Brand, chief customs officer at Boston in Lincolnshire.

The *Lincoln Gazetteer* of 1 October 1784 reported on the first of their many outings: "Last week Sir Joseph Banks gave a grand entertainment on the river Witham to a select party of Ladies and Gentlemen of Boston and Lincoln. They took the diversion of fishing for two days and caught a great quantity of fish among which was a salmon of 20 lbs weight and a salmon trout of 8 lbs."

An outing that took place in September 1791 lasted four days, during which the group caught nearly 845 pounds of fish. Brand records this particular excursion in a series of watercolors; one entitled "Weighing a Fish after a Haul" depicts Sir Joseph Banks himself (at the front in a black hat and holding a fish in a net; see Gallery of Works). The boat nearest Banks is the "covered Boat occupied by the Company. . . . Next to her is the black Boat covered with Tarpaulins for the Servants."

140

A. Cooper
Journal of a Tour Down the Wye, 1786
Manuscript, in pen and ink, with watercolor

PROVENANCE: C. A. Stonehill; bt Paul Mellon, 1960

In the late eighteenth century, it became fashionable to visit wilder parts of Britain, particularly the Wye Valley because of its renowned scenic qualities. Tintern Abbey, then swathed in ivy, was visited by many famous individuals in search of the romantic and the picturesque, including J. M. W. Turner and William Wordsworth. Mr. A. Cooper was typical of these tourists and wrote ecstatically upon his first sighting of the ruins of the Abbey in his illustrated account: "The pointed remains . . . now rose upon the sight, and excited a sensation which I know not how to describe—A sensation compounded of surprise, admiration, and enthusiasm. Never did I behold so majestic a piece of ruins, or one so calculated to affect the mind of the spectator." He is also impressed by the sight of Bishop's Wood, a "novel, and very delightful scene."

"A. Cooper," the name that appears at the foot of the manuscript title page, has not yet been identified. Some evidence of his identity is provided in the second paragraph: "Our party consisted of Mr. Howman, Mr. Dryer, Mr. Lovich Cooper, my father, Mr. Cooper & myself." It is tempting to ascribe the manuscript to the Irish antiquary Austin Cooper (1759–1831), who recorded Ireland's ancient buildings and picturesque sites in numerous albums and loose drawings, now at the National Library of Ireland. There is, however, no evidence that Cooper made the journey to Monmouthshire in May of 1786, two months before he got married in Dublin.

141

Samuel Ireland (d. 1800)
Picturesque Views, on the River Medway, from the Nore to the Vicinity of its Source in Sussex: with Observations on the Public Buildings and other Works of Art in its Neighbourhood, with added watercolor drawings by Samuel Ireland, London, T. and J. Egerton, 1793
Letterpress, with watercolors

PROVENANCE: T. Barse; J. R. Abbey; bt Paul Mellon, 1962

Samuel Ireland published a series of moderately successful travel books illustrated with aquatints made after his own drawings, beginning with *A Picturesque Tour through Holland, Brabant, and Part of France* in 1790. Paul Mellon purchased a second edition of this two-volume work, along with the first edition of Ireland's *Picturesque Views on the River Medway* (1793), from Major J. R. Abbey in 1962. All three Ireland volumes are bound in the same gold-stamped calf binding and contain both the original watercolor drawings for the published engravings as well as extra drawings that were never engraved. The drawing of the hop pickers of Kent includes a charming vignette in the margin that does not appear in the final version.

Although Abbey had sold Mellon the majority of his illustrated books in a series of purchases from 1952 through 1955, he continued to provide Mellon with the occasional title through the early 1960s as his own collecting interests began to focus almost entirely on illuminated manuscripts and fine bindings.

142

Reverend William Coxe (1747–1828)
Historical Tour Through Monmouthshire, with added watercolor drawings by Richard Colt Hoare (1758–1838), London, T. Cadell, 1801, 2 vols.
Letterpress, with watercolors

PROVENANCE: Sir Richard Colt Hoare; Sotheby's, 30 July 1883 (547), bt Quaritch; John Allan Rolls, 1st Baron Llangattock; J. R. Abbey; bt Paul Mellon, 1962
SELECTED LITERATURE: Woodbridge, 1970; Knight, 1995

This magnificent copy of William Coxe's *Historical Tour in Monmouthshire* was printed "in a single Impression on Imperial Paper," with a separate title page and a slightly different title, "for the Use of Sir Richard Colt Hoare." Colt Hoare, an artist and antiquary, went on

a tour of Monmouthshire, in Wales, with his friend the Reverend William Coxe. Their first excursion took place in the summer of 1798; the weather was fine and the two were "delighted with the beauties of the scenery . . . the picturesque ruins of ancient castles . . . and the mansions distinguished by the residence of illustrious persons" (vol. 1, p. i). Planning to produce a book, they took two more tours through the county the next year. Coxe wrote the text, combining vivid descriptions of the landscape with historical accounts of the sites they visited. He dedicated the work to Colt Hoare, "whose persevering activity claimed the author's warmest thanks," and reminded him that the tour had "commenced in your Company, written at your suggestion and embellished by your Pencil." Indeed, Hoare provided the illustrations to be engraved later for the published work. Ninety-six of his original watercolors are bound up in Paul Mellon's copy. This imperial paper copy was printed solely to allow Hoare to preserve his very large drawings—such as the spectacular view of Tintern Abbey shown in the Gallery of Works.

In 1785 Colt Hoare had inherited the great estate at Stourhead, in Wiltshire, from his grandfather. He began building works there a few years later, adding two wings for his great collections of paintings, drawings, and books. Much of his collection was dispersed in a series of sales beginning in 1883. His unique copy of the Monmouthshire tour was sold at Sotheby's in July of that year for two hundred pounds; it was described as "very tastefully illustrated with 96 magnificent Drawings in Sepia."

The Illustrated Book

A group of books in the Mellon Collection printed before 1525, "representing the works of England's first printers," was exhibited at the Grolier Club in New York in 1968. In the preface to the catalogue, these early books were described as "the heart and soul of a new phase of English language and literature." They were also the core of Paul Mellon's collection of illustrated books, which included the first book to be printed in the English language by Britain's first printer (William Caxton's *Recuyell of the Historyes of Troye*, 1473 or 1474), the first to be printed in Britain (Chaucer's *Canterbury Tales*, 1476), the first to be printed in Britain with illustrations (*Myrrour of the Worlde*, 1481; cat. 143), the first illustrated Chaucer (1483; cat. 144), and the first British book printed in more than one color (*The Boke of St. Albans*, 1486; see cat. 127). Mellon's collection grew to encompass magnificent illustrated books produced in the four centuries that followed, including one of the world's foremost collections of William Blake's illuminated books (discussed in the Fine Arts section of this catalogue; see cats. 69–72, 74–76) and a complete set of William Morris's Kelmcott Press publications.

143

William Caxton (ca. 1422–91)
Hier begynneth the book callid the myrrour of the worlde, Westminster, William Caxton, 1481
Letterpress, with woodcuts

PROVENANCE: John Moore Paget, 1792 (bound for him by Richard Payne); Arthur Paget; John Moore Paget; Sir Richard Paget; Sotheby's, 4 Mar. 1920 (502), bt Sir Arthur Howard; Laurence Witten; bt Paul Mellon, 1959
SELECTED EXHIBITIONS: Grolier, *Fifty-five Books*, 1968, no. 5
SELECTED LITERATURE: STC 24762; Bennett, 1952; Hodnett, 1973; Hellinga, 1982; Driver, 2004; Twomey, 2006

William Caxton was the first to print a book in the English language (Raoul Lefèvre's *Recuyell of the Historyes of Troye*, printed in Bruges in 1473 or 1474, also in the Center's collection). In 1481 he produced the first illustrated book printed in Britain, the *Myrrour of the Worlde*—an encyclopedia of astronomy, geography, cosmology, zoology, and other sciences. It is an English version of the 1464 French text *L'Image du monde*, probably written by Gossouin of Metz in 1245–50, which was in turn derived from the *Imago mundi* and other Latin sources, compiled by Honorius Augustodunensis. Caxton had been asked by Hugh Bryce, Alderman of London, to translate the French work at his "coste and dispense," so that he

could present it to Lord Hastings, the Lord Chamberlain. Caxton writes that "an honest man, and a special frende of myn, a Mercer of London named Wylliam Praat . . . delivered to me in frensshe a lytle book named the book of good manners . . . and desired me instantly to translate it into englyssh." He apologizes for his translation, noting that he is "right vnable and of lytil connyng to translate and brynge it in to our maternal tongue." Caxton's edition is illustrated with crude woodcuts made in his workshop. The illustrations include the first map in a British book, a very simple so-called T-O map (in which the three known continents are shown within a circle, with East at the top). It is also one of the earliest works to contain a musical illustration; the opening shown in the Gallery of Works depicts a woman singing to the accompaniment of a recorder.

144

Geoffrey Chaucer (ca. 1343–1400)
The Canterbury Tales, Westminster, William Caxton, probably 1483
Letterpress, with woodcuts

PROVENANCE: Beaupré Bell of Beaupré Hall, Norfolk, 1737; Revd. Mr. Beaty, 1740; Magdalene College, Cambridge; H. P. Kraus; bt Paul Mellon, 1962
SELECTED EXHIBITIONS: Grolier, *Fifty-five Books*, 1968, no. 11
SELECTED LITERATURE: STC 5083; Hellinga, 1982; Carlson, 1997

In 1476 William Caxton printed the editio princeps (the first printed edition of a work that had previously existed only in manuscript) of Chaucer's *Canterbury Tales*. It was the first book printed in England. It is not known who provided Caxton with the manuscript or if he had a patron or other sponsor helping him produce the work. Much of what we know about his productions comes from his own comments in the works themselves. There is, however, no information on sources, dates, or patrons in the first edition of the *Tales*, although Caxton complains in the prologue to the second edition about the poor and incomplete state of manuscripts at his disposal. There is still no agreement among scholars as to which of the eighty or so surviving complete or fragmentary manuscript copies of *The Canterbury Tales* are the closest to the text as Chaucer wrote it.

The second edition is the first illustrated *Canterbury Tales*. Although undated, it was probably issued in 1483. The work contains twenty-three woodcut illustrations, some repeated several times throughout the work. Each pilgrim is depicted on horseback, carrying a rosary. The illustrations probably derive from a series of miniatures in a manuscript of which only a few leaves survive, called the "Oxford Fragments" (Carlson, 1997, pp. 26–30).

After Caxton's death in 1491, the blocks were used by his successor, Wynkyn de Worde, in his edition of the *Tales* issued in 1498.

145

Sebastian Brant (1458–1521)
This present Boke named the Shyp of folys of the worlde was translated ĩ the College of saynt mary Otery in the counte of Devonshyre: out of Laten, Frenche, and Doche into Englysshe tonge, London, Richarde Pynson, 1509
Letterpress, with woodcut

PROVENANCE: William, 7th Duke of Devonshire; Christie's, 30 June 1958 (13); H. P. Kraus; bt Paul Mellon, 1960
SELECTED EXHIBITIONS: Grolier, *Fifty-five Books*, 1968, no. 46
SELECTED LITERATURE: STC 3545; Carlson, 1995

First published in German in Basel in 1497, Sebastian Brant's *Narrenschiff*, or *Ship of Fools*, was one of the most successful published works of its time. There was an immediate demand for it to be translated into other European languages. Alexander Barclay was responsible for the English version, which was printed by Richard Pynson in London in 1509. In an innovative move, Pynson used two typefaces for printing the work. He set Barclay's translation in Gothic, or black letter, type, whereas Brant's Latin text appears in roman—the first roman font to be used in England. The illustrations were copied from the woodcuts in the original Basel edition, many of which were by Albrecht Dürer.

The Shyp of folys describes a ship sailing for the "fool's paradise" of Narragonia, and the passengers represent various types of vice or folly. Brant's translation gives a picture of contemporary English life: he targets ignorant book collectors, ungrateful children, inconstant and vain women, greedy merchants, corrupt lawyers and physicians, and undeserving beggars.

146

Horace, 65-8 BCE
Quinti Horatii Flacci Opera, 2 vols., London, John
Pine, 1733–37
Engravings

PROVENANCE: Robert Hudson; Charles Traylen;
bt Paul Mellon, 1966
SELECTED LITERATURE: Ray, 1976

John Pine, a pupil of the French engraver and print seller
Bernard Picart, was a trade engraver who had produced
illustrations and decoration for books of rather conven-
tional appearance. His edition of Horace, however, was a
masterpiece of unified design and is still considered one
of the most elegant books to be produced in the eigh-
teenth century. Remarkably, the text and the illustrations
for each page were engraved together, on a single copper
plate. The result was a very legible, consistent, and
beautifully designed page. Most of the head- and tail-
piece decorations were copied from classical works,
including the vignette of a lion attacking a horse (see
Gallery of Works). It illustrates the poem "In Cassium
Severum" (*Epodes,* Ode 6), in which Horace challenges
a scurrilous poet, taunting him for confining his abuse to
those who are powerless to reply. The image, a symbol
of an unequal struggle, was a theme that haunted the
artist George Stubbs for more than thirty years.

Pine made only one error in his engraving of the
text: "post est" was engraved on the medal of Augustus
Caesar (vol. 2, p. 108). It was corrected to "potest" in the
second impression. Paul Mellon acquired both versions.

147

Henry Noel Humphreys (1810–79)
*The Art of Illumination and Missal Painting:
A Guide to Modern Illuminators Illustrated by a
Series of Specimens,* London, H. G. Bohn, 1849
Letterpress, with watercolor and gouache

PROVENANCE: Henry Noel Humphreys; Gilbert Ifold
Ellis; C. A. Stonehill; bt Paul Mellon, 1962
SELECTED EXHIBITIONS: RISD, *Victorian Bibliomania,*
1987, no. 52
SELECTED LITERATURE: Leathlean, 1989

Henry Noel Humphreys wrote on a wide variety of
subjects, including gardening, natural history, numismat-
ics, and architecture, as well as book illustration and
design. He issued some of the most interesting and

innovative commercially produced books of the 1840s
and 1850s. Sometimes encased in elaborate bindings
made from papier-mâché and plaster to look like
engraved ebony wood, all were beautifully printed and
illustrated with wood engravings or color lithographs
(known as chromolithographs, which require the use of
multiple lithographic stones to print different colors).
Humphreys was an important figure in the revival
of interest in manuscript illumination during this period
(he was a particular favorite of William Morris). He
wrote and illustrated a number of works on the subject,
including *The Art of Illumination and Missal Painting*
(1849), a treatise on manuscript decorations. He gives
a short history of manuscript illumination, offering
technical advice for modern illuminators.

Paul Mellon's copy of *The Art of Illumination*
belonged to Humphreys himself and is a unique version.
The original chromolithographed paper onlays from the
publisher's binding (printed in fourteen colors) are here
pasted down inside the full olive morocco covers. The
original watercolor copies of the manuscript illumina-
tions are also bound in, in place of the chromolitho-
graphs intended for the published edition. Although it
has long been thought that Humphreys made these
drawings, recent scholarship has shown that it is more
likely that they were done by the leading professional
facsimilist of the day, Caleb W. Wing (Leathlean, 1989,
pp. 202–4). Wing's work is of such high standard that it
has frequently been confused with genuine medieval
illumination.

148

Geoffrey Chaucer (ca. 1343–1400)
The Works of Geoffrey Chaucer, Hammersmith,
Kelmscott Press, 1896 (one of 425 copies printed
on paper)
Letterpress, with wood engravings

PROVENANCE: Algernon Swinburne; Quaritch;
P. A. Rice, 1923; House of El Dieff; bt Paul Mellon, 1970
SELECTED LITERATURE: Robinson, 1982; Peterson, 1984;
Parry, 1996

Paul Mellon was interested in Britain's private-press
movement and, in fact, had a complete set of both
Golden Cockerell and Nonesuch Press titles. He also
had an interest in the most famous of the modern British
private presses, William Morris's Kelmscott Press.
He bought his first copy of the Kelmscott Chaucer in
May 1939. Some thirty years later, he acquired another
copy, along with the rest of the Kelmscott books, in one
fortuitous purchase. In 1970, a New York dealer offered
him a complete set of the fifty-three titles published by
the Press. Most of the copies in the group came from
the collection of Charles Fairfax Murray, an art collector
and lifelong friend of Morris.

Chaucer's *Canterbury Tales* was issued by the Kelmscott Press just before Morris's death. It is considered the crowning achievement of his artistic life. His typography was much enhanced by the large number of decorative designs and letters he drew for the work. He designed the title page, twenty-six large initial words; scores of decorated initials, many used in earlier Kelmscott books; fourteen large outer borders; and eighteen frames for illustrations. Edward Burne-Jones, who supplied eighty-seven illustrations, including the opening to the prologue, wrote of the project: "When the book is done, if we live to finish it, it will be a little like a pocket cathedral—so full of design. & I think Morris the greatest master of ornament in the world" (letter from Burne-Jones to Charles Eliot Norton, 20 Dec. 1894, Pierpont Morgan Library, New York).

Paul Mellon's second copy is a signed presentation copy from both Morris and Burne-Jones to the poet Algernon Swinburne, one of the few contemporary writers whose work Morris had chosen to print at Kelmscott. The inscription is dated 12 July 1896, about three months before Morris's death in October. The copy is accompanied by a letter from Swinburne, addressed to "my dear Morris," that thanks him for the "magnificent gift" that he has begun reading with "sincere admiration & pleasure."

Selected Exhibitions

As cited in abbreviated form in catalogue entries.

Ackermann, *Racehorses*, 1962: *An Exhibition of Eighteenth- and Nineteenth-Century Oil Paintings of Celebrated Racehorses*, Arthur Ackermann and Son, Ltd, London, 1962.

AFA, *British Watercolors*, 1985–86: *British Watercolors: Drawings of the Eighteenth and Nineteenth Centuries from the Yale Center for British Art*, American Federation of Arts, 1985–86. Catalogue by Scott Wilcox.

AGNSW, *Eden*, 1998: *This Other Eden: Paintings from the Yale Center for British Art*, Art Gallery of New South Wales, Sydney; Queensland Art Gallery, Brisbane; and Art Gallery of South Australia, Adelaide, 1998. Catalogue by Malcolm Warner et al.

Arts Council, *British Painting*, 1951: *British Painting, 1925–1950*, organized by the Arts Council and Manchester City Art Gallery for the Festival of Britain, 1951; New Burlington Galleries, London; and Manchester City Art Gallery, 1951.

Arts Council, *James Ward*, 1960: *James Ward, 1769–1859*, Arts Council of Great Britain, London, 1960.

Arts Council, *Stubbs*, 1958: *George Stubbs: Rediscovered Anatomical Drawings from the Free Public Library, Worcester, Massachusetts*, Arts Council of Great Britain, London, 1958.

Barbican, *David Roberts*, 1986: *David Roberts*, Barbican Art Gallery, London, 1986. Catalogue by Helen Guiterman and Briony Llewellyn.

Beinecke, *America Pictured*, 2002: *America Pictured to the Life: Illustrated Works from the Bequest of Paul Mellon*, Beinecke Rare Book and Manuscript Library, New Haven, 2002. Catalogue by George Miles and William Reese.

BFAC, *Portrait Miniatures*, 1889: *Exhibition of Portrait Miniatures*, Burlington Fine Arts Club, London, 1889.

BI: Annual exhibition, British Institution, London, various years.

BI, *Reynolds*, 1813: *Pictures by the Late Sir Joshua Reynolds, Exhibited by Permission of the Proprietors, in Honour of the Memory of That Distinguished Artist, and for the Improvement of British Art*, British Institution, London, 1813

Birmingham, *Canaletto and England*, 1993–94: *Canaletto and England*, Birmingham City Museum and Art Gallery, 1993–94. Catalogue by Michael Liversidge and Jane Farrington.

Birmingham, *Reynolds*, 1961: *Exhibition of Works by Sir Joshua Reynolds, P.R.A., 1723–1792*, Birmingham City Museum and Art Gallery, 1961. Catalogue by John Woodward, assisted by Malcolm Cormack.

Birmingham, *Wilson*, 1948–49: *Richard Wilson and His Circle*, Birmingham City Museum and Art Gallery, and Tate, London, 1948–49.

Blairman, *Walton*, 1946: *Henry Walton, 1746–1813*, H. Blairman & Sons Ltd, London, 1946.

BM, *Drawing in England*, 1987: *Drawing in England: From Hilliard to Hogarth*, British Museum, London, and Yale Center for British Art, New Haven, 1987. Catalogue by Lindsay Stainton and Christopher White.

BM, *Palmer*, 2005–6: *Samuel Palmer: Vision and Landscape*, British Museum, London, and Metropolitan Museum of Art, New York, 2005–6. Catalogue by William Vaughan et al.

Canberra and Melbourne, *Turner*, 1996: *Turner*, National Gallery of Australia, Canberra, and National Gallery of Victoria, Melbourne, 1996. Catalogue by Michael Lloyd.

Colnaghi, *English Drawings and Watercolours*, 1963: *A Loan Exhibition of English Drawings and Watercolours in Memory of the Late D.C.T. Baskett*, Colnaghi, London, 1963.

Colnaghi-Yale, *English Drawings*, 1964–65: *English Drawings and Watercolours from the Collection of Mr. and Mrs. Paul Mellon*, Colnaghi, London, and Yale University Art Gallery, New Haven, 1964–65.

Denver, *Glorious Nature*, 1993–94: *Glorious Nature: British Landscape Painting, 1750–1850*, Denver Art Museum, 1993–94. Catalogue by Katharine Baetjer et al.

Dresden and Berlin, *Turner*, 1972: *William Turner, 1775–1851*, Gemäldegalerie Neue Meister, Dresden, and Nationalgalerie Staatliche Museen Preussischer Kulturbesitz, Berlin, 1972. Catalogue by Joachim Uhlitzsch, Luke Herrmann, and James Millar.

Dublin, *Irish Portraits*, 1969: *Irish Portraits, 1660–1860*, National Gallery of Art, Dublin, 1969. Catalogue by Anne Crookshank and the Knight of Glin.

Edinburgh, *British Portrait Miniatures*, 1965: *British Portrait Miniatures*, The Arts Council Scottish Committee, Edinburgh, 1965.

Fitzwilliam, *John Linnell*, 1982: *John Linnell: A Centennial Exhibition*, The Fitzwilliam Museum, Cambridge, 1982. Catalogue by Katharine Crouan.

Frick, *Rowlandson*, 1990: *The Art of Thomas Rowlandson*, The Frick Collection, New York; The Frick Art Museum, Pittsburgh; and Baltimore Museum of Art, 1990. Catalogue by John Hayes.

Grand Palais, *Gainsborough*, 1981: *Gainsborough, 1727–1788*, Grand Palais, Paris, 1981. Catalogue by John Hayes.

Grand Palais, *Turner*, 1983–84: *J. M. W. Turner*, Grand Palais, Paris, 1983–84. Catalogue by John Gage et al.

Grolier, *Fifty-five Books*, 1968: *Fifty-five Books Printed Before 1525, Representing the Works of England's First Printers: An Exhibition from the Collection of Paul Mellon*, Grolier Club, New York, 1968. Catalogue by Joan Crane.

Grosvenor, 1888: Grosvenor Gallery, London, 1888.

Grosvenor, *Centenary*, 1885: *Centenary of British Art, 1737–1837*, Grosvenor Gallery, London, 1885.

Grosvenor, *Century of British Art*, 1889: *A Century of British Art (Second Series)*, Grosvenor Gallery, London, 1889.

Grosvenor, *Gainsborough*, 1885: *Thomas Gainsborough*, Grosvenor Gallery, London, 1885.

Grosvenor, *Reynolds*, 1883: *Works of Sir Joshua Reynolds*, Grosvenor Gallery, London, 1883.

Guildhall, *Turner*, 1899: *J. M. W. Turner and His Contemporaries*, Guildhall Art Gallery, London, 1899. Catalogue by A. G. Temple.

Hall and Knight, *Fearful Symmetry*, 2000: *Fearful Symmetry: George Stubbs, Painter of the English Enlightenment*, Hall and Knight, New York, 2000. Catalogue edited by Nicholas Hall.

Harewood, *Girtin*, 1999: *Thomas Girtin: Genius in the North*, Harewood House, 1999. Catalogue by David Hill.

Heim, *John Flaxman*, 1976: *John Flaxman*, Heim Gallery, London, 1976, introduction by David Bindman.

Hutchinson House, *Sports and Pastimes*, 1948: *National Gallery of British Sports and Pastimes*, Hutchinson House, UK, 1948.

LACMA, *Visions of Antiquity*, 1993–94: *Visions of Antiquity: Neoclassical Figure Drawings*, Los Angeles County Museum of Art, 1993; Philadelphia Museum of Art, 1993–94; and Minneapolis Institute of Arts, 1993–94. Catalogue by Richard J. Campbell and Victor Carlson.

Laing, *Lewis*, 1971: *John Frederick Lewis, R. A., 1805–1976*, Laing Art Gallery, Newcastle, 1971. Catalogue by Richard Green.

Leeds, *Early English Water Colours*, 1958: *Early English Water Colours*, City Art Gallery, Leeds, 1958.

Leeds, *Exhibition of Paintings*, 1839: *Exhibition of Paintings, Curiosities . . . at the Music Hall for the Relief of the Mechanics' Institute*, Music Hall, Leeds, 1839.

Leeds, *Wheatley*, 1965: *Francis Wheatley, R.A., . . . : An Exhibition Arranged by the Paul Mellon Foundation for British Art*, Aldeburgh Festival of Music and Arts and the City Art Gallery, Leeds, 1965. Catalogue by Mary Webster.

Leicester, *Victorian Romantics*, 1949: *The Victorian Romantics*, Leicester Galleries, 1949.

London, *Cooke*, 1822: *Exhibition of Drawings*, W. B. Cooke's Gallery, no. 9, Soho-Square, London, 1822.

London, *Fawkes*, 1819: *A Collection of Watercolour Drawings in the Possession of Mr Fawkes, 45 Grosvenor Place, London*, London, 1819.

Louvre, *D'Après l'antique*, 2000–01: *D'Après l'antique*, Musée du Louvre, Paris, 2000–01.

Manchester, *Art Treasures*, 1857: *Art Treasures Exhibition*, Manchester, 1857.

Manchester, *Royal Jubilee*, 1887: *Royal Jubilee Exhibition*, Manchester Art Gallery, 1887.

Manchester, 1956: Manchester Art Gallery, 1956.

Marble Hill, *Jones*, 1970: *Thomas Jones (1742–1803)*, Marble Hill House, Twickenham, and National Museum of Wales, Cardiff, 1970.

Mauritshuis and Tate, *Shock of Recognition*, 1970–71: *Shock of Recognition: The Landscape of English Romanticism and the Dutch Seventeenth-Century School*, Mauritshuis, The Hague, and Tate, London, 1970–71. Catalogue by A. G. H. Bachrach and Robin Campbell.

MC, *Collections parisiennes*, 1950: *Chefs d'oeuvres des collections parisiennes*, Musée Carnavalet, Paris, 1950.

MMA, *Empire City*, 2000: *Art and the Empire City: New York, 1825–1861*, Metropolitan Museum of Art, New York, 2000. Catalogue edited by Catherine Hoover Voorsanger and John K. Howat.

Munich, *The Age of Rococo*, 1958: *The Age of Rococo: Art and Culture of the Eighteenth Century*, The Residenz, Munich, 1958. Catalogue translation by Margaret D. Senft-Howie and Brian Sewell.

Munich, *Englische Malerei*, 1979–80: *Zwei Jahrhunderte Englische Malerei: Britische Kunst und Europa 1680 bis 1880*, Haus der Kunst, Munich, 1979–80.

NGA, *Berenson*, 1979: *Berenson and the Connoisseurship of Italian Painting*, National Gallery of Art, Washington D.C., 1979. Handbook by David Alan Brown.

NGA, *Constable*, 1969: *John Constable: A Selection of Paintings from the Collection of Mr. and Mrs. Paul Mellon*, National Gallery of Art, Washington, D.C., 1969.

NGA, *English Drawings*, 1962: *An Exhibition of English Drawings and Watercolours from the Collection of Mr. and Mrs. Paul Mellon*, National Gallery of Art, Washington, D.C., 1962.

NGA, *Gainsborough Drawings*, 1983–84: *Gainsborough Drawings*, National Gallery of Art, Washington, D.C.; Kimbell Art Museum, Fort Worth; and Yale Center for British Art, New Haven, 1983–84. Catalogue by John Hayes and Lindsay Stainton.

NGA, *Hogarth*, 1971: *William Hogarth: A Selection of Paintings from the Collection of Mr. and Mrs. Paul Mellon*, National Gallery of Art, Washington, D.C., 1971.

NGA, *Orientalists*, 1984: *The Orientalists: Delacroix to Matisse: The Allure of North Africa and the Near East*, National Gallery of Art, Washington D.C., 1984. Catalogue edited by MaryAnne Stevens.

NGA, *Turner*, 1968–69: *J. M. W. Turner: A Selection from the Collection of Mr. and Mrs. Paul Mellon*, National Gallery of Art, Washington, D.C., 1968–69. Catalogue by Ross Watson.

NGA, *Wright of Derby*, 1969–70: *Joseph Wright of Derby: A Selection of Paintings from the Collection of Mr. and Mrs. Paul Mellon*, National Gallery of Art, Washington, D.C., 1969–70. Catalogue by R. Watson.

NMGW, *Jones*, 2003–4: *Thomas Jones (1742–1803): An Artist Rediscovered*, National Museum and Gallery of Wales, Cardiff; Whitworth Art Gallery, Manchester; and National Gallery, London, 2003–4. Catalogue by Ann Sumner and Greg Smith et al.

NMR, *Munnings*, 2000: *The Mastery of Munnings*, National Museum of Racing, Saratoga Springs, N.Y., 2000. Catalogue by Lorian Peralto-Ramos.

NPG, *Treasures and Curiosities*, 1968: *Treasures and Curiosities: Drummonds at Charing Cross, 1717–1967*, National Portrait Gallery, London, 1968. Catalogue by Hector Bolitho.

Ottawa, *British Drawings*, 2005; *British Drawings from the National Gallery of Canada*, National Gallery of Canada, Ottawa, 2005. Catalogue by Douglas E. Schoenherr.

Park Lane, *Conversation Pieces*, 1930: *English Conversation Pieces: Exhibition in Aid of the Royal Northern Hospital*, London, 1930.

Park Lane, *Reynolds*, 1937: *Sir Joshua Reynolds: Loan Exhibition in Aid of the Royal Northern Hospital*, London, 1937.

Petit Palais, *Peinture Romantique*, 1972: *La Peinture Romantique anglaise et les préraphaélites*, Musée du Petit Palais, Paris, 1972. Catalogue introduction by Kenneth Clark.

PML, *Drake*, 1988: *Sir Francis Drake and the Age of Discovery*, Pierpont Morgan Library, New York, 1988. Catalogue by Verlyn Klinkenborg.

PML, *English Drawings*, 1972: *English Drawings and Watercolors, 1550–1850: In the Collection of Mr. and Mrs. Paul Mellon*, Pierpont Morgan Library, New York, and Royal Academy, London, 1972. Catalogue by John Baskett and Dudley Snelgrove.

RA: Annual exhibition, Royal Academy, London, from 1769 onward.

RA, *Bicentenary Exhibition*, 1968–69: *Bicentenary Exhibition*, Royal Academy, London, 1968–69.

RA, *British Portraits*, 1956–57: *British Portraits*, Royal Academy, London, 1956–57.

RA, *First Hundred Years*, 1951: *The First Hundred Years of the Royal Academy, 1769–1868*, Royal Academy, London, 1951.

RA, *Girtin Collection*, 1962; *The Girtin Collection: Watercolours by Thomas Girtin and Other Masters*, Royal Academy, London, 1962.

RA, *Great Age of British Watercolours*, 1993: *The Great Age of British Watercolours, 1750–1880*, Royal Academy of Arts, London, and National Gallery of Art, Washington D.C., 1993. Catalogue by Andrew Wilton and Anne Lyles.

RA, *Old Masters*, 1876: *Old Masters*, Royal Academy of Arts, London, 1876.

RA, *Painting in England*, 1964–65: *Painting in England, 1700–1850, from the Collection of Mr. and Mrs. Paul Mellon*, Royal Academy, London, 1964–65. Catalogue by Basil Taylor.

RA, *Paul Oppé Collection*, 1958: *Exhibition of Works from the Paul Oppé Collection: English Watercolours and Old Master Drawings*, Royal Academy, London, 1958.

RA, *Reynolds*, 1986: *Reynolds*, Royal Academy, London, and Grand Palais, Paris, 1986. Catalogue by Nicholas Penny.

RISD, *Victorian Bibliomania*, 1987: *Victorian Bibliomania: The Illuminated Book in Nineteenth-Century Britain*, Rhode Island School of Design, Providence, 1987. Catalogue by Alice Beckwith.

SA: Annual exhibition, Society of Artists, London, from 1760 onward.

Salander-O'Reilly, *Constable*, 1988: *John Constable, R.A. (1776–1837) : An Exhibition: Paintings, Drawings, Watercolors, Mezzotints*, Salander-O'Reilly Galleries, New York, 1988. Catalogue by Charles Rhyne.

SBA: Annual exhibition, Society of British Artists, London, from 1824 onward.

Sheffield, *Girtin Collection*, 1953: *Early Watercolours from the Collection of Thomas Girtin Jnr.*, Graves Art Gallery, Sheffield, 1953.

SNPG, *Cosway*, 1995: *Richard and Maria Cosway: Regency Artists of Taste and Fashion*, Scottish National Portrait Gallery, Edinburgh, 1995. Catalogue by Stephen Lloyd.

South Kensington, *National Portraits*, 1867: *Catalogue of the Second Special Exhibition of National Portraits Commencing with the Reign of William and Mary and Ending with the Year 1800*, South Kensington Museum, London, 1867.

South Kensington, *Portrait Miniatures*, 1865: *Special Exhibition of Portrait Miniatures on Loan at the South Kensington Museum*, South Kensington Museum, London, 1865.

South Kensington, *Special Exhibition*, 1862: *Special Exhibition of Works of Art at the South Kensington Museum*, South Kensington Museum, London, 1862.

South Kensington, 1880–83: South Kensington Museum, London, 1880–83.

Speed, *British Watercolors*, 1977: *British Watercolors: A Golden Age, 1750–1850*, J. B. Speed Museum, Louisville, Ky., 1977.

SPWC: Annual exhibition, Society of Painters in Water-Colours, London, from 1805 onward.

Tate, *Blake*, 1913–14: *Works by William Blake*, Tate, London; Whitworth Institute, Manchester; Art Museum, Nottingham Castle, 1913–14.

Tate, *Blake*, 2000: *William Blake*, Tate, London, and the Metropolitan Museum of Art, New York, 2000. Catalogue by Robin Hamlyn and Michael Phillips.

Tate, *British Painting in the Eighteenth Century*, 1957–58: *British Painting in the Eighteenth Century: An Exhibition under the Gracious Patronage of Her Majesty the Queen*, Tate, London; Montreal Museum of Fine Arts, Montreal; National Gallery of Canada, Ottawa; Art Gallery of Toronto; Toledo Museum of Art, Ohio, in collaboration with the British Council, 1957–58.

Tate, *Constable*, 1991: *Constable*, Tate, London, 1991. Catalogue by Leslie Parris and Ian Fleming-Williams.

Tate, *Constable*, 2006: *Constable: The Great Landscapes*, Tate, London, and National Gallery of Art, Washington, D.C., 2006; The Huntington Library, Art Collections, and Botanical Gardens, San Marino, Calif., 2007. Catalogue edited by Anne Lyles.

Tate, *Cotman*, 1922: *Works by John Sell Cotman and Some Related Painters of the Norwich School*, Tate, London, 1922.

Tate, *Dadd*, 1974–75: *The Late Richard Dadd, 1817–1886*, Tate, London, 1974–75. Catalogue by Patricia Allderidge.

Tate, *Gainsborough*, 1980–81: *Thomas Gainsborough*, Tate, London, 1980–81. Catalogue by John Hayes.

Tate, *Gainsborough*, 2002: *Gainsborough*, Tate, London, 2002. Catalogue by Michael Rosenthal and Martin Myrone.

Tate, *James Gillray*, 2001: *James Gillray: The Art of Caricature*, Tate, London, 2001. Catalogue by Richard Godfrey.

Tate, *Manners and Morals*, 1987–88: *Manners and Morals: Hogarth and British Painting 1700–1760*, Tate, London, 1987–88. Catalogue by Elizabeth Einberg.

Tate, *Reynolds*, 2005: *Joshua Reynolds: The Creation of Celebrity*, Tate, London, and Palazzo dei Diamanti, Ferrara, 2005. Catalogue edited by Martin Postle.

Tate, *Stubbs*, 1984–85: *George Stubbs, 1724–1806*, Tate, London, and Yale Center for British Art, New Haven, 1984–85. Catalogue by Judy Egerton.

Tate, *Stubbs and Wedgwood*, 1974: *Stubbs and Wedgwood: Unique Alliance Between Artist and Potter*, Tate, London, 1974. Catalogue by Bruce Tattersall.

Tate, *Towne*, 1997–98: *Francis Towne*, Tate, London, and Leeds City Art Gallery, 1997–98. Catalogue by Timothy Wilcox.

Tate, *Turner and Venice*, 2003–4: *Turner and Venice*, Tate, London, and Kimbell Art Museum, Fort Worth, 2003–4. Catalogue by Ian Warrell, with essays by David Laven, Jan Morris, and Cecilia Powell.

Tate, *Wilson*, 1982–83: *Richard Wilson: The Landscape of Reaction*, Tate, London, 1982–83. Catalogue by David Solkin.

Tate/RA, *Turner*, 1974: *Turner, 1775–1851*, Tate, London, and Royal Academy, London, 1974–75. Catalogue by Martin Butlin, John Gage, and Andrew Wilton.

Tokyo, *Institute of Art Research*, 1929: *Loan Collection of English Water-Colour Drawings*, Institute of Art Research, Tokyo, 1929.

Toronto and Ottawa, *Turner*, 1951: *Paintings by J. M. W. Turner*, Art Gallery of Toronto, and National Gallery of Canada, Ottawa, 1951.

V&A, *Cotman*, 1982–83: *John Sell Cotman, 1782–1842*, Victoria and Albert Museum, London; Whitworth Art Gallery, Manchester; and City of Bristol Museum and Art Gallery, 1982–83. Catalogue by Miklós Rajnai et al.

V&A, *English Caricature*, 1984: *English Caricature, 1620 to the Present: Caricatures and Satirists, Their Art, Their Purpose and Influence*, Victoria and Albert Museum, London, 1984.

V&A, *Hilliard and Oliver*, 1947: *Nicholas Hilliard and Isaac Oliver: An Exhibition to Commemorate the 400th Anniversary of the Birth of Nicholas Hilliard*, Victoria and Albert Museum, London, 1947. Catalogue by Graham Reynolds.

V&A, *Palmer*, 1926: *Drawings, Etchings, and Woodcuts by Samuel Palmer and Other Disciples of William Blake*, Victoria and Albert Museum, London, 1926.

V&A, *Rococo*, 1984: *Rococo: Art and Design in Hogarth's England*, Victoria and Albert Museum, London, 1984.

Victoria, *British Watercolour Drawings*, 1971: *British Watercolour Drawings in the Collection of Mr. and Mrs. Paul Mellon*, The Art Gallery of Greater Victoria, Canada, 1971.

Villa Hügel, *Metropole London*, 1992: *Metropole London: Macht und Glanz einer Weltstadt, 1800–1840*, Villa Hügel, Essen, 1992. Catalogue by Celina Fox et al.

VMFA, *Hogarth*, 1967: *William Hogarth*, Virginia Museum of Fine Arts, Richmond, 1967. Catalogue edited by William Francis.

VMFA, *Painting in England*, 1963: *Painting in England, 1700–1850: Collection of Mr. and Mrs. Paul Mellon*, Virginia Museum of Fine Arts, Richmond, 1963. Catalogue by Basil Taylor.

VMFA, *Sport and the Horse*, 1960: *Sport and the Horse*, Virginia Museum of Fine Arts, Richmond, 1960.

Whitechapel, *Turner*, 1953: *J. M. W. Turner, R.A., 1775–1851*, Whitechapel Art Gallery, London, 1953.

Wildenstein, *Constable*, 1937: *The Catalogue of a Centenary Memorial Exhibition of John Constable, R.A.: His Origins and Influence; Illustrating the Various Periods of His Work . . .*, Wildenstein, London, 1937. Organized by Percy Moore Turner.

YCBA, *Among the Whores and Thieves*, 1997: *Among the Whores and Thieves: William Hogarth and the Beggar's Opera*, Yale Center for British Art, New Haven, 1997. Catalogue edited by David Bindman and Scott Wilcox.

YCBA, *The Art of James Ward*, 2004: *The Art of James Ward*, Yale Center for British Art, New Haven, 2004.

YCBA, *Behold, the Sea Itself*, 2003: *Behold, the Sea Itself*, Yale Center for British Art, New Haven, 2003.

YCBA, *Blake*, 1982–83: *William Blake: His Art and Times*, Yale Center for British Art, New Haven, and Art Gallery of Ontario, Toronto, 1982–83. Catalogue by David Bindman.

YCBA, *Bonington*, 1991–92. *Richard Parkes Bonington: "On the Pleasure of Painting,"* Yale Center for British Art, New Haven, and Petit Palais, Paris, 1991–92. Catalogue by Patrick Noon.

YCBA, *Canaletto*, 2006: *Canaletto in England: A Venetian Artist Abroad, 1746–1755*, Yale Center for British Art, New Haven, and Dulwich Picture Gallery, London, 2006–07. Catalogue by Charles Beddington.

YCBA, *Classic Ground*, 1981: *Classic Ground: British Artists and the Landscape of Italy, 1740–1830*, Yale Center for British Art, New Haven, 1981. Catalogue by Duncan Bull et al.

YCBA, *Color Printing*, 1978: *Color Printing in England, 1486–1870*, Yale Center for British Art, New Haven, 1978. Catalogue by Joan Friedman.

YCBA, *Compleat Horseman*, 2001: *"The Compleat Horseman": Sporting Books from the Bequest of Paul Mellon*, Yale Center for British Art, New Haven, 2001. Catalogue by Elisabeth Fairman.

YCBA, *The Conversation Piece*, 1980: *The Conversation Piece: Arthur Devis and His Contemporaries*, Yale Center for British Art, New Haven, 1980. Catalogue by Ellen D'Oench.

YCBA, *Country Houses*, 1979: *Country Houses in Great Britain*, Yale Center for British Art, New Haven, 1979. Catalogue by Joy Breslauer, Ellen D'Oench, and Mary Spivy.

YCBA, *Cozens*, 1980: *The Art of Alexander and John Robert Cozens*, Yale Center for British Art, New Haven, 1980. Catalogue by Andrew Wilton.

YCBA, *English Landscape*, 1977: *English Landscape, 1630–1850: Drawings, Prints and Books from the Paul Mellon Collection*, Yale Center for British Art, New Haven, 1977. Catalogue by Christopher White.

YCBA, *English Portrait Drawings*, 1979–80: *English Portrait Drawings and Miniatures*, Yale Center for British Art, New Haven, 1979–80. Catalogue by Patrick Noon.

YCBA, *The Exhibition Watercolor*, 1981: *Works of Splendor and Imagination: The Exhibition Watercolor, 1770–1870*, Yale Center for British Art, New Haven, 1981. Catalogue by Jane Bayard.

YCBA, *Fairest Isle*, 1989: *Fairest Isle: The Appreciation of British Scenery, 1750–1850*, Yale Center for British Art, New Haven, 1989.

YCBA, *Fifty Beautiful Drawings*, 1977: *Exhibition of Fifty Beautiful Drawings*, Yale Center for British Art, New Haven, 1977.

YCBA, *First Decade*, 1986: *Acquisitions: The First Decade, 1977–1986*, Yale Center for British Art, New Haven, 1986.

YCBA, *Fuseli Circle*, 1979: *The Fuseli Circle in Rome: Early Romantic Art of the 1770s*, Yale Center for British Art, New Haven, 1979. Catalogue by Nancy L. Pressly.

YCBA, *Gilded Scenes*, 1985: *Gilded Scenes and Shining Prospects: Panoramic Views of British Towns, 1575–1900*, Yale Center for British Art, New Haven, 1985. Catalogue by Ralph Hyde.

YCBA, *Girtin*, 1986: *Thomas Girtin, 1775–1802*, Yale Center for British Art, New Haven, 1986. Catalogue by Susan Morris.

YCBA, *Great British Paintings*, 2001: *Great British Paintings from American Collections: From Holbein to Hockney*, Yale Center for British Art, New Haven, 2001. Catalogue by Malcolm Warner and Robyn Asleson.

YCBA, *Hollar*, 1994; *Wenceslaus Hollar: A Bohemian Artist in England*, Yale Center for British Art, New Haven, 1994. Catalogue by Richard T. Godfrey.

YCBA, *Human Form Divine*, 1997: *The Human Form Divine: William Blake from the Paul Mellon Collection*, Yale Center for British Art, New Haven, 1997. Catalogue by Patrick Noon.

YCBA, *Lear*, 2000: *Edward Lear and the Art of Travel*, Yale Center for British Art, New Haven, 2000. Catalogue by Scott Wilcox.

YCBA, *Line of Beauty*, 2001: *The Line of Beauty: British Drawings and Watercolors of the Eighteenth Century*, Yale Center for British Art, New Haven, 2001. Catalogue by Scott Wilcox et al.

YCBA, *Masters of the Sea*, 1987: *Masters of the Sea: British Marine Watercolours*, Yale Center for British Art, New Haven, and National Maritime Museum, Greenwich, 1987. Catalogue by Roger Quarm and Scott Wilcox.

YCBA, *Noble Exercise*, 1982: *Noble Exercise: The Sporting Ideal in Eighteenth-Century British Art*, Yale Center for British Art, New Haven, 1982. Catalogue by Stephen Deuchar.

YCBA, *Oil on Water*, 1986: *Oil on Water: Oil Sketches by British Watercolorists*, Yale Center for British Art, New Haven, 1986. Catalogue by Malcolm Cormack.

YCBA, *Paul Mellon Bequest*, 2001: *The Paul Mellon Bequest: Treasures of a Lifetime*, Yale Center for British Art, New Haven, 2001. Catalogue by Malcolm Warner.

YCBA, *Pleasures and Pastimes*, 1990: *Pleasures and Pastimes*, Yale Center for British Art, New Haven, 1990. Catalogue by Elisabeth Fairman.

YCBA, *Presences of Nature*, 1982: *Presences of Nature: British Landscape, 1780–1830*, Yale Center for British Art, New Haven, 1982. Catalogue by Louis Hawes.

YCBA, *Pursuit of Happiness*, 1977: *The Pursuit of Happiness: A View of Life in Georgian England*, Yale Center for British Art, New Haven, 1977. Catalogue by J. H. Plumb, Edward J. Nygren, and Nancy L. Pressly.

YCBA, *Romantic Vision*, 1995–96: *Romantic Vision: Responses to Change*, Yale Center for British Art, New Haven, 1995–96.

YCBA, *Rowlandson Drawings*, 1977–78: *Rowlandson Drawings from the Paul Mellon Collection*, Yale Center for British Art, New Haven, 1977, and Royal Academy, London, 1978. Catalogue by John Riely.

YCBA, *Sandby*, 1985: *The Art of Paul Sandby*, Yale Center for British Art, New Haven, 1985. Catalogue by Bruce Robertson.

YCBA, *Sensation and Sensibility*, 2005: *Sensation and Sensibility: Viewing Gainsborough's Cottage Door*, Yale Center for British Art, New Haven, and The Huntington Library, Art Collections, and Botanical Gardens, San Marino, Calif., 2005.

YCBA, *Sir Thomas Lawrence*, 1993: *Sir Thomas Lawrence: Portraits of an Age, 1790–1830*, Yale Center for British Art, New Haven; Kimbell Art Museum, Fort Worth; Virginia Museum of Fine Arts, Richmond, 1993. Catalogue by Kenneth Garlick.

YCBA, *Stubbs*, 1999: *George Stubbs in the Collection of Paul Mellon: A Memorial Exhibition*, Yale Center for British Art, New Haven, 1999, and Virginia Museum of Fine Arts, Richmond, 2000. Introductory essay by Malcolm Cormack; catalogue by Patrick McCaughey et al.

YCBA, *Toil and Plenty*, 1993–94: *Toil and Plenty: Images of the Agricultural Landscape in England, 1780–1890*, Nottingham University Art Gallery, and Yale Center for British Art, New Haven, 1993–94. Catalogue by Christiana Payne.

YCBA, *Turner and the Sublime*, 1980–81: *Turner and the Sublime*, Yale Center for British Art, New Haven; British Museum, London; and Art Gallery of Ontario, Toronto, 1980–81. Catalogue by Andrew Wilton.

YCBA, *Visionary Company*, 1997: *The Visionary Company: Blake's Contemporaries and Followers*, Yale Center for British Art, New Haven, 1997. Checklist by Jessica Smith.

YCBA, *Wheatley*, 2005: *The Worlds of Francis Wheatley*, Yale Center for British Art, New Haven, 2005. Brochure by Cassandra Albinson.

YCBA, *Wilde Americk*, 2001: *Wilde Americk: Discovery and Exploration of the New World*, Yale Center for British Art, New Haven, 2001. Catalogue by Elisabeth Fairman.

YUAG, *Painting in England*, 1965: *Painting in England, 1700–1850, from the Collection of Mr. and Mrs. Paul Mellon*, Yale University Art Gallery, New Haven, 1965. Catalogue by Basil Taylor.

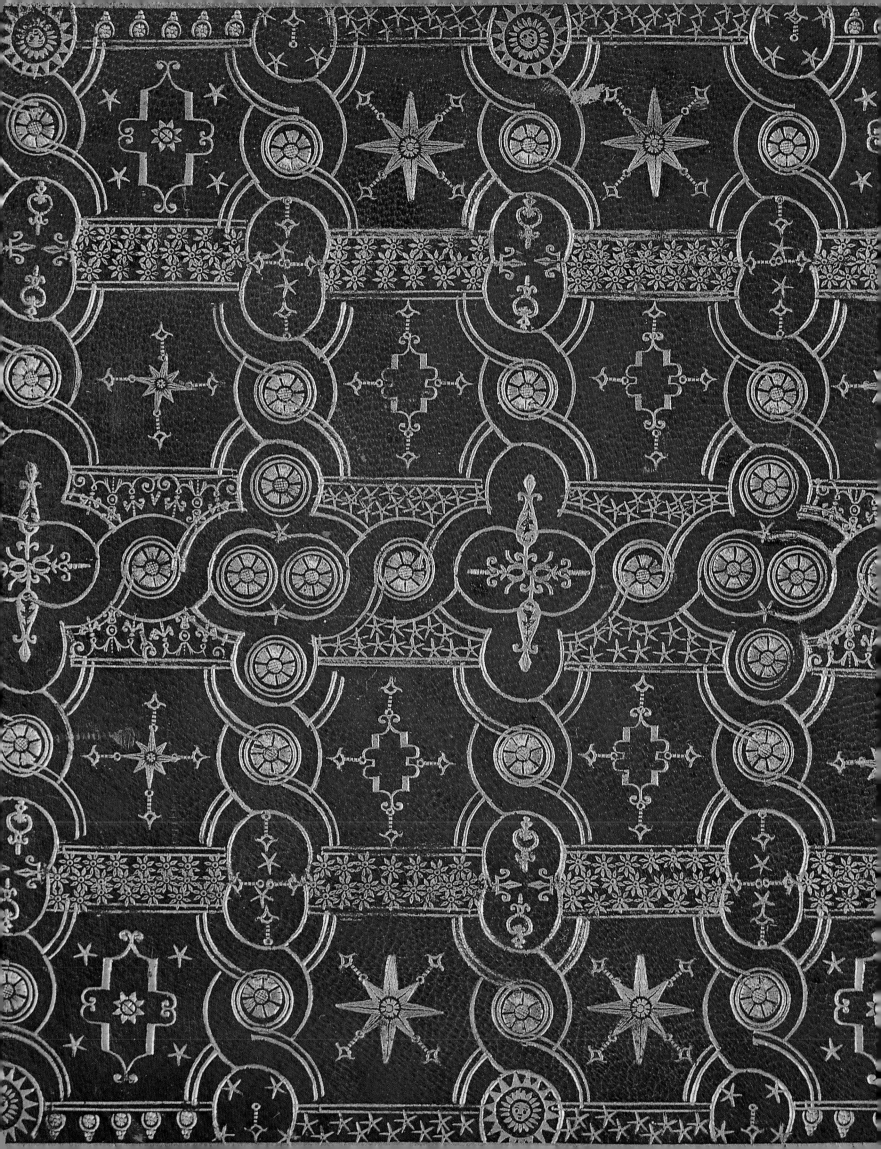

Selected Literature

As cited in abbreviated form in catalogue entries.

Abbey, *Travel*, 1972: J. R. Abbey, *Travel in Aquatint and Lithography, 1770–1860*, London, 1972.

Alison, 1790: Archibald Alison, *Essays on the Nature and Principles of Taste*, Dublin, 1790.

Allderidge, *Richard Dadd*, 1974: Patricia Allderidge, *Richard Dadd*, New York, 1974.

Allderidge, *Late Richard Dadd*, 1974: Patricia Allderidge, *The Late Richard Dadd*, exh. cat., Tate, London, 1974.

Allen and Dukelskaya, 1996: Brian Allen and Larissa Dukelskaya, eds., *British Art Treasures from Russian Imperial Collections in the Hermitage*, New Haven, 1996.

Almeida and Gilpin, 2005: Hermione de Almeida and George Gilpin, *Indian Renaissance: British Romantic Art and the Prospect of India*, Aldershot, 2005.

Andrews, 1989: Malcolm Andrews, *The Search for the Picturesque: Landscape Aesthetics and Tourism in Britain, 1760–1800*, Aldershot, 1989.

Andrews, 1999: Malcolm Andrews, *Landscape and Western Art*, Oxford, 1999.

Angelo, *Reminiscences*: Henry Angelo, *The Reminiscences of Henry Angelo*, 2 vols., London, 1904.

Antal, 1962: Frederick Antal, *Hogarth and His Place in European Art*, London, 1962.

Art Journal, 1856: "The Exhibition of the Society of Painters in Water-colours," *Art Journal* 2 (1856): 175–77.

Art Journal, 1858: "British Artists: Their Style and Character, No. XXXII—John Frederick Lewis," *Art Journal* 4 (1858): 41–43.

Art Journal, 1876: "John Frederick Lewis," *Art Journal* 15 (1876): 329.

Asfour and Williamson, 1999: Amal Asfour and Paul Williamson, *Gainsborough's Vision*, Liverpool, 1999.

Auerbach, 1961: Erna Auerbach, *Nicholas Hilliard*, London, 1961.

Ayrton, 1946: Michel Ayrton, *British Drawings*, London, 1946.

Bachrach, 1994: Fred G. H. Bachrach, *Turner's Holland*, exh. cat., Tate, London, 1994.

Baetjer and Links, 1989: Katharine Baetjer and J. G. Links, *Canaletto*, exh. cat., Metropolitan Museum of Art, New York, 1989.

Bailey, 1997: Anthony Bailey, *Standing in the Sun: A Life of J. M. W. Turner*, London, 1997.

Baker, 2001: Malcolm Baker, *Figured in Marble: The Making and Viewing of Eighteenth-Century Sculpture*, London, 2001.

Ballantine, 1866: James Ballantine, *The Life of David Roberts, R.A.: Compiled from His Journals and Other Sources*, Edinburgh, 1866.

Barbier, 1963: Carl Barbier, *William Gilpin: His Drawing, Teaching, and Theory of the Picturesque*, Oxford, 1963.

Baretti, 1781: Joseph Baretti, *A Guide Through the Royal Academy*, London, 1781.

Barker, 1988: Nicolas Barker, *Two East Anglian Picture Books: A Facsimile of the Helmingham Bestiary and Bodleian Ms. Ashmole 1504*, London, 1988.

Barker and Jackson, 1990: Felix Barker and Peter Jackson, *The History of London in Maps*, London, 1990.

Baskett, 1966: John Baskett, *Constable Oil Sketches*, London, 1966.

Baskett and Snelgrove, 1972: John Baskett and Dudley Snelgrove, *English Drawings and Watercolors, 1550–1850: In the Collection of Mr. and Mrs. Paul Mellon*, exh. cat., Pierpont Morgan Library, New York, and Royal Academy, London, 1972.

Baskett and Snelgrove, 1977: John Baskett and Dudley Snelgrove, *The Drawings of Thomas Rowlandson in the Paul Mellon Collection*, New York, 1977.

Bayard, 1981: Jane Bayard, *Works of Splendor and Imagination: The Exhibition Watercolor, 1770–1870*, exh. cat., Yale Center for British Art, New Haven, 1981.

Beckett, 1985: Oliver Beckett, *James Ward, R.A. (1769–1859): A Flawed Genius?*, London, 1985.

Beckford, *Dreams*: William Beckford, *Dreams, Waking Thoughts and Incidents*, edited by Robert J. Gemmett, Rutherford, 1971.

Beddington, 2006: Charles Beddington, *Canaletto in England: A Venetian Artist Abroad, 1746–1755*, exh. cat., Yale Center for British Art, New Haven, and Dulwich Picture Gallery, London, 2006.

Bell, 1998–99: Evelyne Bell, "The Life and Work of Henry Walton," *Gainsborough's House Review* (1998–99): 40–104.

Bell and Girtin, 1935: G. F. Bell and T. Girtin, "The Drawings and Sketches of John Robert Cozens," *Walpole Society*, vol. 23 (1934–35), 1935.

Belsey, 2002: Hugh Belsey, *Thomas Gainsborough: A Country Life*, London, 2002.

Bendiner, 1979: Kenneth Bendiner, "The Portrayal of the Middle-East in British Painting, 1835–1860," Ph.D. diss., Columbia University, 1979.

Bennett, 1968: Charles E. Bennett, ed., *Settlement of Florida*, Gainesville, 1968.

Bennett, 1952: Henry Stanley Bennett, *English Books and Readers, 1475–1557*, Cambridge, 1952.

Bentley, 1977: G. E. Bentley, Jr., *Blake Books*, Oxford, 1977.

Bentley, 2001: G. E. Bentley, Jr., *The Stranger from Paradise: A Biography of William Blake*, New Haven, 2001.

Bermingham, 1995: Ann Bermingham, "Elegant Females and Gentlemen Connoisseurs: The Commerce of Culture and Self-image in Eighteenth-Century England," in Ann Bermingham and John Brewer, eds., *The Consumption of Culture, 1600–1800: Image, Object, Text*, London, 1995.

Bindman, 1976: David Bindman et al, *John Flaxman*, exh. cat., Heim Gallery, London, 1976.

Bindman, 1977: David Bindman, *Blake as an Artist*, Oxford, 1977.

Bindman, 1979: David Bindman, ed., *John Flaxman*, London, 1979.

Bindman, 1980: David Bindman, *Hogarth*, London, 1980.

Bindman and Baker, 1995: David Bindman and Malcolm Baker, *Roubiliac and the Eighteenth-Century Monument: Sculpture as Theatre*, New Haven, 1995.

Binney, 1973: Marcus Binney, "Wakefield Lodge, Northamptonshire," *Country Life*, 2 August 1973, pp. 297–300.

Binyon, 1931: Laurence Binyon, *Landscape in English Art and Poetry*, London, 1931.

Binyon, 1933: Laurence Binyon, *English Water-colours*, London, 1933.

Blackwood, 1989: John Blackwood, *London's Immortals: The Complete Outdoor Commemorative Statues*, London, 1989.

Blake, 2005: Robin Blake, *George Stubbs and the Wide Creation: Animals, People and Places in the Life of George Stubbs, 1724–1806*, London, 2005.

Blake Archive: Morris Eaves, Robert Essick, and Joseph Viscomi, eds., *The William Blake Archive*, www.blakearchive.org.

Booth, 1986: Stanley Booth, *Sir Alfred Munnings, 1878–1959 : An Appreciation of the Artist and a Selection of His Paintings*, London, 1986.

Borenius, 1936: Tancred Borenius, *Catalogue of the Pictures and Drawings at Harewood House*, Oxford, 1936.

Boymans-van Beuningen, 1979: *The Willem van de Velde Drawings in the Boymans-van Beuningen Museum, Rotterdam*, 3 vols., Rotterdam, 1979.

Brenneman, 1995–96: David Brenneman, "Thomas Gainsborough's 'Wooded Landscape with Cattle by a Pool,' Art Criticism and the Royal Academy," *Gainsborough's House Review* (1995–96): 37–46.

Brewer, 1995: John Brewer, "'The Most Polite Age and the Most Vicious': Attitudes Towards Culture as a Commodity, 1660–1800," in Ann Bermingham and John Brewer, eds., *The Consumption of Culture, 1600–1800: Image, Object, Text*, London, 1995.

Brewer, 1997: John Brewer, *The Pleasures of the Imagination: English Culture in the Eighteenth Century*, London, 1997.

Brun, 2006: Laurent Brun, ed., *Archives de littérature du Moyen Age*, 2006, www.arlima.net.

Bucher, 1981: Bernadette Bucher, *Icon and Conquest: A Structural Analysis of the Illustrations of de Bry's Great Voyages*, Chicago, 1981.

Buckeridge, 1706: Bainbrigg Buckeridge, "An Essay Towards an English School of Painters," in *The Art of Painting and the Lives of the Painters*, by Roger de Piles, London, 1706.

Bury, 1962: Adrian Bury, *Francis Towne: Lone Star of Water-colour Painting*, Exeter, 1962.

Butlin, 1981: Martin Butlin, *The Paintings and Drawings of William Blake*, New Haven, 1981.

Butlin and Joll, 1984: Martin Butlin and Evelyn Joll, *The Paintings of J. M. W. Turner*, 2 vols., rev. ed., New Haven, 1984.

Buttery, 1992: David Buttery, *Canaletto and Warwick Castle*, Chichester, Sussex, 1992.

Cain, 2001: Tom Cain, ed., *The Poetry of Mildmay Fane, Second Earl of Westmoreland*, Manchester, 2001.

Camden, 1695: William Camden, *Britannia*, trans. by E. Gibson, London, 1695.

Carlson, 1995: David R. Carlson, "Alexander Barclay and Richard Pynson: A Tudor Printer and His Writer," *Anglia* 113: 3 (1995): 283–302.

Carlson, 1997: David R. Carlson, "Woodcut Illustrations of the Canterbury Tales, 1483–1602," *The Library*, ser. 6, 19:1 (March 1997): 25–67.

Carter, 1987: Harold Carter, *Sir Joseph Banks (1743–1820): A Guide to Biographical and Bibliographical Sources*, Winchester, 1987.

Clark et al., 1972: Kenneth Clark et al., *La Peinture Romantique anglaise et les préraphaélites*, exh. cat., Petit Palais, Paris, 1972.

Clifford and Legouix, 1976: Timothy Clifford and Susan Legouix, *The Rediscovery of an Artist: The Drawings of James Jefferys*, exh. cat., Victoria and Albert Museum, London, 1976.

Constable, 1953: W. G. Constable, *Richard Wilson*, London, 1953.

Constable, 1962: W. G. Constable, *Canaletto*, 2 vols., Oxford, 1962; rev. ed., J. G. Links, Oxford, 1976.

Constable, 1975: W. G. Constable, *John Constable: Further Documents and Correspondence*, London, 1975.

Constable, 1976: W. G. Constable, *Canaletto: Giovanni Antonio Canal, 1697–1768*, 2nd ed.; rev. by J. G. Links, 2 vols., Oxford, 1976.

Constable, *Correspondence*: *John Constable's Correspondence*, edited by R. B. Beckett, 6 vols., London, 1962–68.

Constable, *Discourses*: *John Constable's Discourses*, edited by R. B. Beckett, Ipswich, 1970.

Cordingly, 1982: David Cordingly, *The Art of the Van de Veldes: Paintings and Drawings by the Great Dutch Marine Artists and Their English Followers*, London, 1982.

Cormack, 1983: Malcolm Cormack, "'The Dort': Some Further Observations," *Turner Studies* 2:2 (Winter 1983): 37–39.

Cormack, 1986: Malcolm Cormack, *Constable*, New York, 1986.

Cormack, 1991: Malcolm Cormack, *The Paintings of Thomas Gainsborough*, Cambridge, 1991.

Craske, 1997: Matthew Craske, *Art in Europe, 1700–1830: A History of the Visual Arts in an Era of Unprecedented Urban Economic Growth*, Oxford, 1997.

Crookshank, 1978: Anne Crookshank, *The Painters of Ireland, c. 1660–1920*, London, 1978.

Crookshank, 1994: Anne Crookshank and the Knight of Glin, *The Watercolours of Ireland: Works on Paper in Pencil, Pastel and Paint, c. 1600–1914*, London, 1994.

Crouan, 1982: Katharine Crouan, *John Linnell*, New York, 1982.

Crown, 1977: Patricia Crown, "Edward F. Burney: A Historical Study in English Romantic Art," Ph.D. diss., UCLA, 1977.

Crown, 1980: Patricia Crown, "Visual Music: E. F. Burney and a Hogarth Revival," *Bulletin of Research in the Humanities* 83 (Winter 1980): 435–72.

Crown, 1982: Patricia Crown, *Drawings by E. F. Burney in the Huntington Collection*, San Marino, 1982.

Daniels, 1986: Stephen Daniels, "The Implications of Industry: Turner and Leeds," *Turner Studies* 6:1 (Summer 1986): 10–17.

Daniels, 1993: Stephen Daniels, *Fields of Vision: Landscape Imagery and National Identity in England and the United States*, Cambridge, 1993.

Daniels, 1999: Stephen Daniels, *Humphry Repton: Landscape Gardening and the Geography of Georgian England*, New Haven, 1999.

Danielsson, 1977: Bror Danielsson, ed., "William Twiti: The Art of Hunting," *Acta Universitatis Stockholmiensis* 37 (1977): 5–116.

Darvall, 1989: Peter Darvall, "Letters: Adam Buck and His London Family," *Burlington Magazine*, November 1989, pp. 775–76.

Davies, 1992: Maurice Davies, *Turner as Professor: The Artist and Linear Perspective*, exh. cat., Tate, London, 1992.

Davies and Long, 1925–26: Randall Davies and Basil S. Long, "John Frederick Lewis, R. A. (1805–76)," *Old Water-Colour Society's Club* 3 (1925–26): 31–50.

Davis, 1992: Elliot Bostwick Davis, "Training the Eye and the Hand: Drawing Books in Nineteenth-Century America," Ph.D. diss., Columbia University, 1992.

Day, 1975: Harold A. E. Day, *John Constable, R.A., 1776–1837: Drawings, the Golden Age*, Eastbourne, 1975.

Dayes, *Works*: Edward Dayes, *The Works of the Late Edward Dayes*, London, 1805, repr. 1971, with an introduction by R. W. Lightbown.

Deuchar, 1982: Stephen Deuchar, *Noble Exercise: The Sporting Ideal in Eighteenth-Century British Art*, exh. cat., Yale Center for British Art, New Haven, 1982.

Deuchar, 1988: Stephen Deuchar, *Sporting Art in Eighteenth-Century England: A Social and Political History*, New Haven, 1988.

Dictionary of Art: Jane Turner, ed., *Dictionary of Art*, 34 vols., London, 1996, and www.groveart.com.

D'Oench, 1979: Ellen D'Oench, "Arthur Devis (1712–1787): Master of the Georgian Conversation Piece," Ph.D. diss., Yale University, 1979.

D'Oench, 1980: Ellen D'Oench, *The Conversation Piece: Arthur Devis and His Contemporaries*, exh. cat., Yale Center for British Art, 1980.

Doherty, 1974: Terence Doherty, *The Anatomical Works of George Stubbs*, London, 1974.

Driver, 2004: Martha Driver, *The Image in Print: Book Illustration in Late Medieval England*, London, 2004.

Duffy, 2003: Stephen Duffy, *Richard Parkes Bonington*, London, 2003.

Dukelskaya and Moore, 2002: Larissa Dukelskaya and Andrew Moore, eds., *A Capital Collection: Houghton Hall and the Hermitage*, New Haven, 2002.

"The Earl of Derby's Miniatures," 1958: "The Earl of Derby's Miniatures," *Connoisseur*, June 1958, pp. 44–46.

Edmond, 1983: Mary Edmond, *Hilliard and Oliver: The Lives and Works of Two Great Miniaturists*, London, 1983.

Edwards, 1970: Ralph Edwards, *Thomas Jones (1742–1803)*, exh. cat., Kenwood House, London, 1970.

Egerton 1976: Judy Egerton, *George Stubbs : Anatomist and Animal Painter*, London, 1976.

Egerton, 1978: Judy Egerton, *British Sporting and Animal Paintings, 1665–1867: A Catalogue*, London, 1978.

Egerton, 1984: Judy Egerton, *George Stubbs, 1724–1806*, exh. cat., Tate, London, and Yale Center for British Art, New Haven, 1984.

Egerton, 1990: Judy Egerton, *Wright of Derby*, exh. cat., Tate, London, 1990.

Egerton, 1995: Judy Egerton, *Turner: The Fighting Temeraire*, exh. cat., National Gallery, London, 1995.

Egerton and Snelgrove, 1978: Judy Egerton and Dudley Snelgrove, *Sport in Art and Books: The Paul Mellon Collection: British Sporting and Animal Drawings c. 1500–1850*, exh. cat., Tate, London, 1978.

Erdman, 1974: David V. Erdman, *The Illuminated Blake*, New York, 1974.

Erffa and Staley, 1986: Helmut von Erffa and Allen Staley, *The Paintings of Benjamin West*, New Haven, 1986.

Esdaile, 1928: Katharine A. Esdaile, *The Life and Works of Louis François Roubiliac*, London, 1928.

Evans, 2002: Mark L. Evans, "Paintings, Prints and Politics during the American War: Henry Walton's *A Girl Buying a Ballad*," *Print Quarterly* 19:1 (March 2002): 12–24.

Evans and Lawrence, 1979: Ifor M. Evans and Heather Lawrence, *Christopher Saxton: Elizabethan Map-maker*, Wakefield, West Yorkshire, 1979.

Evelyn, *Diary*: *The Diary of John Evelyn*, edited by E. S. de Beer, 6 vols., Oxford, 1955.

Fairman, 2001: Elisabeth Fairman, "'Wherin all Trauailers may Vnderstand How to Direct their Voyages,' Maps and Atlases at the Yale Center for British Art from the Bequest of Paul Mellon," *Yale University Library Gazette* 75:3–4 (April 2001): 111–44.

Farington, *Diary*: *The Diary of Joseph Farington*, edited by Kenneth Garlick, Angus Macintyre, and Kathryn Cave, 16 vols., New Haven, 1978–84.

Fleming-Williams, 1990: Ian Fleming-Williams, *Constable and His Drawings*, London, 1990.

Fokker, 1931: T. H. Fokker, *Jan Siberechts: Peintre de la paysanne flamande*, Brussels, 1931.

Ford, 1948: Brinsley Ford, "The Dartmouth Collection of Drawings by Richard Wilson," *Burlington Magazine*, December 1948, pp. 337–45.

Ford, 1951: Brinsley Ford, *The Drawings of Richard Wilson*, London, 1951.

Ford, 1952: Brinsley Ford, "Richard Wilson. II—The Claudean Landscapes," *Burlington Magazine*, November 1952, pp. 307–13.

Ford, 1960: Brinsley Ford, "The Letters of Jonathan Skelton Written from Rome and Tivoli in 1758," *Walpole Society* 36 (1956–58), 1960, pp. 23–84.

Foskett, 1964: Daphne Foskett, *John Smart: The Man and His Miniatures*, London, 1964.

Foskett, 1974: Daphne Foskett, *Samuel Cooper and His Contemporaries*, London, 1974.

Friedman, 1989: A. T. Friedman, *House and Household in Elizabethan England: Wollaton Hall and the Willoughby Family*, Chicago, 1989.

Gage, 1975: John Gage, "The Distinctness of J. M. W. Turner," *Journal of the Royal Society of Arts* 123 (1975): 448–57.

Gage, 1987: John Gage, *J. M. W. Turner: "A Wonderful Range of Mind,"* New Haven, 1987.

Garlick, 1964: Kenneth Garlick, *A Catalogue of the Paintings, Drawings and Pastels of Sir Thomas Lawrence*, Walpole Society, vol. 39, (1964).

Garlick, 1989: Kenneth Garlick, *Sir Thomas Lawrence: A Complete Catalogue of the Oil Paintings*, Oxford, 1989.

Gibson, 2000: Katharine Gibson, "Jan Wyck, c. 1645–1700: A Painter with 'a Grate Deal of Fire,'" *British Art Journal* 2:1 (Autumn 2000): 3–13.

Girtin and Loshak, 1954: Thomas Girtin and David Loshak, *The Art of Thomas Girtin*, London, 1954.

Godfrey, 1994: Richard T. Godfrey, *Wenceslaus Hollar: A Bohemian Artist in England*, exh. cat., Yale Center for British Art, New Haven, 1994.

Godfrey, 2001: Richard Godfrey, *James Gillray: The Art of Caricature*, exh. cat., Tate, London, 2001.

Gowing, 1986: Lawrence Gowing, *The Originality of Thomas Jones*, New York, 1986.

Graham, 1695: Richard Graham, "A short account of the most eminent painters both ancient and modern, continued down to the present times, according to the order of their succession," in John Dryden, ed., *De Arte Graphica/The Art of Painting*, C. A. du Fresnoy, trans., London, 1695.

Grant, 1957–61: Maurice Harold Grant, *A Chronological History of the Old English Landscape Painters (in Oil) from the Sixteenth Century to the Nineteenth Century*, 8 vols., Leigh-On-Sea, 1957–61.

Graves, 1874: Algernon Graves, *Catalogue of the Works of the Late Sir Edwin Landseer: Dedicated by Special Permission to Her Most Gracious Majesty the Queen*, London, 1874.

Graves and Cronin, 1899–1901: Algernon Graves and William Vine Cronin, *A History of the Works of Sir Joshua Reynolds*, 4 vols., London, 1899–1901.

Greysmith, 1973: David Greysmith, *Richard Dadd: The Rock and Castle of Seclusion*, New York, 1973.

Griffiths, 1998: Anthony Griffiths, *The Print in Stuart Britain, 1603–1689*, exh. cat., British Museum, London, 1998.

Griffiths and Kesnerova, 1983: Anthony Griffiths and Gabriela Kesnerova, *Wenceslaus Hollar, prints and drawings: from the collections of the National Gallery, Prague, and the British Museum, London*, exh. cat., British Museum, London, 1983.

Grigson, 1947: Geoffrey Grigson, *Samuel Palmer: The Visionary Years*, London, 1947.

Grigson, 1960: Geoffrey Grigson, *Samuel Palmer's Valley of Vision*, London, 1960.

Grindle, 1999: Nick Grindle, "Big Houses and Little People: How Formal Patterns in the Landscape Relate to Social Compositions in Jan Siberechts' Later Works," *Object* 2 (1999): 89–109.

Grundy, 1909: C. Reginald Grundy, *James Ward, R.A.; His Life and Works, with a Catalogue of His Engravings and Pictures*, London, 1909.

Guentner, 1993: Wendelin A. Guentner, "British Aesthetic Discourse, 1780–1830: The Sketch, the Non Finito, and the Imagination," *Art Journal* 52:2 (Summer 1993): 40–47.

Guinness, 1982: Desmond Guinness, "Robert Healy, and Eighteenth-Century Irish Sporting Artists," *Apollo*, February 1982, pp. 80–85.

Hallett, 2001: Mark Hallett, *Hogarth*, London, 2001.

Hamilton, 1998: James Hamilton, *Turner and the Scientists*, exh. cat., Tate, London, 1998.

Hamilton, 2001: James Hamilton, "Walter Ramsden Fawkes," in *The Oxford Companion to J. M. W. Turner*, Evelyn Joll, Martin Butlin, and Luke Hermann, eds., Oxford, 2001.

Hardie, 1967–68: Martin Hardie, *Water-colour Painting in Britain*, Dudley Snelgrove, ed., with Jonathan Mayne and Basil Taylor, 3 vols., London, 1967–68.

Hargraves, 2006: Matthew Hargraves, *"Candidates for Fame": The Society of Artists of Great Britain, 1760–1791*, New Haven, 2006.

Harris, 1979: John Harris, *The Artist and the Country House*, London, 1979.

Haskell and Penny, 1981: Francis Haskell and Nicholas Penny, *The Most Beautiful Statues: The Taste for Antique Sculpture, 1500–1900*, exh. cat., Ashmolean Museum, Oxford, 1981.

Hawcroft, 1971: Francis Hawcroft, *Watercolors by John Robert Cozens*, exh. cat., Whitworth Art Gallery, Manchester, and Victoria and Albert Museum, London, 1971.

Hawcroft, 1988: Francis Hawcroft, *Travels in Italy, 1776–1783, Based on the "Memoirs" of Thomas Jones*, exh. cat., Whitworth Art Gallery, Manchester, 1988.

Hayes, 1971: John Hayes, *Drawings of Thomas Gainsborough*, 2 vols., London, 1971.

Hayes, 1972: John Hayes, *Rowlandson: Watercolours and Drawings*, London, 1972.

Hayes, 1975: John Hayes, *Gainsborough: Paintings and Drawings*, London, 1975.

Hayes, 1982: John Hayes, *The Landscape Paintings of Thomas Gainsborough*, 2 vols., London, 1982.

Hayes, 1990: John Hayes, *The Art of Thomas Rowlandson*, exh. cat., Frick Collection, New York; Frick Collection, Pittsburgh; and Baltimore Museum of Art, 1990.

Hayes and Stainton, 1983: John Hayes and Lindsay Stainton, *Gainsborough Drawings*, exh. cat., National Gallery of Art, Washington, D.C.; Kimbell Art Museum, Fort Worth; and Yale Center for British Art, New Haven, 1983–84.

Hazlitt, *Complete Works*: William Hazlitt, *The Complete Works of William Hazlitt*, edited by P. P. Howe, 21 vols., New York, 1967.

Hellinga, 1982: Lotte Hellinga, *Caxton in Focus: The Beginning of Printing in England*, London, 1982.

Hemming, 1989: Charles Hemming, *British Landscape Painters: A History and Gazetteer*, London, 1989.

Herrmann, 1986: Luke Herrmann, *Paul and Thomas Sandby*, London, 1986.

Herrmann, 2000: Luke Herrmann, *Nineteenth-Century British Painting*, London, 2000.

Hill, 1984: David Hill, *In Turner's Footsteps: Through the Hills and Dales of Northern England*, London, 1984.

Hill, 2005: David Hill, *Cotman in the North: Watercolours of Durham and Yorkshire*, New Haven, 2005.

Hilliard, *Arte of Limning*: Nicholas Hilliard, *A Treatise Concerning the Arte of Limning*, edited by R. K. R. Thornton and T. G. S. Cain, Ashington, Northumberland, 1981.

Hind, 1922: Arthur Mayger Hind, *Wenceslaus Hollar and His Views of London and Windsor in the Seventeenth Century*, London, 1922.

Hodnett, 1973: Edward Hodnett, *English Woodcuts, 1480–1535*, Oxford, 1973.

Hodnett, 1978: Edward Hodnett, *Francis Barlow: First Master of English Book Illustration*, Berkeley, 1978.

Hogarth, *Analysis of Beauty*: William Hogarth, *The Analysis of Beauty*, London, 1753.

Holcomb, 1972: Adele M. Holcomb, "'Indistinctness Is My Fault': A Letter about Turner from C. R. Leslie to James Lenox," *Burlington Magazine*, August 1972, pp. 555–58.

Hoozee, 1979: Robert Hoozee, *L'Opera completa di Constable*, Milan, 1979.

Hulton, 1977: Paul H. Hulton, *The Work of Jacques Le Moyne de Morgues: A Huguenot Artist in France, Florida, and England*, London, 1977.

Hulton, 1984: Paul H. Hulton, *America 1585: The Complete Drawings of John White*, Chapel Hill, N.C., 1984.

Hulton, 1991: Paul Hulton, *Luigi Balugani's Drawings of African Plants: From the Collection Made by James Bruce of Kinnaird on His Travels to Discover the Source of the Nile, 1767–1773*, New Haven, 1991.

Irwin, 1979: David Irwin, *John Flaxman, 1755–1826, Sculptor, Illustrator, Designer*, New York, 1979.

Jacques, 1979: David Jacques, "Capability Brown at Warwick Castle," *Country Life*, 22 February 1979, pp. 474–76.

Jenkins, 1988: Ian Jenkins, "Adam Buck and the Vogue for Greek Vases," *Burlington Magazine*, June 1988, pp. 448–57.

Joll, Butlin, and Herrmann, 2001: Evelyn Joll, Martin Butlin, and Luke Hermann, eds., *The Oxford Companion to J. M. W. Turner*, Oxford, 2001.

Jones, 1990: Rica Jones, "Wright of Derby's Techniques of Painting," in Judy Egerton, *Wright of Derby*, exh. cat., Tate, London, 1990.

Jones, 1997: Rica Jones, "Gainsborough's Materials and Methods: A 'Remarkable Ability to Make Paint Sparkle,'" *Apollo*, August 1997, pp. 19–26.

Jones, *Memoirs*: A. P. Oppé, "Memoirs of Thomas Jones," *Walpole Society* 32 (1946–48), 1951.

Kendall, 1932–33: G. Kendall, "Notes on the Life of John Wootton with a List of Engravings after His Pictures," *Walpole Society* 21 (1932–33): 23–43.

Keynes, 1971: Geoffrey Keynes, *William Blake's Water-colour Designs for the Poems of Thomas Gray*, London, 1971.

Keynes and Wolf, 1953: Geoffrey Keynes and Edwin Wolf, *William Blake's Illuminated Books: A Census*, New York, 1953.

Kingzett, 1980–82: Richard Kingzett, "A Catalogue of Works by Samuel Scott," *Walpole Society* 48 (1980–82): 1–134.

Kitson, 1937: Sydney D. Kitson, *The Life of John Sell Cotman*, London, 1937.

Klonk, 1997: Charlotte Klonk, "From Picturesque Travel to Scientific Observation: Artists' and Geologists' Voyages to Staffa," in Michael Rosenthal, Christiana Payne, and Scott Wilcox, eds., *Prospects for the Nation: Recent Essays in British Landscape, 1750–1880*, New Haven, 1997.

Knight, 1995: Jeremy Knight, ed., *An Historical Tour in Monmouthshire*, Cardiff, 1995.

Kriz, 1997: Kay Dian Kriz, *The Idea of the English Landscape Painter: Genius as Alibi in the Early Nineteenth Century*, New Haven, 1997.

Lambert, 2005: Ray Lambert, *John Constable and the Theory of Landscape Painting*, Cambridge, 2005.

Leathlean, 1989: Howard Leathlean, "Henry Noel Humphreys and the Getting-up of Books in the Mid-Nineteenth Century," *Book Collector* 38:2 (Summer 1989): 192–209.

Legouix, 1980: Susan Legouix, *Image of China: William Alexander*, London, 1980.

Legouix and Conner, 1981: Susan Legouix and Patrick Conner, *William Alexander: An English Artist in Imperial China*, exh. cat., The Royal Pavilion, Art Gallery and Museums, Brighton, and Nottingham University Art Gallery, Nottingham, 1981.

Leith-Ross, 2000: Prudence Leith-Ross, *The Florilegium of Alexander Marshal in the Collection of Her Majesty the Queen at Windsor Castle*, London, 2000.

Le Moyne de Morgues, 1984: Jacques Le Moyne de Morgues, *Portraits of Plants*, exh. cat., Victoria and Albert Museum, London, 1984.

Leslie, 1843: C. R. Leslie, ed., *Memoirs of the Life of John Constable . . .* , London, 1843.

Leslie, 1855: C. R. Leslie, *A Hand-book for Young Painters*, London, 1855.

Leslie, 1860: C. R. Leslie, *Autobiographical Recollections*, 2 vols., London, 1860.

Levey, 1979: Michael Levey, *Thomas Lawrence, 1769–1830*, exh. cat., National Portrait Gallery, London, 1979.

Levey, 2005: Michael Levey, *Sir Thomas Lawrence*, London, 2005.

Lewis, 1978: Major-General Michael Lewis, *John Frederick Lewis, R. A.*, Leigh-on-Sea, 1978.

Links, 1994: J. G. Links, *Canaletto*, London, 1994.

Linnell, 1994: David Linnell, *Blake, Palmer, Linnell and Co.: The Life of John Linnell*, Sussex, 1994.

Lister, 1974: Raymond Lister, *Samuel Palmer: A Biography*, London, 1974.

Lister, 1988: Raymond Lister, *Catalogue Raisonné of the Works of Samuel Palmer*, Cambridge, 1988.

Lister, 1989: Raymond Lister, *British Romantic Painting*, Cambridge, 1989.

Liversidge and Farrington, 1993: Michael Liversidge and Jane Farrington, eds., *Canaletto and England*, exh. cat., Birmingham Museums and Art Gallery, Birmingham, 1993–94.

Lloyd, 1995: Stephen Lloyd, *Richard and Maria Cosway: Regency Artists of Taste and Fashion*, exh. cat., Scottish National Portrait Gallery, Edinburgh, 1995.

Lockspeiser, 1973: Edward Lockspeiser, "Pictures of Nothing," in *Music and Painting: A Comparative Study from Turner to Schoenberg*, London, 1973.

Long, 1923: Basil S. Long, "Robert Hills," *Walker's Quarterly* 12 (1923): n.p.

Longstaffe-Gowan, 2001: Todd Longstaffe-Gowan, *The London Town Garden, 1740–1840*, New Haven, 2001.

Lovell, 2005: Margaretta Lovell, *Art in a Season of Revolution*, Philadelphia, 2005.

Lowman, 1685: R. Lowman, *An Exact Narrative and Description of the Wonderfall and Stupendious Fireworks in Honour of Their Majesties Coronations, and for the High Entertainment of Their Majesties, the Nobility, and City of London; made on the Thames, and perform'd to the Admiration and Amazement of the Spectators, on April the 24th 1685*, London, 1685.

Lyles, 1988: Anne Lyles, *Turner and Natural History: The Farnley Project*, exh. cat., Tate, London, 1988.

Lyles and Hamlyn, 1997: Anne Lyles and Robin Hamlyn, *British Watercolours from the Oppé Collection, with a Selection of Drawings and Oil Sketches*, exh. cat., Tate, London, 1997.

Maas, 1969: Jeremy Maas, *Victorian Painters*, London, 1969.

Macaulay, 1942: Rose Macaulay, *Life Among the English*, London, 1942.

MacClintock, 1992: Dorcas MacClintock, "Queen Charlotte's Zebra," *Discovery* 23:1 (1992).

Manners and Williamson, 1920: Lady Victoria Manners and G. C. Williamson, *John Zoffany, R. A., His Life and Works: 1735–1810*, London; New York, 1920.

Mannings and Postle, 2000: David Mannings and Martin Postle, *Sir Joshua Reynolds: A Complete Catalogue of His Paintings*, 2 vols., New Haven, 2000.

Malton, 1792: Thomas Malton, *A Picturesque Tour Through the Cities of London and Westminster*, London, 1792.

Mellon, 1992: Paul Mellon, with John Baskett, *Reflections in a Silver Spoon: A Memoir*, New York, 1992.

Meyer, 1984: Arline Meyer, *John Wootton, 1682–1764: Landscapes and Sporting Art in Early Georgian England*, exh. cat., Kenwood House, London, 1984.

Millar, 1969: Sir Oliver Millar, *The Later Georgian Pictures in the Collection of Her Majesty the Queen*, London, 1969.

Moore, 1982: Andrew W. Moore, *John Sell Cotman, 1782–1842*, exh. cat., Norwich Castle Museum, Norwich, 1982.

Morris, 1986: Susan Morris, *Thomas Girtin, 1775–1802*, exh. cat., Yale Center for British Art, New Haven, 1986.

Morris, 1989: David Morris, *Thomas Hearne and His Landscape*, London, 1989.

Morris and Milner, 1985: David Morris and Barbara Milner, *Thomas Hearne, 1744–1817: Watercolours and Drawings*, exh. cat., Bolton Museum and Art Gallery, Bolton, 1985.

Morton, 1993: Alan Q. Morton, *Science in the Eighteenth Century: The King George III Collection*, London, 1993.

Mowl, 1998: Timothy Mowl, *William Beckford: Composing for Mozart*, London, 1998.

Murdoch, Murrell, and Noon, 1981: John Murdoch, Jim Murrell, and Patrick Noon, *The English Miniature*, London, 1981.

Nemerov, 1998: Alexander Nemerov, "The Ashes of Germanicus and the Skin of Painting: Sublimation and Money in Benjamin West's *Agrippina*," *Yale Journal of Criticism* 11:1 (Spring 1998): 11–27.

Nicolson, 1968: Benedict Nicolson, *Joseph Wright of Derby: Painter of Light*, 2 vols., London, 1968.

Noon, 1979–80: Patrick Noon, *English Portrait Drawings and Miniatures*, exh. cat., Yale Center for British Art, New Haven, 1979–80.

Noon, 1991: Patrick Noon, *Richard Parkes Bonington, "On the Pleasure of Painting,"* exh. cat., Yale Center for British Art, New Haven, and Petit Palais, Paris, 1991.

Northall, 1766: John Northall, *Travels Through Italy: Containing New and Curious Observations of That Country*, London, 1766.

Northcote, 1815: James Northcote, *Memoirs of Sir Joshua Reynolds*, 2 vols., London, 1815.

Nygren, 1976: Edward J. Nygren, *The Art of James Ward, R.A. (1769–1859)*, Ph.D. diss., Yale University, 1976.

Nygren, 1986: Edward J. Nygren, *Views and Visions: American Landscapes Before 1830*, exh. cat., National Gallery of Art, Washington, D.C., 1986.

ODNB: *Oxford Dictionary of National Biography*, Oxford, 2004, and www.oxforddnb.com.

O'Keefe, 1826: John O'Keefe, *Recollections of the Life of John O'Keefe, Written by Himself*, 2 vols., London, 1826.

Olson, 1985: Roberta J. M. Olson, "The Draftsman's Comet," *Drawing* 2:3 (September–October 1985): 49–55.

Olson and Pasachoff, 1998: Roberta J. M. Olson and Jay M. Pasachoff, *Fire in the Sky: Comets and Meteors, the Decisive Centuries, in British Art and Science*, Cambridge, 1998.

Oppé, 1920: A. P. Oppé, "Francis Towne, Landscape Painter," *Walpole Society*, vol. 8 (1919–20), 1920, pp. 95–126.

Oppé, 1947: A. P. Oppé, *The Drawings of Paul and Thomas Sandby in the Collection of His Majesty the King at Windsor Castle*, London, 1947.

Oppé, 1948: A. P. Oppé, *The Drawings of William Hogarth*, London, 1948.

Oppé, 1952: A. P. Oppé, *Alexander and John Robert Cozens*, London, 1952.

Ormond, 1981: Richard Ormond, *Sir Edwin Landseer*, London, 1981.

Ottley, 1814: William Young Ottley, Description of Lot 1621, *Drawings by the Masters of All Schools, Particularly the Italian*, auction cat., T. Philipe, London, 20 June 1814.

Ovid, *Metamorphoses: Ovid's Metamorphoses, in fifteen books. Translated by Mr. Dryden. Mr. Addison . . . Mr. Croxall. And other eminent hands. Publish'd by Sir Samuel Garth, M.D. Adorn'd with sculptures . . .* , 2 vols., Dublin, 1727.

Paley, 1970: Morton D. Paley, *Energy and the Imagination: A Study of the Development of Blake's Thought*, Oxford, 1970.

Paley, 1991: William Blake, *Jerusalem*, facsimile, edited by Morton D. Paley, London, 1991.

Palmer, 1892: A. H. Palmer, *The Life and Letters of Samuel Palmer, Painter and Etcher*, London, 1892.

Parry, 1996: Linda Parry, ed., *William Morris*, London, 1996.

Pasquin, 1796: Anthony Pasquin, *An Authentic History of the Professors of Painting, Sculpture, and Architecture, who have practised in Ireland*, London, 1796; repr., London, 1970.

Paulson, 1971: Ronald Paulson, *Hogarth: His Life, Art, and Times*, 2 vols., New Haven, 1971.

Paulson, 1972: Ronald Paulson, *Rowlandson; A New Interpretation*, New York, 1972.

Paulson, 1992–93: Ronald Paulson, *Hogarth*, 3 vols., New Brunswick, 1992–93.

Paulson, 1996: Ronald Paulson, *The Beautiful, Novel, and Strange: Aesthetics and Heterodoxy*, Baltimore, 1996.

Payne, 1993: Christiana Payne, *Toil and Plenty: Images of the Agricultural Landscape in England, 1780–1890*, exh. cat., Nottingham University Art Gallery, Nottingham, and Yale Center for British Art, New Haven, 1993–94.

Pedicord, 1980: Harry William Pedicord, "The Changing Audience," in *The London Theatre World, 1660–1800*, Robert D. Hume, ed., Carbondale, 1980.

Pennington, 1982: Richard Pennington, *A Descriptive Catalogue of the Etched Work of Wenceslaus Hollar, 1607–1677*, Cambridge, UK, 1982.

Peralta-Ramos, 2000: Lorian Peralta-Ramos, *The Mastery of Munnings: Sir Alfred J. Munnings, 1878–1959*, exh. cat., National Museum of Racing, Saratoga Springs, New York, 2000.

Peterson, 1984: William Peterson, *A Bibliography of the Kelmscott Press*, Oxford, 1984.

Pierce, 1960: S. Rowland Pierce, "Jonathan Skelton and His Watercolours," *Walpole Society*, vol. 36 (1956–58), 1960, pp. 10–22.

Podeschi, 1981: John Podeschi, *Books on the Horse and Horsemanship: Riding, Hunting, Breeding and Racing, 1400–1941*, London, 1981.

Pointon, 1985: Marcia Pointon, *The Bonington Circle: English Watercolour and Anglo-French Landscape, 1790–1855*, Brighton, 1985.

Powell, 1987: Cecilia Powell, *Turner in the South: Rome, Naples, Florence*, New Haven, 1987.

Praz, 1971: Mario Praz, *Conversation Pieces*, University Park, Pennsylvania, 1971.

Pressly, 1979: Nancy L. Pressly, *The Fuseli Circle in Rome: Early Romantic Art of the 1770s*, exh. cat., Yale Center for British Art, New Haven, 1979.

Pressly, 1999: William L. Pressly, *The French Revolution as Blasphemy: Johan Zoffany's Paintings of the Massacre at Paris, August 10, 1792*, Berkeley, 1999.

Prown, 2002: Jules D. Prown, *Art as Evidence: Writing on Art and Material Culture*, New Haven, 2002.

Quinn, 1955: David Beers Quinn, *The Roanoke Voyages, 1584–1590*, London, 1955.

Quinn, 1975: David Beers Quinn, *The Last Voyage of Thomas Cavendish, 1591–1592*, Chicago, 1975.

Rajnai, 1982: Miklós Rajnai, ed., *John Sell Cotman, 1782–1842*, exh. cat., Victoria and Albert Museum, London; Whitworth Art Gallery, Manchester; and City of Bristol Museum and Art Gallery, 1982–83.

Rajnai and Allthorpe-Guyton, 1979: Miklós Rajnai and Majorie Allthorpe-Guyton, *John Sell Cotman, 1782–1842: Early Drawings (1798–1812) in the Norwich Castle Museum*, exh. cat., Norfolk Museums Service, Norfolk, 1979.

Rawlinson, 1908–13: W. G. Rawlinson, *The Engraved Work of J. M. W. Turner*, 2 vols., London, 1908, 1913.

Ray, 1976: Gordon Ray, *The Illustrator and the Book in England from 1790 to 1914*, New York, 1976.

Redford, 1994: Bruce Redford, ed., *The Letters of Samuel Johnson*, 5 vols., Princeton, 1992–94.

Reynolds, 1971: Graham Reynolds, *Nicholas Hilliard and Isaac Oliver*, London, 1971.

Reynolds, 1984: Graham Reynolds, *The Later Paintings and Drawings of John Constable*, New Haven, 1984.

Reynolds 1996: Graham Reynolds, *Early Paintings and Drawings of John Constable*, New Haven, 1996.

Reynolds, 1998: Graham Reynolds, *English Portrait Miniatures*, 2nd ed. rev., Cambridge, 1998.

Reynolds, *Discourses:* Sir Joshua Reynolds, *Discourses on Art*, Robert R. Wark, ed., 3rd ed. rev., London, 1997.

Rhyne, 1981, pt. 1: Charles S. Rhyne, "Constable Drawings and Watercolors in the Collections of Mr. and Mrs. Paul Mellon and the Yale Center for British Art: Part 1, Authentic Works," *Master Drawings* 19:2 (Summer 1981): 123–45, 189–205.

Rhyne, 1981, pt. 2: Charles S. Rhyne, "Constable Drawings and Watercolors in the Collections of Mr. and Mrs. Paul Mellon and the Yale Center for British Art: Part 2, Reattributed Works," *Master Drawings* 19:4 (Winter 1981): 391–425, 463–70.

Ribeiro, 1984: Aileen Ribeiro, *Dress in Eighteenth-Century Europe, 1715–1789*, London, 1984.

Ribeiro, 1989: Aileen Ribeiro, *A Visual History of Costume: The Eighteenth Century*, London, 1989.

Roberts, 1910: W. F. Roberts, *Wheatley, R.A.: His Life and Works*, London, 1910.

Roberts, 1995: Jane Roberts, *Views of Windsor: Watercolours by Thomas and Paul Sandby from the Collection of Her Majesty Queen Elizabeth II*, exh. cat., Royal Collection, London, 1995.

Robertson, 1985: Bruce Robertson, *The Art of Paul Sandby*, exh. cat., Yale Center for British Art, New Haven, 1985.

Robertson, 1987: (E.) Bruce Robertson, "Paul Sandby and the Early Development of English Watercolor," Ph.D. diss., Yale University, 2 vols., 1987.

Robinson, 1895: John Robert Robinson, *"Old Q": A Memoir of William Douglas, Fourth Duke of Queensbury K. T.*, London, 1895.

Robinson, 1958: M. S. Robinson, *Van de Velde Drawings: A Catalogue of Drawings in the National Maritime Museum Made by the Elder and the Younger Willem Van de Velde*, Cambridge, UK, 1958.

Robinson, 1982: Duncan Robinson, *William Morris, Edward Burne-Jones and the Kelmscott Chaucer*, London, 1982.

Robinson, 1990: M. S. Robinson, *Van de Velde: A Catalogue of the Paintings of the Elder and the Younger Willem van de Velde*, Greenwich, UK, 1990.

Rodner, 1997: William S. Rodner, *J. M. W. Turner: Romantic Painter of the Industrial Revolution*, Berkeley, Calif., 1997.

Rogers, 1993: Malcolm Rogers, *Master Drawings from the National Portrait Gallery*, exh. cat., National Portrait Gallery, London, 1993.

Rohatgi, 1997: Pauline Rohatgi, "Early Impressions of the Islands: James Forbes and James Wales in Bombay, 1766–95," in *Bombay to Mumbai: Changing Perspectives*, Mumbai, India, 1997.

Rosenthal, 1983: Michael Rosenthal, *Constable: The Painter and His Landscape*, New Haven, 1983.

Rosenthal, 1993: Michael Rosenthal, "Landscape as High Art," in *Glorious Nature: British Landscape Painting, 1750–1850*, exh. cat., Denver Art Museum, Denver, 1993.

Rosenthal, 1999: Michael Rosenthal, *The Art of Thomas Gainsborough: "A Little Business for the Eye,"* New Haven, 1999.

Roundell, 1974: James Roundell, *Thomas Shotter Boys, 1803–1874*, London, 1974.

Ruskin, *Works: The Works of John Ruskin*, E. T. Cook and Alexander Wedderburn, eds., 39 vols., London, 1903–12.

Saumarez Smith, 1993: Charles Saumarez Smith, *Eighteenth-Century Decoration: Design and the Domestic Interior in England*, London, 1993.

Schoenherr, 2005: Douglas E. Schoenherr, *British Drawings from the National Gallery of Canada*, Ottawa, 2005.

Shanes, 2000: Eric Shanes, "Identifying Turner's Chamonix Watercolours," *Burlington Magazine*, November 2000, pp. 687–94.

Shaw Sparrow, 1922: Walter Shaw Sparrow, *British Sporting Artists from Barlow to Herring*, London, 1922.

Shaw Sparrow, 1929: Walter Shaw Sparrow, *George Stubbs and Ben Marshall*, London, 1929.

Shaw Sparrow, 1933: Walter Shaw Sparrow, "British Art at the Royal Academy," *The Field*, 30 December 1933.

Shaw Sparrow, 1936: Walter Shaw Sparrow, "Our Earliest Sporting Artist, Francis Barlow," *Connoisseur*, July 1936, pp. 36–40.

Shirley, 1999: Rodney W Shirley, "A Map of the British Isles, 1513: An Early Example of Colour Map Printing," *Cartographica Helvetica* 20 (July 1999): 13–17.

Siltzer, 1979: Frank Siltzer, *Story of British Sporting Prints*, London, 1979.

Sim, 1984: Katharine Sim, *David Roberts, R.A., 1796–1864: A Biography*, London, 1984.

Sitwell, 1937: Sacheverell Sitwell, *Narrative Pictures: A Survey of English Genre and Its Painters*, London, 1937.

Skelton, 1978: R. A. Skelton, *County Atlases of the British Isles, 1579–1850*, Folkstone, Kent, 1978, no. 1.

Sloan, 1986: Kim Sloan, *Alexander and John Robert Cozens: The Poetry of Landscape*, New Haven, 1986.

Sloan, 2000: Kim Sloan, *"Noble Art": Amateur Artists and Drawing Masters, c. 1600–1800*, exh. cat., British Museum, London, 2000.

Smith et al, 2002: Greg Smith, Peter Bower, Anne Lyles, and Susan Morris, *Thomas Girtin: The Art of Watercolour*, exh. cat., Tate, London, 2002.

Snelgrove, 1981: Dudley Snelgrove, *British Sporting and Animal Prints, 1658–1874*, London, 1981.

Solkin, 1982: David Solkin, *Richard Wilson: The Landscape of Reaction*, exh. cat., Tate, London, 1982.

Solkin, 1993: David H. Solkin, *Painting for Money: The Visual Arts and the Public Sphere in Eighteenth-Century England*, New Haven, 1993.

Sotheby's, 1976: Sotheby's, *Catalogue of Important Eighteenth- and Nineteenth-Century Drawings and Watercolours*, 15 July 1976.

Sporting Magazine, various issues.

Stainton and White, 1987; Lindsay Stainton and Christopher White, *Drawing in England from Hilliard to Hogarth*, exh. cat., British Museum, London, and Yale Center for British Art, New Haven, 1987.

Staley, 1989: Allen Staley, *Benjamin West: American Painter at the English Court*, exh. cat., Baltimore Museum of Art, 1989.

STC: *A Short-title Catalogue of Books Printed in England, Scotland, and Ireland and of English Books Printed Abroad, 1475–1640*, 2nd ed., London, 1976–91.

Stephens, 1870: F. G. Stephens, *Catalogue of prints and drawings in the British Museum. Division I. Political and personal satires*, London, 1870–1954.

Stokes, 1929: Hugh Stokes, "John Frederick Lewis, R.A. (1805–1876)," *Walker's Quarterly* 28 (1929): n.p.

Story, 1892: Alfred Story, *The Life of John Linnell*, 2 vols., London, 1892.

Strickland, 1969: Walter George Strickland, *A Dictionary of Irish Artists*, Shannon, 1969.

Strong, 1983; Sir Roy Strong, *Artists of the Tudor Court: The Portrait Miniature Rediscovered, 1520–1620*, exh. cat., Victoria and Albert Museum, London, 1983.

Sumner and Smith, 2003: Ann Sumner and Greg Smith et al., *Thomas Jones (1742–1803): An Artist Rediscovered*, exh. cat., National Museum and Gallery of Wales, Cardiff; Whitworth Art Gallery, Manchester; and National Gallery, London, 2003.

Sunderland, 1970: John Sunderland, "John Hamilton Mortimer and Salvator Rosa," *Burlington Magazine*, August 1970, pp. 520–31.

Sunderland, 1977: John Sunderland, "Two Self-portraits by James Jeffreys?," *Burlington Magazine*, April 1977, pp. 279–80.

Sutton, 1977: Denys Sutton, "The Cunning Eye of Thomas Rowlandson," *Apollo*, April 1977, pp. 277–85.

Symmons, 1984: Sarah Symmons, *Flaxman and Europe: The Outline Illustrators and Their Influence*, New York, 1984.

Taft, 2001: Sarah Taft, "Steamboats," in Evelyn Joll, Martin Butlin, and Luke Hermann, eds., *The Oxford Companion to J. M. W. Turner*, Oxford, 2001.

Tattersall, 1974: Bruce Tattersall, *Stubbs & Wedgwood: Unique Alliance Between Artist and Potter*, exh. cat., Tate, London, 1974.

Tayler, 1971: Irene Tayler, *Blake's Illustrations to the Poems of Gray*, Princeton, 1971.

Taylor, 1963: Basil Taylor, "The Intimate English Portrait," *Apollo*, April 1963, p. 276.

Taylor, 1965: Basil Taylor, "Portraits of George Stubbs," *Apollo*, May 1965, supplement between pp. 422 & 423.

Taylor, 1971: Basil Taylor, *Stubbs*, London, 1971

Thicknesse, 1788: Philip Thicknesse, *A Sketch of the Life and Paintings of Thomas Gainsborough, Esq*, London, 1788.

Thornes, 1999: John E. Thornes, *John Constable's Skies: A Fusion of Art and Science*, Birmingham, 1999.

Thrower, 1984: Norman Thrower, ed., *Sir Francis Drake and the Famous Voyage, 1577–1580*, Berkeley, Calif., 1984.

Tindall, 2002: Gillian Tindall, *The Man Who Drew London: Wenceslaus Hollar in Reality and Imagination*, London, 2002.

Troubled Life, 2000: *The Troubled Life of Elizabeth Carnegie, Third Earl of Hopetoun*, Hopetoun House, Hopetoun, 2000.

Trumble, 2004: Angus Trumble, "Who Was Robert Burnard?," *Apollo*, September 2004, pp. 84–87.

Trumble and Wilcox, 2005: Angus Trumble and Scott Wilcox, "Object Lesson: Two Landscapes by Gainsborough," *Yale Alumni Magazine*, September/October 2005, p. 58.

Turner, 1840: Dawson Turner, *Outlines in Lithography from a Small Collection of Pictures: For Private Circulation*, Yarmouth, 1840.

Turner, *Correspondence: Collected Correspondence of J. M. W. Turner*, edited by John Gage, Oxford, 1980.

Twomey, 2006: Michael Twomey, "Middle English Translations of Medieval Encyclopedias," *Literature Compass* 3:3 (2006): 331–40.

Uglow, 1997: Jenny Uglow, *Hogarth: A Life and a World*, London, 1997.

Vaughan, 1996: Frank A. Vaughan, *Again to the Life of Eternity: William Blake's Illustrations to the Poems of Thomas Gray*, Selinsgrove, 1996.

Vaughan, *Blake*, 1999: William Vaughan, *William Blake*, London, 1999.

Vaughan, *British Painting*, 1999: William Vaughan, *British Painting: The Golden Age from Hogarth to Turner*, London, 1999.

Vaughan, 2002: William Vaughan, *Gainsborough*, London, 2002.

Vaughan et al., 2005: William Vaughan et al., *Samuel Palmer: Vision and Landscape*, exh. cat., British Museum, London, and Metropolitan Museum of Art, New York, 2005–06.

Venning, 2003: Barry Venning, *Turner*, London, 2003.

Vertue, 1745; George Vertue, *A description of the works of the ingenious delineator and engraver Wenceslaus Hollar, disposed into classes of different sorts; with some account of His life*, London, 1745.

Vertue, *Note Books*: George Vertue, *Note Books*, in *Walpole Society*, 6 vols., London, 1930–47.

Viscomi, 1993: Joseph Viscomi, *Blake and the Idea of the Book*, Princeton, 1993.

Walker, 1972: Stella A. Walker, *Sporting Art, England, 1700–1900*, New York, 1972.

Walker, 1986: John Walker, "Hogarth's Painting *The Beggar's Opera*: Cast and Audience at the First Night," in John Wilmerding, ed., *Essays in Honor of Paul Mellon, Collector and Benefactor*, Washington, D.C., 1986.

Walpole, *Anecdotes of Painting*: Horace Walpole, *Anecdotes of Painting in England*, 5 vols., Strawberry Hill, 1780.

Warner, 2001: Malcolm Warner, *The Paul Mellon Bequest: Treasures of a Lifetime*, exh. cat., Yale Center for British Art, New Haven, 2001.

Warner and Blake, 2004: Malcolm Warner and Robin Blake, *Stubbs and the Horse*, exh. cat., National Gallery, London; Walters Art Museum, Baltimore; Kimbell Art Museum, Fort Worth, Yale Center for British Art, New Haven, 2004.

Warrell, 2003: Ian Warrell, *Turner and Venice*, exh. cat., Tate, London, 2003.

Waterhouse, 1958: Ellis K. Waterhouse, *Gainsborough*, London, 1958.

Waterhouse, 1994: Ellis K. Waterhouse, *Painting in Britain, 1530–1790*, 5th ed., rev. and with an introduction by Michael Kitson, London, 1994.

Webster, 1965: Mary Webster, *Francis Wheatley, R.A. . . . : An Exhibtion Arranged by the Paul Mellon Foundation for British Art*, exh. cat., Aldeburgh Festival of Music and Arts and the City Art Gallery, Leeds, 1965.

Webster, 1970: Mary Webster, *Francis Wheatley*, London, 1970.

Webster, 1977: Mary Webster, *Johan Zoffany, 1733–1810*, exh. cat., National Portrait Gallery, London, 1976.

Weeks, 2004: Emily Weeks, "The 'Reality Effect': The Orientalist Paintings of John Frederick Lewis (1805–1876)," Ph.D. diss., Yale University, 2004.

Wendorf, 1996: Richard Wendorf, *Sir Joshua Reynolds: The Painter in Society*, Cambridge, 1996.

Whinney, 1971: Margaret Whinney, *English Sculpture, 1720–1830*, exh. cat., Victoria and Albert Museum, London, 1971.

Whinney and Millar, 1957: Margaret Whinney and Oliver Millar, *English Art, 1625–1714*, Oxford, 1957.

White, 1977: Christopher White, *English Landscape, 1630–1850: Drawings, Prints and Books from the Paul Mellon Collection*, exh. cat., Yale Center for British Art, New Haven, 1977.

Whitley, 1928: William Whitley, *Artists and Their Friends in England, 1700–1799*, 2 vols., London, 1928.

Wickett and Duvall, 1971: William Wickett and Nicholas Duval, *The Farmer's Boy: The Story of Suffolk Poet Robert Bloomfield, His Life and Poems, 1766–1823*, Lavenham, Suffolk, 1971.

Wilcox, 1997: Timothy Wilcox, *Francis Towne*, exh. cat., Tate, London, and Leeds City Art Gallery, 1997.

Wilcox and Titterington, 1984: Timothy Wilcox and Christopher Titterington, *William Turner of Oxford (1789–1862)*, exh. cat., Oxfordshire County Museum, Woodstock; Bankside Gallery, London; and Museum and Art Gallery, Bolton, 1984–85.

Wilcox et al., 2001: Scott Wilcox et al., *The Line of Beauty: British Drawings and Watercolors of the Eighteenth Century*, exh. cat., Yale Center for British Art, New Haven, 2001.

Wilenski, 1960: R. H. Wilenski, *Flemish Painters, 1430–1830*, New York, 1960.

Williamson, 1931: G. C. Williamson, *English Conversation Pictures of the Eighteenth and Early Nineteenth Centuries*, London, 1931.

Williamson and Engleheart, 1902: G. C. Williamson and Henry L. D. Engleheart, *George Engleheart, 1750–1829: Miniaturist to George III*, London, 1902.

Wilton, 1977: Andrew Wilton, *British Watercolours, 1750–1850*, Oxford, 1977.

Wilton, 1986: Andrew Wilton, "Rediscovered Turner Sketchbook," *Turner Studies* 6:2 (Winter 1986): 9–23.

Wilton, 2001: Andrew Wilton, "Sketchbooks," in Evelyn Joll, Martin Butlin, and Luke Hermann, eds., *The Oxford Companion to J. M. W. Turner*, Oxford, 2001.

Wilton, *Cozens*, 1980: Andrew Wilton, *The Art of Alexander and John Robert Cozens*, exh. cat., Yale Center for British Art, New Haven, 1980.

Wilton, *Pars*, 1979: Andrew Wilton, *William Pars: Journey Through the Alps*, Zurich, 1979.

Wilton, *Turner*, 1979: Andrew Wilton, *J. M. W. Turner: His Art and Life*, New York, 1979.

Wilton, *Turner*, 1980: Andrew Wilton, *Turner and the Sublime*, exh. cat., Art Gallery of Ontario, Toronto and Yale Center for British Art, New Haven, 1980.

Wimsatt, 1965: William K. Wimsatt, *The Portraits of Alexander Pope*, New Haven, 1965.

Wood, 1994: Frances Wood, "Britain's First View of China: The Macartney Embassy, 1792–1794," *RSA Journal* 142:5447 (March 1994): 59–68.

Woodbridge, 1970: Kenneth Woodbridge, *Landscape and Antiquity: Aspects of English Culture at Stourhead, 1718 to 1838*, Oxford, 1970.

Woodward, 1951: John Woodward, *Tudor and Stuart Drawings*, London, 1951.

Wraxall, 1836: N. W. Wraxall, *Posthumous Memoirs of His Own Time*, 2 vols., London, 1836.

YCBA, 1977: *Selected Paintings, Drawings, and Books*, with a foreword by Paul Mellon, New Haven, 1977.

Index

A NOTE TO THE READER
Catalogued works are illustrated in the Gallery of Works section, identified by cat. number, and by thumbnails in the catalogue entries. Pages on which other illustrations appear are indicated in the Index by italics.

Abbey, Major John Roland, collection of books, 4, 46, 61–62, 66–68, 70 n.11, n.12, n.14, 302, 307–8
The Abbey Mill, Knaresborough (Girtin), cat. 85, 282
Abbott, Lemuel Francis, 279
Abington, James, 255
Abington, Mrs. John (Frances "Fanny" Barton), 255; *Mrs. Abington as Miss Pru* (Reynolds), cat. 31, 28, 30, 255
An Academy by Lamplight (Wright of Derby), cat. 41, 259–60
Account of the Last Voyage of Thomas Cavendish, cat. 122, 66, 300
Adam, Robert, 51, 68
Adams, C. K., 45
Adams, Sir Thomas, 252
Adelaide, Queen, 293
Agar-Ellis, George James Welbore, 281; *George James Welbore Agar-Ellis* (Lawrence), cat. 83, 281
Agasse, Jacques-Laurent, 292
Albert, Prince of Saxe-Coburg and Gotha, consort of Queen Victoria, 293
Alexander, William, 278–79; *City of Lin Tsin, Shantung, with a View of the Grand Canal*, cat. 80, 279
Alexander Pope (Roubiliac), cat. 15, 10, 247, 248
Alison, Archibald, 273
Alken, Henry Thomas, 58, 303; *The Beaufort Hunt*, 56, 58, 70 n.4; *The First Steeple Chase on Record*, cat. 129, 303
"All Human Forms identified even Tree Metal Earth & Stone" (Blake), cat. 76, 55, 276–77
Americana, 4, 57, 61–62, 64, 66–68, 71 n.28; *see also* Virginiana
Ambleside (Towne), cat. 44, 261
"And there was heard a great lamenting in Beulah" (Blake), cat. 74, 276–77
Anecdotes of Painting in England (Walpole), cat. 132, 240, 243, 244, 245, 246, 304
Anne of Denmark, Queen, 241
The Arbra Sacra on the Banks of Lake Nemi (Wilson), cat. 21, 251
Argyll, 2nd Duke of (John Campbell), 247
The Artist and His Family (Buck), cat. 77, 277
The Artist and His Family (West), cat. 43, 261
The Art of Illumination and Missal Painting (Humphreys), cat. 147, 310
Arundel, 14th Earl of (Thomas Howard), 241–42
Associated Artists in Water Colours, 290
Athlone, 1st Earl of (Alexander Cambridge), 297
Atlas of the Counties of England and Wales (Saxton), cat. 118, 64, 298–99

An Audience Watching a Play at Drury Lane (Rowlandson), cat. 64, 272–73
Audubon, John, *Birds of America*, 58, 70 n.4, 303
Auerbach, Erna, 240, 241
Augustus I, King, 247
A. W. Mellon Educational and Charitable Trust, 6–7

Babb, James T., 59–62, 64, 68, 78 n.2, n.8, n.13
Baddeley, Robert, 255
Badeslade, Thomas, *A Compleat Sett of Mapps of England and Wales*, cat. 138, 307, *138*
Balugani, Luigi, 68, 303; *Carthamus tinctorius (Safflower)*, 69
Ballantine, James, 306
Banks, Sir Joseph, 255, 258, 307
Banks, Sarah Sophia, 307; *Sir Joseph Banks's Fishery Book*, cat. 139, 307
Bannister, Jack, 272, 273
Barclay, Alexander, 309
The Bard. A Pindaric Ode. "And weave with bloody hands the tissue of thy line" (Blake), cat. 71, 275
Barker, Thomas, 278
Barlow, Francis, 244–46; *David Slaying the Lion*, 245; *Hare Hunting*, cat. 10, 245; *Man Hunting with a Pointed Staff and a Hound*, cat. 9, 244–45; *Otter Hunting*, 245
Barnes, Edward Larrabee, 16
Barrett, George, Junior, 280
Barrett, George, Senior, 261, 265, 271
Barry, James, 269
Basire, James, 274
Baskett, John, *11*, 35
Bayard, Jane, 291
Bay Scene in Moonlight (John "Warwick" Smith), cat. 58, 269
Beaumont, Sir George, 265, 291
Beckett, R. B., 46
Beckford, William, 251, 270–71, 275
Bedford, Duchess of (Georgiana Gordon), 293
Bedford, 6th Duke of (John Russell), 293
Beechey, Sir William, 45
The Beggar's Opera (Hogarth), cat. 14, 247
Bell, John, 277
Bell, John Zephaniah, 292; *David Ogilvy, 9th Earl of Airlie, and His Daughter*, 292
Benlowe, Edward, *Theophila*, 244
Bennett, Charles Augustus. *See* Tankerville, 5th Earl of
Berenson, Bernard, 6
Berners, Dame Juliana, 302; *The Boke of St. Albans (The Book of Hawking, Hunting, and the Blasing of Arms)*, cat. 127, 301–2, 309

Bevan, Robert, 32
Bickerstaff, Isaac, 255, 289
Bicknell, Louisa, 287
Biddle, Moncure, 59, 275
Bigges, Walter, 299
Binyon, Laurence, 289
Birch, William, *The City of Philadelphia*, 68
Blaeu, Johann, *Atlas Major*, 64
Blake, Catherine, 275, 277
Blake, Robert, 275
Blake, William, 4, 51, 57–59, 271, 274–77, 291, 295; "All Human Forms identified even Tree Metal Earth & Stone," cat. 76, 55, 276–77; *All Religions Are One*, 275; *America: A Prophecy*, 274; "And there was heard a great lamenting in Beulah," cat. 74, 276–77; *The Bard. A Pindaric Ode. "And weave with bloody hands the tissue of thy line,"* cat. 71, 275; *The Book of Job*, 58, 274, 291; *The Book of Los*, 274; *The Book of Thel*, 59; *Elegy Written in a Country Churchyard. "Oft did the harvest to their sickle yield,"* cat. 72, 275–76; *Europe: A Prophecy*, 59, 274; *The First Book of Urizen*, 272, 274; *The Horse*, cat. 73, 276; illustrations to poems of Thomas Gray, cats. 70–72, 275; *Illustrations to Robert Thornton's Pastorals of Virgil*, 295; *Jerusalem*, cats. 74–76, 59, *60*, 61, 274, 276–77; *Milton a Poem*, 274; *The Progress of Poesy. A Pindaric Ode. "On Cythera's day,"* cat. 70, 275; *Songs of Experience*, 275; *Songs of Innocence*, 58–59, 274–75; *Songs of Innocence and of Experience*, cat. 69, 59, 275; "Then the Divine hand found the Two limits, Satan and Adam," cat. 75, 276–77; *There Is No Natural Religion*, 58, 275
Bloemen, Jan Frans van (l'Orizzonte), 250
Blome, Richard, *Gentleman's Recreation*, 244–46
Bloomfield, Robert, *The Farmer Boy*, 291
Blunt, Sir Charles William, 271
Blunt, Elizabeth, 271
Boazio, Baptista, 299; *The Famouse West Indian voyadge*, cat. 121, 299
Bodmer, Karl, atlas to *Reise in das Innere Nord-America* (Maximilian von Wied-Neuwied), 62
Boke of St. Albans (Berners), cat. 127, 301, 302, 309
Bolingbroke, 1st Viscount (Henry St. John), 248
Bolingbroke, 2nd Viscount (Frederick St. John), 253
Bollingen Foundation, 5, 7, 47, 58–59, 70 n.5

Bonasone, Giulio, 295

Bonington, Richard Parkes, 47, 51, 292–94; *Bonington* (Shirley), 46; *Grand Canal, Venice*, cat. 108, 293; *Shipping in an Estuary, Probably near Quilleboeuf*, cat. 107, 292–93

Bonnard, Paul, 66

The Book of Hawking, Hunting, and the Blasing of Arms. See *Boke of St Albans*

Booth, Sophia, 286

Borst, Kenneth, 20, *21*, 22

Boswell, James, 44, 59, 70n.8, 255; *Boswell's London Journal*, 59

botanical books, 4, 59–61, 66, 68, 240, 303–4

Boydell, John, 261, 266

Boydell, Messrs., printers, 281

Boyle, Richard. See Burlington, 1st Earl of

Boys, Thomas Shotter, 294; *L'Institut de France, Paris*, cat. 110, 294; *Original Views of London as It Is*, 294; *Picturesque Architecture in Paris, Ghent, Rouen, etc.*, 294

Brand, William, 307

Brandon, Robert, 240

Brant, Sebastian, 309; *Shyp of Folys*, cat. 145, 309

Brenchley, John, 269

Brewster, Kingman, 15–16, 20, *21*, 24n.3

Brick House, Upperville, Va., 8, *9*, 10, 16, 36, 61, 66; book collection in, 61–63, *66*

A Briefe and true report of the new found land of Virginia (Hariot), cat. 123, 240, 299–300

Bristol, 4th Earl of (Frederick Augustus Hervey), 270

Brixen, Bishop of, 64

Brooke, Lord (Francis Greville), 249

Brookes, Rupert, *The Old Vicarage, Grantchester*, 4

Brooking, Charles, 47

Brown, Ford Madox, 51

Brown, John, 267–68; *The Geographers*, cat. 56, 268; *Letters on the Italian Opera*, 268

Brown, Lancelot "Capability," 249, 259

Brown, Ric, 16

Browne, George and Mary, 267; *The Browne Family* (Wheatley), cat. 53, 266–67

The Browne Family (Wheatley), cat. 53, 266–67

Bruce, Andrew Douglas. See Elgin, Lord

Bruce, David, 5

Bruce, James, 68, 303

Bry, Theodor de, 300; *America*, 240; *A Briefe and true report of the new found land of Virginia* (Hariot), cat. 123, 240, 299–300

Bryce, Hugh, 309

Buck, Adam, 277; *The Artist and His Family*, cat. 77, 277

Buck, Samuel, 284

Buckeridge, Bainbrigg, 242–43; *Essay Towards an English School of Painting*, 245

Buckingham, 2nd Duke of (George Villiers), 245

Burdett, Peter Perez, 259

Burghley, 2nd Baron (Robert Cecil), 240

Burke, Edmund, 251

Burlington, 1st Earl of (Richard Boyle), 243

Burnard, Elizabeth Stodden, 291

Burnard, Elizabeth Westlake, 291

Burnard, Jane Chapman, 291

Burnard, Richard Parnell, 291

Burnard, Robert, 291–92; *John Gubbins Newton and His Sister, Mary Newton*, cat. 106, 292

Burne-Jones, Edward, *The Works of Geoffrey Chaucer*, cat. 148, 68, 310–11

Burnett, James. See Monboddo, Lord

Burney, Charles, 277

Burney, Edward Francis, 277–78; *The Triumph of Music* (*The Glee Club*), cat. 78, 277–78

Burton, John, *Essay Towards a Complete New System of Midwifery*, 251, 254

Butlin, Martin, *The Paintings of J. M. W. Turner*, 51

Butts, Thomas, 274

Byrne, William, 265

Byron, 6th Baron (George Gordon Noel Byron), *Childe Harold's Pilgrimage*, 285

Cabot, John, 299

Cadell, Robert, 285

Callcott, Augustus Wall, *The Pool of London*, 285

Cambridge, 1st Duke of (Adolphus Frederick, Prince), 293

Cambridge, 2nd Duke of (George, Prince), 293–94

Cambridge, Alexander. See Athlone, 1st Earl of

camera obscura, 256

Campbell, John. See Argyll, 2nd Duke of

Campbell, Joseph, 5

Canal, Giovanni Antonio (Canaletto), 248–49, 282; *The City of Westminster from near the York Water Gate*, cat. 17, 249; *Warwick Castle*, cat. 16, 249; *Warwick Castle: the South Front*, 249

Cannadine, David, 6

Canterbury Tales (Caxton, 1483), cat. 144, 309

capriccio, 249

Carter, Beverly, 10

Carter, John, 59–61

Carter, Thomas, 247

Carter-Wood, Florence, 297

cartography. See maps

Castelreagh, Viscount (Frederick William Robert Stewart), 294–95; *A Frank Encampment in the Desert of Mount Sinai* (Lewis), cat. 111, 291, 295

Catherine I, Czarina, 247, 261

Cavendish, Georgiana. See Devonshire, Duchess of

Cavendish, Lord John, 249

Cavendish, Sir Thomas, 300; *Account of the Last Voyage of Thomas Cavendish*, cat. 122, 66, 300

Caxton, William, 64, 309; *Canterbury Tales* (1476), 309; *Canterbury Tales* (1483), cat. 144, 309; *Myrrour of the Worlde*, cat. 143, 302, 309; *Recuyell of the Historyes of Troye*, 309

Cecil, Robert. See Burghley, 2nd Baron

Celebration on the Thames near Whitehall (Van de Velde), cat. 8, 244

Cézanne, Paul, *Boy in a Red Waistcoat*, 43

Chambers, Sir William, 258, 259, 274

Chandler, Richard, *Ilonian Antiquities*, 264

The Channel Sketchbook (J. M. W. Turner), cat. 94, 35, 36, 286

Chardin, Jean-Siméon, 266

Charles I, King, 32, 241–42

Charles II, King, 242–43, 245

Charles Stuart, 3rd Duke of Richmond and 6th Duke of Lennox (Samuel Cooper), cat. 6, 243

Charlotte, Queen, 1, 252, 258, 278, 293; portrait (Lawrence), 280

Chaucer, Geoffrey, 260; *The Canterbury Tales*, 269, 261; *The Canterbury Tales* (1476), 309; *The Canterbury Tales* (1483), cat. 144, 309; *The Works of Geoffrey Chaucer*, cat. 148, 68, 310–11

Cheek, Leslie, 5

Cheere, Henry, 247, 259

Cholmeley family, 289

chromolithography, 294, 297, 310

Churchill, Sir Winston, 297

City of Lin Tsin, Shantung, with a View of the Grand Canal (Alexander), cat. 80, 279

The City of Westminster from near the York Water Gate (Canaletto), cat. 17, 249

Claude (Lorrain). See Lorrain, Claude

The Claudean Aqueduct and Colosseum (Jones), cat. 48, 263–64

Clement VII, Pope, 250

Clifford, Timothy, 269

Cloud Study (Constable), cat. 98, 287–88

Collins, James, *Hare Hunting*, after Barlow, 245

Collins Baker, C. H., 44–45

Colonel James Stevenson (Smart), cat. 45, 262

color printing, 298, 302–3

Colvin, Howard, *A Biographical Dictionary of British Architects*, 51

Columbus, Christopher, 298

A Comparative Anatomical Exposition... (Stubbs), cats. 28–30, 254

A Compleat Sett of Mapps of England and Wales (Badeslade), cat. 138, 307

Congreve, William, *Love for Love*, 255

The Connoisseurs (Rowlandson), cat. 66, 273

Conolly, Louisa, 265

Conolly, Thomas, 265; *Tom Conolly of Castletown Hunting with His Friends* (Healy), cat. 50, 265

Conolly, William, 265

Constable, John, 47, 250, 270, 279, 283, 286–89, 292, 297; *Cloud Study*, cat. 98, 287–88; *East Bergholt Church*, cat. 96, 287; *Fulham Church from Across the River*, cat. 97, 287; *Golding Constable's House, East Bergholt*, cat. 95, 287; *Hadleigh Castle, The Mouth of the Thames—Morning After a Stormy Night*, cat. 100, 288–89; *Hampstead Heath, with a Bonfire*, cat. 99, 288; *The Hay Wain*, 286, 288; *The Later Paintings and Drawings of John Constable* (Reynolds), 51; letter to John Thomas Smith, cat. 136, 305–6; *Sir Richard Steele's Cottage, Hampstead*, cat. 101, 289; *Stratford Mill, "the Young Waltonians,"* 34, 35, 288; *The White Horse*, 288

Constable, Lionel Bicknell, 306

Constable, Maria, 287–89

Constable, W. G., 45, 46

Cooper, A., 307; *Journal of a Tour Down the Wye*, cat. 140, 307

Cooper, Austin, 307

Cooper, Samuel, 242–43; *Charles Stuart, 3rd Duke of Richmond and 6th Duke of Lennox*, cat. 6, 243

Cooper, Sidney, 303

Cook, Captain James, 258

Cooke, George, 294

Cooke, W. B., 284

Cormack, Malcolm, 32, 35

Cornforth, John, *Early Georgian Interiors*, 51

Cosway, Richard, 262–63, 271; *Elizabeth, Countess of Hopetoun*, cat. 46, 263; *James Hope, 3rd Earl of Hopetoun*, cat. 47, 263

Cotman, John Sell, 289; *In Rokeby Park*, cat. 102, 289

Courtney, William, 251

Coxe, Reverend William, 308; *Historical Tour Through Monmouthshire*, cat. 142, 308

Cozens, Alexander, 251, 270; *Mountainous Landscape*, cat. 22, 251; *The Various Species of Landscape Composition, in Nature*, 251

Cozens, John Robert, 251, 263, 270–71, 282; *Galleria di Sopra, Albano*, cat. 60, 270; *The Lake of Albano and Castel Gandolfo*, cat. 61, 271

Craft, William, 254

The craft of venery (Twiti), cat. 125, 67, 301–2

The Creation of the Heavens (Flaxman), cat. 63, 272

Critz, John de, the elder, 241

Crowe, William, 242

Crown, Patricia, 277

Cruikshank, Isaac Robert, *Going to a Fight*, 67

Cumberland, Duke of (Ernest Augustus; later King of Hanover), 294

Cumberland, Duke of (William Augustus), 255

Cumberland, George, 277

Cuyp, Aelbert, 285; *Maas at Dordrecht*, 285

Dadd, Richard, 296–97; *Death of Abimelech at Thebez*, cat. 115, 296–97; *The Flight Out of Egypt*, 297

Dale, Chester, 5

Danby, Francis, 306

Daniel, Sir Augustus, 45

Daniels, Stephen, 284

Darlington, 3rd Earl of (William Henry Vane), 279

Dartmouth, 2nd Earl of (William Legge), 250–51

Darwin, Erasmus, 259; *The Botanic Garden*, 303

David, Jacques-Louis, 292; *Oath of the Horatii*, 297

Day, Alexander, 269

Day, Richard, 10

Dayes, Edward, 278, 282; *Queen Square, London*, cat. 79, 278

Death of Abimelech at Thebez (Dadd), cat. 115, 296–97

Delacroix, Eugène, 292

Deleram, Francis, "Frances, Duchess of Richmond," 63

Derby, 11th Earl of (Edward Stanley), 251

Derby, 13th Earl of (Edward Smith-Stanley), 241

Destruction of Jerusalem by Titus (Roberts), cat. 137, 68, 306

Devereux, Robert. *See* Essex, 2nd Earl of

Devis, Arthur, 46, 249–50; *Mr. and Mrs. Hill*, cat. 18, 249–50

Devonshire, Duchess of (Georgiana Cavendish), 273; *Georgiana, Duchess of Devonshire, Her Sister Harriet, Viscountess Duncannon and a Musician* (Rowlandson), cat. 65, 273

Dickens, Charles, 293,

Divers voyages touching the discouerie of America (Hakluyt), cat. 119, 299

Donati, Giovanni Battista, 291

Donati's Comet (William Turner of Oxford), cat. 104, 290–91

Dort, or Dordrecht, the Dort Packet-boat from Rotterdam Becalmed (J. M. W. Turner), cat. 90, 30, 33, 284–85

Douglas, William. *See* Queensbury, 4th Duke of

Drake, Sir Francis, 299–300; *A True Description of the Naval Expedition of Francis Drake*, cat. 120, 66, 202–203, 299

drawing manuals, 67, 305

drawing masters, 251, 255, 267, 279, 282, 289, 292, 295

drawing schools, 261–64, 265

drawings, 8, 242–45, 251, 255–58, 261, 264, 268–69, 286; architectural, 68, 267; botanical, 4, 240, 303–4

Drummond, Andrew, 259; *The Drummond Family*, cat. 39, 259

Drummond, John and Charlotte Beauclerk, 259; *The Drummond Family*, cat. 39, 259

The Drummond Family (Zoffany), cat. 39, 259

Dublin Society of Artists, 264

Ducannon, Viscountess (Harriet; later Countess of Bessborough), *Georgiana, Duchess of Devonshire, Her Sister Harriet, Viscountess Duncannon and a Musician* (Rowlandson), cat. 65, 273

Dudley, Robert, *Arcano de Mare*, 64

Dugdale, Sir William, 241

Dughet, Gaspard, 261

Duke collection, 8

Dunlop, James, 306

Dunlop, Nora G., 306

Dürer, Albrecht, 240, 295, 309; designs on celestial globe, 64

Duthie, Alexander, 291

Duveen, Denis I., 59

Dyce, William, *Pegwell Bay*, 291

Dyck, Sir Anthony van, 30, 51, 247–48, 259, 267, 281

Dyer, John, *The Fleece*, 284

Eagle, A Celebrated Stallion (Ward), cat. 84, 281

East Bergholt Church (Constable), cat. 96, 287

Edward I, King, 275

Edward II, King, 301

Edward, Prince of Wales, 297

Edwards, Edward, 269

Edwards, Richard, 275

Egerton, Judy, 286, 292

Egg, Augustus Leopold, 296

Eisenhower, Dwight D., President, 5

Elegy Written in a Country Churchyard (Blake), cat. 72, 275–76

Elements of the Graphic Arts, sequel to (Robertson), cat. 135, 305

Elgin, Lord (Andrew Douglas Alexander Thomas Bruce), 68

Elizabeth I, Queen, 240–41, 298–300; portrait (Hilliard), 240; portrait (Hogenberg), cat. 118, 64, 298–99

Elizabeth II, Queen, 5, 297

Elizabeth, Countess of Hopetoun (Cosway), cat. 46, 263

Elizabeth, Princess (Elizabeth Stuart), 241; *Portrait of a Lady* (Hilliard), cat. 2, 241; portrait (Oliver), 241

Engleheart, George, 262, 271; *A Lady of the Blunt Family*, cat. 62, 271

An Epitome of Painting (Luttrell), cat. 133, 67–68, 305

Erskine, David, 267

Essex, 2nd Earl of (Robert Devereux), 241; *Robert Devereux, 2nd Earl of Essex* (Oliver), cat. 3, 240–41

Etty, William, 46

Evelyn, John, 244, 305; *Sculptura*, 305

The Exhibition Stare-case, Somerset House (Rowlandson), cat. 68, 27, 274

extra-illustrated books, 304, 306

Faber, John II, 245

The Famouse West Indian voyadge (Boazio), cat. 121, 299

fancy picture, 255

Fane, Mildmay. *See* Westmorland, 2nd Earl of

Fairbrother, Louisa, 294

Faithorne, William, 244

Farington, Joseph, 250, 262, 282, 285, 290, 306

Farr, Dennis, 46

Farren, Elizabeth, 280

Favourites, the Property of H.R.H. Prince George of Cambridge (Landseer), cat. 109, 36, 293–94

Fawkes, Walter Ramsden, 283–85

Fenton, Lavinia, 247

Ferdinand II, Holy Roman Emperor, 241, 242

Ferrières, Henri de, 301; *Le Liure du Roy Modus et de la Reine Racio*, cat. 126, 301; *Le Livre du Roy Modus et de la Royne Racio*, cat. 124, 67, 301

The First Steeple Chase on Record (Alken), cat. 129, 303

Fleming, James, 247

Fisher, Archdeacon John, 287–89

Edward II, King, 301

Edward, Prince of Wales, 297

Edwards, Edward, 269

Edwards, Richard, 275

Egerton, Judy, 286, 292

Fitzwilliam, 7th Viscount (Richard Fitzwilliam), 266

Flaxman, John, 271–72, 275–76, 306; *The Apotheosis of Homer*, 271; *The Creation of the Heavens*, cat. 63, 272; *Enoch Raised to Heaven*, 272

Foley, 2nd Baron (Thomas Foley), 253

Forbes, Elizabeth, 303

Forbes, James, 303; *A Voyage from England to Bombay*, cat. 130, 303; *Oriental Memoirs*, 303

Ford, Henry, 2

Forrester, Gillian, 259

Fox, Charles James, 253, 273

Francia, Louis, 292–93

A Frank Encampment in the Desert of Mount Sinai, 1842 (Lewis), cat. 111, 291, 295

Frankl, Gerald, *Portrait of Basil Taylor*, 6

Free Society of Artists, 249, 261–62, 271

Friedrich, Caspar David, 269

Frith, William Powell, 293, 296

Froeberg, Kenneth, 13, 20, 21, 22–24, 25

Frye, Thomas, 264

Fulham Church from Across the River (Constable), cat. 97, 287

Fuseli, Henry, 268, 293

Gainsborough, Thomas, 30, 46, 51, 257–58, 259, 262, 286, 297; *The Gravenor Family*, cat. 35, 257; *Harvest Wagon*, 257; *Landscape with Cattle*, cat. 37, 257–58; *Mary, Countess Howe*, 257; *Mr. and Mrs. Andrews*, 257; *Mrs. Richard Brinsley Sheridan*, 257; *Wooded Landscape with Castle*, cat. 38, 258; *A Woodland Pool with Rocks and Plants*, cat. 36, 257

Galleria di Sopra, Albano (J. R. Cozens), cat. 60, 270

Gamble, Ellis, 247

Gannon, William, 58–62

Gardner, Daniel, 45

Garlick, Kenneth, 46

Garrick, David, 248, 255, 258

Gay, John, *The Beggar's Opera*, 247

The Geographers (Brown), cat. 56, 268

Geographie opus nouissima (Ptolemy), compiled by Waldseemüller, cat. 117, 298

George I, King, 294, 307

George III, King, 63, 255, 258, 265, 271, 273, 293

George, Prince of Cambridge, 293

George, Prince of Wales, 263, 271, 279

George James Welbore Agar-Ellis, later 1st Lord Dover (Lawrence), cat. 83, 281

Georgiana, Duchess of Devonshire, Her Sister Harriet, Viscountess Duncannon and a Musician (Rowlandson), cat. 65, 273

Gheeraerts, Marcus, the younger, 241

Gheeraerts, Sara, 241

Gibson, Francis, 289

Gilpin, Sawrey, 265, 268, 281

Gilpin, Reverend William, 261, 268, 305; *Hints to form the taste & regulate ye judgment in sketching Landscape*, cat. 134, 305; *Observations, Relative Chiefly to Picturesque Beauty*, 262; *Three Essays*, 305

Giller, W., engraving after Landseer, 294

Girtin, Thomas, 255, 267, 270, 278, 282, 293; *The Abbey Mill, Knaresborough*, cat. 85, 282; *Bolton Bridge*, 282

Golding Constable's House, East Bergholt (Constable), cat. 95, 287

Goldsmith, Oliver, 255

Gordon, Duchess of (Jane Gordon), 273

Gordon, 5th Duke of (George Gordon), 273

Gordon, George. *See* Gordon, 5th Duke of

Gordon, Georgiana. *See* Bedford, Duchess of

Gordon, Jane. *See* Gordon, Duchess of

Gorges, Tristram, 300

Gossouin of Metz, *L'Image du monde*, 309

Grafton, 2nd Duke of (Charles Fitzroy), 256

Grafton, 3rd Duke of (Augustus Henry Fitzroy), 256

Graham, Richard, 242

Grand Canal, Venice (Bonington), cat. 108, 293

Grand Tour, 248–50, 256, 258, 263, 270, 271

Granger, James, 304; Grangerized books, 304

Grasse, Admiral François de, 63

Gravelot, Hubert-François, 257–58

Gravenor, John and Anne, 257; *The Gravenor Family* (Gainsborough), cat. 35, 257

The Gravenor Family (Gainsborough), cat. 35, 257

Gray, Hannah, 22

Gray, Thomas, poems illustrated by Blake, cats. 70–72, 275

Green, James, 280

Green, Valentine, 266

Gresse, John Alexander, 280

Greville, Francis. *See* Brooke, Lord

Greville, George. *See* Warwick, 2nd Earl of

Gribelin, Simon, 244

Grolier Club, New York, *Fifty-five Books Printed Before 1525*, 64, 68, 309

Gros, Antoine-Jean, 292–93

Guinness, Desmond, 264

Hadfield, Maria, 263

Hadleigh Castle, The Mouth of the Thames—Morning After a Stormy Night (Constable), cat. 100, 288–89

Haghe, Louis, 306

Hake, Henry, 45

Hakewill, James, *Picturesque Tour of Italy*, 284

Hakluyt, Richard, 240, 299–300; *Divers voyages touching the discouerie of America*, cat. 119, 299

Halifax, Earl of, 5, 253

Hamilton, Gavin, 258

Hamilton, Hugh Douglas, 264

Hamilton, James, 285

Hampstead Heath, with a Bonfire (Constable), cat. 99, 288

Handel, George Frederick, 247, 248

Harbledown, a Village near Canterbury (Skelton), cat. 42, 260–61

Hardie, Martin, 8, 46

Hare Hunting (Barlow), cat. 10, 245

Hariot, Thomas, 299–300; *Briefe and True Report of the New Found Land of Virginia*, cat. 123, 240, 299–300

Harley, Edward. *See* Oxford, 2nd Earl of

Harris, Eileen, *The Genius of Robert Adam*, 51

Hastings, 2nd Baron (Edward Hastings), 309

Hastings, Edward. *See* Hastings, 2nd Baron

Hastings, Warren, 258

The Harvest Moon (Palmer), cat. 114, *ii*, 296

Harvey, George, *Harvey's Scenes of the Primitive Forest*, 62

Haydon, Benjamin Robert, 291, 293

Hayley, William, 271, 274–76; *Ballads*, illustrated by Blake, 276

Hayman, Francis, 247, 257

Hazlitt, William, 263, 271

Healy, Robert, 264–65; *Tom Conolly of Castletown Hunting with His Friends*, cat. 50, *viii*, 265

Healy, William, 264

Hearne, Thomas, 262, 265; *A View on the Island of Antigua*, cat. 51, 265

Helmingham Herbal and Bestiary, cat. 131, *vi*, 67, 303–4

Henry IV, King, 302

Henry VII, King, 304

Hepworth, Barbara, 32

heraldry, 301

Herbert, William. *See* Pembroke, 3rd Earl of

Herrick, Robert, 299

Herring, William, 260

Hervey, Frederick Augustus. *See* Bristol, 4th Earl of

Higden, Ranulf, *Policronicon*, 64

Hill, Anna Barbara and George, 250

Hill, David, 289

Hilles, Frederick, 44

Hilliard, Nicholas, 240–41; *Portrait of a Lady*, cat. 2, 241; *A treatise concerning the arte of limning*, 240

Hills, Robert, 280, 290; *Cattle in Groups*, 280; *Etchings of Quadropeds*, 280; *Sketches in Flanders and Holland*, 280; *A Village Snow Scene*, cat. 82, 280

Hind, A. M., 242

Hints to form the taste & regulate ye judgment in sketching Landscape (Gilpin), cat. 134, 305

Historical Tour Through Monmouthshire (Coxe), cat. 142, 308

history painting, 247, 251, 255, 261, 278, 281

Hoare, Sir Richard Colt, 308; *Historical Tour Through Monmouthshire* (Coxe), cat. 142, 308

Hoare, William, of Bath, 248

Hodges, Walter Perry, Alken after, title page of *The Beaufort Hunt*, 58

Hogarth, William, 46, 51, 247–48, 249, 257, 274; *Hogarth: His Life, Art, and Times* (Paulson), 50; *The Beggar's Opera*, cat. 14, 247

Hogenberg, Remegius; portrait of Elizabeth I, 64, 298–99

Holbein, Hans, 240; *Hans Holbein at the Court of Henry VIII* (Strong), 47

Holland, Henry, 259

Hollar, Wenceslaus, 241–44; *The Long View of London from Bankside*, 241–42; *View of the East Part of Southwark, Looking Towards Greenwich*, cat. 5, 242; *A View from St. Mary's, Southwark, Looking Towards Westminster*, 242; *View of Steiereck on the Danube*, cat. 4, 242

Holt, Dr., 254

Honorius Augustodunensis, *Imago mundi*, 309

Hope, Eliza, 263

Hope, Elizabeth. *See* Hopetoun, Countess of

Hope, James. *See* Hopetoun, 3rd Earl of

Hopetoun, 3rd Earl of (James Hope), 263; *James Hope, 3rd Earl of Hopetoun*, cat. 47, 263

Hopetoun, Countess of (Elizabeth Hope), 263; *Elizabeth, Countess of Hopetoun*, cat. 46, 263

Hoppner, John, 45

Horace, 310; *Quinti Horatii Flacci Opera*, cat. 146, 310

Hornebolte, Lucas, 240

The Horse (Blake), cat. 73, 276

horse portraits, 246, 252–53, 265, 279, 293, 297; *see also* race horses

horse racing, 252–53, 279, 281; Paul Mellon, interest in, 8, 16, 253; steeplechasing, 303; Wakefield Lawn Races, 256; *see also* horse portraits; race horses

Hoskins, John the elder, 242

Hough, Bishop John, 247

Hounds in a Landscape (Wootton), cat. 13, 246–47

Howard, Sir Arthur, 64

Howard, Thomas. *See* Arundel, 14th Earl of

Howitt, Samuel, 302

Humphreys, Henry Noel, 310; *The Art of Illumination and Missal Painting*, cat. 147, 310

Humphry, Ozias, 45, 253–54, 257, 262, 269

Hudson, Thomas, 254, 259

Hunt, William Holman, 51

Hunt, Leigh, 293

Hunt, William Henry, 290

Hunter, John, 252, 254

Hunter, William, 252

Huntington, Henry E., 44

Hussein of Gebel Tor, 295

Ince, William Henry, 306

India, 258–59, 262, 303

In Rokeby Park (Cotman), cat. 102, 289

Interior of St. Paul's Cathedral (Malton), cat. 55, 267

Ireland, Samuel, 308; *A Picturesque Tour through Holland, Brabant, and Part of France*, 308; *Picturesque Views on the River Medway*, cat. 141, 308

Isabey, Eugène, 293

Isham, Ralph, 59

James I, King, 240–42

James II, King, 242, 244

James Hope, 3rd Earl of Hopetoun (Cosway), cat. 47, 263

Jefferys, James, 269–70; *Deluge*, 269; *Pride Led by the Passions*, 269; *Scene at Gibralter*, 269; *Self-portrait*, cat. 59, 269–70

Jervas, Charles, 248

Johann II, Prince of Liechtenstein, 64

John, Augustus, 297

John, Gwen, 32

John Gubbins Newton and His Sister, Mary Newton (Burnard), cat. 106, 292

Johnson, Guy, 66

Johnson, Phillip, 16

Johnson, Dr. Samuel, 255, 274, 279

Joll, Evelyn, *The Paintings of J. M. W. Turner*, 51

Jones, Thomas, 251, 261, 262–64, 268, 269, 271; *The Claudean Aqueduct and Colosseum*, cat. 48, 263–64

Journal of a Tour Down the Wye (A. Cooper), cat. 140, 307

Jung, Carl, 5, 58

Juvenal, 269

Kahn, Louis: Kimbell Art Museum, 10, 16, *20*, 22; Salk Institute, 16, *17*; Yale Center for British Art, 10, *13–14*, 15–18, *19–25*, 38; Yale University Art Gallery, 16

Kauffman, Angelica, 45

Kay, Henry Isherwood, 45

Keats, John, 293

Kelly, Richard, 24

Kelmscott Press, 68, 298, 310–11; *The Works of Geoffrey Chaucer*, cat. 148, 68, 310–11

Kent, William, 256

King, Peter Malcolm. *See* Lovelace, 4th Earl of

King, Thomas, 273

Kitson, Michael, 36, 38, 52

Kneller, Sir Godfrey, 245–46, 248

Knight, Richard Payne, 270

Kraus, Hans Peter, 63, 64

A Lady of the Blunt Family (Engleheart), cat. 62, 271

Laer, Pieter van (Il Bamboccio), 243

Lafosse, Jean-Baptiste Adolphe, lithograph after Landseer, 294

Lake, Sir James Winter, 304

The Lake of Albano and Castel Gandolfo (J. R. Cozens), cat. 61, 271

Lambert, George, 260

landscape painting, 243, 245, 250–51, 257–58, 260, 263, 270, 277–78, 282–90, 291, 305; and Constable, 286–89; and plein air painting, 260, 271, 288, 290; and Turner, 282–86

Landscape with Cattle (Gainsborough), cat. 37, 257–58

Landseer, Sir Edwin, 246, 293, 294; *The Cat's Paw*, 293; *Favourites, the Property of H.R.H. Prince George of Cambridge*, cat. 109, *36*, 293–94; *The Hunting of Chevy Chase*, 293; *The Monarch of the Glen*, 293; *The Old Shepherd's Chief Mourner*, 293

Landseer, John, 293

Laroon, Marcellus, the Younger, 47; *Marcellus Laroon* (Raines), *42*, 47

Lascelles, Edward, 282–83

Laudonnière, René Goulaine de, 240; *Laudonnière and King Athore* (Le Moyne), 240

Lavater, Johann Kasper, *Essays on Physiognomy*, 268

Lawrence, Sir Thomas, 30, 46, 268, 280–81, 289, 292–94; *Arthur Atherley*, 280; *George James Welbore Agar-Ellis, later 1st Lord Dover*, cat. 83, 281; *Sir Francis Baring, Bt, John Baring, and Charles Wall*, 280

Lederer, John, *The Discoveries of John Lederer*, 63

Leeds (J. M. W. Turner), cat. 88, 283–84

Lefèvre, Raoul, *Recuyell of the Historyes of Troye*, 309

Legge, William. *See* Dartmouth, 2nd Earl of

Legouix, Susan, 269

Leitch, William Layton, 306

Le Liure du Roy Modus et de la Reine Racio (Henri de Ferrières), cat. 126, 301

Le Livre du Roy Modus et de la Royne Racio (Henri de Ferrières), cat. 124, 67, 301

Lely, Sir Peter, 46, 243

Le Moyne de Morgues, Jacques, 240, 300; *La Clef des champs*, 240; *Laudonnière and King Athore*, 240; *A Young Daughter of the Picts*, cat. 1, 240, 300

Lenox, Colonel James, 33, 285

Lennox, 6th Duke of (Charles Stuart), 243; *Charles Stuart, 3rd Duke of Richmond and 6th Duke of Lennox* (Samuel Cooper), cat. 6, 243

Leopold I, Holy Roman Emperor, 64

Leslie, Charles Robert, 33, 285, 293, 306

Lewis, Frederick Christian, 294

Lewis, John Frederick, 294–95; *A Frank Encampment in the Desert of Mount Sinai, 1842*, cat. 111, 291, 295

Lewis, Wilmarth Sheldon, 44

Linnell, John, 274, 290–92, 295; *The Farmer Boy*, 291; *Shepherd Boy (Shepherd Boy Playing a Flute)*, cat. 105, 291

Linschoten, Jan, *Voyages into Ye Easte and Weste Indies*, 66–67

L'Institut de France, Paris (Boys), cat. 110, 294

Lippmann, Walter, 6

Loch Coruisk, Isle of Skye—Dawn (Robson), cat. 103, 290

Locke, John, library of, 57, 63

Loo, Jean-Baptiste van, 248

Lorrain, Claude, 250, 257–58, 261, 271, 286

Louis XIV, King, 245

Loutherbourg, Philippe Jacques de, 261–62, 277

Lovelace, 4th Earl of (Peter Malcolm King), 63

Lowinsky, Thomas Edmond, 8

Lucas, David: prints after Constable, 306; engraving after *Sir Richard Steele's Cottage* (Turner), 289

Luttrell, Dorothy, 305

Luttrell, Edward, 305; *An Epitome of Painting*, cat. 133, 67–68, 305

Lyon, George Francis, *Sketches of the Second Parry Arctic Expedition*, 67

Macartney, Lord George, 278

MacCulloch, John, 284

Magellan, Ferdinand, 67

Malton, James, 267

Malton, Thomas (the elder), 267

Malton, Thomas, 267; *Interior of St. Paul's Cathedral*, cat. 55, 267; *A Picturesque Tour Through the Cities of London and Westminster*, 267; *Picturesque Views of Oxford*, 267

Man Hunting with a Pointed Staff and a Hound (Barlow), cat. 9, 244–45

Mannings, David, *Sir Joshua Reynolds*, *51*

manuscripts, 298, 300–301, 303, 304, 308, 309

maps, 63, 64–66, 298–99, 307, 309

The Market Girl (The Silver Age) (Walton), cat. 52, 266

Marlow, William, 248

Marshal, Alexander, 304; *St. George and the Dragon*, in *Anecdotes of Painting in England* (Walpole), cat. 132, 304–5

Marshall, Ben, 279; *Muly Moloch*, cat. 81, 279

Marshall, John, 284

Matisse, Henri, 66

Mayer, Lance, 292

McKay, William, 45

Medici, Ferdinando de', Cardinal, 269

Medlycote, Thomas, 250

Mellon, Andrew, 2, *3*, 4, 58; collector of art, 2, 4–6; and National Gallery of Art, 4–7

Mellon, Mary Conover, 5, 58–59

Mellon, Nora McMullen, 4

Mellon, Paul, *xi*, *3*, *4*, *5*, *11*; biography of, 2–11; collector of art, 5–10, 29–32; collector of books, 4, 57–70, 298, 301, 303–304, 307, 309; and construction of Yale Center for British Art, *13*, 15–18, *20–22*, 24, 25, 38; and horses, 4–5, 8, 16, 297; *Paul Mellon on Dublin* (Munnings), cat. 116, 297; and publication of Studies in British Art, 46–47

Mellon, Rachel Lambert Lloyd (Bunny), 5, 8, 22; collector of books, 59, 68, 71n.20, 303

Mellon, Thomas, 7

Mellon Chansonnier, 59

Mendelssohn, Felix, 285

Mengs, Anton Raphael, 258

Mercier, Philippe, 47

Mer de Glace, in the Valley of Chamouni, Switzerland (J. M. W. Turner), cat. 86, 72–73, 283

Merian, Matthäus, the elder, 241

Merivale, John, 262

Merke, Henri, 302

Meyers, Marshall, *13*, 22, 25

Michelangelo, 255, 272, 295

Middleton, 1st Baron (Sir Thomas Willoughby), 245

Millais, John Everett, 293

Millar, Oliver, *Zoffany and His Tribuna*, 47

Milton, John, 248, 274, 295; *Paradise Lost*, 277

miniature painting, 240–43, 249, 262–63, 265, 268, 271, 305, 309

Mr. and Mrs. Hill (Devis), cat. 18, 249–50

Mrs. Abington as Miss Pru (Reynolds), cat. 31, *28*, 30, 255

Moll, Herman, 307

Monboddo, Lord (James Burnett), 268

Monro, Dr. Thomas, 265, 270, 278, 282, 289

Montagu, Lady Mary Wortley, 248

A Moonlight Scene with a Winding River (Palmer), cat. 112, 295

Moore, Henry, 32

Moore, James, 282

Morland, George, 272, 281

Morland, Thomas Hornby, 281

Morris, William, 309–10; *The Works of Geoffrey Chaucer*, cat. 148, 68, 310–11

Morritt, John, 289

Mortimer, John Hamilton, 47, 269

Mountainous Landscape (Alexander Cozens), cat. 22, 251

Mullaly, Terence, 9

Mulready, William, 290

Muly Moloch (Marshall), cat. 81, 279

Munnings, Sir Alfred, 246, 279, 297; *Paul Mellon on Dublin*, cat. 116, 297

Murray, Charles Fairfax, 310

music, 247, 259, 273, 277, 309

Myrrour of the Worlde (Caxton), cat. 143, 302, 309

Napoleon I, Emperor, 269, 283, 284

National Gallery of Art, Washington, D.C., 16, 18, 36, 51, 61; bequest of Chester Dale, 5; bequests of Paul Mellon, 5, 9, 36; East Building, 15, 18; founding of, 4–7

Nattes, J. C., 280

natural history: animal subjects, 244, 252–54, 280, 281, 293–94; books, 4, 59, 303–4; *see also* botanical books; drawings, botanical; horse portraits; sporting art; sporting books

Negus, Francis, 307

Neoclassicism, 248, 258, 277

Nesfield, William Andrews, 280

Newhouse, Charles B., *The Roadsters Album*, 58

Newton, Charity, 292

Newton, Sir Isaac, 247

Newton, John, 292

Newton, John Gubbins and Mary, *John Gubbins Newton and His Sister, Mary Newton* (Burnard), cat. 106, 292

Nicoll, John, 50

Nicolson, Benedict, *Joseph Wright of Derby, Painter of Light*, 49

Nicholson, Ben, 32

Nivelon, François, 250

Noon, Patrick, 243

The Norman Gate and Deputy Governor's House (Sandby), cat. 32, 255–56

Northeast View of Wakefield Lodge in Whittlebury Forest, Northampton (Sandby), cat. 33, 256

Northwick, 2nd Baron (John Rushout), 68

Oak Spring Garden Library, 59, 68, 70n.4, n.7, n.11, 303

O'Keefe, John, 265

Old Dominion Foundation, 7, 47, 59

Old Masters, 305; collected by Andrew Mellon, 2, 4–6; influence of, 249, 254–55, 257, 281, 283–86, 304

Oliver, Isaac, 240–41; *Robert Devereux, 2nd Earl of Essex*, cat. 3, 240–41

Oliver, Peter, 241

Olivier, Pierre, 241

On the Washburn (J. M. W. Turner), cat. 87, 283

Oppé, A. P., 261

Oriental Field Sports (Williamson), cat. 128, 302

Orme, Edward, 302

Ottley, William Young, 268

Ovid, *Metamorphoses*, 266

Oxford, 2nd Earl of (Edward Harley), 246

A Paddle-steamer in a Storm (J. M. W. Turner), cat. 93, 285–86

Paley, William, 291

Palmer, Alfred Herbert, 296

Palmer, Hannah, 295

Palmer, Samuel, 291, 295–96; *The Golden Valley*, 296; *The Harvest Moon*, cat. 114, ii, 296; *A Moonlight Scene with a Winding River*, cat. 112, 295; *The Timber Wain*, 296; *The Weald of Kent*, cat. 113, 295–96

Palmerston, 2nd Viscount (Henry Temple), 264

Parry, Sir William, 67

Pars, William, 261, 263, 264, 268; *A View of Rome Taken from the Pincio*, cat. 49, 264

Pasquin, Anthony, 264, 277

Patch, Thomas, 258

Paul Mellon Centre for Studies in British Art, London, 11n.4, 36, 38, 40–41, 44, 48–51, 52

Paul Mellon Foundation for British Art, 7, 10, 16, 47–49, 51; publications of, 7, 47–49

Paul Mellon on Dublin (Munnings), cat. 116, 297

Paulson, Ronald, *Hogarth: His Life, Art, and Times*, 50

Payne, Christiana, 280, 296

Payne, Sir Ralph, 265

Pei, I. M., 15–16

Pembroke, 3rd Earl of (William Herbert), 304

Pennington, Richard, 241

perspective, 241, 248, 267, 278, 282

Pether, William, 259

Pevsner, Sir Nikolaus, 46

Phillip, John "Spanish," 296

Phillipps, Sir Thomas, 66, 70n.21, 296, 299

physiognomy, 268

Picasso, Pablo, 66

Picturesque, the, 256, 261–62, 265, 278, 280, 286, 288, 289, 305, 307; tour books of, 262, 266–67, 284, 294, 308

Picturesque Views on the River Medway (Ireland), cat. 141, 308

Pillsbury, Edmund, 10

Pine, John, *Quinti Horatii Flacci Opera* (Horace), cat. 146, 310

Piranesi, Giovanni Battista, 268

Pope, Alexander, 247, 248; *Alexander Pope* (Roubillac), cat. 15, 10, 248; *Iliad*, translation of, 277; "Summer—The Second Pastoral," 291

Porter, John, *The craft of venery*, cat. 125, 301

Portrait of a Lady (Hilliard), cat. 2, 241

Portrait of a Man (Wright of Derby), cat. 40, 259–60

portraiture, 240–41, 250, 254–55, 257–62, 269–71, 273, 277, 280, 292, 297; collected by Paul Mellon, 30; conversation piece, 249–50, 267; estate portraiture, 245, 256, 286, 289; sculpture, 248; *see also* horse portraits; miniature painting

Postle, Martin, *Sir Joshua Reynolds*, 51

Pottle, Frederick, 44

Price, Sir Uvedale, 255

print techniques: aquatint, 255, 263, 267, 302–3, 308; chromolithography, 310; etching, 274–75, 289, 295, 306; line engraving, 245, 264, 310; lithography, 284; mezzotint engraving, 68, 245, 259, 264, 281, 305

The Progress of Poesy. A Pindaric Ode. "On Cythera's day" (Blake), cat. 70, 275

Prown, Jules David, 10, 30, 32, 49, 50, 261; and construction of the Yale Center for British Art, 13, 15–23, 21–22, 25

Ptolemy, 298; *Geographie opus nouissima*, compiled by Waldseemüller, cat. 117, 298

Pumpkin with a Stable-lad (Stubbs), cat. 25, 2, 253

Purchas, Samuel, 299, 300

Pyne, W. H., 280

Pynson, Richard, cat. 145, 64, 309

Queen Square, London (Dayes), cat. 79, 278

Queensbury, 4th Duke of (William Douglas), 273–74

Quinti Horatii Flacci Opera (Horace), cat. 146, 310

race horses: Dublin, 297; Eagle, 281; Escape, 279; Fort Marcy, 16; Gimcrack, 253; Mill Reef, 8; Muly Moloch, 279; Pumpkin, 253; Sea Hero, 8; Turf, 253

Raines, Robert, *Marcellus Laroon*, 42, 47

Raleigh, Sir Walter, 240, 299–300

Ramsay, Allan, 51

Randall, David, 58–59

Raphael, 250, 255; *Alba Madonna*, 43; *St. George and the Dragon*, 304–5

Read, Herbert, 46

Redouté, Pierre Joseph, 59, 303

Reinagle, Ramsay Richard, 306

Rembrandt van Rijn, 260, 285

Revett, Nicolas, 264; *Antiquities of Athens*, 264

Reynolds, Graham, 35, 241; *The Later Paintings and Drawings of John Constable*, 51

Reynolds, Sir Joshua, 30, 44, 46, 248, 250, 254–55, 258, 271, 278, 293; *Discourses*, 255; *Mrs. Abington as Miss Prue in William Congreve's "Love for Love,"* cat. 31, 28, 30, 255; *Reynolds* (Waterhouse), 46; and the Royal Academy, 255, 260; *Sir Joshua Reynolds* (Mannings and Postle), 51

Ricci da Montepulciano, Giovanni, Cardinal, 269

Rich, John, 247

Rich, Robert, *News from Virginia*, 63

Richardson, Jonathan, the elder, 248

Richmond, 3rd Duke of (Charles Lennox), 251, 265

Richmond, George, 291

Rimbault, Stephen, 258

Ritchie, Andrew, 10, 33

Rivet, Charles, 293

Robert Devereux, 2nd Earl of Essex (Oliver), cat. 3, 240–41

Roberts, David, 306; *The Destruction of Jerusalem by Titus*, 306; sketch of *Destruction of Jerusalem by Titus*, from *Record Books*, cat. 137, 68, 306

Roberts, William, 45

Robertson, Alexander, 305

Robertson, Andrew, 305

Robertson, Archibald, 67, 305; *Elements of the Graphic Arts*, 67, 305; sequel to *Elements of the Graphics Arts*, cat. 135, 305

Robinson, Duncan, 10

Robinson, Lionel and Philip, 63, 66

Robson, George Fennel, 280, 290; *Loch Coruisk, Isle of Skye—Dawn*, cat. 103, 290; *Scenery of the Grampians*, 290

Rochambeau, comte de (Jean-Baptiste Donatien de Vimeur), 63

Rockefeller, John D., 2

Rockingham, 2nd Marquis of (Charles Watson-Wentworth), 251, 252

Romanticism, 252, 269, 275, 281, 284, 285, 288, 295

Rome from the Villa Madama (Wilson), cat. 19, 250

Romney, George, 45, 271

Rooker, M. A.; *A Collection of Landscapes*, 256

Roosevelt, Franklin D., President, 6–7

Rosa, Salvator, 260, 261

Rose, Joseph, 259

Rosenbach, A. S. W., 63, 301

Rosenthal, Michael, 288

Roslin Castle, Midlothian (Sandby), cat. 34, 256

Rouault, Georges, 66

Roubiliac, Louis-François, 247–48; *Alexander Pope*, cat. 15, 10, 248

Rousseau, Jean-Jacques, 271

Rovere, Francesco Maria della. *See* Urbino, Duke of

Rowlandson, Thomas, 8, 272–74; *An Audience Watching a Play at Drury Lane*, cat. 64, 272–73; *The Connoisseurs*, cat. 66, 273; *The Exhibition Stare-case, Somerset House*, cat. 68, 27, 274; *Georgiana, Duchess of Devonshire, Her Sister Harriet, Viscountess Duncannon and a Musician*, cat. 65, 273; *A Worn-out Debauchee*, cat. 67, 273–74

Rowlandson, William, 272

Roxburghe Club, 67, 303

Royal Academy of Arts, London, 1, 46, 250, 252, 255, 258, 260, 263, 264, 265, 271, 274, 277, 279, 281, 283, 285, 290, 294, 306; *The Exhibition Stare-case, Somerset House* (Rowlandson), cat. 68, 274; *Painting in England, 1700–1850*, 9, 29, 47, 49; presidents of, 255, 261, 280, 289, 297; Royal Academy Schools, 262, 266–67, 269, 271, 272, 277–78, 280, 282, 286, 291, 293, 296

Rubens, Sir Peter Paul, 280–81; *Peace Embracing Plenty*, 30, 31

Runciman, Alexander, 267

Rundell, Bridge, and Rundell, silversmiths, 271

Rushout, John. *See* Northwick, 2nd Baron

Ruskin, John, 282, 285–86, 290, 294–95
Russell, John. *See* Bedford, 6th Duke of
Rust, Elizabeth, 265
The Rustic Lover (Wheatley), cat. 54, 267
Ruysch, Johannes, 298
Rysbrack, Michael, 248

St. George and the Dragon (Marshal), cat. 132, 304–5
St. John, Sir Frederick. *See* Bolingbroke, 2nd Viscount
St. John, Henry. *See* Bolingbroke, 1st Viscount
Salk, Jonas, 16–18
Sandby, Paul, 255–56, 269; aquatints after Pars, 264; *Lady Frances Scott and Lady Elliott*, 256; *Norman Gate*, 256; *The Norman Gate and Deputy Governor's House*, cat. 32, 255–56; *Northeast View of Wakefield Lodge in Whittlebury Forest, Northampton*, cat. 33, 256; *Roslin Castle, Midlothian*, cat. 34, 256
Sandby, Thomas, 255
Sargent, John Singer, 51, 297
Sassoon, Sir Philip, 46
Saxton, Christopher, 298; *Atlas of the Counties of England and Wales*, cat. 118, 64, 298–99
Sayer, Robert, 244
Schöner, Johann, "Brixen Globes," 64
Schongauer, Martin, 295
Schoolmaster Printer, 302
Scott, Samuel, 248
Scott, Sir Walter, 285, 290, 293; *Lord of the Isles*, 290; *Poetical Works*, 285; *Rokeby*, 289
Seckford, Sir Thomas, 298
Sedley, Sir Charles, 289
Self-portrait (Jefferys), cat. 59, 269–70
Serota, Sir Nicholas, 48
Shakespeare, William, 248, 277
Shanes, Eric, 283
Shepherd (Sheppard), William, 244
Shepherd Boy (*Shepherd Boy Playing a Flute*) (Linnel), cat. 105, 291
Sheridan, Richard Brinsley, 273; *The School for Scandal*, 255
Shipley, William, drawing school of, 262–64, 266
Shipping in an Estuary, Probably near Quilleboeuf (Bonington), cat. 107, 292–93
Shirley, Andrew, *Bonington*, 46
Shyp of Folys, (Brant), cat. 145, 309
Siberechts, Jan, 245; *Wollaton Hall and Park, Nottinghamshire*, cat. 11, 245
Sickert, Walter, *The Camden Town Murder*, 32
Sidney, Lady Mary, 240
Sidney, Sir Philip, 240–41
Siltzer, Frank, 303

Sir Joseph Banks's Fishery Book (Sarah Banks), cat. 139, 307
Sir Richard Steele's Cottage, Hampstead (Constable), cat. 101, 289
Skeaping, John, 32
Skelton, Jonathan, 260–61; *Harbledown, a Village near Canterbury*, cat. 42, 260–261
Sleeping Leopard (Stubbs), cat. 26, 253
Sloane, Sir Hans, 242
Smart, John, 262; *Colonel James Stevenson*, cat. 45, 262
Smart, Samuel, wife of, 264
Smith, Douglas, 49
Smith, Greg, 263
Smith, John, *Generall historie of Virginia*, 63
Smith, John Raphael, 281
Smith, John Thomas, 305–6; letter from Constable, cat. 136, 305–6
Smith, John "Warwick," 251, 261, 263, 264, 268–69; *Bay Scene in Moonlight*, cat. 58, 269; *Select Views in Great Britain*, 268; *Select Views in Italy*, 268; *The Villa Medici, Rome*, cat. 57, 269
Smith-Stanley, Edward. *See* Derby, 13th Earl of
Smythson, Robert, 245
Snelgrove, Dudley, 10
Soane, Sir John, 267
Society of Artists of Great Britain, 250; academy of, 265; Duke of Richmond's sculpture gallery, 272; members and exhibitors, 1, 250–52, 255–56, 259–65, 269, 278
Society of Arts, 265, 267, 269
Society of Dilettanti, 264, 269
Society of Painters in Water-Colours, 268, 280, 289–90, 294–95
Solkin, David, 250, 259–60
Songs of Innocence and of Experience (Blake), cat. 69, 59, 275
South, William, 253
Spencer, Mary, 251, 254
sporting art, 244–47, 264, 279, 303; collected by Paul Mellon, 10, 36, 46, 253
sporting books, 301–3; collected by Paul Mellon, 4, 46, 58–61, 66–68, 298
Staffa, Fingal's Cave (J. M. W. Turner), cat. 91, 32, 33, 285
Stag Hunt (Jan Wyck), cat. 12, 246
Stanfield, Clarkson, 306
Stanley, Edward. *See* Derby, 11th Earl of
Staunton, Sir George, 279
Steele, Sir Richard (Isaac Bickerstaff), 255, 289
Stevens, Stoddard, 16
Stevenson, James, *Colonel James Stevenson* (Smart), cat. 45, 262
Stewart, Frederick William Robert. *See* Castlereagh, Viscount

Stirling of Keir, General Archibald, 59
Stokes, Charles, 284
Stoop, Dirck, 245
Stothard, Thomas, 306
Strong, Roy: *The English Icon*, 48, 49; *Hans Holbein at the Court of Henry VIII*, 47
Stuart, Charles. *See* Lennox, 6th Duke of; Richmond, 3rd Duke of
Stuart, Frances Teresa, 243
Stubbs, George, 5, 38, 46, 51, 247, 251–54, 265, 279, 281, 293; *The Anatomy of the Horse*, 251, 254; *A Comparative Anatomical Exposition*, cats. 28–30, 252, 254; *Hyena with a Groom on Newmarket Heath*, 37; *Lustre, Held by a Groom*, 36; *Pumpkin with a Stable-lad*, cat. 25, 2, 253; *Self-portrait*, 253; *Sleeping Leopard*, cat. 26, 253; *A Comparative Anatomical Exposition...: Fowl Skeleton*, cat. 30, 254; *Studies for Comparative Anatomical Exposition...: Human Figure, Anterior View*, cat. 28, 254; *Studies for Comparative Anatomical Exposition...: Tiger, Lateral View*, cat. 29, 254; *Study for the Self-portrait in Enamel*, cat. 27, 253–54; *Turf, with Jockey Up, at Newmarket*, cat. 24, 30, 253; *Zebra*, cat. 23, 1, 6, 252
Stubbs, George Townly, 252
Studies for Comparative Anatomical Exposition...: Human Figure, Anterior View (Stubbs), cat. 28, 254
Studies for Comparative Anatomical Exposition...: Tiger, Lateral View (Stubbs), cat. 29, 254
Study for the Self-portrait in Enamel (Stubbs), cat. 27, 253–54
Sublime, the, 251, 252, 256, 281, 284
Sunderland, John, 269
Sutton, Denys, 9, 47, 49
Swift, Jonathan, 248
Swinburne, Algernon, 311

Tankerville, 5th Earl of (Charles Augustus Bennett), 293
Tatham, Frederick, 277
Taylor, Basil, 5–10, 46, 29, 253, 292; and Paul Mellon Foundation for British Art, 7, 10, 46–49, 52; *Portrait of Basil Taylor* (Frankl), 6
Taylor, Charles, 21
Taylor, John Edward, 283
Teerlinc, Levina, 240
Temple, Henry. *See* Palmerston, 2nd Viscount
Temple of Minerva Medica, Rome (Wilson), cat. 20, 250–51
Thackeray, William Makepeace, 294
"Then the Divine hand found the Two limits, Satan and Adam" (Blake), cat. 75, 276–77

Thicknesse, Philip, 257
Thorold, Mrs. John, 253
Tillemans, Peter, 249
Tinker, Chauncey Brewster, 44, 58–61
Tom Conolly of Castletown Hunting with His Friends (Healy), cat. 50, viii, 265
Toms, William Henry, *Chorographia Britanniae*, 307
topographical drawing, 240, 251, 265, 267, 268, 270
topographical painting, 248–49, 269, 278
Towne, Francis, 261–62, 263, 264, 268; *Ambleside*, cat. 44, 261
Townley, Charles, 267
Transylvanus, Maximilianus, *De Moluccis Insulis*, 67
The Triumph of Music (*The Glee Club*), cat. 78, 277–78
A True Description of the Naval Expedition of Francis Drake, cat. 120, 66, 202–03, 299
Turf, with Jockey Up, at Newmarket (Stubbs), cat. 24, 30, 253
Turner, Dawson, 265, 289
Turner, Joseph Mallord William, 47, 255, 265–66, 270, 278, 282–86, 293, 307; *The Channel Sketchbook*, cat. 94, 35, 36, 286; *Dort, or Dordrecht, the Dort Packet-boat from Rotterdam Becalmed*, cat. 90, 30, 33, 284–85; *The Eruption of the Souffrier Mountains*, 284; *Fighting Temeraire*, 285; *Fishermen at Sea*, 285; *Fort Vimieux*, 285; *Glacier and Source of the Arveron*, 283; *Large Farnley Sketchbook*, 283; *Leeds*, cat. 88, 283–84; *Mer de Glace, in the Valley of Chamouni, Switzerland*, cat. 86, 72–73, 283; and "Monro Academy," 269, 278, 282; *On the Washburn*, cat. 87, 283; *A Paddle-steamer in a Storm*. cat. 93, 285–86; *The Paintings of J. M. W. Turner* (Butlin and Joll), 51; and the Royal Academy, 267, 282–84; *Source de l'Arveron, Valley of Chamouni*, 283; sketchbooks of, 35, 36, 283; *Staffa, Fingal's Cave*, cat. 91, 32, 33, 285; *Venice, The Mouth of the Grand Canal*, cat. 92, 285; *Vesuvius in Eruption*, cat. 89, 284; *Wreckers—Coast of Northumberland, with a Steam-boat Assisting a Ship off Shore*, 33
Turner, William, of Oxford, 290–91; *Donati's Comet*, cat. 104, 290–91
Twiti, William, 301; *The craft of venery*, cat. 125, 67, 301–2
Tyers, Jonathan, 247
typography, 310–11

Urban VIII, Pope, 270

Urbino, Duke of (Francesco Maria della Rovere), 304

Valk, Gerald, "America," in *Atlas Minor* (Visscher), *65*

Van Devanter, Willis, 61–62, 68

Varley, Cornelius, 291

Varley, John, 290–91

Velde, Willem van de, the elder, 243–44; *Celebration on the Thames near Whitehall*, cat. 8, 244

Velde, Willem van de, the younger, 243–44

Venice, The Mouth of the Grand Canal (J. M. W. Turner), cat. 92, 285

Verlaine, Paul, *Parallèlement*, 66

Vernet, Claude-Joseph, 250, 269

Vertue, George, 241, 243, 244, 245, 246, 248

Vesuvius in Eruption (J. M. W. Turner), cat. 89, 284

Victoria, Queen, 8, 293

View of the East Part of Southwark, Looking Towards Greenwich (Hollar), cat. 5, 242

A View of Rome Taken from the Pincio (Pars), cat. 49, 264

View of Steiereck on the Danube (Hollar), cat. 4, 242

View of the Waterhouse and Old St. Paul's, London (Thomas Wyck), cat. 7, 243

A View on the Island of Antigua (Hearne), cat. 51, 265

A Village Snow Scene (Hills), cat. 82, 280

The Villa Medici, Rome (John "Warwick" Smith), cat. 57, 269

Villiers, George. *See* Buckingham, 2nd Duke of

Vimeur, Jean-Baptiste Donatien de. *See* Rochambeau, comte de

Virgil, 271, 295

Virginia Museum of Fine Arts, Richmond: bequests of Paul Mellon, 5, 36; *Painting in England, 1700–1850*, 4, 8–9; *Sport and the Horse*, 5–6, 8

Virginiana, 63, 240, 300

Visscher, Claesz Janz., 243

Visscher, Nicholas, *Atlas Minor*, 64; "America" (Valk), *65*

Vivares, François, 251

A Voyage from England to Bombay (Forbes), cat. 130, 303

Wade, George, 247

Waldseemüller, Martin, 64; *Geographie opus nouissima*, cat. 117, 298

Wales, 250, 263, 268, 275, 289–90, 298–99, 307–8

Wales, Prince of. *See* Edward, Prince of Wales; George, Prince of Wales

Wales, Frederick, 22

Walker, John, 7

Walpole, Horace, 44, 255, 256, 264; *Anecdotes of Painting in England*, cat. 132, 243, 246, 304; *Catalogue of Engravers*, 304; collection of, 241, 243; *Correspondence*, 44

Walpole, Robert, 1st Earl of Orford, 8, 247

Walton, Henry, 265–66; *The Golden Age*, 266; *The Market Girl (The Silver Age)*, cat. 52, 266

Ward, Humphrey, 45

Ward, James, 280, 281; *Eagle, A Celebrated Stallion*, cat. 84, 281; *Gordale Scar*, 281; *Waterloo Allegory*, 281

Ward, William, 281

Wark, Robert R., 45

Warner, Malcolm, 252

Warrell, Ian, 285

Warren, Sir Peter, 247

Warwick, 2nd Earl of (George Greville), 269

Warwick Castle (Canaletto), cat. 16, 249

Washington, George, President, 63

watercolor painting, 8, 45–46, 255, 260–62, 263–71, 277, 280–82, 289–91; Associated Artists in Water Colours, 290; Old Water-Colour Society, 280; Society of Painters in Water-Colours, 268, 280, 289–91, 294–95

Waterhouse, Sir Ellis, 44–46, 49–51, 245; *Painting in Britain, 1530–1790*, 46; *Reynolds*, 46, 51

Watson-Wentworth, Charles. *See* Rockingham, 2nd Marquis of

The Weald of Kent (Palmer), cat. 113, 295–96

Webster, Mary, *Francis Wheatley*, 49

Wedgwood, Josiah, 252–53, 259, 271

Wellesley, Sir Arthur. *See* Wellington, 1st Duke of

Wellington, 1st Duke of (Sir Arthur Wellesley), 262

Wells, William, *Western Scenery*, 61

West, Benjamin, 261, 266, 291; *Agrippina Landing at Brundisium*, 261; *The Artist and His Family*, cat. 43, 261; *Death of General Wolfe*, 261

West, Betsy, 261

West, John, 261

West, Robert, 264

West, Thomas, *Guide to the Lakes*, 262

Westmorland, 2nd Earl of (Mildmay Fane), 299

Wheatley, Francis, 46–47, 266–67; *The Browne Family*, cat. 53, 266–67; *The Cries of London*, 267; *Francis Wheatley* (Webster), 49; *The Rustic Lover*, cat. 54, 267; *The Rustic Lover* (print), 267

Whistler, James Abbott McNeill, 51

Whitaker, Thomas Dunham, *The History of Yorkshire*, 284

White, Christopher, 51–52

White, James, 262

White, John, 240, 299–300

Whitley, William T., 45

Wigstead, Henry, 272

Wilcox, Tim, 262

Wilkie, Sir David, 51, 291

Wilkinson, Sir John Gardner, 294

William III, King, 307

William IV, King, 293

Williams, Iolo, 8

Williamson, George C., 45

Williamson, Thomas, 302; *Oriental Field Sports*, cat. 128, 302

Willoughby, Sir Francis, 245

Willoughby, Sir Thomas. *See* Middleton, 1st Baron

Wilson, Benjamin, 258

Wilson, John, 306

Wilson, Richard, 46, 250–51, 258, 263, 306; *The Arbra Sacra on the Banks of Lake Nemi*, cat. 21, 251; *Destruction of the Children of Niobe*, 250; Italian Sketchbook, 49; *Rome from the Janiculum*, 250; *Rome from the Villa Madama*, cat. 19, 250; *Temple of Minerva Medica, Rome*, cat. 20, 250–51

Wilton, Andrew, 286

Wimsatt, William K., 248

Wing, Caleb W., 310

Winstanley, Hamlet, 251

Witten, Laurence, 63–64, 70n.9

Wollaton Hall and Park, Nottinghamshire (Siberechts), cat. 11, 245

Wooded Landscape with Castle (Gainsborough), cat. 38, 258

A Woodland Pool with Rocks and Plants (Gainsborough), cat. 36, 257

Woollett, William, 265, 269

Wootton, John, 246–47; *Althorp Hounds and the Magpie*, 247; *Hounds and a Magpie*, 247; *Hounds in a Landscape*, cat. 13, 246–47; *Releasing the Hounds*, 247

Worde, Wynken de, 64; *Canterbury Tales*, 309

Wordsworth, William, 307; "Prelude VI," 288

The Works of Geoffrey Chaucer (Kelmscott Press), cat. 148, 68, 310–11

A Worn-out Debauchee (Rowlandson), cat. 67, 273–74

Wren, Sir Christopher, 267

Wright, Joseph, of Derby, 45, 251, 259–60; *An Academy by Lamplight*, cat. 41, 260; *Joseph Wright of Derby, Painter of Light* (Nicolson), 49; *Philosopher by Lamplight*, 260; *The Philosopher Giving a Lecture on the Orrery*, 259; *Portrait of a Man*, cat. 40, 259–60; *Three Persons Viewing the Gladiator by Candle-Light*, 259

Wright, Thomas, 250

Wyck, Jan, 243, 245–46; *Stag Hunt*, cat. 12, 246

Wyck, Thomas, 243, 245; *View of London Before the Great Fire*, 243; *View of the Waterhouse and Old St. Paul's, London*, cat. 7, 243

Yale Center for British Art, New Haven, *14*; Academic Advisory Committee, 38; acquisitions by, 35; bequest of books by Paul Mellon, 68, 298; construction of 10, *13–14*, *15–18*, *19–25*, 38; directors of, 10, 15; founding of, 2, 9–10, 30, 36–38, 44, 57; *Studies in British Art*, 38

Yale University Art Gallery, New Haven, 10, 15, 16, 47

Yale University, New Haven: Beinecke Library, Mellon gifts to, 2, 57, 68, 71n.16; and Paul Mellon, 4, 44, 58–59; *see also* Yale Center for British Art; Yale University Art Gallery

Young, Edward, *Night Thoughts*, 274–75

Young, Sir William, 267

A Young Daughter of the Picts (Le Moyne) cat. 1, 240, 300

Zebra (Stubbs), cat. 23, 1, 2, 6, 252

Zoffany, Johan Joseph, 46, 258–59, 265; *The Drummond Family*, cat. 39, 259; Royal Academy members attending a life drawing class, 263; *Zoffany and His Tribuna* (Millar), 47

Zucarelli, (Giacomo) Francesco, 250

Photography Credits

Catalogues 1–148
Richard Caspole, Yale Center for British Art

Catalogue 116: Image by Courtesy of Felix Rosenstiel's Widow & Son Ltd., London. © Sir Alfred Munnings Art Museum
Page xi: Photograph: William B. Carter, Yale Department of Public Information

John Baskett
FIGS. 1, 2, 9: Richard Caspole, Yale Center for British Art
FIG. 3: © Condé Nast Archive/CORBIS, Photo by Horst P. Horst
FIG. 4: Photo by Brown Brothers, from Stewart H. Holbrook, *The Age of the Moguls: Mainstream of America* (Garden City, N.Y.: 1953)
FIG. 6: Photo from Paul Mellon, with John Baskett, *Reflections in a Silver Spoon: A Memoir* (New York: 1992)
FIG. 8: Photo by John Baskett
FIG. 11: Photo by Carroll Cavanagh

Jules David Prown
FIG. 2: © Marc L. Lieberman/Salk Institute for Biological Studies
FIG. 3: Photo by George Pohl
FIG. 4: Photo by Will Brown, Yale Center for British Art, Department of Rare Books and Manuscripts, YCBA Archives
FIGS. 5, 12: Photo by C.T. Alburtus
FIG. 7: © 2003 Kimbell Art Museum, Fort Worth, Texas, Photo by Michael Bodycomb
FIGS. 11, 13, 15, 16: Photo by William B. Carter, Yale Department of Public Information
FIG. 14: Photo by Thomas Brown

Duncan Robinson
FIGS. 1–10, 12: Richard Caspole, Yale Center for British Art
FIG. 5: Image courtesy 2007 Artist Rights Society (ARS), New York / DACS, London
FIG. 11: © Virginia Museum of Fine Arts, Photo by Katherine Wetzel

Brian Allen
FIGS. 7–9: Courtesy of Ian Parry (Photographer) and the Paul Mellon Centre for Studies in British Art

William Reese
FIGS. 1–7, 10–12: Richard Caspole, Yale Center for British Art
FIGS. 8, 9: Photo by Steve Tucker